ART LOVER'S TRAVEL GUIDE TO AMERICAN MUSEUMS 1997

ART LOVER'S TRAVEL GUIDE TO AMERICAN MUSEUMS 1997

BY PATTI SOWALSKY AND JUDITH SWIRSKY

ABBEVILLE PRESS PUBLISHERS
NEW YORK LONDON PARIS

To Jerry and Leo, our husbands and best friends.

Patti, in particular, wishes to dedicate the fifth anniversary edition of On Exhibit to her friend and mentor Phil Desind, whose recent passing leaves a hole in the lives of artists and collectors alike. A gallery owner for more than thirty years, Desind, who only recently was described as an "80 year-old going on 20," was a major force in the recognition and promotion of contemporary American realist art. He will be sorely missed.

ISBN 0-7892-0363-4

First Edition

10 9 8 7 6 5 4 3 2 1

Library of Congress Cataloging-in-Publication Data available upon request.

CONTENTS

A Special Anniversary Notice 9
Acknowledgments .. 9
Introduction .. 10
Important Information 11
How to Use this Guide 12
Explanation of Codes 13
Museums and Exhibitions by State
 Alabama .. 16
 Alaska ... 22
 Arizona .. 23
 Arkansas ... 31
 California .. 33
 Colorado ... 76
 Connecticut 82
 Delaware ... 90
 District of Columbia 91
 Florida .. 102
 Georgia .. 128
 Hawaii ... 136
 Idaho .. 138
 Illinois .. 139
 Indiana .. 153
 Iowa ... 162
 Kansas ... 170
 Kentucky ... 176
 Louisiana .. 179
 Maine .. 183
 Maryland ... 187
 Massachusetts 192
 Michigan ... 213
 Minnesota .. 222
 Mississippi 228
 Missouri ... 231
 Montana .. 237
 Nebraska ... 241
 Nevada ... 244

New Hampshire . 245
New Jersey . 247
New Mexico . 254
New York . 259
North Carolina . 308
North Dakota . 317
Ohio . 318
Oklahoma . 330
Oregon . 334
Pennsylvania . 337
Rhode Island . 354
South Carolina . 357
South Dakota . 361
Tennessee . 364
Texas . 368
Utah . 386
Vermont . 388
Virginia . 391
Washington . 399
West Virginia . 406
Wisconsin . 407
Wyoming . 414
Selected Listing of Traveling Exhibitions . 417
Selected Listing of Museums and Exhibitions
 with Acoustiguide Tours Available . 429
Special Acknowledgement from Accoustiguide 430
Alphabetical Listing of Museums . 431

A SPECIAL ANNIVERSARY NOTICE

Congratulations to us! We're five years old!
And how are we celebrating this momentous occasion?
With some new additions to the family, of course!

In addition to thousands of loyal fans who consider the On Exhibit *Art Lover's Travel Guide* series to be their "art bible," we are proud to announce that we have added two distinguished corporations to the On Exhibit family: namely, the Accoustiguide Corporation, known for more than forty years as the originator of the audio tour, and Abbeville Press, our new worldwide distributor.

In the years to come, our new "family" promises to continue providing the art-loving traveler — and art professional — with the most factual, timely, and comprehensive guide available to the hundreds of treasure houses that preserve America's artistic heritage.

ACKNOWLEDGMENTS

No man — or in this case two women — is an island. Even in the somewhat solitary process of writing a book, the help, counsel, and encouragement of others is essential. We owe a debt of thanks first to our children John and Susan Sowalsky and Marjorie and Larry Zelner, who have solved numerous technical problems for us with their expertise. A special note of thanks is extended to Ron Feldman of Ronald Feldman Fine Arts, who recognized that a good resource to fine art museums was long overdue, and who helped us to make the On Exhibit series a reality. We are deeply grateful as well for the aid and support of our corporate sponsor, Irvin Feld and Kenneth Feld Productions, Inc., as well as to the many exhibition services that have supplied us with invaluable information.

Finally, we want to thank the thousands of art lovers and hundreds of participating museums who have enthusiastically supported our effort.

INTRODUCTION

Celebrating its fifth successful year of annual publication, On Exhibit's *Art Lover's Travel Guide to American Museums* is the comprehensive guide to art museums nationwide. Easy to use, up to date, and completely reliable, it is the ultimate museum reference.

Why did we create On Exhibit? Like you, we are among the millions of art lovers who enjoy visiting museums wherever we go. All too often, reliable information (especially about little-known hidden treasures) was difficult, if not totally impossible, to find. Listings for high-quality exhibitions in major cities often contained no information regarding admission or ticket requirements. Other exhibits were entirely overlooked simply because newspaper and magazine reviews appeared just as a show was about to close.

Written for those who travel on business or for pleasure and love to explore interesting art museums, On Exhibit's annual travel guides allow you to "know before you go" with complete assurance. With this guide in hand, you will never again miss a "little gem" of a museum or an important exhibition for lack of information.

We encourage you to join the thousands of art lovers who are loyal fans of On Exhibit. Like them, you are certain to be completely delighted with this quick, yet comprehensive overview of the America's artistic riches.

IMPORTANT INFORMATION

In the museum world, nothing is written in stone. All hours, fees, days closed, and especially exhibitions, including those not marked as tentative, are subject to change at any time. The information in this guide is as accurate as possible at the time of publication. However, we strongly suggest that you call to confirm any exhibition you wish to see. We particularly request that you note the exclamation point ("!"). This is used to remind you to call or check for information or any other verification.

Please note that exhibitions at most college and university museums are only scheduled during the academic year. In addition, some museums that have no exhibition listings simply did not have the information available at press time. Please call ahead to any museum for an update.

Not all museums responded to our request for information, and therefore have abbreviated listings.

Every effort has been made to check the accuracy of all museum information, as well as exhibition schedules. If you find any inaccuracies, please accept our apologies — but do let us know. Finally, if we have inadvertently omitted your favorite museum, a letter to us would be most appreciated, so we can include it in the 1998 edition.

HOW TO USE THIS GUIDE

The On Exhibit *Art Lover's Travel Guide* has been designed to be reader-friendly.

All museums are listed in a logical alphabetically by state, and then by city within each state.

Most permanent collection and museum facility information is expressed in easily recognized standard abbreviations. These are explained in the front of the book — and, for your convenience, on the back of the enclosed bookmark.

Group tour reservations must be arranged well in advance. When calling, be sure to check on group size requirements and fee information.

As a reminder, it is recommended that students and seniors always present proper I.D.'s in order to qualify for museum fee discounts wherever they are offered.

EXPLANATION OF CODES

The coding system we have developed for this guide is made up primarily of standardized, easy to recognize abbreviations. All codes are listed under their appropriate categories.

MAIN CATEGORIES

AM	American	IND	Indian
AF	African	IMPR	Impressionist
AN/GRK	Ancient Greek	JAP	Japanese
AN/R	Ancient Roman	LAT/AM	Latin American
AS	Asian	MEX	Mexican
BRIT	British	MED	Medieval
BYZ	Byzantine	NAT/AM	Native American
CH	Chinese	OC	Oceanic
CONT	Contemporary	OM	Old Masters
DU	Dutch	OR	Oriental
EGT	Egyptian	P/COL	Pre-Columbian
EU	European	P/RAPH	Pre-Raphaelite
FL	Flemish	REG	Regional
FR	French	REN	Renaissance
GER	German	RUSS	Russian
IT	Italian	SP	Spanish

MEDIUM

CER	Ceramics	PHOT	Photography
DEC/ART	Decorative Arts	POST	Posters
DRGS	Drawings	PTGS	Paintings
GR	Graphics	SCULP	Sculpture
PER/RMS	Period Rooms	W/COL	Watercolors

13

SUBJECT MATTER

AB	Abstract	FIG	Figurative
ANT	Antiquities	FOLK	Folk Art
ARCH	Architectural	LDSCP	Landscape
CART	Cartoon	PRIM	Primitive
EXP	Expressionist	ST/LF	Still Life
ETH	Ethnic		

REGIONS

E	East	S	South
MID/E	Middle East	W	West
N	North		

PERM/COLL Permanent Collection

The punctuation marks used for the permanent collection codes denote the following:

The colon (":") is used after a major category to indicate sub-listings with that category. For example, "AM: ptgs, sculp" indicates that the museum has a collection of American paintings and sculpture.

The semi-colon (";") indicates that one major category is ending and another major category listing is beginning. For example, "AM: ptgs; SP: sculp; DU; AF" indicates that the museum has collections that include American paintings, Spanish sculpture, and works of Dutch and African origin.

A number added to any of the above denotes century, i.e., "EU: ptgs 19, 20" means that the collection contains European painting of the nineteenth and twentieth centuries.

MUSEUM SERVICES

Y	Yes
☎	Telephone Number
Ⓟ	Parking
!	Call to Confirm or for Further Information
♿	Handicapped Accessibility
🍴	Restaurant Facilities
ADM	Admission
SUGG/CONT	Suggested Contribution — Pay What You Wish, But You Must Pay Something
VOL/CONT	Voluntary Contribution — Free Admission, Contribution Requested.
F	Free
F/DAY	Free Day
SR CIT	Senior Citizen, with I.D. (Age may vary)
GT	Group Tours
DT	Drop in Tours
MUS/SH	Museum Shop
H/B	Historic Building
S/G	Sculpture Garden
TBA	To Be Announced
TENT!	Tentatively Scheduled
ATR!	Advance Tickets Required - Call
CAT	Catalog
WT	Exhibition Will Travel - see index of traveling exhibitions
⌒	Acoustiguide Tour Available

HOLIDAYS

ACAD!	Academic Holidays — Call For Information		
LEG/HOL!	Legal Holidays — Call For Information		
THGV	Thanksgiving		
MEM/DAY	Memorial Day		
LAB/DAY	Labor Day		
M	Monday	F	Friday
TU	Tuesday	SA	Saturday
W	Wednesday	S	Sunday
T	Thursday		

15

MUSEUMS AND EXHIBITIONS BY STATE

ALABAMA

Birmingham

Birmingham Museum of Art
2000 8th Ave. North, **Birmingham, AL 35203**
✆: 205-254-2566
HRS: 10-5 Tu-Sa, Noon-5 S DAY CLOSED: M HOL: 12/25, 1/1; THGV
VOL/CONT: Y ᕦ: Y; Fully accessible ℗ Y; Adjacent to the museum MUS/SH: Y ⑂ Y; Restaurant
GR/T: Y GR/PH: CATR! 205-254-2318 DT: Y TIME: 11:30 & 12:30 Tu & Sa; 1:30 S; other ! S/G: Y
PERM/COLL: AM: ptgs; EU: ptgs; OR; AF; P/COL; DEC/ART; PHOT

The Birmingham Museum of Art, with over 17,000 works in its permanent collection, is the largest municipal museum in the Southeast. In addition to the most extensive Asian art collection in the Southeast, the museum houses the largest collection of Wedgewood china outside of England. "Art & Soul," an 8 minute video presentation is available to familiarize visitors with the museum. **NOT TO BE MISSED:** Multi-level outdoor Sculpture Garden featuring a waterfall designed by sculptor Elyn Zimmerman and two mosaic lined pools designed by artist Valerie Jaudon; Hitt Collection of 18th century French paintings & decorative arts; Beeson collection of Wedgewood (largest of its kind outside of England).

ON EXHIBIT/97:

01/19/97–03/29/97	SOUTHERN ARTS AND CRAFTS 1890-1940 — 130 objects by southern artists and craftsmen will be highlighted in an exhibition that explores the southern counterpart of the international arts and crafts movement. WT
05/18/97–08/31/97	AFRICAN, PRE-COLUMBIAN AND NATIVE AMERICAN ARTS IN ALABAMA COLLECTIONS — Many of the items on view will be on loan from private collections and have never before been on public display. CAT
09/28/97–01/04/98	ROBERT CARGO QUILTS (Working Title)

Daphne

American Sport Art Museum and Archives
Affiliate Institution: U.S. Sports Academy
One Academy Dr., **Daphne, AL 36526**
✆: 334-626-3303 WEB ADDRESS: http://www.sport.ussa.edu
HRS: 10-2 M-F DAY CLOSED: Sa, S HOL: LEG/HOL, ACAD!
ᕦ: Y ℗ Y; Free MUS/SH: Y GR/T: Y GR/PH: CATR! DT: Y TIME: Available upon request
PERM/COLL: AM: ptgs, sculp , gr all on the single theme of American sports heroes

The largest collection of sports art in America may be found at this museum which also features works highlighting an annual sport artist of the year. Of special interest is a series of 33 photographic prints by 1994 Sport Artist of the Year, Robert Riger. **NOT TO BE MISSED:** "The Pathfinder," a large sculpture of a hammer-thrower by John Robinson where the weight of the ball of the hammer is equal to the rest of entire weight of the body of the figure.

ON EXHIBIT/97:

	Bi-monthly exhibitions are planned including participation in the local annual celebration of the arts organized by the City of Mobile.
01/97–02/97	SPORT ARTIST OF THE YEAR
08/07/97–09/97	INTERNATIONAL YOUTH SPORT ART SHOW — Works by 14 to 19-year-old students from around the world will be featured in this juried exhibition.

16

Dothan

Wiregrass Museum of Art

126 N. College St., **Dothan, AL 36302**
✆: 334-794-3871
HRS: 10-5 Tu-Sa, 1-5 S DAY CLOSED: M HOL: LEG/HOL!
VOL/CONT: Y ✦: Y; Entrance ramp, elevator, handicapped restrooms, wheelchairs available Ⓟ Y; At the Dothan Civic Center parking lot GR/T: Y GR/PH: CATR! H/B: Y; Located in former 1912 electric plant
PERM/COLL: REG

The main floor galleries of this regional visual arts museum feature a variety of works that reflect the ever-changing world of art with emphasis on solo exhibits showcasing important emerging artists of the South. The museum is located in the S. E. corner of Alabama approximately 100 miles from Montgomery. PLEASE NOTE: The museum will be closed from mid 9/96 to 1/24/97! in order to renovate part of its 1912 historic building and add more gallery exhibition space. **NOT TO BE MISSED:** ARTventures, a "hands on" gallery for children, schools, & families.

ON EXHIBIT/97:

ONGOING:	AFRICAN ART
03/08/97	GRAND RE-OPENING: 400 YEARS OF ART
03/08/97–04/27/97	A FLASH OF BRILLIANCE: AMERICAN CUT GLASS
03/08/97–04/27/97	AFRICAN-AMERICAN CERAMICISTS
03/08/97–05/04/97	UNDERWATER PHOTOGRAPHY OF DONALD TIPTON
05/03/97–07/20/97	A SILVER SETTING: VICTORIAN SILVER, 1860-1890
05/11/97–07/06/97	TROPICAL RHYTHMS: THE COLLAGES OF BETH APPLETON
06/15/97–08/03/97	FRANK STELLA: A COLLECTION OF PRINTS, 1967-1995 — 16 prints by Stella ranging from late 1960's lithographed posters to recent prints will be on loan from the Hood collection. WT
07/13/97–08/24/97	THE NAVY ART OF THOMAS HART BENTON
07/27/97–10/19/97	GLASS FROM A PRIVATE COLLECTION
08/10/97–09/07/97	LOCAL COLOR: DWAL (DOTHAN WIREGRASS ART LEAGUE)
08/31/97–11/30/97	SURREALIST WORKS ON PAPER
09/13/97–11/09/97	19TH & 20TH CENTURY WORKS FROM A PRIVATE COLLECTION
10/26/97–01/18/98	IN THE STYLE OF PAULINE BURDESHAW
10/26/97–01/18/98	THE POSH PURSE: A DECORATIVE ACCESSORY, CIRCA 1780-1940
11/15/97–01/11/98	BEVERLY B. ERDREICH: MARC CHAGALL WORKS ON PAPER

Fayette

Fayette Art Museum

530 Temple Ave. N., **Fayette, AL 35555**
✆: 205-932-8727
HRS: 9-Noon & 1-4 M-F DAY CLOSED: Sa, S HOL: LEG/HOL!
VOL/CONT: Y ✦ Y Ⓟ Y; Ample parking with spaces for the handicapped
GR/T: Y GR/PH: CATR! DT: Y TIME: daily during museum hours H/B: Y
PERM/COLL: AM: ptgs 20; FOLK

Housed in a 1930's former school house, this collection consists mainly of folk works as well as a 2,600 piece collection that spans the career of Lois Wilson (1905-1980) and may be seen in two of the museum's galleries. **NOT TO BE MISSED:** The largest collection of folk art in the Southeast.

ON EXHIBIT/97: Rotating exhibitions drawn from the 2,000 piece permanent collection.

ALABAMA

Gadsden

Gadsden Museum of Fine Arts
2829 W. Meighan Blvd., **Gadsden, AL 35904**
☎ 205-546-7365
HRS: 10-4 M-W & F, 10 AM - 8 PM T, 1-5 S DAY CLOSED: Sa. HOL: LEG/HOL!
VOL/CONT: Y ᬒ Y ℗ Y; Free and ample GR/T: Y GR/PH: CATR!
PERM/COLL: EU: Impr/ptgs; CONT; DEC/ART

During 1996, (call for specifics) the Gadsden Museum of Arts will be relocated to the renovated historic Duncan Department Store whose antique atmosphere will be retained in combination with a new state-of-the-art museum facility.

Huntsville

Huntsville Museum of Art
700 Monroe St., S.W., **Huntsville, AL 35899**
☎ 205-535-4350 WEB ADDRESS: http://www.hsv.tis.net/hma
HRS: 10-5 Tu-F, 9-5 Sa, 1-5 S DAY CLOSED: M HOL: 12/25, 1/1, THGV
ᬒ Y; Totally accessible with wheelchairs available ℗ Y; Limited free parking in the civic center building in which the museum is located; metered parking in garage across the street.
GR/T: Y GR/PH: CATR! DT: Y TIME: selected S afternoons
PERM/COLL: AM: ptgs, drgs, phot, sculp, folk, dec/art, reg 18-20; EU: works on paper; OR; AF

Focusing on American paintings and graphics from the 18th through the 20th-century as well as works by regional artists, the Huntsville Museum promotes the recognition and preservation of artistic heritage in its own and other Southeastern states. Located across from Big Spring Park in downtown Huntsville, the museum serves as the leading visual arts center in North Alabama. **NOT TO BE MISSED:** Large Tiffany style stained glass window.

ON EXHIBIT/97:

12/01/96–02/16/97	WHITE MOUNTAIN PAINTERS, 1834-1926 — 50 late 19th & early 20th-century works by artists inspired by the beauty of the White Mountains and other facets of the New Hampshire landscape will be on exhibit. BROCHURE WT
12/15/96–02/16/97	SPLENDORS OF A GOLDEN AGE: ITALIAN PAINTINGS FROM BURGHLEY HOUSE — 60 Old Master paintings, many of which have not been seen outside of Britain in 200 years, will be on loan from the grandest Elizabethan house in England. This is the last stop for the exhibition in an American museum. CAT ADM FEE ATR! WT
02/23/97–04/13/97	ENCOUNTERS: MARK MARCHLINSKI — Mixed media works by this University of Alabama professor created by the manipulation of electroplated sheet metal.
03/02/97–04/13/97	LOST AND FOUND: SCULPTURE BY JIM OPASIK/ASSEMBLAGES BY MARY DEACON OPASIK — Works by two artists who unite and transform lost and found items in the creation of their sculptures.
04/20/97–06/08/97	FRANK STELLA PRINTS FROM THE COLLECTION OF DR. WILLIAM HOOD — 16 prints by Stella ranging from late 1960's lithographed posters to recent prints will be on loan from the Hood collection. WT
04/27/97–06/25/97	IGUG GOLDEN MOUSE AWARDS COMPUTER ART COMPETITION — On exhibit will be works by winners of the 13th annual international competition of computer art.
05/11/97–07/27/97	EMBRACING BEAUTY: AESTHETIC PERFECTION IN CONTEMPORARY ART — 2D & 3D works in a variety of media by nationally significant artists for whom the notion of beauty is a primary concern.

18

Huntsville Museum of Art - continued

05/11/97–07/20/97	RECENT ACQUISITIONS
06/15/97–08/17/97	ENCOUNTERS: WILL BERRY — Rich & colorful abstract paintings and monotypes inspired by historic textile designs will be been in this presentation of works by Berry, a nationally emerging talent from Tennessee.
08/03/97–09/28/97	INTENTION/INVENTION: ADVANCED PHOTOGRAPHY IN THE 1990'S — Works by classically-trained photographers who utilize electronic media to manipulate and transform imagery.
08/10/97–10/12/97	ENCOUNTERS: DALE KENNINGTON — Everyday rituals in contemporary society are addressed in the contemporary realist paintings by Kennington on view in this exhibit.
08/24/97–10/19/97	CHEAP SHOTS: TOY CAMERA IMAGERY — A display of images by 4 Alabama Gulf Coast photographers created by working with simple toy cameras.

Mobile

Mobile Museum of Art
4850 Museum Dr., Langan Park, **Mobile, AL 36608**
☏ 334-343-2667
HRS: 10-5 Tu-S DAY CLOSED: M HOL: LEG/HOL! CITY/HOL!
&: Y; Ramps, elevators, restrooms Ⓟ Y; Free parking on site of main museum. MUS/SH: Y
GR/T: Y GR/PH: CATR! S/G: Y
PERM/COLL: AM: 19; AF; OR; EU; DEC/ART; CONT/CRAFTS

Beautifully situated on a lake in the middle of Langan Park, this museum offers the visitor an overview of 2,000 years of culture represented by more than 4,000 pieces in its permanent collection. PLEASE NOTE: Admission is charged for some traveling exhibitions. **NOT TO BE MISSED:** Boehm porcelain bird collection; 20th-century decorative arts collection

ON EXHIBIT/97:

01/08/97–02/25/97	AFRICAN-AMERICAN ARTISTS FROM THE MOBILE AREA
01/10/97–02/02/97	FOCUS ON THE PERMANENT COLLECTION
02/07/97–04/06/97	THE AMERICAN SCENE AND THE SOUTH: PAINTINGS AND WORKS ON PAPER, 1930-1946 — Works by John Curry, Paul Cadmus, Philip Evergood and Louis Lozowick will be featured in the first in-depth exhibition to explore American Scene painting of the 1930's and 40's, a dominant art movement during the Depression that promoted realistic, understandable styles with subject matter specific to the United States. CAT WT
03/22/97–05/18/97	MOBILE ART ASSOCIATION SPRING/SUMMER JURIED SHOW
04/12/97–05/25/97	FULL DECK ART QUILTS — Ranging from photographic realism to abstraction, the quilts on view, created by 56 artists, are creative interpretations of a 52-card deck.
06/06/97–07/20/97	IDA KOHLMEYER: RETROSPECTIVE — A retrospective of works by Kohlmeyer, a New Orleans-based painter and sculptor. WT
08/01/97–09/28/97	ART FROM THE DRIVER'S SEAT: AMERICANS AND THEIR CARS — Paintings, drawings, photographs and etchings from the Terry and Eva Herndon Collection will be featured in an exhibition that allows the visitor to look into the rear view mirror at the history of America's relationship with the automobile. CAT WT

ALABAMA

Mobile Museum of Art - continued

10/04/97–11/23/97	MOBILE ART ASSOCIATION ANNUAL JURIED EXHIBITION
10/10/97–11/23/97	JOHN RODERICK DEMPSTER MacKENZIE CAT
11/29/97–01/04/98	THE WATERCOLOR AND GRAPHIC ARTS SOCIETY'S ANNUAL JURIED EXHIBITION

Mobile

Mobile Museum of Art Downtown

300 Dauphin St., **Mobile, AL 36602**
☎ 334-694-0533
HRS: 8:30-4:30 M-F
&: Y ℗ Y; Metered and lot parking available.

A renovated early 1900's hardware store is home to this downtown art museum gallery.

Montgomery

Montgomery Museum of Fine Arts

One Museum Dr., P.O. Box 230819, **Montgomery, AL 36117**
☎ 334-244-5700
HRS: 10-5 Tu-Sa, till 9 T, Noon-5 S DAY CLOSED: M HOL: LEG/HOL!
&: Y; Fully accessible ℗ Y; Ample and free MUS/SH: Y ‖ Y; 11-2 Tu-Sa GR/T: Y GR/PH: CATR!
PERM/COLL: AM: ptgs, gr, drgs 18-20; EU: ptgs, gr, sculp, dec/art 19; CONT/REG; BLOUNT COLLECTION OF AM ART

Situated like a jewel in its lake-studded park-like setting, the Montgomery Museum features among its treasures the Blount collection that documents the evolution of American art from the 18th-century to the present. **NOT TO BE MISSED:** "A Peaceable Kingdom With Quakers Bearing Banners" by Edward Hicks; ARTWORKS, an interactive gallery for children

ON EXHIBIT/97:

02/01/97–03/30/97	THE 32ND MONTGOMERY ART GUILD MUSEUM EXHIBITION — An exhibition of juried works by local artists. TENT!
02/01/97–03/30/97	WALTER O. EVANS COLLECTION OF AFRICAN-AMERICAN ART — Portraits, landscapes and mythological imagery will be seen in this remarkable exhibition of historical and contemporary works of art by black artists. TENT!
04/12/97–05/11/97	NECEA CERAMICS — A biannual survey of contemporary works presented by the National Council of Education for the Ceramic Arts. TENT! WT
04/26/97–06/08/97	WHIRLIGIGS AND WEATHERVANES: CONTEMPORARY SCULPTURE — Bringing together professional and amateur artists to highlight their talent, ingenuity and wit, these wind-powered sculptures sometimes make biting social commentary, create dynamic sculptural statements and build upon the humorous aspects of modern life. TENT! WT
06/21/97–08/17/97	THE PASSIONATE OBSERVER: THE PHOTOGRAPHS OF CARL VAN VECHTEN TENT! WT
07/19/97–10/12/97	RODIN: SCULPTURE FROM THE IRIS AND B. GERALD CANTOR COLLECTION — On loan from the most important and extensive private collections of its kind will be 52 sculptures by celebrated 19th-century French sculptor, Rodin. TENT! WT

Montgomery Museum of Fine Arts

08/30/97–12/26/97
THE PHOTOGRAPHS OF DOROTHEA LANGE — In the first major retrospective of her work, nearly 90 photographs that include Lange's images of American migrant families during the Great Depression, and photos of the wartime relocation of Japanese-Americans will be seen along with other powerful works that comment on American life from the 30's through the 50's. CAT WT

09/97–11/97
ANGELS AND SCRIBES — Presented will be 27 hand-written and illustrated manuscripts, on loan from the Memphis Brooks Museum of Art, dating from the 12th to the 18th centuries. TENT! WT

10/25/97–11/15/97
WORCESTER PORCELAIN FROM THE LOEB COLLECTION OF DECORATIVE ARTS — An exhibition of Worcester Porcelain some of which was gifted by the Lobe's to the museum, will be displayed with other pieces that will be on loan from the Lobe's private collection. TENT!

11/97–12/97
ARTNOW: MICHAEL OLSZEWSKI — An exhibition of Olszweski's dyed, handstitched and embroidered fabric constructions designed by the artist to communicate intimate feelings common to all of us; such as sorrow, separation, aging, and death.

11/15/97–02/08/98
AFTER THE PHOTO - SECESSION: AMERICAN PICTORIAL PHOTOGRAPHY, 1910-1955 — 150 photographs documenting the social and artistic development of this pictorial medium between the World Wars will be featured in the first major exhibition to focus on this subject. TENT! CAT WT

11/28/97–01/25/98
LIFE CYCLES: THE CHARLES E. BURCHFIELD COLLECTION — On view will be 62 paintings by Burchfield (1893-1967), a man whose original style helped to inspire several generations of artists. His works reflected strong concerns for the dwindling of America's virginal landscape, the passage of time, and memories of childhood. TENT! WT

ALASKA

Anchorage

Anchorage Museum of History and Art
121 W. Seventh Ave., **Anchorage, AK 99501**
✆ 907-343-4326
HRS: 9-6 M-S mid May-mid Sept; 10-6 Tu-Sa, 1-5 S rest of the year DAY CLOSED: M winter HOL: LEG/HOL!
ADM: Y ADULT: $5.00 CHILDREN: F (under 18) STUDENTS: $4.50 SR CIT: $4.50
&: Y MUS/SH: Y ❚❙ Y; Cafe
GR/T: Y GR/PH: CATR! 907-343-6187 DT: Y TIME: 10, 11, 1 & 2 Alaska Gallery (summer only)
PERM/COLL: ETH

The Anchorage Museum of History & Art is dedicated to the collection, preservation, and exhibition of Alaskan ethnology, history, and art. PLEASE NOTE: Winter admission fees are $4.00 adult & $3.50 seniors.

Ketchikan

Totem Heritage Center
601 Deermount, **Ketchikan, AK 99901**
✆ 907-225-5900
HRS: 8-5 Daily (mid May through Sep); 1-5 Tu-F (Oct- mid May - no adm fee)
HOL: THGV, 12/25, 1/1, EASTER, VETERAN'S DAY
F/DAY: S PM ADM: Y ADULT: $2.00 CHILDREN: F (4 & under)
&: Y
GR/PH: CATR!
PERM/COLL: CONT: N/W Coast Indian art; Totem poles

33 Tlingit and Haida totem poles and pole fragments of the 19th-century, brought to Ketchikan from Tongass and Village Islands and Old Kasaan during the totem pole revival project are the highlight of this museum.

Mesa

Mesa Southwest Museum

53 N. Macdonald, **Mesa, AZ 85201**
☏ 602-644-2571
HRS: 10-5 Tu-Sa, 1-5 S DAY CLOSED: M HOL: LEG/HOL!
ADM: Y ADULT: $4.00 CHILDREN: $2.00 (3-12) STUDENTS: $3.50 SR CIT: $3.50
♿: Y ⓟ Y; Street parking in front of the museum & covered parking directly behind the museum on the first level of the parking garage. Handicapped spaces located in front of the museum. MUS/SH: Y GR/T: T GR/PH: CATR! 602-644-3553 or 3071
PERM/COLL: ETH; P/COL; CER

Changing exhibitions of ancient to contemporary works based on Southwestern themes are featured in this multi-faceted museum. **NOT TO BE MISSED:** "Finding The Way," by Howard Post; "Superstition Sunrise," full-color wall mural by Jim Gucwa; "Hohokam Life," by Ka Graves, a series of watercolor interpretations of Hohokam Indian life (300 B.C.-1450 A.D.)

ON EXHIBIT/97:

02/08/97–03/30/97	MEXICAN MASKS OF THE 20TH CENTURY: A LIVING TRADITION — A wide variety of masks will be featured in an exhibition designed to introduce the viewer to the traditions of mask making in Mexican culture. WT
04/19/97–07/20/97	ED MELL: A HOMECOMING
05/24/97–09/21/97	XICANINDIO PRESENTS FOUR NATIVE-AMERICAN ARTISTS
11/17/97–01/11/98	CERATOPSIANS: LIFE AND TIMES OF THE HORNED DINOSAURS TENT!

Phoenix

The Heard Museum

22 E. Monte Vista Rd., **Phoenix, AZ 85004-1480**
☏ 602-252-8840
HRS: 9:30-5 M-Sa, Noon-5 S, Till 8 PM W HOL: LEG/HOL!
F/DAY: 5-9 W ADM: Y ADULT: $5.00 CHILDREN: F (under 4) ! STUDENTS: $4.00 SR CIT: $4.00
♿: Y; Barrier free ⓟ Y; Free MUS/SH: Y GR/T: Y GR/PH: CATR! Activities coord. DT: Y TIME: Many times daily!
PERM/COLL: NAT/AM; ETH; AF; OR; OC; SO/AM

The collection of the decorative and fine arts of the Heard Museum, which spans the history of Native American Art from the pre-historic to the contemporary, is considered the most comprehensive collection of its kind in the entire country. Named after the Heards who founded the museum based on their great interest in the culture of the native people of Arizona, the museum is housed in the original structure the Heards built in 1929 adjacent to their home called Casa Blanca. PLEASE NOTE: A new branch of the museum called Heard Museum North is now open at the Boulders Resort in Scottsdale (10-5:30 M-Sa, 12-5 S; Adm: $2.00 Adults, $1.00 children 4-12). The exhibition "Rain" will be on view there from 9/11/96 through Fall/97. **NOT TO BE MISSED:** Experience the cultures of 3 Native American tribes with hands-on family oriented "Old Ways, New Ways"

ON EXHIBIT/97:

ON PERMANENT DISPLAY:	NATIVE PEOPLES OF THE SOUTHWEST: THE PERMANENT COLLECTION OF THE HEARD MUSEUM — A magnificent display of superb Native American artifacts including pottery, baskets, jewelry, weaving and kachina dolls.
	OLD WAYS, NEW WAYS — A state-of-the-art interactive exhibit that features enjoyable hands-on art activities for the entire family.
through 5/4/97	INVENTING THE SOUTHWEST: THE FRED HARVEY COMPANY AND NATIVE AMERICAN ART — Baskets, pottery, jewelry, paintings, and other art objects from this renowned collection will be displayed in an exhibit designed to tell the story of early American railroad travel and its effect on Native American people and their art.

ARIZONA

The Heard Museum - continued

through 8/97	FOLLOWING THE SUN AND MOON: HOPI KACHINA DOLLS — From the permanent collection, this display features Kachina dolls from the early 1900's to the present.
10/12/96–03/24/97	PERSONAL PASSION, PROFITABLE PURSUIT: THE KATHERINE HARVEY COLLECTION OF NATIVE AMERICAN FINE ART
10/26/96–09/97	MAYAN LIFE: SOURCE AND SYMBOL — A precise view of daily life in rural Guatemala that celebrates the deeply rooted respect of the Mayan people for their traditions, customs and ceremonies will be seen in the paintings on view by folk artist Nicolas Reanda.
01/97–07/97	RECENT ACQUISITIONS FROM THE HEARD MUSEUM COLLECTION — Native American paintings, pottery, kachina dolls and sculpture from the 1960's & 70's will be on view.
04/26/97–09/98	CONTEMPORARY SOUTHWESTERN JEWELRY (Working Title)

Phoenix

Phoenix Art Museum

1625 N. Central Ave., **Phoenix, AZ 85004-1685**
☎ 602-257-1222
HRS: 10-5 Tu-S, till 9 PM T & F DAY CLOSED: M HOL: 12/25, 1/1, 7/4, THGV
ADM: Y
&: Y ℗ Y; Ample parking around the museum MUS/SH: Y ⑪ Y; Eddie's Art Museum Cafe
GR/T: Y GR/PH: CATR! 602-257-1880 DT: Y TIME: 2:00 daily & 6:00 on W; Gallery Talks 2:15 daily
PERM/COLL: AM: Western, cont; AS; EU: 18-19

The Phoenix, one of the largest art museums in the Southwest, has a broad range of fine and decorative art dating from the Renaissance to today. A special treat for families is the hands-on "Art Works" gallery and the Thorne Miniature Rooms of historic interiors. The museum has recently completed a major 2 year, 25 million dollar expansion project that doubles its gallery space to 65,000 square feet, and divides the museum's collection into three major areas: Art of Asia, Art of the Americas & Europe to 1900, and Art of Our Time, 1900 to the Present. In addition food service facilities have been added and a new 4,500 square foot, covered sculpture pavilion is being planned. PLEASE NOTE: Admission to the museum galleries is free. However for most exhibitions there will be a charge of $5.00 adults, $4.00 seniors, $2.00 students and children over 6, free for children under 6 and for everyone from 5-9 T . **NOT TO BE MISSED:** "Attack Gallery" for children and their families; Thorne miniature rooms of historic interiors.

ON EXHIBIT/97:

09/21/96–02/02/97	CLOTHES AS ART: HIGHLIGHTS FROM THE MUSEUM'S FASHION DESIGN COLLECTION
12/14/96–02/23/97	CONVERGING CULTURES: ART AND IDENTITY IN SPANISH AMERICA — On exhibit from the Brooklyn Museum's collection, will be more than 250 rarely seen Spanish Colonial objects ranging from large architectural pieces, furniture, and Peruvian textiles, to Mexican manuscripts, and Spanish Colonial jewelry. CAT WT
12/21/96–02/23/97	La FAMILIA MEXICANA: PORTRAIT OF A NATION — Featured will be 100 color photographs by Lourdes Almedia that focus on a wide range of Mexican families from the jungles of Chiapas to the wealthy of Mexico City.
01/18/97–03/30/97	WORLDS WITHIN WORLDS: THE RICHARD ROSENBLUM COLLECTION OF CHINESE SCHOLAR'S ROCKS — For centuries the Chinese have revered the special aesthetic and spiritual qualities of rocks used by scholars as vehicles of contemplation. The 90 rock treasures on view reveal their aesthetic merits as vehicles for meditation. TENT! CAT WT

Phoenix Art Museum - continued

02/15/97–06/08/97	FASHIONS OF THE ROCK 'n ROLL ERA

03/22/97–06/15/97 IT'S ONLY ROCK & ROLL — 100 artworks by major American artists will be featured in an exhibition that examines the impact rock & roll music has made in contemporary art since the 1960's. WT

07/12/97–09/28/97 CANYONLAND VISIONS & CROSSING THE FRONTIER — A dual exhibition celebrating the Southwest will include works by Ernest Blumenschein, one of the primary artistic figures of Taos, New Mexico, as well as watercolors and photographs selected from the extensive holdings of the Amon Carter Museum. WT

10/18/97–11/23/97 32ND ANNUAL COWBOY ARTISTS OF AMERICA SALE & EXHIBITION

12/13/97–02/08/98 RECYCLING REALITY: SURREALIST SCULPTURE — Works incorporating manufactured objects will be seen in the surrealist sculptures on view by such 20th-century masters as Dali, Picasso, Duchamp and Breton. WT

12/13/97–02/08/98 AFRICAN ART FROM THE FALETTI COLLECTION — Wood carvings, masks, figural pieces, beaded objects and textiles will be among the 75 works featured in this exhibition.

Phoenix

Sylvia Plotkin Judaica Museum

3310 No. 10th Ave., **Phoenix, AZ 85013**
☎ 602-264-4428
HRS: 10-3 Tu & T, Noon-3 S; OPEN AFTER FRI. EVENING SERVICES & by appt only on W DAY CLOSED: M, F, Sa
HOL: LEG/HOL!; JEWISH HOL! JULY & AUG
VOL/CONT: Y
♿: Y; Restrooms; museum on ground floor (no steps)
Ⓟ Y; Free behind building MUS/SH: Y
GR/T: Y GR/PH: CATR!
PERM/COLL: JEWISH ART

Considered to be one of the most important centers of Jewish art and culture in the Southwest, the Sylvia Plotkin Judaica Museum (renamed in honor of its recently deceased founder and director) has holdings spanning 5,000 years of Jewish history and heritage. The museum will be moving in the summer of '97 to a new building on the grounds of the new Temple Israel site at 56th St. & Shea, Phoenix. PLEASE NOTE: It is advised to call ahead for summer hours! **NOT TO BE MISSED:** Recreated composite neighborhood synagogue of Tunis housed in the Bush Gallery.

ON EXHIBIT/97:

12/22/96–02/19/97 BETA ISRAEL: JEWS OF ETHIOPIA — An exhibition of ceramic baskets, metalworks and textiles relating to the daily rural lives and religious traditions of Ethiopian Jews called "Beta Israel" (House of Israel) whose presence in that country extends back more than 2,000 years.

FALL/97 HISTORY OF TEMPLE BETH EL — This exhibition will be presented in celebration of the dedication of its new museum building opening on the grounds of Temple Beth Israel in the summer of '97.

ARIZONA

Prescott

Phippen Museum of Western Art
4701 Hwy 89 N, **Prescott, AZ 86301**

☎ 520-778-1385

HRS: 10-4 M & W-Sa, 1-4 S DAY CLOSED: Tu HOL: 12/25, 1/1, THGV
ADM: Y ADULT: $3.00 CHILDREN: F (12 & under) STUDENTS: $2.00 SR CIT: $2.00
&: Y ℗ Y; Free and ample MUS/SH: Y
PERM/COLL: PTGS, SCULP

The museum's collection of paintings and sculpture of Western America also includes contemporary works by Native American and Anglo artists. **NOT TO BE MISSED:** 3 foot high bronze of Father Keno by George Phippen; spectacular view and historic wagons in front of the museum

ON EXHIBIT/97:

04/05/97–06/23/97 R. G. SMITH: THE MAN AND HIS WORK — Featured in this retrospective exhibition will be oil paintings, watercolors and mixed media works by "Bud" Smith, a man who for the past 50 years has had the dual careers of painting aviation and combat art works in addition to working as a configuration and design engineer for McDonald Douglas. Winner of numerous awards for artistic excellence, Smith's works hang in many distinguished public places including the National Air and Space Museum, The Pentagon and aboard numerous American Naval Aircraft Carriers.

Scottsdale

Fleisher Museum
17207 N. Perimeter Dr., **Scottsdale, AZ 85255**

☎ 602-585-3108

HRS: 10-4 Daily HOL: LEG/HOL!
&: Y; Entrance & elevators ℗ Y; Free and ample MUS/SH: Y
GR/T: Y GR/PH: CATR!
H/B: Y; All materials used in building indigenous to State of Arizona S/G: Y
PERM/COLL: AM/IMPR; ptgs, sculp (California School)

Located in the 261 acre Perimeter Center, the Fleisher Museum was, until recently, the first and only museum to feature California Impressionist works. More than 80 highly recognized artists of this genre who painted from the 1880's-1940's are represented in the collection. Russian & Soviet Impressionism from the Cold War era are also represented in the permanent collection as well. **NOT TO BE MISSED:** "Mount Alice at Sunset" by Franz A. Bischoff, best known as the "King of the Rose Painters."

ON EXHIBIT/97:

02/09/97–04/04/97 EAST MEETS WEST — On view in a first-time, major, historically significant exhibition of American Impressionist works created on both sides of the continent will be 55 paintings from the illustrious Hartford Steam Boiler Inspection and Insurance Company corporate collection shown with works from the permanent collection of the Fleisher Museum. Represented in the Hartford collection of paintings from the East will be works by Carlson, Hassam, Lawson, Metcalf, Twachtman and others who lived or worked in Connecticut. Maurice Braun, Alson Clark, Percy Gray, Guy Rose and William Wendt will be among the Western artists whose paintings will be on view from the Fleisher collection of California Impressionist works. CAT

Scottsdale

Scottsdale Center for the Arts
7383 Scottsdale Mall, **Scottsdale, AZ 85251**
☎ 602-874-4610
HRS: WINTER: 10-5 M-Sa, till 8 T, Noon-5 S; SUMMER: Noon-5 S-T, Noon-8 F & Sa HOL: LEG/HOL!
VOL/CONT: Y
&: Y ℗ Y; Free and ample parking MUS/SH: Y
GR/T: Y GR/PH: CATR! 602-874 4641 DT: Y TIME: 1:30 S (10/96 through 4/97)
PERM/COLL: CONT; REG

Four exhibition spaces and a beautiful outdoor sculpture garden are but a part of this community-oriented multi-disciplinary cultural center. **NOT TO BE MISSED:** "The Dance" a bronze sculpture (1936) by Jacques Lipschitz; "Ambient Landscape" by Janet Taylor; "Time/Light Fusion" sculpture (1990) by Dale Eldred

ON EXHIBIT/97:

10/26/96–02/09/97	BEYOND THE VISIBLE TERRAIN: THE ART OF ED MELL — This comprehensive overview of work by native Arizonan, Ed Mell, known for his interpretations of the nature unique to the Southwest, will include large-scale canvases, bronzes, pastels, lithographs and some of his early paintings and studies. BOOK
11/30/96–02/16/97	ALISON DUNN: INSIDE/OUT — Dunn's works, consisting of shaped canvases with a variety of paint applications, explore the boundaries of space & time inspired by themes from mythology, philosophy, and literature.
12/13/96–02/23/97	CHIHULY BASKETS — 23 of Chihuly's glass basket sets accompanied by working drawings will be on view in an exhibition that juxtaposes them with examples of Native American baskets from which this contemporary glass master took his inspiration. CAT WT
02/15/97–04/13/97	WATER RITES — Working in conjunction with the Public Art & Collections Committee, several artists will create both permanent and temporary artworks along Scottsdale's network of manmade canals in an attempt to explore the canal's history & origins, and to enhance the understanding of water as a precious natural resource.
02/22/97–04/27/97	LOS ZANJEROS: PHOTOGRAPHS BY DOROTHEA LANGE — A display of 5 of Lange's most famous gritty photographs of the zanjeros, migrant farm workers employed in hard labor to control the flow of water from irrigation ditches to the fields.
02/22/97–04/27/97	BARBARA JO McLAUGHLIN: LAND FORMS/LIFE FORMS — McLaughlin interprets the extreme qualities found in nature through her organic works composed of plywood and discarded wood.
03/07/97–05/04/97	WATERWAYS: PAST, PRESENT AND FUTURE — Artists, anthropologists, geologists, and historians will participate in this interactive multi-media exhibition of the subject of water.
03/07/97–05/04/97	FOLLOWING THE WATER: HISTORICAL AND CONTEMPORARY PHOTOGRAPHS OF SALT RIVER VALLEY CANALS — An exhibition of photographs by Marie Navarre and Sharon Southerland that document the impact and dramatic changes of the Valley's canal system on the surrounding neighborhoods.
04/26/97–09/14/97	A MUSEUM IN THE MAKING: THE JANSSEN COLLECTION OF FINE ART — Highlighted in this exhibition which is part of an on-going series, will be works on loan from the outstanding private collection of Scottsdale resident, Stephanie Janssen.
05/03/97–08/24/97	NEW DIRECTIONS IN DESIGN AND ARCHITECTURE
05/17/97–08/31/97	OUR FUTURE IN THE DESERT: ARCHITECTURAL EXPLORATIONS — Models, drawings, videos, and other media by 20 of Arizona's visionary architects will be on view in an exhibition that presents creative alternatives to living harmoniously with the land in a desert environment.

ARIZONA

Tempe

ASU Art Museum
Affiliate Institution: Arizona State University
Nelson Fine Arts Center & Mathews Center, **Tempe, AZ 85287-2911**
☎ 602-965-ARTS
HRS: 10-9 Tu, 10-5 W-Sa, 1-5 S (Nelson Ctr.); 10-5 Tu-Sa (Matthews Ctr.) DAY CLOSED: M HOL: LEG/HOL!
VOL/CONT: Y
&: Y ℗ Y; Metered parking or $3.00 lot weekdays till 7; Free Tu after 7 and weekends; physically-challenged parking in front
of Nelson Center on Mill Ave. MUS/SH: Y
GR/T: Y GR/PH: CATR! 602-965-5254 H/B: Y; Award winning new building by Antoine Predock
PERM/COLL: AM: ptgs, gr; EU: gr 15-20; AM: crafts 19-20; LAT/AM: ptgs, sculp; CONT; AF; FOLK

For more than 40 years the ASU Art Museum, founded to broaden the awareness of American visual arts in
Arizona, has been a vital resource within the valley's art community. The ASU Art Museum consists of both the
Nelson Center and the Matthews Center. **NOT TO BE MISSED:** ASU Zoo (Whimsical works of animal art in
all media)

ON EXHIBIT/97:

ONGOING	AMERICAN GALLERY — An overview of the history of American art from early paintings by limners to works by Georgia O'Keeffe, Alexander Calder, Charles Demuth and other 20th-century greats.
	LATIN AMERICAN GALLERY: MEXICAN ART FROM THE LATIN AMERICAN COLLECTION — Superb paintings by such past masters as Rivera, Siqueiros and Tamayo, joined by those of contemporary artists are displayed with examples of vice-regal religious statuary and baroque-inspired Mexican retablos.
11/03/96–02/15/97	LUCA BUVOLI: SILENT SIGHT — Buvoli's figures fashioned from trash and scrap items found in NYC, are inspired by the love of American comics he saw growing up in Italy and used as his point of reference to comment on contemporary adult life.
11/16/96–02/02/97	HEIDI KUMAO: HIDDEN MECHANISMS — A display of small installations created by using the 19th-century zoetrope technology that Kumao utilizes as vignettes to comment on the vanity and effort of excessive obedience.
02/01/97–04/27/97	ART AT THE EDGE OF FASHION — A group exhibition in which 8 artists from across the country create sculpture, dramatic installations, photographs and videos based on the language of clothing and fashion.
02/22/97–05/25/97	BORDERLINE GLASS: WORKS BY JAMEX AND EINAR DE LA TORRE — Sculptural objects created of blown-glass and flame-work techniques combined with found objects echo the icons of the artists' native Mexico and include many of the varied influences of other cultures that converge at the border.
03/08/97–05/31/97	TEMPORAL COMPLETIONS: THERESE CHABOT, ASHLEY MILLER & FRANCESCA PENSERINI — Installations by 3 artists from Quebec explore the barriers between public and private, natural and artificial.
05/10/97–08/24/97	SELECTIONS FROM THE PERMANENT COLLECTION
05/17/97–09/30/97	SELECTIONS FROM THE PERMANENT COLLECTION
06/07/97	LATIN AMERICAN ART
09/13/97–12/07/97	LYNN RANDOLPH: MILLENNIAL MYTHS, TECHNOSCIENCE, AND WOMEN — Paintings by Randolph reflect the realism and symbolism of early Renaissance masters within her apocalyptic visions of the impact of modern technology and science.

Tucson

Center for Creative Photography
Affiliate Institution: University of Arizona
Tucson, AZ 85721
☎ 520-621-7968
HRS: 11-5 M-F, Noon-5 S DAY CLOSED: Sa HOL: LEG/HOL!
VOL/CONT: Y ♿: Y; Ramp & electronic door Ⓟ Y; Metered public parking in garage on NE corner of Speedway & Park
MUS/SH: Y GR/T: Y GR/PH: CATR! education dept
PERM/COLL: PHOT 19-20

The singular focus of this collection is the photographic image, its history and documentation. **NOT TO BE MISSED:** Works by Ansel Adams, Richard Avedon, Imogen Cunningham, Laura Gilpin, Marion Palfi, & Edward Weston

ON EXHIBIT/97:

12/08/96–02/16/97	TALKING PICTURES: PEOPLE SPEAK OUT ABOUT THE PHOTOGRAPHS THAT SPEAK TO THEM — An exhibition of 56 photographs chosen by various individuals who have been asked to highlight a single work that has impacted on their personal experience and remained as a significant memory. Remarks by these individuals that explain their choices will be accessible to the viewer through a hand-held remote receiver. CAT WT
02/26/97–04/13/97	ENCOUNTERS 7: THE WAVING OF FOLIAGE, THE COMING AND GOING OF SHIPS — Live projections by Richard Torchia.
04/20/97–07/06/97	AN EXCESS OF FACT: LEE FRIEDLANDER: THE SONORAN DESERT
07/13/97–09/14/97	SANDRA SEMCHUK: HOW FAR BACK IS HOME...

Tucson Museum of Art
140 N. Main Ave., **Tucson, AZ 85701**
☎ 520-624-2333
HRS: 10-4 M-Sa, Noon-4 S; Closed M June, July, Aug. & all major holidays HOL: LEG/HOL!
F/DAY: Tu ADM: Y ADULT: $2.00 CHILDREN: F (UNDER 12) STUDENTS: $1.00 SR CIT: $1.00
♿: Y; No stairs; has ramp & elevator P: Y; Free lot on north side of building; lot on east side of building free with validation of ticket; commercial underground parking garage under city hall across street. MUS/SH: Y
🍴Y; Janos Restaurant in neighboring J. Corbett House GR/T: Y GR/PH: CATR!
DT: Y TIME: daily during museum hours H/B: Y; Located on the site of the original Presidio S/G: Y
PERM/COLL: P/COL; AM: Western; CONT/SW; SP: colonial; MEX

Past meets present in this museum and historic home complex set in the Plaza of the Pioneers. The contemporary museum building itself, home to more than 4,000 works in its permanent collection, is a wonderful contrast to five of Tucson's most prominent historic homes that are all situated in an inviting park-like setting. One, the historic 1860's Edward Nye Fish House on Maine Ave., has recently opened as the museum's John K. Goodman Pavilion of Western Art. PLEASE NOTE: Tours of the Historic Block at 11 AM W & T from Oct. 1 - May 1. **NOT TO BE MISSED:** Pre-Columbian collection

ON EXHIBIT/97:

11/15/96–11/19/97	CONTEMPORARY SOUTHWEST IMAGES XI: THE STONEWALL FOUNDATION SERIES — Artist to be announced.
11/24/96–03/23/97	EL NACIMIENTO: CASA CORDOVA — Over 200 hand-painted miniature Mexican figurines will be seen in the 20th year of the presentation of this traditional and intricate nativity scene.
01/07/97–03/09/97	SEVEN YEARS IN TIBET: THE PHOTOGRAPHS OF HEINRICH HARRER
01/24/97–03/23/97	LASTING IMPRESSIONS: THE DRAWINGS OF THOMAS HART BENTON — Approximately 70 drawings and watercolors from his working studio collection provide an amazingly rich visual record of the artist's experiences of a lifetime. BROCHURE WT
01/31/97–03/23/97	JOHN P. SCHAFFER: PEOPLE, PLACES AND THINGS: THIRTY YEARS IN PHOTOGRAPHY

Tucson Museum of Art- continued

02/21/97–03/23/97	WOMEN ARTISTS AND THE WEST SHOW & SALE VII — Examples of traditional western and realist themes by the best women artists will be seen in the seventh presentation of this ongoing series.
03/21/97–05/18/97	THE TUCSON SEVEN — A major exhibition of works by 7 of the most highly regarded and famous artists living in Tucson who are all originally from different parts of the country and who as friends, form a highly unique artistic group. CAT
04/11/97–06/08/97	CALIDO: A SURVEY OF CONTEMPORARY WARM GLASS — In conjunction with the Glass Artists Society Biennial Meeting, this exhibition examines the "warm glass" techniques of kiln casting, fusing, pate-de-verre and slumping.
06/20/97–08/17/97	ARIZONA BIENNIAL
10/24/97–12/14/97	22ND ANNUAL EXHIBITION OF WESTERN FEDERATION OF WATERCOLOR SOCIETIES — A juried exhibition of 80 watercolors selected from submissions made by members of 9 western watercolor societies.
11/07/97–01/04/98	CONTEMPORARY SOUTHWEST IMAGES XII: THE STONEWALL FOUNDATION SERIES

Tucson

University of Arizona Museum of Art
Olive And Speedway, **Tucson, AZ 85721-0002**
☎ 520-621-7567
HRS: LAB/DAY-MID MAY: 9-5 M-F & Noon-4 S; MID MAY-LAB/DAY: 10-3:30 M-F & Noon-4 S DAY CLOSED: Sa
HOL: LEG/HOL!; ACAD! ᕱ: Y; Automatic doors, elevators ℗ Y; Metered parking in visitor section of garage on the corner of Park Ave. north of Speedway Blvd. (Free on Sundays) MUS/SH: Y
GR/T: Y GR/PH: CATR! DT: Y TIME: 12:15 first & last W Month (Sept-Apr)
PERM/COLL: IT: Kress Collection 14-19; CONT/AM: ptgs, sculp; CONT/EU: ptgs, sculp; OR: gr; CONT: gr; AM: ptgs, gr

One of the most complete university collections of Renaissance and later European and American works can be enjoyed when visiting the Tucson-based University of Arizona Museum of Art. PLEASE NOTE: It is advised that you call ahead for museum hours as the exact dates upon which the museum changes hours as noted is variable from year to year. **NOT TO BE MISSED:** 61 plaster models & sketches by Jacques Lipchitz; 26 panel retablo of Ciudad Rodrigo by Gallego (late 15th C)

ON EXHIBIT/97:

01/15/97–03/02/97	CLIFF BENJAMIN: ECLIPSE — Visitors to the museum will have a chance to observe artist Benjamin as he paints one of his signature mural-sized works over the period of one week directly onto the wall in the museum's South Gallery.
01/22/97–02/21/97	FAUX POST — An exhibition of "Artistamps" miniature artworks by John Held, Jr. that mimic actual postage stamps in design, scale and range of subject. WT
02/09/97–03/16/97	BEATRICE MANDELMAN: TAOS MODERNIST — Mandelman, who began her artistic career as a WPA social realist painter, later progressed to abstraction and collage. The works on exhibit reflect her connection to the landscape of Taos, her long-time residence, Mexico, and many other lands she visited during her lifetime. CAT WT
04/02/97–05/12/97	PENETRATING IMAGE: PHOTOGRAPHY & GLASS — Photographic expressions in glass will be featured in this exhibition of works by artists working throughout the nation.
MID/97–LATE/97	LAS (IN)VISIBLOES: WOMEN ARTISTS OF URUGUAY — Gender roles, South American patriarchy, the previous 12 year dictatorship, economic survival and family life in contemporary Uruguay will be addressed in works of diverse media created by 25 artists from Montevideo. WT
08/24/97–10/10/97	MEMORIES OF CHILDHOOD — Ten images accompanied by stories dealing with their earliest memories will be featured in this exhibition of the works and personal narratives of the 15 artists on view. WT
10/97–04/98	ROBERT WICK: RECENT OUTDOOR SCULPTURES — 14 of Wick's large-scale sculptures will be disbursed throughout the campus.
11/97–01/98	RODIN: SCULPTURE FROM THE IRIS AND B. GERALD CANTOR COLLECTION — On loan from the most important and extensive private collections of its kind will be 52 sculptures by celebrated 19th-century French sculptor, Rodin. WT

Fort Smith

Fort Smith Art Center
423 N. 6th St., **Fort Smith, AR 72901**
☏ 501-784-2787
HRS: 9:30-4:30 Tu-Sa, 2-4 S DAY CLOSED: M HOL: EASTER, 7/4, 12/21 - 1/1
VOL/CONT: Y
&: Y; To lower floor ℗ Y; Free MUS/SH: Y
GR/T: Y GR/PH: CATR! 501-782-6371 H/B: Y; Pilot House for Belle Grove Historic District
PERM/COLL: CONT/AM: ptgs, gr, sculp, dec/arts; PHOT; BOEHM PORCELAINS

Located mid-state on the western border of Oklahoma, the Fort Smith Art Center, housed in a Victorian Second Empire home, features a permanent display of photographic works and an impressive collection of porcelain Boehm birds. **NOT TO BE MISSED:** Large Boehm Porcelain Collection

ON EXHIBIT/97:

02/97–	SMALL WORKS ON PAPER
04/97–	47TH ANNUAL ART COMPETITION
09/97–	3RD ANNUAL NATIVE AMERICAN INVITATIONAL EXHIBITION
10/97–	CHARLES PEER: PASTEL LANDSCAPES OF ARKANSAS
11/97–	21ST ANNUAL PHOTOGRAPHY COMPETITION
12/97–	CHILDREN'S CHRISTMAS CARD DESIGN COMPETITION

Little Rock

The Arkansas Arts Center
9th & Commerce, MacArthur Park, **Little Rock, AR 72203**
☏ 501-372-4000
HRS: 10-5 M-Sa, till 8:30 F, Noon-5 S HOL: 12/25
VOL/CONT: Y
&: Y; Galleries, restaurant, museum shop accessible by elevator or ramp ℗ Y; Free MUS/SH: Y ⅋ Y; The Vineyard in the Park Restaurant 11:15-1:30 M-F GR/T: Y GR/PH: CATR! H/B: Y; Housed in a 1840 Greek Revival building S/G: Y
PERM/COLL: AM: drgs 19-20; EU: drgs; AM: all media; EU: all media; OR; CONT/CRAFTS

Housed in an 1840 Greek Revival building, the art center features American and European drawings along with a variety of contemporary crafts. **NOT TO BE MISSED:** "Earth," a bronze sculpture by Anita Huffington

ON EXHIBIT/97:

01/10/97–02/23/97	DRAWINGS FROM THE O'NEAL COLLECTION — Included in this presentation of 57 Old Master and modern 16th - 20th-century drawings by Continental and British artists will be examples of architectural and stage designs along with British Victorian and Pre-Raphaelite drawings. CAT WT
01/25/97–03/16/97	POWERFUL EXPRESSIONS: DRAWINGS TODAY — For the past 25 years Townsend Wolfe has acted as Director & Chief Curator of the Art Center, promoting and assembling an important collection of drawings. Included in this enormous exhibition of his choices will be works by Will Barnet, Robert Bermelin, Jim Dine, Sidney Goodman, Jasper Johns, Jacob Lawrence and other modern masters. WT
02/28/97–05/25/97	AMERICAN STILL-LIFE AND INTERIORS 1915-1995: SELECTIONS FROM THE METROPOLITAN MUSEUM OF ART — The vitality of still-life painting in the 20th-century is celebrated in this exhibition of 62 works by 57 artists including Stuart Davis, Jim Dine, Marsden Hartley, Georgia O'Keeffe, Rosenquist and Warhol. WT

ARKANSAS

The Arkansas Arts Center - continued

02/28/97–04/13/97	TWENTIETH CENTURY RUSSIAN DRAWINGS FROM A PRIVATE COLLECTION — 70 Russian drawings by internationally known 20th-century artists and others renowned only in their country will be on view in this exhibit of wide ranging realist, constructivist, surreal, retro-expressionist, conceptualist pop, and sots (i.e.: social protest) art.
03/28/97–04/27/97	THE 27TH ANNUAL MID-SOUTHERN WATERCOLORISTS EXHIBITION — A juried exhibition of works by watercolor artists of the region.
05/02/97–06/97	IRWIN KREMEN: COLLAGE AND SCULPTURE — 75 collages and 15 sculptures by artist and clinical psychologist Kremen, who has been on the faculty of Duke University since 1963, will be featured in an exhibition honoring his 70th birthday.
05/23/97–06/97	THE 24TH ANNUAL PRINTS, DRAWINGS AND PHOTOGRAPHS EXHIBITION — A biennial juried exhibition of prints, drawings and photographs by artists of the region.
10/97–11/97	RUTH BERNHARD AT 90: KNOWN AND UNKNOWN — A look at Bernhard's 60 year career includes vintage material from the artist's own archives and examples of the transcendent nudes for which she is best known.　WT
10/24/97–12/97	RE-ALIGNING VISIONS: SOUTH AMERICAN DRAWING (1960-1990) — 90 drawings by 75 leading Latin American artists will be on loan from public and private sources in an exhibition of works ranging from the contemporary interpretation of 16th & 17th-century old master techniques, to photographic realism, expressive figuration and abstraction.　WT

Pine Bluff

The Arts & Science Center for Southeast Arkansas
701 Main St., **Pine Bluff, AR 71601**
☎ 501-536-3375
HRS: 8-5 M-F, 10-4 Sa, 1-4 S　HOL: 1/1, EASTER, 7/4, THGV, 12/24, 12/25
&: Y ℗ Y; Free　GR/T: Y　GR/PH: CATR! Erin Branham ($.50 pp)　DT: Y
PERM/COLL: EU: ptgs 19; AM: ptgs, gr 20; OM: drgs; CONT/EU: drgs, DELTA ART, REG

The museum, whose new building opened in Sept. '94, is home to a more than 1,000 piece collection of fine art that includes one of the country's most outstanding permanent collections of African-American artworks. The museum also contains a noted collection of American drawings (1900 to the present) which is always on view. **NOT TO BE MISSED:** Collection of African/American art by Tanner, Lawrence, Bearden and others; Art Deco & Art Nouveau bronzes

ON EXHIBIT/97:

12/16/96–02/21/97	THE GOOD EARTH: CHINESE FOLK ART & ARTIFACTS　WT
02/27/97–03/30/97	JOANN JONES & SHEILA CANTRELL — Still lifes in color and black & white by Arkansas artists Jones & Cantrell will be featured.
04/04/97–06/30/97	YORUBA PEOPLE OF WEST AFRICA — West African art & artifacts will be on exhibit.
07/97–MID/97	1997 IRENE ROSENZWEIG BIENNIAL EXHIBITION — A juried exhibition of works by artists from Arkansas, Louisiana, Mississippi, Missouri, Oklahoma and Tennessee.
MID/97–EARLY/97	GEORGE DORNBECK — Dornbeck's watercolors and gouache works will be on view.
EARLY/97–12/97	ARKANSAS WETLANDS: DUCK DECOYS — An array of items from local collectors highlights the rich wildlife & sporting tradition of the area.

Bakersfield

Bakersfield Museum of Art
1930 "R" St., **Bakersfield, CA 93301**
☎ 805-323-7219
HRS: 10-4 M-Sa DAY CLOSED: M HOL: LEG/HOL!& AUG
ADM: Y ADULT: $3.00 CHILDREN: F STUDENTS: $2.00 SR CIT: $2.00
&: Y; Entrance, restrooms ℗ Y; Free and ample parking MUS/SH: Y GR/T: Y GR/PH: CATR! DT: Y
PERM/COLL: PTGS; SCULP; GR; REG

Works by California regional artists are the main focus of this museum and its collection. Box lunches available 3 days in advance to tour groups may be enjoyed among the sculptures and flowers of the museum's gardens. The museum presents 5-7 traveling exhibitions and 2 local juried exhibitions annually. **NOT TO BE MISSED:** The monthly Artist Guild Show in the lobby where works by local professional artists are individually highlighted.

ON EXHIBIT/97:

01/04/97–02/24/97	THE BAKERSFIELD CALIFORNIAN: 100 YEARS
04/03/97–04/28/97	PROCESS ART IN THE 70'S & 80'S
05/03/97–06/02/97	STEPHANIE STOCKTON: A RETROSPECTIVE

Berkeley

Judah L. Magnes Memorial Museum
Russell St., **Berkeley, CA 94705**
☎ 510-549-6950
HRS: 10-4 S-T DAY CLOSED: F, Sa HOL: JEWISH & FEDERAL/HOL!
SUGG/CONT: Y ADULT: $3.00 &: Y; Most galleries ℗ Y; Plentiful street parking MUS/SH: Y
GR/T: Y GR/PH: CATR! DT: Y TIME: W-S H/B: Y; 1908 Berkeley landmark building (Burke Mansion) S/G: Y
PERM/COLL: FINE ARTS; JEWISH CEREMONIAL ART, RARE BOOKS & MANUSCRIPTS; ARCHIVES OF WESTERN U.S. JEWS

Founded in 1962, the Judah L. Magnes Memorial Museum is the third largest Jewish museum in the Western Hemisphere and the first Jewish museum to be accredited by the American Association of Museums. Literally thousands of prints, drawings and paintings by nearly every Jewish artist past and present are represented in the permanent collection. **NOT TO BE MISSED:** "The Jewish Wedding" by Trankowsky; Menorahs 14-20th C.; Room of Remembrance

ON EXHIBIT/97:

12/08/96–04/97	WHEN ARTISTS BECAME WORKERS: 20TH CENTURY AMERICAN JEWISH PAINTINGS ON SOCIAL THEMES

University of California Berkeley Art Museum and Pacific Film Archive
Affiliate Institution: University of California
2625 Durant Ave., **Berkeley, CA 94720-2250**
☎ 510-642-0808 WEB ADDRESS: http://www.bampfa.berkeley.edu
HRS: 11-5 W-S, 11-9 T DAY CLOSED: M, Tu HOL: LEG/HOL!
F/DAY: 11-12 & 5-9 T ADM: Y ADULT: $6.00 CHILDREN: F (under 12) STUDENTS: $4.00 SR CIT: $4.00
&: Y; Fully accessible; ramps to all galleries and entrances ℗ Y; Several commercial lots in the area; also Student Union Garage, & others. For further information call Parking Services at 510-642-4283. MUS/SH: Y ⑪ Y; Cafe 11-4 M-S
GR/T: Y GR/PH: CATR! 510-642-5188 DT: Y TIME: 12:15 T (Curator's Choice) S/G: Y
PERM/COLL: AM: all media 20; VISUAL ART; AS; CH: cer, ptgs; EU: Ren-20

Since its founding in the 1960's with a bequest of 45 Hans Hoffman paintings from the artist himself, the UAM, with collections spanning the full range of the history of art, has become one of the largest and most important university art museums in the country. The museum building, a work of art in itself, is arranged with overlapping galleries to allow for the viewing of works from multiple vantage points. **NOT TO BE MISSED:** Contemporary collection including masterpieces by Calder, Cornell, Frankenthaler, Still, Rothko, and others

CALIFORNIA

University of California Berkeley Art Museum and Pacific Film Archive - continued

University of California Berkeley Art Museum and Pacific Film Archive - continued

ON EXHIBIT/97:

12/04/96–03/02/97	THE MASK OF VENICE: PRINTS AND DRAWINGS BY TIEPOLO AND HIS CIRCLE — Role-playing, masks and identity in 18th-century Venice.　　　　　WT
12/18/96–04/20/97	MASTERWORKS OF GREEK AND ROMAN ART FROM THE HEARST MUSEUM OF ANTHROPOLOGY — Major artistic styles of the Greek and Roman world (700 BC-200 AD) will be seen in the works of sculpture and pottery featured in this exhibition.WT
01/08/97–04/06/97	HIROSHI SUGIMOTO — Evocative long-exposure photographs of movie theater interiors.
01/15/97–03/09/97	GARRETT ECKBO: THE ART OF THE SOCIAL LANDSCAPE — Mounted as a tribute to American landscape architect Eckbo, this exhibition pays homage to the career of one of the most influential figures in 20th-century private garden & corporate landscape design.
03/19/97–05/25/97	JAY DeFEO: MAJOR WORKS — Best known for her monumental, thickly encrusted abstract canvases, this first time exhibition of the works of the late Bay Area artist, DeFeo features 35 paintings, drawings and photocollages.
07/23/97–09/21/97	THE FRAGRANCE OF INK: KOREAN LITERATI PAINTINGS OF THE CHOSON DYNASTY (1392-1910) — On exhibit will be rarely seen ink paintings from the Korea University Museum in Seoul.
08/97–10/97	ROSIE LEE TOMPKINS — Wonderful abstract quilts resonant of African-American traditions are featured in this exhibition.
10/08/97–12/28/97	KNOWLEDGE OF HIGHER WORLDS: RUDOLPH STEINER'S BLACKBOARD DRAWINGS — A display of colorful drawings that delineate philosopher's influential theories.
10/15/97–12/18/97	LUC TUYMANS: DRAWINGS

Claremont

Montgomery Gallery

Affiliate Institution: Pomona College
Montgomery Gallery- 330 College Ave., **Claremont, CA 91711**
☎ 909-621-8283
HRS: Noon-5 Tu-F; 1-5 Sa, S　DAY CLOSED: Tu　HOL: ACAD!, LEG/HOL!, SUMMER
&: Y; Both galleries are wheelchair accessible　ⓟ Y; Free and ample street parking　MUS/SH: Y
GR/T: Y　GR/PH: CATR!　H/B: Y; Member NRHP
PERM/COLL: AM: ptgs 19-20; AM: cer 20; AM: gr, drgs; EU: gr, drgs; JAP: gr; NAT/AM; KRESS PANELS: 15-16

The Montgomery Gallery of Pomona College and the Lang Gallery of Scripps College are united under the title of the Galleries of the Claremont Colleges. Included in their permanent collections are woodblock prints by the Japanese master, Hiroshige, and watercolors by American artist Millard Sheets. Please note that many objects in the permanent collection, though not on permanent exhibition, may be seen by prior arrangement.

ON EXHIBIT/97:

01/21/97–03/29/97	RUTH ST. DENIS & EDWARD WESTON: PHOTOGRAPHY & THE DANCE — Weston's photographs of St. Denis will be featured.
01/21/97–03/29/97	NEW CURATOR'S CHOICE
01/21/97–03/29/97	THE WORK OF ART AND THE COMPUTER
01/21/97–03/29/97	TONY GLEATON PHOTOGRAPHS: AFRICAN HERITAGE IN SOUTH & CENTRAL AMERICA

Davis

Richard L. Nelson Gallery & The Fine Arts Collection, UC Davis
Affiliate Institution: Univ. of California
Davis, CA 95616
☎ 916-752-8500
HRS: Noon-5 M-F, 2-5 S DAY CLOSED: Sa HOL: LEG/HOL! ACAD/HOL; SUMMER!
VOL/CONT: Y &: Y; Completely accessible ℗ Y; On campus on lots 1, 2, 5, 6 (Handicapped), & 10; $2.00 parking fee charged weekdays MUS/SH: Y GR/T: Y GR/PH: CATR!
PERM/COLL: DRGS, GR, PTGS 19; CONT; OR; EU; AM; CER

The gallery, which has a 2,500 piece permanent collection acquired primarily through gifts donated to the institution since the 1960's, presents an ongoing series of changing exhibitions. **NOT TO BE MISSED:** "Bookhead" and other sculptures by Robert Arneson; Deborah Butterfield's "Untitled" (horse)

ON EXHIBIT/97:

01/21/97–02/08/97	ARTISTS' VALENTINES
02/16/97–03/21/97	MICHAEL TOMPKINS (Working Title) — Paintings and studies.
04/13/97–05/16/97	FRED WILSON: TABLEAUS (Working Title)

Downey

Downey Museum of Art
10419 Rives Ave., **Downey, CA 90241**
☎ 310-861-0419
HRS: Noon-5 W-S DAY CLOSED: M, Tu HOL: LEG/HOL!
VOL/CONT: Y &: Y ℗ Y; Ample free off-street parking GR/T: Y GR/PH: CATR!
PERM/COLL: REG: ptgs, sculp, gr, phot 20; CONT

With over 400 20th-century and contemporary works by southern California artists, the Downey Museum has been the primary source of art in this area for over 35 years.

Fresno

Fresno Art Museum
2233 N. First St., **Fresno, CA 93703**
☎ 209-441-4220
HRS: 10-5 Tu-F; Noon-5 Sa, S DAY CLOSED: M HOL: LEG/HOL!
F/DAY: Tu ADM: Y ADULT: $2.00 CHILDREN: F (15 & under) STUDENTS: $1.00 SR CIT: $1.00
&: Y ℗ Y; Free MUS/SH: Y ¶ Y!; T ONLY 12-2:00
GR/T: Y GR/PH: CATR! 209-485-4810 S/G: Y
PERM/COLL: P/COL; MEX; CONT/REG; AM: gr, sculp

In addition to a wide variety of changing exhibitions, pre-Columbian Mexican ceramic sculpture, French Post-impressionist graphics, and American sculptures from the permanent collection are always on view. **NOT TO BE MISSED:** Hans Sumpf Gallery of Mexican Art containing pre-Columbian ceramics through Diego Rivera masterpieces.

ON EXHIBIT/97:

ONGOING: ROBERT CREMEAN: CURIA, NINE SECTIONED LAY-INS WITH PREDELLA, 1979-82

KENNETH E. STRATTON COLLECTION OF PRE-COLUMBIAN MEXICAN ART: MASTERPIECES OF MEXICAN PRE-COLUMBIAN CERAMIC SCULPTURE — 90 clay sculptures from the Stratton Collection dating from 500 to 2,500 years in age, will be on permanent view in the Hans Sumpf Gallery of Mexican Art. These ancient works from 14 cultures were all created before the Europeans entered the New World. The gallery and its superb collection were made possible through the generosity of Stratton and Sumpf, benefactors to the museum and lifelong friends.

CALIFORNIA

Fresno Art Museum - continued

07/26/96–08/17/97	PACHA TAMBO: EARTH RESTING PLACE — The Janet B. and E.O. Hughes Collection of Pre-Columbian Peruvian Art.
09/10/96–08/17/97	THE KENNETH E. STRATTON COLLECTION OF PRE-COLUMBIAN MEXICAN ART
11/15/96–04/10/97	THE DIRECTOR'S CHOICE: FROM THE PERMANENT COLLECTION
12/04/96–02/23/97	LA FEMME: THE PRINTS OF PAUL ALBERT BESNARD AND PAUL CÉSAR HELLEU — Selections from the Elizabeth Dean Collection of French Art.
12/10/96–03/07/97	BRIAN D. COHEN: THE UNFOLDING IMAGE
01/14/97–03/02/97	SUSAN MOLDENHAUER: MARKINGS
01/16/97–03/02/97	RAPHAEL X. REICHERT: GENESIS 1:26 AND 1:28 — Presented at the Fresno Airport Satellite Gallery.
03/04/97–05/18/97	A.F. NORMART: THE JERUSALEM PROJECT
03/11/97–05/11/97	GEIR JORDAHL: THE SAN JOAQUIN RIVER
03/11/97–05/11/97	THE HANSEN FAMILY: ALONG THE RIVER
04/17/97–05/23/97	CHAIRISMA
05/16/97–08/17/97	REUBEN NAKIAN: A CENTENNIAL SURVEY
05/16/97–08/17/97	ARSHILE GORKY: HYBRIDS, WORKS ON PAPER
05/16/97–08/17/97	SAM TCHAKALIAN
05/16/97–08/17/97	ADOLPH AND ELLA ODORFER: DOS AMANTES — On view at the Fresno Airport Satellite Gallery.
05/23/97–08/17/97	THE ETCHINGS OF AUGUSTE AND EUGENE DELATRE — Selections from the Elizabeth Dean Collection.
06/05/97–10/14/97	WORK FROM THE PERMANENT COLLECTION

Fresno

Fresno Metropolitan Museum
1555 Van Ness Ave., **Fresno, CA 93721**
📞 209-441-1444
HRS: 11-5 daily HOL: LEG/HOL!
F/DAY: 1st W ADM: Y ADULT: $4.00 CHILDREN: $3.00 (4-12) STUDENTS: $3.00 SR CIT: $3.00
&: Y ℗ Y; Ample parking in free lot adjacent to the museum MUS/SH: Y GR/T: Y GR/PH: CATR! H/B: Y
PERM/COLL: AM: st/lf 17-20; EU; st/lf 17-20; EU; ptgs 16-19; PHOT (Ansel Adams)

Located in the historic "Fresno Bee" building, the Fresno Metropolitan Museum is the largest cultural center in the central San Joaquin Valley. **NOT TO BE MISSED:** Oscar & Maria Salzar collection of American & European still-life paintings 17-early 20

ON EXHIBIT/97:

08/09/96–04/14/97	WESTERN BOOTS — The history, skill and craftsmanship of bootmaking will be examined in this exhibition.
04/09/97–06/01/97	TWO HUNDRED YEARS OF ENGLISH NAIVE ART 1700-1900 — 100 late 17th & 18th-century charming English naive oil paintings, watercolors, and objects of decorative art will be on loan from public & private collections in Britain, the U.S. & Canada. CAT WT
04/09/97–06/01/97	AGE OF EMPIRE: 200 YEARS OF ENGLISH ART — Divided into several themes, the 100 works on loan from important private and public collections will highlight the daily lives and taste of English people during the age of empire (1700-1900). More than 100 paintings, watercolors, decorative arts, carved wood figures, textiles, scrimshaw and objects of tin and copper will be on exhibit. WT

Fresno Metropolitan Museum - continued

06/03/97–09/01/97	BUSYTOWN — An interactive science & math exhibition based on the books and images of Richard Scarry's children's books. WT
09/13/97–11/30/97	MINGEI: JAPANESE FOLK ART FROM THE MONTGOMERY COLLECTION — 15th through 19th-century paintings, textiles, sculpture, woodwork, ceramics, lacquerware, metalwork, basketry, and paper objects will be presented in an exhibit of 175 objects of "Mingei" folk art (gei) for people (min) on loan from one of the world's greatest collections of its kind. WT

Irvine

The Irvine Museum
18881 Von Karman Ave. 12th Floor, **Irvine, CA 92715**
☎ 714-476-2565
HRS: 11-5 Tu-Sa HOL: LEG/HOL!
&: Y Ⓟ Y; Free parking with validation GR/T: Y GR/PH: CATR! 714-476-0294 DT: Y TIME: 11:15 T
PERM/COLL: California Impressionist Art 1890-1930

Opened in Jan. 1993, this new museum places its emphasis on the past by promoting the preservation and display of historical California art with particular emphasis on the school of California Impressionism (1890-1930).

La Jolla

Museum of Contemporary Art, San Diego
700 Prospect St., **La Jolla, CA 92037-4291**
☎ 617-454-3541
HRS: 10-5 Tu-Sa, Noon-5 S, till 8 W (La Jolla), till 8 F (Downtown) DAY CLOSED: M HOL: 12/25, 1/1, THGV, 2nd week Aug F/DAY: 1st Tu of month ADM: Y ADULT: $4.00 CHILDREN: F (under 12) STUDENTS: $2.00 SR CIT: $2.00
&: Y Ⓟ Y; 2 hour free street parking at La Jolla; validated $2.00 2 hour parking at America Plaza garage for downtown location during the week plus some metered street parking and pay lots nearby. MUS/SH: Y ⑪ Y; Museum Cafe (at La Jolla location)
GR/T: Y GR/PH: CATR! ext. 180 DT: Y TIME: 2 & 3 PM Sa, S & 6:30 F S/G: Y
PERM/COLL: CONT: ptgs, sculp, drgs, gr, phot

Perched on a bluff overlooking the Pacific Ocean, this 50 year old museum reopened in March 1996 after extensive renovation and expansion. Additional exhibition space, landscaping that accommodates outdoor sculpture, a new café and an Education Complex are but a few of the museum's new features. Both this and the downtown branch at 1001 Kettner Blvd. at Broadway in downtown San Diego, 92101, operate as one museum with 2 locations where contemporary art (since the 1950's) by highly regarded national and international artists as well as works by emerging new talents may be seen. PLEASE NOTE: Docent tours of MCA Downtown are offered at 6:30 F & 2:00 Sa & S.

ON EXHIBIT/97:

through 02/23/97	MAURO STACIOLI: TONDO — San Diego Location — A site-specific sculptural installation of a perfectly round wheel poised on its edge placed as a complement to the Helmut Jahn-designed office building behind it.
through 02/23/97	RUSSELL FORESTER: STARS AND TRITES — In response to the 1996 presidential election, Forester reconfigures the American flag by combining systems of lights with objects found in popular American culture to create a multi-media installation.
09/21/96–01/26/97	REGINA SILVEIRA: GONE WILD — La Jolla Location — Brazilian artist Silveira will create a site-specific illusionistic work called "Gone Wild" on the south & west walls of MCA's Axline Court. The work will respond to the spots of the terrazzo floor by extending and exaggerating their pattern in order to incorporate it into her creation.
09/22/96–01/26/97	BLURRING THE BOUNDARIES: INSTALLATION ART — La Jolla location

CALIFORNIA

Laguna Beach

Orange County Museum of Art, Laguna Beach
307 Cliff Dr., **Laguna Beach, CA 92651**
📞 714-494-1122
HRS: 11-5 Tu-S DAY CLOSED: M HOL: 1/1, 7/4, THGV, 12/25
ADM: Y ADULT: $5.00 CHILDREN: F (under 12) STUDENTS: $4.00 SR CIT: $4.00
♿: Y; Completely wheelchair accessible ℗ Y; Metered street parking only MUS/SH: Y
GR/T: Y GR/PH: CATR! DT: Y TIME: 2:00 Tu, W, F, Sa, S
PERM/COLL: AM: cont/art; PHOT; CALIF: early - mid 20

The Orange County Museum of Art, Laguna Beach, recently became one of a three part museum association which includes the Newport Beach venue and the South Coast Plaza Gallery listed below. Now nearly 80 years old, this museum is the oldest cultural institution in Orange County. American art with a special emphasis on California artists is the focus of the collection at the main museum, while contemporary art by California artists is on view at the Orange Coast Museum of Art South Coast Plaza Gallery, 3333 Bristol St., Suite 1000 in Costa Mesa. PLEASE NOTE: Hours of operation at the South Coast Plaza Gallery are 12-9 M-F, 10-7 Sa, 11-6:30 S; admission is free. **NOT TO BE MISSED:** Collection of avant garde photographic prints

ON EXHIBIT/97:

01/17/97–03/30/97	AN OCEAN APART: CONTEMPORARY VIETNAMESE ART FROM THE UNITED STATES AND VIETNAM — Aspects of Vietnamese customs & traditions and their transformation & adaptation through the influence of American culture will be seen in this exhibition of 80 contemporary works by 34 Vietnamese and Vietnamese-American artists. WT
06/28/97–09/07/97	MARK ROTHKO: THE SPIRIT OF MYTH, EARLY PAINTINGS FROM THE 1930'S AND 1940'S — 26 landscape, figurative and portrait expressionist paintings will be seen in an exhibition that provides an important understanding to his later more familiar atmospheric color-field works. BROCHURE WT

Lancaster

Lancaster Museum/Art Gallery
44801 North Sierra Hwy., **Lancaster, CA 93534**
📞 805-723-6250
HRS: 11-4 Tu-Sa, 1-4 S DAY CLOSED: M HOL: LEG/HOL! & 1-2 WEEKS BEFORE OPENING OF EACH NEW EXHIBIT! ♿: Y; Wheelchair accessible ℗ Y; Ample and free MUS/SH: Y GR/T: Y GR/PH: CATR!
PERM/COLL: REG; PHOT

About 75 miles north of Los Angeles, in the heart of America's Aerospace Valley, is the City of Lancaster Museum, a combined history and fine art facility that serves the needs of one of the fastest growing areas in southern California. The gallery offers 8 to 9 rotating exhibitions annually.

Long Beach

Long Beach Museum of Art
2300 E. Ocean Blvd., **Long Beach, CA 90803**
📞 310-439-2119
HRS: 10-5 W-S, till 8 F; Sculpture Garden open 7-5 daily & till 8 PM F DAY CLOSED: M, Tu HOL: LEG/HOL!
F/DAY: F 5-8 PM ADM: Y ADULT: $2.00 CHILDREN: F (under 12) STUDENTS: $1.00 SR CIT: $1.00
♿: Y ℗ Y; Free street parking MUS/SH: Y ⑪ Y; Chatz Cafe (310-434-5077), Babcock & Cooke (310-434-5881)
GR/T: Y GR/PH: CATR! DT: Y TIME: Noon-5 Sa, S H/B: Y S/G: Y
PERM/COLL: REG 19-20; EU 19-20; CONT/SCULP; GER: 20; AM: 19-20; EU: Modernists 20; CALIF: postwar ptgs, sculp; VIDEOS

Long Beach Museum of Art - continued

Situated on a bluff overlooking the Pacific Ocean, the Long Beach Museum is housed in a 1912 California Arts & Crafts-style residence and carriage house. Its fine holdings of modern and California regional art were enhanced, in 1979, with the bequest of an important collection of 20th-century German art from the estate of Milton Wichner. Included in this collection (much of which is not on permanent view) are numerous works by Jawlensky, Kandinsky, Feininger, Moholy-Nagy, and Fischinger. **NOT TO BE MISSED:** The Mexican "Days of the Dead Festival" held each fall; the "Children's Cultural Festival held each spring (please call for specifics for both events); one of the largest collection of artists' videos in the country.

ON EXHIBIT/97:

12/01/96–04/20/97	BEAUTY'S PLEA: GIFTS TO THE COMMUNITY — Over 40 works by Kandinsky, Jawlensky, Feininger, Picasso, Matisse, Rivera, Archipenko and many other notable artists will be featured in an exhibition that pays tribute to the generosity of patrons who have given these exceptional works to the museum over a 46 year period.
12/01/96–04/20/97	NEW VISIONS: SELINA TRIEFF — Trieff, a New York-based figurative painter influenced by Hans Hoffman, Mark Rothko and Ad Reinhart, all of whom were her teachers, has painted mainly haunting self-portraits during her 40 year career which represent the various ages and stages common to all women. This exhibition will focus on approximately 12 of her works.
05/03/97–09/14/97	NEW VISIONS: VIDEO — Selected from a western U.S. juried competition, this exhibition presents works by 3 recipients of the 1996 New Visions: Video production grant.

Long Beach

University Art Museum

Affiliate Institution: California State University, Long Beach
1250 Bellflower Blvd., **Long Beach, CA 90840**
☎ 310-985-5761
HRS: Noon-8 Tu-T, Noon-5 F-S DAY CLOSED: M HOL: ACAD/HOL! LEG/HOL!
SUGG/CONT: Y ADULT: $1.00 CHILDREN: $.50 SR CIT: $0.50
&: Y; Ample access to gallery located on 5th floor of library ℗ Y; Parking permits may be purchased for Lot A just beyond the Visitor Information Kiosk; advance reservations may be made for Lot 12 MUS/SH: Y
GR/T: Y GR/PH: CATR! education dept. S/G: Y
PERM/COLL: CONT: drgs, gr; SCULP

Walking maps are available for finding and detailing the permanent site-specific Monumental Sculpture Collection owned by this outstanding university art museum and located throughout its 322 acre campus. **NOT TO BE MISSED:** Extensive collection of contemporary works on paper

ON EXHIBIT/97:

01/28/97–03/09/97	MORRIS LAPIDUS: MID-CENTURY MODERNIST — The development of architect Lapidus' theories and style will be featured in an exhibition of the designs he did in Miami, a sister city to Long Beach.
03/18/97–04/26/97	THE VELVET YEARS, 1965-1967: WARHOL'S FACTORY, PHOTOGRAPHS BY STEPHEN SHORE — Paul Shore's photographs, taken in Andy Warhol's studio, focus attention on the intersection of visual art, performance art and music. Warhol helped to organize the Velvet Underground, a group including musicians Lou Reed, John Cage, Sterling Morrison, Maureen "Moe" Tucker and Nico for whom he designed their first album cover. Working within the documentary tradition, Shore's work in the 1970's helped lay the groundwork for the acceptance of color photography as a legitimate photographic art form.
03/18/97–04/26/97	RICHARD TUTTLE: RENAISSANCE UNFRAMED

CALIFORNIA

Los Angeles

Autry Museum of Western Heritage
4700 Western Heritage Way, **Los Angeles, CA 90027-1462**
☎ 213-667-2000
HRS: 10-5 Tu-S and selected Monday holidays! DAY CLOSED: M HOL: THGV, 12/25
ADM: Y ADULT: $7.00 CHILDREN: $3.00 (2-12) STUDENTS: $5.00 SR CIT: $5.00
&: Y ℗ Y; Free parking adjacent to the museum MUS/SH: Y ¶ Y; Golden Spur Cafe for breakfast & lunch
GR/T: Y GR/PH: CATR!
PERM/COLL: FINE & FOLK ART

Fine art is but one aspect of this multi-dimensional museum that acts as a showcase for the preservation and understanding of both the real and mythical historical legacy of the American West. **NOT TO BE MISSED:** Los Angeles Times Children's Discovery Gallery; Spirit of Imagination

ON EXHIBIT/97:

12/14/96–03/02/97	PHOTOGRAPHING MONTANA, 1894-1928: THE WORLD OF EVELYN CAMERON — Late 19th to early 20th-century photographs by Cameron covering her 30 year career offer an unparalleled personal record of her fascination with the spirit and energy of ranching, cowboy and pioneer life in eastern Montana.
12/14/96–03/02/97	SADDLEMAKER TO THE STARS: THE LEATHER AND SILVER ART OF EDWARD H. BOHLIN — From 1918 until his death in 1981, Bohlin crafted the exquisite silver-mounted saddles, bridles, gun belts and other accessories on view in this exhibition. Most of his creations were custom orders for rodeo, horses show and such legendary movie clientele as Tom Mix, Clayton Moore, John Wayne, Clark Gable and others.
03/97–05/97	INDIAN HUMOR — The objects of visual expression seen in this exhibition document the diversity and contexts of humor among contemporary Native American artists and communities.
03/22/97–06/01/97	THE FINE ART OF CALIFORNIA INDIAN BASKETRY — The aesthetics and artistry of various basketmaking traditions in California will be highlighted in this exhibition.
03/22/97–06/01/97	GLASS TAPESTRY: PLATEAU BEADED BAGS FROM THE ELAINE HORWITCH COLLECTION — The history of beaded bags and the cultures of the Columbia Plateau region will be seen in a display of 240 late 19th to early 20th-century woven root bags accompanied by a small number of gloves. WT
06/14/97–LATE/97	THE SCENERY HABIT: TOURISTS AND NATIONAL PARKS IN THE WEST
10/97–01/98	MENNONITE FURNITURE: A MIGRANT TRADITION
10/97–01/98	CANYONLAND VISIONS & CROSSING THE FRONTIER — A dual exhibition celebrating the Southwest will include works by Ernest Blumenschein, one of the primary artistic figures of Taos, New Mexico, as well as watercolors and photographs selected from the extensive holdings of the Amon Carter Museum. TENT! WT

California Afro-American Museum
600 State Drive, Exposition Park, **Los Angeles, CA 90037**
☎ 213-744-7432
HRS: 10-5 Tu-S DAY CLOSED: M HOL: THGV, 12/25, 1/1
&: Y; Restrooms, parking, ramps ℗ Y; Limited ($3.00 fee) next to museum MUS/SH: Y GR/T: Y GR/PH: CATR!
PERM/COLL: BENJAMIN BANNISTER: drgs; TURENNE des PRES: ptgs; GAFTON TAYLOR BROWN: gr; AF: masks; AF/AM: cont NOTE: The permanent collection is not on permanent display!

The primary goal of this museum is to collect and preserve art and artifacts documenting the Afro-American experience in America. Exhibitions and programs focus on contributions made to the arts and various other facets of life including a vital forum for playwrights and filmmakers. The building itself features a 13,000 square foot sculpture court through which visitors pass into a spacious building topped by a ceiling of tinted bronze glass.

ON EXHIBIT/97:

06/20/97–08/17/97	IN THE SPIRIT OF RESISTANCE: AFRICAN-AMERICAN MODERNISTS AND THE MEXICAN MURALIST SCHOOL — Influences of the Mexican Muralist movement on African-American modernist artists will be explored in the works on view by Rivera, Orozco, Catlett, Lawrence, Woodruff and others. CAT WT

Los Angeles

Fisher Gallery, University of Southern California
Affiliate Institution: University of Southern California
823 Exposition Blvd., **Los Angeles, CA 90089-0292**
✆ 213-740-4561
HRS: Noon-5 Tu-F, 11-3 Sa (closed during summer) DAY CLOSED: M HOL: LEG/HOL! SUMMER
♿: Y ℗ Y; Visitor parking on campus for $6.00 per vehicle
PERM/COLL: EU: ptgs, gr, drgs; AM: ptgs, gr, drgs; PTGS 15-20 (ARMAND HAMMER COLL; ELIZABETH HOLMES FISHER COLL.)

Old master paintings from the Dutch and Flemish schools as well as significant holdings of 19th-century British and French art are two of the strengths of the Fisher Gallery. PLEASE NOTE: the permanent collection is available to museums, scholars, students, and the public by appointment.

ON EXHIBIT/97:

09/18/96–04/05/97	THE DRINKING MAIDEN — In this exhibition of sculpture by Ernst Wenck from the permanent collection, one of the works entitled "The Drinking Maiden" will be available for viewing on the World Wide Web allowing virtual visitors to manipulate the camera in order to see all sides of the work.
11/20/96–02/08/97	MYTHIC PROSENT II Tent. Name
02/26/97–04/19/97	TURNER'S PICTORA POESIS: ILLUSTRATIONS OF THE ENGLISH POETS — On loan from a rare private collection of the illustrations Turner made of the English poets will be engravings of such literary luminaries as Lord Byron, Sir Walter Scott, Thomas Moore, John Milton and others. CAT
12/07/97–02/15/98	ASIAN TRADITIONS/MODERN EXPRESSION: ASIAN-AMERICAN ARTISTS AND ABSTRACTION, 1945-1970 — The achievements of Asian American artists and how they were able to make use of traditional Asian art techniques and philosophies to develop a creative blending of Eastern and Western art. Dates Tent! TENT!

The Gallery 825/Los Angeles Art Association
Affiliate Institution: Los Angeles Art Association
825 N. La Cienega Blvd., **Los Angeles, CA 90069**
✆ 310-652-8272
HRS: Noon-5 Tu-Sa DAY CLOSED: M, S HOL: LEG/HOL!
VOL/CONT: Y ♿: Y; But very limited ℗ Y; Free in rear of building

For over 70 years the gallery of the Los Angeles Art Association has been exhibiting and promoting some of the most important California artists on the art scene today. Solo exhibitions are presented in the newly designed Helen Wurdemann Gallery.

ON EXHIBIT/97:

01/18/97–02/21/97	SENIOR ALUMNI EXHIBITION
03/01/97–03/28/97	OBJECTS/IMAGES/IDEAS
04/05/97–05/01/97	URBAN STRUCTURES
05/10/97–06/06/97	ART & SOUL
06/14/97–07/11/97	SALON du PETIT
07/19/97–08/08/97	TBA
08/17/97–09/12/97	PRIMARY COLORS — Featured will be a collaborative exhibition between Gallery 825/LA Art Association, Watts Towers Art Center, and SITE, all non-profit arts organizations.
09/27/97–10/24/97	INSTALLATION EXHIBITION
11/01/97–11/28/97	ELEMENTAL: FIRE, WIND, WATER AND AIR
12/06/97–01/02/98	GALLERY 825 1997 OPEN

CALIFORNIA

Los Angeles

Laband Art Gallery

Affiliate Institution: Loyola Marymount University
7900 Loyola Blvd., **Los Angeles, CA 90045**
☎ 310-338-2880
HRS: late Aug - mid May: 11-5 W-F, Noon-4 Sa DAY CLOSED: M, S
HOL: Jun - Aug.; LEG/HOL, ACAD/HOL, RELIGIOUS/HOL ♿: Y
PERM/COLL: FL: om; IT: om; DRGS; GR

The Laband Art Gallery usually features exhibitions based on multi-cultural projects relating to Latin and Native American subjects, current social and political issues, and Jewish & Christian spiritual traditions.

ON EXHIBIT/97:

01/24/97–03/01/97	LOS ANGELES PRINTMAKING SOCIETY 14TH NATIONAL EXHIBITION — The finest recent traditional and experimental examples of contemporary printmaking in North America will be seen in this biennial exhibition. CAT
03/21/97–04/26/97	CORPORA IN EXTREMIS: RECENT WORK BY PATTY WICKMAN AND HANNELINE ROGEBERG — The virtuoso figurative style paintings on exhibit by L.A. based Wickman and N.Y. based Rogeberg, all combine Baroque lighting and movement with the individual contemporary psychological and spiritual insights of each artist. CAT
08/22/97–10/05/97	LOS ANGELES AT THE CENTER AND ON THE EDGE: 30 YEARS OF POLITICAL GRAPHICS — A survey of political art produced from 1963-1995 by a bevy of southern California artists.
10/30/97–12/06/97	ELOQUENT LINE: CONTEMPORARY JAPANESE CALLIGRAPHY — Featured will be 58 works by 58 contemporary calligraphers inspired by American abstract expressionist painting, Zen mysticism, and whose creations reflect their individualized responses to the traditional elements of the art. TENT! CAT

Los Angeles County Museum of Art

5905 Wilshire Blvd., **Los Angeles, CA 90036**
☎ 213-857-6000 WEB ADDRESS: http://www.lacma.org/
HRS: 10-5 Tu-T; 10-9 F (except for Japanese Art Pavilion); 11-6 Sa, S DAY CLOSED: M, Tu HOL: 12/25, 1/1, THGV
F/DAY: 2nd W ADM: Y ADULT: $6.00 CHILDREN: $1.00 (6-17) STUDENTS: $4.00 SR CIT: $4.00
♿: Y; Fully accessible with wheelchairs available
Ⓟ Y; Paid parking available in lot directly across the street from the entrance to the museum. MUS/SH: Y
❖ Y; Plaza Cafe 10-4:30 Tu-T, 10- 8:30 F, 11-5:30 Sa & S
GR/T: Y GR/PH: CATR! 213-857-6108
DT: Y TIME: Frequent & varied (call for information)
PERM/COLL: AN/EGT: sculp, ant; AN/GRK: sculp, ant; AN/R: sculp, ant; CH; ptgs, sculp, cer; JAP: ptgs, sculp, cer; AM/ART; EU/ART; DEC/ART

The diversity and excellence of the collections of the Los Angeles Museum offer the visitor to this institution centuries of art to enjoy from ancient Roman or pre-Columbian art to modern paintings, sculpture, and photography. PLEASE NOTE: The Pavilion for Japanese Art is the only gallery NOT open on Friday evening. **NOT TO BE MISSED:** George de La Tour's "Magdelene with the Smoking Flame," 1636-1638; "Under the Trees" by Cézanne.

ON EXHIBIT/97:

06/23/96–01/05/97	SOME GRIDS — 30 20th-century works of art in a variety of media selected from the permanent collection will be featured in an exhibition designed to show how the grid acts as a defining element in a work of art.

Los Angeles County Museum of Art - continued

07/25/96–02/08/97 HEARTS AND GIZZARDS: A CHILD'S GALLERY OF QUILTS — Designed mainly for children, this exhibition of quilts from the permanent collection accompanied with examples of 19th-century children's clothing and toys, seeks to directly involve young visitors in learning about the history and construction of quilts.

09/19/96–01/05/97 MARK CHAGALL 1907-1917 — More than 80 of Chagall's paintings, gouaches and drawings depicting family members, religious subjects, street scenes of Paris city and Russian village, and self-portraits created during his formative artistic years in Russia and Paris will be on view in the first major exhibition of his early works. CAT WT ◠

10/31/96–01/26/97 FABRIC OF ENCHANTMENT: BATIK FROM THE NORTH COAST OF JAVA — 50 batik textiles selected from the museum's permanent collection will be featured in an exhibition that traces the stylistic development of these fabrics from the mid-19th to the mis-20th-century. Highlights of this display will include cloth designed by Eliza van Zuylen, whose flawless backgrounds and minute white lines have made them highly prized by Western collectors, and other rare batiks whose designs reflect colonial rule. CAT

11/14/96–01/26/97 ROY DeCARAVA: A RETROSPECTIVE — Groundbreaking pictures of everyday life in Harlem, civil rights protests, lyrical studies of nature, and photographs of jazz legends will be among the 200 black & white photographs on view in the first comprehensive survey of DeCarava's works. CAT WT

11/17/96–02/09/97 RITUAL AND SPLENDOR: ANCIENT TREASURES FROM THE SHUMEI FAMILY COLLECTION — More than 290 Chinese, Afghan, Iranian, Egyptian and Greek works of art will be featured in the last American venue for this spectacular collection before it travels to its permanent home in a new Japanese museum designed by I. M. Pei. Some of the highlights will include a rare 16th-century Islamic carpet, a precious gilt-bronze and jade Chinese pendant from the 3rd-2nd century B.C., and a number of 12th-13th-century Persian ceramics.

02/23/97–05/11/97 EXILES AND ÉMIGRÉS: 1933-1945 — 23 internationally acclaimed European painters, sculptors, photographers and architects forced to flee from the Nazi rise to power in 1933 will be featured in a major exhibition that examines the impact of their emigration upon their artistic output. Paintings by Kandinsky, Beckman, Schwitters, Kokoschka and others will be included in the first part of the exhibition which deals with artists who sought refuge in Paris, London and Amsterdam while works by Léger, Ernst, Tanguy, Marc Chagall, Marcel Breuer, Walter Gropius, and Mies van der Rohe will form the central part of the show devoted to those artists who fled to America. ONLY VENUE CAT ◠

02/27/97–05/18/97 THE END OF THE CENTURY: PRINTS SINCE 1970 FROM THE COLLECTION — 90 predominately American prints created since 1970 by Jim Dine, Jasper Johns, Roy Lichtenstein, Frank Stella, Andy Warhol and many other artistic luminaries will be selected for viewing from the museum's holdings.

02/27/97–05/18/97 RICHARD OGINZ: DRAWINGS FROM A SCULPTOR'S VIEW — On exhibit will be 21 meticulously detailed ink or pencil drawings of interior and exterior views of Los Angeles by Oginz, winner of the museum's Young Talent Award.

03/06/97–05/18/97 RAISED BY WOLVES: PHOTOGRAPHS AND DOCUMENTS OF RUNAWAY KIDS BY JIM GOLDBERG — Goldberg juxtaposes photographs, documents, text, video and other objects in an emotionally charged multi-media installation that weaves a narrative about young American children who leave dysfunctional families and live instead on the streets of San Francisco and Hollywood. CAT WT

03/23/97–06/08/97 GALANOS — 70 costumes by Los Angeles-based American couturier, James Galanos, a designer who has received every major design award, will be displayed with original sketches and examples of his signature bead-work. CAT

CALIFORNIA

Los Angeles

Los Angeles Municipal Art Gallery
Affiliate Institution: Barnsdall Art Park
4800 Hollywood Blvd., **Los Angeles, CA 90027**
☎ 213-485-4581
HRS: 12:30-5 W-S, till 8:30 F DAY CLOSED: M, Tu HOL: 12/25, 1/1
ADM: Y ADULT: $1.50 CHILDREN: F (under 12) STUDENTS: $1.50 SR CIT: $1.50
&: Y; handicapped parking Ⓟ Y; Ample free parking in the Park
DT: Y TIME: house only $2.00 (adult) Tu-S Noon, 1, 2, 3 H/B: Y; 1921 Frank Lloyd Wright Hollyhock House
PERM/COLL: CONT: S/Ca art

The Los Angeles Municipal Art Gallery of the Barnsdall Art Park is but one of several separate but related arts facilities, one of which is the Junior Arts Center Gallery. **NOT TO BE MISSED:** Frank Lloyd Wright Hollyhock House and drawings

ON EXHIBIT/97:

12/04/96–02/02/97	SKIN AND BONES — An exhibition of contemporary sculpture with organic forms.
02/19/97–04/13/97	SENSUALITY IN THE ABSTRACT — Abstract paintings and photographs will be on view.
07/16/97–09/07/97	1997 LOS ANGELES JURIED EXHIBITION
09/24/97–11/16/97	HELLO AGAIN: A NEW WAVE OF RECYCLED ART AND DESIGN — Innovative, surprising and often amusing objects created by internationally-known artists will be included in an exhibition of furniture, jewelry, musical instruments, art & architectural works fashioned from such recycled items as plastic soda bottles, old maps, junk mail, bottle caps, used kitchen appliances and the like. WT

The Museum of African American Art
4005 Crenshaw Blvd., 3rd Floor, **Los Angeles, CA 90008**
☎ 213-294-7071
HRS: 11-6 W-Sa, Noon-5 S DAY CLOSED: M-T HOL: 12/25, 1/1, EASTER, THGV
&: Y; Elevator to third floor gallery location Ⓟ Y; Free MUS/SH: Y
PERM/COLL: AF: sculp, ptgs, gr, cer; CONT/AM; sculp, ptgs, gr; HARLEM REN ART

Located on the third floor of the Robinsons May Department Store, this museum's permanent collection is enriched by the "John Henry Series" and other works by Palmer Hayden. Due to the constraints of space these works and others are not always on view. The museum requests that you call ahead for exhibition information. **NOT TO BE MISSED:** "John Henry Series" and other works by Palmer Hayden (not always on view).

The Museum of Contemporary Art, Los Angeles
250 S. Grand Ave., **Los Angeles, CA 90012**
☎ 213-626-6222S
HRS: 11-5 Tu, W, F-S; 11-8 T DAY CLOSED: M HOL: 12/25, 1/1, THGV
F/DAY: 5-8 T ADM: Y ADULT: $6.00 CHILDREN: F (under 12) STUDENTS: $4.00 SR CIT: $4.00
&: Y; Fully accessible, wheelchairs available Ⓟ Y; For California Plaza Parking Garage (enter from Lower Grand Ave): weekday parking fee of $2.75 every 20 minutes charged before 5 PM & $4.40 flat rate after 5 PM weekdays and weekends; For The Music Center Garage (enter from Grand Ave. between Temple & First): before 6 PM a $15.00 deposit is required upon entry with $8.00 returned with ticket VALIDATED at MOCA information center. MUS/SH: Y ⑪Y; Cafe 8:30-4 Tu-F; 11-4:30 Sa, S GR/T: Y GR/PH: CATR! 213-621-1751 education dept. DT: Y TIME: 12, 1 & 2 daily; 6:00 T
H/B: Y; First American building commission by Arata Isozaki
PERM/COLL: CONT: all media

The Museum of Contemporary Art, Los Angeles - continued

The Museum of Contemporary Art (MOCA) is the only institution in Los Angeles devoted exclusively to art created from 1940 to the present by modern-day artists of international reputation. The museum is located in two unique spaces: MOCA at California Plaza, the first building designed by Arata Isozaki; and the Geffen Contemporary at MOCA, (152 North Central Ave., L.A., CA 90013), a former warehouse redesigned into museum space by architect Frank Ghery. PLEASE NOTE: Gallery educators are available in the galleries from 11 a.m. to 4 p.m. daily and till 8 p.m. on T. There is shuttle bus service between the two museum spaces. Admission is valid at both museum buildings on the date purchased.

ON EXHIBIT/97:

through 08/17/97	IMAGES OF AN ERA: SELECTIONS FROM THE PERMANENT COLLECTION — The Geffen Contemporary at MOCA — Examples of the best works in the permanent collection from 1945-1975 presented in chronological order will be on long term display in 16 of the museum's galleries. A "time line" in the corridors linking the galleries traces the artistic, personal, social, creative and political forces in play during this period,
09/29/96–01/19/97	JUST PAST: THE CONTEMPORARY IN MOCA'S PERMANENT COLLECTION, 1975-96 — The Geffen Contemporary at MOCA — Recent acquisitions and works created by artists emerging in the 70's, 80's and 90's will be on exhibit.
11/03/96–01/26/97	THE POWER OF SUGGESTION: NARRATIVE AND NOTATION IN CONTEMPORARY DRAWING — MOCA at California Plaza — In this group exhibition of drawings by emerging artists from New York and Los Angeles, the issue of the reinvention of the narrative through serial and notational approaches to drawing will be addressed.
11/24/96–02/02/97	FOCUS SERIES: PARADISE CAGE: KIKI SMITH AND COOP HIMMELBLAU — MOCA at California Plaza — This collaborative effort between artist Smith and architect Himmelblau will result in the presentation of a dramatic 60-foot cage-like installation resembling the Garden of Paradise which acts as sanctuary for humans and animals.
11/24/96–03/02/97	FOCUS SERIES: JENNIFER PASTOR WT
02/16/97–05/18/97	ELLSWORTH KELLY: A RETROSPECTIVE — MOCA at California Plaza — Highlighted in this comprehensive 5 decade survey of Kelly's paintings, sculpture and works on paper will be his significant contribution to the art of the 20th-century. CAT WT ◯
03/16/97–07/06/97	UNCOMMON SENSE — The Geffen Contemporary at MOCA — A presentation of individual artists' projects, collaborative works, performances and other creative endeavors by 8 artists whose works investigate social issues and whose creations often exist outside of the traditional boundaries of art.
07/13/97–10/05/97	JEFF WALL — A retrospective of 30 photographic works created by Canadian artist Wall since 1946 will consist of large color transparencies in light boxes that are luminous pictorial narratives reflecting the artist's concern with contemporary social issues. CAT WT
08/10/97–11/02/97	ROBERT GOBER — In his first solo U.S. museum show, Gober will create a site-specific installation of a large-scale multi-level sculpture in the form of a house through which visitors may walk and enjoy such unusual features as "fountain" piece, a staircase with water running down its steps. WT

Los Angeles

UCLA at The Armand Hammer Museum of Art and Cultural Center
10899 Wilshire Blvd., Los Angeles, CA 90024
☎ 310-443-7000
HRS: 11-7 Tu, W, F, Sa; 11-9 T; 11-5 S DAY CLOSED: M HOL: 12/25, 1/1, THGV, 7/4
F/DAY: 6-9 T ADM: Y ADULT: $4.50 CHILDREN: F (under 17) STUDENTS: $3.00 SR CIT: $3.00
♿: Y; Ramps and elevator ℗ Y; underground visitor parking available at $2.75 for the first two hours with a museum stamp, $1.50 for each additional 20 minutes, and a flat $3.00 rate after 6:30 T. MUS/SH: Y
GR/T: Y GR/PH: CATR! 310-443-7041 DT: Y TIME: PERM/COLL: 1:00 W, F, S; CHANGING EXHS: 1 PM Tu-S
PERM/COLL: EU: 15-19

CALIFORNIA

UCLA at The Armand Hammer Museum of Art and Cultural Center - continued

With the largest collection of works by Daumier in the country (more than 10,000) plus important collections of Impressionist, Post-Impressionist, and Contemporary art, the Armand Hammer Museum is considered a major U.S. artistic cultural resource. Opened in 1990, the museum is now part of UCLA. It houses the collections of the Wight Art Gallery and the Grunwald Center for the Graphic Arts (one of the finest university collections of graphic arts in the country with 35,000 works dating from the Renaissance to the present). **NOT TO BE MISSED:** Five centuries of Masterworks: over 100 works by Rembrandt, van Gogh, Cassatt, Monet, and others; the UCLA Franklin D. Murphy Sculpture Garden, one of the most distinguished outdoor sculpture collections in the country featuring 70 works by Arp, Calder, Hepworth, Lachaise, Lipchitz, Matisse, Moore, Noguchi, Rodin and others.

ON EXHIBIT/97:

ONGOING	THE ARMAND HAMMER COLLECTION
	THE ARMAND HAMMER DAUMIER AND CONTEMPORARIES COLLECTION
	THE UCLA GRUNWALD CENTER FOR THE GRAPHIC ARTS
	THE UCLA FRANKLIN D. MURPHY SCULPTURE GARDEN — One of the most distinguished outdoor sculpture collections in the country.
01/14/97–03/09/97	BOYDELL'S SHAKESPEARE PICTURE GALLERY — 30 of the Bard's folio plates will be on loan to the exhibit from the Boydell Shakespeare Gallery.
01/29/97–03/23/97	TOO JEWISH? CHALLENGING TRADITIONAL IDENTITIES — The resurgence of ethnic consciousness over the past decade and its profound effect on many Jewish artists will be explored in an exhibition featuring 45 works by 23 artists not bound to each other by stylistic homogeneity. CAT WT
04/16/97–06/29/97	PICTURING CHILDHOOD: ILLUSTRATED CHILDREN'S BOOKS FROM UNIVERSITY OF CALIFORNIA COLLECTIONS — The issues of how society's changing conceptions of childhood influenced the genre of children's books from the mid-16th-century to the present will be explored in this fascinating exhibition of over 150 illustrated books, watercolors, drawings, models, toys, pop-ups and other objects. Original works of art will be shown alongside published works.
07/23/97–10/05/97	SCENE OF THE CRIME — 75 diverse works created by West Coast artists Ed & Nancy Kienholz, Ed Rucha, Chris Burden and Vija Celmins over the past 30 years will be on view with those created by new talents in an exhibition designed to suggest the residue or reflection of an event redolent of criminality, violation or mysterious turbulence.
10/29/97–01/04/98	UNIVERSAL LIMITED ART EDITIONS: FORTY YEARS, 1957-1997 — On display will be 160 prints, books, portfolios, and 3 dimensional objects by 24 artists such as Helen Frankenthaler, Jasper Johns, Robert Rauchenberg, Larry Rivers, all of whom have created art at this Long Island workshop at some point in their careers. CAT WT

Los Angeles

Watts Towers Arts Center
1727 E. 107th St., **Los Angeles, CA 90002**
☎ 213-847-4646
HRS: Art Center: 10-4 Tu-Sa, Noon-4 S; (Watts Tower open Sa, S! $1.00 adults) DAY CLOSED: M HOL: LEG/HOL!
♿: Y ℗ Y; Visitors parking lot outside of Arts center GR/T: Y GR/PH: CATR! for weekday Tower tours
PERM/COLL: AF; CONT; WATTS TOWER

Fantastic lacy towers spiking into the air are the result of a 33 year effort by the late Italian immigrant visionary sculptor Simon Rodia. His imaginative use of the "found object" resulted in the creation of one of the most unusual artistic structures in the world.

Watts Towers Arts Center - continued
ON EXHIBIT/97:

01/12/97–02/16/97	L.A. FROM WITHIN — Installations by artists Fielden Harper and Ann Phong.
02/26/97–03/30/97	MABEL BOYD — Photography by the late Mable Boyd.
04/06/97–05/10/97	NEW IDENTITIES OF LOS ANGELES
05/25/97–07/06/97	DOODLES — Doodles by artists, musicians, politicians, and others will be on exhibit.
07/16/97–08/10/97	1997 LOS ANGELES JURIED EXHIBITION
08/17/97–09/14/97	L.A. ART ASSOCIATION EXHIBITION
09/21/97–10/26/97	EXHIBITION OF INSTALLATIONS AND SCULPTURES BY MASUD KORDAFAN

Malibu

Frederick R. Weisman Museum of Art
Affiliate Institution: Pepperdine Center for the Arts, Pepperdine University
24255 Pacific Coast Highway, **Malibu, CA 90263**
☎ 310-456-4851
HRS: 11-5 Tu-S DAY CLOSED: M HOL: LEG/HOL!
&: Y; Completely accessible with ramps and elevators Ⓟ Y; Free
GR/T: Y GR/PH: CATR! DT: Y TIME: call for specifics!
PERM/COLL: PTGS, SCULP, GR, DRGS, PHOT 20

Opened in 1992, this museum's permanent collection and exhibitions focus primarily on 19th & 20th-century art.
NOT TO BE MISSED: Selections from the Frederick R. Weisman Art Foundation

ON EXHIBIT/97:

ONGOING	SELECTIONS FROM THE FREDERICK R. WEISMAN COLLECTIONS
01/11/97–03/31/97	SAM FRANCIS: JUNGIAN IMAGERY — Francis's interest in the psychology of Carl Jung will be reflected in the spiritual portraits and abstracted works on exhibit.
05/97–07/97	GERARDO RUEDA — Paintings by this late Spanish master will be seen in the first American retrospective of his works.

The J. Paul Getty Museum
17985 Pacific Coast Highway, **Malibu, CA 90265**
☎ 310-458-2003
HRS: 10-5 Tu-S (ADVANCE PARKING RESERVATIONS A MUST - CALL 310-458-2003) DAY CLOSED: M HOL: 12/25, 7/4, 1/1, THGV
&: Y; Parking, ramps, elevators, some wheelchairs, & other amenities Ⓟ Y; Advance parking reservations are a must! Call 310-458-2003, 9-5 daily for information & reservations MUS/SH: Y ⊪ Y; 9:30-4:30 (Lunch 11-2:30)
GR/T: Y GR/PH: CATR! H/B: Y; Museum building based on 1st century Roman villa
PERM/COLL: AN/GRK; AN/R; EU: ptgs, drgs, sculp; DEC/ART; AM: phot 20; EU: phot 20; Illuminated Manuscripts

The outstanding collections of the Getty Museum are housed in the recreation of the Villa dei Papiri, an ancient Roman country house. Modern casts of ancient sculpture and illusionistic wall paintings decorate the gardens. PLEASE NOTE THE FOLLOWING: (1) In late 1997 the Getty will open its new facility in Los Angeles. The new set of buildings, designed by Richard Meier, will be joined by a series of gardens, terraces, fountains and courtyards and will be located in one of the great public viewpoints in Los Angeles. (2) No walk-in traffic is permitted at the museum's present location. (3) Due to the impending move there will be no more exhibitions scheduled at the present location after 4/6/97. **NOT TO BE MISSED:** "Irises" by Vincent Van Gogh, 1889; Pontormo's "Portrait of Cosimo I de Medici," c. 1537; "Bullfight Suerte de Varas" by Goya, 1824 (recently acquired)

CALIFORNIA

The J. Paul Getty Museum - continued
ON EXHIBIT/97:

ONGOING	THE GETTY KOUROS — An exhibition that examines both sides of the ongoing controversy involving the authenticity of the Getty Kouros.
12/17/96–04/06/97	FIGURE DRAWINGS — Drawings that explore the representation of the human body over the course of 4 centuries will be seen in this exhibition of 26 works by Dürer, Leonardo Da Vinci, Carraci, Rubens, Rembrandt, Courbet, and others.
01/04/97–04/06/97	THE EYE OF SAM WAGSTAFF — An exhibition designed to pay tribute to Wagstaff (1921-1987), a man whose pioneering photography collection forms the cornerstone of the Getty's photographic holdings.

Monterey

Monterey Museum of Art
559 Pacific St., **Monterey, CA 93940**
☎ 408-372-5477
HRS: 11-5 W-Sa, 1-4 S, till 8 PM 3rd T of the month DAY CLOSED: M HOL: LEG/HOL!
SUGG/CONT: Y ADULT: $3.00 CHILDREN: F (under 12)
&: Y; Entrance ramp to ground floor; elevator; restrooms Ⓟ Y; Street parking and paid lots nearby to main museum
MUS/SH: Y GR/T: Y GR/PH: CATR! DT: Y TIME: 2:00 S; 1:00 Sa & S for La Mirada H/B: Y
PERM/COLL: REG/ART; AS; PACIFIC RIM; FOLK; ETH; GR; PHOT

With a focus on its ever growing collection of California regional art, the Monterey Museum is planning a modern addition to its original building, La Mirada, the adobe portion of which dates back to the late 1700's when California was still under Mexican rule. PLEASE NOTE: The suggested donation fee for La Mirada, located at 720 Via Mirada, is $3.00. **NOT TO BE MISSED:** Painting and etching collection of works by Armin Hansen

ON EXHIBIT/97:

1/17/97	WESTERN PAINTING & SCULPTURE
01/10/97–04/27/97	WHALING ON THE CENTRAL COAST
01/10/97–04/20/97	PAUL WUNDERLICH: LITHOGRAPHS (Working Title)
01/17/97–03/23/97	PENINSULA PEOPLE: PHOTOGRAPHS BY JOHN McCLEARY
01/17/97–03/30/97	19TH & 20TH CENTURY PHOTOGRAPHS: IMAGES FROM TONY AND MERRITY PAGE
3/22/97	FOLK ART FROM THE PERMANENT COLLECTION
04/05/97–05/04/97	ARTISTS AT WORK
04/05/97–06/01/97	MONTEREY PENINSULA ARTISTS
04/26/97–08/24/97	KAREN NAGANO
05/08/97–06/01/97	CALIFORNIA ART SCHOLARS (Working Title)
05/08/97–06/01/97	YOUTH ARTS FESTIVAL
06/07/97–08/31/97	CALIFORNIA BELLS, PAINTINGS FROM THE IRVINE MUSEUM: (Working Title)
06/14/97–09/07/97	DODY WESTON THOMPSON: PHOTOGRAPHS (Working Title)
06/14/97–09/07/97	GREG KONDOS: CALIFORNIA PAINTINGS (Working Title)
08/30/97–11/23/97	JILL EGGERS: PAINTINGS (Working Title) — Paintings and drawings of interiors and still lifes by Eggers. WT
09/20/97–12/28/97	ARTISTS' EQUITY STUDIO TOUR EXHIBITION

Moraga

Hearst Art Gallery
Affiliate Institution: St. Mary's College
Box 5110, **Moraga, CA 94575**
☎ 510-631-4379
HRS: 11-4:30 W-S DAY CLOSED: M, Tu HOL: LEG/HOL!
VOL/CONT: Y ADULT: $1.00 ♿: Y Ⓟ Y; Free
MUS/SH: Y GR/T: Y GR/PH: CATR!
PERM/COLL: AM: Calif. Ldscp ptgs 19-20; IT: Med/sculp; EU: gr; AN/CER; CHRISTIAN RELIGIOUS ART 15-20

Contra Costa County, not far from the Bay Area of San Francisco, is home to the Hearst Art Gallery, built with the aid of the William Randolph Hearst Foundation. Located on the grounds of St. Mary's College, one of its most outstanding collections consists of Christian religious art representing many traditions, cultures and centuries. **NOT TO BE MISSED:** 150 paintings by William Keith (1838 - 1911), noted California landscape painter

ON EXHIBIT/97:

01/18/97–03/02/97	MARK ROTHKO: THE SPIRIT OF MYTH, EARLY PAINTINGS FROM THE 1930'S AND 1940'S — 26 landscape, figurative and portrait expressionist paintings will be seen in an exhibition that provides an important understanding to his later more familiar atmospheric color-field works.	CAT WT
03/15/97–04/27/97	MARY, MOTHER OF GOD	BROCHURE
06/07/97–09/07/97	EARLY CALIFORNIA IMPRESSIONISTS: THE RONALD E. WALKER COLLECTION	CAT
09/20/97–11/09/97	TERRY ST. JOHN	CAT
11/22/97–01/25/98	SPACE: THE FINAL FRONTIER	BROCHURE

Newport Beach

Orange County Museum of Art, Newport Beach
850 San Clemente Dr., **Newport Beach, CA 92660**
☎ 714-759-1122
HRS: 10-5 Tu-Sa, 12-5 S DAY CLOSED: M HOL: 12/25, 1/1, THGV
F/DAY: Tu ADM: Y ADULT: $4.00 CHILDREN: F (under 12) STUDENTS: $2.00 SR CIT: $2.00
♿: Y; Ramps; museum on one level Ⓟ Y; Free off-street parking
MUS/SH: Y ⅋ Y; 11:30-2:20 M-F
GR/T: Y GR/PH: CATR!
DT: Y TIME: 12:15 & 1:15 Tu-F; 2:00 Sa, S S/G: Y
PERM/COLL: REG: Post War Ca. art (PLEASE NOTE: The permanent collection is not usually on display).

With an emphasis on contemporary and modern art, the Newport Beach, now part of a three museum Orange County association, was founded in 1962. Featuring post World War 11 California art this venue is dedicated to the promotion of pace-setting trends in contemporary and cutting-edge works of art.

ON EXHIBIT/97:

12/08/96–01/26/97	JOE GOODE — 65 paintings and works on paper on loan from public and private collections nationwide will be on view in the first comprehensive retrospective presentation of the work of Joe Goode, a seminal figure in the Venice, CA. art scene. The artist's integration of color field painting, pop art and abstraction within his works will be explored in the works on view.	CAT

CALIFORNIA

Orange County Museum of Art, Newport Beach - continued

01/25/97–06/15/97 PHOTOGRAPHY AT NEWPORT HARBOR ART MUSEUM: GIFTS FROM THE SMITH/WALKER FOUNDATION — 75 works devoted to photography and works on paper will be mounted in the first installation of the museum's new gallery space. The evolution of photographic idioms will be addressed in the portraiture, landscape, documentary and conceptual images on view.

03/08/97–06/01/97 THE CAVE — A multiple channel video installation consisting of the integration of video installation work by Beryl Korot and music by Steve Reich will make its premier West Coast presentation at this venue.

04/19/97–06/08/97 THE FIFTH NEWPORT BIENNIAL OF CALIFORNIA ART — Works by 15 established and emerging artists working in California will be featured in a broad statewide survey reflecting recent artistic trends. CAT

06/07/97–09/07/97 FLEURS DU MAL: GEORGIA O'KEEFFE AND ROBERT MAPPLETHORP — This presentation of works by two of the 20th-century's most notorious American artists will focus on the flower as a metaphorical image which embodies physical and spiritual realms.

06/07/97–01/04/98 BILL VIOLA: THE THEATER OF MEMORY — The museum's new installation gallery will host as its inaugural exhibition Viola's "The Theater of Memory," a seminal work in the permanent collection that will be on exhibit for the first time since 1988.

06/20/97–08/15/97 CALIFORNIA STILL LIFES IN THE COLLECTION — Selected works by California artists in the permanent collection will be shown in conjunction with the exhibition above.

06/20/97–08/17/97 AMERICAN STILL LIFE AND INTERIORS, 1915-1994: SELECTIONS FROM THE METROPOLITAN MUSEUM OF ART — The vitality of still-life painting in the 20th-century is celebrated in this exhibition of 62 works by 57 artists including Stuart Davis, Jim Dine, Marsden Hartley, Georgia O'Keeffe, Rosenquist and Warhol. CAT WT

09/13/97–01/04/98 THE GRAPHIC ART OF PABLO PICASSO — Examples of all print processes employed by Picasso in his works including lithographs, etchings, serigraphs, stencils, woodcuts and linocuts will be seen in an exhibition designed to illuminate the development of the Master's graphic oeuvre and its dominant themes. All of the works will be on loan from the collection of the Grunwald Center for the Graphic Arts in Los Angeles.

Oakland

Oakland Museum of California
1000 Oak St, **Oakland, CA 94607**
☎ 510-238-2200
HRS: 10-5 W-Sa, Noon-7 S DAY CLOSED: M, Tu HOL: THGV, 12/25, 1/1, 7/4
F/DAY: 4-7 S ADM: Y ADULT: $5.00 CHILDREN: F (5 & under) STUDENTS: $3.00 SR CIT: $3.00
♿: Y; Wheelchair accessible including phones and restrooms
Ⓟ Y: Entrance on Oak & 12th St. small fee charged
MUS/SH: Y ⏚ Y
GR/T: Y GR/PH: CATR! 510-273-3514
DT: Y TIME: weekday afternoons on request; 12:30 weekends S/G: Y
PERM/COLL: REG/ART; PTGS; SCULP; GR; DEC/ART

The art gallery of the multi-purpose Oakland Museum of California features works by important regional artists that document the visual history and heritage of the state. Of special note is the Kevin Roche - John Dinkaloo designed building itself, a prime example of progressive museum architecture complete with terraced gardens. **NOT TO BE MISSED:** California art; newly installed "On-line Museum" database for access to extensive information on the museum's art, history and science collections (open for public use 1:00-4:30 T).

50

Oakland Museum of California - continued
ON EXHIBIT/97:

11/23/96–01/26/97 LLYN FOULKES: BETWEEN A ROCK AND A HARD PLACE — A retrospective of paintings and assemblages by Foulkes, one of California's most original and enigmatic artists, reveals his unusual visions of the underside of American life and mythology.
CAT WT

02/08/97–07/20/97 EXPRESSIONS IN WOOD: MASTERWORKS FROM THE WORNICK COLLECTION — 40 of the most innovative examples of turned vessels and other shaped wood objects created over the last 15 years will be on display. CAT

02/08/97–07/27/97 HELLO AGAIN: A NEW WAVE OF RECYCLED ART AND DESIGN — Innovative, surprising and often amusing objects created by internationally known artists will be included in an exhibition of furniture, jewelry, musical instruments, art & architectural works fashioned from such recycled items as plastic soda bottles, old maps, junk mail, bottle caps, used kitchen appliances and the like.

03/15/97–07/20/97 MAIDU PAINTINGS BY DAL CASTRO: FROM THE AESCHLIMAN-McGREAL COLLECTION OF THE OAKLAND MUSEUM OF CALIFORNIA — A retrospective exhibition of self-taught Native American Castro's vivid folk-style paintings created between 1975-1993 depicts his interpretations of Nisenan Maidu creation myths, animal legends, ceremonies and portraits of tribal elders and ancestors.

03/15/97–07/20/97 MEMORY AND IMAGINATION: THE LEGACY OF MAIDU INDIAN ARTIST FRANK DAY —- Frank Day (1902-1976) was a self-taught Konkow Maidu artist whose works were responsible for a revitalization of Native American ceremonialism in northern California. In this exhibition 50 of his paintings will be featured with artifacts from his home and paintings by contemporary Maidu artists who were influenced by his work.

09/13/97–01/04/98 A POETIC VISION: THE PHOTOGRAPHS OF ANNE BRIGMAN — 75 images from 1905-1949 will be featured in the first retrospective of Brigman, a major pictorialist photographer known for her manipulation and hand-working of negatives and prints which produced poetic effects similar to those of Tonalist painters. CAT

09/13/97–12/14/97 THE ART OF JOHN CEDERQUIST: REALITY OF ILLUSION — 30 major works featured in this mid-career survey consist of traditional furniture forms combined with pictorial images of perspective drawing, veneering, inlaying, and photo-realist painting to create a disorienting though surprising and amusing trompe-l'oeil effect of multi-layered reality. CAT WT

09/13/97–12/14/97 WILLIAM T. WILEY (Working Title) — Sculptures, drawings and other works will be created on site by Wiley, one of California's most innovative and playful artists. While he works, Wiley's visiting friends will collaborate with him in discussion and join with him in musical interludes.

Oxnard

Carnegie Art Museum
424 S. C St., **Oxnard, CA 93030**
☎ 805-385-8157
HRS: 10-5 T, 11-6 F, 10-5 Sa, 1-5 S (Museum closed between exhibits) DAY CLOSED: M HOL: MEM/DAY, LAB/DAY, THGV, 12/25 F/DAY: 3-6 F SUGG/CONT: Y ADULT: $2.00 CHILDREN: F (under 6) STUDENTS: $1.50
SR CIT: $1.50&: Y Ⓟ Y; Free parking in the lot next to the museum MUS/SH: Y GR/T: Y GR/PH: CATR! H/B: Y
PERM/COLL: CONT/REG; EASTWOOD COLL.

Originally built in 1906 in the neo-classic style, the Carnegie, located on the coast just south of Ventura, served as a library until 1980. Listed NRHP **NOT TO BE MISSED:** Collection of art focusing on California painters from the 1920's to the present.

ON EXHIBIT/97:
ONGOING 8-10 works from the museum's permanent collection of 20th-century California art.

CALIFORNIA

Palm Springs

Palm Springs Desert Museum, Inc.

101 Museum Drive, **Palm Springs, CA 92262**
☎ 619-325-7186
HRS: 10-5 Tu-T & Sa-S, 10-8 F DAY CLOSED: M HOL: LEG/HOL! & SUMMER
F/DAY: 1st F ADM: Y ADULT: $6.00 CHILDREN: F (under 6)) STUDENTS: $3.00 SR CIT: $5.00
&: Y; South entrance handicapped ramp ℗ Y; Free parking in the north museum lot, the south lot (which has a handicap
entrance); daily pay parking (free of charge in the evening) in the Desert Fashion Plaza shopping center lot across from museum.
MUS/SH: Y ⅋ Y; Toor Gallery Cafe open 11-3 daily & 11-7 F
GR/T: Y GR/PH: CATR! DT: Y TIME: 2 Tu-S (Nov-May)
H/B: Y; Architectural landmark S/G: Y
PERM/COLL: CONT/REG

Contemporary American art with special emphasis on the art of California and other western states is the main
focus of the 4,000 piece fine art and 2,000 object Native American collection of the Palm Springs Desert Museum.
The museum, housed in a splendid modern structure made of materials that blend harmoniously with the
surrounding landscape, has just added 20,000 square feet of gallery space with the opening of the Steve Chase Art
Wing and Education Center **NOT TO BE MISSED:** Leo S. Singer Miniature Room Collection; Miniature of
Thomas Jefferson Reception Room at the State Department

ON EXHIBIT/97:

01/10/97–03/02/97	THE ARCHITECTURE OF E. STEWART WILLIAMS — Included in this exhibition of photographs and architectural materials for projects designed by Palm Springs architect Williams, will be his plans for the museum's building completed in 1975.
01/14/97–03/23/97	RAINFOREST DIARIES OF TONY FOREST — British artist Foster's personal perceptions of the flora & fauna of the rainforests of Costa Rica will be seen in the watercolors and drawings on view that are accompanied by written diaries.
01/22/97–02/32/97	GOLD, JADE AND FORESTS: COSTA RICA — 140 precious objects that reflect traditional pre-Columbian Costa Rican depictions of human and animal figures will be highlighted in an exhibit that features objects of gold, jade, stone, and pottery. CAT WT
01/22/97–06/01/97	PEOPLE OF THE MIMBRES — Little known aspects of tribal life will be seen depictions of animals and humans on the black-on-white pottery of the Mimbres valley tribe. Many of the intricate subtle geometric designs on these vessels are reminiscent of those created by descendants of the Minbres at Casa Grandes, Zuni, and Acoma. WT
03/11/97–04/13/97	ARTISTS COUNCIL 28TH ANNUAL NATIONAL JURIED EXHIBITION — 50 works by artists from across the nation will be featured in this exhibition of juried works.
04/15/97–07/27/97	CALIFORNIA DESERT WILDFLOWERS — 25 colorful photographs taken by museum staff members will be seen in an exhibition of works that reflects the diversity of spring wildflowers indigenous to the area.
04/16/97–07/20/97	B. LEWIN COLLECTION OF 20TH CENTURY MEXICAN ART — Among the 75 sculptures and paintings on loan from this exceptional private collection will be works by such 20th-century Mexican masters as Rufino Tamayo, Frida Kahlo, José Clemente Orozco, Diego Rivera, David Alfaro Siqueiros and others.
06/24/97–01/04/98	ORGAN PIPE CACTUS NATIONAL MONUMENT — The next best thing to actually being there, this exhibition of photographic murals, descriptive graphics and video displays allows the viewer to enjoy the wonder of the stately Organ Pipe Cactus and other abundant desert flora of the region.
08/03/97–11/30/97	THE WEST IN AMERICAN ART: SELECTIONS FROM THE HARMSEN COLLECTION — Presented in five separate thematic units will be paintings that address a continuing fascination with the American West. Works on view will range from 19th-century landscape paintings by Bierstadt, Berninghaus and others to works by the Taos Society of Artists & the Santa Fe Colony, to dramatic images that freeze a moment of tension or high drama. BROCHURE WT

Palo Alto

Palo Alto Cultural Center

1313 Newell Rd., **Palo Alto, CA / 94303**
☎ 415-329-2366
HRS: 10-5 Tu-Sa, 7-10 T, 1-5 S HOL: 12/25, 1/1, 7/4
&: Y; No steps in building ℗ Y; Free and adjacent to the center MUS/SH: Y
GR/T: Y GR/PH: CATR! DT: Y TIME: call for information
PERM/COLL: CONT/ART; HIST/ART

Located in a building that served a the town hall from the 1950's to 1971, this active community art center's mission is to present the best contemporary fine art, craft, design, special exhibitions, and new art forms.

ON EXHIBIT/97:

02/97–04/97	MINGEI & MERCHANTS — Japanese folk art, prints and furnishings will be on exhibit.
02/97–04/97	THE INTIMATE BRUSH: CONTEMPORARY ASIAN WOMEN ARTISTS
04/97–05/97	HARD TO FIND — A display of works selected from area collections.
07/97–08/97	PULLEY --- An invitational exhibition and auction.
07/97–08/97	RADIUS 1997 — A juried exhibition of works by 6 emerging regional artists.
09/97–01/98	DOMINIC DI MARE — A review of the evolution of forms from Di Mare's improvisational weavings will be seen in the first retrospective exhibition of his work. CAT WT
09/97–01/98	IVAN BAVCAR — This unusual exhibition features photogravures by Bavcar, a sightless French photographer whose works re-enact memory.
09/97–01/98	JILLIAN DOROAN — The intimate, opalescent photographs by Doroan seen in this exhibit reflect her investigation of the healing waters in Budapest, Russia and the Red Sea.
09/97–01/98	LINDA CONNER — A thematic presentation of photographic works in search of a spiritual place.

Pasadena

Norton Simon Museum

411 W. Colorado Blvd., **Pasadena, CA 91105**
☎ 818-449-6840
HRS: Noon-6 T-S DAY CLOSED: M-W HOL: 1/1; 12/25; THGV
ADM: Y ADULT: $4.00 CHILDREN: F(under 12) STUDENTS: $2.00 SR CIT: $2.00
&: Y; Wheelchair access & availability ℗ Y; Ample parking available at the museum MUS/SH: Y
GR/T: Y GR/PH: CATR! Nancy Gubin S/G: Y
PERM/COLL: EU: ptgs 15-20; sculp 19-20; IND: sculp; OR: sculp; EU/ART 20; AM/ART 20

Thirty galleries with 1,000 works from the permanent collection that are always on display plus a beautiful sculpture garden make the internationally known Norton Simon Museum home to one of the most remarkable collections of art in the world. The seven centuries of European art on view from the collection contain remarkable examples of work by Old Master, Impressionist, and important modern 20th-century artists. PLEASE NOTE: The museum, undergoing interior renovation, is adding a wood and glass tea house situated in a newly landscaped sculpture garden where visitors will be able to enjoy light refreshment surrounded by sculptural masterworks. **NOT TO BE MISSED:** IMP & POST/IMP Collection including a unique set of 71 original master bronzes by Degas

ON EXHIBIT/97:

01/11/96–02/02/97	NATURE AS MUSE: ETCHINGS, LITHOGRAPHS, WATERCOLORS, AND PHOTO-GRAPHS FROM THE SEVENTEENTH THROUGH THE TWENTIETH CENTURIES — An exploration of the ways in which Rembrandt, Hiroshige, Picasso, Edward & Brett Weston, Tamayo and other masters have interpreted the motif of the natural world.

CALIFORNIA

Pasadena

Pacific Asia Museum
46 N. Los Robles Ave., **Pasadena, CA 91101**
✆ 818-449-2742
HRS: 10-5 W-S DAY CLOSED: M, Tu HOL: 1/1, MEM/DAY, 7/4, THGV, 12/25, 12/31
F/DAY: 3rd Sa ADM: Y ADULT: $4.00 CHILDREN: F (under 12) STUDENTS: $2.00 SR CIT: $2.00
&: Y; Limited - no second level access Ⓟ Y; Free parking at the Pasadena Mall southwest of the museum; $3.00 fee at lot north
of museum MUS/SH: Y GR/T: Y GR/PH: CATR! DT: Y TIME: 2 PM S
H/B: Y; California State Historical Landmark S/G: Y
PERM/COLL: AS: cer, sculp; CH: cer, sculp; OR/FOLK; OR/ETH; OR/PHOT

The Pacific Asia Museum, which celebrated its 25th anniversary in '96, is the only one in southern California devoted exclusively to the arts of Asia. The collection, housed in the gorgeous 1929 National Register listed Nicholson Treasure House structure built in the Chinese Imperial Palace style, features one of only two authentic Chinese style courtyard gardens in the U.S. open to the public. **NOT TO BE MISSED:** Chinese courtyard garden

ON EXHIBIT/97:

05/01/96–01/19/97	COLLECTORS' CHOICE: AN EXHIBITION IN HONOR OF GRACE NICHOLSON — In commemoration of the museum's 25th anniversary, items from the estate of Grace Nicholson, as well as objects similar to those sold by her in her Chinese Treasure House (now Pacific Asia Museum), will be on exhibit.
10/25/96–06/97	RARELY SEEN CERAMICS FROM THE PERMANENT COLLECTION INCLUDING OBJECTS FROM THE LYDMAN, SNUKAL, AND OTTO COLLECTIONS
02/12/97–08/10/97	GOSSAMER THREADS AND GOLDEN DRAGONS: A SELECTION OF CHINESE TEXTILES FROM THE PACIFIC ASIA MUSEUM COLLECTION — Textiles from the late Ming (1368-1644)and early Qing (1644-1911) will be displayed in an exhibition that includes several court "Dragon Robes" and other garments worn by members of the court.
09/10/97–03/24/98	TRADE AND TREASURE: THE MANILA/ACAPULCO GALLEON TRADE — Gold and silver artifacts, ivory religious statues, furniture, textiles and boat models from the Ayala Museum in Manila will be among the many objects on display in an exhibition documenting 400 years of Spanish Galleon Trade with the countries of the Far East.

Penn Valley

Museum of Ancient & Modern Art
11392 Pleasant Valley Rd., **Penn Valley, CA 95946**
✆ 916-432-3080
HRS: 10-5 M-Sa DAY CLOSED: M HOL: 1/1, EASTER, 7/4, LAB/DAY, THGV, 12/25
&: Y Ⓟ Y; Free and plentiful MUS/SH: Y GR/T: Y GR/PH: CATR! DT: Y TIME: upon request if available
PERM/COLL: AN/GRK; AN/R; ETRUSCAN; GR; CONT; DU; FR; GER; CONT/AM; DEC/ART; PHOT

Although the permanent collection has been assembled over a short 20 year period, the scope and extent of its holdings is truly mind-boggling. In addition to the outstanding collection of ancient Western Asiatic artworks, the museum features a group of historical art books containing woodcuts, etchings and engravings printed as early as 1529, a wonderful assemblage of African masks and sculptures from over 20 different tribes, and a superb group of Rembrandt etchings and other European masterpieces. The museum is located approximately 50 miles northeast of Sacramento. **NOT TO BE MISSED:** One of the largest collections of 18th Dynasty Egypt in the U.S.; Theodora Van Runkel Collection of Ancient Gold; Hall of Miniatures; the TIME MACHINE

Riverside

Riverside Art Museum
3425 Seventh St., **Riverside, CA 92501**
☎ 909-684-7111
HRS: 10-4 M-Sa DAY CLOSED: S
HOL: LEG/HOL! GALLERIES CLOSED DURING THE MONTH OF AUG.
SUGG/CONT: Y ADULT: $1.00
&: Y ℗ Y; Limited free parking at museum; metered street parking
MUS/SH: Y ‖ Y; Open weekdays
GR/T: Y GR/PH: CATR! DT: Y TIME: daily upon request
H/B: Y; 1929 building designed by Julia Morgan, architect of Hearst Castle
PERM/COLL: PTGS, SCULP, GR

Julia Morgan, the architect of the Hearst Castle also designed this handsome and completely updated museum building in 1929. Listed on the NRHP, the museum is located in the Los Angeles and Palm Springs area. Aside from its professionally curated exhibitions, the museum displays the work of area students during the month of May.

ON EXHIBIT/97:

ONGOING

NETWORK EXHIBITIONS — Artists' projects, educational programs, and museum collections that are accessible through changing exhibitions via Internet.

UCR/California Museum of Photography
Affiliate Institution: Univ. of California
3824 Main St., **Riverside, CA 92521**
☎ 909-784-FOTO WEB SITE: http://www.cmp.ucr.edu
HRS: 11-5 W-Sa, Noon-5 S DAY CLOSED: M, Tu HOL: EASTER, THGV, 12/25, 1/1
F/DAY: W ADM: Y ADULT: $2.00 CHILDREN: F (under 12) STUDENTS: $1.00 SR CIT: $1.00
&: Y ℗ Y; Street parking and several commercial lots and garages nearby.
MUS/SH: Y
GR/T: Y GR/PH: CATR! Lori Fiacco
PERM/COLL: PHOT 19-20; CAMERA COLLECTION

Converted from a 1930's Kress dimestore into an award winning contemporary space, this is one of the finest photographic museums in the country. In addition to a vast number of photographic prints the museum features a 6,000 piece collection of photographic apparatus, and an Internet gallery, the only resource of its kind in a southern California museum. PLEASE NOTE: 30 minute informal gallery talks about cameras and/or various aspects of photography are offered at 2 PM every Saturday. **NOT TO BE MISSED:** "Images and Apparatus," a "please touch" Interactive Gallery; Watkins Screen, a huge antique 1880's English oak screen that holds 26 enormous albumen prints by Watkins of the American West; 6,000 piece collection of Ansel Adams photographs; Image.Caption, the first permanent media literacy exhibition for young people in Riverside County.

ON EXHIBIT/97:

02/01/97–05/25/97

MISTAKEN IDENTITIES: TWO ADOPTEES/TWO STORIES — A collaborative exhibition by Anne Fessler and Carol Flax

06/16/97–08/18/97

OCEAN VIEW — Photographs by Kevin Jon Boyle, an artist fascinated with the California coastline, will be seen in an exhibition that explores the myth that health and happiness in California are to be found only at the ocean's edge.

CALIFORNIA

Sacramento

Crocker Art Museum
216 O St., **Sacramento, CA 95814**
☏ 916-264-5423 WEB ADDRESS: http://www.sacto.org/crocker
HRS: 10-5 Tu-S, till 9 T DAY CLOSED: M HOL: LEG/HOL!
ADM: Y ADULT: $4.50 CHILDREN: $2.00 (7-17) STUDENTS: $4.50 SR CIT: $4.50
♿: Y; Fully handicapped accessible Ⓟ Y; On-site paid parking MUS/SH: Y
GR/T: Y GR/PH: CATR! 916-264-5537 DT: Y TIME: !
H/B: Y; Over 100 years old
PERM/COLL: PTGS: REN-20; OM/DRGS 15-20; CONT; OR; SCULP

This inviting Victorian gingerbread mansion, the oldest public art museum in the West, was built in the 1870's by Judge E. B. Crocker. It is filled with his collection of more than 700 European and American paintings displayed throughout the ballroom and other areas of the original building. Contemporary works by northern California artists are on view in the light-filled, modern wing whose innovative facade is a re-creation of the Crocker home. **NOT TO BE MISSED:** Early California painting collection

ON EXHIBIT/97:

ONGOING	THE NEW EUROPEAN GALLERIES — A reinstallation of 15th to 19th-century European paintings, sculpture and decorative arts that document the history of European art as it evolved over a 400-year period.
09/13/96–03/09/97	THE GRAVEN IMAGE: OLD MASTER PRINTS FROM THE COLLECTION — 15th through 19th-century European prints that trace the development of printmaking as an art form will be on exhibit.
01/25/97–03/09/97	AMERICAN VIEWS: OIL SKETCHES BY THOMAS HILL — 60 small landscape oil paintings by 19th-century artist Hill include scenes he painted of the White Mountains, Mount Shasta, Lake Tahoe, Yosemite, Yellowstone, the Columbia River and Alaska. WT
02/97	PENNIES, PAPER, COWRIES AND COINS! THE ART AND HISTORY OF MONEY — Aztec copper axe money, African copper bracelets and Chinese cowrie shells will be seen with other curious and unusual monetary objects used as currency throughout history.
02/02/97	NETSUKE! FORM AND FASHION IN EDO JAPAN — Featured will be a display of netsuke, small sculpted works used by the Japanese of the Edo period (1615-1868) as belt toggles for their kimonos.
02/14/97	SMALL EUROPEAN PAINTINGS — 16th to 18th-century small and rarely seen master-pieces will be on exhibit.
MID/97	THE MIDDLE PATH: BUDDHIST SCULPTURE FROM SOUTH AND SOUTHEAST ASIA — Sculpture that corresponds to Hinayana, Mahayana and Vajrayana, the three major Buddhists will be presented in an exhibition that traces their historical development and traditions.
04/18/97	UELSMANN: YOSEMITE — Uelsmann's black and white photographs/duotones, with superimposed images will be on exhibit.
06/06/97	REGIONAL CONTEMPORARY SHOW
08/15/97–10/05/97	CALIFORNIA IMPRESSIONISTS — On exhibit will be nearly 65 works, painted between 1895 and the beginning of WWII, that define the California Impressionist style. WT

San Diego

Mingei International Museum of Folk Art

University Towne Centre, 4405 La Jolla Village Dr., 1-7, **San Diego, CA 92122**
☎ 619-453-5300
HRS: 10-4 Tu-S DAY CLOSED: M HOL: LEG/HOL!
ADM: Y ADULT: $5.00 CHILDREN: $2.00 (6-17) STUDENTS: $2.00 SR CIT: $5.00
&: Y ℗ Y; Parking a short distance from the museum in the University Towne Centre lots MUS/SH: Y
GR/T: Y GR/PH: CATR!
PERM/COLL: FOLK: Jap, India, Af, & over 70 other countries; international doll coll.; Palestinian costumes

In Aug. 1996, this museum, dedicated to furthering the understanding of world folk art, moved its superb collection into a new 41,000 square foot facility on the Central Plaza of Balboa Park which is also the site of the San Diego Museum of Art, the Timken Museum of Art, and numerous other art related institutions. It is interesting to note that Mingei, the name of this museum, (founded in 1974 to further the understanding of arts of people from all cultures), is a combination of the Japanese words for people (min) and art (gei). **NOT TO BE MISSED:** A small wax doll (clothed in its original fabric and a bonnet characteristic of the Tudor period) that once belonged to a lady-in-waiting to English Queen, Mary Stuart.

ON EXHIBIT/97:

01/97–06/97	THE BEADED UNIVERSE: STRANDS OF CULTURE	WT

Museum of Photographic Arts

1649 El Prado, Balboa Park, **San Diego, CA 92101**
☎ 619-239-5262
HRS: 10-5 Daily DAY CLOSED: M HOL: LEG/HOL!
F/DAY: 2nd Tu ADM: Y ADULT: $3.50 CHILDREN: F (under 12)
&: Y ℗ Y; Available free throughout Balboa Park MUS/SH: Y
GR/T: Y GR/PH: CATR! DT: Y TIME: 1:00 Sa, S
PERM/COLL: PHOT

The Museum of Photographic Arts, dedicated exclusively to the care and collection of photographic works of art, is housed in an original structure built in 1915 for the Panama-California Exposition located in the heart of beautiful Balboa Park (designated as the number one urban park in America).

ON EXHIBIT/97:

12/04/96–02/12/97 CURRENT FICTIONS: WORK BY EMERGING ARTISTS — Works by emerging artists who seek to expand the traditional notions of the photographic medium by transforming the physical nature of the photographic image itself will be seen in the first of a series of exhibitions highlighting young, up-and-coming talents.

02/15/97–04/13/97 WHISPERED SILENCES: JAPANESE AMERICAN DETENTION CAMPS, FIFTY YEARS LATER — 44 platinum-palladium photographs accompanied by tales from people of Japanese ancestry who were forced to live in detention camps during WWII, will be featured in an exhibition of images of the now-ruined buildings of the camps taken by Joan Meyers. WT

04/15/97–07/23/97 SELECTIONS FROM THE PERMANENT COLLECTION TENT!

07/25/97–09/21/97 SEEING THE UNSEEN: DR. HAROLD EDGERTON AND THE WONDERS OF STROBE ALLEY — In honor of Dr. Harold Edgerton, the noted scientist, photographer and teacher who is credited with the development of the stroboscope and the electronic flash for photographic illumination, this exhibition will highlight his creative output and his working process, theories, tools and experiments. WT

CALIFORNIA

San Diego

San Diego Museum of Art

1450 El Prado, Balboa Park, **San Diego, CA 92101**
☎ 619-232-7931
HRS: 10-4:30 Tu-S DAY CLOSED: M HOL: 1/1; 12/25; THGV
ADM: Y ADULT: $7.00 CHILDREN: $2.00 (6-17) SR CIT: $5.00
&: Y ⓟ Y; Parking is available in Balboa Park and in the lot in front of the museum. MUS/SH: Y ⑪ Y; Sculpture Garden
Cafe 10-3 Tu-F; 9-4:30 Sa, S (CATR! 696-1990)
GR/T: Y GR/PH: CATR! DT: Y TIME: 10, 11, 1 & 2 Tu-T & Sa; 1 & 2 F, S
H/B: Y; Built in 1926, the facade is similar to one at Univ. of Salamanca S/G: Y
PERM/COLL: IT/REN; SP/OM; DU; AM: 20 EU; ptgs, sculp 19; AS; AN/EGT; P/COL

Whether strolling through the treasures in the sculpture garden or viewing the masterpieces inside the Spanish colonial-style museum building, a visit to this institution, located in San Diego's beautiful Balboa Park, is a richly rewarding and worthwhile experience. In addition to family-oriented, self-led discovery guides of the collection available in both English and Spanish, the museum recently installed the Image Gallery, the first Micro Gallery system in the country developed to provide easy-to-use touch screen interactive multi-media access to the permanent collection. PLEASE NOTE: There is a special admission fee of $4.00 for military with I.D. **NOT TO BE MISSED:** Frederick R. Weisman Gallery of Calif. art; Thomas Eakin's "Elizabeth With a Dog"; Works by Toulouse-Lautrec; World-renowned collection of Indian paintings

ON EXHIBIT/97:

10/12/96–01/05/97	ART WORKS: THE PAINEWEBBER COLLECTION OF CONTEMPORARY MASTERS — Many of the major art trends of the past 4 decades including Abstract Expressionism, Minimalism, Conceptualism, and Neo-Expressionism will be seen in the only West Coast venue of 70 important works from this stellar corporate collection. CAT WT
01/05/97–05/04/97	ART ALIVE 1997
01/25/97–03/09/97	MUNCH AND WOMEN: IMAGE AND MYTH — Nearly 74 prints by Munch, considered one of the pioneers of European Modernism, will be seen in an exhibition that reveals some of the artist's more positive images of women. CAT WT
02/08/97–03/16/97	ARTIST'S GUILD JURIED EXHIBITION — Art in all media will be shown in an annual juried exhibition of works by members of the Artist's Guild, one of the founding organizations of the museum.
03/22/97–05/18/97	ARCHILLES RIZZOLI: ARCHITECT OF MAGNIFICENT VISIONS — 85 works on paper, illuminated poems, large architectural and selected hallucinatory drawings will be among the items featured in this premiere public introduction of the work of visionary architect Rizzoli, 1896-1981.
04/19/97–06/15/97	AN ENDURING LEGACY: MASTERPIECES OF ASIAN ART FROM THE ROCKEFELLER FAMILY — Selected Pan-Asian sculpture, ceramic and painting masterpieces (11th-century B.C.E. to the 18th-century) from 13 different nations will be on view in an exhibition on loan from the most highly regarded public collection of Asian art in the country.
06/07/97–07/20/97	HOSPICE: A PHOTOGRAPHIC INQUIRY — The photographs of Jim Goldberg, Nan Goldin, Sally Mann, Jack Radcliffe and Kathy Vargas detailing the emotional and collaborative experience of living and working in hospices in different regions of the country will be seen in this exhibition specially commissioned by the Corcoran. Their works will touch upon every aspect of hospice care revealing the spiritual, emotional and physical needs of the terminally ill and their families. WT
06/21/97–08/17/97	TWO HUNDRED YEARS OF ENGLISH NAIVE ART 1700-1900 — 100 late 17th & 18th-century charming English naive oil paintings, watercolors, and objects of decorative art will be on loan from public & private collections in Britain, the U.S. & Canada. CAT WT
08/30/97–10/26/97	ALPHONSE MUCHA WT

San Diego

Timken Museum of Art
1500 El Prado, Balboa Park, **San Diego, CA 92101**
☎ 619-239-5548 WEB ADDRESS: http://gort.ucsd.edu/sj/timkin
HRS: 10-4:30 Tu-Sa, 1:30-4:30 S DAY CLOSED: M HOL: LEG/HOL!; MONTH OF SEPT
VOL/CONT: Y &: Y GR/T: Y GR/PH: CATR! DT: Y TIME: 10-12 Tu-T
PERM/COLL: EU: om/ptgs 13-19; AM: ptgs 19; RUSS/IC 15-19; GOBELIN TAPESTRIES

Superb examples of European and American paintings and Russian icons are but a few of the highlights of the Timkin Museum of Art located in beautiful Balboa Park, site of the former 1915-16 Panama California Exposition. Treasures displayed within the six galleries and the rotunda of this museum make it a "must see." **NOT TO BE MISSED:** "Portrait of a Man" by Frans Hals; "The Magnolia Flower" by Martin Johnson Heade

ON EXHIBIT/97:

12/14/96–03/31/97	THE VALLEY OF MEXICO — The Timkin's "View of the Valley of Mexico" by Conrad Wise Chapman (1842-1910) will be joined by other of Chapman's depictions of Mexico on loan from the collection of the Valentine Museum in Richmond, VA, which holds the balance of the artist's estate. Dates Tent! TENT!

San Francisco

Asian Art Museum of San Francisco
Affiliate Institution: The Avery Brundage Collection
Golden Gate Park, **San Francisco, CA 94118**
☎ 415-379-8801
HRS: 10-4:45 W-S, 10 AM-8:45 PM 1st W each month DAY CLOSED: M, Tu HOL: 12/25, 1/1, THGV
F/DAY: 1st W of the month ADM: Y ADULT: $6.00 CHILDREN: F (under 12) STUDENTS: $3.00 SR CIT: $4.00
&: Y; Elevator, restrooms, wheelchairs & parking available Ⓟ Y; Free parking throughout Golden Gate Park plus all day $3.00 weekend parking with shuttle service to all museums in the park in the UCSF garage located at the corner of Irving St. & Second Ave. �11 Y GR/T: Y GR/PH: CATR! 415-668-8921 DT: Y TIME: frequent daily tours!
PERM/COLL: OR: arts; MID/E: arts; BRUNDAGE COLLECTION (80 % OF THE HOLDINGS OF THE MUSEUM)

With a 12,000 piece collection that covers 40 countries and 6,000 years, the Asian Art Museum is the largest of its kind outside of Asia. PLEASE NOTE: There are special hours during major exhibitions. Please call for specifics. **NOT TO BE MISSED:** Earliest dated Chinese Buddha (338 A.D.)

ON EXHIBIT/97:

12/20/96–03/30/97	YOUNG BAE: 1980-1992 — 20 exceptional works from the permanent collection will be featured in an exhibition highlighting Bae, one of Korea's foremost contemporary artists.
02/12/97–03/30/97	GLORIUS KIMONO: TEXTILES FROM THE KYOTO NATIONAL MUSEUM — More than 100 kosode and kimono will be on view.
SPRING/97	LIVING MASTERS: CHAO SHAO AN — Chinese paintings crafted in traditional Chinese style will be seen in a presentation of 80 works by one of Hong Kong's best-known artists.
SUMMER/97	INDIA: A CELEBRATION! — The charm, beauty and diversity that is India will be showcased in a series of exhibitions and public programs in celebration of the 50th anniversary of Indian independence.
10/97–02/16/98	DECORATIVE PAINTING OF KOREA — This stunning display of Korean decorative art includes large-scale pieces from the museum's holdings exhibited with works on loan from west coast public and private collections.

CALIFORNIA

San Francisco

Cartoon Art Museum

814 Mission St., San Francisco, CA 94103
☏ 415-CAR-TOON
HRS: 11-5 W-F, 10-5 Sa, 1-5 S DAY CLOSED: Tu HOL: 1/1, 7/4, 12/25, THGV
ADM: Y ADULT: $4050 CHILDREN: $2.00 (6-12) STUDENTS: $3.00 SR CIT: $3.00
&: Y; Sidewalk ramps & elevator; museum all one level ℗ Y; Fifth & Mission Garage MUS/SH: Y
GR/T: Y GR/PH: CATR! DT: Y TIME: Upon request if available
PERM/COLL: CARTOON ART; GRAPHIC ANIMATION

The Cartoon Art Museum, founded in 1984, is located in a new 6,000 square foot space that includes a children's and interactive gallery. With a permanent collection of 11,000 works of original cartoon art, newspaper strips, political cartoons, and animation cells, this is one of only 3 museums of its kind in the country and the only West Coast venue of its kind.

ON EXHIBIT/97: Over 7 exhibitions are mounted annually.

09/11/96–01/12/97	PANELS FROM MIKE TWOHY (LOCAL NEW YORKER CARTOONIST)
09/18/96–01/12/97	THE LIFE AND TIMES OF UNCLE SCROOGE: DON ROSA
09/18/96–01/12/97	GOREY WORLD: THE ART OF EDWARD GOREY
01/22/97–04/20/97	BILL GRIFFITH (ZIPPY THE PINHEAD)
01/22/97–04/20/97	BIRAN BIGGS OF FREDERICK AND ELOISE FAME
01/29/97–04/27/97	ENKI BILAL RETROSPECTIVE
05/97–09/97	HANNA-BARBERA RETROSPECTIVE
05/97–09/97	(SPOTLIGHT) PETER BRABBÉ'S "PAPOOFNIK" (SPOTLIGHT)

Center for the Arts Yerba Buena Gardens

710 Mission St., San Francisco, CA 94103-3138
☏ 415-978-2787 WEB ADDRESS: http://www.hia.com/hia/yerbabuena
HRS: 11-6 Tu-S, till 8 PM 1st Tu of the month HOL: LEG/HOL!
F/DAY: 6-8 1st T ADM: Y ADULT: $4.00 CHILDREN: $2.00 STUDENTS: $2.00 SR CIT: $2.00
&: Y; Fully accessible ℗ Y; There is a public parking garage at 5th and Mission Sts., one block away from the Center.
MUS/SH: Y ⅋ Y; OPTS Cafe
GR/T: Y GR/PH: CATR! ext. 113 S/G: Y

Opened in 1993 as part of a still evolving arts complex that includes the newly relocated San Francisco Museum of Modern Art, the Cartoon Art Museum, and the Ansel Adams Center for Photography, this fine arts and performance center features theme-oriented and solo exhibitions by a culturally diverse cross section of Bay Area artists. PLEASE NOTE: Admission for seniors is free from 11-3 on Thursdays. **NOT TO BE MISSED:** The building itself, designed by prize-winning architect Fumihiko Maki, to resemble a sleek ocean liner complete with porthole windows.

ON EXHIBIT/97:

11/26/96–02/23/97	HALL OF FAME HALL OF FAME — This unique display of unusual art and artifacts from Hall of Fame venues nationwide will include a wide variety of items from baseball to the Kentucky Derby, and from rock-and-roll to the American Indian.
03/12/97–06/01/97	BADGE OF HONOR: AN INSTALLATION BY PEPON OSORIO — Featured will be Osorio's installation of a jail cell and a teenager's bedroom, and the banter between an inmate and his son.
03/12/97–06/01/97	ORGANICALLY GROWN — Works by artists who use their studios as laboratories for botanical and biological experimentation.
03/12/97–06/01/97	SURVIVAL SYSTEM TRAIN AND OTHER SCULPTURE BY KENJI YANOBE — Large kinetic machine sculptures by Japanese artist Yanobe will be featured in the artist's first U.S. exhibition.
06/10/97–08/10/97	BAY AREA NOW: PART I
08/26/97–11/02/97	BAY AREA NOW: PART II

San Francisco

Coit Tower
1 Telegraph Hill, **San Francisco, CA**
☎ 415-274-0203
HRS: 9-4:30 daily (winter); 10-5:30 daily (summer) Ⓟ Y; very limited timed parking
PERM/COLL: murals

Though not a museum, art lovers should not miss the newly restored Depression-era murals that completely cover the interior of this famous San Francisco landmark. 25 social realist artists working under the auspices of the WPA participated in creating these frescoes that depict rural and urban life in California during the 1930's. Additional murals on the second floor may be seen only at 11:15 on Saturday mornings. The murals, considered one of the city's most important artistic treasures, and the spectacular view of San Francisco from this facility are a "must see" when visiting this city.

The Fine Arts Museums of San Francisco
Affiliate Institution: M. H. DeYoung Mem. Mus. & Calif. Palace of Legion of Hon.
Calif. Palace of the Legion of Honor, Lincoln Park, **San Francisco, CA 94121**
☎ 415-863-3330 WEB ADDRESS: http://www.famsf.org
HRS: See museum description HOL: Most holidays that fall on M & Tu, when the museum is regularly closed
ADM: Y ADULT: $6.00 CHILDREN: F (under 12) STUDENTS: $3.00 SR CIT: $4.00
♿: Y; Museums, restaurants and bookstores fully accessible Ⓟ Y; Free parking in the park MUS/SH: Y
� 2 Cafes open 10 AM-4 PM
GR/T: Y GR/PH: CATR! 425-750-3638 DT: Y TIME: W-S (DeYoung) & Tu-S (Palace)! H/B: Y; Calif. Palace of Legion of Honor modeled on Hotel de Salm in Paris
PERM/COLL: DeYoung: PTGS, DRGS, GR, SCULP; AM: dec/art; BRIT: dec/art; AN/EGT; AN/R; AN/GRK; AF; OC. CA. PALACE OF LEGION OF HONOR: EU: 13-20; REN; IMPR: drgs, gr

The DeYoung Museum: Situated in the heart of Golden Gate Park, the DeYoung features the largest collection of American art on the West Coast ranging from Native American traditional arts to contemporary Bay Area art.

The California Palace of the Legion of Honor: One of the most dramatic museum buildings in the country, the recently renovated and reopened Palace of the Legion of Honor houses the museum's European art, the renowned Aschenbach graphic art collection, and one of the world's finest collections of sculpture by Rodin (Legion Information Hot Line # 415-863-3330).

PLEASE NOTE: The hours and admission fees for each museum are as follows:

DeYoung: hours 9:30-5:15 M-W, till 8:45 1st W & occasional Tu during special exhibitions (call 415-863-3330); admission $6.00 adults, $4.00 sr/cit, $3.00 ages 12-17, children free under 12, free 1st W of the month.

Palace of the Legion of Honor: hours 9:30-5:15 Tu-S, till 8:45 1st Sa of the month; admission $6.00 adult, $4.00 sr/cit, $3.00 12-17, children free under 12, (Free adm. 2nd W of month but closes at 4:45 that day)

NOT TO BE MISSED: Rodin's "Thinker" & The Spanish Ceiling (Legion of Honor); Textile collection (DeYoung); Gallery One, a permanent art education center for children & families (DeYoung)

ON EXHIBIT/97:
10/26/96–01/12/97 MASTERWORKS OF MODERN SCULPTURE FROM THE NASHER COLLECTION — LEGION — More than 70 works on loan from the world's most important private collection of modern sculpture will be featured in the first survey of its kind to be presented in the Bay Area. CAT WT

CALIFORNIA

The Fine Arts Museums of San Francisco - continued

10/26/96–01/18/97 19TH AND 20TH-CENTURY SCULPTORS' PRINTS AND DRAWINGS: SELECTIONS FROM THE ASCHNEBACH FOUNDATION FOR THE GRAPHIC ARTS — LEGION

11/16/96–04/13/97 THE SHAPE OF BELIEF: AFRICAN ART FROM THE DR. MICHAEL R. HEIDE COLLECTION — DeYOUNG — 70 eclectic and visually compelling works from the Michael Heide collection of West African masks and sculptures, which have recently been added to the already-important permanent collection of African art, will be featured in this exhibition. Heide, who began his collection while acting as a Peace Corps volunteer in Africa in the 60's, bequeathed the collection to the museum prior to his death from AIDS in 1993. CAT

12/07/96–07/13/97 IF THE SHOE FITS — DeYOUNG — A small but charming one gallery exhibition of 18th through 20th-century wearable art shoes.

01/25/97–04/06/97 THE PEALE FAMILY: CREATION OF AN AMERICAN LEGACY, 1770-1870 — For the first time in 30 years, works by Charles Wilson Peale and 10 other members of one of America's premier artistic families will be featured in a rare gathering and presentation of their oeuvre. "The Staircase Group" and "Rubens Peale With a Geranium" will among the 173 items on exhibit. WT ◯

02/15/97–04/27/97 MASTERPIECES FROM THE PIERPONT MORGAN LIBRARY — LEGION — Dürer's pen-and-ink drawing "Adam & Eve," one of the 11 remaining velum copies of the Gutenberg Bible, and an autographed Mozart manuscript will be among the 175 beautiful and rare works on loan from the distinguished collection of the Pierpont Morgan Library. WT

02/26/97–06/22/97 ART OF THE AMERICAS: PRIDE OF PLACE — DeYOUNG — Exceptional works by Thomas Cole, George Caleb Bingham, Georgia O'Keeffe, Charles Sheeler and Richard Diebenkorn will be featured in the second of a series and will explore the ways in which cultural chauvinism and insecurities associated with regionalism, nationalism and internationalism have impacted the popular and critical landscape in the Americas.

05/17/97–08/10/97 LIFE AND AFTERLIFE IN ANCIENT PERU: TREASURES FROM THE MUSÉO ARQUEOLOGICO RAPFEL LARCO HERRERA — DeYOUNG — Among the 250 pre-Hispanic art treasures (created before the Spanish Conquest of 1532) on loan from this world renowned collection will be realistic ceramics of the early Moche people, spectacular gold regalia of the pre-Inca kings, and other important icons of ancient Peruvian art that are most often reproduced in art history books. CAT WT

07/12/97–11/16/97 ART OF THE AMERICA SERIES: IDENTITY CRISIS — deYOUNG — Presented will be the second of four exhibitions highlighting the diversity that is part of the American tradition.

09/06/97–11/30/97 PAINTINGS FROM UTRECHT IN THE GOLDEN AGE — LEGION — 90 paintings from public and private collections worldwide will be seen in the first U.S. exhibition to focus on the Italian influence on 17th-century Dutch paintings of the Utrecht school. Many of the works on view fall into a category known as Utrecht "Caravaggisti," characterized by dramatic chiaroscuro lighting effects, a technique learned first hand by Dutch artists from their counterparts in Italy. CAT WT ◯

10/04/97–01/04/98 CROWN POINT PRESS — LEGION — Founded in the San Francisco Bay Area in 1962, Crown Point Press quickly became "THE" place for painters and sculptors interested in etching. This presentation of works ranging from minimalism to realism produced here between 1965 to the present will include examples by artists of international reputation including Richard Diebenkorn, Sol LeWitt, Wayne Thiebaud, Chuck Close, Helen Frankenthaler, Tony Cragg (Britain), Katsura Funakoshi (Japan), Gunter Brus (Austria) and others. CAT WT

San Francisco

The Friends of Photography, Ansel Adams Center
250 Fourth St., **San Francisco, CA 94103**
✆ 415-495-7000
HRS: 11-5 Tu-S, 11-8 1st T of the month DAY CLOSED: M HOL: LEG/HOL!
ADM: Y ADULT: $4.00 CHILDREN: $2.00 (12-17) STUDENTS: $3.00 SR CIT: $2.00
&: Y; Restrooms, ramp (front of bldg), wheelchair lift (side of bldg) Ⓟ Y; Several commercial parking facilities located nearby
MUS/SH: Y GR/T: Y GR/PH: CATR! (education dept) DT: Y TIME: 1:15 Sa
PERM/COLL: PHOT; COLLECTION OF 125 VINTAGE PRINTS BY ANSEL ADAMS AVAILABLE FOR STUDY ONLY

Founded in 1967 by a group of noted photographers including Ansel Adams, Brett Weston, and Beaumont Newhall, the non-profit Friends of Photography is dedicated to expanding public awareness of photography and to exploring the creative development of the media.

ON EXHIBIT/97:

| 01/11/97–03/16/07 | SCIENCE AS SUBJECT IN CONTEMPORARY PHOTOGRAPHY — Featured will be recent works by artists addressing the issue of the interaction of art and science. |

03/26/97–06/15/97 ANSEL ADAMS, A LEGACY: MASTERWORKS FROM THE COLLECTION OF THE FRIENDS OF PHOTOGRAPHY (Working Title) — More than 100 of Adams' finest images will be on exhibit. WT

06/25/97–09/07/97 SUMMER OF LOVE: A PICTORIAL CELEBRATION — Psychedelic posters and other memorabilia will be included in this photographic survey of the hippie era which includes Bay Area rock bands, Haight-Ashbury street culture, and the drug & tattoo scene.

09/17/97–11/16/97 DOMINIQUE BLAIN — A mid-career survey of Blain, one of Canada's most important contemporary photographers.

11/26/97–02/08/98 OUTSIDE HISTORY — 120 images by mostly unknown people will be seen in the first of a four-part series entitled "Forums on Visual Culture" which examines the medium's practice and limitations.

The Mexican Museum
Affiliate Institution: Fort Mason Bldg. D.
Laguna & Marina Blvd., **San Francisco, CA 94123**
✆ 415-441-7683
HRS: Noon-5 W-S, till 8 PM 1st. W of the month DAY CLOSED: M, Tu HOL: LEG/HOL!
F/DAY: 1st W of the month ADM: Y ADULT: $3.00 CHILDREN: F (under 10) STUDENTS: $2.00 SR CIT: $2.00
&: Y; Ramp at front of building Ⓟ Y; Plentiful and free MUS/SH: Y
GR/T: Y GR/PH: CATR! 415-202-9704 H/B: Y; Fort Mason itself is a former military site in Golden Gate Rec. Area
PERM/COLL: MEX; MEX/AM; FOLK; ETH; MORE THAN 300 OBJECTS FROM THE NELSON ROCKEFELLER COLLECTION OF MEX/FOLK ART

With more than 9,000 objects in its collection, the Mexican Museum, founded in 1975, is the first institution of its kind devoted exclusively to the art and culture of Mexico and its people. Plans are underway to open in a new museum building in the Yerba Buena Gardens district in 1998. This 50,000 square foot facility will house one of the most extensive collections of Mexican and Mexican-American art in the U.S. **NOT TO BE MISSED:** "Family Sunday," a hands-on workshop for children offered the second Sunday of each month (call 415-202-9704 to reserve).

ON EXHIBIT/97:

09/19/96–02/02/97 RODOLFO MORALES: JUEGOS Y EVOCACIONES — 76 paintings and collages focusing on women, religious art, and the home & family will be seen in this retrospective exhibition of works by Mexican artist Morales, who defines childhood myths, folk legends, and popular stories in his works.

CALIFORNIA

San Francisco

Museo ItaloAmericano
Ft. Mason Center, Bldg. C, **San Francisco, CA 94123**
\ 415-673-2200
HRS: Noon-5 W-S, till 8 PM 1st W of the month DAY CLOSED: M, Tu HOL: LEG/HOL!
F/DAY: 1st W ADM: Y ADULT: $2.00 CHILDREN: F STUDENTS: $1.00 SR CIT: $1.00
占: Y ℗ Y; Ample free parking MUS/SH: Y
GR/T: Y GR/PH: CATR!
PERM/COLL: IT & IT/AM: ptgs, sculp, phot 20

This unique museum, featuring the art of many contemporary Italian and Italian-American artists was established in 1978 to promote public awareness and appreciation of Italian art and culture. Included in the collection are such modern masters as Francesco Clemente, Sandro Chia, and Luigi Lucioni, to name but a few. **NOT TO BE MISSED:** "Tavola della Memoria," a cast bronze sculpture from 1961 by Arnaldo Pomodoro; Mark Di Suvero's steel sculpture "Wittgenstein's Ladder," 1977

ON EXHIBIT/97:
01/15/97–03/15/97	SELECTIONS FROM THE PERMANENT COLLECTION
03/19/97–06/01/97	JAY DeFEO: MAJOR WORKS — Best known for her monumental, thickly encrusted abstract canvases, this first time exhibition of the works of the late Bay Area artist, DeFeo features 35 paintings, drawings and photo-collages.
06/04/97–08/31/97	SEI ARTISTI ITALO-AMERICANI/SIX ITALIAN-AMERICAN ARTISTS

San Francisco Art Institute Galleries
800 Chestnut St, **San Francisco, CA 94113**
\ 415-771-7020
HRS: 10-5 Tu-Sa, till 8 T, Noon-5 S DAY CLOSED: S, M HOL: LEG/HOL!
占: Y ℗ Y; Street parking only

Founded in 1871, the Art Institute is the oldest cultural institution on the West Coast and one of San Francisco's designated historical landmarks. The main building is a handsome Spanish colonial style building designed in 1926 by architect Arthur Brown. Featured in the Walter/Bean Gallery are exhibitions by artists from the Bay Area and across the nation. **NOT TO BE MISSED:** Mural by Diego Rivera

ON EXHIBIT/97:
ONGOING	SALON SERIES
12/05/96–01/12/97	115TH SAN FRANCISCO ART INSTITUTE ANNUAL EXHIBITION: BRIDGES: A COLLABORATIVE PROJECT
01/23/97–02/23/97	VICTORIA VESNA: Body INCorporated
03/06/97–05/06/97	ADALIND KENT AWARD EXHIBITION
05/17/97–05/25/97	SPRING SHOW
06/05/97–07/06/97	A GARDEN AND A GRAVE: VIDEO INSTALLATION BY FRANCES HEGARTY AND ALANNA O'KELLY

San Francisco

San Francisco Craft & Folk Art Museum

Landmark Building A, Fort Mason, **San Francisco, CA 94123-1382**

☎ 415-775-0990

HRS: 11-5 Tu-S, till 7 PM 1st W of the month DAY CLOSED: M HOL: 1/1, 1/14, MEM/DAY, 7/4, LAB/DAY, THGV, 12/25

ADM: Y ADULT: $1.00 CHILDREN: $.50 (12-17) SR CIT: $0.50

&: Y; Limited to first floor only ℗ Y; Ample and free MUS/SH: Y ⑪ Y; Right next door to famous Zen vegetarian restaurant, Greens GR/T: Y GR/PH: CATR! DT: Y TIME: 11:15 1st W of month & every Sat.

H/B: Y; Building served as disembarkation center during WW II & Viet Nam

PERM/COLL: No permanent collection

6 to 10 witty and elegant exhibitions of American and international contemporary craft and folk art are presented annually in this museum, part of a fascinating, cultural waterfront center in San Francisco. PLEASE NOTE: Group tours are free of charge to those who make advance reservations.

ON EXHIBIT/97:

01/11/97–03/23/97	THE LEAVITT COLLECTION OF ETHIOPIAN FOLK PAINTING
01/11/97–03/23/97	BEATRICE WOOD: THE LUSTER OF 103 — Ceramics and drawings accompanied by her famous lustre ware will be featured in an exhibition celebrating Wood's 103rd birthday. WT
03/29/97–06/01/97	EARTH AND AIR — Outstanding works by Robert Brady (wood), Ronna Neuenschwander (clay), Terry Turrell (wood), Margaret Ford (wood & clay), Flora Mace (glass), and Joey Kirkpatrick (glass) will be seen in an exhibition chosen by the museum's curator.
03/29/97–06/01/97	NAVAJO FOLK ART — Navajo folk art, a discipline only about a decade old, will be featured in the first exhibition of its kind to be shown on the West Coast.
06/07/97–08/10/97	CALIFORNIA FAIENCE — Historic California pottery will be on exhibit. TENT!
06/07/97–08/10/97	SHA-SHA HIGBY COSTUMES — Performance artist Higby's artful costumes will be accompanied by a live performance with the show.
08/16/97–10/19/97	ED TRINKELLER — Featured will be historic metal pieces by Trinkeller, one of California's earliest metal artists who worked with architect Julia Morgan.
08/16/97–10/19/97	CONTEMPORARY METAL ARTISTS — Tableware and large sculptural works will be presented in this invitational exhibition for metal artists throughout the country.
11/01/97–01/04/98	THE STRAW TRAIL — A ground-breaking presentation of some of the finest examples of straw art in the world.

San Francisco Museum of Modern Art

151 Third St., **San Francisco, CA 94103-3159**

p: 415-357-4000 WEB ADDRESS: http://www.sfmoma.org

HRS: 11-6 F-Tu, till 9 T DAY CLOSED: W HOL: 1/1, 7/4, THGV, 12/25

F/DAY: 1st Tu ADM: Y ADULT: $7.00 CHILDREN: F (13 & under) STUDENTS: $3.50 SR CIT: $3.50

&: Y; Totally wheelchair accessible ℗ Y; Pay garages at Fifth & Mission, the Moscone Center Garage(255 Third St.), and the Hearst Garage at 45 Third St. MUS/SH: Y ⑪ Y; Caffé Museo open 10-6 Tu-S, till 9 PM T

GR/T: Y GR/PH: CATR! 415-357-4191 DT: Y TIME: daily (call 415-357-4096) or inquire in lobby

PERM/COLL: AM: ab/exp ptgs; GER: exp; MEX; REG; PHOT; FAUVIST: ptgs; S.F. BAY AREA ART; VIDEO ARTS

A trip to San Francisco if only to visit the new home of this more than 60 year-old museum would be worthwhile for any art lover. Housed in a light filled architecturally brilliant and innovative building designed by Mario Botta, the museum features the most comprehensive collection of 20th-century art on the West Coast. It is interesting to note that not only is this structure the largest new American art museum to be built in this decade, it is also the second largest single facility in the U.S. devoted to modern art. PLEASE NOTE THE FOLLOWING: 1. Admission is half price from 5-9 on Thursday evenings; 2. Spotlight tours are conducted every Thursday and live jazz in the galleries is provided on the 3rd Thursday of each month; 3. Special group tours called "Modern Art Adventures" can be arranged (415-357-4191) for visits to Bay Area private collections artists' studios, and a variety of museums and galleries in the area. 4.The museum's hours as listed are new as of 1/1/97. **NOT TO BE MISSED:** "Woman in a Hat" by Matisse, one of 30 superb early 20th c. works from the recently donated Elise Hass Collection.

CALIFORNIA

San Francisco Museum of Modern Art - continued

ONGOING — FROM MATISSE TO DIEBENKORN: WORKS FROM THE PERMANENT COLLECTION — Many of the very best works from the museum's permanent collection will be shown in the vastly expanded gallery space of the new museum building. Included in this exhibition will be prime examples of European & American Modernism, Surrealism, Abstract Expressionism, and California Art. In addition to highlighting individual artists such as Matisse, Klee, Still and Guston, the exhibition will also feature a room-sized light installation by James Turrell.

PICTURING MODERNITY: PHOTOGRAPHS FROM THE PERMANENT COLLECTION

HUMANE TECHNOLOGY: THE EAMES STUDIO AND BEYOND — A reinstallation of the actual conference room designed and used by the renowned team of Charles and Ray Eames.

08/23/96–02/25/97 — TOM BONAURO: SELECTIONS FROM THE PERMANENT COLLECTION OF ARCHITECTURE AND DESIGN — Included in this survey of work by innovative graphic designer Bonauro will be his Levi's 501 advertising campaign images.

09/26/96–01/28/97 — CROSSING THE FRONTIER: PHOTOGRAPHS OF THE DEVELOPING WEST, 1849 TO THE PRESENT — 300 images on view trace the way land has been used in the developing West from the gold rush days to the present. CAT WT

10/10/96–02/04/97 — COMMONPLACE MYSTERIES: PHOTOGRAPHS BY PETER HUJAR, ANDREA MODICA, AND BILL OWENS — Featured will be photographic images by three artists whose works offer critical, clear-eyed looks at the social landscape of our times.

10/31/96–03/11/97 — KATHARINA FRITSCH — Works by Fritsch, a young German sculptor selected to represent her country in the summer 1995 Venice Biennale, will be featured in the first solo museum survey of her work. ONLY VENUE CAT

12/12/96–02/25/97 — SOUVENIRS OF SAVINGS: MINIATURE BANK BUILDINGS FROM THE COLLECTION OF ACE ARCHITECTS — 100 miniature metal banks that look like architectural models of America's small-town banks between 1910-1927 will be presented in an exhibition that reflects the progression of architectural bank design during this time span.

01/97–06/97 — PAUL KLEE

01/17/97–06/03/97 — STEVEN PIPPIN: NEW WORK — Featured will be British photographer Pippin's works which he creates by transforming ordinary household washing machines into cameras and film-developing instruments in order to challenge the all-too-often mundane approach to today's photography.

01/24/97–04/20/97 — PERMANENT COLLECTION: MEDIA (Working Title) BROCHURE

02/14/97–05/13/97 — ROBERT ARNESON: SELF-PORTRAIT OF THE ARTIST — Recently deceased, the self-portraits on view by Arneson, a renowned Bay Area artist will trace path of his entire career. Arneson was best known for the highly original honest depictions of himself and other subjects, all of which included his unique brand of biting humor and gritty commentary.

02/14/97–06/03/97 — SEYDOU KEITA — 24 evocative portraits by Keita (b. 1923), a self-taught African photographer of distinguished reputation, provide a rare look into the everyday life in Mali in the 1950's and 60's. WT

02/14/97–05/13/97 — KARA WALKER: NEW WORK

San Francisco Museum of Modern Art - continued

03/14/97–07/06/97	CENTERING THE CIVIC: THE FIRST SAN FRANCISCO PRIZE
04/18/97–EARLY/97	ICONS — An exhibition that examines the way in which 12 of today's most powerful and significant icons influence our everyday lives.
05/09/97–08/12/97	PERMANENT COLLECTIONS: MEDIA (Working Title) BROCHURE
06/06/97–08/26/97	PETER FISHLI & DAVID WEISS: IN A RESTLESS WORLD (NEW WORK PRESENTATION) — Consisting of ordinary items presented with irony and humor, the works on view by Swiss artists Fishli & Weiss, features installations art that transform everyday objects by investing them with an often emotional charge that leads to unique commentary on contemporary art. WT
06/20/97–09/09/97	RAISED BY WOLVES: PHOTOGRAPHS AND DOCUMENTS OF RUNAWAY KIDS BY JIM GOLDBERG — Goldberg juxtaposes photographs, documents, text, video and other objects in an emotionally charged multi-media installation that weaves a narrative about young American children who leave dysfunctional families and live instead on the streets of San Francisco and Hollywood. WT
07/18/97–11/07/97	PERMANENT COLLECTION: ÉMIGRÉ GRAPHICS
08/08/97–11/25/97	SHIRO KURAMATA 1943-1991 — A display of works by one of Japan's most acclaimed designers known for transforming ordinary objects from traditional functional pieces into surreal and minimalist works.
08/22/97–01/04/98	TATSUO MIYAJIMA: NEW WORK — Miyajima's installation "Counterline" of 125 LED elements represents time in relation to space and environment by expressing continuous transformation.
09/26/97–01/13/98	POLICE PHOTOGRAPHY — Historical and contemporary photographs taken as police evidence will be shown in an exhibit that examines their significance in a broader social context.
10/10/97–02/27/98	MAKING ART HISTORY: ON THE TRAIL OF DAVID PARK
12/19/97–03/17/98	FABRICATIONS — A presentation of architectural installations formed of assembled pieces that are intended to inform and amuse by engaging the viewer in a direct physical experience.

San Jose

Egyptian Museum and Planetarium
Rosicrucian Park, 1342 Naglee Ave., **San Jose, CA 95191**
☎ 408-947-3636
HRS: 9-5 Daily HOL: 1/1, 12/25, THGV,
ADM: Y ADULT: $6.00 CHILDREN: $3.50 (7-15) STUDENTS: $4.00 SR CIT: $4.00
℗ Y; Free lot at corner of Naglee and Chapman plus street parking MUS/SH: Y
GR/T: Y GR/PH: 408-287-2807 DT: Y TIME: rock tomb only periodically during day
PERM/COLL: ANT: ptgs, sculp, gr; CONT: emerging Bay Area artists

Without question the largest Egyptian collection in the West, the Rosicrucian is a treasure house full of thousands of objects and artifacts from ancient Egypt. Even the building itself is styled after Egyptian temples and, once inside, the visitor can experience the rare opportunity of actually walking through a reproduction of the rock tombs cut into the cliffs at Beni Hasan 4,000 years ago. **NOT TO BE MISSED:** A tour through the rock tomb, a reproduction of the ones cut into the cliffs at Beni Hasan 4,000 years ago; Egyptian gilded ibis statue in Gallery B

CALIFORNIA

San Jose

San Jose Museum of Art

110 S. Market St., **San Jose, CA 95113**
☎ 408-294-2787 WEB ADDRESS: http://www.sjiving.com/sjma
HRS: 10-5 Tu-S, 10 AM-8 PM T DAY CLOSED: M HOL: LEG/HOL!
F/DAY: 1st T ADM: Y ADULT: $6.00 CHILDREN: F (under 6) STUDENTS: $3.00 SR CIT: $3.00
&: Y; Building and restrooms are wheelchair accessible
Ⓟ Y; Paid public parking is available underground at the museum and at several locations within 3 blocks of the museum.
MUS/SH: Y; in museum & Cafe ⫩Y; "The Artful Cup," a coffee bar across the street from the museum
GR/T: Y GR/PH: CATR! 408-291-5393
DT: Y TIME: 12:30 & 2:30 Tu-S & 6:30 T H/B: Y; 1892 Richardsonian Romanesque S/G: Y
PERM/COLL: AM: 19-20; NAT/AM; CONT

Contemporary art is the main focus of this vital and rapidly expanding museum. Originally housed in a landmark building that once served as post office/library, the museum added 45,000 square feet of exhibition space in 1991 to accommodate the needs of the cultural renaissance now underway in San Jose. Beginning in 1994, the Whitney Museum of American Art in New York agreed to send the San Jose Museum of Art four large exhibitions drawn from the Whitney's permanent collection. Each exhibition will be installed for a period of 18 months. PLEASE NOTE: 1. The museum's Historic Wing is closed for seismic upgrading. 2. Signed tours for the deaf are given at 12:30 on the 2nd Sat. of the month.

ON EXHIBIT/97:

through 02/02/97	AMERICAN ART 1940-1965: TRADITIONS RECONSIDERED. SELECTIONS FROM THE PERMANENT COLLECTION OF THE WHITNEY MUSEUM OF AMERICAN ART — Works by such modern masters as Jackson Pollock, Mark Rothko, Louise Nevelson, Jasper Johns, Andy Warhol and others may be seen with those of lesser-known figures in the 2nd of 4 exhibitions of works on loan from the Whitney Museum of Art. PLEASE NOTE: 15-20 minute Spotlight tours of this exhibition are given every weekday at 12:30 PM. ATR!
11/24/96–02/23/97	ELVIS + MARILYN: 2 X IMMORTAL — In the first major museum exhibition to examine the impact of Elvis Presley and Marilyn Monroe on American culture, more than 100 works on view by such artists as Andy Warhol, Robert Arneson, Robert Rauchenberg, Audry Flack and others will allow the viewer to explore, compare and contrast the power of these two quintessentially American icons. CAT WT
02/22/97–05/11/97	THE EUREKA FELLOWSHIP AWARDS: 1996-1998 — Works by 12 Bay Area artists, each recipients of the tri-annual San Francisco-based Fleishhaker Fellowship award of $15,000, will be featured in this presentation of their works.
03/09/97–05/25/97	BASIL BLACKSHAW - PAINTER — Regarded as Northern Ireland's leading artist, this 4-decade retrospective of portraits, still lifes, landscapes, and images of horses and dogs reflect Blackshaw's romantic passion for the rural, and not the political, life of his country. CAT WT
03/09/97–05/25/97	TWO IN MONTANA: DEBORAH BUTTERFIELD AND JOHN BUCK, SCULPTURE AND WOODBLOCK PRINTS — Five horse sculptures by Butterfield, created from the melding of a plethora of found objects will be featured with Buck's neo-primitive sculptures in an exhibition that reflects the deep concerns of these Montana-based artists for the social, environmental and political concerns of our times. CAT WT
05/31/97–08/24/97	WILLIAM WEGMAN: PHOTOGRAPHS, PAINTINGS, DRAWINGS AND VIDEO — From the well-known photographic images of his pet Weimaraners to his soft-edge paintings, this non-thematic exhibition of 57 works offers a broad overview of noted contemporary American artist Wegman's work. CAT WT
06/07/97–09/14/97	MANUEL NERI: EARLY WORKS, 1953-1978 — The emotionally charged creativity of this Bay Area sculptor will be seen in a presentation of a critical selection of the most dramatic, important and beautiful examples of his cut and painted plaster figures, fiberglass casts, canvases and drawings. CAT WT

San Jose Museum of Art - continued

09/06/97–11/02/97 NEW ART IN CHINA, POST 1989 — This exhibition of 84 works by 30 artists presents the opportunity to explore the many facets of unofficial contemporary Chinese art.

 CAT WT

10/18/97–10/18/98 AMERICAN ART IN THE AGE OF TECHNOLOGY: SELECTIONS FROM THE PERMANENT COLLECTION OF THE WHITNEY MUSEUM OF ART (Working Title) — Artwork created over the past 30 years will be explored in the 3rd of a four part series of works on loan from the Whitney Museum of American Art, NYC. From traditional artforms large-scale room sized installations to video and kinetic art, this exhibition will feature works by Jonathan Borofsky, Jeff Koons, Dan Flavin, Nam June Paik, Claus Oldenburg and many other internationally renowned contemporary masters. CAT

11/23/97–02/15/98 JOHN REGISTER: A RETROSPECTIVE — More than 40 significant paintings by Register (1939-1996), an American realist artist, will be presented in a major retrospective showcasing his trademark images of cafe interiors, empty chairs in hotel lobbies, phone booths and other works depicting contemporary American urban landscapes. CAT WT

San Marino

Huntington Library, Art Collections and Botanical Gardens

1151 Oxford Rd., **San Marino, CA 91108**

✆ 818-405-2141

HRS: 12-4:30 Tu-F, 10:30-4:30 Sa, S; MEM/DAY-LAB/DAY: 10:30-4:30 daily DAY CLOSED: M HOL: LEG/HOL!

F/DAY: 1st T of month SUGG/CONT: Y ADULT: $7.50 CHILDREN: F (under 12) STUDENTS: $4.00 SR CIT: $6.00

♧: Y Ⓟ Y; On grounds behind Pavilion MUS/SH: Y

�11 Y; 1-4 Tu-F; 11:30-4:00 Sa, S; ENG. TEA 1-3:45 Tu-F; Noon-3:34 Sa, S

GR/T: Y GR/PH: CATR! 818-405-2140 DT: Y TIME: introductory slide show given during day

H/B: Y; 1910 estate of railroad magnate, Henry E. Huntington S/G: Y

PERM/COLL: BRIT: ptgs, drgs, sculp, cer 18-19; EU: ptgs, drgs, sculp, cer 18; FR: ptgs, dec/art, sculp 18; REN: ptgs; AM: ptgs, sculp, dec/art 18-20

The multi-faceted Huntington Library, Art Collections & Botanical Gardens makes a special stop at this complex a must. Known for containing the most comprehensive collections of British 18th & 19th-century art outside of London, the museum also houses an outstanding American collection and a library that is one of the greatest research libraries in the world. A new installation of furniture and decorative arts designed by California architects Charles & Henry Greene will open on 10/25/96 in the Dorothy Collins Brown Wing which has been closed for the past 3 years for refurbishing. **NOT TO BE MISSED:** "Blue Boy" by Gainsborough; "Pinkie" by Lawrence; Gutenberg Bible; 12 acre desert garden; Japanese garden

ON EXHIBIT/97:

11/19/96–02/09/97 LET THERE BE LIGHT: WILLIAM TYNDALE AND THE MAKING OF THE ENGLISH BIBLE — The only surviving copy of the first edition of Tyndale's New Testament (1526) will be on view for the first time in America accompanied by Anne Boleyn's copy of 1534.

MID/97–LATE/97 PHOTOGRAPHS OF FRENCH GARDENS BY MICHAEL KENNA (Working Title)

05/11/97–07/20/97 GEORGE III AND AMERICAN NATURAL HISTORY: MARK CATESBY'S WATERCOLORS FROM THE ROYAL COLLECTION, WINDSOR CASTLE

CALIFORNIA

San Simeon

Hearst Castle
Affiliate Institution: Hearst San Simeon State Historical Monument
750 Hearst Castle Rd., **San Simeon, CA 93452-9741**
☎ 805-927-2020
HRS: 8:20-3:20 (to reserve a tour call toll free 1-800-444-4445) HOL: 12/25, 1/1, THGV
ADM: Y ADULT: $14.00 CHILDREN: $8.00 (6-12)
&: Y; CATR! 805-927-2020 for wheelchair-accessible tours ℗ Y; Free and plentiful for cars, buses, & RV'S
MUS/SH: Y ⑪ Y GR/T: Y GR/PH: CATR! 1-800-444-4445 H/B: Y
PERM/COLL: IT/REN: sculp, ptgs; MED: sculp, ptgs; DU; FL; SP; AN/GRK: sculp; AN/R: sculp; AN/EGT: sculp

One of the prize house museums in the state of California is Hearst Castle, the enormous (165 rooms) and elaborate former estate of William Randolph Hearst. The contents of the sculptures and paintings displayed throughout the estate is a mixture of religious and secular art and antiquities attesting to the keen eye Mr. Hearst had for collecting. PLEASE NOTE: a 10% discount for groups of 12 or more has recently been implemented. Evening Tours are available for a fee of $25 adults and $13 for children ages 6-12 (hours vary according to the sunset). There are 4 different daytime tours offered. All last approximately 1 hour & 50 minutes, include a walk of ½ mile, and require the climbing of 150 to 400 stairs. All tickets are sold for specific tour times. Be sure to call 1-800-444-4445 to reserve BOTH, individual or group tours. For foreign language tours CATR! 805-927-2020. **NOT TO BE MISSED:** Paintings and sculptures by Gerome, Canova & Thorvaldson; a collection of 155 Greek vases

Santa Ana

The Bowers Museum of Cultural Art
2002 N. Main St., **Santa Ana, CA 92706**
: 714-567-3600
HRS: 10-4 Tu-S, till 9 PM T DAY CLOSED: M HOL: 12/25, 1/1
ADM: Y ADULT: $6.00 CHILDREN: $2.00 (5-12) STUDENTS: $4.00 SR CIT: $4.00
&: Y; Wheelchair accessible ℗ Y; Free parking lot on the S.W. corner of Main & 20th and behind KIDSEUM @ 18th & Main
MUS/SH: Y ⑪ Y; Topaz Cafe GR/T: Y GR/PH: CATR! 714-567-3680 DT: Y TIME: 1 & 2 most days
PERM/COLL: PACIFIC RIM 19-20; P/COL: cer; AM; dec/art 19-20; AF; N/AM: eth; S/AM: eth

Dedicated to the display & interpretation of the fine art of the indigenous peoples of the Americas, the Pacific Rim, & Africa, the Bowers, with its multi-faceted collection, is the largest museum in Orange County. Housed in a restored Spanish mission-style building (1932), the museum also has a number of large exhibit halls for changing exhibits. PLEASE NOTE: Museum admission includes the KIDSEUM, an interactive, hands-on cultural art museum for children (open 2-5 W-F; 11-5 Sa & S). **NOT TO BE MISSED:** "Seated Priest" from Oaxaca, Mexico (Classic Period); "Seated Shaman" from Colima, Mexico (200 BC-200 AD)

ON EXHIBIT/97:
ONGOING PARTNERS IN ILLUSION: WILLIAM AND ALBERTA McCLOSKEY — A display of still lifes and portraits painted by the McCloskey's, a husband and wife artistic team.

EASELS IN THE ARROYOS: PLEIN AIR PAINTINGS — Created between 1900-1940, these important California plein-air and impressionist paintings from the museum's collection are on permanent view with comparative works from before and after the period.

AFRICAN ICONS OF POWER: TIMELESS ARTWORKS FROM THE PAUL AND RUTH TISHMAN COLLECTION — The power and sophistication of African art can be seen in the approximately 100 pieces on view from one of the finest collections of its kind.

REALM OF THE ANCESTORS: ARTS OF OCEANA — Ritual objects, sculpture, costumes and artifacts on exhibit in the Oceana Gallery tell of the culture of Southeast Asia and Pacific Oceana.

The Bowers Museum of Cultural Art - continued

VISION OF THE SHAMAN, SONG OF THE PRIEST — A display of ancient pre Columbian Mexican and Central American ceramics and textiles.

ARTS OF NATIVE AMERICA — From beadwork to basketry, this exhibit showcases a rich display of Native American artifacts.

CALIFORNIA LEGACIES — The multi-cultural history of Orange County and the West is highlighted in a series of ongoing exhibitions.

10/06/96–03/16/97 SEEKING IMMORTALITY: CHINESE TOMB SCULPTURE FROM THE SCHLOSS COLLECTION — On exhibit will be 150 2nd-century BC to 8th-century AD ceramic objects which recreated life in ancient China and were placed in burial tombs to be used in the afterlife of the deceased.

04/97–08/97 SPLENDID HERITAGE: MASTERPIECES OF NATIVE AMERICAN ART FROM THE MASCO COLLECTION — 45 rare Native American masterpieces including apparel, ceremonial objects, paintings, weapons, and adornments will be on view providing the viewer with an opportunity to savor exceptional expressions of Indian aesthetic genius.

Santa Barbara

Santa Barbara Museum of Art
1130 State St., **Santa Barbara, CA 93101-2746**
☎ 805-963-4364 WEB ADDRESS: http://artdirect.com/
HRS: 11-5 Tu-W & F-Sa, 11-9 T, Noon-5 S DAY CLOSED: M HOL: 12/25, 1/1, THGV
F/DAY: T & 1st S ADM: Y ADULT: $4.00 CHILDREN: F (under 6) STUDENTS: $2.50 SR CIT: $3.00
&: Y; Outside ramp; elevator to all levels ⓟ Y; 2 city parking lots each one block away from the museum MUS/SH: Y
GR/T: Y GR/PH: CATR! ex. 334 DT: Y TIME: 1:00 Tu-S; Noon W & Sa
PERM/COLL: AN/GRK; AN/R; AN/EGP; AS; EU: ptgs 19; CONT; PHOT

With 15,000 works of art, a considerable number for a community of its size, the Santa Barbara Museum offers a variety of collections that range from antiquities of past centuries to the contemporary creations of today. PLEASE NOTE: Due to a remodeling project the museum will only be presenting a limited number of special exhibitions in addition to the Asian Art Gallery, Roman antiquities and 18th through 20th-century art which will remain on view during construction. **NOT TO BE MISSED:** Fine collection of representative works of American Art

ON EXHIBIT/97:

11/02/96–02/97 EARLY SANTA BARBARA CONNECTION — An exhibition that reveals the early and important connections photographers have historically made with Santa Barbara.

11/23/96–02/02/97 THE LIE OF THE LAND

11/23/96–02/02/97 THE FURNITURE OF RUDOLPH M. SCHINDLER CAT

11/29/96–02/16/97 A PAINTER'S PARADISE: ARTISTS AND THE CALIFORNIA LANDSCAPE — This survey of the evolution of landscape painting in California from the early 19th to the mid-20th-century, explores the influence of French Barbizon, Impressionist, and Modernist movements upon the medium.

02/22/97–04/27/97 THE SELF AND THE OTHER: PERSONHOOD AMONG THE BAYLE, COTE D'IVOIRE, WEST AFRICA WT

02/22/97–04/27/97 KINSHIPS: ALICE NEEL LOOKS AT THE FAMILY — Unconventional yet captivating and frankly honest portrait paintings by Neel (1900-1983), one of the greatest figurative artists of her day. WT

03/08/97–05/04/97 KATAGAMI: JAPANESE STENCILS (Working Title) — 75 stencils and other related artworks mainly from the permanent collection will be highlighted in a major exhibition of Japanese stencils or katagami, the foremost pattern-bearing tools in the Japanese textile dyeing process known as katazome. These masterfully cut stencils which embody the Japanese genius for design have influenced international design sensitivities for generations. CAT WT

CALIFORNIA

Santa Barbara

University Art Museum, Santa Barbara
Affiliate Institution: University of California
Santa Barbara, CA 93106
📞 805-893-2951
HRS: 10-4 Tu-Sa, 1-5 S & HOL DAY CLOSED: M HOL: 1/1, 12/25/, 7/4, THGV, EASTER
&: Y; Wheelchair accessible MUS/SH: Y
GR/T: Y GR/PH: CATR! DT: Y TIME: acad year only: 2:00 Sa & 12:15 alternate Tu
PERM/COLL: IT: ptgs; GER: ptgs; FL: ptgs; DU: ptgs; P/COL; ARCH/DRGS; GR; OM: ptgs; AF; ARCH; DRGS

Outstanding among the many thousands of treasures in the permanent collection is one of the world's finest groups of early Renaissance medals and plaquettes. **NOT TO BE MISSED:** 15th through 17th-century paintings from the Sedgwick Collection; Architectural drawing collection; Morgenroth Collection of Renaissance medals and plaquettes

ON EXHIBIT/97:

11/23/96–02/02/97	THE LIE OF THE LAND
02/19/97–04/27/97	KINSHIPS: ALICE NEEL LOOKS AT THE FAMILY — Unconventional yet captivating and frankly honest portrait paintings by Neel (1900-1983), one of the greatest figurative artists of her day.
02/22/97–04/27/97	THE SELF AND THE OTHER: PERSONHOOD AND IMAGES AMONG THE BAULE, COTE D'IVOIRE, WEST AFRICA
05/09/97–06/15/97	STUDENT EXHIBITIONS

Santa Clara

DeSaisset Museum
Affiliate Institution: Santa Clara University
Santa Clara, CA 95053
📞 408-554-4528
HRS: 11-4 Tu-S DAY CLOSED: M HOL: LEG/HOL!
&: Y; Wheelchair access ramp ⓟ Y; Free in front of museum with free parking permit at front gate
GR/T: Y GR/PH: CATR! H/B: Y; Adjacent to Mission Santa Clara
PERM/COLL: AM: ptgs, sculp, gr EU: ptgs, sculp, gr 16-20 AS; dec/art; AF; CONT: gr, phot, IT/REN: gr

Serving Santa Clara University and the surrounding community, the DeSaisset, since its inception in 1955, has been an important Bay Area cultural resource. PLEASE NOTE: It is wise to call ahead as the museum may have limited hours between rotating exhibitions. **NOT TO BE MISSED:** California history collection

ON EXHIBIT/97:

ONGOING	CALIFORNIA HISTORY EXHIBIT
01/28/97–03/26/97	VISION QUEST: MEN, WOMEN AND SACRED SITES OF THE SIOUX NATION — Photographs resulting from a collaborative effort between photographer Don Doll and prominent Sioux men & women across 15 reservations in 5 states will be on view in an exhibition that highlights portraiture of the Sioux within their environment, panoramic images of Sioux land and sacred sites, and dancers in their traditional garb. BOOK WT
04/17/97–04/20/97	ART AND FLOWERS — A presentation of floral arrangements that relate thematically to works from the permanent collection.
09/97–12/97	BOW WOW HAUS (Working Title) — A group show.
09/97–03/98	THE HEART MOUNTAIN STORY: PHOTOGRAPHS BY HANSEL MEITH AND OTTO HAGEL OF THE WORLD WAR II INTERNMENT OF JAPANESE AMERICANS — Featured will be 25 never before seen black & white photographs depicting the internment of Japanese Americans during WWII and the impact of that confinement on their lives. Dates Tent! TENT!

Santa Clara

Triton Museum of Art
1505 Warburton Ave., **Santa Clara, CA 95050**
☎ 408-247-3754
HRS: 10-5 W-S, till 9 PM Tu HOL: LEG/HOL! VOL/CONT: Y
&: Y; Fully Accessible ℗ Y; Free parking adjacent to the museum MUS/SH: Y GR/T: Y GR/PH: CATR! S/G: Y
PERM/COLL: AM: 19-20; REG; NAT/AM; CONT/GR

Located in a seven acre park adjacent to the city of Santa Clara, the Triton has grown by leaps and bounds to keep up with the cultural needs of its rapidly expanding "Silicon Valley" community. The museum is housed in a visually stunning building that opened to the public in 1987. **NOT TO BE MISSED:** The largest collection in the country of paintings by American Impressionist Theodore Wores; "Native Americans: Yesterday & Today" (on permanent display)

ON EXHIBIT/97:

11/16/96–02/02/97	DRAWINGS: REALISM TO ABSTRACTION, A CONTEMPORARY SURVEY OF THE BAY AREA
02/22/97–04/27/97	YOSHIO TAYLOR: FIGURATIVE CERAMIC SCULPTURES
02/22/97–04/30/97	CLAY AND GLASS: ASSOCIATION OF CALIFORNIA CERAMIC ARTISTS
05/17/97–08/10/97	A CONTEMPORARY SURVEY OF BAY AREA EMERGING AFRICAN-AMERICAN ARTISTS
05/17/97–08/10/97	A VISUAL HERITAGE 1945 TO 1970: BAY AREA AFRICAN-AMERICAN ARTISTS
09/97–10/97	FOCUS: CALIFORNIA; SELECTIONS FROM THE BANK OF AMERICA CORPORATE COLLECTION

Santa Cruz

The Museum of Art and History at the McPherson Center
705 Front St., **Santa Cruz, CA 95060**
☎ 408-429-1964
HRS: 11-4 Tu-S, till 8 T DAY CLOSED: M HOL: LEG/HOL!
F/DAY: 1st & 3rd T ADM: Y ADULT: $3.00 CHILDREN: F (under 12) STUDENTS: $2.00 SR CIT: $3.00
&: Y ℗ No on site parking. Some garages nearby. MUS/SH: Y ⼀⼀Y; Indoor courtyard/cafe
GR/T: Y GR/PH: CATR! DT: Y TIME: Noon usually 1st & 3rd T
PERM/COLL: CONT

Recently renamed The Museum of Art and History at the McPherson Center this facility, is concerned with the promotion of visual culture in our society. It presents art exhibitions from the permanent collection (with emphasis on contemporary works), changing exhibitions of internationally renowned artists, and group exhibitions that demonstrate various art techniques, mediums, crafts and historic periods.

ON EXHIBIT/97:

10/05/96–01/26/97	CABINET OF CURIOSITIES: ODDITIES AND WONDERS FROM MUSEUMS AND COLLECTIONS AROUND THE MONTEREY BAY — Beautiful and bizarre objects will be featured in an exhibition that explores the nature of collecting, what it tells us about history and how fashions in collecting have changed.
12/21/96–02/23/97	CATNAP: A FUN, FELINE TIME-TRAVELING JOURNEY THROUGH ART — Featured will be Steven Norton's amusing portraits of cats each of which he imbues with the characteristic persona of historically recognizable artists.
03/05/97–04/27/97	TIME AND PLACE: 50 YEARS OF SANTA CRUZ STUDIO CERAMICS — Clay works produced in studios in Santa Cruz County over the past 50 years will be on exhibit.
05/10/97–06/29/97	GAZA BOWEN: WALKING THROUGH TIME — New works.
07/12/97–09/14/97	ALL STARS: AMERICAN SPORTING PRINTS
09/27/97–11/23/97	ROMANCE OF THE BELLS: MISSION PAINTINGS FROM THE IRVINE COLLECTION — 1920's and 1930's paintings will be seen in an exhibition highlighting California's rich Mission heritage.

CALIFORNIA

Santa Monica

Santa Monica Museum of Art
2437 Main St., **Santa Monica, CA 90405**
☎ 310-399-0433
HRS: 11-6 W-S, till 10 F DAY CLOSED: M, Tu HOL: 12/25, 1/1, 7/4, THGV
SUGG/CONT: Y ADULT: $4.00 CHILDREN: $1.00 (under 12) STUDENTS: $2.00 SR CIT: $2.00
&: Y; Wheelchair accessible Ⓟ Y; Validated parking at Edgemar or across the street at the Santa Monica City Lot #11; on-site parking for the disabled MUS/SH: Y GR/T: Y GR/PH: CATR! H/B: Y; Located in former Ice House
PERM/COLL: NO PERMANENT COLLECTION

Located in the former 1908 Imperial Ice Company building, this museum with its 25 foot ceilings provides ideal space for large scale works of art. Devoted to the display of art by living artists, it is the only art museum in the area dedicated to making contemporary art more accessible to a culturally and economically diverse audience.

Santa Rosa

Sonoma County Museum
425 Seventh Ave., **Santa Rosa, CA 95401**
☎ 707-579-1500
HRS: 11-4 W-S DAY CLOSED: M, Tu HOL: LEG/HOL!
ADM: Y ADULT: $2.00 CHILDREN: F (UNDER 12) STUDENTS: $1.00 SR CIT: $1.00
&: Y; Wheelchair accessible Ⓟ Y; Free parking in museum's east lot or in adjacent parking garage. MUS/SH: Y
GR/T: Y GR/PH: CATR! H/B: Y; 1910 Federal Post Office
PERM/COLL: AM: ptgs 19 ; REG

The museum is housed in a 1909 Post Office & Federal Building that was restored and moved to its present downtown location. It is one of the few examples of Classical Federal Architecture in Sonoma County. **NOT TO BE MISSED:** Collection of works by 19th-century California landscape painters

ON EXHIBIT/97:

11/01/96–01/26/97	CONTEMPORARY ART OF VIETNAM — On display will be contemporary paintings, mixed media works and even water puppets by Vietnamese and Vietnamese-American artists.
03/21/97–04/20/97	ARTISTRY IN WOOD — An annual presentation of carved artworks by members of the Sonoma County Woodworkers Association.
05/02/97–06/22/97	POSADA MEXICAN PRINTS — Featured will be prints by Jose Guadalupe Posada on loan from the Taylor Museum's collection of his works which is considered one of the best of its kind in the country.
07/97–09/97	IN THE REDWOODS — 18th & 19th-century artistic interpretations of the Coast Redwoods will be on exhibit.

Stanford

Stanford University Museum and Art Gallery
Lomita Dr. & Museum Way, **Stanford, CA 94305**
☎ 415-723-4177
HRS: 10-5 Tu-F; 1-5 Sa, S DAY CLOSED: M HOL: 12/25, 1/1, 7/4, THGV
VOL/CONT: Y &: Y; Limited to Rodin Sculpture Collection only Ⓟ Y; Metered parking at the museum MUS/SH: Y
DT: Y TIME: Rodin Garden: 2 PM W, Sa, S; Gallery: 12:15 T, 2 PM S S/G: Y
PERM/COLL: PHOT; PTGS; SCULP (RODIN COLLECTION); DEC/ART; GR; DRGS; OR; CONT/EU

Due to severe earthquake damage the museum will be closed until it is incorporated within the new Visual Arts Center scheduled to open in the fall of 1998. However the Art Gallery is open with a regular schedule of exhibitions. PLEASE NOTE: Public tours of site-specific sculpture throughout the campus are available at 2 PM on the first Sunday of each month. **NOT TO BE MISSED:** Rodin sculpture collection

Stanford University Museum and Art Gallery - continued

ON EXHIBIT/97:

07/16/96–04/27/97	UNDER CONSTRUCTION: IRIS AND B. GERALD CANTOR CENTER FOR THE VISUAL ARTS AT STANFORD UNIVERSITY — Building models, architectural plans and elevations will be on display in a small exhibition designed to highlight the new $32 million dollar Iris and B. Gerald Cantor Center for the Visual Arts at Stanford University scheduled to open in the fall of 1988.
07/16/96–04/27/97	BODY LANGUAGE: THE HUMAN FORM IN ART — From the permanent collection, this multi-media exhibition examines the ways in which the human image has been used in art internationally to convey formal, spiritual and social concepts.

Stockton

The Haggin Museum

1201 N. Pershing Ave., **Stockton, CA 95203**

☎ 209-462-1566

HRS: 1:30-5 Tu-S; Open to groups by advance appt! DAY CLOSED: M HOL: 12/25, 1/1, THGV
SUGG/CONT: Y ADULT: $2.00 CHILDREN: $1.00 STUDENTS: $1.00 SR CIT: $1.00
♿: Y; Call in advance to arrange for use of elevator, ground level entry Ⓟ Y; Free street parking where available
MUS/SH: Y GR/T: Y GR/PH: CATR! DT: Y TIME: 1:45 Sa, S
PERM/COLL: AM: ptgs 19; FR: ptgs 19; AM: dec/art; EU: dec/art

Wonderful examples of 19th-century French and American paintings from the Barbizon, French Salon, Rocky Mountain, and Hudson River Schools are displayed in a setting accented by a charming array of decorative art objects. **NOT TO BE MISSED:** "Lake in Yosemite Valley" by Bierstadt; "Gathering for the Hunt" by Rosa Bonheur

Ventura

Ventura County Museum of History & Art

100 E. Main St., **Ventura, CA 93001**

☎ 805-653-0323

HRS: 10-5 Tu-S DAY CLOSED: M HOL: 12/25, 1/1, THGV
ADM: Y ADULT: $3.00 CHILDREN: F (under 16) STUDENTS: $3.00 SR CIT: $3.00
♿: Y Ⓟ Y; No charge at adjacent city lot MUS/SH: Y
GR/T: Y GR/PH: CATR! DT: Y TIME: 1:30 S; "ask me" docents often on duty
PERM/COLL: PHOT; CONT/REG; REG

Art is but a single aspect of this museum that also features historical exhibitions relating to the history of the region. **NOT TO BE MISSED:** 3-D portraits of figures throughout history by George Stuart. Mr. Stuart has created nearly 200 figures which are rotated for viewing every 4 months. He occasionally lectures on his works (call for information)!

ON EXHIBIT/97:

12/08/96–02/09/97	BANK OF A. LEVY ART COLLECTION
02/22/97–04/27/97	HENRY CHAPMAN FORD: PAINTER OF EARLY CALIFORNIA
05/07/97–07/14/97	ASSEMBLY OF THE ARTS INVITATIONAL: VENTURA COUNTY PHOTOGRAPHERS
07/26/97–09/08/97	NATIVE AMERICAN ART FROM MUSEUM AND PRIVATE COLLECTIONS
09/20/97–11/30/97	THE COAST ROAD — A historical exhibition co-sponsored by the Automobile Club of southern California.
12/12/97–02/98	HANDMADE HISTORY: QUILTS FROM COUNTY COLLECTIONS

COLORADO

Aspen

The Aspen Art Museum
590 N. Mill St., **Aspen, CO 81611**
☎ 970-925-8050 WEB ADDRESS: http://www.aspen.com/arm
HRS: 10-6 Tu-Sa, Noon-6 S, till 8 PM T DAY CLOSED: M HOL: 12/25, 1/1, THGV, OTHER!
F/DAY: 6-8 T ADM: Y ADULT: $3.00 CHILDREN: F(under 12) STUDENTS: $2.00 SR CIT: $2.00
&: Y Ⓟ Y MUS/SH: Y
GR/T: Y GR/PH: CATR! DT: e H/B: Y; The museum is housed in a former hydroelectric plant (c.1855) S/G: Y
PERM/COLL: SCULP

Located in an area noted for its natural beauty and access to numerous recreational activities, this museum, with its emphasis on contemporary art, offers the visitor a chance to explore the cultural side of life in the community. A free reception is offered every Thursday evening from 6-8 PM for refreshments and gallery tours. PLEASE NOTE: The galleries may occasionally be closed between exhibits.

ON EXHIBIT/97:

12/19/96–04/06/97	200 YEARS OF AMERICAN STILL LIFE PAINTING
12/19/96–02/02/97	HISTORICAL SKI PHOTOGRAPHY
04/24/97–05/11/97	YOUNG ARTISTS
06/05/97–07/27/97	TONY OURSLER
06/05/97–09/21/97	NANCY RUBINS
10/09/97–11/30/97	ROARING FORK OPEN

Boulder

CU Art Galleries
Affiliate Institution: University of Colorado/Boulder
Campus Box 318, **Boulder, CO 80309**
☎ 303-492-8300
HRS: 8-5 M-F, till 8 Tu, Noon-4 Sa; Summer Hours: 8-4:30 M-T, 1-8 F, 1-5 Sa DAY CLOSED: S
HOL: 1/1, 7/4, CHRISTMAS VACATION
VOL/CONT: Y &: Y Ⓟ Y; Paid parking in Euclid Auto Park directly south of the building
PERM/COLL: PTGS 19-20; GR 19-20; PHOT 20; DRGS 15-20; SCULP 15-20

Leanin' Tree Museum of Western Art
6055 Longbow Dr., **Boulder, CO 80301**
☎ 1-800-777-8716
HRS: 8-4:30 M-F, 10-4 Sa DAY CLOSED: S HOL: LEG/HOL!
VOL/CONT: Y
&: Y; Elevator Ⓟ Y; Free MUS/SH: Y
GR/T: Y GR/PH: CATR! 303-530-1442 DT: Y
PERM/COLL: WESTERN: sculp, ptgs, reg; CONT/REG; Largest collection of ptgs by actualist Bill Hughes (1932-1993) in the country.

This unusual museum, just 40 minutes from downtown Denver, is housed in the corporate offices of Leanin' Tree, producers of Western greeting cards. With 200 original oil paintings and 75 bronze sculptures by over 90 artist members of the Cowboy Artists of America, Leanin' Tree is home to the largest privately owned collection of contemporary cowboy and western art on public view in America. **NOT TO BE MISSED:** "Checkmate," by Herb Mignery, a monumental 10' high bronze sculpture depicting a mounted cowboy wrestling with a wild horse; "Invocation" by Buck McCain, a dramatic monumental 15' bronze sculpture of a horse and Native American rider.

Colorado Springs

Colorado Springs Fine Arts Center
Affiliate Institution: Taylor Museum for Southwestern Studies
30 W. Dale St., **Colorado Springs, CO 80903**
☎ 719-634-5581
HRS: 9-5 Tu-F, 10-5 Sa, 1-5 S DAY CLOSED: M HOL: LEG/HOL!
F/DAY: Sa 10-12; 5-7 Tu ADM: Y ADULT: $3.00 CHILDREN: $1.00 (6-12) STUDENTS: $1.50 SR CIT: $1.50
&: Y ℗ Y; In rear of museum MUS/SH: Y ❦ Y; 11:30-3:00 Tu-F (summer only)
GR/T: Y GR/PH: CATR! 719-475-2444 S/G: Y
PERM/COLL: AM: ptgs, sculp, gr 19-20; REG; NAT/AM: sculp; CONT: sculp

Located in an innovative 1930's building that incorporates Art Deco styling with a Southwestern Indian motif, this multi-faceted museum is a major center for cultural activities in the Pikes Peak region. **NOT TO BE MISSED:** Collection of Charles Russell sculpture and memorabilia; hands-on tactile gallery called "Eyes of the Mind"; New sculpture acquisitions: "The Family," by William Zorach, "Hopi Basket Dancers," by Doug Hyde, "Resting at the Spring," by Allan Houser

ON EXHIBIT/97:

ONGOING	SACRED LAND: INDIAN AND HISPANIC CULTURES OF THE SOUTHWEST
	CHARLES M. RUSSELL: ART OF THE AMERICAN WEST
	EYES OF THE MIND: TACTILE GALLERY – A JOURNEY INTO TOUCH
09/21/96–01/12/97	BOARDMAN ROBINSON: AMERICAN ILLUSTRATOR AND MURALIST, 1876-1952
12/06/96–01/05/97	GALLERY OF TREES AND LIGHTS
01/17/97–02/97	NEW VISIONS I: THREE LOCAL ARTISTS
02/18/97	THE HISTORY OF PHOTOGRAPHY
03/97	GUADALUPE AND CONTEMPORARY SANTOS AND SANTEROS
04/03/97–06/97	THE NATURE OF LOOKING
04/31/97–08/97	SELECTIONS FROM THE PERMANENT COLLECTION
05/31/97–08/97	CRITIQUES CHOICE
06/97–07/97	NEW VISIONS II: THREE LOCAL ARTISTS
FALL/97	ARTS AND CULTURE OF THE UTE INDIANS OF COLORADO, 1840-1996

Gallery of Contemporary Art
Affiliate Institution: University of Colorado Springs
1420 Austin Bluffs Pkwy., **Colorado Springs, CO 80933-7150**
☎ 719-262-3567
HRS: 10-4 M-F, 1-4 Sa DAY CLOSED: S HOL: LEG/HOL!
ADM: Y ADULT: $1.00 CHILDREN: F (under 12) STUDENTS: $0.50 SR CIT: $0.50
&: Y; Wheelchair accessible ℗ Y; Metered pay parking available GR/T: Y GR/PH: call 719-593-3567

This non-collecting university art gallery, one of the most outstanding contemporary art centers in the nation, concentrates on cutting-edge exhibitions of contemporary art with approximately 6 exhibitions throughout the year. It is the only gallery in the Colorado Springs (Pikes Peak) region to feature contemporary art.

ON EXHIBIT/97:

11/15/96–01/03/97	SELECTION 6: WORKS FROM THE POLAROID COLLECTION — David Hockney, Lucas Samaras, Robert Frank, and Robert Rauchenberg are but a few of the 93 internationally recognized and emerging artists whose 139 works utilizing Polaroid color and black & white film in a broad range of traditional and experimental techniques will be on view in this exhibition. WT
01/17/97–02/28/97	PIKES PEAK WATERCOLOR SOCIETY NATIONAL JURIED EXHIBITION — On view will be the first national juried competition presented as a collaborative effort by this established watercolor group.
03/14/97–04/18/97	CU COLORADO SPRINGS ART FACULTY BIENNIAL

COLORADO

Denver

Denver Art Museum
100 West 14th Ave. Pkwy., **Denver, CO 80204**
☏ 303-640-4433
HRS: 10-5 Tu-Sa, Noon-5 S DAY CLOSED: M HOL: LEG/HOL!
F/DAY: Sa ADM: Y ADULT: $3.00 CHILDREN: F (under 5) STUDENTS: $1.50 SR CIT: $1.50
&: Y; Ramp at main entrance ℗ Y; Public pay lot located south of the museum on 13th St.; 2 hour metered street parking in front of the museum MUS/SH: Y ⅋ Y; Lunch served 11-2
GR/T: Y GR/PH: CATR! 303-640-7596 DT: Y TIME: 1:30 Tu-S; (11 & 1:30 Tu-Sa SUMMER); 12-12:30 F H/B: Y; Designed by Gio Ponti in 1971 S/G: Y
PERM/COLL: AM: ptgs, sculp, dec/art 19; IT/REN: ptgs; FR; ptgs 19-20; AS; P/COL; SP; AM: cont; NAT/AM; ARCH: gr

With over 40,000 works featuring 19th-century American art, a fine Asian and Native American collection, and works from the early 20th-century Taos group, the Denver Art Museum, renowned for its internationally significant collections of world art, houses the largest and most comprehensive art collection between Kansas City and Los Angeles. PLEASE NOTE: The museum offers many free family-related art activities on Saturday. Call for specifics! **NOT TO BE MISSED:** The outside structure of the building itself is entirely covered with one million grey Corning glass tiles.

ON EXHIBIT/97:

THROUGH 6/22/97	NEW CONCEPTS: THE INDUSTRIAL REVOLUTION, 1776-1996 — Two centuries of industrial design will be highlighted in the works on exhibit.
THROUGH 6/22/97	JUNE MORRIS SCHWARTZ: THE ART AND CRAFT OF ENAMELED METALWORK — Featured will be 20 of Schwartz's unique metal works.
12/07/96–03/30/97	JOHN deANDREA — deAndrea's unbelievably life-like sculptures of the human form will be on exhibit.
12/14/96–12/97	YESTERDAY AND TODAY: TRADITIONAL BRONZE SCULPTURE OF RURAL INDIA — 70 objects of Indian folk art from the permanent collection will be on exhibit.
07/27/97–09/27/97	UNIVERSAL LIMITED ART EDITIONS: FORTY YEARS, 1957-1997 — On display will be 160 prints, books, portfolios, and 3 dimensional objects by 24 artists such as Helen Frankenthaler, Jasper Johns, Robert Rauchenberg, Larry Rivers, all of whom have created art at this Long-Island workshop at some point in their careers. CAT WT
11/97	OPENING OF EUROPEAN GALLERIES — This newly renovated floor of the Denver Art Museum will house its outstanding Ancient World-Greek, Roman and Egyptian collection along with American works that continue into the 20th-century
11/15/97–01/25/98	RENAISSANCE AND BAROQUE MASTER PAINTINGS FROM THE NATIONAL MUSEUM OF ART OF ROMANIA — An exhibit of 30 important 15th through 17th-century European masterpieces including works by such Italian, Spanish, German, Flemish and Dutch masters as Rembrandt, El Greco, Jordaens and others will be on view for the first time in America. WT

Museo De Las Americas
861 Santa Fe Drive, **Denver, CO 80204**
☏ 303-571-4401
HRS: 10-5 Tu-Sa DAY CLOSED: M HOL: 12/25, 1/1, 7/4, THGV
ADM: Y ADULT: $2.50 CHILDREN: F (under 10) STUDENTS: $1.00 SR CIT: $1.00
&: Y ℗ Y; 2 hour non-metered street parking MUS/SH: Y
GR/T: Y GR/PH: Call to arrange for certain exhibitions H/B: Y; Housed in a former J.C. Penny store built in 1924
PERM/COLL: HISPANIC COLONIAL ART; CONT LAT/AM

The Museo de las Americas, opened in July 1994, is the first Latino museum in the Rocky Mountain region dedicated to showcasing the art, history, and culture of the people of the Americas from ancient times to the present. PLEASE NOTE: Bilingual tours are available with admission price - CATR!

Denver

Museum of Western Art
1727 Tremont Pl., **Denver, CO 80202**
☎ 303-296-1880
HRS: 10-4:30 Tu-Sa and by appointment! DAY CLOSED: S, M HOL: 12/25, 1/1, THGV
ADM: Y ADULT: $3.00 CHILDREN: F (under 7) STUDENTS: $2.00 SR CIT: $2.00
&: Y; Wheelchairs available Ⓟ Y; Commercial parking lots adjacent to museum building MUS/SH: Y
GR/T: Y GR/PH: call 303-296-1880 DT: Y TIME: upon request during summer H/B: Y
PERM/COLL: AM: Regional Western ptgs & sculp

The history of the building that houses one of the most important collections of classic Western Art in the world is almost as fascinating as the collection itself. Located in the historic "Navarre" building, this 1880 Victorian structure, originally used as a boarding school, later became infamous as a bordello and gambling hall. Today images of the West from landscape to action to Native American themes are housed within the award-winning renovated galleries of this outstanding gem of a museum. **NOT TO BE MISSED:** "Cows Scull on Red" by Georgia O'Keeffe

The Turner Museum
On Capital Hill at 773 Downing St., **Denver, CO 80218-3428**
☎ 303-832-0924
HRS: 2-5 M-F & S, Open daily by appt.! HOL: !
ADM: Y ADULT: $7.50 STUDENTS: $5.00 SR CIT: $5.00
&: Y Ⓟ Y; Over 40 spaces plus on street parking across from the museum building. MUS/SH: Y ⲓⲓ Y!
GR/T: Y! GR/PH: group rates available: 303-832-0924 DT: Y
H/B: Y; Former Governor's House S/G: Y
PERM/COLL: J. M. W. TURNER COLLECTION (INCLUDING RARE ORIGINAL PRINTS); THOMAS MORAN PTGS

The Turner Museum, one of Denver's best kept secrets, intimately acquaints you with every aspect of the works of English artist J. M. W. Turner. Elegant meals arranged by appointment allow one to dine among the more than 2,000 works of art. PLEASE NOTE: It is advisable to call ahead before visiting as the museum is actively looking to move to a larger facility and may do so at any time. **NOT TO BE MISSED:** "Genius Unfolding," two series of proofs

Englewood

The Museum of Outdoor Arts
7600 E. Orchard Rd. #160 N., **Englewood, CO 80111**
☎ 303-741-3609
HRS: Open daily during daylight hours year-round HOL: LEG/HOL!
ADM: Y ADULT: $3.00 CHILDREN: $1.00 STUDENTS: $1.00 SR CIT: $1.00
&: Y
PERM/COLL: SCULP

Fifty-five major pieces of sculpture ranging from contemporary Colorado artists to those with international reputations are placed throughout the 400 acre Greenwood Plaza business park, located just south of Denver, creating a "museum without walls." A color brochure with a map is provided to lead visitors through the collection.

COLORADO

Pueblo

Sangre DeCristo Arts & Conference Center & Children's Center
210 N. Santa Fe Ave., **Pueblo, CO 81003**
☎ 719-543-0130
HRS: 11-4 M-Sa DAY CLOSED: S HOL: LEG/HOL!
♿: Y; Fully accessible Ⓟ Y; 2 free lots MUS/SH: Y GR/T: Y GR/PH: CATR!
PERM/COLL: AM: Regional Western 19-20; REG: ldscp, cont

A broad range of Western art is represented in the collection covering works from the 19th and early 20th century through contemporary Southwest and modern regionalist pieces. **NOT TO BE MISSED:** Francis King collection of Western Art; Art of the "Taos Ten"

ON EXHIBIT/97:

12/28/96–04/26/97	WHERE THE WEST BEGINS: ARTISTS IN COLORADO, 1860-1960 — The center invites you to "come and appreciate the best view of Colorado to be seen this winter" by feasting your eyes on this stunning selection of paintings that detail the beauty of the state. On loan from the collection of Nelson and Susan Reiger will be works by such renowned artists as Albert Bierstadt, George Caleb Bingham, Joseph Henry Sharp and others including one unsigned work attributed to Thomas Moran.
01/11/97–03/08/97	ZIP 810 — A diverse array of artworks of Pueblo by Pueblo artists.
01/11/97–03/08/97	PAINTING THE TOWN: NATHAN SOLANO — Local artist Solano's colorful, contemporary paintings of Pueblo will be on exhibit.
01/18/97–03/15/97	BRICK BY BRICK, RAIL BY RAIL: A PUEBLO HISTORY — Eighty historic photographs will be shown with a multitude of artifacts in an exhibition detailing the history of organizations and individuals throughout the community of Pride City.
01/25/97–05/03/97	MATERIAL WORLD: A GLOBAL FAMILY PORTRAIT — Vivid images taken by Peter Menzel and 15 other photographers traveling to 30 countries, will be featured in an exhibition that acts as a contemporary documentary of the global community of man. Each photographer produced a single image taken of an "average" family in each country by posing them with all of their possessions in front of their home.
03/22/97–05/17/97	PLEASE TOUCH! A TACTILE EXHIBIT — Ceramic, bronze, wood, glass and fiber artworks by local artists will be featured in a "hands-on" exhibition that invites the visitor to get up close and personal.
03/22/97–05/17/97	VERY SPECIAL ARTS COLORADO Tent. Name — Artworks by physically, mentally or emotionally challenged Colorado residents will be featured in an exhibition that highlights their talents.
03/29/97–05/24/97	AN AMERICAN COLLECTION: VERY SPECIAL ARTS — Artworks by 22 American professional artists with disabilities will be highlighted in an exhibition designed to promote greater awareness of their talents.
05/10/97–08/30/97	KINGS RANSOM: TREASURES FROM OUR COLLECTIONS — In addition to magnificent works of art from the Francis King Collection of Western Art that act as a visual record of the West, this exhibition, presented in celebration of the Center's 25th anniversary, will also highlight historic santos from the premier Ruth Gast Collection.
05/17/97–08/23/97	RETROSPECTIVE 25 — This summer-long exhibition showcases artworks throughout the building by more than 80 regional talents.
06/06/97–09/13/97	PROMOTING THE WEST: ART OF THE SANTA FE RAILROAD — In celebration of the Sangre de Christo's 25th anniversary, 60 of the finest paintings from the Santa Fe Railroad Collection will be on view in this blockbuster exhibition. By inviting artists to travel West at the Railroad's expense in return for the rights to a single image of their choice, the Santa Fe collection amassed nearly 600 stunning works that act as an aesthetic historical record of the Western landscape.

Sangre DeCristo Arts & Conference Center & Children's Center - continued

09/06/97–11/08/97	DAVID CARICATO — Spectacular wood masks carved by local artist Caricato will be on exhibit.
09/06/97–11/08/97	MOTHERHOOD: A PHOTOGRAPHIC EXHIBITION - JUDITH PHILLIPS — Social, racial and cultural depictions of mothers throughout Colorado will be featured in a delightful portrait exhibition that celebrates their diverse experiences.
09/13/97–12/13/97	FACES OF THE SOUTHWEST - GENE KLOSS — Etchings chronicling the culture of the Southwest by the late Gene Kloss will be on view in this commemorative exhibition.
09/27/97–11/22/97	MEXICAN MASKS OF THE 20TH CENTURY: A LIVING TRADITION — A wide variety of masks will be featured in an exhibition designed to introduce the viewer to the traditions of mask making in Mexican culture. WT
11/01/97–12/27/97	COLLABORATIONS: CROSSING THE BOUNDARIES — Unique collaborative artworks created by the melding of each participating artist's particular talent will be showcased in this exhibition
11/22/97–01/98	SUSHE FELIX (Working Title) — Featured will be works by the Colorado State Fair Art Exhibition "Best of Show" winner for 1996.

Trinidad

A. R. Mitchell Memorial Museum of Western Art

150 E. Main St., P.O. Box 95, **Trinidad, CO 81082**
☎ 719-846-4224
HRS: early Apr-through Sep: 10-4 M-Sa; Oct-Mar by appt. DAY CLOSED: S HOL: 7/4
VOL/CONT: Y
&: Y; Main floor and restrooms Ⓟ Y; Street parking on Main St.; parking in back of building MUS/SH: Y
GR/T: Y GR/PH: CATR! DT: Y TIME: often available upon request H/B: Y
PERM/COLL: AM: ptgs; HISP: folk; AM: Western

Housed in a charming turn of the century building that features its original tin ceiling and wood floors, the Mitchell contains a unique collection of early Hispanic religious folk art and artifacts from the old West both of which are displayed in a replica of an early Penitente Morada. The museum is located in southeast Colorado just above the New Mexico border. **NOT TO BE MISSED:** 250 works by Western artist/illustrator Arthur Roy Mitchell

CONNECTICUT

Bridgeport

The Discovery Museum
4450 Park Ave., **Bridgeport, CT 06604**
☎ 203-372-3521
HRS: 10-5 Tu-Sa, Noon-5 S, (Open 10-5 M during Jul & Aug) DAY CLOSED: M! HOL: LEG/HOL!
ADM: Y ADULT: $6.00 CHILDREN: $4.00 STUDENTS: $4.00 SR CIT: $4.00
&: Y; Totally accessible ℗ Y; Ample on-site parking MUS/SH: Y ¶ Y; Cafeteria
GR/T: Y GR/PH: CATR!
PERM/COLL: AM: ptgs, sculp, phot, furniture 18-20; IT/REN & BAROQUE: ptgs (Kress Coll)

14 unique hands-on exhibitions that deal with color, line and perspective, the Bridgeport Brass Collection and a 300 piece permanent collection of 18th - 20th-century American art are but 3 of the special features of The Discovery Museum. **NOT TO BE MISSED:** The Hoppin Collection of 19th-century mourning pictures, samplers and silhouettes; Mid-1950's paintings & murals from the Bridgeport Brass Collection that document the history of the company and of the area.

ON EXHIBIT/97:

01/15/97–05/30/97	LAND HO! THE MYTHICAL WORLD OF RODNEY GREENBLAT — A three-dimensional exhibition focusing on two imaginary civilizations that learn to get along despite their differences.
MID/97–LATE/97	37TH ANNUAL BARNUM FESTIVAL JURIED ART EXHIBITION
08/97	CONNECTICUT CONTEMPORARY — Works by the 5 top winners of the Juried 1996 Barnum Festival will be featured.
10/97–12/31/97	FOUR WAYS WITH COLOR

Housatonic Museum of Art
510 Barnum Ave., **Bridgeport, CT 06608**
☎ 203-579-6727
HRS: 10-4 M-Tu; 1-8 W, T; F (By Appointment only) DAY CLOSED: Sa, S HOL: LEG/HOL! ACAD!
&: Y ℗ Y; Free parking in student lot across the street; call ahead to arrange for handicapped parking behind the building
PERM/COLL: AM 19-20; EU: 19-20; AF; CONT: Lat/Am; CONT: reg; ASIAN; CONT: Hispanic

With a strong emphasis on contemporary and ethnographic art, the Housatonic Museum displays works from the permanent collection. PLEASE NOTE: The museum will be closed during '97 due to its impending move to a new building.

Brooklyn

New England Center for Contemporary Art, Inc.
Route 169, **Brooklyn, CT 06234**
☎ 860-774-8899
HRS: 10-5 Tu-F; 1-5 Sa, S DAY CLOSED: M HOL: 12/25, 1/1, THGV
&: Y ℗ Y; Free and ample MUS/SH: Y S/G: Y
PERM/COLL: AM: cont/ptgs; CONT/SCULP; OR: cont/art

In addition to its sculpture garden, great emphasis is placed on the display of the contemporary arts of China in this art center which is located on the mid-east border of the state near Rhode Island. **NOT TO BE MISSED:** Collection of contemporary Chinese art; Collection of artifacts from Papua, New Guinea

Farmington

Hill-Stead Museum
35 Mountain Rd., **Farmington, CT 06032**
☎ 860-677-4787
HRS: MAY-OCT: 10-5 Tu-S; NOV-APR: 11-4 DAY CLOSED: M HOL: 12/25, 1/1
ADM: Y ADULT: $6.00 CHILDREN: $3.00 (6-12) STUDENTS: $5.00 SR CIT: $5.00
&: Y; First floor only; advance notice required ℗ Y MUS/SH: Y
GR/T: Y! GR/PH: CATR! DT: Y TIME: hour long tours on the hour & half hour H/B: Y; National Historical Landmark
PERM/COLL: FR: Impr/ptgs; GR: 19; OR: cer; DEC/ART

Designated a National Historic Landmark in 1991, Hillstead, located in a suburb just outside of Hartford, is a Colonial Revival home that was originally a "gentleman's farm" built by Alfred Atmore Pope at the turn of the century to house his still intact collection of early French Impressionist paintings. PLEASE NOTE: Guided tours begin every half hour, the last one being 1 hour before closing. On the first Sunday of each month, visitors may tour the house at their own pace. **NOT TO BE MISSED:** Period furnishings; French Impressionist paintings

Greenwich

The Bruce Museum
Museum Drive, **Greenwich, CT 06830-7100**
☎ 203-869-0376
HRS: 10-5 Tu-Sa, 2-5 S DAY CLOSED: M HOL: LEG/HOL! MONDAYS EXCEPT DURING SCHOOL VACATIONS
F/DAY: Tu ADM: Y ADULT: $3.50 CHILDREN: F (under 5) STUDENTS: $2.50 SR CIT: $2.50
&: Y; Fully accessible, wheelchairs available ℗ Y; On-site parking available with handicapped parking in front of the museum.
MUS/SH: Y H/B: Y; original 1909 Victorian manor is part of the museum
PERM/COLL: AM: ptgs, gr, sculp 19; AM: cer, banks; NAT/AM; P/COL; CH: robes

In addition to wonderful 19th-century American works of art, the recently restored and renovated Bruce Museum also features a unique collection of mechanical and still banks, North American and pre-Columbian artifacts, and an outstanding department of natural history. Housed partially in its original 1909 Victorian manor, the museum is just a short stroll from the fine shops and restaurants in the charming center of historic Greenwich. **NOT TO BE MISSED:** Two new acquisitions: namely, "The Kiss," a 23 1/2" bronze sculpture by Auguste Rodin, and an oil painting entitled "The Mill Pond, Cos Cob, CT," by Childe Hassam.

ON EXHIBIT/97:

08/18/96–03/97	ORDER & CHAOS - PATTERNS OF THE NATURAL WORLD — Art and nature combine in an interactive exhibition designed to find artistic rhythms and patterns in objects of nature.
11/03/96–02/09/97	ADELE SIMPSON: AN AMERICAN FASHION DESIGNER — Clothing from the museum's collection will be seen in an exhibition that documents Simpson's contribution to American fashion within the context of her time.
11/29/96–01/26/97	SMALL SCALES — Small scale rooms and houses by Greenwich Miniaturists will be on exhibit.
01/97–04/98	DESIGNING DINOSAURS — Featured will be models, paintings, skeletons and other artifacts used by artists in rendering creative depictions of dinosaurs and their environment.
01/19/97–04/13/97	GREENWICH COLLECTS — An exhibition of 19th and 20th-century works of art will be on loan from local collections.
02/23/97–06/08/97	THE TRIBAL EYE: ANTIQUE KILIMS OF ANATOLIA — Fifty "flat weave" rugs from the major tribal groups, weaves and patterns of Asiatic Turkey will be featured.
04/27/97–08/31/97	WAVES, WIND AND SAIL — This 2-part exhibition will be presented in the two following segments: "Waves, Wind and Sail: Marine Art & Artifacts," an exhibition of paintings, models and artifacts illustrating sailing in the North Atlantic during the 19th & 20th centuries and "Waves, Wind and Sail: The Art & Science of Sailing," consisting of interactive displays of the principles of sailing.

The Bruce Museum - continued

06/11/97–11/09/97	ADORNMENT — Artifacts illustrating one's status, taste in fashion, aesthetics and personal identity will be on view in an exhibition designed to illustrate the meaning and beauty of "Adornment" throughout the world.
FALL/97	FASHION PHOTOGRAPHY
11/21/97–01/18/98	GLASS PLANETS AND MINERAL MARVELS — The Josh Simpson Glass Planet Series will be complemented with stunning mineral specimens from the museum's collection.

Greenwich

Bush-Holley House Museum

Affiliate Institution: The Historical Society of the Town of Greenwich
39 Strickland Rd., **Greenwich, CT 06807**
📞 203-869-6899
HRS: Noon-4 Tu-F, 1-4 S DAY CLOSED: M, Sa HOL: 12/25, 1/1, THGV
ADM: Y ADULT: $4.00 CHILDREN: F (under 12) STUDENTS: $3.00 SR CIT: $3.00
&: Y; but quite limited! ℗ Y GR/T: Y GR/PH: call 203-869-6899 H/B: Y; Located in 18th-century Bush-Holley House
PERM/COLL: DEC/ART 18-19; AM: Impr/ptgs

American Impressionist paintings and sculpture groups by John Rogers are the important fine art offerings of the 1732 Bush-Holley House. It was in this historical house museum, location of the first Impressionist art colony, that many of the artists in the collection resided while painting throughout the surrounding countryside. **NOT TO BE MISSED:** "Clarissa," by Childe Hassam

ON EXHIBIT/97:	Changing exhibitions of local history may be seen in addition to the permanent collection of paintings and sculptures.

Hartford

Wadsworth Atheneum

600 Main St., **Hartford, CT 06103-2990**
📞 860-278-2670
HRS: 11-5 Tu-S, till 8 PM 1st T of the month DAY CLOSED: M HOL: 12/5, 1/1, THGV, 7/4
F/DAY: T; Sa before noon ADM: Y ADULT: $6.00 CHILDREN: $3.00 ages 6-17 STUDENTS: $4.00 SR CIT: $4.00
&: Y; Wheelchair access through Avery entrance on Atheneum Square ℗ Y: Limited metered street parking; some commercial lots nearby; free parking in Travelers outdoor lot #7 SATURDAYS AND SUNDAYS ONLY! MUS/SH: Y ‼ Y; Lunch Tu-Sa, Brunch S, Dinner till 8 PM 1st T of the month
GR/PH: CATR! ext. 3046 DT: Y TIME: 1:00 Tu & T; Noon & 2:00 Sa, S H/B: Y S/G: Y
PERM/COLL: AM: ptgs, sculp, drgs, dec/art; FR: Impr/ptgs; SP; IT; DU: 17; REN; CER; EU: OM 16-17; EU: dec/art

Founded in 1842, the Wadsworth Atheneum is the oldest museum in continuous operation in the country. In addition to the many wonderful and diverse facets of the permanent collection, a gift in 1994 of two important oil paintings by Picasso; namely, "The Women of Algiers" and "The Artist," makes the collection of works by Picasso one of the fullest in New England museums. Even more recently the museum opened the Helen and Harry Grey Court, a dramatic new Main Street lobby containing two large-scale wall drawings created and donated by the artist Sol LeWitt. **NOT TO BE MISSED:** Caravaggio's "Ecstasy of St. Francis"; Wallace Nutting collection of pilgrim furniture; Colonial period rooms; African-American art (Fleet Gallery); Elizabeth B. Miles English Silver Collection

New Britain

The New Britain Museum of American Art
56 Lexington St., **New Britain, CT 06052**
📞 860-229-0257
HRS: 10- Tu-F, 1-5 Sa, Noon-5 S DAY CLOSED: M HOL: 1/1, 7/4, THGV. 12/25, EASTER
F/DAY: Sa 10-12 ADM: Y ADULT: $3.00 CHILDREN: F (under 12) STUDENTS: $2.00 SR CIT: $2.00
♿: Y; Entrance, elevators, restrooms Ⓟ Y; Free on street parking MUS/SH: Y
GR/T: Y GR/PH: CATR!
PERM/COLL: AM: ptgs, sculp, gr 18-20

The New Britain Museum, only minutes from downtown Hartford, and housed in a turn of the century mansion, is one of only five museums in the country devoted exclusively to American art. The collection covers 250 years of artistic accomplishment including the nation's first public collection of illustrative art. A recent bequest by Olga Knoepke added 26 works by Edward Hopper, George Tooker and other early 20th-century Realist artworks to the collection. PLEASE NOTE: Tours for the visually impaired are available with advance notice. **NOT TO BE MISSED:** Thomas Hart Benton murals; Paintings by Child Hassam and other important American Impressionist masters.

ON EXHIBIT/97:

10/12/96–01/26/97	AMERICAN ARTISTS ABROAD — "Aqueduct near Rome" by Thomas Cole, "St. Peter's Rome" by George Innis, and "Spanish Girl of Segovia" by Robert Henri are but three of the paintings on view in this museum-wide exhibition that highlight the broad scope of global subjects as depicted by American artists.
01/08/97–03/02/97	NEW/NOW: IRENE REED — Soft sculpture and textiles.
01/18/97–04/06/97	ALL IN THE FAMILY: WOLF KAHN et al
02/27/97–04/27/97	30TH ANNIVERSARY: MEMBERS PURCHASE FUND — Some of the most significant works in the museum collection acquired with Member Purchase Fund monies will be displayed in celebration of the 30th anniversary of that fund.
03/12/97–05/04/97	NEW/NOW: FRANCES HYNES — Watercolors and oil paintings.
03/22/97–09/97	COSTUMES IN THE PAINTINGS COLLECTION
04/16/97–05/10/97	THE CONNECTICUT ACADEMY: JURIED EXHIBITION
05/04/97–08/10/97	MEDIUM IS THE MESSAGE: WATERCOLORS
05/14/97–07/06/97	NEW/NOW: SANDRA NEWBURY — Silver gelatin photographs.
07/16/97–09/07/97	NEW/NOW: HELENA HEMMARCK — Woven tapestries.
08/23/97	MEDIUM IS THE MESSAGE: SCREENED PRINTS
09/16/97–11/30/97	ARTHUR DOVE: 1942-43 SMALL PAINTINGS TENT! WT

New Canaan

Silvermine Guild Art Center
1037 Silvermine Rd., **New Canaan, CT 06840**
📞 203-966-5617
HRS: 11-5 Tu-Sa, 1-5 S DAY CLOSED: M HOL: 12/25, 1/1, 7/4, & HOL. falling on Mondays
♿: Y; Ground level entries to galleries Ⓟ Y; Ample and free MUS/SH: Y
GR/T: Y GR/PH: CATR! H/B: Y; The Silvermine Guild was established in 1922 in a barn setting S/G: Y
PERM/COLL: PRTS: 1959-present

Housed in an 1890 barn and established as one of the first art colonies in the country, the vital Silvermine Guild exhibits works by well-known and emerging artists. Nearly 30 exhibitions are presented yearly.

CONNECTICUT

Silvermine Guild Art Center - continued
ON EXHIBIT/97:

01/12/97–02/09/97	NEW MEMBERS SHOW
02/16/97–03/16/97	BONNIE WOIT ONE-PERSON SHOW
02/16/97–03/16/97	JAK KOVATCH ONE-PERSON SHOW
02/16/97–03/16/97	ROBIN GNEITING ONE-PERSON SHOW
03/23/97–04/20/97	ELIZABETH COLEMAN ONE-PERSON SHOW
03/23/97–04/20/97	ARTHUR BURKE ONE-PERSON SHOW
03/23/97–04/20/97	ALISTAIR DUNN ONE-PERSON SHOW
05/09/97–06/13/97	48TH ANNUAL ART OF THE NORTHEAST
06/22/97–08/17/97	OPEN GUILD GROUP SHOW
08/24/97–09/07/97	SEVENTH ANNUAL JURIED COMPETITION
09/14/97–10/12/97	NATIONAL PHOTOGRAPHY BIENNIAL
10/19/97–11/16/97	DON AND WILMS ERVIN TWO-PERSON SHOW
10/19/97–11/16/97	LINDA ADATO ONE-PERSON SHOW
10/19/97–11/16/97	ALLEYNE HOWELL ONE-PERSON SHOW
11/22/97–12/24/97	CRAFT AMERICA '97

New Haven

Yale Center for British Art
Affiliate Institution: Yale University
1080 Chapel St, **New Haven, CT 06520-8280**
☎ 203-432-2800
HRS: 10-5 Tu-Sa, Noon-5 S DAY CLOSED: M HOL: LEG/HOL!
&: Y; Entire building is fully accessible ℗ Y; Parking lot behind the Center and garage directly across York St. MUS/SH: Y
GR/T: Y GR/PH: CATR! 203-432-2858 DT: Y TIME: Introductory & Architectural tours on Sa H/B: Y; Last building
designed by noted American architect, Louis Kahn
PERM/COLL: BRIT: ptgs, drgs, gr 16-20

With the most comprehensive collection of English paintings, prints, drawings, rare books and sculpture outside
of Great Britain, the Center's permanent works depict British life and culture from the 16th-century to the present.
The museum is housed in the last building designed by the late great American architect, Louis Kahn. **NOT TO
BE MISSED:** "Golden Age" British paintings by Turner, Constable, Hogarth, Gainsborough, Reynolds

ON EXHIBIT/97:

02/01/97–04/06/97	'AMONG THE WHORES AND THIEVES': WILLIAM HOGARTH AND THE BEGGAR'S OPERA — Two of Hogarth's 5 versions depicting an amusing and outrageous scene from John Gay's "The Beggar's Opera," a theatrical sensation of 1728, will be on view with an array of prints, books and other works that describe the social, theatrical and political significance of the mingling of low life and art in the 18th-century. CAT
04/02/97–07/06/97	WILLIAM BLAKE FROM THE PAUL MELLON COLLECTION — A magnificent display of Blake's illuminated manuscripts, engravings, and drawings from the collection of Paul Mellon, class of '29 will be on exhibit in celebration of the 20th anniversary of the Center. Among the most notable works on display will be a unique colored copy of Blake's masterwork "Jerusalem," tempera paintings from his series of Bible illustrations, and 40 sheets from the watercolor illustrations to the "Poems of Thomas Gray". ONLY VENUE

New Haven

Yale University Art Gallery
Affiliate Institution: Yale University
1111 Chapel St., **New Haven, CT 06520**
☎ 203-432-0600
HRS: 10-5 Tu-Sa, 2-5 S DAY CLOSED: M HOL: 12/25. 1/1, 7/4, THGV; MONTH OF AUGUST
♿: Y; Entrance at 201 York St., wheelchairs available, barrier free ℗ Y; Metered street parking plus parking at Chapel York Garage, 201 York St. MUS/SH: Y
GR/T: Y GR/PH: CATR! 203-432-0620 education dept. DT: Y TIME: Noon W & other! S/G: Y
PERM/COLL: AM: ptgs, sculp, dec/art; EU: ptgs, sculp; FR: Impr, Post/Impr; OM: drgs, gr; CONT: drgs, gr; IT/REN: ptgs; P/COL; AF: sculp; CH; AN/GRK; AN/EGT

Founded in 1832 with an original bequest of 100 works from the John Trumbull Collection, the Yale University Gallery has the distinction of being the oldest museum in North America. Today over 100,000 works from virtually every major period of art history are represented in the outstanding collection of this highly regarded university museum. PLEASE NOTE: In 1997 the museum will be closed for the month of August. **NOT TO BE MISSED:** "Night Cafe" by van Gogh

ON EXHIBIT/97:

12/22/96–03/31/97	THE PLEASURES OF PARIS: PRINTS BY TOULOUSE-LAUTREC
04/11/97–07/31/97	THE GREAT COLLECTORS SERIES: HIGHLIGHTS FROM THE COLLECTION OF THURSTON TWIGG-SMIT
04/11/97–06/08/97	CROSSING THE FRONTIER: PHOTOGRAPHS OF THE DEVELOPING WEST, 1849 TO THE PRESENT — 300 images on view trace the way land has been used in the developing West from the gold rush days to the present. WT
09/97–01/98	BAULE: AFRICAN ART/WESTERN EYES — 125 of the greatest works of art from Baule culture on loan from public and private collections in the U.S., Europe and Africa, will be featured in the first large museum exhibition of its kind. Known for their refinement, diversity and quality, the items on view will include examples of naturalistic wooden sculpture, objects of ivory, bronze and gold, and masks & figures derived from human and animal forms. WT
09/06/97–11/07/97	MUNCH AND WOMEN: IMAGE AND MYTH — Nearly 74 prints by Munch, considered one of the pioneers of European Modernism, will be seen in an exhibition that reveals some of the artist's more positive images of women. CAT WT

New London

Lyman Allyn Art Museum
625 Williams St., **New London, CT 06320**
☎ 860-443-2545
HRS: 10-5 Tu-Sa, 1-5 S, till 9 PM W DAY CLOSED: M HOL: LEG/HOL!
ADM: Y ADULT: $3.00 CHILDREN: F (12 & under) STUDENTS: $2.00 SR CIT: $2.00
♿: Y; Wheelchair accessible ℗ Y; Free parking on the premises MUS/SH: Y
GR/T: Y GR/PH: CATR! DT: Y TIME: Free highlight tours 2:00 W & Sa S/G: Y
PERM/COLL: AM: ptgs, drgs, furn, Impr/ptgs; HUDSON RIVER SCHOOL: ptgs; AF; tribal; AS & IND: dec/art; P/COL; ANT

The Deshon Allyn House, a 19th-century whaling merchants home located on the grounds of the fine arts museum and furnished with period pieces of furniture and decorative arts, is open by appointment to those who visit the Lyman Allyn Art Museum. **NOT TO BE MISSED:** 19th-century Deshon Allyn House open by appointment only

ON EXHIBIT/97:

ONGOING	OUTDOORS ON THE MUSEUM GROUNDS — SCULPTURE BY SOL LEWITT, CAROL KREEGER DAVIDSON, NIKI KETCHMAN, DAVID SMALLEY, GAVRIEL WARREN, JIM VISCONTI AND ROBERT TAPLIN

CONNECTICUT

Norwich

The Slater Memorial Museum
Affiliate Institution: The Norwich Free Academy
108 Crescent St., **Norwich, CT 06360**
📞 860-887-2506
HRS: 9-4 Tu-F & 1-4 Sa-S through 6/30; 1-4 M-S (Jul-Aug) HOL: LEG/HOL! STATE/HOL!
ADM: Y ADULT: $2.00
ⓟ Y; Free alongside museum. However parking is not permitted between 1:30 - 2:30 during the week to allow for school buses to operate. MUS/SH: Y
GR/T: Y GR/PH: CATR! ext. 218 H/B: Y; 1888 Romanesque building designed by architect Stephen Earle
PERM/COLL: AM: ptgs, sculp, gr; DEC/ART; OR; AF; POLY; AN/GRK; NAT/AM

Opened in 1886, the original three-story Romanesque structure has expanded from its original core collection of antique sculpture castings to include a broad range of 17th through 20th-century American art. This museum has the distinction of being one of only two fine arts museums in the U.S. located on the campus of a secondary school.
NOT TO BE MISSED: Classical casts of Greek, Roman and Renaissance sculpture

ON EXHIBIT/97:

12/08/96–01/23/97	EXHIBITION OF MULTI-CULTURES / PAST & PRESENT	
02/02/97–03/06/97	CHARLOTTE FULLER EASTMAN IN RETROSPECT	CAT
02/02/97–03/06/97	PRINTMAKERS NETWORK OF SOUTHERN NEW ENGLAND EXHIBIT	
03/16/97–04/24/97	54TH ANNUAL CONNECTICUT ARTISTS' EXHIBITION	
06/20/97–08/28/97	SUMMER SOLO SHOWS: EDWIN O. LOMERSON, III & PETER PELLETTIER	

Old Lyme

Florence Griswold Museum
96 Lyme St., **Old Lyme, CT 06371**
📞 860-434-5542
HRS: Summer: 10-5 Tu-Sa, 1-5 S; Winter: 1-5 W-S DAY CLOSED: M HOL: LEG/HOL!
ADM: Y ADULT: $4.00 CHILDREN: F (under 12) STUDENTS: $3.00 SR CIT: $2.00
♿: Y ⓟ Y; Ample and free MUS/SH: Y
GR/T: Y GR/PH: call 203-434-5542 DT: Y TIME: daily upon request H/B: Y
PERM/COLL: AM: Impr/ptgs; DEC/ART

The beauty of the Old Lyme Connecticut countryside in the early part of the 20th-century attracted dozens of artists to the area. Many of the now famous American Impressionists worked here during the summer and lived in the Florence Griswold boarding house, which is now a museum that stands as a tribute to the art and artists of that era.
NOT TO BE MISSED: The Chadwick Workplace: newly opened and restored early 20th-century artists' studio workplace of American Impressionist, William Chadwick. Free with admission, the Workplace is open in the summer only. Please call ahead for hours and other particulars.

ON EXHIBIT/97: Temporary exhibitions usually from the permanent collection.
EACH DECEMBER CELEBRATION OF HOLIDAY TREES — A month-long display of trees throughout the house is presented annually. Every year a new theme is chosen and each tree is decorated accordingly.

88

Ridgefield

The Aldrich Museum of Contemporary Art
258 Main St., **Ridgefield, CT 06877**
☎ 203-438-4519
HRS: 1-5 Tu-S DAY CLOSED: M, Tu HOL: LEG/HOL!
ADM: Y ADULT: $3.00 CHILDREN: F (under 12) STUDENTS: $2.00 SR CIT: $2.00
&: Y ℗ Y; Free MUS/SH: Y GR/T: Y GR/PH: CATR! DT: Y TIME: 3:00 S H/B: Y S/G: Y

The Aldrich Museum of Contemporary Art, one of the foremost contemporary art museums in the Northeast, offers the visitor a unique blend of modern art housed within the walls of a landmark building dating back to the American Revolution. One of the first museums in the country dedicated solely to contemporary art, the Aldrich exhibits the best of the new art being produced. **NOT TO BE MISSED:** Outdoor Sculpture Garden

ON EXHIBIT/97: Changing quarterly exhibitions of contemporary art featuring works from the permanent collection, collectors works, regional artists, and installations of technological artistic trends.

01/19/97–04/20/97	MAKING IT REAL	WT
01/19/97–03/30/97	ROLAND FLEXNER: RECENT DRAWINGS	
01/19/97–04/20/97	ROBERT COTTINGHAM: AN AMERICAN ALPHABET	

Stamford

Whitney Museum of American Art at Champion
Atlantic St. & Tresser Blvd., **Stamford, CT 06921**
☎ 203-358-7630
HRS: 11-5 Tu-Sa DAY CLOSED: S, M HOL: THGV; 1/1; 12/25; 7/4
&: Y: No stairs; large elevator from parking garage ℗ Y: Free on-site parking MUS/SH: Y
GR/T: Y GR/PH: CATR! DT: Y TIME: 12:30 Tu, T, Sa

The Whitney Museum of American Art at Champion, the only branch of the renowned Whitney Museum outside of New York City, features changing exhibitions of American Art primarily of the 20th-century. Many of the works are drawn from the Whitney's extensive permanent collection and exhibitions are supplemented by lectures, workshops, films and concerts.

ON EXHIBIT/97: Call for current exhibition and special events information.!

Storrs

The William Benton Museum of Art, Connecticut State Art Museum
Affiliate Institution: University of Connecticut
245 Glenbrook Rd. U-140, **Storrs, CT 06269-2140**
☎ 860-486-4520
HRS: 10-4:30 Tu-F; 1-4:30 Sa, S HOL: LEG/HOL!
&: Y; Entrance at rear of building; museum is fully accessible ℗ Y; Weekdays obtain visitor's pass as sentry booth & proceed to metered parking; Weekends or evenings park in metered or unmetered spaces on any campus lot. Handicapped spaces in visitor's lot behind the museum. MUS/SH: Y GR/T: Y GR/PH: CATR! 203-486-1705 Education office
PERM/COLL: EU: 16-20; AM: 17-20; KATHE KOLLWITZ: gr; REGINALD MARSH: gr

Installed in "The Beanery," the former 1920's Gothic style dining hall of the university, the Benton has, in the relatively few years it's been open, grown to include a major 3,000 piece collection of American art. **NOT TO BE MISSED:** "Helene de Septeuil" by Mary Cassatt

ON EXHIBIT/97:
03/97–05/97	LANDSCAPE PHOTOGRAPHS FROM THE COLLECTION OF SANDRA AND DAVID BAKALAR Dates Tent! TENT!	
SUMMER/97	MOLAS: TEXTILES OF THE SUN BLAS ISLANDS, PANAMA	

DELAWARE

Wilmington

Delaware Art Museum
2301 Kentmere Pkwy., **Wilmington, DE 19806**
☎ 302-571-9590
HRS: 10-5 Tu-Sa, Noon-5 S DAY CLOSED: M HOL: 12/25, 1/1, THGV
F/DAY: 10-1 Sa ADM: Y ADULT: $5.00 CHILDREN: F (under 6) STUDENTS: $2.50 SR CIT: $3.50
&: Y; Fully accessible ⓟ Y; Free lot behind museum MUS/SH: Y
GR/T: Y GR/PH: CATR! DT: Y TIME: 11 AM 3rd Tu & Sa of the month
PERM/COLL: AM: ptgs 19-20; BRIT: P/Raph; GR; SCULP; PHOT

Begun as a repository for the works of noted Brandywine Valley painter/illustrator Howard Pyle, the Delaware Art Museum has grown to include other collections of note especially in the areas of Pre-Raphaelite painting and contemporary art. **NOT TO BE MISSED:** "Summertime" by Edward Hopper; "Milking Time" by Winslow Homer

ON EXHIBIT/97:

01/21/97–04/20/97 CONTEMPORARY ART

02/07/97–04/06/97 MYTH, MAGIC, MYSTERY: ONE HUNDRED YEARS OF AMERICAN CHILDREN'S BOOK ILLUSTRATION — From the "golden age" works to the images of today, this exhibition surveys the entire range of children's book illustration from 1895-1995. Such timeless classics as Goldilocks, Cinderella, Little Red Riding Hood, Mother Goose and Hansel & Gretel will be highlighted as they have appeared through the generations.
CAT WT

04/25/97–06/22/97 INSPIRATION AND CONTEXT: THE DRAWINGS OF ALBERT PALEY — 44 drawings and 5 maquettes will be featured in a 20 year survey of jewelry, sculpture and entry gates designed by Paley, an internationally acclaimed artist who changed contemporary metalworking from a utilitarian craft into a dynamic art form. CAT

04/25/97–06/22/97 ARCHIBALD KNOX — Long associated with British Art Nouveau, Knox was one of the most innovative and progressive designers in modern British history. This first ever exhibition of his work in America features loan items from London's Silver Studio Collection and objects selected from the permanent collection of the Wolfsonian Foundation in Miami, FL. BOOK WT

07/11/97–09/08/97 ROBERT STRAIGHT

07/11/97–09/08/97 LISA BARTOLOZZI

10/11/97–01/05/98 SHAKER: THE ART OF CRAFTSMANSHIP — 19th-century objects and furniture of simplicity, order and fine craftsmanship from the first and most influential Shaker community (established in New Lebanon, New York in 1785), will be seen in the first major exhibition of its kind in America. CAT WT

Art Museum of the Americas
201 18th St., NW, **Washington, DC 20006**
✆ 202-458-6016
HRS: 10-5 Tu-Sa DAY CLOSED: S, M HOL: LEG/HOL!
VOL/CONT: Y
℗ Y; Metered street parking GR/T: Y GR/PH: call 202-458-6301
PERM/COLL: 20th century LATIN AMERICAN ART

Established in 1976, and housed in a Spanish colonial style building completed in 1912, this museum contains the most comprehensive collection of 20th-century Latin American art in the country. **NOT TO BE MISSED:** The loggia behind the museum opening onto the Aztec Gardens

ON EXHIBIT/97:

04/10/97–06/14/97	OLGA DE AMARAL: NINE STELAE AND OTHER LANDSCAPES

Arthur M. Sackler Gallery
1050 Independence Ave., SW, **Washington, DC 20560**
✆ 202-357-3200 WEB ADDRESS:http/www.si.edu/Asia
HRS: 10-5:30 Daily HOL: 12/25
♿: Y; All levels accessible by elevator ℗ Y; Free 3 hour parking on Jefferson Dr; some metered street parking MUS/SH: Y
GR/T: Y GR/PH: call 202-357-4880 ext. 245 DT: Y TIME: 11:30 & 12:30 daily
PERM/COLL: CH: jade sculp; JAP: cont/cer; PERSIAN: ptgs; NEAR/E: an/silver

Opened in 1987 under the auspices of the Smithsonian Institution, the Sackler Gallery, named for its benefactor, houses some of the most magnificent objects of Asian art in America.

ON EXHIBIT/97:

CONTINUING	PUJA: EXPRESSIONS OF HINDU DEVOTION — Approximately 180 bronze, stone and wooden objects made in India as offerings in an essential element of Hindu worship known as "puja" will be seen in an exhibition focusing mainly on their functional use rather than their aesthetic beauty.
	THE ARTS OF CHINA — A new selection of objects will be put on view in 3/96 to replace many currently on view in this exhibition.
06/30/96–04/06/97	PRESERVING ANCIENT STATUES FROM JORDAN — Accompanying photography documenting their excavation 10 years ago and their subsequent conservation and treatment processes will be 8 ancient plaster statues on loan from the Department of Antiquities in Jordan. Dating from the 7th millennium B.C., these works, found in an ongoing excavation in Jordan, are possibly the oldest human sculptures to be found in the Near East.
11/03/96–04/06/97	ART OF THE PERSIAN COURTS — On long term loan to the Sackler, this exhibition features more than 100 14th to 19th-century paintings, manuscripts, drawings and works of calligraphy from one of the finest private collections of Persian and Mughal Indian book art. BOOK
05/04/97–02/98	ART AND PATRONAGE UNDER SHAH JAHAN — Included among the items in this exhibition that were created during the reign of Jahan, India's 3rd Mughal emperor who built the Taj Mahal, will be a rare illustrated 13th-century manuscript, considered one of the finest examples of Mughal art, and the 141-carat Taj Mahal emerald.
05/18/97–11/02/97	KING OF THE WORLD — 44 paintings and 2 illuminations from the Padshahnama, an imperial manuscript form 17th-century India, will be on loan from the imperial Indian painting collection of Queen Elizabeth II of England. The exhibition offers a once-in-a-lifetime opportunity to view one of the greatest manuscripts in the world detailing the first decade of the reign of Mughal dynasty Emperor Shah Jahan, builder of the Taj Mahal. CAT WT

DISTRICT OF COLUMBIA

The Corcoran Gallery of Art

17th St. & New York Ave., NW, **Washington, DC 20006**
☎ 202-638-3211 or1439
HRS: 10-5 M & W-S, till 9 PM T DAY CLOSED: Tu HOL: 12/25, 1/1
SUGG/CONT: Y ADULT: $3.00 CHILDREN: F (under 12) STUDENTS: $1.00 SR CIT: $1.00
&: Y Ⓟ Y; Limited metered parking on street; commercial parking lots nearby MUS/SH: Y ❙❙ Y; Cafe 11-3 daily & till 8:30
T; Jazz Brunch 11-2 S (202-638-3211 ext. 1439)
GR/T: Y GR/PH: CATR! 202-786-2374 DT: Y TIME: Noon daily, 7:30 T, (10:30 & 2:30 Sa, S!)
PERM/COLL: AM & EU: ptgs, sculp, works on paper 18-20

The beautiful Beaux Art building built to house the collection of its founder, William Corcoran, contains works that span the entire history of American art from the earliest limners to the cutting-edge works of today's contemporary artists. In addition to being the oldest art museum in Washington, the Corcoran has the distinction of being one of the three oldest art museums in the country. Recently the Corcoran became the recipient of the Evans-Tibbs Collection of African-American art, one of the largest and most important groups of historic American art to come to the museum in nearly 50 years. PLEASE NOTE: There is a special suggested contribution fee of $5.00 for families. **NOT TO BE MISSED:** "Mt. Corcoran" by Bierstadt; "Niagra" by Church; Restored 18th-century French room Salon Doré

ON EXHIBIT/97:

10/26/96–02/10/97 PETAH COYNE: BLACK/WHITE/BLUE — In this exhibition of 15 recent works, objects associated with ceremony and overt femininity that Coyne covers with excessive amounts of dripped candle wax will be on view.

01/11/97–03/31/97 UNIVERSAL LIMITED ART EDITIONS (ULAE): FORTY YEARS OF PRINTMAKING, 1957-1997 — 160 prints, books, portfolios and three-dimensional objects by Frankenthaler, Johns, Rauchenberg and others will be included in an exhibition celebrating the 40th anniversary of Universal Limited Art Editions, one of the finest contemporary print workshops in the country. CAT WT

02/01/97–05/05/97 MANUEL NERI: EARLY WORK, 1953-1978 — The emotionally charged creativity of this Bay Area sculptor will be seen in a presentation of a critical selection of the most dramatic, important and beautiful examples of his cut and painted plaster figures, fiberglass casts, canvases and drawings. CAT WT

03/97–06/97 MILT HINTON: JAZZ PHOTOGRAPHS — During the 6 decades of his career Hinton, known as the Dean of the jazz base, traveled extensively on the road with many bands and legendary musicians. What started as a hobby of taking pictures of his friends ended up with a body of more than 40,000 photographic images of jazz artists, recording studios, and related works some of which will be on view in this exhibition.

04/25/97–06/06/97 THE PEALE FAMILY: CREATION OF AN AMERICAN LEGACY, 1770-1870 — For the first time in 30 years works by Charles Wilson Peale and 10 other members of one of America's premier artistic families will be featured in a rare gathering and presentation of their oeuvre. "The Staircase Group" and "Rubens Peale With a Geranium" will be among the 173 items on exhibit. CAT WT ∩

05/21/97–06/23/97 THE WASHINGTON PRINT CLUB — Works by talented area artists in a variety of print media will be showcased in this exhibition.

05/21/97–08/09/97 JOSHUA JOHNSTON "A SELF-TAUGHT GENIUS": AN AFRICAN-AMERICAN PORTRAIT PAINTER — Johnston, a man widely regarded as a "folk artist," was for many years thought to have been a slave of the artistic Peale family (see exhibition above). This rare presentation of his works presented at the same time as the Peale exhibition will provide an unprecedented opportunity to gain a broader understanding not only of Johnston's portraits but also of his relationship to the artists of the Peale family.

06/97–08/97 NUDES: WORKS ON PAPER — On exhibit from the permanent collection will be prints, drawings and etchings focusing on the nude figure.

The Corcoran Gallery of Art

06/01/97–07/30/97 JOYFUL NOISE: THE ART OF LARI PITTMAN — From early works to new paintings, this mid-career survey of Pittman's most ambitious and seminal works provides the viewer with the opportunity to see how the artist instills in his works many aspects of his personal hybrid make-up and identity. CAT WT

09/13/97 UNLOCKED DOORS: GORDON PARKS RETROSPECTIVE — All aspects of his varied career will be included in the first traveling Gorden Parks retrospective. Considered by many to be an American Renaissance man, Parks, a filmmaker, novelist, poet and musician is best known as a photojournalist whose powerful images deliver messages of hope in the face of adversity. WT

10/03/97–01/05/98 EDVARD MUNCH: PORTRAITS AND SELF-PORTRAITS — In the first U.S. exhibition of its kind, 55 of Munch's most intriguing portraits and self-portraits will be on loan from public and private collections. Best known for his anguished painting "The Scream," Munch, a Norwegian artist (1863-1944) often created images that were reflective of his personal life tragedies.

12/97–01/98 45TH BIENNIAL EXHIBITION OF CONTEMPORARY AMERICAN PAINTING — A presentation of works that express trends in contemporary American painting.

Dumbarton Oaks Research Library & Collection

1703 32nd St., NW, **Washington, DC 20007-2961**
☎ 202-639-1700
HRS: 2-5 Tu-S DAY CLOSED: M HOL: LEG/HOL!
VOL/CONT: Y ♿: Y; Partial access to collection Ⓟ On-street parking only MUS/SH: Y
GR/T: Y GR/PH: CATR! 202-339-6409 H/B: Y; 19th-century mansion is site where plans for U.N. Charter were created
PERM/COLL: BYZ; P/COL; AM: ptgs, sculp, dec/art; EU: ptgs, sculp, dec/art

This 19th-century mansion, site of the international conference of 1944 where discussions leading to the formation of the United Nations were held, is best known for its rare collection of Byzantine and Pre-Columbian art. Beautifully maintained and now owned by Harvard University, Dumbarton Oaks is also home to a magnificent French Music Room and to 16 manicured acres that contain formally planted perennial beds, fountains and a profusion of seasonal flower gardens. PLEASE NOTE: Although there is no admission fee to the museum a donation of $1.00 would be appreciated. **NOT TO BE MISSED:** Music Room; Gardens (open daily Apr - Oct, 2-6 PM, $3.00 adult, $2.00 children/seniors; 2-5 PM daily Nov-Mar, F)

ON EXHIBIT/97:
ONGOING PRE-COLUMBIAN COLLECTION — Prime works from Mesoamerica, lower Central America and the Andes collected by Robert Woods Bliss.

BYZANTINE COLLECTION — The recently re-installed and expanded collection of early Byzantine silver joins the on-going textile exhibit from the permanent collection.

Federal Reserve Board Art Gallery

2001 C St., **Washington, DC 20551**
☎ 202-452-3686
HRS: 11-2 M-F or by reservation HOL: LEG/HOL! WEEKENDS
♿: Y; Off 20th St. Ⓟ Y; Street parking only GR/T: Y GR/PH: CATR! H/B: Y; Designed in 1937 by Paul Cret
PERM/COLL: PTGS, GR, DRGS 19-20 (emphasis on late 19th century works by Amer. expatriates); ARCH: drgs of Paul Cret
PLEASE NOTE: The permanent collection may be seen by appointment only.

Founded in 1975, the collection, consisting of both gifts and loans of American and European works of art, acquaints visitors with American artistic and cultural values. **NOT TO BE MISSED:** The atrium of this beautiful building is considered one of the most magnificent public spaces in Washington, D.C.

ON EXHIBIT/97:
10/15/96–04/11/97 SATIRICAL ETCHINGS OF JAMES GILLRAY — On exhibit will be 48 hand-colored etchings, all biting cariactures by Gillray (1756-1815), an English artist who poked fun at the foibles of the troubled elite of his day.

93

DISTRICT OF COLUMBIA

Freer Gallery of Art
Jefferson Dr. at 12th St., SW, **Washington, DC 20560**
☎ 202-357-2700 WEB ADDRESS: http://www.si.edu/amsg-fga.
HRS: 10-5:50 Daily HOL: 12/25
&: Y; Entry from Independence Ave.; elevators; restrooms ℗ Y; Free 3 hour parking on the Mall MUS/SH: Y
GR/T: Y GR/PH: 202-357-4880 ext. 245 DT: Y TIME: 11:30 & 12:30 Daily H/B: Y; Member NRHP
PERM/COLL: OR: sculp, ptgs, cer; AM/ART 20; (FEATURING WORKS OF JAMES McNEILL WHISTLER; PTGS

One of the many museums in the nation's capitol that represent the results of a single collector, the Freer Gallery,
renowned for its stellar collection of the arts of all of Asia, is also home to one of the world's most important
collections of works by James McNeill Whistler. **NOT TO BE MISSED:** "Harmony in Blue and Gold," The
Peacock Room by James McNeill Whistler

ON EXHIBIT/97:

ONGOING | ANCIENT EGYPTIAN GLASS — 15 rare and brilliantly colored glass vessels created during the reigns of Amenhotep III (1391-1353 B.C.) and Akhenaten (1391-1353 B.C.) are highlighted in this exhibition.

SPRING/97 | BEYOND PAPER: CHINESE CALLIGRAPHY ON OBJECTS — The importance of calligraphy in Chinese culture will be highlighted in the 36 7th through 19th-century examples on view.

Through EARLY/97 | JAPANESE CERAMICS FROM SETO AND MINO — From the permanent collection 50 glazed ceramics from the adjacent regions of Seto and Mino in central Japan will trace the evolution of these wares from their beginnings 1,200 years ago. Included will be 9th to 15th-century pieces that reflect the influence of imported Chinese ceramics, innovative wares by Mino potters of the 16th to 17th centuries that constitute the single most important body of work in the history of Japanese ceramics, and 7th through 19th-century presentation pieces made for the Tokugawa shogun. CAT

03/01/96–SPRING/97 | CROSSCURRENTS IN CHINESE AND ISLAMIC CERAMICS — Beginning with the establishment of trade routes in the 14th-century, blue and white porcelains and green-glazed celadons made in China were traded by them to the Near Eastern countries of Turkey and Iran. The 23 objects in this exhibition demonstrate the ways in which the interactions of these countries led to the adaptation and integration of each others' unique decorative elements.

03/09/96–SPRING/97 | CHOICE SPIRITS: WORKS BY THOMAS DEWING AND DWIGHT TRYON — From the permanent collection this presentation of 33 works by American tonalists Thomas Dewing (1851-1938) and Dwight Tryon (1849-1925) illustrates the nature of aestheticism in the U.S. at the turn of the century.

Hillwood Museum
4155 Linnean Ave., NW, **Washington, DC 20008**
☎ 202-686-8500
HRS: BY RESERVATION ONLY: 9, 10:45, 12:30, 1:45, 3:00 Tu-Sa DAY CLOSED: S, M HOL: FEB. & LEG/HOL!
ADM: Y ADULT: $10.00 CHILDREN: $5.00 STUDENTS: $5.00 SR CIT: $10.00
&: Y ℗ Y; Free parking on the grounds of the museum MUS/SH: Y ❙❙ Y; Reservations accepted (202) 686-8893)
GR/T: Y GR/PH: CATR! 202-686-5807 S/G: Y
PERM/COLL: RUSS: ptgs, cer , dec/art; FR: cer, dec/art, glass 18-19

The former home of Marjorie Merriweather Post, heir to the Post cereal fortune, is filled primarily with the art and
decorative treasures of Imperial Russia which she collected in depth over a period of more than 40 years. PLEASE
NOTE: In depth special interest tours may be arranged by appointment. NOTE: children under 12 are not
permitted in the house. There are no changing exhibitions. **NOT TO BE MISSED:** Carl Faberge's Imperial Easter
Eggs and other of his works; glorious gardens surrounding the mansion

Hirshhorn Museum and Sculpture Garden

Affiliate Institution: Smithsonian Institution
Independence Ave. at Seventh St., NW, **Washington, DC 20560**
☎ 202-357-2700
HRS: Museum: 10-5:30 Daily; Plaza: 7:30 AM - 5:30 PM, S/G: 7:30 AM - dusk HOL: 12/25
♿: Y; Through glass doors near fountain on plaza ⓟ Y; Free 3 hour parking on Jefferson Dr.; some commercial lots nearby
MUS/SH: Y ⅋ Y; Plaza Cafe - summer only!
GR/T: Y GR/PH: CATR! 202-357-3235 DT: Y TIME: 12 M-F; 12 & 2 Sa, S S/G: Y
PERM/COLL: CONT: sculp, art; AM: early 20th; EU: early 20th; AM: realism since Eakins

Endowed by the entire collection of its founder, Joseph Hirshhorn, this museum focuses primarily on modern and contemporary art of all kinds and cultures plus newly acquired works. One of its most outstanding features is its extensive sculpture garden. PLEASE NOTE: No tours are given on holidays. **NOT TO BE MISSED:** Rodin's "Burghers of Calais"; gallery of works by Francis Bacon, third floor; Andy Warhol's self-portrait, lower level

ON EXHIBIT/97:

10/17/96–01/12/97	RICHARD LINDNER — The anonymity and intensity of the modern urban experience depicted in the hard-edged, brilliantly colored stark imagery of Lindner, a German-born American post war artist (1901-1978) will be seen in the first American retrospective of his works in nearly 20 years.
11/07/96–01/19/97	DIRECTIONS: RUDOLPH SCHWARZKOGLER — On exhibit will be photographs of bandaged and masked figures that represent this late artist's participation in a performance-based movement of the 60's in Austria known as "Akionismus."
11/20/96–05/07/97	THE COLLECTION IN CONTEXT: PAUL GAUGUIN — A one gallery presentation explores the context of Gauguin's wood sculpture "Cylinder Decorated with the Figure of Hina and Two Attendants."
02/13/97–05/11/97	JEFF WALL — A retrospective of 30 photographic works created by Canadian artist Wall since 1946 will consist of large color transparencies in light boxes that are luminous pictorial narratives reflecting the artist's concern with contemporary social issues. CAT WT
02/27/97–06/15/97	DIRECTIONS - JUAN MUÑOZ — An exhibition of psychological, narrative installations by this Madrid-based sculptor based on his ruminations of William de Kooning's paintings.
05/23/97–06/15/97	THE COLLECTION IN CONTEXT: RAYMOND DUCHAMP-VILLON — Examples of works by French sculptor Decamp-Dillon (1876-1918) that reveal his response and belief in the machine will be seen in a one gallery presentation of his works.

Howard University Gallery of Art

2455 6th St., NW, **Washington, DC 20059**
☎ 202-806-7070
HRS: 9:30-4:30 M-F; 1-4 S (may be closed some Sundays in summer!) DAY CLOSED: Sa HOL: LEG/HOL!
♿: Y ⓟ Y; Metered parking; Free parking in the rear of the College of Fine Arts evenings and weekends
GR/T: Y GR/PH: CATR! Scott Baker
PERM/COLL: AF/AM: ptgs, sculp, gr; EU: gr; IT: ptgs, sculp (Kress Collection); AF

In addition to an encyclopedic collection of African and African-American art and artists there are 20 cases of African artifacts on permanent display in the east corridor of the College of Fine Arts. Student and faculty exhibitions are scheduled for presentation in '97. PLEASE NOTE: It is advisable to call ahead in the summer as the gallery might be closed for inventory work. **NOT TO BE MISSED:** The Robert B. Mayer Collection of African Art

DISTRICT OF COLUMBIA

National Gallery of Art

4th & Constitution Ave., N.W., **Washington, DC 20565**
☎ 202-737-4215 WEB ADDRESS: http://www.si.edu
HRS: 10-5 M-Sa, 11-6 S HOL: 12/25, 1/1
&: Y; Fully accessible; wheelchairs available ℗ Y; Limited metered street parking; free 3 hour mall parking as available.
MUS/SH: Y ❚❚Y; 3 restaurants plus Espresso bar
GR/T: Y GR/PH: CATR! 202-842-6247 DT: Y TIME: daily!
PERM/COLL: EU: ptgs, sculp, dec/art 12-20: OM; AM: ptgs, sculp, gr 18-20; REN: sculp; OR: cer

The two buildings that make up the National Gallery, one classical and the other ultra modern, are as extraordinary and diverse as the collection itself. Considered one of the premier museums in the world, more people pass through the portals of the National Gallery annually than almost any other museum in the country. Self-guided tour brochures of the permanent collection for families as well as walking tour brochures for adults are available for use in the museum. In addition, advance reservations may be made for tours given in a wide variety of foreign languages. **NOT TO BE MISSED:** The only Leonardo Da Vinci oil painting in an American museum collection; Micro Gallery, the most comprehensive interactive, multi-media computer information system in an American museum featuring 13 workstations that allow visitors to research any work of art in the entire permanent collection.

ON EXHIBIT/97:

ONGOING	MICRO GALLERY — Available for public use, the recently opened Micro Gallery consists of 13 computer terminals that make it possible for visitors to access detailed images of, and in-depth information to, nearly every one of the 1700 works on display in the National Gallery's permanent collection.
09/22/96–01/26/97	ENCOUNTERS WITH MODERN ART: WORKS FROM THE ROTHSCHILD FAMILY COLLECTIONS — Outstanding works from many of the major schools of modern European art (including futurism, cubism, constructivism, and de Stijl) will be seen in the works on loan from the Herbert and Nannette Rothschild collection. Motivated by the fact that they were friends of Braque, Arp, Brancusi, Severini, Léger and many other members of the French art community of their day, the Rothschild's collection reflects their personal enthusiasm in acquiring the works on view. CAT WT ◠
01/26/97–04/06/97	SPLENDORS OF IMPERIAL CHINA: TREASURES FROM THE NATIONAL PALACE MUSEUM, TAIPEI — In one of the most dazzling and important exhibitions of Chinese fine and decorative art ever brought to America, 300 painting, calligraphic, jade, bronze and ceramic masterpieces created over 4 millennia will be on view with a wide variety of decorative arts objects. PLEASE NOTE: Tickets to this exhibition will cost $12.00 for adults, $6.00 for children ages 4-16, and $10.00 for students and seniors. Group rates and season passes will also be available. WT ◠
02/09/97–05/11/97	SIX CENTURIES/SIX ARTISTS — From the brilliant technique of Dürer to the sensuality of Boucher, this exhibition of 15th through 20th-century works on paper will highlight one artist in each of the six rooms of the exhibit. Due to their fragile nature, all the works on view, selected from the museum's vast holdings of 91,000 works on paper will be shown on a rotating basis. ONLY VENUE
02/16/97–05/11/97	THE VICTORIANS: BRITISH PAINTING IN THE REIGN OF QUEEN VICTORIA (1837-1901) — 70 paintings highlighting the achievements of British painters during the reign of Queen Victoria will be on view in the first major survey of Victorian art to ever be mounted in America. Included in the exhibition will be well known works by Whistler, Sargent, Leighton, J. M. W. Turner, Rossetti, Tissot and others. ONLY VENUE CAT ◠
03/30/97–07/27/97	PICASSO: THE EARLY YEARS 1892-1906 — In the first comprehensive presentation of its kind, 125 works have been selected to demonstrate the various artistic styles Picasso explored during the early years of his career. The exhibition closely examines Picasso's Blue and Rose period works along with others that reveal the artist's remarkable achievements prior to the advent of cubism. CAT WT ◠

National Gallery of Art - continued

06/08/97–09/01/97 CROWN POINT PRESS — Founded in the San Francisco Bay Area in 1962, Crown Point Press quickly became "THE" place for painters and sculptors interested in etching. This presentation works ranging from minimalism to realism produced here between 1965 to the present will include examples by artists of international reputation including Richard Diebenkorn, Sol LeWitt, Wayne Thiebaud, Chuck Close, Helen Frankenthaler, Tony Cragg (Britain), Katsura Funakoshi (Japan), Gunter Brus (Austria), and others. CAT WT

06/29/97–09/28/97 MILLENNIUM OF GLORY: SCULPTURE OF ANGKOR AND ANCIENT CAMBODIA — 90 objects revealing the riches of Cambodian art will be featured in the first major exhibition of its kind in America. Both Hindu and Buddhist traditions will be highlighted in works ranging from monumental sandstone images of gods, guardians, female dancers, and legendary creatures to refined ritual bronzes. ONLY VENUE CAT ◠

09/28/97–01/11/98 THOMAS MORAN — 75 of the finest paintings and watercolors will be featured in the first ever retrospective exhibition of the brilliant work of Thomas Moran, one of the foremost American landscape painters of the 19th-century. CAT WT ◠

National Museum of African Art
Affiliate Institution: Smithsonian Institution
950 Independence Ave., N.W., **Washington, DC 20560**
☎ 202-357-4600
HRS: 10-5:30 Daily HOL: 12/25
♿: Y; Fully accessible elevators, restrooms, telephones, water fountains Ⓟ Y; Free 3 hour parking along the Mall
MUS/SH: Y GR/T: Y! DT: Y
PERM/COLL: AF/ART

Opened in 1987, the National Museum of African Art has the distinction of being the only museum in the country dedicated to the collection, exhibition, conservation and study of the arts of Africa.

ON EXHIBIT/97:

PERMANENT IMAGES OF POWER AND IDENTITY — 121 objects both from the permanent collection and on loan to the museum are grouped according to major geographical & cultural regions of sub-Saharan Africa.

THE ANCIENT WEST AFRICAN CITY OF BENIN, A.D. 1300-1897 — A presentation of cast-metal heads, figures and architectural plaques from the museum's permanent collection of art from the royal court of the capital of the Kingdom of Benin as it existed before British colonial rule.

THE ART OF THE PERSONAL OBJECT — Aesthetically important and interesting utilitarian objects reflect the artistic culture of various African societies.

PURPOSE AND PERFECTION: POTTERY AS A WOMAN'S ART IN CENTRAL AFRICA — Female artistry in Africa is observed in this display of pottery from the permanent collection of the museum.

THE ANCIENT NUBIAN CITY OF KERMA, 2500-1500 B.C. — A semi-permanent installation of 40 works from the Museum of Fine Arts in Boston celebrates Kerma, also known as Kush, the oldest city in Africa outside of Egypt that has been excavated.

10/30/96–02/23/97 MEMORY: LUBA ART AND THE MAKING OF HISTORY — On exhibit will be 100 splendid objects that serve as visual links to memory and history among the Luba, one of the most important kingdoms of central Africa from the 17th to the 19th centuries. WT

01/29/97–03/23/97 A KING AND HIS CLOTH: ASANTEHENE AGYEMAN PREMPEH I — "Adinkra" cloth that once belonged to the king of the Asante nation in Ghana from 1888 -1896 will be featured in an exhibition that reveals the tumultuous upheaval of his time as interpreted in the cloth on view along with historical photographs.

DISTRICT OF COLUMBIA

National Museum of African Art - continued

04/16/97–08/17/97	ADIRE: RESIST-DYED CLOTHS OF THE YORUBA — Indigo resist-dyed "Adire" cloths produced by the Yoruba artists of southwestern Nigeria on view from the permanent collection represent stunning examples of a woman's traditional art.
06/25/97–10/19/97	TREASURES OF THE TERVUREN MUSEUM: THE ROYAL MUSEUM OF CENTRAL AFRICA, TERVUREN, BELGIUM — An exhibition of 125 magnificent, specially selected objects will be on loan from the world's greatest collection of central African art.　　WT
09/16/97–04/29/98	THE NSUKKA GROUP: TRADITION, INNOVATION, AND EXPERIMENTATION IN NIGERIAN MODERN ART — In an exhibition inaugurating a newly refurbished skylight gallery that will be devoted to the exhibition of modern African art, works by 7 artists associated with the Department of Fine and Applied Arts at the University of Nigeria, Nsukka will be featured. All of the works bridge the past and the present by utilizing tradition in the creation of their contemporary artworks.

National Museum of American Art

Affiliate Institution: Smithsonian Institution
8th & G Sts., NW, **Washington, DC 20560**
✆ 202-357-2700　WEB ADDRESS: http://www.nmaa.si.edu
HRS: 10-5:30 DAILY　HOL: 12/25
&: Y; Ramp to garage & elevator at 9th & G Sts., NW; all restrooms Ⓟ Y; Metered street parking with commercial lot nearby
MUS/SH: Y ❢❢ Y; Patent Pending Cafe 10-3:30 Daily　GR/T: Y　GR/PH: CATR! 202-357-3111　DT: Y　TIME: Noon & 2 weekdays　H/B: Y; Housed on Old Patent Office (Greek Revival architecture) mid 1800'S
PERM/COLL: AM: ptgs, sculp, gr, cont/phot, drgs, folk, Impr; AF/AM

All aspects of American art from the earliest works by limners to emerging artists of today are shown within the walls of this mid-19th-century Greek Revival building. **NOT TO BE MISSED:** George Catlin's 19th-century American-Indian paintings; Thomas Moran's Western Landscape paintings; James Hampton's "The Throne of the Third Heaven of the Nation's Millennium General Assembly"

ON EXHIBIT/97:

10/04/96–02/02/97	AMERICAN KALEIDOSCOPE: THEMES AND PERSPECTIVES IN RECENT ART — Like a kaleidoscope which alters the perspective of the viewer with each turn, this exhibition of works by 15 contemporary American artists from diverse regional, ethnic, and political backgrounds will focus on the unity, variety and continuity of American culture in a rich interplay of styles and subject matter. Exhibition Web Address: http://www.nmaa.si.edu.kscope　　CAT
11/22/96–04/20/97	AMERICAN PHOTOGRAPHS: THE FIRST CENTURY — 150 daguerreotypes, ambrotypes, tintypes, a variety of paper formats and mechanical photo illustrations will be featured in the museum's first comprehensive exhibition of early photography. The works are part of the recently acquired Charles Issaacs Collection.　　CAT
04/04/97–08/03/97	SINGULAR IMPRESSIONS: THE MONOTYPE IN AMERICA　　BOOK
05/30/97–09/28/97	THE BARD BROTHERS: PAINTING AMERICA UNDER SAIL AND STEAM — An exhibition of 40 paintings, watercolors, and drawings of marine scenes and ships traveling along the Hudson River that were painted from the 1820's to the end of the 19th-century by James and John Bard.　　BOOK
09/26/97–01/25/98	ON THE MIDDLE BORDER: THE ART OF CHARLES E. BURCHFIELD — 75 watercolors will be presented in an exhibit that highlights American artist Burchfield's distinctive and original style within the context of the culture and artistic environment in which he worked.　　CAT　WT

National Museum of Women in the Arts
1250 New York Ave., N.W., **Washington, DC 20005**
☏ 202-783-5000
HRS: 10-5 M-Sa, Noon-5 S DAY CLOSED: M HOL: 1/1, 12/25, THGV
SUGG/CONT: Y ADULT: $3.00 CHILDREN: F STUDENTS: $2.00 SR CIT: $2.00
♿: Y; Wheelchairs available Ⓟ Y; Paid parking lots nearby MUS/SH: Y ⅋ Y; Cafe 11:30-2:30 M-Sa
GR/T: Y GR/PH: CATR! 202-783-7370 H/B: Y; 1907 Renaissance Revival building by Waddy Wood
PERM/COLL: PTGS, SCULP, GR, DRGS, 15-20; PHOT

Unique is the word for this museum established in 1981 and located in a splendidly restored 1907 Renaissance Revival building. The more than 800 works in the permanent collection are the result of the personal vision and passion of its founder, Wilhelmina Holladay, to elevate and validate the works of women artists throughout the history of art. **NOT TO BE MISSED:** Rotating collection of portrait miniatures (late 19th - early 20th c.) by Eulabee Dix; Lavinia Fontana's "Portrait of a Noblewoman"

ON EXHIBIT/97:

ONGOING	ESTABLISHING THE LEGACY: FROM THE RENAISSANCE TO MODERNISM — A presentation of works from the permanent collection tracing the history of women artists from the Renaissance to the present.
10/10/96–01/12/97	PARTNERS IN PRINTMAKING: WORKS FROM SOLO IMPRESSIONS — Featured will be prints created at the New York SOLO Impressions, Inc. workshop by such well-known artists as Nancy Spero, Aaltoon Sultan, Ida Appelbroog, Louise Bourgeois and others that explore the theme of collaboration between artists and printmakers.
02/13/97–05/04/97	PERSISTENT PRESENCE: A HISTORY OF WOMEN PHOTOGRAPHERS — Throughout the history of photography women have played a vital role. Organized by the Akron Art Museum, this exhibition of over 200 vintage photographs by 125 artists presents a first-time comprehensive look at their achievements.
04/06/97–05/29/97	TOUCHABLE SCULPTURE: LIFECASTS WT
10/09/97–01/11/98	AMERICAN INDIAN POTTERY: THE LEGACY OF GENERATIONS — In celebration of the living legacy of the tradition of pottery making, works by American Indian women artists of the 19th & 20th centuries will be shown with those of their contemporary protegées.

National Portrait Gallery
Affiliate Institution: Smithsonian Institution
F St. at 8th, N.W., **Washington, DC 20560**
☏ 202-357-1447
HRS: 10-5:30 Daily HOL: 12/25
♿: Y; Through garage entrance corner 9th & G ST. Ⓟ Y; Metered street parking; some commercial lots nearby
MUS/SH: Y ⅋ Y; 11-3:30 GR/T: Y GR/PH: CATR! 202-357-2920 DT: Y TIME: inquire at information desk
H/B: Y; This 1836 Building served as a hospital during the Civil War S/G: Y
PERM/COLL: AM: ptgs, sculp, drgs

Housed in an old Patent Office built in 1836, and used as a hospital during the Civil War, this museum allows the visitor to explore U.S. history as told through portraiture. **NOT TO BE MISSED:** Gilbert Stuart's portraits of George Washington & Thomas Jefferson; Self Portrait by John Singleton Copley

ON EXHIBIT/97:

08/30/96–09/01/97	IMAGE OF THE PRESIDENT: PHOTOGRAPHS BY GEORGE TAMES 1944-1974 (Working Title) — On exhibit will be 35 photographs of 6 presidents by Tames, a Pulitzer Prize winning photographer who, for more than 4 decades, covered the American presidency for the New York Times.
10/25/96–07/06/97	RED, HOT & BLUE: A SALUTE TO AMERICAN MUSICALS — The history of the American musical and the personalities who gave it life will be seen in a jointly-sponsored exhibition with the National Museum of American History. In addition to numerous portraits of famous theatrical individuals, video and film clips and theatrical memorabilia will be on display in this nostalgic trip down Broadway's memory lane.

DISTRICT OF COLUMBIA

National Portrait Gallery - continued

01/31/97–09/14/97 LE TUMULTE NOIR — 16 lithographs from a 44-work portfolio created in 1927 by Paul Colin, will be on view in an exhibit that documents the extraordinary Parisian reaction to black culture made by African-American performer Josephine Baker in the 1920's.

01/31/97–09/14/97 BREAKING RACIAL BARRIERS: AFRICAN-AMERICANS IN THE HARMON FOUNDATION COLLECTION — Drawn from the Harmon Foundation's bequest to the permanent collection of the museum, this exhibition strives to present in reconstructed and renamed format a 1940's exhibition entitled "Portraits of Outstanding Americans of Negro Origin." Then as now, the main focus of the exhibition was to attempt to address various aspects of racial inequality.

09/26/97–01/25/98 MATHEW BRADY AND THE AMERICAN PUBLIC — From early daguerreotypes, tiny cartes de visites, and majestic Imperial photographic works spanning the history of 19th-century American photography, will be featured in the first modern exhibition to focus on the career of Mathew Brady.

10/17/97–02/08/98 EDWARD STEICHEN, AN AMERICAN MODERN: THE CONDE NAST YEARS — Close-up still lifes, celebrity portraits, and urban scenes will be among the photographs on view by Steichen, one of the founders of the Photo-Secessionist Movement. WT

11/07/97–09/12/98 GEORGE MARSHALL — In celebration of the 50th anniversary of the Marshall Plan, paintings, photographs, documents and other memorabilia will be featured in an exhibit detailing the military career of General George C. Marshall. Images of such notables as Roosevelt, Churchill and Chaing Kai-shek with whom Marshall dealt will be accompanied by a reading copy of Marshall's famous Harvard commencement speech heralding the Marshall Plan which was to have an enormous impact on free societies worldwide.

The Phillips Collection

1600 21st St., N.W., **Washington, DC 20009-1090**
📞 202-387-2151
HRS: 10-5 Tu-Sa, Noon-7 S, 5-8:30 T for "Artful Evenings" - call for info! DAY CLOSED: M HOL: 1/1, 7/4, 12/25, THGV
ADM: Y ADULT: $6.50 CHILDREN: F (18 & under) STUDENTS: $3.25 SR CIT: $3.25
♿: Y; All galleries accessible by wheelchair ℗ Limited metered parking on street; commercial lots nearby MUS/SH: Y
🍴 Y; Cafe 10:45-4:30 M-Sa; Noon-6:15 S
GR/T: Y GR/PH: CATR! ext 247 DT: Y TIME: 2:00 W & Sa H/B: Y S/G: Y
PERM/COLL: AM: ptgs, sculp 19-20; EU: ptgs, sculp, 19-20

Housed in the 1897 former residence of the Duncan Phillips family, the core collection represents the successful culmination of one man's magnificent obsession with collecting the art of his time. PLEASE NOTE: The museum fee applies to weekends only. Admission on weekdays is by contribution. **NOT TO BE MISSED:** Renoir's " Luncheon of the Boating Party"; Sunday afternoon concerts that are free with the price of museum admission and are held Sept. through May at 5 PM.; "Artful Evenings" ($5.00 pp) for socializing, art appreciation, entertainment, drinks and refreshments.

ON EXHIBIT/97:
ONGOING SMALL PAINTINGS AND WORKS ON PAPER

09/21/96–02/09/97 IMPRESSIONISTS OF THE SEINE: A CELEBRATION OF RENOIR'S LUNCHEON OF THE BOATING PARTY — Renoir's "The Luncheon of the Boating Party," the single most important painting ever acquired for the museum's permanent collection, will be joined by 55 Impressionist works on loan from both public and private collections in another 75th-anniversary exhibition that provides the first exclusive focus on Impressionist views of outdoor leisure on the Seine between Argenteuil and Chatou. ONLY VENUE
 ADM FEE ATR!

03/08/97–06/22/97 PASTELS BY JOAN MITCHELL — Eleven of Mitchell's colorful and energetic abstract pastels from the 1990's will be on exhibit with an earlier key work from 1978 entitled "Tilleau."

03/22/97–05/25/97 WILLIAM CHRISTENBERRY: SELECTED WORKS — Paintings, constructions, works on paper, and photographs covering the full range of Christenberry's work will be on exhibit with some later works and a special installation of Klan images.

The Phillips Collection - continued

06/14/97–08/31/97 FRUIT, FLOWERS AND FAMILIAR OBJECTS — 70 works from the permanent collection will be featured in an exhibit designed to trace the evolution of the modern still-life painting by showing how the 19th-century tradition of still-life painting plays out in 20th-century still-life works by Bonnard, Tamayo, Man Ray, Walt Khun and others. Cubist examples by Braque & Picasso and later modernist works by Rouault, Avery, Shan, and Morandi will be included as part of this historical progression. WT

09/20/97–01/04/98 ARTHUR DOVE: A RETROSPECTIVE EXHIBITION — Nearly 80 paintings, collages, and pastels spanning the entire career of Dove, a key figure in the development of American Modernism, will be on exhibit accompanied by several photos taken of him by his contemporaries Stieglitz and Strand. CAT WT

Renwick Gallery of the National Museum of American Art

Affiliate Institution: Smithsonian Institution
Pennsylvania Ave. at 17th St., N.W., **Washington, DC 20560**
✆ 202-357-2247
HRS: 10-5:30 Daily HOL: 12/25
♿: Y; Ramp that leads to elevator at corner 17th & Pa. Ave. Ⓟ Limited street parking; commercial lots and garages nearby
MUS/SH: Y GR/T: Y GR/PH: 10, 11 & 1 Tu-T (CATR! 202-357-2531)
H/B: Y; French Second Empire style building is known primarily for its displays of American crafts. The museum designed in 1859 by James Renwick, Jr.
PERM/COLL: CONT/AM: crafts; AM: ptgs

Built in 1859 and named not for its founder, William Corcoran, but rather for its architect, James Renwick, this charming French Second Empire style building is known primarily for its displays of American crafts. The museum in 1994, became the recipient of the entire KPMG Peat Marwick corporate collection of American crafts. **NOT TO BE MISSED:** Grand Salon furnished in styles of 1860's & 1870's

ON EXHIBIT/97:

09/13/96–01/12/97 CONSERVATION BY DESIGN; A CONTEMPORARY WORK IN WOOD — A unique display of 36 objects designed expressly to address issues of responsible forest management and the responsible use of temperate & tropical woods will be featured in an exhibition of functional and sculptural works by artists from the U.S. England, Australia, and Canada. CAT

09/13/96–01/12/97 CALICO AND CHINTZ: ANTIQUE QUILTS FROM THE PATRICIA SMITH COLLECTION — 26 American wholecloth, pieced and quilted textiles (many predating the Civil War) will be on loan from the largest and finest collection of its kind .

03/14/97–07/13/97 THE RENWICK GALLERY AT TWENTY-FIVE — In celebration of the 25th anniversary of the Renwick Gallery, important works from the permanent collection, many of which have been off view for some time, will be showcased along with recent acquisitions.

09/12/97–01/04/98 MICHAEL LUCERO: SCULPTURE '76 -'95 — Lucero's glazed ceramic, bronze and mixed media sculptures reflecting reworked European, Native American, Afro-Carolinian, and ancient Mayan forms will be featured in a display detailing 2 decades of change in his works. CAT WT

Sewall-Belmont House

144 Constitution Ave., N.W., **Washington, DC 20002**
✆ 202-546-3989
HRS: 10-3 Tu-F; Noon-4 Sa, S DAY CLOSED: M HOL: THGV, 12/25, 1/1
VOL/CONT: Y
Ⓟ Limited street parking only GR/T: Y GR/PH: 202-546-3989 DT: Y TIME: 10-3 Tu-F; Noon-4 Sa, S H/B: Y
PERM/COLL: SCULP, PTGS

Paintings and sculpture depicting heroines of the women's rights movement line the halls of the historic Sewall-Belmont House. One of the oldest houses on Capitol Hill, this unusual museum is a dedicated to the theme of women's suffrage.

ON EXHIBIT/97: No traveling exhibitions

FLORIDA

Belleair

Florida Gulf Coast Art Center, Inc.
222 Ponce De Leon Blvd., **Belleair, FL 34616**
☎ 813-584-8634
HRS: 10-4 Tu-F (Pilcher Gallery); 10-4 Tu-Sa, Noon-4 S (Shillard Smith Gallery) HOL: LEG/HOL!
&: Y ℗ Y; Ample free parking MUS/SH: Y
GR/T: Y GR/PH: CATR! Elaine Georgilas DT: Y TIME: call for information S/G: Y
PERM/COLL: AM: ptgs 1940-1950'S; CONT FLORIDA ART: 1960 - present; CONT/CRAFTS

In operation for 50 years this art center, just south of Clearwater near Tampa, features a permanent collection of over 700 works of art (late 19th - 20th c) with a focus on American artists including I. Bishop, Breckenridge, Bricher, and Inness. PLEASE NOTE: The Pilcher Gallery houses works from the permanent collection while the Smith Gallery is host to traveling exhibitions.

Boca Raton

Boca Raton Museum of Art
801 W. Palmetto Park Rd., **Boca Raton, FL 33486**
☎ 561-392-2500
HRS: 10-4 T & T-S, till 9 PM W DAY CLOSED: M HOL: LEG/HOL!
ADM: Y ADULT: $3.00 CHILDREN: F (under 12) STUDENTS: $1.00 SR CIT: $2.00
&: Y ℗ Y; Free MUS/SH: Y
GR/T: Y GR/PH: CATR! DT: Y TIME: daily! S/G: Y
PERM/COLL: PHOT; PTGS 20

With the addition to its permanent holdings in 1990 of late 19th & 20th-century art from the collection of Dr. and Mrs. John Mayers, the Boca Raton Museum of Art is well worth a visit – even on a sunny day!

ON EXHIBIT/97:

12/96–1997	THE INTERNATIONAL BIENNIAL: ITALY 1997 — Italian art and culture will be presented in a year-long series of exhibitions.
01/15/97–03/09/97	MATTA: DREAMSCAPES — Featured will be paintings by Chilean-born artist Matta, an artist who bridges the gap between European Surrealism and American Abstract Expressionism by maintaining some elements of both within his works.
01/15/97–03/09/97	WILFREDO LAM: PASTELS — Semi-abstract images of lurking menace, demons, animals and tropical vegetation by Cuban Surrealist Lam reflect the symbolic iconography of his Caribbean homeland.
03/19/97–05/11/97	VALERIO ADAMI — On view will be 26 of Adami's large-scale brightly colored paintings depicting distorted urban and suburban landscape images bordered by strong black outlines. 20 of the artist's drawings will also be on view.
05/21/97–07/13/97	46TH ANNUAL ALL FLORIDA JURIED EXHIBITION — Works on paper, photography, paintings and sculpture by artists statewide will be featured in Florida's oldest juried competition.
07/23/97–09/07/97	PERMANENT COLLECTION — Works in all media donated to the museum by members of the community will be on exhibit.
09/17/97–11/09/97	RICHARD FLORSHEIM
11/19/97–01/11/98	SURREALISM IN AMERICAN ART

Boca Raton

International Museum of Cartoon Art
201 Plaza Real, **Boca Raton, FL 33432**
☎ 407-391-2200
HRS: 11-5 Tu-Sa, Noon-5 S DAY CLOSED: M
ADM: Y ADULT: $6.00 CHILDREN: 6-12 $3; F 5 & under STUDENTS: $4.00 SR CIT: $5.00
Ⓟ Y; Parking throughout Mizner Park in which the museum is located. MUS/SH: Y
❢❢ Y: Cafe open 11 AM - 10 PM Tu-Sa & 12-6 S
PERM/COLL: CARTOON ART

Started by Mort Walker, creator of the of the "Beetle Bailey" cartoon comic and relocated to Florida after 20 years of operation in metropolitan NY, this museum with over 160,000 works on paper, 10,000 books, 1,000 hours of animated film, and numerous collectibles & memorabilia, is dedicated to the collection, preservation, exhibition and interpretation of an international collection of original works of cartoon art. Though open for visitors in temporary galleries, the museum hopes to be fully operational by late 1997.

Coral Gables

Lowe Art Museum
Affiliate Institution: University of Miami
1301 Stanford Dr., **Coral Gables, FL 33146-6310**
☎ 305-284-3535
HRS: 10-5 Tu, W, F-Sa; Noon-7 T; Noon-5 S DAY CLOSED: M HOL: ACAD!
ADM: Y ADULT: $5.00 CHILDREN: F (under 12) STUDENTS: $3.00 SR CIT: $3.00
♿: Y; Ramp, parking & doors accessible Ⓟ Y; On premises MUS/SH: Y
GR/T: Y GR/PH: CATR! S/G: Y
PERM/COLL: REN & BAROQUE: ptgs, sculp (Kress Collection); AN/R; SP/OM; P/COL; AF; EU: dec/art; OR: ptgs, sculp, gr, cer; AM: ptgs, gr; LAT/AM; NAT/AM; AF

Since its establishment in 1950, the Lowe has acquired such a superb and diverse permanent collection that it is recognized as one of the major fine art resources in Florida. More than 7,000 works from a wide array of historical styles and periods including the Kress Collection of Italian Renaissance and Baroque Art, and the Cintas Collection of Spanish Old Master paintings are represented in the collection. **NOT TO BE MISSED:** Kress Collection of Italian Renaissance and Baroque art

ON EXHIBIT/97:

12/12/96–01/26/97	TWENTY-ONE YEARS WITH CHRISTO AND JEANNE-CLAUDE: THE TOM GOLDEN COLLECTION — Featured will be 91 works including original drawings, collages, wrapped objects, lithographs and photographic editions.
12/12/96–01/26/97	PABLO PICASSO CERAMICS — A selection of Picasso's pottery and pencil works drawn mainly from the museum's holdings will be featured.
02/06/97–03/30/97	MASTERWORKS IN HAITIAN ART — Major developments in the evolution of Haitian art will be seen in the colorful, playful and purposeful paintings and sculptures on exhibit. WT
02/06/97–03/30/97	HAITIAN BEADED FLAGY FROM THE SHEILA NATASHA SIMROD FRIEDMAN COLLECTION
04/10/97–05/25/97	MEXICAN MASKS OF THE 20TH CENTURY: A LIVING TRADITION — A wide variety of masks will be featured in an exhibition designed to introduce the viewer to the traditions of mask making in Mexican culture. WT
04/10/97–05/25/97	UNIVERSITY OF MIAMI STUDENT/MASTER OF FINE ARTS EXHIBITION — An annual juried exhibition.
06/05/97–07/27/97	LASTING IMPRESSIONS: THE DRAWINGS OF THOMAS HART BENTON — Approximately 70 drawings and watercolors from the artist's working studio collection provide an amazingly rich visual record of the artist's experiences of a lifetime. BROCHURE WT

FLORIDA

Lowe Art Museum - continued

06/05/97–07/27/97	ANSEL ADAMS: THE MAN WHO CAPTURED EARTH'S BEAUTY — The beauty and grandeur of the Western landscape captured by the camera of Adams, one of America's most outstanding photographers, will be seen in the 24 photographs on view. WT
09/18/97–11/16/97	THE STUDIO MUSEUM IN HARLEM: 25 YEARS OF AFRICAN-AMERICAN ART — In celebration of the Studio Museum's 25th anniversary, this traveling exhibition will highlight paintings, sculpture, and works on paper created by noted African-American artists between 1968-1993. WT
12/11/97–02/09/98	IT'S ONLY ROCK & ROLL — 100 artworks by major American artists will be featured in an exhibition that examines the impact rock & roll music has made in contemporary art since the 1960's. WT

Daytona Beach

Museum of Arts and Sciences
1040 Museum Blvd., **Daytona Beach, FL 32014**
☎ 904-255-0285
HRS: 9-4 Tu-F; Noon-5 Sa, S DAY CLOSED: M HOL: LEG/HOL!
ADM: Y ADULT: $4.00 CHILDREN: $1.00 STUDENTS: $1.00
点: Y Ⓟ Y; Ample free parking MUS/SH: Y GR/T: Y GR/PH: CATR!
PERM/COLL: REG: ptgs, gr, phot; AF; P/COL; EU: 19; AM: 18-20; FOLK; CUBAN: ptgs 18-20; OR; AM: dec/art, ptgs, sculp 17-20

The Museum of Arts and Sciences which serves as an outstanding cultural resource in the state of Florida recently added a wing designed to add thousands of square feet of new gallery space. Visitors to the museum enter along a nature drive through Tuscawill Park. PLEASE NOTE: The new 12,000 square foot Arts & Humanities Wing featuring the Anderson C. Bouchelle Center for the study of International Decorative Arts and the Helena & William Schulte Gallery of Chinese Art opened to the public in 11/96. **NOT TO BE MISSED:** The Dow Gallery of American Art, a collection of over 200 paintings, sculptures, furniture, and decorative arts (1640-1910).

ON EXHIBIT/97:

01/97–06/97	JAPANESE WOODBLOCK PRINTS — Classical composition and printing techniques will be demonstrated in the 25 important works on view by such Japanese masters as Hiroshige, Hanorubu, and Hokusai.
01/97–06/97	PACIFIC EXOTICS: THE WOODBLOCK PRINTS OF PAUL JOCOULET — On display from the permanent collection will be 60 prints by Jocoulet, the greatest non-Japanese master of the medium.
01/18/97–04/20/97	GREEK ART FROM THE HOUSTON COLLECTION — Fine pottery, glass, bronze, and marble objects will be on view with gold & silver coinage dating from the 6th-century B.C. to the 4th-century A.D.
01/18/97–04/20/97	ST. JOHN'S PORTFOLIO: PHOTOGRAPHS BY LEE DUNKEL — A display of 30 black & white silverpoint photos of the St. John's river and environs.
04/26/97–09/97	FLORIDA CRACKERS — Cracker heritage in Florida from its 16th-century English roots to its 20th-century backwoods culture will be traced in this unique and comprehensive exhibition.
04/26/97–09/14/97	PICASSO CERAMICS FROM THE FT. LAUDERDALE MUSEUM — Inspired by Pre-Columbian pottery and his Spanish heritage, the 50 ceramic and sculptural objects highlighted in this exhibition, created by Picasso between 1947-1971, demonstrate his artistic development within this medium. WT
04/26/97–06/97	CUBISM AND ITS LEGACY — The history of the Cubist period will be seen in this exhibition of 18 prints on canvas & paper from Picasso to Braque.

Daytona Beach

Southeast Museum of Photography
Affiliate Institution: Daytona Beach Community College
1200 Volusia Ave., **Daytona Beach, FL 32115**
☎ 904-254-4475
HRS: 10-3 Tu-F; 5-7 Tu; 1-4 Sa, S DAY CLOSED: M HOL: LEG/HOL!
&: Y ℗ Y; On college campus GR/T: Y GR/PH: CATR! 904-947-5469 DT: Y TIME: 20 minute "Art for Lunch" tours!
PERM/COLL: PHOT

Thousands of photographs from the earliest daguerreotypes to the latest experiments in computer assisted manipulation are housed in this modern 2 floor gallery space opened in 1992. Examples of nearly every photographic process in the medium's 150 year old history is represented in this collection. **NOT TO BE MISSED:** Kidsdays, a Sunday afternoon program for children and parents where many aspects of the photographic process can be experienced.

ON EXHIBIT/97:

09/10/96–01/17/97	LAND OF PARADOX: CONTEMPORARY PHOTOGRAPHS BY YUJI SAIGA, NAOYA HATAKEYAMA, NORIO KOBAYASHI, AND TOSHIO YAMANE — Featured will be images of Japan's constructed landscape captured by the lens of 4 contemporary Japanese photographers.
09/10/96–01/17/97	FIFTY YEARS ON THE MANGROVE COAST: PHOTOGRAPHS BY WALKER EVANS AND RODGER KINGSTON
10/11/96–01/17/97	RUSSIA: CHRONICLES OF CHANGE — Experimental photographic essays by 7 contemporary Russian photographers.
10/11/96–01/17/97	HERE AND THERE: PHOTOGRAPHS OF FLORIDA AND THE AMAZON BY ALEX WEBB
02/07/97–04/25/97	TYPOLOGIES: PHOTOGRAPHS BY BARBARA NORFLEET
02/07/97–04/25/97	JAZZ! PORTRAITS OF BLACK MUSICIANS
02/07/97–04/25/97	LOTTE JACOBI: PHOTOGRAPHER AND MENTOR — Jacobi's portraits, dance & theater photographs and photogenic drawings will be featured in this 50-year career survey of her work.
02/07/97–04/25/97	CINDY BERNARD: THE SECURITY ENVELOPE GRID — Bernard blends the graphic designs of commerce with abstractions of art in her large photographic installation.

DeLand

The DeLand Museum of Art
600 N. Woodland Blvd., **DeLand, FL 32720-3447**
☎ 904-734-4371
HRS: 10-4 Tu-Sa, 1-4 S DAY CLOSED: M HOL: LEG/HOL!
ADM: Y ADULT: $2.00 CHILDREN: $1.00 (4-12) STUDENTS: $1.00 SR CIT: $2.00
&: Y: Fully handicapped accessible ℗ Y; Free and ample MUS/SH: Y
GR/T: Y GR/PH: CATR! DT: Y TIME: ! H/B: Y; Building is 1892 Taylor Family Mansion
PERM/COLL: AM: 19-20; CONT: reg; DEC/ART; NAT/AM

The DeLand, opened in the New Cultural Arts Center in 1991, is located between Daytona Beach and Orlando. It is a fast growing, vital institution that offers a wide range of art and art-related activities to the community and its visitors. PLEASE NOTE: The permanent collection is not usually on display.

FLORIDA

The DeLand Museum of Art - continued
ON EXHIBIT/97:

11/07/96–01/26/97 ANSEL ADAMS: A LIFE OF ART AND ADVOCACY — Highlighted in this exhibition will be aspects of Adams' career as an advocate for the medium of photography and for the environment. WT

02/16/97–04/06/97 NATURAL FLORIDA — Works by John James Audubon and Roger Tory Peterson will be seen in an exhibition featuring contemporary Florida artists whose works depict the rapidly changing environment of Florida's wilderness and wildlife.

04/12/97–06/01/97 ELDER ARTS EXPO — Works by talented artists in the community age 62 and older will be on display.

04/12/97–06/01/97 SALVADOR DALI: HOMAGE TO THE GREAT MASTERS, THE MYTHOLOGY NOUVELLE — 12 drypoint etchings, photographs, and didactic panels from the Dali Museum in St. Petersburg, Florida will be on loan in the first of a series of annual loans or exchanges of permanent collections between Florida museums and the DeLand Museum of Art.

06/08/97–07/11/97 MOSAIC — The diversity and heritage of artists working in the community will be featured in this multi-cultural exhibition.

07/19/97–08/15/97 TROY WHITE — Aviation art by White, a DeLand artist, pilot and skydiver.

07/19/97–08/15/97 NEW TALENT IN FLORIDA — A display of works by younger contemporary artists.

Ft. Lauderdale

Museum of Fine Art
1 E. Las Olas Blvd., **Ft. Lauderdale, FL 33301-1807**
☎ 305-525-5500
HRS: 10-9 Tu, 10-5 W-Sa, Noon-5 S DAY CLOSED: M HOL: LEG/HOL!
ADM: Y ADULT: $5.00 CHILDREN: F (under 12) STUDENTS: $2.00 SR CIT: $4.00
♿: Y; Parking area & ramp near front door; wheelchairs available Ⓟ Y; Metered parking ($.75 per hour) at the Municipal Parking facility on S.E. 1st Ave. bordering the museum on the East side. MUS/SH: Y
GR/T: Y GR/PH: CATR! ext. 39 DT: Y TIME: 1:00 & 6:30 Tu; 1:00 T & F (Free with admission) H/B: Y; Built by renowned architect Edward Larrabee Barnes S/G: Y
PERM/COLL: AM: gr, ptgs, sculp 19-20; EU: gr, ptgs, sculp 19-20; P/COL; AF; OC; NAT/AM

Aside from an impressive permanent collection of 20th-century European and American art, this museum is home to the William Glackens collection, the most comprehensive collection of works by the artist and others of his contemporaries who, as a group, are best known as "The Eight" and/or the Ashcan School. **NOT TO BE MISSED:** The William Glackens Collection

ON EXHIBIT/97:

09/06/96–02/16/97 SELECTIONS FROM OUR PERMANENT COLLECTION: ISSUES AND DUTIES — A selection of permanent collection works that relate to such social issues as AIDS and ecology.

09/06/96–02/16/97 GINA PELLON — Cuban painter Pellon's CoBrA-style works will be seen in an exhibition that compares and contrasts them with other paintings by CoBrA artists.

10/96–01/97 BRIDGING THE GULF OF TIME — Linkages between the ancestral past, present and future will be seen in this exhibition combining the recent works of award-winning south Florida African-American artists George Gadson & Dinizulu Dene Tinne with ceremonial flags from the private collection of Haitian art collector Margaret Armand.

Museum of Fine Art - continued

10/25/96–01/05/97	BURNING ISSUES: CONTEMPORARY AFRICAN-AMERICAN ART — Works in a variety of media will be on view in an exhibition by 10 to 15 contemporary African-American artists.
10/25/96–01/12/97	ASAFO! AFRICAN FLAGS OF THE FANTE — European military and ancient African oral traditions are combined in the patchwork, applied and embroidered flags of the Fante people of Ghana created from the time of their European colonialization in 1850 to Ghanaian independence in 1957.
11/08/96–02/09/97	BEYOND REALISM: DRAWINGS BY CYRIL DAVID — An magnificent display of meticulously rendered photographic-like pencil drawings by contemporary modern master David whose works are in the permanent collections of the Metropolitan Museum of Art in New York, and the National Museum of American Art in Washington, D.C.
01/17/97–03/16/97	FROM THE ENDS OF THE EARTH: JUDAIC TREASURES OF THE LIBRARY OF CONGRESS — 140 objects spanning 3,000 years of Jewish history will be on loan from one of the largest repositories of the largest and most comprehensive repositories of its kind. Among the items on view will be Judaic maps, amulets, manuscripts, books printed before 1501, ketuboth (marriage contracts) and letters written by or to prominent figures including Sigmund Freud, Albert Einstein and Abraham Lincoln.
01/17/97–03/16/97	HOLOCAUST SERIES: WORKS BY JOE NACASTRI — Both large-scale installations and smaller intimate works by Nacastri speak to the Holocaust experience itself and to the violence which seems to be endemic to human experience.
01/24/97–04/07/97	TREASURES FROM THE SALVADOR DALI MUSEUM, ST. PETERSBURG, FLORIDA — Nearly 30 paintings, 10 sculptures, and numerous drawings & watercolors will be on loan for the first time from the Dali Museum, which houses the most comprehensive collection of Dali's work in the world.
01/24/97–04/06/97	JUAN GONZÁLEZ: ENCHANTED VISIONS — Illusionistic drawings and paintings by Cuban-American master draftsman González (d.1993) reveal the reason he received such wide acclaim and 3 National Endowment awards for art bestowed upon him during his lifetime.
02/14/97–05/04/97	FLORENCIO GELABERT: RECENT WORKS — Multi-media conceptual sculpturals by Gelabert, one of the most gifted young artists to recently arrive from Cuba, speak to the sculptors viewpoint on oppression and redemption.
02/28/97–08/03/97	CURATORS' CHOICE — Works from the permanent collection reflect the personal tastes of curators Laurence Pamer and Jorge Santis.
04/01/97–05/15/97	EDUARDO Da ROSA — 14 canvases and 14 sculptures by DaRosa, a promising south Florida artist whose large figures convey great pathos and drama.
04/25/97–08/03/97	MARY ELLEN MARK: 25 YEARS — An exhibition of gritty photographic portrayals by one of the best and internationally acclaimed photo-journalists working today.CAT WT
04/25/97–08/01/97	MIGUEL PADURA: ENIGMATIC CANVASES — An exhibition of works by Padura, one of the fastest rising stars within the Latin American art market.
05/09/97–08/03/97	SELECTIONS FROM THE PERMANENT COLLECTION IN THE FARQUAR GALLERY
05/30/97–08/03/97	OZMUN FROM THE PERMANENT COLLECTION

FLORIDA

Gainesville

Samuel P. Harn Museum of Art
Affiliate Institution: Univ. of Florida
SW 34th St. & Hull Rd., **Gainesville, FL 32611-2700**
☎ 352-392-9826
HRS: 11-5 Tu-F, 10-5 Sa, 1-5 S (last adm. is 4:45) DAY CLOSED: M HOL: STATE HOL!
&: Y; Wheelchair accessible ℗ Y; Ample MUS/SH: Y
GR/T: Y GR/PH: CATR! DT: Y TIME: 2:00 Sa, S; 12:30 W; Family tours 1:15 2nd S of mo.
PERM/COLL: AM: ptgs, gr, sculp; EU: ptgs, gr, sculp; P/COL; AF; OC; IND: ptgs, sculp; JAP: gr ; CONT

Although opened to the public only as recently as 1990, the Harn Museum has one of the strongest collections of African art in the region and is one of Florida's three largest art museums. **NOT TO BE MISSED:** African art collection; "A Distant View: Florida Paintings" by Herman Herzog; MOSAIC, the new art related video, & CD-ROM study center of the permanent coll.

ON EXHIBIT/97:

01/08/96–/97	AFRICAN ART AT THE HARN MUSEUM: SPIRIT EYES, HUMAN HANDS — A re-installation of 85 of the museum's African objects used for masquerade, ceremonial and ritual purposes that reflect traditional African beliefs in the mystery and power of the spirit world.
03/31/96–08/97	TIME AND PLACE: AMERICAN ART IN THE PERMANENT COLLECTION — Paintings, sculpture, prints, drawings and photographs from the museum's permanent collection will be on view in an exhibition exploring the thematic associations and stylistic diversity unique to this period of American art.
07/14/96–08/97	CHINESE CERAMICS FROM THE PERMANENT COLLECTION — Monumental Han dynasty vases and elegant Tang Dynasty court lady figurines will be seen in an exhibition from the permanent collection that explores the accomplishments of the Chinese potter.
07/14/96–08/97	INDIAN PAINTING FROM THE PERMANENT COLLECTION — 16th to 19th-century Indian Mughal, Rajasthani, and Pahari style works will be featured in this presentation of 29 miniature paintings from the permanent collection.
10/13/96–02/97	BEVERLET PEPPER: NEW SCULPTURE
11/24/96–03/31/97	DESTINY MANIFEST: AMERICAN LANDSCAPE PAINTING IN THE NINETIES — The reemergence of landscape painting in contemporary art will be explored in the 24 works on view. CAT
12/14/96–02/09/97	AMERICAN NAIVE PAINTINGS FROM THE NATIONAL GALLERY OF ART — 35 19th-century paintings featuring portraits, landscapes, and genre scenes by both unknown and well established artists from diverse backgrounds will be on view. WT
02/97–04/97	LEONARDO DREW — Installed in the museum's rotunda will be several sculptures by Drew who utilizes cast-off materials including cotton and rope to create sculptures which reflect his legacy as an African-American and inheritor of a predominately white modernist culture. BROCHURE
02/24/97–06/97	THE PHOTOGRAPHY OF ANDRÉ KERTESZ AND HENRI CARTIER-BRESSON (Working Title)
05/17/97–07/13/97	THE AMERICAN SCENE AND THE SOUTH: PAINTINGS AND WORKS ON PAPER, 1930-1946 — Works by John Curry, Paul Cadmus, Philip Evergood and Louis Lozowick will be featured in the first in-depth exhibition to explore American Scene painting of the 1930's and 40's, a dominant art movement during the Depression that promoted realistic, understandable styles with subject matter specific to the United States. CAT WT
06/97–10/97	STEPHEN ANTONAKOS — Commissioned for the museum's rotunda will be the installation of a "room" by Antonakos, an artist known for his large-scale interior and exterior "neons" and "rooms."
07/13/97–09/15/97	RUTH BERNHARD AT 90: KNOWN AND UNKNOWN — A look at Bernhard's 60 year career includes vintage material from the artist's own archives and examples of the transcendent nudes for which she is best known.

Samuel P. Harn Museum of Art - continued

08/04/97–10/27/97	THE SPIRIT OF MONTMARTRE: CABARETS, HUMOR, AND THE AVANT-GARDE 1875-1905 — Focusing on the collection between artists, writers. and musicians from the Jane Voorhees Zimmerli Art Museum of Rutgers, this exhibition documents the artistic community which developed in Montmartre at the end of the 19th-century. WT
09/28/97–11/24/97	AMERICAN CRAFT IN THE MACHINE AGE: 1920-1945
10/13/97–01/12/98	AFRICAN ART: PERMUTATIONS OF POWER

Jacksonville

Cummer Gallery of Art

829 Riverside Ave., **Jacksonville, FL 32204**
📞 904-356-6857
HRS: 10-9 Tu & T; 10-5 W-F, Sa; 12-5 S DAY CLOSED: M HOL: 12/25, 1/1, EASTER, 7/4, THGV
F/DAY: 4-9 Tu ADM: Y ADULT: $5.00 CHILDREN: F under 5 STUDENTS: $3.00 SR CIT: $3.00
&: Y; Ramps, restrooms, etc. Ⓟ Y; Opposite museum at 829 Tiverside Ave. MUS/SH: Y
GR/T: Y GR/PH: CATR! 904-355-0630 DT: Y TIME: 10-3 Tu-F(by appt); 2:15 S (w/o appt)
H/B: Y; Garden founded in 1901 S/G: Y
PERM/COLL: AM: ptgs; EU: ptgs; OR; sculp; CER; DEC/ART; AN/GRK; AN/R; P/COL; IT/REN

Named for its founders and located on the picturesque site of the original family home, visitors can travel through 4,000 years of art history along the chronologically arranged galleries of the Cummer Museum. Though the building itself is relatively new, the original formal gardens remain for all to enjoy. **NOT TO BE MISSED:** One of the earliest and rarest collections of Early Meissen Porcelain in the world

ON EXHIBIT/97:

11/19/96–01/19/97	CELESTIAL MOTIFS — A holiday exhibition featuring the angel as subject matter.
12/12/96–02/16/97	RUSSIAN IMPERIAL PORCELAIN, 1744-1917 FROM THE RAYMOND F. PIPER COLLECTION — Opulent and extravagant porcelains from the Imperial Porcelain Factory in St. Petersburg, Russia, created between the reigns of Elizabeth I and Nicholas II, will be featured in this exhibition. CAT WT
12/12/96–03/15/97	EMPIRE AND EMPATHY: VINTAGE PHOTOGRAPHS FROM RUSSIA — On loan from a private Jacksonville collection, these rare photographs document the high and low of Russian society on the cusp of revolution.
01/30/97–04/13/97	JACKSONVILLE WATERCOLOR SOCIETY ARTIST OF THE YEAR
02/07/97–04/13/97	CALIFORNIA IMPRESSIONISTS — On exhibit will be nearly 65 works, painted between 1895 and the beginning of WWII, that define the California Impressionist style. CAT WT
05/09/97–08/10/97	A NIGHT AT THE OPERA: HISTORIC AND CONTEMPORARY PERFORMANCE COSTUMES — A dazzling display of costumes from the Metropolitan Opera Company will be on exhibit in conjunction with the grand opening of the Jacksonville Symphony & Performing Arts Center.
10/24/97–12/28/97	XIV MARINE SOCIETY EXHIBITION — A national juried exhibition featuring works by artists of the American Society of Marine Artists.
11/23/97–12/07/97	AIDS QUILT EXHIBITION TENT!

FLORIDA

Jacksonville

The Jacksonville Museum of Contemporary Art
4160 Boulevard Center Dr., **Jacksonville, FL 32207**
📞 904-398-8336
HRS: 10-4 Tu, W, F; 10-10 T; 1-5 Sa, S DAY CLOSED: M HOL: LEG/HOL!
ADM: Y ADULT: $3.00 CHILDREN: F (under 6) STUDENTS: $2.00 SR CIT: $2.00
&: Y Ⓟ Y; Free and ample MUS/SH: Y
GR/T: Y GR/PH: CATR! ed. dept. S/G: Y
PERM/COLL: CONT; P/COL

The finest art from classic to contemporary is offered in the Jacksonville Museum, the oldest museum in the city.
NOT TO BE MISSED: Collection of Pre-Columbian art on permanent display

ON EXHIBIT/97:

12/12/96–01/19/97	BREAKING BOUNDARIES: DRAWING IN THE 90'S — An exhibit of contemporary drawings from across the nation. TENT!
12/12/96–01/19/97	ART IN CELEBRATION — As part of the traveling "Artrain" project sponsored by the Smithsonian Institution, an actual train which is a museum in motion will bring works commemorating significant historical events since 1972, by such world-renowned artists as Georgia O'Keeffe, James Rosenquist, Dale Chihuly, William de Kooning and others.
01/07/97–02/16/97	MARCIA RAFF — Sculptures of bronze, wood and stone by local artist Raff will be on view.
02/14/97–04/27/97	ELECTRONIC SUPER HIGHWAY: NAM JUNE PAIK IN THE '90'S — Paik's monumental multi-television monitor installation addresses the significance of the electronic media on modern culture. TENT! CAT WT
02/25/97–04/20/97	PAUL KARABINIS — Contemporary photographic tableau by Karabinis, a professor of photography at the University of North Florida, will be featured.
05/08/97–07/13/97	LINDA BROADFOOT — An exhibition of large dramatic photographs.
06/12/97–08/10/97	RICHARD CARNER — Local artist Carner's wood sculptures will be highlighted.
06/12/97–08/10/97	FLORIDA CRAFTSMEN: PHILIP WARD MEMORIAL CERAMICS EXHIBITION — A historical overview of the contemporary ceramics movement in Florida will be included in this retrospective exhibition of the last 3 decades of Florida clayworks.
07/29/97–09/21/97	JOE SEGAL — On exhibit will be works by local sculptor Segal who utilizes the splitting, charring and burning of wood and mixed media to explore the relationship and interaction of materials in his creations.
09/30/97–11/23/97	ALLISON WATSON — Paintings that focus on the beauty of the Florida landscape by local artist Watson will be featured in this exhibition.
11/21/97–01/11/98	MILDRED THOMPSON — A display of African-American artist Thompson's large color field paintings inspired by new physics theories.
12/02/97–01/25/98	MARK MESSERSMITH — An exhibition of paintings by Florida artist Messersmith.

Lakeland

Polk Museum of Art
800 E. Palmetto, **Lakeland, FL 33801**
☎ 941-688-7743
HRS: 9-4 Tu-F, 10-4 Sa, Noon-4 S DAY CLOSED: M HOL: LEG/HOL!
VOL/CONT: Y &: Y; Fully accessible by wheelchair;" Hands-On" for visually impaired ℗ Y; Free lot in front of museum
MUS/SH: Y GR/T: Y GR/PH: CATR! S/G: Y
PERM/COLL: P/COL; REG; AS: cer, gr; EU: cer, glass, silver 15-19: AM: 20; PHOT

Located in central Florida about 40 miles east of Tampa, the 37,000 square foot Polk Art Museum, built in 1988, offers a complete visual and educational experience to visitors and residents alike. The Pre-Columbian Gallery with its self-activated slide presentation and its hands-on display for the visually handicapped is but one of the innovative aspects of this vital community museum and cultural center. **NOT TO BE MISSED:** "El Encuentro" by Gilberto Ruiz; Jaguar Effigy Vessel from the Nicoya Region of Costa Rica (middle polychrome period, AD 800-1200)

ON EXHIBIT/97:

12/07/96–02/02/97	ROARING DOWN THE MOUNTAIN WIND: POWER AND PRIDE IN LATER KOREAN PAINTING — Screens and scroll paintings of political, genre scenes, still lifes, landscapes and tigers on loan from a private collection will be shown along with a number of small personal objects in an exhibition designed to highlight art forms favored by the people of Korea during the late 18th to the early 20th-century
01/04/97–03/23/97	ETCHINGS OF FLORIDA BY KENT HAGERMAN
02/15/97–04/13/97	MY MESSAGE IS THE PEOPLE: AN EXHIBITION OF DRAWINGS AND PRINTS BY MOSES SOYER FROM THE MUSEUM OF ARTS AND SCIENCES, DAYTONA BEACH — An exhibition of realist works by Moses Soyer (1899-1974), a painter who was among the aesthetic heirs of Robert Henri, George Bellows, and John Sloan, and who is considered one of the most important American figurative painters of the 20th-century
03/28/97–06/22/97	KIMURA MORIKAZU: MASTER OF THE TEMMOKU — Donated to the museum by Mr. G.E. Robert Mayer, these 22 Chinese-style iron glazed vessels by Morikazu are examples of his perfection temmoku glazes, a technique derived from iron oxide.
03/28/97–06/22/97	THE THIRTY-TWO ASPECTS OF DAILY LIFE — On exhibit will be the complete 1888 folio of late Ukioyo-e prints by Yoshitoshi depicting images of women at work.
04/05/97–06/22/97	THE PATTERN AND DECORATION MOVEMENT: SELECTIONS FROM THE PMA COLLECTION
04/26/97–06/29/97	CASTING HER BREAD UPON THE WATERS: FOLK ART IMAGES OF RUBY C. WILLIAMS — Folk art images by Williams, a Florida native, reflect both her life experiences and those of her neighbors.
04/26/97–06/29/97	FROM THE EDGE OF PARADISE: EDOUARD DUVAL CARRIE — Paintings by Carrie, a Haitian-born artist who blends African and French cultures to create surreal works which contain elements of the baroque & modern and whose subject matter is inspired by a combination of Christian & voodoo religions and aspects of Asian philosophies.
06/28/97–09/07/97	GUNTER WIRTH: CONSTRUCTIVE BALANCE
06/28/97–09/07/97	FLORIDA PHOTOGRAPHERS FROM THE PMA
07/11/97–09/07/97	SOUL'S SHADOW: PHOTOGRAPHY FROM THE SOUTHERN CRESCENT — Memories of a rural South and images of the new will be seen in this social history survey of 20th-century photographic works by emerging southern artists.
09/12/97–11/02/97	EXPANDING EXPRESSIONS: CONTEMPORARY MASTER PRINTS FROM THE DOROTHY MITCHELL COLLECTION — Brad Davis, Sam Gilliam and Miriam Schapiro are among the 7 internationally-known artists whose prints will be featured in an exhibition that explores new territory in their use of non-toxic acrylic inks as a means to developing and exploring new possibilities in the medium of printmaking.
11/04/97–01/04/98	BEARING WITNESS: CONTEMPORARY WORKS BY AFRICAN AMERICAN WOMEN ARTISTS — Issues of race, ethnicity, gender, class, sexual orientation and religion will be seen in this multi-media exhibition of works by 27 prominent contemporary artists including Elizabeth Catlett, Betye Saar, Faith Ringold, Lois Mailou Jones and others.

WT

FLORIDA

Maitland

Maitland Art Center
231 W. Packwood Ave., **Maitland, FL 32751-5596**
☎ 407-539-2181
HRS: 10-4:30 M-F; Noon-4:30 Sa, S HOL: LEG/HOL!
VOL/CONT: Y &: Y; All public areas and facilities are accessible
P: Y; Across the street from the Art Center with additional parking just west of the Center MUS/SH: Y
GR/T: Y GR/PH: CATR! (Ann Spalding, Ed. Coord.) DT: Y TIME: upon request if available
H/B: Y; State of Florida Historic Site
PERM/COLL: REG: past & present

The stucco buildings of the Maitland Center are so highly decorated with murals, bas reliefs, and carvings done in the Aztec-Mayan motif, that they are a "must-see" work of art in themselves. One of the few surviving examples of "Fantastic" Architecture remaining in the southeastern U.S., the Center is listed in the N.R.H.P. **NOT TO BE MISSED:** Works of Jules Andre Smith, (1890 - 1959), artist and founder of the art center

ON EXHIBIT/97:

01/11/97–02/16/97	DUO — Works by Carlos Richmond and Kim Ik-Mo, two central Florida artists will be on exhibit.
02/23/97–03/30/97	ART IN A CHANGING ERA: RUSSIAN CHILDREN'S ART — 25 artworks by children at the Kirov Performing and Visual Arts School will be featured. WT
04/05/97–05/11/97	ARTHUR JONES, WOODWORK — A display of traditional and contemporary vessels created from indigenous woods by self-taught central Florida artist Jones.
05/16/97–08/29/97	CHINA: EXPLORING THE INTERIOR, 1903-1904 — 49 photographic enlargements printed from original negatives will be presented in an exhibition that documents the personal record of Maine photographer R. Harvey Sargent's life in northern China in the wake of the Boxer Rebellion.
09/06/97–10/19/97	RIMA JABBUR: RECENT WORKS — Featured will be paintings by Jabbur, a central Florida artist who was born in the Middle East and raised in Syria.
11/14/97–01/04/98	PALETTE/PLATE — A invitational exhibition of works created for the gallery by 30-35 central Florida artists.

Melbourne

Brevard Art Center and Museum Inc.
1463 Highland Ave., **Melbourne, FL 32935**
☎ 407-242-0737
HRS: 10-5 Tu-Sa, 1-5 S DAY CLOSED: M HOL: LEG/HOL!
ADM: Y ADULT: $3.00 CHILDREN: $2.00
&: Y; Ramps, restrooms, wheelchairs available
℗ Y; Free and ample in lot on Pineapple Ave. in front of the museum MUS/SH: Y GR/T: Y GR/PH: CATR! DT: Y
TIME: 2-4 Tu-F; 12:30-2:30 Sa; 1-5 S
PERM/COLL: OR; REG: works on paper

Serving as an active community cultural center, the recently renovated Brevard Art Center & Museum is located in the historic Eay Gallie district of Melbourne near the center of the state.

ON EXHIBIT/97: Exhibits change routinely

112

Miami

The Art Museum at Florida International University
University Park, PC 110, **Miami, FL 33199**
☎ 305-348-2890
HRS: 10-9 M, 10-5 Tu-F, Noon-4 Sa DAY CLOSED: S HOL: ACAD!, MEM/DAY, 7/4
⚹: Y ℗ Y; Metered parking available in the PC parking area across from the museum GR/T: Y GR/PH: CATR! S/G: Y
PERM/COLL: GR: 20; P/COL; CONT/HISPANIC (CINTAS FOUNDATION COLL); ARTPARK AT FIU

Major collections acquired recently by this fast growing institution include the Coral Gable's Metropolitan Museum and Art Center's holdings of African, Oriental, Pre-Columbian, 18-20th-century American & Latin American art and a long-term loan of the Cintas Fellowship Foundation's Collection of contemporary Hispanic art. **NOT TO BE MISSED:** "Museum Without Walls" Art Park featuring the Martin Z. Margulies Sculpture Collection including works by Calder, Serra, de Kooning, DiSuvero, Flannigan, Caro, Barofsky and Dubuffet.

ON EXHIBIT/97:

01/10/97–02/15/97	AMERICAN ART TODAY: THE GARDEN — An exhibition designed to explore the ways in which contemporary artists interpret the traditional theme of the garden.
02/28/97–04/02/97	GUIDO LLINAS AND LOS ONCE AFTER CUBA — On exhibit will be works by Llinas, an artist who was part of the Los Once group of Cuban exile artists influenced primarily by American abstract expressionism.
SPRING/97–SUMMER/97	STUDENT & FACULTY SHOWS
09/12/97–11/09/97	LIFE CYCLES: THE CHARLES E. BURCHFIELD COLLECTION — On view will be 62 paintings by Burchfield (1893-1967), a man whose original style helped to inspire several generations of artists. His works reflected strong concerns for the dwindling of America's virginal landscape, the passage of time, and memories of childhood. WT

Miami

The Miami Art Museum of Dade County
101 W. Flagler St., **Miami, FL 33130**
☎ 305-375-3000
HRS: 10-5 Tu-F; till 9 T; Noon-5 Sa, S DAY CLOSED: M HOL: THGV, 12/25, 1/1
F/DAY: 5-9 T; by cont. Tu ADM: Y ADULT: $5.00 CHILDREN: F (under 12) STUDENTS: $2.50 SR CIT: $2.50
⚹: Y; Elevator on N.W. 1st St. ℗ Y; Discounted rate of $2.00 with validated ticket at Cultural Center Garage, 50 NW 2nd Ave.
MUS/SH: Y GR/T: Y GR/PH: CATR! 305-375-4073 DT: Y TIME: 12:15 1st Tu; 7:00 T; family tours 2:00 Sa
H/B: Y; Designed by Philip Johnson 1983 S/G: Y
PERM/COLL: The acquisition of a permanent collection is now underway.

Exhibiting and collecting post-war international art, with a focus on art of the America's is the primary mission of this center for the fine arts. This stunning facility, formerly called the Center for the Fine Arts, was designed and built in 1983 by noted American architect Philip Johnson. It recently changed its name to The Miami Art Museum of Dade County. PLEASE NOTE: There is a special program or performance at the center every Thursday night at 7:30. On Tuesday visitors are admitted for a contribution of their choice.

ON EXHIBIT/97:

10/11/96–01/12/97	NEW WORK: RUBEN TORRES-LLORCA — In this exhibition the artist has created what he calls "Nine Visits of the Artist's Studio" consisting of nine small room assemblages full of specific items relating to the artist himself and his creative process.
11/01/96–04/27/97	DREAM COLLECTION: II — On view will be the first gifts to the museum's holdings accompanied by works that embody the vision for the permanent collection.
12/19/96–02/23/97	CONTINUITY AND CONTRADICTION: A NEW LOOK AT THE PERMANENT COLLECTION — From the Museum of Contemporary Art, San Diego, an exhibition of 50 varied artworks by Joseph Cornell, Sol LeWitt, Roy Lichtenstein, Kiki Smith and others reflect the diversity and vitality of this collection.

FLORIDA

The Miami Art Museum of Dade County - continued

03/13/97–05/25/97	ART WORKS: THE PAINE WEBBER COLLECTION OF CONTEMPORARY MASTERS — Many of the major art trends of the past 4 decades including Abstract Expressionism, Minimalism, Conceptualism, and Neo-Expressionism will be seen in the only West Coast venue of 70 important works from this stellar corporate collection.
05/10/97–06/27/97	1997 SOUTH FLORIDA CULTURAL CONSORTIUM FELLOWSHIP RECIPIENTS EXHIBITION — Works by 6 south Florida artists who have received this distinguished fellowship.
09/18/97–11/30/97	POINTS OF ENTRY — Three inter-related photographic exhibitions document the history of the American immigrant experience. CAT WT
12/18/97–03/07/98	TRIUMPH OF THE SPIRIT: CARLOS ALFANSO, A SURVEY 1976-1991 — 25 large-scale paintings and 20 works on paper accompanied by related sculptures by the late Cuban-American painter Alfonso, will be on loan from private and public U.S. collections in the first career survey of his work. CAT

Miami

Miami-Dade Community College Kendall Campus Art Gallery

11011 Southwest 104th St., **Miami, FL 33176-3393**
☎ 305-237-2322
HRS: 8-4 M & T; Noon-7:30 Tu-W (Jun-early Aug); 8-4 M, T, F; Noon-7:30 Tu, W Other DAY CLOSED: Sa, S HOL: 12/25, LEG/HOL!
⅃: Y Ⓟ Y; Free parking anywhere in student lots except for areas prohibited as marked ¶ Y; Restaurant DT: Y
PERM/COLL: CONT: ptgs, gr, sculp, phot; GR: 15-19

With nearly 600 works in its collection, the South Campus Art Gallery is home to original prints by such renowned artists of the past as Whistler, Tissot, Ensor, Corot, Goya, in addition to those of a more contemporary ilk by Hockney, Dine, Lichtenstein, Warhol and others. **NOT TO BE MISSED:** "The Four Angels Holding the Wings," woodcut by Albrecht Dürer, 1511

Miami Beach

Bass Museum of Art

2121 Park Ave., **Miami Beach, FL 33139**
☎ 305-673-7530 WEB ADDRESS: http://ci.miami-beach.fl.us/culture/bass/bass/html
HRS: 10-5 Tu-Sa, 1-5 S, 1-9 2nd & 4th W of the month DAY CLOSED: M HOL: LEG/HOL!
F/DAY: after 5 2nd & 4th W ADM: Y ADULT: $5.00 CHILDREN: F (under 6); other! STUDENTS: $3.00 SR CIT: $3.00
⅃: Y Ⓟ Y; On-site metered parking and street metered parking MUS/SH: Y
GR/T: Y GR/PH: CATR! S/G: Y
PERM/COLL: PTGS, SCULP, GR 19-20; REN: ptgs, sculp; MED; sculp, ptgs; PHOT; OR: bronzes

Just one block from the beach in Miami in the middle of a 9 acre park is one of the great cultural treasures of Florida. Located in a stunning 1930 Art Deco building, the museum is home to more than 6 centuries of artworks including a superb 500 piece collection of European art donated by the Bass family for whom the museum is named. **NOT TO BE MISSED:** "Samson Fighting the Lion," woodcut by Albrecht Dürer

ON EXHIBIT/97:

12/12/96–02/09/97	REAL — Figurative narrative works by contemporary African-American artists will be presented in an exhibition designed to look at how their contemporary realist works are used to convey the essence of their artists lives in relation to the traditions of earlier generations of black artists.
12/12/96–01/19/97	HONORÉ DAUMIER: PRINTS AND SCULPTURES FROM THE BENJAMIN TRUSTMAN COLLECTION — On loan from one of the most exceptional collections of works by Daumier, a 19th-century French lithographer, journalist and artist who chronicled the social conditions of his time, will be 85 prints on the theater, legal profession, women and others. Works of sculpture including his most famous "Ratapoil," a caricature of Napoleon, will also be on exhibit.

Bass Museum of Art - continued

02/06/97–04/06/97	MERET OPPENHEIM: BEYOND THE TEACUP — Works on loan from his family, private lenders, and European museums will be featured in the first retrospective exhibition in America for Oppenheim (1913-1985), an artist who is considered an icon of 20th-century art and the Surrealist movement and who is best recognized as the creator of a fur-lined tea cup entitled "Déjuner en Fourrure," 1936. CAT WT
04/23/97–06/30/97	DESERT CLICHÉ: ISRAEL NOW - LOCAL IMAGES — Divided into themes including popular clichés, nationally charged symbols and myths, overused media images and the like, this exhibition focuses on stereotypical Israeli images as a response to the political entanglement characterizing life in modern-day Israel. CAT
09/97	PUTT-MODERNISM: MINIATURE GOLF COURSE AND EXHIBITION — A unique fully playable 18 hole miniature golf course with each hole designed by one of 19 different artists. This interactive installation will take each participant through holes that combine elements of humor, kitsch, and social commentary as interpreted by such artists as Sandy Skoglund, Michael Graves, Jenny Holzer and others.

Miami Beach

The Wolfsonian
1001 Washington Ave., **Miami Beach, FL 33139**
☎ 305-531-1001
HRS: 10-6 Tu-Sa, till 9 T, Noon-5 S
F/DAY: 6-9 T ADM: Y ADULT: $5.00 CHILDREN: F (under 6) STUDENTS: $3.50 SR CIT: $3.50
MUS/SH: Y GR/T: Y GR/PH: CATR!
PERM/COLL: AM & EU: furn, glass, cer, metalwork, books, ptgs, sculp, works on paper, & industrial design 1885-1945

Recently opened, The Wolfsonian, which oversees the 70,000 object Mitchell Wolfson, Jr. collection of American and European art and design dating from 1885-1945, was established to demonstrate how art and design are useful in cultural, social and political contexts. It is interesting to note that the museum is located in the heart of the lively newly redeveloped South Beach area. PLEASE NOTE: Admission entry fees are reduced in the summer.

ON EXHIBIT/97:

02/97–05/97	ARCHIBALD KNOX, 1864-1933 — Long associated with British Art Nouveau, Knox was one of the most innovative and progressive designers in modern British history. This first ever exhibition of his work in America features loan items from London's Silver Studio Collection and objects selected from the permanent collection of the Wolfsonian Foundation in Miami, FL.
06/97–09/97	MIND MOVES: CONTEMPORARY VISIONS OF THE PAST — An exhibition of works from the permanent collection selected for viewing by contemporary architects, artists and writers.
10/97–02/98	ART OF (in) TOLERANCE — German anti-semitic beer steins and American enlistment posters will be among the items on view in an exhibit designed to elucidate how particular imagery can result in communicating messages that are the essence of hatred and discrimination.

Naples

Philharmonic Center for the Arts
5833 Pelican Bay Blvd., **Naples, FL 33963-2740**
☎ 941-597-1111
HRS: OCT-MAY: 10-4 M-F, (10-4 Sa theater schedule permitting) HOL: LEG/HOL!
ADM: Y ADULT: $3.00 STUDENTS: $1.50
&: Y ℗ Y; Free MUS/SH: Y
GR/T: Y GR/PH: CATR! ext. 279 DT: Y TIME: OCT & MAY: 11 AM T & Sa; NOV-APR: 11 AM M through Sa

FLORIDA

Philharmonic Center for the Arts - continued

Four art galleries, two sculpture gardens, and spacious lobbies where sculpture is displayed are located within the confines of the beautiful Philharmonic Center. Museum quality temporary exhibitions are presented from October through May of each year.

ON EXHIBIT/97:

12/10/96–01/25/97	PICASSO CERAMICS — Inspired by Pre-Columbian pottery and his Spanish heritage, the 50 ceramic and sculptural objects highlighted in this exhibition, created by Picasso between 1947-1971, demonstrate his artistic development within this medium. WT
12/10/96–01/25/97	DARRYL POTTORFS "WINTER WORK"
12/10/96–01/25/97	ROBERT RAUSCHENBERG'S "ANAGRAMS"
02/04/97–03/29/97	THE MAGIC OF GLASS — In celebration of 35 years of contemporary glass in the United States, this exhibit highlights works by 15 contemporary American masters of the medium.
02/04/97–03/29/97	LYNN CHADWICK: TO CREATE AND CONSTRUCT — On exhibit will be works by Chadwick, one of the most important sculptors working today.
04/08/97–05/24/97	AMERICA SEEN: PEOPLE AND PLACE — The American experience of the 1920's through the 1950's is explored through 78 paintings, prints and photographs. Included are works by Grant Wood, Norman Rockwell, John Stuart Curry, Thomas Hart Benton and others who document two world wars, the Great Depression, the New Deal, the growth of the American city and the nostalgia for simple rural life. WT

North Miami

The Joan Lehman Museum of Contemporary Art

770 NE 125th St., **North Miami, FL 33161**
☎ 305-893-6211
HRS: 10-5 Tu-Sa, 12-5 S DAY CLOSED: . HOL: 12/25, 1/1, THGV
F/DAY: Tu (vol/contr) ADM: Y ADULT: $4.00 CHILDREN: F (under 12) STUDENTS: $2.00 SR CIT: $2.00
♿: Y P: Y; Free parking to the east, south and west of the museum.
GR/T: Y GR/PH: CATR! DT: Y TIME: 2 PM Tu & S, 1 PM Sa
PERM/COLL: CONT

In operation since 1981, the museum was, until now, a small but vital center for the contemporary arts. Recently the museum opened a new state-of-the-art building renamed The Joan Lehman Museum of Contemporary Art in honor if its great benefactor. Part of a new civic complex for North Miami, the museum provides an exciting and innovative facility for exhibitions, lectures, films and performances.

ON EXHIBIT/97:

12/20/96–02/23/97	ROBERT CHAMBERS — Billowing and expanding cascades of crumpled silk revealed behind an open theater curtain form the basis of this multi-media installation by Miami-based artist Chambers.
12/20/96–02/16/97	PAINTING INTO PHOTOGRAPHY, PHOTOGRAPHY INTO PAINTING — The interplay between painting and photography will be explored in an exhibition that highlights the crossover in recent years between the two mediums. Works by such contemporary artistic luminaries as Richard Artschwager, John Baldessari, Chuck Close, Gerhard Richter and others will be featured.
03/06/97–04/20/09	HIGHLIGHTS FROM THE PERMANENT COLLECTION — Works by Jasper Johns, Alex Katz, James Rosenquist, Roberto Juarez, and others from this newly established collection will be shown in an exhibition designed to complement the museum's new building and gallery space.
05/08/97–07/27/97	TABLEAUX — On exhibit will be recent figurative narrative sculpture which makes allusions to painting.

Ocala

Appleton Museum of Art
4333 E. Silver Springs Blvd., **Ocala, FL 34470-5000**
☎ 352-236-5050
HRS: 10-4:30 Tu-Sa, 1-5 S DAY CLOSED: M HOL: 1/1
ADM: Y ADULT: $3.00 CHILDREN: F (under 18) STUDENTS: $2.00 SR CIT: $3.00
&: Y; Elevators, wheelchairs, and reserved parking available ℗ Y; Free MUS/SH: Y ‖ Y; Courtside Cafe
GR/T: Y GR/PH: CATR! 352-236-7113 DT: Y TIME: 1:15 Tu-F
PERM/COLL: EU; PR/COL; AF; OR; DEC/ART

The Appleton Museum in central Florida, home to one of the finest art collections in the Southeast, recently opened the Edith-Marie Appleton wing which allows for the display of a great deal more of its ever expanding collection. Situated among acres of tall pines and magnolias, the dramatic building sets the tone for the many treasures that await the visitor within its walls. PLEASE NOTE: Admission fees are expected to increase after 1/97! **NOT TO BE MISSED:** Rodin's "Thinker," Bouguereau's "The Young Shepherdess" and "The Knitter"; 8th-century Chinese Tang Horse

ON EXHIBIT/97:

11/19/96–01/12/97	SELECTIONS FROM CHROMA — Ranging from abstraction to photo-realism the paintings on view by 12 Florida artists are all noted for their use of color.
11/19/96–01/12/97	JAMES BOJARZUK — Abstract paintings will be featured in an exhibition for Bojarzuk, an artist who is creating a work of interchangeable panels specifically for the museum's new Rotunda gallery.
01/21/97–03/16/97	THE WEAVE OF LIFE — Symbolism and design in Native American art will be explored in textile weavings, a craft traditionally done by men, and basketry, a female craft.
03/23/97–05/25/97	BRITISH WATERCOLORS AND DRAWINGS (Working Title) — 18th and 19th-century British drawings and watercolors from what is considered their golden age will be on loan from private collections.
06/01/97–07/27/97	AILENE FIELDS: ALLEGORY - THE TIMELESS TRUTH — Various fairy tales and classical myths as depicted by Fields will be seen in the 33 alabaster and bronze sculptural forms on view.
06/01/97–07/27/97	CHILDREN'S INTERNATIONAL PEACE MURALS — Created by children the world over, the six 25' x 8' murals reflect their concerns about war and peace in their own cultural context.
08/03/97–09/28/97	TBA
10/03/97–11/02/97	BILL SCHAAF - HORSES (Working Title) — Multi-media abstracted images of horses by Schaaf will be on view.
10/03/97–11/02/97	AMERICAN ACADEMY OF EQUINE ART INVITATIONAL SHOW — Paintings, drawings, sculpture and watercolor images on the theme of the horse by artists from across the country will be seen in this juried exhibition.
11/09/97–01/04/98	KATHERINE MYERS - PAINTINGS (Working Title)

Orlando

Orlando Museum of Art
2416 North Mills Ave., **Orlando, FL 32803-1483**
☎ 407-896-4231
HRS: 9-5 Tu-Sa, Noon-5 S DAY CLOSED: M HOL: LEG/HOL!
ADM: Y ADULT: $4.00 CHILDREN: $2.00 (4-11) STUDENTS: $4.00 SR CIT: $4.00
&: Y ℗ Y; Free on-site parking for 200 cars in the front of the museum; overflow lot approximately 1/8 mile away.
MUS/SH: Y GR/T: Y GR/PH: CATR! - ext. 260 DT: Y TIME: 2:00 T & S
PERM/COLL: P/COL; AM; 19-20; AM: gr 20; AF

Orlando Museum of Art - continued

Designated by the state of Florida as a "Major Cultural Institution," the Orlando Museum, established in 1924, recently completed Phase One of its expansion program. When Phase II, which was launched in the fall of 1995, is complete, the OMA will be the only museum in the nine-county area of central Florida capable of providing residents and tourists with "world class" art exhibits. PLEASE NOTE: The "Imperial Tombs of China," the only traveling exhibition scheduled for the museum in 1997, will be the debut show for the completion of Phase II of the museum's new wing. **NOT TO BE MISSED:** Permanent collection of Pre-Columbian artifacts (1200 BC to 1500 AD) complete with "hands-on" exhibit; Art Encounter

ON EXHIBIT/97:

ONGOING	18TH, 19TH AND 20TH-CENTURY AMERICAN PORTRAITS & LANDSCAPES ON LONG-TERM LOAN FROM MARTIN AND GRACIA ANDERSON — On view are works by Thomas Moran, Rembrandt Peale, John Henry Twatchman and others whose paintings reflect the many forces that shaped American art from the Colonial period to the early 20th-century.
	SELECTIONS FROM THE PAUL AND RUTH TISHMAN COLLECTION OF AFRICAN ART LOANED BY THE WALT DISNEY WORLD COMPANY — One of the finest collections of its kind in size and quality.
	PRE-COLUMBIAN ART — 150 Pre-Columbian artifacts (1200 BC to 1500 AD)
	GLIMMERS OF A FORGOTTEN REALM: MAYA ARCHAEOLOGY FROM CARACOL, BELIZE — Recent discoveries from one of the most important Classic Maya Cities
	ART ENCOUNTER — A hands-on art exhibition for young children and families sponsored by The Walt Disney Company offered at 12-5 Tu-F & S, and 10-5 Sa. Visitors to this exhibition enter through a separate entrance to the left of the main museum entry. The hands-on experience is included in the general admission fee.
	PEGGY CROSBY STUDENT GALLERY — "Young at Art" student work
05/02/97–09/15/97	IMPERIAL TOMBS OF CHINA — In one of the most dazzling and important exhibitions of Chinese fine and decorative art ever brought to America, 300 painting, calligraphic, jade, bronze and ceramic masterpieces created over 4 millennia will be on view with a wide variety of decorative arts objects. PLEASE NOTE: Tickets to this exhibition will cost $12.00 for adults, $6.00 for children ages 4-16, and $10.00 for students and seniors. Group rates and season passes will also be available. CAT ADM FEE ATR! WT ⌒

Palm Beach

Hibel Museum of Art

150 Royal Poinciana Plaza, **Palm Beach, FL 33480**
☎ 407-833-6870
HRS: 10-5 Tu-Sa, 1-5 S DAY CLOSED: M HOL: THGV, 12/25, 1/1, 7/4
&: Y; Through rear door; all works displayed on ground floor
Ⓟ Y; Free parking in the rear of the museum and the Royal Poinciana Plaza in front of the museum
MUS/SH: Y GR/T: Y GR/PH: CATR! DT: Y TIME: Upon request if available
PERM/COLL: EDNA HIBEL: all media

The 20 year old Hibel Museum is the world's only publicly owned non-profit museum dedicated to the art of a single living American woman.

ON EXHIBIT/97:

02/15/97–06/30/97	SPECIAL EXHIBIT TO CELEBRATE THE 20TH ANNIVERSARY OF THE HIBEL MUSEUM

Palm Beach

The Society of the Four Arts
Four Arts Plaza, **Palm Beach, FL 33480**
☎ 516-655-7227
HRS: 12/4-4/17: 10-5 M-Sa, 2-5 S HOL: Museum closed May-Oct
SUGG/CONT: Y ADULT: $3.00 ⅊: Y Ⓟ Y; Ample free parking GR/T: Y GR/PH: CATR! S/G: Y
PERM/COLL: SCULP

Rain or shine, this museum provides welcome relief from the elements for all vacationing art fanciers by presenting monthly exhibitions of paintings or decorative arts. **NOT TO BE MISSED:** Philip Hulitar Sculpture Garden

ON EXHIBIT/97:

01/11/97–02/09/97	MiNGEi: JAPANESE FOLK ART FROM THE MONTGOMERY COLLECTION — 15th through 19th-century paintings, textiles, sculpture, woodwork, ceramics, lacquerware, metalwork, basketry, and paper objects will be presented in an exhibit of 175 objects of "Mingei" folk art (gei) for people (min) on loan from one of the world's greatest collections of its kind. WT
02/15/97–03/16/97	TWO HUNDRED YEARS OF ENGLISH NAIVE ART 1700-1900 — 100 late 17th & 18th-century charming English naive oil paintings, watercolors, and objects of decorative art will be on loan from public & private collections in Britain, the U.S. & Canada. CAT WT
02/28/97–04/19/97	19TH ANNUAL GIFTED CHILD EXHIBITION
03/22/97–04/13/97	THE SPIRIT OF MONTMARTRE: CABARETS, HUMOR, AND THE AVANT-GARDE 1875-1905 — Focusing on the collection between artists, writers and musicians from the Jane Voorhees Zimmerli Art Museum of Rutgers, this exhibition documents the artistic community which developed in Montmartre at the end of the 19th-century. WT

Pensacola

Pensacola Museum of Art
407 S. Jefferson St., **Pensacola, FL 32501**
☎ 904-432-6247
HRS: 10-5 Tu-F, 10-4 Sa, 1-4 S DAY CLOSED: M HOL: LEG/HOL!
F/DAY: Tu ADM: Y ADULT: $2.00 STUDENTS: $1.00
⅊: Y Ⓟ Y; Free vacant lot across street; also 2 hour metered and non-metered street parking nearby. MUS/SH: Y
GR/T: Y GR/PH: CATR! DT: Y TIME: ! check for availability H/B: Y
PERM/COLL: CONT/AM: ptgs, gr, works on paper; Glass: 19, 20

Now renovated and occupied by the Pensacola Museum of Art, this building was in active use as the city jail from 1906 - 1954.

ON EXHIBIT/97:

12/15/96–02/16/97	DORIS LEEPER AND HER SCULPTURES — Sculpture of multiple geometric shapes, often abstract in style, will be featured in an exhibition of works by Leeper, one of the nation's most outstanding sculptors who is a long-time Florida resident.
01/07/97–02/21/97	KEN FALANA: A WORLD OF COLOR — Painstaking collage constructions by Falana, one of Florida's major artists, reflect his passion for exploring pattern & color relationships through vibrant 2 & 3 dimensional works. CAT WT
03/02/97–04/27/97	A RIVER OF GRASS: PAINTINGS OF THE EVERGLADES — One of a pair of exhibitions by Florida artists whose works document the beauty of the Everglades. WT
04/29/97–06/01/97	PHOTOGLYPHS: RIMMA GELOVINA AND VALERIY GERLOVIN — Featured will be photographs by this Russian husband-and-wife team who were part of the movement to circumvent official censorship of art while in Russia.
06/14/97–07/28/97	AN OCEAN APART: CONTEMPORARY VIETNAMESE ART FROM THE UNITED STATES AND VIETNAM — Aspects of Vietnamese customs & traditions and their transformation & adaption through the influence of American culture will be seen in this exhibition of 80 contemporary works by 34 Vietnamese and Vietnamese-American artists. WT
08/08/97–09/28/97	THE MEMBERS SHOW

FLORIDA

Sarasota

John and Mable Ringling Museum of Art
5401 Bay Shore Rd., **Sarasota, FL 34243**
☎ 941-355-5101
HRS: 10-5:30 Daily HOL: THGV, 12/25, 1/1
F/DAY: Sa ADM: Y ADULT: $8.50 CHILDREN: F (12 & under) SR CIT: $7.50
&: Y ; All art & circus galleries; first floor only of mansion
Ⓟ Y; Free MUS/SH: Y ¶ Y; 11-4 DAILY
GR/T: Y GR/PH: CATR! DT: Y TIME: call 813-351-1660 (recorded message)
H/B: Y ; Ca'D'Zan was the winter mansion of John & Mable Ringling S/G: Y
PERM/COLL: AM: ptgs, sculp.; EU: ptgs, sculp 15-20; DRGS; GR; DEC/ART; CIRCUS MEMORABILIA

Sharing the grounds of the museum is Ca'd'Zan, the winter mansion of circus impresario John Ringling and his wife Mable. Their personal collection of fine art in the museum features one of the country's premier collections of European, Old Master, and 17th-century Italian Baroque paintings. **NOT TO BE MISSED:** The Rubens Gallery - a splendid group of paintings by Peter Paul Rubens.

ON EXHIBIT/97:

ONGOING	MAIOLICA TO MONSTRANCE: DECORATIVE ARTS AT THE RINGLING
01/19/96–12/28/97	JOHN RINGLING: DREAMER-BUILDER-COLLECTOR
01/19/97–03/31/97	COLLECTION HIGHLIGHTS I, JOHN RINGLING COLLECTS: PAINTINGS
02/01/97–12/28/97	THE ASTOR ROOMS: NINETEENTH CENTURY BEAUX ARTS STYLE
03/29/97–12/28/97	PETER PAUL RUBENS AND THE TRADITIONS OF TAPESTRY
04/27/97–08/31/97	COLLECTION HIGHLIGHTS II, JOHN RINGLING COLLECTS: PAINTING AND SCULPTURE
05/31/97–12/28/97	ALEXANDER SERIES TAPESTRIES
09/27/97–12/28/97	COLLECTION HIGHLIGHTS III, JOHN RINGLING COLLECTS: GAVET, CYPRIOT, & DECORATIVE ARTS

St. Petersburg

Florida International Museum
100 Second St. North, **St. Petersburg, FL 33701**
☎ 813-824-6734
HRS: 9 AM - 6 PM daily
ADM: Y ADULT: $14.50 CHILDREN: $5.00 (5-16) SR CIT: $13.25
&: Y; Fully accessible with wheelchairs available free of charge
Ⓟ Y; On-site garage parking with entry at 218 Second Ave. North MUS/SH: Y ¶ Y; On-site food service GR/T: Y GR/PH: Call for reservations and information

Created to host grand-scale traveling exhibitions from some of the world's most prestigious museums, Florida International Museum, now in its 3rd year, will offer "Alexander the Great - The Exhibition," a presentation that once again promises to be one of the artistic highlights of the year. PLEASE NOTE: The museum will be closed for the holidays on 11/28, 12/24, 12/25, 12/31 and 1/1.

120

Florida International Museum - continued
ON EXHIBIT/97:

10/01/97–03/31/97	ALEXANDER THE GREAT - THE EXHIBITION — Organized primarily by The Greek Ministry of Culture and The Fondazione Memmo of Rome, Italy, more than 500 masterpieces on loan from 45 museums worldwide, will be displayed topically in this never-to-be-duplicated collection of art and statuary. Ranging from classic marble statues of Alexander the Great and a gold medallion portrait of his mother to an original 10' long pebble mosaic, this exhibition is intended to dazzle all who view it. PLEASE NOTE: Tickets must be purchased for a specific date and entry time as only a limited number of visitors will be admitted every 15 minutes. Ticket prices are $14.50 for adults, $13.25 for seniors, and $5.00 for children ages 5-16 (special rates for groups of 20 or more) and may be purchased in advance by calling 1-800-777-9882 or 813-821-1448. They will also be available at the Museum Box Office. ONLY VENUE

St. Petersburg

Museum of Fine Arts-St. Petersburg Florida
255 Beach Dr., N.E., **St. Petersburg, FL 33701**
☎ 813-896-2667
HRS: 10-5 Tu-Sa, 1-5 S, till 9 PM 3rd T of the month DAY CLOSED: M HOL: THGV, 12/25, 1/1
F/DAY: S ADM: Y ADULT: $5.00 CHILDREN: F (under 6) STUDENTS: $2.00 SR CIT: $3.00
♿: Y; Galleries & restrooms Ⓟ Y; Visitors parking lot. Parking also available on Beach Dr. & Bayshore Dr. MUS/SH: Y
GR/T: Y GR/PH: CATR! (tour coord.) DT: Y TIME: 10, 11, 1 & 2 Tu-F; 11 & 2 Sa; 1 & 2 S S/G: Y
PERM/COLL: AM: ptgs, sculp, drgs, gr; EU: ptgs, sculp, drgs, gr; P/COL; DEC/ART;
P/COL; OR; STEUBEN GLASS; NAT/AM & TRIBAL

With the addition in 1989 of 10 new galleries, the Museum of Fine Arts, considered one of the finest museums in the Southeast, is truly an elegant showcase for its many treasures that run the gamut from Dutch and Old Master paintings to the largest collection of photography in the state. PLEASE NOTE: Spanish language tours are available by advance appointment. **NOT TO BE MISSED:** Small but first rate 23 piece Parrish collection of Pre-Columbian Art

ON EXHIBIT/97:

ONGOING	RODIN BRONZES FROM THE IRIS AND B. GERALD CANTOR FOUNDATION
11/24/96–04/06/97	SCENT BOTTLES THROUGH THE CENTURIES FROM THE COLLECTION OF JOAN HERMANOWSKI
01/12/97–05/18/97	CONTEMPORARY ART, MFA PERMANENT COLLECTION TENT!
01/12/97–05/18/97	SEA OF GRASS: JIMMY ERNST TENT!
01/19/97–03/16/97	PAUL CAPONIGRO: MEDITATIONS IN LIGHT — 50 of Caponigro's silver prints from 1958-1996 will be on exhibit.
03/30/97–04/06/97	MASKS OF THE WORLD: ERNESTINE O'CONNELL COLLECTION
03/31/97–04/07/97	ART IN BLOOM — Floral interpretations based on selected works in the museum.
06/01/97–09/21/97	CONTEMPORARY PAINTINGS, PRINTS & PHOTOGRAPHY FROM THE MFA COLLECTION
06/01/97–09/21/97	THE OKLAHOMA CITY CHILDREN'S MEMORIAL ART QUILTS
06/01/97–09/21/97	CHIAM GROSS: FANTASY DRAWINGS & WATERCOLORS
12/07/97–01/25/98	ROBERT VICKERY: IMAGINARY REALITIES — On exhibit will be works by Vickery, a realist painter whose tempera works are little gems of interplay between light and shadow.

FLORIDA

St. Petersburg

Salvador Dali Museum

100 Third St. South, **St. Petersburg, FL 33701**
☎ 813-823-3767 WEB ADDRESS: http://www.highwayone.com/dali
HRS: 9:30-5:30 M-Sa, Noon-5:30 S HOL: THGV, 12/25
ADM: Y ADULT: $8.00 CHILDREN: F (10 & under) STUDENTS: $4.00 SR CIT: $7.00
&: Y ℗ Y; Free parking on museum grounds MUS/SH: Y
GR/T: Y GR/PH: CATR! tours 9:30-3:30 M-Sa
DT: Y TIME: Call for daily schedule
PERM/COLL: SALVADOR DALI: ptgs, sculp, drgs, gr

Unquestionably the largest and most comprehensive collection of Dali's works in the world, the museum holdings amassed by Dali's friends A. Reynolds and Eleanor Morse include 95 original oils, 100 watercolors and drawings, 1,300 graphics, sculpture, and other objects d'art that span his entire career. **NOT TO BE MISSED:** Outstanding docent tours that are offered many times daily.

ON EXHIBIT/97:

02/01/97–04/28/97	VISIONARY STATES — Graphic works by Ernst, Magritte, Dali, Miro, Picasso, Duchamp, Tanguy and other greats of the Surrealist movement will be featured in this complete overview of their use of multi-media print forms. WT
02/21/97–03/16/97	STUDENT SURREALIST ART EXHIBIT — The popularity of Surrealism for new generations of young artists will be demonstrated in the selection of works on display by Pinellas County students.

Tallahassee

Florida State University Museum of Fine Arts

Fine Arts Bldg., Copeland & W. Tenn. Sts., **Tallahassee, FL 32306-2055**
☎ 904-644-6836
HRS: 10-4 M-F; 1-4 Sa, S (closed weekends during summer) HOL: LEG/HOL! Acad! AUG
&: Y ℗ Y; Metered parking in front of the building with weekend parking available in the lot next to the museum
GR/T: Y GR/PH: CATR!
DT: Y TIME: upon request if available
PERM/COLL: EU; OR; CONT; PHOT; GR; P/COL: Peruvian artifacts; JAP: gr

With 7 gallery spaces, this is the largest art museum within 2 hours driving distance of Tallahassee. **NOT TO BE MISSED:** Works by Judy Chicago

ON EXHIBIT/97:

01/10/97–02/16/97	FACULTY AWARD & VISITING ARTISTS: ARTS OF ASIA SERIES: TRADITIONAL CHINESE PAINTING
02/21/97–04/06/97	THE GUN AS IMAGE
05/02/97–05/30/97	THE KIDS "GUERNICA": CHILDREN'S PEACE MURALS FROM AROUND THE WORLD
06/06/97–07/11/97	ARTISTS' LEAGUE SUMMER ANNUAL & NEW ACQUISITIONS
09/02/97–10/05/97	COMBINED TALENTS
10/10/97–11/16/97	THE ART OF PUBLIC ART — A presentation of mixed materials, drawings, architectural renderings of proposals, and photo-documentation of completed projects. TENT!

122

Tallahassee

Lemoyne Art Foundation, Inc.
125 N. Gadsden, **Tallahassee, FL 32301**
☎ 904-222-8800
HRS: 10-5 Tu-Sa, 1-5 S DAY CLOSED: M HOL: 1/1, 7/4, 12/25 (may be closed during parts of Aug!)
F/DAY: S ADM: Y ADULT: $1.00 CHILDREN: F (12 & under) STUDENTS: $1.00 SR CIT: $1.00
&: Y Ⓟ Y; parking lot adjacent to the Helen Lind Garden and Sculptures; also, large lot across street available weekends and evenings MUS/SH: Y DT: Y TIME: daily when requested H/B: Y S/G: Y
PERM/COLL: CONT/ART; sculp

Located in an 1852 structure in the heart of Tallahassee's historic district, the Lemoyne is named for the first artist known to have visited North America. Aside from offering a wide range of changing exhibitions annually, the museum provides the visitor with a sculpture garden that serves as a setting for beauty and quiet contemplation. **NOT TO BE MISSED:** Three recently acquired copper sculptures by George Frederick Holschuh

ON EXHIBIT/97:
01/17/97–02/16/97	PAINTINGS OF HIRAM WILLIAMS — An exhibition of paintings by Williams gifted to the museum's permanent collection.
01/17/97–01/16/97	ENCAUSTIC PAINTINGS: NANCY REID GUNN
02/21/97–03/23/97	PHILIP WARD MEMORIAL CERAMICS EXHIBITION
03/28/97–04/27/97	COMMON HEROES — Paintings by Dean Mitchell will be on exhibit.
05/30/97–06/29/97	CONTEMPORARY SENSIBILITIES

Tampa

Museum of African American Art
1308 N. Marion St., **Tampa, FL 33602**
☎ 813-272-2466
HRS: 10-4 Tu-F, 1-5 Sa DAY CLOSED: S, M HOL: 1/1, EASTER, THGV, 12/25
ADM: Y ADULT: 3.00 CHILDREN: 2.00 (15 & under) SR CIT: $2.00
&: Y; 1st floor gallery and restrooms; elevator to 2nd floor by spring '95 Ⓟ Y; Free and ample MUS/SH: Y
GR/T: Y GR/PH: CATR!
PERM/COLL: AF/AM ART: late 19-20

Paintings, drawings, sculpture, prints and traditional African art are housed in this museum which has one of the oldest, most prestigious and comprehensive collections of African-American art in the country. Established in 1991 with the acquisition of the Barnett-Aden Collection of African-American Art, the collection includes works by such notable African-American artists as Edward M. Bannister, Henry Ossawa Tanner, Jacob Lawrence, Lois Mailou Jones, William H. Johnson and others. **NOT TO BE MISSED:** "Negro Boy" by Hale Woodruff; "Little Brown Girl" by Laura Wheeler Waring

ON EXHIBIT/97:
11/96–01/97	ROMARE BEARDON AS PRINTMAKER	WT
02/97–04/97	DAUGHTERS OF HARRIET POWERS — An exhibition of quilts.	
04/97–07/97	ART CHANGES THINGS: THE ART AND ACTIVISM OF GEORGETTE SEABROOKS POWELL	
07/97–08/97	BEARING WITNESS/ AMAZING GRACES — Paintings, sculpture and mixed media works will be on exhibit.	
09/97–11/97	CHARLES NELSON - A NEW TALENT	
11/97–02/98	SELECTED WORKS	
11/97–02/98	ALVIN HOLLINGSWORTH — A show of paintings & mixed media.	

FLORIDA

Tampa

Tampa Museum of Art
600 North Ashley Dr., **Tampa, FL 33602**
☎ 813-274-8130
HRS: 10-5 M-Sa, 10-9 W, 1-5 S HOL: 12/25, 1/1, 7/4
F/DAY: 5-9 W & 1-5 S VOL/CONT: Y ADM: Y ADULT: $5.00 CHILDREN: 6-18 $3.00; F under 6 STUDENTS: $4.00
 SR CIT: $4.00
♿: Y; Wheelchairs available, follow signs to handicapped entrance Ⓟ Y; Covered parking under the museum for a nominal
hourly fee. Enter the garage from Ashley Dr. & Twiggs St. MUS/SH: Y
GR/T: Y GR/PH: CATR! DT: Y TIME: 1:00 W & Sa, 2:00 S S/G: Y
PERM/COLL: PTGS: 19-20; GR: 19-20; AN/GRK; AN/R; PHOT

A superb 400 piece collection of Greek and Roman antiquities dating from 3,000 BC to the 3rd century AD is one
of the highlights of this comprehensive and vital art museum. The Tampa Museum has recently installed a vast new
sculpture garden, part of an exterior expansion program completed in 1995. **NOT TO BE MISSED:** Joseph V.
Noble Collection of Greek & southern Italian antiquities on view in the new Barbara & Costas Lemonopoulos
Gallery.

ON EXHIBIT/97:

12/01/96–01/26/97	GLADYS S. KASHDIN: IN RETROSPECT — A 50 year survey of paintings and works on paper by Kashdin, a Tampa-based artist/professor. CAT
02/02/97–04/13/07	THE FIRE OF HEPHAISTOS: LARGE CLASSICAL BRONZES FROM NORTH AMERICAN COLLECTIONS — 52 of the finest large-scale classical sculptures on loan from North American collections will be seen in the first U.S. exhibition of its kind devoted to large classical bronzes and the technology involved in creating them. CAT
04/27/97–06/29/97	ABRAHAM RATTNER RETROSPECTIVE — Often called the "painter of the tragic," this retrospective exhibition of 50 works by Rattner (1893-1978) provides the viewer with a rare opportunity to rediscover one of the most accomplished American expressionist and figurative artists of the 20th-century. CAT
09/07/97–11/16/97	THE WHITE HOUSE COLLECTION OF AMERICAN CRAFTS — 72 examples of some of the finest contemporary American crafts which were assembled in 1993 for the White House collection will be featured in this first time exhibition. CAT WT

USF Contemporary Art Museum
Affiliate Institution: College of Fine Arts
4202 E. Fowler Ave., **Tampa, FL 33620**
☎ 813-974-4133
HRS: 10-5 M-F, 1-4 Sa DAY CLOSED: S HOL: STATE & LEG/HOL!
♿: Y Ⓟ Y; Free parking in front of museum (parking pass available from museum security guard)
GR/T: Y GR/PH: CATR! DT: Y
PERM/COLL: CONT: phot, gr

Located in a new building on the Tampa campus, the USF Contemporary Art Museum houses one of the largest
selections of contemporary prints in the Southeast.

ON EXHIBIT/97:

01/06/97–02/15/97	KEITH EDMIER — An artist project with daredevil Evel Kenievel.
03/01/97–03/15/97	PUBLISHERS' CHOICE: PRINTS & MULTIPLES — An exhibition held in conjunction with the southern Graphics Council Conference.
03/08/97–04/12/97	RAPTURE — In this unusual collaborative installation created by surgeon David Teplica and ethnomusicologist Bryan Shuler, photographs are set within a subtle musical environment.

USF Contemporary Art Museum - continued

04/29/97–07/05/97 DENNIS OPPENHEIM: LANDSCAPE — Photographs, drawings, films and videos of the artist's land projects will be on exhibit.

09/05/97–10/18/97 CROSS/INGS: CONTEMPORARY AFRICAN ART — Works by 10 African artists explore the idea of movement/relocation in terms of the physical, mental & metaphysical.

11/08/97–12/22/97 SHOUTS FROM THE WALL — On loan from the Abraham Lincoln Brigade archive at Brandeis University will be a presentation of photographs and posters from the Spanish Civil War. WT

11/08/97–12/19/97 ARTIST PROJECT — An exhibition to be determined that will have a relationship to the Spanish Civil War show described above.

Vero Beach

Center for the Arts, Inc.
3001 Riverside Park Dr., **Vero Beach, FL 32963**
☎ 561-231-0707
HRS: 10-4:30 Daily & till 8 Tu; SUMMER: 10-4:30 Tu-Sa, 1-4:30 S, till 8 Tu DAY CLOSED: M! HOL: LEG/HOL!
SUGG/CONT: Y ADULT: $2.00 STUDENTS: $2.00 SR CIT: $2.00
♿: Y; Fully accessible with wheelchair entry through north entrance.
Ⓟ Y; Ample free parking on north side of building
MUS/SH: Y GR/T: Y GR/PH: CATR! ext. 25 DT: Y TIME: 1:30-3:30 W-Sa; (Summer: 1:30 - 3:30 Sa, S) S/G: Y
PERM/COLL: AM/ART 20

Considered the premier visual arts facility within a 160 mile radius on Florida's east coast, the Center for the Arts, which offers national, international and regional art exhibitions throughout the year, maintains a leadership role in nurturing the cultural life of the region. **NOT TO BE MISSED:** "Royal Tide V" by Louise Nevelson; "Watson and the Shark" by Sharron Quasius; "Transpassage T.L.S.," 20 ft. aluminum sculpture by Ralph F. Buckley

ON EXHIBIT/97:

01/25/97–03/09/97 LIGHT AND TEXTURE: THE MONOCHROMATIC PAINTINGS OF DAVID BUDD

01/25/97–03/09/97 AMERICAN PAINTINGS FROM THE MASCO AND RICHARD MANOOGIAN COLLECTIONS

03/16/97–04/13/97 THE WHIMSICAL WORKS OF JAMES RIZZI

03/29/97–05/04/97 THE WEST IN AMERICAN ART: FROM THE BILL AND DOROTHY HARMSEN COLLECTION — Presented in five separate thematic units will be paintings that address a continuing fascination with the American West. Works on view will range from 19th-century landscape paintings by Bierstadt, Berninghaus and others to works by the Taos Society of Artists & the Santa Fe Colony, to dramatic images that freeze a moment of tension or high drama. BROCHURE WT

05/17/97–06/15/97 1997 FLORIDA BIENNIAL COMPETITIVE

05/18/97–06/15/97 NEW WORKS BY KENNETH KERSLAKE

06/28/97–08/04/97 TBA: SELECTIONS FROM THE CENTER FOR THE ARTS COLLECTION

09/20/97–11/16/97 THE PHOTOGRAPHS OF JAMES BALOG

11/28/97–01/04/98 COLLECTORS' CHOICE

FLORIDA

West Palm Beach

Norton Gallery and School of Art
1451 S. Olive Ave., **West Palm Beach, FL 33401**
✆ 561-832-5196 WEB ADDRESS: http://www.norton.org
HRS: 10-5 Tu-Sa, 1-5 S DAY CLOSED: M HOL: 1/1, MEM/DAY, 7/4, THGV, 12/25
SUGG/CONT: Y ADULT: $5.00 CHILDREN: F (under 12) STUDENTS: $3.00
&: Y ℗ Y; Free lot behind museum MUS/SH: Y ⅋ Y; Outdoor buffet!
GR/T: Y GR/PH: CATR! 407-832-5196 (ed.office) DT: Y TIME: 2:00 daily
PERM/COLL: AM: ptgs, sculp 19-20; FR: ptgs, sculp 19-20; OR: sculp, cer

Started in 1940 with a core collection of French Impressionist and modern masterpieces as well as fine works of American painting, the Norton holdings now include major pieces of contemporary sculpture, and a noteworthy collection of Asian art. It is no wonder that the Norton enjoys the reputation of being one of the finest small museums in the United States. PLEASE NOTE: By 1/97 the museum expects to be finished with its multi-million dollar renovation and expansion project that will more than double its gallery space. **NOT TO BE MISSED:** Paul Manship's frieze across the main facade of the museum flanked by his sculptures of Diana and Actaeon

ON EXHIBIT/97:

01/20/97–03/30/97	THE TREASURES OF THE NORTON COLLECTION — Considered one of the greatest museums in the Southeast, the Norton owns important collections of European Impressionist and modern master works, great American paintings & sculpture, and one of the greatest Asian collections in the country. This exhibition will present a selection of some of the finest works in each of the categories mentioned.
01/20/97–03/30/97	A GOLDEN AGE: OLD MASTER PRINTS FROM THE NORTON MUSEUM OF ART — 15th to 19th-century prints by some of the most illustrious artists in the history of art will be shown as a group for the first time ever. This rich display will include examples of works by Dürer, Rembrandt, Breughel, Hogarth, Piranesi, Goya, Manet and others.
01/20/97–03/09/97	AN AMAZING ART: CONTEMPORARY LABYRINTHS BY ADRIAN FISHER — For this exhibition Fisher, a contemporary artist who constructs mazes in all media, will install one in the interior of the museum and another on the outside.
01/20/97–03/23/97	RODIN: SCULPTURE FROM THE IRIS AND B. GERALD CANTOR COLLECTION — On loan from the most important and extensive private collections of its kind will be 52 sculptures by celebrated 19th-century French sculptor, Rodin. ADM FEE ATR! WT
03/15/97–05/04/97	ALEX KATZ: UNDER THE STARS, AMERICAN LANDSCAPES — In the first retrospective of his landscapes, large-scale works by Katz, painted throughout the course of his career will include a variety of images from the woodlands and beaches of his summer home in Maine, to urban "landscapes" of New York City. CAT WT
03/15/97–05/04/97	JOSEPH CORNELL: BOXES AND COLLAGES — More than 40 of Cornell's boxes and collages filled with associations of home, family, childhood, and allusions to literature will be seen in the works on loan from the Cornell Foundation.
04/02/97–05/18/97	IN THE EYE OF THE STORM: AN ART OF CONSCIENCE, 1930-1970 - SELECTIONS FROM THE COLLECTION OF PHILIP J. AND SUZANNE SCHILLER — Visual commentaries on economic, political and social developments in America during this 40 year period of time will be highlighted in the works of Moses Soyer, Philip Evergood, Ben Shahn, Romare Beardon, Jacob Lawrence and others selected for viewing from this extensive Chicago-based collection. BOOK WT
06/07/97–07/20/97	INSIGHT: WOMEN'S PHOTOGRAPHS FROM THE GEORGE EASTMAN HOUSE COLLECTION WT
09/20/97–11/09/97	AFFINITIES OF FORM: ARTS OF AFRICA, OCEANIA AND THE AMERICAS FROM THE RAYMOND AND LAURE WIELGUS COLLECTION — Nearly 100 objects from this major collection will be featured in an exhibition that explores each culture's unique themes, materials and techniques. BOOK WT
11/15/97–01/11/98	HOSPICE: A PHOTOGRAPHIC INQUIRY — The photographs of Jim Goldberg, Nan Goldin, Sally Mann, Jack Radcliffe and Kathy Vargas detailing the emotional and collaborative experience of living and working in hospices in different regions of the country will be seen in this exhibition specially commissioned by the Corcoran. Their works will touch upon every aspect of hospice care revealing the spiritual, emotional and physical needs of the terminally ill and their families. CAT WT

126

Winter Park

The Charles Hosmer Morse Museum of American Art
445 Park Avenue North, **Winter Park, FL 32789**
✆ 407-645-5311
HRS: 9:30-4 Tu-Sa, 1-4 S DAY CLOSED: M HOL: 1/1, MEM/DAY, 7/4, LAB/DAY, THGV, 12/25
ADM: Y ADULT: $3.00 CHILDREN: F (under 12) STUDENTS: $1.00
&: Y; fully handicapped accessible ℗ Y; At rear of museum MUS/SH: Y
GR/T: Y GR/PH: CATR! DT: Y TIME: available during regular hours
PERM/COLL: Tiffany Glass; AM: ptgs (early 20); AM: art pottery 19-20

More than 4,000 pieces of Tiffany glass were rescued in 1957 from the ruins of Laurelton Hall, Tiffany's Long Island home by Florida millionaire Hugh McKean and his wife. These form the basis, along with superb works by early 20th-century artists including Emile Galle, Frank Lloyd Wright, Maxfield Parish, George Innis, and others, of the collection at this most unique little-known gem of a museum which has recently moved into new and larger quarters. **NOT TO BE MISSED:** The "Electrolier," Tiffany's 1893 elaborate 10' high chandelier, which was an important early example of the use of electrified lighting and an item that paved the way for Tiffany's leaded glass lamps; 2 marble, concrete and Favrile glass columns designed over 100 years ago by Tiffany for his Long Island mansion.

The George D. and Harriet W. Cornell Fine Arts Museum
Affiliate Institution: Rollins College
1000 Holt Ave., **Winter Park, FL 32789-4499**
✆ 407-646-2526
HRS: 10-5 Tu-F; 1-5 Sa, S DAY CLOSED: M HOL: 12/25, 1/1, THGV, 7/4, LAB/DAY
VOL/CONT: Y
&: Y ℗ Y; Free parking in the adjacent "H" Lot & in the parking lot next to the Field House
GR/T: Y GR/PH: CATR! Becky Savill
PERM/COLL: EU: ptgs, Ren-20; SCULP; DEC/ART; AM: ptgs, sculp 19-20; PHOT; SP: Ren/sculp

Considered one of the most outstanding museums in Central Florida, the Cornell, located on the campus of Rollins College, houses fine examples in many areas of art including American landscape painting, French portraiture, works of Renaissance and Baroque masters, and contemporary prints. **NOT TO BE MISSED:** Paintings from the Kress Collection; "Christ With the Symbols of the Passion," by Lavinia Fontana

ON EXHIBIT/97:

11/09/96–01/12/97	NANCY GRAVES: EXCAVATIONS IN PRINT — 45 works by Graves will be on view in the first comprehensive exhibition of her innovative graphics in which the use of unconventional materials and techniques allows her to break down boundaries within and between traditional mediums. CAT WT
01/18/97–03/02/97	BEYOND THE WOODCUT IN FLORIDA
03/07/97–05/04/97	MASTERPIECES FROM THE TOBIN COLLECTION OF THEATER ART
05/31/97–09/14/97	TREASURES OF THE CHINESE NOBILITY: THE CHAUNCY P. LOWE COLLECTION
09/26/97–10/26/97	THE ART OF NANCY JAY — A presentation of designs for the anticipated $3.5 million expansion to the present museum which will quadruple the existing 5,000 square feet of space.
11/01/97–01/04/98	MILTON AVERY'S "EBB & FLOW": A SURVEY OF WORKS ON PAPER

GEORGIA

Albany

Albany Museum of Art
311 Meadowlark Dr., **Albany, GA 31707**
☎ 912-439-8400
HRS: 10-5 Tu-Sa, till 7 PM W DAY CLOSED: S, M HOL: LEG/HOL!
SUGG/CONT: Y &: Y ℗ Y; Ample free parking MUS/SH: Y GR/T: Y GR/PH: CATR! DT: Y
PERM/COLL: AM: all media 19- 20; EU: all media 19-20; AF: 19-20; AM: dec/art 18-20; EU: dec/art 18-20; REG; AM: cont

With one of the largest collections of traditional African art in the South, the Albany Museum, started in 1964, is also home to an important collection of contemporary American art. **NOT TO BE MISSED:** A 1500 piece collection of African art that includes works from 18 different cultures.

ON EXHIBIT/97:

09/12/96–07/19/98	ART FROM AFRICA: EVERYDAY LIFE, RELIGION, LEADERSHIP, PERFORMANCE
09/12/96–04/13/97	SEPIK ART OF PAPUA NEW GUINEA — Inventive and powerful imagery rich in religious and artistic traditions will be seen in the housepost masks, and standing figures and other Guinean objects on display.
09/12/96–04/27/97	MOSE TOLLIVER — Selected from the permanent collection the 14 paintings on view by African-American folk artist Tolliver reveal his naive and often humorous interpretations of animals and human figures.
11/07/96–01/12/97	ROMARE BEARDON: PERSONAL MEMORIES AND BLUE REVERIES — Images from Beardon's African-American culture and childhood combined with art historical references create the universal themes expressed in the 27 collages, lithographs, watercolors and screenprints on exhibit.
01/15/97–03/16/97	AFFINITIES OF FORM: ARTS OF AFRICA, OCEANIA AND THE AMERICAS FROM THE RAYMOND AND LAURE WIELGUS COLLECTION — Nearly 100 objects from this major collection will be featured in an exhibition that explores each culture's unique themes, materials and techniques. BOOK WT
01/16/97–03/08/97	I DREAM A WORLD: PORTRAITS OF BLACK WOMEN WHO CHANGED AMERICA — 75 large black & white portrait photographs of exemplary African-American women by Pulitzer Prize-winning photographer, Brian Lanker. CAT WT
01/18/97–05/01/97	PERMANENT COLLECTION
03/20/97–05/18/97	DR. JAY AND ANN McKEEL ROSS: COLLECTION OF CONTEMPORARY ART FROM GRAPHICS STUDIO — On view by such contemporary artistic icons as Robert Mapplethorp, Jim Dine, Roy Lichenstein, Chuck Close, James Rosenquist and others will be 53 lithographic prints created by them at the renowned Graphics Studio.
04/24/97–12/07/97	THE ART OF GLASS: FROM ROMAN TO TIFFANY
05/08/97–01/18/98	WORKS ON PAPER
05/22/97–08/10/97	KAREKIN GOEKJIAN — 35 of Goekjiana's photographic images of Southern ruins will be on exhibit.
05/29/97–08/03/97	TODD MURPHY — On exhibit will be figurative works by Murphy, an Atlanta-based artist whose works are based on personal and physical exploration.
08/14/97–10/19/97	AMERICA SEEN: PEOPLE AND PLACES — The American experience of the 1920's through the 1950's is explored through 78 paintings, prints and photographs. Included are works by Grant Wood, Norman Rockwell, John Stuart Curry, Thomas Hart Benton and others who documented two world wars, the Great Depression, the New Deal, the growth of the American city and the nostalgia for simple rural life. WT
08/21/97–10/26/97	SELECTIONS FROM THE PERMANENT COLLECTION
10/23/97–01/04/98	HERB RITTS: WORK — More than 200 photographs will be on view in the first full-scale exhibition devoted to the work of American photographer Ritts. WT
10/30/97–12/28/97	REGIONAL ARTS COUNCIL JURIED EXHIBITION

Athens

Georgia Museum of Art

Affiliate Institution: The University of Georgia Performing & Visual Arts Complex
90 Carlton St., **Athens, GA 30602-1719**
☎: 706-542-GOMA WEB ADDRESS: http://www.budgets.uga.edu/east_campus/
HRS: 10-5 Tu-T & Sa, till 9 PM F, 1-5 S DAY CLOSED: M HOL: LEG/HOL!
♿: Y; Wheelchair access at rear of building Ⓟ Y; Parking located adjacent to the new building. MUS/SH: Y
GR/T: Y GR/PH: CATR! Trudy Snyder H/B: Y
PERM/COLL: AM: sculp, gr; EU: gr; JAP: gr; IT/REN: ptgs (Kress Collection); AM: ptgs 19-20

The Georgia Museum of art, which moved to a new facility on Carlton St. on the east campus of the university in September of '96, has grown from its modest beginnings in 1945 with the 100 piece collection donated by Alfred Holbrook, to more than 7,000 works now included in its permanent holdings. **NOT TO BE MISSED:** American paintings from the permanent collection on view continually in the south gallery.

ON EXHIBIT/97:

12/14/96–02/02/97	VIEWS OF ATHENS
12/14/96–01/26/97	AN EYE ON FLANDERS: THE GRAPHIC ART OF JULES de BRUYCKER
01/15/97–03/16/97	AFFINITIES OF FORM: ARTS OF AFRICA, OCEANIA AND THE AMERICAS FROM THE RAYMOND AND LAURE WIELGUS COLLECTION — Nearly 100 objects from this major collection will be featured in an exhibition that explores each culture's unique themes, materials and techniques. BOOK WT
02/01/97–06/08/97	JUPITER AND HIS CHILDREN
02/05/97–03/23/97	20TH-CENTURY WATERCOLORS: FROM KANDINSKY TO WYETH
03/26/97–06/01/97	ROY WARD FLORAL STUDIES
03/29/97–06/15/97	METALSMITHING
04/12/97–06/08/97	THE PALETTE IN A PEN'S WORLD
09/12/97–11/05/97	GOLD, JADE, AND FORESTS: PRE-COLUMBIAN TREASURES OF COSTA RICA — 140 precious objects that reflect traditional cultural Columbian Costa Rican depictions of human and animal figures will be highlighted in an exhibit that features objects of gold, jade, stone, and pottery. WT
09/27/97–11/16/97	FRITZ BULTMAN: COLLAGES
12/06/97–02/01/98	BREWER COLLECTION OF WORKS ON PAPER

Hammonds House Galleries and Resource Center

503 Peoples St., **Atlanta, GA 31310**
☎ 404-752-8730
HRS: 10-6 Tu-F; 1-5 Sa, S DAY CLOSED: M HOL: LEG/HOL!
ADM: Y ADULT: $2.00 CHILDREN: $1.00 STUDENTS: $1.00 SR CIT: $1.00
♿: Y; Barrier free Ⓟ Y; Free 32 car lot on the corner of Lucile & Peoples; some street parking also available MUS/SH: Y
DT: Y TIME: Upon request H/B: Y; 1857 East Lake Victorian House restored in 1984 by Dr. Otis T. Hammonds
PERM/COLL: AF/AM: mid 19-20; HAITIAN: ptgs; AF: sculp

As the only fine art museum in the Southeast dedicated to the promotion of art by peoples of African descent, Hammonds House features changing exhibitions of nationally known African-American artists. Works by Romare Bearden, Sam Gilliam, Benny Andrews, James Van Der Zee and others are included in the 125 piece collection. **NOT TO BE MISSED:** Romare Bearden Collection of post 60's serigraphs; Collection of Premiero Contemporary Haitian Artists

ON EXHIBIT/97:

11/24/96–01/12/97	ARTIST-IN-RESIDENCE AND LOCAL ARTISTS' EXHIBITION
12/26/96–01/01/97	COMMUNITY KWANZA CELEBRATION

GEORGIA

Atlanta

High Museum of Art
1280 Peachtree St., N.E., **Atlanta, GA 30309**
☎ 404-733-4400 WEB ADDRESS: http://www.isotropic.com/highmuse/highhome.html
HRS: 10-5 Tu-Sa, Noon-5 S DAY CLOSED: M HOL: 1/1; 12/25; THGV
F/DAY: 1-5 T ADM: Y ADULT: $6.00 CHILDREN: $2.00 (6-17) STUDENTS: $4.00 SR CIT: $4.00
&: Y; Ramps, elevator, wheelchairs available
P: Y; Limited paid parking on deck of Woodruff Art Center Building on the side of the museum; some limited street parking
MUS/SH: Y GR/T: Y GR/PH: CATR"! 404-898-1145 DT: Y TIME: call before visiting for schedule
H/B: Y; Building designed by Richard Meier, 1983
PERM/COLL: AM: dec/art 18-20; EU: cer 18; AM: ptgs, sculp 19; EU: ptgs, sculp, cer, gr, REN- 20; PHOT 19-20 ; AM; cont
(since 1970)

The beauty of the building, designed in 1987 by architect Richard Meier, is a perfect foil for the outstanding collection of art within the walls of the High Museum itself. Part of the Robert W. Wooruff Art Center, this museum is a "must see" for every art lover who visits Atlanta. PLEASE NOTE: Admission entry fees vary according to the exhibitions being presented. **NOT TO BE MISSED:** The Virginia Carroll Crawford Collection of American Decorative Arts; The Frances and Emory Cocke Collection of English Ceramics

ON EXHIBIT/97:

11/02/96–01/19/97	HENRI MATISSE: MASTERWORKS FROM THE MUSEUM OF MODERN ART — Spanning the progression of Matisse's entire artistic career, the 100 works on view in this exhibition include examples of his paintings, drawings, sculptures, cutouts, prints, illustrated books, a stained glass window, and even sets of liturgical vestments. ONLY VENUE ADM FEE ◠
02/01/97–03/23/97	ALONE IN A CROWD: PRINTS BY AFRICAN-AMERICAN ARTISTS OF THE 1930'S- 1940'S FROM THE COLLECTION OF REBA AND DAVE WILLIAMS — A gallery of 20th-century works from the museum's permanent African-American collection will accompany this exhibition of 100 rare prints by African-American artists working (many under the auspices of the WPA) in a wide variety of styles and techniques during the Depression decades. CAT WT
02/11/97–04/06/97	HARRY CALLAHAN — Focusing on the exploration of photographic possibilities, this exhibition of 125 works includes innovative examples created through the manipulation of multiple images, collage, and extreme contrast by Callahan, an American artist known for his remarkable contribution to the medium. CAT WT
03/29/97–06/22/97	ART AT THE EDGE: PETAH COYNE — In this exhibition of 15 recent works, objects associated with ceremony and overt femininity that Coyne covers with excessive amounts of dripped candle wax will be on view. CAT WT
04/22/97–06/15/97	CROWNING ACHIEVEMENTS: AFRICAN ARTS OF DRESSING THE HEAD — Included in the staggering array of shapes and materials that make up the traditional and contemporary objects on view will be African hats, headdresses and hairstyles noted for their aesthetic richness, artistry and symbolism. Many of the 195 pieces on view are meant to serve the purpose of constructing identity and transforming peoples lives. WT
07/01/97–09/28/97	MASTERPIECES FROM THE PIERPONT MORGAN LIBRARY COLLECTIONS — Durer's pen-and-ink drawing "Adam & Eve," one of the 11 remaining velum copies of the Guttenburg Bible, and an autographed Mozart manuscript will be among the 175 beautiful and rare works on loan from the distinguished collection of the Pierpont Morgan Library. WT
11/04/97–02/15/98	PABLO PICASSO: MASTERWORKS FROM THE MUSEUM OF MODERN ART — 125 of Picasso's paintings, sculptures, drawings and prints from the from the extensive holdings of the MoMA will be on view in an exhibition that provides an overview of his entire career. ONLY VENUE ADM FEE ◠

Atlanta

High Museum of Folk Art & Photography Galleries at Georgia-Pacific Center

30 John Wesley Dobbs Ave., **Atlanta, GA 30303**

☎ 404-577-6940 WEB ADDRESS: http://www.isotropic.com/highmuse/highhome.html

HRS: 10-5 M-Sa DAY CLOSED: S HOL: LEG/HOL!

&: Y

Ⓟ Y; Paid parking lot in the center itself with a bridge from the parking deck to the lobby; other paid parking lots nearby

MUS/SH: Y DT: Y

Folk art and photography are the main focus in the 45,000 square foot exhibition space of this Atlanta facility formally called the High Museum of Art at Georgia-Pacific Center.

ON EXHIBIT/97:

09/28/96–02/01/97 — NO TWO ALIKE: AFRICAN-AMERICAN IMPROVISATIONAL QUILTS (Working Title) — 40 visually stunning contemporary quilts from the immense Eli Leon collection of Oakland, CA will be on view in a four part exhibition that explores expressive concepts utilized in the art of African-American quiltmaking.

09/28/96–01/18/97 — FROM THE COLLECTION: RECENT ACQUISITIONS IN PHOTOGRAPHY — From the permanent collection of over 3,500 photographic works on display will be recent acquisitions by Edward Serotta, Cindy Sherman, Annie Leibovitz, Bruce Nauman, Sally Mann and other notable artists of the medium.

02/11/97–04/12/97 — POINTS OF ENTRY, FINDING AMERICA: SEVEN EMIGREE PHOTOGRAPHERS AND THE CHANGING AMERICAN VISION, 1932-1956 — Three inter-related photographic exhibitions document the history of the American immigrant experience.
CAT WT

04/26/97–08/23/97 — MUSEUM STUDIES — An exhibition of compelling photographs by established and emerging artists comment on the ways in which contemporary photographers respond to museums both as an idea and an institution.

Michael C. Carlos Museum of Art and Archaeology

Affiliate Institution: Emory University

571 South Kilgo St., **Atlanta, GA 30322**

☎: 404-727-4282 WEB ADDRESS: http://www.emory.edu/CARLOS/carlos.html

HRS: 10-5 M-Sa, Noon-5 S HOL: 12/25, 1/1, THGV

SUGG/CONT: Y ADULT: $3.00

&: Y Ⓟ Y; Visitor parking for a small fee at the Boisfeuillet Jones Building; free parking on campus except in restricted areas. Handicapped parking Plaza level entrance on S. Kilgo St.

MUS/SH: Y ⅌ Y; Café Antico 8:30 -4:30 M-F, 10:30- 4:30 Sa, 12-5 S

GR/T: Y GR/PH: CATR! DT: Y TIME: 2:30 Sa, S

H/B: Y

PERM/COLL: AN/EGT; AN/GRK; AN/ROM; P/COL; AS; AF; OC; WORKS ON PAPER 14-20

Founded on the campus of Emory University in 1919 (making it the oldest art museum in Atlanta), this distinguished institution changed its name in 1991 to the Michael C. Carlos Museum in honor of its long time benefactor. Its dramatic 35,000 square foot building which opened in the spring of 1993 is a masterful addition to the original Beaux-Arts edifice. The museum has recently acquired one of the largest (1,000 pieces) collections of Sub-Saharan African art in America. **NOT TO BE MISSED:** Carlos Collection of Ancient Greek Art; Thibadeau Collection of pre-Columbian Art; recent acquisition of rare 4th century Volute-Krater by the Underworld painter of Apulia

GEORGIA

Michael C. Carlos Museum of Art and Archaeology - continued
ON EXHIBIT/97:

10/19/96 - 10/98	TEARS OF THE MOON: ANCIENT AMERICAN PRECIOUS METALS FROM THE PERMANENT COLLECTION — Metal objects in gold, silver and bronze ranging from ceremonial knives, drinking cups, inlaid jewelry, miniature representations of fruits, and other items of daily life will be on view in an exhibition that explores different metallurgical techniques among the ancient and colonial peoples of Peru.
ONGOING	AFRICAN ART
	ASIAN ART
11/09/96–01/20/97	STEVEN BROOKE: VIEWS OF ROME — On exhibit will be 200 sepia toned photographs by Brooke, inspired by the eternal city of Rome. **WT**
01/97–04/97	PRINTS IN THE COLLECTION OF THE MICHAEL C. CARLOS MUSEUM — Examples of 15th through 20th-century woodcuts, engravings, etchings, aquatints, lithographs, and silkscreen prints from the museum's holdings will be on exhibit.
02/08/97–05/18/97	DISCOVERY AND DECEIT: ARCHAEOLOGY AND THE FORGER'S CRAFT — Authentic and forged antiquities will be juxtaposed in an exhibition that demonstrates how scholars determine the real works from the fake. **WT**
05/97–08/97	THE AMERICAN EXPERIENCE, 1920-1950: WORKS ON PAPER FROM THE CARL W. MULLIS, JR., COLLECTION — A variety of graphic media by 25 artists of American Scene works that document the experience of American culture will be presented in thematic categories including the rural scene, urban realities, the world of entertainment, and the impact of war.
06/97–09/97	AN ENDURING LEGACY: MASTERPIECES FROM THE MR. AND MRS. JOHN D. ROCKERFELLER III COLLECTION — Selected Pan-Asian sculpture, ceramic and painting masterpieces (11th-century B.C.E. to the 18th-century) from 13 different nations will be on view in an exhibition on loan from the most highly regarded public collection of Asian art in the country. **WT**

Atlanta

Ogelthorpe University Museum
Affiliate Institution: Ogelthorpe University
4484 Peachtree Road, NE, **Atlanta, GA 30319**
\ 404-364-8555
HRS: 11-4 Tu-F; 1-4 Sa, S; other by appt! DAY CLOSED: M & Sa HOL: LEG/HOL!
&: Y ℗ Y; Free and ample MUS/SH: Y
GR/T: Y GR/PH: Call 404-365-8555 to reserve
DT: Y TIME: Upon request if available
PERM/COLL: Realsitic figurative art, historical, metaphysical and international art

Established just recently, this museum, dedicated to showing realistic art, has already instituted many "firsts" for this area including the opening of each new exhibition with a free public lecture, the creation of an artist-in-residence program, and a regular series of chamber music concerts. In addition, the museum is devoted to creating and sponsoring its own series of original and innovative special exhibitions instead of relying on traveling exhibitions from other sources. **NOT TO BE MISSED:** 14th-century Kamakura Buddha from Japan; "The Three Ages of Man" by Giorgione (on extended loan); 18th-century engravings illustrating Shakespeare's plays

Augusta

Morris Museum of Art
One 10th Street, **Augusta, GA 30901-1134**
✆ 706-724-7501
HRS: 10-5:30 Tu-Sa, 12:30-5:30 S DAY CLOSED: M HOL: 12/25, 1/1, THGV
F/DAY: S ADM: Y ADULT: $2.00 CHILDREN: F (under 12) STUDENTS: $1.00 SR CIT: $1.00
♿: Y; Elevators in main lobby direct to 2nd floor museum, ramps to bldg.
℗ Y; Free in marked spaces in West Lot; paid parking in city lot at adjacent hotel.
MUS/SH: Y GR/T: Y GR/PH: CATR!
PERM/COLL: REG: portraiture (antebellum to contemporary), still lifes, Impr, cont; AF/AM

Rich southern architecture and decorative appointments installed in a contemporary office building present a delightful surprise to the first time visitor. Included in this setting are masterworks from antebellum portraiture to vivid contemporary creations that represent a broad-based survey of 250 years of painting in the South. **NOT TO BE MISSED:** The Southern Landscape Gallery

ON EXHIBIT/97:

01/23/97–05/04/97	ALASKAN ART FROM THE JUNEAU EMPIRE COLLECTION — 54 works from the Juneau Empire Newspaper collection will consist of Alaskan "old master" works of the late 19th & early 20th centuries, contemporary snow and ice landscape paintings, and an ethnographic work specially commissioned for the collection by Bill C. Ray.
05/22/97–08/17/97	NOBODY KNOWS THE TROUBLE I'VE SEEN: PRINTS AND PAINTINGS BY LAMAR BAKER (1908-1994) — On view will be artworks by Baker reflecting his lifelong concern with the themes of social and economic injustice and racism. WT
09/04/97–11/02/97	AMERICAN ICONS: FROM MADISON TO MANHATTAN: THE ART OF BENNY ANDREWS, 1958-1997 — Works by Benny Andrews from his Chicago art student days of the 1950's to his "Revival" series inspired by his childhood in Georgia, to his newest "Music Series" will be seen in this retrospective exhibition.
11/20/97–01/25/98	ART OF THE SOUTH: A FIFTH ANNIVERSARY EXHIBITION — New acquisitions will be seen in this anniversary exhibition celebrating the Morris Museum of Art's first five years.

Columbus

The Columbus Museum
1251 Wynnton Rd., **Columbus, GA 31906**
✆ 706-649-0713
HRS: 10-5 Tu-Sa, 1-5 S DAY CLOSED: M HOL: LEG/HOL!
SUGG/CONT: Y
♿: Y; Fully accessible ℗ Y; Ample and free MUS/SH: Y
GR/T: Y GR/PH: CATR! DT: Y TIME: 3:00 S!
PERM/COLL: PTGS; SCULP; GR 19-20; DEC/ART; REG; FOLK

The new Mediterranean style addition to the Columbus Museum has added 30,000 feet of well lit exhibition space that provides a splendid setting for its permanent collection of works by American masters of the 19th & 20th centuries. **NOT TO BE MISSED:** "Fergus, Boy in Blue" by Robert Henri; A hands-on discovery gallery for children.

ON EXHIBIT/97:

09/29/96–01/26/97	RECENT PRINTS BY ART WERGER (Working Title)

GEORGIA

The Columbus Museum - continued

12/03/96–06/08/97	HIGH STYLE IN THE LOW COUNTRY: CLASSICAL AMERICAN FURNITURE AND DECORATIVE ARTS FROM SAVANNAH — Nearly 70 examples of late 18th and early 19th-century furniture made and used in Savannah will be on loan from the Telfair Academy Collection. TENT!
12/03/96–06/08/97	BEYOND FUNCTION: CONTEMPORARY SOUTHEASTERN CRAFTS WT
01/26/97–03/16/97	THERE ON THE TABLE: THE AMERICAN STILL LIFE — From classical realism to early abstraction, the still life paintings of the late 19th to mid-20th-century in this exhibition attest to the endless and fertile use of this topic as subject matter in art. BROCHURE WT
02/09/97–03/30/97	DOROTHEA LANGE: A RETROSPECTIVE — In the first major retrospective of her work, nearly 90 photographs that include Lange's images of American migrant families during the Great Depression, and photos of the wartime relocation of Japanese-Americans will be seen along with other powerful works that comment on American life from the 30's through the 50's. CAT WT
03/09/97–06/29/97	THE COCHRAN COLLECTION OF TWENTIETH-CENTURY PRINTS
03/30/97–03/15/98	JIMMY CARTER
04/29/97–07/20/97	CONTEMPORARY PRINTS FROM THE PERMANENT COLLECTION
05/25/97–08/10/97	CONTEMPORARY SOUTHERN ARTISTS
06/22/97–08/17/97	AMERICAN FRAMES, 1870-1920 — An examination of trends in framing from 1870-1940 that provides information on artists' frames in the NMAA collection. WT
07/97–SUMMER/99	DECORATIVE ARTS FROM THE PERMANENT COLLECTION Dates Tent! TENT!
07/97–02/98	CHATTAHOOCHEE RIVER PHOTOS Dates Tent! TENT!
09/14/97–11/09/97	THE AMERICAN SCENE AND THE SOUTH: PAINTINGS AND WORKS ON PAPER, 1930-1946 — Works by John Curry, Paul Cadmus, Philip Evergood and Louis Lozowick will be featured in the first in-depth exhibition to explore American Scene painting of the 1930's and 40's, a dominant art movement during the Depression that promoted realistic, understandable styles with subject matter specific to the United States. CAT WT
10/12/97–11/30/97	ART FROM THE DRIVER'S SEAT: AMERICANS AND THEIR CARS — Paintings, drawings, photographs and etchings from the Terry and Eva Herndon Collection will be featured in an exhibition that allows the visitor to look into the rear view mirror at the history of America's relationship with the automobile. CAT WT
11/11/97–03/01/98	WORKS ON PAPER FROM THE PERMANENT COLLECTION — Industrial themes. BROCHURE

Savannah

Telfair Museum of Art
121 Barnard St., **Savannah, GA 31401**
☏ 912-232-1177
HRS: 10-5 Tu-Sa, 2-5 S DAY CLOSED: M HOL: LEG/HOL!
F/DAY: S ADM: Y ADULT: $5.00 CHILDREN: $1.00 (6-12) STUDENTS: $2.00 SR CIT: $3.00
&: Y; Use President St. entrance ℗ Y; Metered street parking MUS/SH: Y
GR/T: Y GR/PH: CATR! DT: Y TIME: on occasion! H/B: Y; 1819 Regency Mansion designed by William Jay
PERM/COLL: AM: Impr & Ashcan ptgs; AM: dec/art; Brit: dec/art; FR: dec/art

Named for its founding family and housed in a Regency mansion designed in 1818 by architect William Jay, this museum contains the largest and most important collection of the drawings and pastels of Kahlil Gilbran. The Telfair, which is the oldest public art museum in the Southeast, also has major works by many of the artists who have contributed so brilliantly to the history of American art. **NOT TO BE MISSED:** Original Duncan Phyfe furniture; casts of the Elgin Marbles

ON EXHIBIT/97:

11/27/96–02/08/97	PHOTOGLYPHS: RIMMA GELOVINA AND VALERIY GERLOVIN — Featured will be photographs by this Russian husband-and-wife team who were part of the movement to circumvent official censorship of art while in Russia.
11/27/96–02/08/97	THE PHOTOGRAPHY OF HELEN LEVITT — Commonplace events in the urban life of the 1940's will be seen in a exhibition of photographs by Levitt, an artist inspired by Henri Cartier-Bresson, Walker Evans and Ben Shahn.
03/11/97–05/11/97	EDWARD POTTHAST: AM AMERICAN IMPRESSIONIST — More than 60 paintings of Potthast's works from a private collection will be on view.
08/19/97–10/26/97	HOSPICE: A PHOTOGRAPHIC INQUIRY — The photographs of Jim Goldberg, Nan Goldin, Sally Mann, Jack Radcliffe and Kathy Vargas detailing the emotional and collaborative experience of living and working in hospices in different regions of the country will be seen in this exhibition specially commissioned by the Corcoran. Their works will touch upon every aspect of hospice care revealing the spiritual, emotional and physical needs of the terminally ill and their families. CAT WT
11/30/97–02/08/98	THREE GENERATIONS OF AFRICAN AMERICAN WOMEN SCULPTORS: A STUDY IN PARADOX — Ranging from the mid 19th-century to the present will be an exhibition of sculptural works by 10 African-American women artists.

HAWAII

Honolulu

The Contemporary Museum
2411 Makiki Heights Drive, **Honolulu, HI 96822**
✆ 808-526-1322
HRS: 10-4 Tu-Sa, Noon-4 S DAY CLOSED: M HOL: LEG/HOL!
F/DAY: 3rd T ADM: Y ADULT: $5.00 CHILDREN: F (under 12) STUDENTS: $3.00 SR CIT: $3.00
&: Y ℗ Y; Free but very limited parking MUS/SH: Y ⑪ Y; Cafe
DT: Y TIME: 1:30 Tu-S S/G: Y
PERM/COLL: AM: cont; REG

Terraced gardens with stone benches overlooking exquisite vistas complement this museum's structure which is situated in a perfect hillside setting. Inside are modernized galleries in which the permanent collection of art of the past 40 years is displayed. **NOT TO BE MISSED:** David Hockney's permanent environmental installation "L'Enfant et les Sortileges" built for a Ravel opera

ON EXHIBIT/97:

12/04/96–02/02/97	SHIRTS AND SKIN: THE ABSENT FIGURE IN CONTEMPORARY ART	
02/12/97–04/06/97	SPACE, TIME AND MEMORY - PHOTOGRAPHY AND BEYOND IN JAPAN	
04/16/97–06/22/97	BUILDING TCM's COLLECTION - A BEHIND THE SCENES LOOK	
07/02/97–09/07/97	TCM BIENNIAL EXHIBITION OF HAWAII ARTISTS	
10/07/97–11/16/96	CROSSINGS: CONTEMPORARY PHOTOGRAPHY FROM FRANCE	WT
12/03/97–02/01/98	LAURA SMITH - RECENT WORKS	
12/03/97–02/01/98	RAY YOSHIDA - A RETROSPECTIVE	

Honolulu

Honolulu Academy of Arts
900 S. Beretania St., **Honolulu, HI 96814-1495**
✆ 808-532-8700
HRS: 10-4:30 Tu-Sa, 1-5 S DAY CLOSED: M HOL: LEG/HOL!
VOL/CONT: Y ADULT: $5.00 CHILDREN: F (under 12) STUDENTS: $3.00 SR CIT: $3.00
&: Y; Wheelchair access & parking at Ward Ave. gate (call 532-8759 to reserve) ℗ Y; Lot parking at the Academy Art Center for $1.00 with validation; some street parking also available MUS/SH: Y
⑪ Y; 11:30-1:00 Tu-F; Supper 6:30 S call 808-531-8865 GR/T: T GR/PH: CATR! 808-538-3693 ext. 255
DT: Y TIME: 11:00 Tu -Sa; 1:00 S H/B: Y; 1927 Building Designed By Bertram G. Goodhue Assoc. S/G: Y
PERM/COLL: OR: all media; AM: all media; EU: all media; HAWAIIANA COLLECTION

Thirty galleries and six garden courts form the basis of Hawaii's only general art museum. This internationally respected institution features extensive notable collections that span the history of art and come from nearly every corner of the world. PLEASE NOTE: Exhibitions may be seen in the main museum and in the Art Center. **NOT TO BE MISSED:** James A. Michner collection of Japanese Ukiyo-e Woodblock prints; Kress Collection of Italian Rennaissance Paintings

ON EXHIBIT/97:

07/20/96–07/97	THE CERAMIC TRADITION OF ASIA: HIGHLIGHTS OF THE HONOLULU ACADEMY OF ARTS COLLECTION — Ceramic traditions in East Asia will be examined in the first of a continuing series of presentations relating to Pan Saian themes.

Honolulu Academy of Arts - continued

08/23/96–03/09/97 MODERN DESIGN, 1920-1960 — European art and American art, glass, silver and ceramics will be on seen in an exhibition focusing on expressions of modern design.

11/29/96–01/12/97 MILLARD SHEETS: WATERCOLORIST IN HAWAII — 30 watercolor landscapes and coastal scenes will be presented in an exhibition works done by Sheets, a noted member of the California Watercolor School, during the several summers he spent in Hawaii in the 1930's. The works, with richly saturated color and transparent washes, speak to the amazing ability of the artist to capture the shifting light and atmosphere of the Islands.

12/19/96–01/19/97 CATHERINE E.B.COX AWARD EXHIBITION — Featured in the Sculpture Terrace will be works by Dorrien. effigy vessels by Shigeru Miyamoto, the 4th recipient of the Catherine E.B. Cox Award which is generally given every other year.

12/19/96–01/19/97 ARTISTS OF HAWAII, 1996 — This annual exhibition, the 46th, highlights the most important work being done by artists state-wide.

02/04/97–02/28/97 FRANK SHERIFF AND DAVID SMITH

02/04/97–02/28/97 HONOLULU PRINTMAKERS ANNUAL JURIED EXHIBITION

02/13/97–03/23/97 TOUCH OF GOLD: PRECIOUS APPAREL EAST AND WEST — Featured will be a presentation of 50 ceremonial garments from the permanent textile collection each decorated with precious gold thread symbolizing the wealth and status of the owner.

02/13/97–03/23/97 SANTOS: TREASURES OF RELIGIOUS ART FROM THE REPUBLIC OF THE PHILIPPINES — A display of santos from local mainland and Filipino collections, that are associated with their most popular annual fiestas.

03/06/97–04/06/97 CONTEMPORARY CHINESE PAINTINGS BY CHEN KE-ZHAU

03/06/97–04/06/97 PAINTINGS BY YU WEN

04/16/97–06/08/97 EVERYTHING ELVIS: JONI MABE'S TRAVELING PANORAMIC ENCYCLOPEDIA — Collecting her first Elvis memento the day after he died, Mabe has assembled a massive archival museum of Elvis relics, memorabilia, imagery, souvenirs and artwork that has become a shrine rather than mere kitsch.

04/17/97–06/08/97 ELVIS + MARILYN: 2 X IMMORTAL — In the first major museum exhibition to examine the impact of Elvis Presley and Marilyn Monroe on American culture, more than 100 works on view by such artists as by Andy Warhol, Robert Arneson, Robert Rauchenberg, Audry Flack and others will allow the viewer to explore, compare and contrast the power of these two quintessentially American icons. CAT WT

05/17/97–06/08/97 GORDON SASAKI AND AKIO KAMEYA

07/10/97–08/10/97 ARTIST OF HAWAII 1997 — The oldest multi-media state-wide juried exhibition in Hawaii.

08/12/97–08/31/97 IMAGE FOUNDATION JURIED EXHIBITION (Working Title)

09/97–10/97 SOUTHWESTERN WEAVING: A CONTINUUM Dates Tent! TENT! WT

09/04/97–10/12/97 HAWAII STATE FOUNDATION ON CULTURE AND ARTS 30TH ANNIVERSARY (Working Title) — A retrospective peek at works from the state art collection provides the public with a rare opportunity to experience the breadth of quality and diversity in many media that reflect Hawaii's cultural legacy and heritage. CAT

10/97–11/97 HAWAII IN TRANSITION: STUDIES FROM THE VOYAGE OF LOUIS DeFREYCINET (Working Title) — 14 watercolors and ink studies from the Academy's collection created by members of the Freycient voyage of 1819, will offer the viewer a fascinating glimpse of a changing Hawaii just before the arrival of the missionaries.

11/06/97–01/04/98 ELECTRONIC SUPER HIGHWAY: NAM JUNE PAIK IN THE '90'S — Paik's monumental multi-television monitor installation addresses the significance of the electronic media on modern culture. CAT WT

IDAHO

Boise

Boise Art Museum
670 S. Julia Davis Dr., **Boise, ID 83702**
☎ 208-345-8330
HRS: 10-5 Tu-F; Noon-5 Sa, S; Open 10-5 M June & Aug DAY CLOSED: M HOL: LEG/HOL!
ADM: Y ADULT: $3.00 CHILDREN: $1.00 (grades 1-12) STUDENTS: $2.00 SR CIT: $2.00
&: Y ℗ Y; Free and ample parking MUS/SH: Y
GR/T: Y GR/PH: CATR! DT: Y TIME: 12:15 Tu, 1:00 Sa
PERM/COLL: REG; GR; OR; AM: (Janss Collection of American Realism)

Home of the famed Glenn C. Janss Collection of American Realism, the Boise Art Museum in its parkland setting is considered the finest art museum in the state of Idaho. **NOT TO BE MISSED:** "Art in the Park," held every September, is one of the largest art and crafts festivals in the region.

ON EXHIBIT/97:

11/29/96–02/02/97	WILLIAM WEGMAN: PHOTOGRAPHS, PAINTINGS, DRAWINGS AND VIDEO — From the well-known photographic images of his pet Weimaraners to his soft-edge paintings, this non-thematic exhibition of 57 works offers a broad overview of noted contemporary American artist Wegman's work. WT
02/08/97–04/06/97	CROSSING BOUNDARIES: CONTEMPORARY ART QUILTS — On exhibit will be 39 contemporary quilts created by members of the Art Quilt Network in America that represent a departure from the traditional by the inclusion of innovative techniques and the incorporation of painting, photography and printmaking into their works. WT
06/26/97–08/17/97	THE PAINTED PHOTOGRAPH: AN HISTORICAL SURVEY OF HAND-COLORED IMAGES — Photographic images ranging from the earliest daguerreotypes of the 1840's to contemporary works of the 1990's will be on exhibit in the first comprehensive survey of the evolution of hand-colored photographs.
08/30/97–10/26/97	KINSHIPS: ALICE NEEL LOOKS AT THE FAMILY — Unconventional yet captivating and frankly honest portrait paintings by Neel (1900-1983), one of the greatest figurative artists of her day. WT
11/28/97–02/01/98	PICASSO CERAMICS FROM THE BERNIE BERCUSEN COLLECTION, FORT LAUDERDALE MUSEUM OF ART WT

Carbondale

University Museum
Affiliate Institution: Southern Illinois University at Carbondale
Carbondale, IL 62901
☎ 618-453-5388
HRS: 9-3 Tu-Sa, 1:30-4:30 S DAY CLOSED: M HOL: ACAD & LEG/HOL!
&: Y Ⓟ Y; Metered lot just east of the Student Center (next to the football stadium) MUS/SH: Y
GR/T: Y GR/PH: CATR! DT: Y TIME: upon request if available S/G: Y
PERM/COLL: AM: ptgs, drgs, gr; EU: ptgs, drgs, gr, 13-20; PHOT 20; SCULP 20; CER; OC; DEC/ART

Continually rotating exhibitions feature the fine and decorative arts as well as those based on science related themes of anthropology, geology, natural history, and archaeology. **NOT TO BE MISSED:** In the sculpture garden, two works by Ernert Trova, "AV-A-7 and AV-YELLOW LOZENGER," and a sculpture entitled "Starwalk" by Richard Hunt.

ON EXHIBIT/97:

11/03/96–05/31/97	ARCHITECTURAL PHOTOS (RICHARD NICKEL) AND ARCHITECTURAL ORNAMENTS (LOUIS SULLIVAN)
01/14/97–03/07/97	SAMPLING OF AFRICA: ETHNOGRAPHIC ART FROM THE SUIC PERMANENT COLLECTION
03/18/97–05/31/97	CINEMA & PHOTOGRAPHY 20TH ANNIVERSARY EXHIBIT
04/06/97–05/31/97	CLAY CUP EXHIBIT
04/18/97–05/04/97	RICKERT/ZIEBOLD ART EXHIBIT
06/10/97–07/25/97	TRADITIONAL BOW MAKERS
08/26/97–10/15/97	MIDWEST PHOTOGRAPHY INVITATIONAL #9
08/26/97–10/26/97	EXHIBIT OF 20TH CENTURY FRENCH IMPRESSIONIST PIERRE NEVEU
08/26/97–10/26/97	CHARLES SWEDLAND: PHOTOGRAPHY RETROSPECTIVE
11/04/97–11/30/97	PEOPLE'S CHOICE ART EXHIBIT

Champaign

Krannert Art Museum
Affiliate Institution: University of Illinois
500 E. Peabody Dr., **Champaign, IL 61820**
☎ 217-333-1860
HRS: 10-5 Tu, T-Sa; 10 AM-8 PM W; 2-5 S DAY CLOSED: M HOL: LEG/HOL!
VOL/CONT: Y &: Y; Ramps, elevators Ⓟ Y; On-street metered parking MUS/SH: Y ⑪ Y; Cafe/bookstore
GR/T: Y GR/PH: CATR! DT: Y TIME: !
PERM/COLL: P/COL; AM: ptgs; DEC/ART; OR; GR; PHOT; EU: ptgs; AS; AF; P/COL; ANT

Located on the campus of the University of Illinois, Krannert Art Museum is the second largest public art museum in the state. Among its 8,000 works ranging in date from the 4th millennium B.C. to the present is the highly acclaimed Krannert collection of Old Master paintings. **NOT TO BE MISSED:** "Christ After the Flagellation," by Murillo; "Portrait of Cornelius Guldewagen, Mayor of Haarlem," by Frans Hals; Reinstalled Gallery of African Art

ON EXHIBIT/97:

11/16/96–01/12/97	CONTEMPORARY SERIES #10: GREG COLSON — Presented will be sculptor Colson's assemblages of found objects.
11/16/96–01/12/97	BEATRICE REISE — Abstract patterned paintings by New York-based artist Reise will be featured in a traveling exhibition of her work. WT

Krannert Art Museum - continued

01/10/97–03/02/97	CRITIQUES OF PURE ABSTRACTION — 32 paintings, sculptures, prints, photographs and videos will be featured in an exhibition by 20 artists including Richard Artschwager, John Baldessari, Ross Bleckner, Johathan Borofsky and others who respond to the ideals of pure abstraction in their works and yet seek to reform it in order to address the demands of contemporary issues. CAT WT
01/24/97–03/23/97	PHOTOGRAPHS BY ALVIN COBURN — Featured will be 25 recently discovered atmospheric images of New York City taken by early 20th-century photographer Coburn.
01/24/97–03/23/39	CONTEMPORARY SERIES #11: MICHELE BLONDEL — Works by Blondel will be featured in the 11th presentation of the museum's Contemporary Art Series.
04/25/97–06/15/97	RODIN — On loan from the most important and extensive private collections of its kind will be 52 sculptures by celebrated 19th-century French sculptor, Rodin. WT
04/25/97–06/15/97	OUTSIDER ART FROM THE COLLECTION OF ROBERT VOGELE — Ship models and whimsical three dimensional objects by visionary artists will be on loan from one of the finest American collections of outsider art.

Chicago

The Art Institute of Chicago

111 So. Michigan Ave., **Chicago, IL 60603-6110**
✆ 312-443-3600 WEB ADDRESS: http://www.artic.edu
HRS: 10:30-4:30 M & W-F; 10:30-8 Tu; 10-5 Sa; Noon-5 S & HOL! HOL: 12/25
F/DAY: Tu! SUGG/CONT: Y ADULT: $7.00 CHILDREN: $3.50 STUDENTS: $3.50 SR CIT: $3.50
&: Y; Wheelchair accessible; wheelchairs available by reservation Ⓟ Y; Limited metered street parking; several paid parking lots nearby MUS/SH: Y ⅋ Y; the Cafeteria & The Restaurant on the Park
GR/T: Y GR/PH: CATR! DT: Y TIME: 2:00 daily & 12:15 Tu H/B: Y
PERM/COLL: AM: all media; EU: all media; CH; JAP; IND; EU: MED; AF; OC; PHOT

Spend "Sunday in the park with George" while standing before Seurat's "Sunday Afternoon on the Island of La Grande Jatte," or any of the other magnificent examples of the school of French Impressionism, just one of the many superb collections housed in this world-class museum. **NOT TO BE MISSED:** "American Gothic" by Grant Wood; "Paris Street; Rainy Weather" by Gustave Caillebotte

ON EXHIBIT/97:

ONGOING	EIGHTEENTH-CENTURY FRENCH VINCENNES-SEVRES PORCELAIN
	AYALA ALTARPIECE — One of the oldest and grandest Spanish medieval altarpieces in the U.S.
	ALSDORF GALLERY OF RENAISSANCE JEWELRY — One of the most significant collections of its type ever given to an American museum.
	WITH EYES OPEN: A MULTIMEDIA EXPLORATION OF ART
	ART INSIDE OUT: EXPLORING ART AND CULTURE THROUGH TIME
	DOWNEY ART LEAGUE
	TELLING IMAGES: STORIES IN ART — Geared for children ages 7-12, original works of art relating to folklore, history, mythology, and fantasy that provide an introduction to storytelling in art through the use of culturally diverse objects, will be installed in the Kraft Education Center interpretive gallery.

The Art Institute of Chicago - continued

02/12/97–06/22/97 ROOTED IN CHICAGO – TEXTILE DESIGN TRADITIONS: ROBERT D. SAILORS, ANGELO TESTA, BEN ROSE, ELEANOR AND HENRY KLUCK, ELSE REGENSTEINER, AND JULIA McVICKER — On display will be woven and printed textiles by 7 artists, several of whom had their beginnings in Chicago.

02/14/97–05/04/97 DRAWN FROM THE SOURCE: LOUIS I. KAHN'S TRAVEL SKETCHES — 70 drawings by renowned American architect Louis Kahn (1901-1974) will be featured in a rare exhibition of his travel drawings of sites and structures in Italy, France, Greece, and Egypt. The works on view, which pre-date his mature buildings, provide the viewer with an opportunity to explore some of the elements that influenced Kahn's early architectural thinking. WT

02/14/97–05/04/97 THE GRAND TOUR: TRAVEL SKETCHES IN THE PERMANENT COLLECTION

02/20/97–05/11/97 IVAN ALBRIGHT — In the most comprehensive retrospective for Albright, an Illinois native, to date, 120 paintings, small-scale sculptures, and works on paper will be shown with other selected objects. Albright, well-known for his honest and often gritty meticulously rendered images microscopically detailed also painted self-portraits, 20 of which will be included in this exhibition. CAT WT

SPRING/97 GALLERIES OF MODERN ART: 1950-1970 — European and American paintings and sculpture dating from 1950-1970 will be installed in newly renovated gallery space.

03/29/97–06/22/97 CHARLES RENNIE MACKINTOSH: ARCHITECT, DESIGNER, AND ARTIST (Working Title) — More than 200 objects including architectural drawings, room settings, furniture, decorative arts, architectural models and watercolors will be on exhibit in the most comprehensive show ever mounted for Glasgow-born Mackintosh, an architect whose breakthrough style combined a distillation of Scottish baronial, Japanese, and various elements from nature. WT ◠

04/12/97–06/22/97 MICHELANGELO AND HIS INFLUENCE: DRAWINGS FROM WINDSOR CASTLE — The great impact Michelangelo's work had on the imagination, technique, style, and imagery of his contemporaries and followers will be seen in an exhibition of 18 of the master's drawings on view with 55 sheets and a small number of engravings created by the artists he influenced. CAT WT ◠

04/12/97–06/22/97 DRAWINGS REDISCOVERED: ITALIAN DRAWINGS BEFORE 1600 IN THE ART INSTITUTE OF CHICAGO (Working Title) — Some of the finest 15th & 16th-century Italian drawings from the permanent collection will be featured in an exhibition that groups them according to the place of origin.

04/19/97–07/06/97 BAULE: AFRICAN ART/WESTERN EYES — 125 of the greatest works of art from Baule culture on loan from public and private collections in the U.S., Europe and Africa will be featured in the first large museum exhibition of its kind. Known for their refinement, diversity and quality, the items on view will include examples of naturalistic wooden sculpture, objects of ivory, bronze and gold, and masks & figures derived from human and animal forms. WT

10/97–01/98 RENOIR PORTRAITS — More than 60 of Renoir's finest portrait paintings will be featured in the first full-scale reassessment of its kind since the artist's death. It is anticipated that the purchase of admission tickets to this exhibition will be required. CAT WT

ILLINOIS

Chicago

Chicago Cultural Center
78 East Washington St., **Chicago, IL 60602**
📞: 312-744-6630 WEB ADDRESS: http://www.ci.chi.il.us/Tourism/See/CulturalCenter/
HRS: 10-7 M-T, 10-6 F, 10-5 Sa, Noon-5 S HOL: LEG/HOL!
&: Y; Wheelchair accessible through the 77 E. Randolph entrance
GR/T: Y GR/PH: CATR! Mary Murphy 312-744-8032 H/B: Y
PERM/COLL: The broad ranging Harold Washington Library Center Public Art Collection of over 50 works sited on every floor of the building. This collection, which represents the single largest public art project in the city's history, is considered one of the finest assemblages of public art in the world. CATR for guided tours of the collection.

Located in the renovated 1897 historic landmark building, originally built to serve as the city's central library, this vital cultural center, affectionately called the "People's Place," consists of 8 exhibition spaces, two concert halls, two theaters and a dance studio. The facility, which serves as Chicago's architectural showplace for the lively and visual arts, offers guided architectural tours of the building at 1:30 on Tu & W, and at 2 PM on Sa.

ON EXHIBIT/97:

12/09/96–02/23/97	OUTSIDER ART: AN EXPLORATION OF CHICAGO COLLECTIONS — More than 200 works by American and European self-taught visionary "masters" will be featured in a presentation showcasing paintings, drawings, sculpture and a variety of non-traditional objects.
12/20/96–01/24/97	HERE'S LOOKING AT YOU: 45 YEARS OF PHOTOJOURNALISM BY ART SHAY — A retrospective exhibition of works by Shay, an author, WWII field navigator (with actor Jimmy Stewart) and distinguished *Life Magazine* photojournalist.
01/18/97–03/16/97	AWESTRUCK BY THE MAJESTY OF THE HEAVENS: ARTISTIC PERSPECTIVES FROM THE ADLER PLANETARIUM'S HISTORY OF ASTRONOMY COLLECTION — On exhibit from Chicago's Adler Planetarium will be 50 rarely seen late 15th through mid 19th-century works on paper including celestial charts, heroic portrait prints, book plates, and astronomical diagrams documenting discoveries in the history of astronomy.
01/31/97–03/06/97	PASSIONATE AND CHAOTIC: PAINTINGS BY EULALIO BUENO SILVA JR. — An exhibition of 25 landscape, still-life, and portrait paintings explore Chicago resident Silva's growth as a self-taught artist.
03/13/97–04/17/97	WAYEN ATKINSON: NATURE IN WATERCOLOR — Atkinson's nostalgic watercolors of nature comment on the slower, kinder and safer pace of yesteryear.
03/15/97–05/18/97	LANDFALL PRESS: 25 YEARS — A major loan exhibition of works by 65 prominent American artists who have created their limited edition prints at Chicago's Landfall Press. WT
04/97–09/97	GREAT MOMENTS IN CHICAGO HISTORY
04/05/97–05/25/97	THE EYE AND THE HAND: ARTS AND CRAFTS OF MOROCCO — More than 100 beautiful and diverse examples of Moroccan textiles, jewelry, ceramics, and objects of wood, leather and metal created in Morocco over the last 2 centuries will be seen in this overview exhibition. CAT WT
06/07/97–08/10/97	NEW ART IN CHINA, POST 1989 — This exhibition of 84 works by 30 artists presents the opportunity to explore the many facets of unofficial contemporary Chinese art. CAT WT

Chicago

The David and Alfred Smart Museum of Art
Affiliate Institution: The University of Chicago
5550 S. Greenwood Ave., **Chicago, IL 60637**
✆ 312-702-0200 WEB ADDRESS: http://csmaclab-www.uchicago.edu/SmartMuseum/index.html
HRS: 10-4 Tu-F; Noon-6 Sa, S DAY CLOSED: M HOL: LEG/HOL!
&: Y; Wheelchair accessible ℗ Y: Free parking on lot next to museum after 4:00 weekdays, and all day on weekends
MUS/SH: Y GR/T: Y GR/PH: CATR! 312-702-4540 DT: Y TIME: 1:30 S during special exhibitions S/G: Y
PERM/COLL: AN/AGK: Vases (Tarbell Coll); MED/SCULP; O/M: ptgs, sculp (Kress Coll); OM: gr (Epstein Coll); SCULP: 20

Among the holdings of the Smart Museum of Art are Medieval sculpture from the French Romanesque church of Cluny III, outstanding Old Master prints by Dürer, Rembrandt, and Delacroix from the Kress Collection, sculpture by such greats as Degas, Matisse, Moore and Rodin, and furniture by Frank Lloyd Wright from the world famous Robie House. PLEASE NOTE: During 1997 many of the exhibitions at this museum will be loan presentations from the Oriental Art Institute which is undergoing renovation. **NOT TO BE MISSED:** Mark Rothko's "Untitled," 1962

ON EXHIBIT/97:

09/10/96–03/09/97	FACES OF ANCIENT EGYPT: ANCIENT EGYPTIAN ART FROM THE COLLECTION OF THE ORIENTAL INSTITUTE MUSEUM (Working Title) — During construction of the Oriental Institute's new building many works from their collection will be on exhibit at this venue. The exhibition focuses primarily on the nature and function of "portaiture" in Ancient Egypt.
04/01/97–06/08/97	CLASSICAL ART FROM THE PERMANENT COLLECTION (Working Title)
04/17/97–06/15/97	FROM BLAST TO POP: ASPECTS OF MODERN BRITISH ART 1915-1965 — Paintings, works on paper and sculpture from the museum's collection will be featured in an exhibition of works by many of Britain's most avant-garde 20th-century artists.
07/01/97–03/08/98	TREASURES OF DARKNESS: ART OF SUMER — Excavated by the Oriental Art Institute, these ancient treasures on loan from them date from the earliest period of Mesopotamian history.
10/16/97–01/04/98	STILL MORE DISTANT JOURNEYS: THE ARTISTIC EMIGRATIONS OF LASAR SEGALL (1891-1957) — Featured will be modernist works by Segall, a European-born artist associated with the German Expressionist movement, who fled from the Nazi regime to Brazil.

Martin D'Arcy Gallery
Affiliate Institution: The Loyola Univ. Museum of Medieval, Renaissance and Baroque Art
6525 N. Sheridan Rd., **Chicago, IL 60626**
✆ 312-508-2679
HRS: 12-4 M-F during the school year; Closed Summers DAY CLOSED: Sa, S HOL: ACAD!, LEG/HOL! & SUMMER
&: Y ℗ Y; Free visitor parking on Loyola Campus
GR/T: Y GR/PH: CATR! 312-508-2597 DT: Y TIME: often available upon request
PERM/COLL: MED & REN; ptgs, sculp, dec/art

Sometimes called the "Cloisters of the Midwest," The Martin D'Arcy Gallery of Art is the only museum in the Chicago area focusing on Medieval and Renaissance art. Fine examples of Medieval, Renaissance, and Baroque ivories, liturgical vessels, textiles, sculpture, paintings and secular decorative art of these periods are included in the collection. **NOT TO BE MISSED:** A pair of octagonal paintings on Verona marble by Bassano; A German Renaissance Collectors Chest by Wenzel Jamitzer; A silver lapis lazuli & ebony tableau of the Flagellation of Christ that once belonged to Queen Christina of Sweden

ON EXHIBIT/97:

ONGOING	PERMANENT COLLECTION OF MEDIEVAL, RENAISSANCE, AND BAROQUE ART

ILLINOIS

Chicago

Mexican Fine Arts Center Museum
1852 W. 19th St., Chicago, IL 60608
☎ 312-738-1503
HRS: 10-5 Tu-S HOL: LEG/HOL! ঐ: Y MUS/SH: Y
PERM/COLL: MEX: folk; PHOT; GR; CONT

Mexican art is the central focus of this museum, the first of its kind in the Midwest and the largest in the nation. Founded in 1982, the center seeks to promote the works of local Mexican artists and acts as a cultural focus for the entire Mexican community residing in Chicago.

ON EXHIBIT/97: There are many special shows throughout the year. Please call for specific details on solo exhibitions and on "Dia de los Muertos," which are exhibitions held annually from the beginning of October through the end of November.

Museum of Contemporary Art
220 East Chicago Ave., Chicago, IL 60611-2604
☎ 312-280-2660
HRS: 10-6 M & T-S, 10-9 Tu & W HOL: THGV, 12/25, 1/1
F/DAY: M ADM: Y ADULT: $6.00 CHILDREN: F (12 & under) STUDENTS: $3.50 SR CIT: $3.50
ঐ: Y; Wheelchair ramp at entrance, elevator available Ⓟ Y; On-street and pay lot parking available nearby MUS/SH: Y
❒ Y; 11-4:30 Tu-Sa; Noon-5 S
GR/T: Y GR/PH: CATR! DT: Y TIME: several times daily!
PERM/COLL: CONTINUALLY CHANGING EXHIBITIONS OF CONTEMPORARY ART

Some of the finest and most provocative cutting-edge art by both established and emerging talents may be seen in the new ultra-modern $46.5 million building and sculpture garden located on a prime 2 acre site overlooking Lake Michigan. Brilliantly designed, the building is the first American project for noted Berlin architect Josef Paul Kleihues, and features nearly 5 times the exhibition space of its former facility. **NOT TO BE MISSED:** "Dwellings" by Charles Simonds (an installation on a brick wall in the cafe/bookstore that resembles cliff dwellings); a 3 story sound sculpture on the stairwell by Max Neuhaus.

ON EXHIBIT/97:
THE FOLLOWING EXHIBITIONS WILL BE FEATURED DURING THE INAUGURAL YEAR:

INSTALLATION OF WORKS FROM THE PERMANENT COLLECTION — Minimal, conceptual, post-conceptual, surrealist and works of art from Chicago will be included in an exhibition designed to showcase the strengths of the museum's holdings. Alexander Calder, Donald Judd and Bruce Nauman are among the artists whose works will be featured.

SERIES DEVOTED TO YOUNGER & LESSER-KNOWN ARTISTS — In addition to the works of Joe Scanlan which will be featured in his first solo show in an American museum, this series will also present first-time solo exhibitions for Jennifer Pastor, Michael J Grey, and Jorge Pardo. Its purpose is to provide the public with the first opportunity to be introduced to works by important emerging or under-recognized contemporary artists.

07/02/96–05/25/97 IN THE SHADOW OF STORMS: ART OF THE POSTWAR ERA FROM THE MCA COLLECTION — Organized in 2 concentric rings, the outer gallery will present works chronologically while the inner ring will focus on clusters of work by Alexander Calder, Leon Golub, Donald Judd, Bruce Mauman, Jeff Koons, Ed Paschke and other artists whose works have been collected in depth by the museum.

11/02/96–01/12/97 MERET OPPENHEIM: BEYOND THE TEACUP — Works on loan from his family, private lenders, and European museums will be featured in the first retrospective exhibition in America for Oppenheim (1913-1985), an artist who is considered an icon of 20th-century art and the Surrealist movement and who is best recognized as the creator of a fur-lined tea cup entitled "Déjeuner en Fourrure," 1936.

Museum of Contemporary Art - continued

11/16/96–03/23/97 ART IN CHICAGO, 1945-1995 — In the first historical survey of art created in the MCA's vicinity, works of artistic development greatly influenced by the city's politics, social activism, architectural history, segregated neighborhoods, and industrial & financial interests will be on view. Many of the 150 works in all media by 135 artists reflect the strong influence Chicago's galleries, museums, collectors, non-profit spaces and community-based movements had in the creation of the art featured in this exhibition.
CAT ∩

11/16/96–03/23/97 TIME ARTS CHICAGO — A survey of the city's recent history of film, video and performance will be presented as both an exhibition and as a series of live programs in the MCA's new 300 seat theater.

01/25/97–04/06/97 JORGE PARDO — Pardo, a Cuban born Los Angeles based artist will organize an exhibition of works from the MCA's collection installed in a house of his construction. He will also create a new architectural work to be placed in a non-gallery setting inside the museum.

04/19/97–06/29/97 CRIMES AND SPLENDORS: THE DESERT CANTOS OF RICHARD MISRACH — 200 images of the American desert from Misrach's Desert Cantos series begun in 1969 will be seen in the first photographic survey of this monumental series which acts as the artist's commentary on civilization and the environment.

04/19/97–06/29/97 MICHAEL JOAQUIN GREY — On exhibit will be sculptures by Grey, based on a cosmology of the artist's own which he calls "zoop" after his versions of primordial soup.

04/19/97–07/20/97 PERFORMANCE ANXIETY — A major exhibition of existing and newly commissioned installation pieces by 9 to 10 well-known and emerging artists will be accompanied by a performance series of both historic and new performances.

04/19/97–06/08/97 ABIGALE LANE — Lane will create a site-specific new video installation in this solo presentation of her work.

06/21/97–08/17/97 ALIX PEARLSTEIN — This installation by Pearlstein, an artist known for her playful use of everyday objects to create bizarre scenes, is entitled "Interiors," and is composed of video, sculpture and a series of drawings that all relate to one another.

06/21/97–05/98 SELECTIONS FROM THE PERMANENT COLLECTION — 100 works highlighting major developments in art-making from 1945 to the present will on exhibit from the permanent collection.

07/12/97–09/28/97 HARRY CALLAHAN — Focusing on the exploration of photographic possibilities, this exhibition of 125 works includes innovative examples created through the manipulation of multiple images, collage, and extreme contrast by Callahan, an American artist known for his remarkable contribution to the medium. CAT WT

07/12/97–09/21/97 MONA HATOUM — Sculpture, photography and a new installation entitled "Quarters" will be featured in the first one-person show in America for Palestinian-born artist Hatoum.

08/02/97–09/28/97 SITE/NONSITE: INSTALLATION ART OF THE LATE 20TH CENTURY — Presented will be an exhibition that reflects the strength of the museum's holdings with major installations of works by Felix Gonzalez-Torres, Sol LeWitt, Bruce Nauman, Robert Smithson and others. WT

10/11/97–01/04/98 TOSHIO SHIBATA — Large format meticulous gelatin silver point landscape photographs will be featured in the first solo U.S. exhibition for Tokyo-based photographer Shibata.

10/11/97–01/25/98 HALL OF MIRRORS: ART AND FILM SINCE 1945 — 100 art objects, 100 film excerpts and 12 room-sized installations will be accompanied by a film series in an exhibit that explores the relationship between cinema and the visual arts.

ILLINOIS

Chicago

Museum of Contemporary Photography of Columbia College Chicago
600 South Michigan Ave., **Chicago, IL 60605-1996**
📞 312-663-5554
HRS: Sep-May: 10-5 M-F, Noon-5 Sa, till 8 PM T; June-Jul: 10-4 M-F, Noon-4 Sa DAY CLOSED: S HOL: LEG/HOL! AUG
VOL/CONT: Y
&: Y Ⓟ Y; Public parking available nearby
GR/T: Y GR/PH: CATR! DT: Y TIME: call for information
PERM/COLL: CONT/PHOT

Contemporary photography by American artists forms the basis of the permanent collection of this college museum facility.

ON EXHIBIT/97:

09/96–08/97	THE MIDWEST PHOTOGRAPHERS PROJECT — 100 photographs by established and emerging artists living in the Illinois region will be shown on a rotating basis in the print study room which was established in 1982 as a center for photographic study.
11/16/96–01/11/97	THE MIDWEST PHOTOGRAPHERS PROJECT: ILLINOIS PHOTOGRAPHY IN THE 1990'S — On loan to the exhibition will be 100 innovative transparencies and prints created over the last decade by artists living in the Illinois area.
01/25/97–03/22/97	CRITICAL MASS: MERIDEL RUBENSTEIN, STEINA AND WOODY VASULKA, AND EDDEN ZWEIG — Photographs, video and narrative will be featured in this multi-media collaborative installation which commemorates the making of the atom bomb 50 years ago and the impact at the time of the encounter between Western science technology and Native American attitudes towards the mysteries of the physical worlds.
04/05/97–05/31/97	AMPHIBIANS, BIOTECHNOLOGY, CONSTELLATIONS: PHOTOGRAPHY AND SCIENCE (Working Title) — Images of muscle tissue, mammograms, brain scans, stars & constellations and even rotting vegetation will be seen in this group exhibition which focuses on the role of photography in the service of science.
10/07/97–11/02/97	WHEN AARON MET HARRY: CHICAGO PHOTOGRAPHY 1946-1971

Oriental Institute Museum
Affiliate Institution: University of Chicago
1155 E. 58th St., **Chicago, IL 60637**
📞 312-702-9520
HRS: 10-4 Tu-Sa, Noon-4 S, till 8:30 PM W DAY CLOSED: M HOL: 12/25, 1/1, 7/4. THGV

&: Y; Accessible by wheelchair from west side of building Ⓟ Y; On-street or coin operated street level parking on Woodlawn Ave. between 58th & 59th Sts. (1/2 block east of the institute) MUS/SH: Y
GR/T: Y GR/PH: catr! 312-702-9507 DT: Y TIME: 2:30 S
PERM/COLL: AN: Mid/East

Hundreds of ancient objects are included in the impressive comprehensive collection of the Oriental Institute. Artifacts from the ancient Near East dating from earliest times to the birth of Christ provide the visitor with a detailed glimpse into the ritual ceremonies and daily lives of ancient civilized man. PLEASE NOTE: The museum will be closed until the spring of 1998 due to a major renovation project. **NOT TO BE MISSED:** Ancient Assyrian 40 ton winged bull; 17' tall statue of King Tut; Colossal Ancient Persian winged bulls

Chicago

The Polish Museum of America
984 North Milwaukee Ave., **Chicago, IL 60622**
📞 312-384-3352
HRS: 11-4 M-S SUGG/CONT: Y ADULT: $2.00 CHILDREN: $1.00
&: Y; Wheelchairs available by reservation 312-384-3352 **P**: Y: Free parking with entrance from Augusta Blvd.
GR/T: Y GR/PH: 312-384-3352
PERM/COLL: ETH: ptgs, sculp, drgs, gr

The promotion of Polish heritage is the primary goal of this museum founded in 1935. One of the oldest and largest ethnic museums in the U.S., their holdings range from the fine arts to costumes, jewelry, and a broad ranging scholarly library featuring resource information on all areas of Polish life and culture. **NOT TO BE MISSED:** Polonia stained glass by Mieczyslaw Jurgielewicz

Terra Museum of American Art
664 N. Michigan Ave., **Chicago, IL 60611**
📞 312-664-3939
HRS: Noon-8 Tu, 10-5 W-Sa, Noon-5 S DAY CLOSED: M HOL: 12/25, 1/1, THGV, 7/4
F/DAY: Tu & 1st S of month SUGG/CONT: Y ADULT: $4.00 CHILDREN: F (under 14) SR CIT: $2.00
&: Y; Elevator access to all floors MUS/SH: Y
GR/T: Y GR/PH: CATR! education dept. DT: Y TIME: Noon & 2:00 daily
PERM/COLL: AM: 17-20

With over 800 plus examples of some of the finest American art ever created, the Terra, located in the heart of Chicago's "Magnificent Mile," reigns supreme as an important repository of a glorious artistic heritage. **NOT TO BE MISSED:** "Gallery at the Louvre" by Samuel Morse; Maurice Prendergast paintings and monotypes

ON EXHIBIT/97:
 01/17/97–03/28/97 AN AMERICAN CENTURY OF PHOTOGRAPHY: THE HALLMARK PHOTOGRAPHIC COLLECTION — In this exhibition an examination of the strides that have been made in photography and the present impact on the medium by computers and electronic imaging will be seen in an overview of 200 works by 130 of the most outstanding past and present artists in the field. WT

Edwardsville

The University Museum
Affiliate Institution: So. Illinois Univ. at Edwardsville
Box 1150, **Edwardsville, IL 62026-2996**
📞 618-692-2996
HRS: 10-4 M-F DAY CLOSED: Sa, S HOL: LEG/HOL!
&: Y; Elevator Ⓟ Y: Paid parking lot next to the museum building S/G: Y
PERM/COLL: DRGS; FOLK; CER; NAT/AM

Works in many media from old masters to young contemporary artists are included in the permanent collection and available on a rotating basis for public viewing enjoyment. The museum is located in the western part of the state not far from St. Louis, Missouri. **NOT TO BE MISSED:** Louis Sullivan Architectural Ornament Collection located in the Lovejoy Library

ON EXHIBIT/97:
 01/14/97–02/28/97 OTHER BLOODS — A presentation of works by six black artists who were all born in the Midwest and the South but who all are currently working in the New York area.

ILLINOIS

The University Museum - continued

03/10/97–04/11/97	THE ART OF THERAPY — Works by members of the American Art Therapy Association will be on exhibit with those of their clients.
05/17/97–07/03/97	SOFA-SIZED PAINTINGS — Still in the planning stages as of 8/96, this invitational or juried exhibition will feature works on the theme of "life sized" paintings of artist's sofas.
07/14/97–08/15/97	LETTERING ARTISTS — This dual presentation features one exhibition of works by local & regional calligraphers and another from a nationally known collection of lettering artists.

Evanston

Mary and Leigh Block Gallery

Affiliate Institution: Northwestern University
1967 Sheridan Road, **Evanston, IL 60208-2410**
✆ 847-491-4000
HRS: Noon-5 Tu-W, Noon-8 PM T-S (Gallery closed summer; S/G open year round) DAY CLOSED: M
HOL: LEG/HOL! SUMMER (Gallery only) &: Y
℗ Y; Visitor parking on premises (pick up parking permits at Gallery for weekdays). Parking free after 5:00 and all day Sa & S
MUS/SH: Y GR/T: Y GR/PH: CATR! 708-491-4002 S/G: Y
PERM/COLL: EU: gr, drgs 15-19; CONT: gr, phot; architectural drgs (Griffin Collection)

In addition to its collection of works on paper this fine university museum features an outdoor sculpture garden (open free of charge year round) which includes outstanding examples of 20th-century works by such artistic luminaries as Joan Miro, Barbara Hepworth, Henry Moore, Jean Arp and others. **NOT TO BE MISSED:** The sculpture garden with works by Henry Moore, Jean Arp, Barbara Hepworth, and Jean Miro (to name but a few) is one of the major sculpture collections in the region.

ON EXHIBIT/97:

01/16/97–03/09/97	FRANTISEK DRTIKOL: A RETROSPECTIVE & RUDOLPH KOPPITZ: VIENNESE "MASTER OF THE CAMERA" — In this two-part exhibition 94 photographs (including 58 vintage pigment prints) by Drtikol, a modernist photographer and seminal figure in Czech photography will be seen in the first major retrospective of his work in North America. Works by Koppitz, one of leading Viennese art photographers during the years between the wars will also be on exhibit.
04/17/97–06/22/97	CURATOR'S CHOICE — Three small exhibitions, one relating to American themes and the other addressing art of the Northern Renaissance, will feature works of long standing from the permanent collection along with recent acquisitions.
07/10/97–08/16/97	HENRY SIMON: A RETROSPECTIVE — Over 100 of Simon's regional social realist paintings, drawings and lithographs, many of which were created when he worked for the Illinois Art Project during the Great Depression, will be featured in an exhibit reflecting some of his personal themes as well as allusions to significant events in American history.

Freeport

The Freeport Art Museum and Cultural Center

121 No. Harlem, **Freeport, IL 61032**
✆ 815-235-9755
HRS: Noon-5 W-S, till 7 PM Tu DAY CLOSED: M HOL: 1/1, EASTER. 7/4, THGV, 12/25
SUGG/CONT: Y ADULT: $1.00 CHILDREN: F STUDENTS: $0.50 SR CIT: $0.50
&: Y; Except for three small galleries ℗ Y; Lot behind museum GR/T: Y GR/PH: CATR!
PERM/COLL: EU: 19-20; AM: 19-20; CONT: ptgs, sculp; P/COL; AN/R; NAT/AM; AN/EGT; AS; AF; OC

The Freeport Art Museum and Cultural Center - continued

The Freeport Museum, located in northwestern Illinois, has six permanent galleries of paintings, sculpture, prints, and ancient artifacts as well as temporary exhibitions featuring the work of noted regional artists. It houses one of the largest Florentine mosaic collections in the world. **NOT TO BE MISSED:** Especially popular with children of all ages are the museum's classical and Native American galleries.

ON EXHIBIT/97:

01/10/97–03/16/97	WILDLIFE ART
04/25/97–06/08/97	ANYTHING CAN HAPPEN IN A COMIC STRIP — The 100th anniversary of the comic strip will be commemorated in an exhibit in the Children's Gallery.　　WT
06/13/97–08/22/97	CONTEMPORARY QUILTS

Mount Vernon

Mitchell Museum

Richview Rd., **Mount Vernon, IL 62864-0923**
✆ 618-242-1236
HRS: 10-5 Tu-Sa, 1-5 S　DAY CLOSED: M　HOL: LEG/HOL!
VOL/CONT: Y
&: Y ⓟ Y; On-site parking available　MUS/SH: Y　GR/T: Y　GR/PH: CATR!　S/G: Y
PERM/COLL: AM: ptgs, sculp (late 19- early 20)

Works from the "Ashcan School" with paintings by Davies, Glackens, Henri, Luks, and Maurice Prenderghast are one of the highlights of the Mitchell Museum which also features significant holdings of late 19th and early 20th-century American art. The museum is located in south central Illinois. **NOT TO BE MISSED:** Sculpture park

ON EXHIBIT/97:

02/22/97–04/06/97	FUNDAMENTAL SOUL: THE HAGAR GIFT OF SELF-TAUGHT AFRICAN AMERICAN ART — More than 109 works by 37 self-taught southern, African and American artists will be on exhibit.　　WT
02/22/97–04/13/97	TAWFIK YOUSSEF PHOTOGRAPHS — Youssef's black and white photographs offer a serene close up of nature will be on view in the Administration Building.
03/01/97–04/13/97	TEMPLE AND VILLAGE: PATTERNS AND PRINTS OF INDIA — On loan from the collection at Iowa State University will be 50 traditionally designed hand-printed, dyed and embroidered Indian textiles that reveal their rich regional diversity.
04/19/97–06/22/97	HOME AND YARD: THE MATERIAL CULTURE OF THE RURAL ELDERLY LIVING ALONE ALONG THE MISSISSIPPI RIVER VALLEY IN SOUTHERN ILLINOIS — An exhibit that documents the way in which 40 elderly families have shaped the spaces in which they live.
05/24/97–07/06/97	AFTER THE FLOOD: PHOTOS BY RICHARD SPRENGELER — An exhibit of brilliantly colored views of St. Louis will be on view in the Administration Building.
05/25/97–07/20/97	ANYTHING CAN HAPPEN IN A COMIC STRIP — The 100th anniversary of the comic strip will be commemorated in an exhibit in the Children's Gallery.　　WT
07/12/97–09/14/97	DR. DURAND: RECENT PHOTOS — This presentation of experimental black and white photos will be on view in the Administration Building.
07/26/97–08/30/97	TURN, TURNING, TURNED — On exhibit will be 35 wood works by both formally trained and self-taught artists that explore techniques ranging from the strictly traditional to computer generated forms turned on a computer driven lathe.

ILLINOIS

Peoria

Lakeview Museum of Arts and Sciences

West Lake Ave., **Peoria, IL 61614**
☎ 309-686-7000
HRS: 10-5 Tu-Sa, Noon-4 S, till 8 PM W DAY CLOSED: M HOL: LEG/HOL!
F/DAY: Tu ADM: Y ADULT: $2.50 CHILDREN: $1.50 STUDENTS: $1.50 SR CIT: $1.50
&: Y Ⓟ Y; Free MUS/SH: Y
GR/T: Y GR/PH: CATR! S/G: Y
PERM/COLL: DEC/ART; AM: 19-20; EU:19

A multi-faceted museum that combines the arts and sciences, the Lakeview offers approximately 10 touring exhibitions per year. PLEASE NOTE: Prices of admission may change during special exhibitions! **NOT TO BE MISSED:** Discovery Center, a particular favorite with children.

ON EXHIBIT/97:
PERMANENT EXHIBITIONS:	ILLINOIS FOLK ART GALLERY
	AFRICAN ART GALLERY
	PERMANENT COLLECTION SHOWS
02/22/97–04/06/97	26TH BRADLEY INTERNATIONAL PRINT AND DRAWING EXHIBITION — A juried exhibition of outstanding works by American and European artists.

Quincy

Quincy Art Center

1515 Jersey St., **Quincy, IL 62301**
☎ 217-223-5900
HRS: 1-4 Tu-S DAY CLOSED: M HOL: LEG/HOL!
VOL/CONT: Y
&: Y Ⓟ Y; Free MUS/SH: Y GR/T: Y GR/PH: CATR! DT: Y TIME: Often available upon request
H/B: Y; 1888 building known as the Lorenzo Bull Carriage House
PERM/COLL: PTGS; SCULP; GR

The Quincy Art Center is housed in an 1887 carriage house designed by architect Joseph Silsbee who was a mentor and great inspiration to Frank Lloyd Wright. The museum and its historic district with architecture ranging from Greek Revival to Prairie Style, was noted by Newsweek Magazine as being architecturally significant. Located in the middle of the state, the museum is not far from the Missouri border. **NOT TO BE MISSED:** The Quincy Art Center, located in an historic district that *Newsweek* Magazine called one of the most architecturally significant corners in the country, is composed of various buildings that run the gamut from Greek Revival to Prairie Style architecture.

ON EXHIBIT/97:
01/10/97–03/02/97	GOYA BULL FIGHT ETCHINGS: FROM A QUINCY COLLECTION
01/10/97–04/18/97	BYRON BURFORD: THE CIRCUS WORKS
03/15/97–04/18/97	47TH ANNUAL QUAD-STATE EXHIBITION — All media will be represented in this juried exhibition of works by artists from Illinois, Indiana, Iowa and Missouri.
05/30/97–06/06/97	TWO-WOMAN EXHIBIT: PAINTINGS BY PHYLLIS BRAMSON AND VERA KLEMENT
07/20/97–08/31/97	ROBERT DOARES DRAWINGS — Christian religious works in graphite on panel.
07/20/97–08/31/97	QUINCY COLLECTS

Rock Island

Augustana College Gallery of Art
7th Ave. & 38th St., Art & Art History Dept., **Rock Island, IL 61201-2296**
☎ 309-794-7469
HRS: Noon-4 Tu-Sa (Sep-May) DAY CLOSED: M, S HOL: ACAD! & SUMMER
&: Y; Call ahead for access assistance
Ⓟ Y; Parking available next to Centennial Hall at the northwest corner of Seventh Ave. & 38th St.
GR/T: Y GR/PH: CATR!
PERM/COLL: SWEDISH AM: all media

Swedish American art is the primary focus of this college art gallery.

ON EXHIBIT/97:

01/07/97–03/27/97	PIECED, PATTERNED, STITCHED AND ASSEMBLED — Color and texture will be the focus of the innovative works on view in fiber, collage, and mixed media works created by artists nationwide.
01/10/97–02/22/97	MASTER PRINTS FROM GEMINI G.E.L. — Prints by 22 contemporary leading American artists created at the Gemini G.E.L. workshop in L.A. will be seen in an exhibition encompassing every art style including figurative, expressionist, minimalist, deconstructionist, and more. WT
04/06/97–05/04/97	ANNUAL JURIED COMPETITION — A juried exhibition open to artists residing within a 150 mile radius of the Quad cities.

Rockford

Rockford Art Museum
711 N. Main St., **Rockford, IL 61103**
☎ 815-968-ARTS
HRS: 11-5 Tu-F, 12-5 Sa, 1-5 S; Summer: 11-5 Tu, W, F; till 7:30 T; 12-5 Sa; 1-5 S DAY CLOSED: M HOL: LEG/HOL!
F/DAY: e SUGG/CONT: Y
&: Y Ⓟ Y; Free and ample MUS/SH: Y GR/T: Y GR/PH: CATR! S/G: Y
PERM/COLL: AM: ptgs, sculp, gr, dec/art 19-20; EU: ptgs, sculp, gr, dec/art 19-20; AM/IMPR; TAOS ART, GILBERT COLL: phot

With 10,000 square feet of exhibition space, this is the largest arts institution in the state outside of Chicago. It houses an 800 piece collection of 19th & 20th-century art. **NOT TO BE MISSED:** "The Morning Sun" by Pauline Palmer, 1920; ink drawings and watercolors by Reginald Marsh (available for viewing only upon request)

ON EXHIBIT/97:

11/18/96–02/28/97	IT'S A MALLEABLE WORLD: CERAMICS FROM THE PERMANENT COLLECTION
01/24/97–04/06/97	RURAL INSPIRATIONS — Works by Midwest artists in many media and of differing style and conceptual approaches will be featured in an exhibit that explores elements from rural environments.
05/02/97–07/06/97	FIGURE EIGHT — An exploration of the styles and trends in contemporary figure painting will be addressed in works on exhibit created by eight regional artists.
08/01/97–10/12/97	MATERIAL WORLD FOCUS: REDEFINING THE ART OBJECT II — Contemporary treatment of the art object will showcase non-traditional media and unique materials used in the creation of art.
11/07/97–01/18/98	TOM HEFLIN

ILLINOIS

Rockford

Rockford College Art Gallery / Clark Arts Center

5050 E. State, **Rockford, IL 61108**
☎ 815-226-4034
HRS: ACAD: 2-5 Daily HOL: ACAD! & SUMMER
VOL/CONT: Y
&: Y; Elevator at west side of Clark Art Center Ⓟ Y; Free; near Clark Arts Center GR/T: Y GR/PH: CATR!
PERM/COLL: PTGS, GR, PHOT, CER 20; ETH; REG

Located on a beautiful wooded site in a contemporary building, this museum presents a stimulating array of exhibitions ranging from American Indian baskets to contemporary mixed media and photography. **NOT TO BE MISSED:** African sculpture

ON EXHIBIT/97:

02/02/97–03/02/97	ROBERT McCAULEY
03/21/97–04/02/97	UnCOMMON LIVES EXHIBIT
04/07/97–04/25/97	MOBY DICK IN THE HEARTLAND Dates Tent!

Springfield

Springfield Art Association

700 North Fourth St., **Springfield, IL 62702**
☎ 217-523-2631
HRS: 9-4 M-F, 1-3 Sa HOL: LEG/HOL! (including Lincoln's birthday)
&: Y Ⓟ Y; Free MUS/SH: Y GR/T: Y GR/PH: CATR! DT: Y TIME: 1-3 W-S
PERM/COLL: AM: ptgs, gr, cer, dec/art; EU: ptgs; RUS: dec/art; CH; JAP

Fanciful is the proper word to describe the architecture of the 1833 Victorian structure that houses the Springfield Art Association, a fine arts facility that has been important to the cultural life of the city for more than a century.

ON EXHIBIT/97:

12/07/96–01/25/97	HOLIDAYS! IS IT A CULTURAL REVELATION/REVOLUTION ? — Included in this multi-cultural mix of holiday accruements will be Christmas lights, Baltic ornamentation, Hanukkah displays, Asian New Year displays and Dia de Los Muertos altars.
02/01/97–04/12/97	BEYOND TIME — Vintage European posters and photographs, circa 1915-1940, will be on loan from the A.G. Edwards & Sons Corporate Collection.
04/26/97–06/14/97	FUNDAMENTAL SOUL: THE HAGAR GIFT OF SELF-TAUGHT AFRICAN-AMERICAN ART — More than 109 works by 37 self-taught southern, African and American artists will be on exhibit. WT
06/28/97–09/06/97	un-COMMON PERSPECTIVE: TOWARDS THE MILLENNIUM — Gallery installations and site-specific sculpture addressing the concerns facing mankind at the millennium will be interpreted in the works on view by Mauri Formigoni, Eric Manabat and Gail Wagner.
09/13/97–10/04/97	PERSONA GAR-BAGE — On display will be works created from found objects by Springfield Art Association's art camp students.
10/11/97–11/29/97	HEALING LEGACIES — A multi-media exhibition by both professional and non-professional artists documenting the common thread of breast and ovarian cancer.
12/06/97–01/30/98	PINBALL WIZARD — Pinball machines from the past 100 years will be featured in this lighthearted historical display.

Anderson

Alford House - Anderson Fine Arts Center
226 W. Historic W. 8th St., **Anderson, IN 46016**
☎ 317-649-1248
HRS: 10-5 Tu-Sa, till 8:30 T, 12-5 S DAY CLOSED: M HOL: LEG/HOL! AUG
&: Y; Entryway and ramps ℗ Y; Free MUS/SH: Y ⍡ Y; Garden on the Green; Caffé Pietro
GR/T: Y GR/PH: CATR! 317-920-2649
PERM/COLL: REG: all media; AM: all media 20

With an emphasis on education, this museum presents 2 children's exhibitions annually; one in Dec.-Jan., and the other from May to the end of June.

ON EXHIBIT/97:

ONGOING	FRESH — A hands-on exhibit for children
01/12/97–02/23/97	CATHERINE WOLFE CLUB (NEW YORK) CENTENNIAL ART TOUR
03/02/97–03/23/97	IN-FOCUS: PHOTOGRAPHY COMPETITION
04/05/97–06/22/97	EVERY PICTURE TELLS A STORY: CHILDREN'S BOOK AUTHOR/ ILLUSTRATIONS

Bloomington

Indiana University Art Museum
Affiliate Institution: Indiana University
Bloomington, IN 47405
☎ 812-855-5445
HRS: 10-5 W-F, 10-5 Sa, Noon-5 S DAY CLOSED: M, Tu HOL: LEG/HOL!
VOL/CONT: Y &: Y; Use north entrance; wheelchairs available
P: Y; Indiana Memorial Union pay parking lot one block west of the museum
GR/T: Y GR/PH: CATR! 812-855-1045 DT: Y TIME: 2:00 Sa S/G: Y
PERM/COLL: AF; AN/EGT; AN/R; AN/GRK; AM: all media; EU: all media 14-20; OC; P/COL; JAP; CH; OR

Masterpieces in every category of its collection from ancient to modern, make this is one of the finest university museums to be found anywhere. Among its many treasures is the largest university collection of African art in the United States. **NOT TO BE MISSED:** The stunning museum building itself designed in 1982 by noted architect I. M. Pei.

ON EXHIBIT/97:

01/97–03/09/97	MALAGASY TEXTILES
01/15/97–03/09/97	DOMINICO TIEPOLO: MASTER DRAFTSMAN
01/17/97–03/16/97	CERAMIC GESTURES: NEW VESSELS BY MAGDALENE ODUNDO — On exhibit will be 15 elegant handbuilt vessels by noted contemporary Kenyan ceramist, Odundo, that act as expressions of form rather than utility. CAT WT
MID/97–05/97	PRECIOUS ILLUMINATIONS
04/02/97–05/25/97	THE PEOPLES AMERICA: FARM SECURITY ADMINISTRATION PHOTOGRAPHS — Both the poverty and recovery from the Great Depression will be examined in this presentation of documentary Farm Security Administration photographs selected for viewing from the permanent collection.
04/02/97–05/25/97	ARTISANS IN SILVER: PRECIOUS ILLUMINATIONS — Handcrafted candleholders by 50 contemporary master silversmiths will be on exhibit.
05/97–06/97	THE LIFE TO THE VIRGIN IN TEXTILES AND PRINTS — From the permanent collection this thematic exhibition explores images of the Virgin Mary as seen in textiles and 15th to 18th-century works on paper.
10/97–12/97	FLIGHTS OF FANCY: CLOTHING'S DECORATIVE FINISHES — Surface embellishments and decorative finishes of 19th and 20th-century men's and women's clothing will be seen on items selected from the museum's Elizabeth Sage Historic Costume Collection.

INDIANA

Columbus

Indianapolis Museum of Art - Columbus Gallery
390 The Commons, **Columbus, IN 47201-6764**
📞 812-376-2597
HRS: 10-5 Tu-T & Sa, 10-8 F, Noon-4 S DAY CLOSED: M HOL: LEG/HOL!
VOL/CONT: Y
&: Y; Elevator to gallery; restrooms ℗ Y; Free MUS/SH: Y
GR/T: Y GR/PH: CATR!
PERM/COLL:

In an unusual arrangement with its parent museum in Indianapolis, six exhibitions are presented annually in this satellite gallery, the oldest continuously operating satellite gallery in the country. The gallery is uniquely situated inside a shopping mall in an area designated by the city as an "indoor park."

ON EXHIBIT/97:

12/15/96–02/16/97	GOYA, LOS CAPRICHOS — 80 etchings from Goya's celebrated "Los Caprichos" series will be on exhibit. WT
03/02/97–05/04/97	QUILT NATIONAL: CONTEMPORARY DESIGNS IN FABRIC
05/18/97–07/06/97	ARTFORMS BY ELLSWORTH KELLY
07/20/97–09/14/97	DESIGN DIASPORA: BLACK ARCHITECTS AND INTERNATIONAL ARCHITECTURE 1970-1990
09/27/97–11/23/97	GLASS EXHIBITION
12/07/97–02/01/98	CRECHES FROM THE COLLECTION OF XENIA MILLER

Elkhart

Midwest Museum of American Art
429 S. Main St., **Elkhart, IN 46515**
📞 219-293-6660
HRS: 11-5 Tu-F; 1-4 Sa, S; 7-9 PM T DAY CLOSED: M HOL: LEG/HOL!
F/DAY: S ADM: Y ADULT: $2.00 CHILDREN: F (under 5) STUDENTS: $1.00 SR CIT: $1.00
&: Y ℗ Y; Free city lot just north of the museum MUS/SH: Y
GR/T: Y GR/PH: CATR! DT: Y TIME: 12:20-12:40 T (Noontime talks- free)
PERM/COLL: AM/IMPR; CONT; REG; SCULP; PHOT

Chronologically arranged, the permanent collection, numbering more than 600 paintings, sculptures, photographs, and works on paper, traces 150 years of American art history with outstanding examples ranging from American Primitives to contemporary works by Chicago Imagists. The museum is located in the heart of the Midwest Amish country. **NOT TO BE MISSED:** Original paintings by Grandma Moses, Norman Rockwell, and Grant Wood; The Vault Gallery (gallery in the vault of this former bank building.)

ON EXHIBIT/97:

12/06/96–02/23/97	NATIONAL ASSOCIATION OF WOMEN ARTISTS TRAVELING EXHIBITION WT
05/16/97–06/29/97	THE CATHERINE LORILLARD WOLFE ART CLUB: A CENTENNIAL EXHIBITION
10/17/97–11/30/97	19TH ELKHART JURIED REGIONAL

Evansville

Evansville Museum of Arts & Science
411 S.E Riverside Dr., **Evansville, IN 47713**
☎ 812-425-2406
HRS: 10-5 Tu-Sa, Noon-5 S DAY CLOSED: M HOL: 12/25, 1/1, 7/4, THGV, LAB/DAY
&: Y; Wheelchairs available; ramps; elevators Ⓟ Y; Free and ample parking GR/T: Y S/G: Y
PERM/COLL: PTGS; SCULP; GR; DRGS; DEC/ART

Broad ranging in every aspect of its varied collections, the Evansville's holdings of fine art include prime examples from European medieval sculpture and American primitive paintings to ancient Peruvian and Chinese artifacts. PLEASE NOTE: The main and contemporary galleries of the museum will be undergoing extensive renovation during 1997. **NOT TO BE MISSED:** "Madonna and Child" by Murillo

ON EXHIBIT/97:

11/23/96–01/18/97	THE 48TH MID-STATES ART EXHIBITION — A juried exhibition of contemporary art from 6 Midwestern states.
11/23/96–01/18/97	BARRIER FREE: THE MUSCULAR DYSTROPHY ASSOCIATION ART COLLECTION — Established in 1992 as a means to call attention to the capabilities of people with disabilities, all of the works on view from this collection were created by artists who have been afflicted with one of the 40 neuromuscular diseases being researched by the Muscular Dystrophy Association.
02/08/97–03/16/97	GEORGE WINTER: THE MAN AND HIS ART — An exhibition of 80 works by Winter, a 19th-century artist best known for his watercolor depictions of Native American culture. WT
04/23/97–05/18/97	4TH BIENNIAL FINE ARTS CAMERA CLUB COMPETITION
05/21/97–06/22/97	4TH ANNUAL S W INDIANA ARTISTS COLLABORATIVE EXHIBITION
06/25/97–08/24/97	EXPEDITION: ALONG THE BANKS OF THE OHIO — Works by eight contemporary American realist artists will be featured. ONLY VENUE ATR! WT
08/27/97–10/19/97	ELLEN GLASGOW: ARTIST-IN-RESIDENCE — Oil paintings, pastels and monotypes by Kentucky artist Glasgow will be on exhibit.
11/23/97–02/01/98	THE LIMESTONE LEGACY: THREE PERSPECTIVES — From sculpture to historic structures, this multi-disciplinary exhibition examines the economic, social, and technological evolution and impact of the Indiana limestone industry.

Fort Wayne

Fort Wayne Museum of Art
311 E. Main St., **Fort Wayne, IN 46802-1997**
☎ 219-422-6467
HRS: 10-5 Tu-Sa, Noon-5 S DAY CLOSED: M HOL: 12/25, 1/1, THGV, 7/4
F/DAY: 1st S ADM: Y ADULT: $3.00 CHILDREN: $2.00
&: Y; Fully accessible Ⓟ Y; Parking lot adjacent to building with entrance off Main St. MUS/SH: Y
GR/T: Y GR/PH: CATR! education dept. S/G: Y
PERM/COLL: AM: ptgs, sculp, gr 19-20; EU: ptgs, sculp, gr 19-20; CONT

Since the dedication of the new state-of-the-art building in its downtown location in 1984, the Fort Wayne Museum, established 75 years ago, has enhanced its reputation as a major vital community and nationwide asset for the fine arts. Important masterworks from Dürer to de Kooning are included in this institution's 1,300 piece collection. **NOT TO BE MISSED:** Etchings by Albrecht Dürer on the theme of Adam and Eve.

ON EXHIBIT/97:

11/16/96–01/26/97	INDIANA'S IMPRESSIONISTS: THE HOOSIER GROUP — A survey of 5 Indiana artists working from the mid-19th-century into the early 20th-century will be presented in celebration of the 75th anniversary of the museum.

155

INDIANA

Fort Wayne Museum of Art - continued

02/01/97–03/30/97 BEARING WITNESS: CONTEMPORARY WORKS BY AFRICAN-AMERICAN WOMEN ARTISTS — Issues of race, ethnicity, gender, class, sexual orientation and religion will be seen in this multi-media exhibition of works by 27 prominent contemporary artists including Elizabeth Catlett, Betye Saar, Faith Ringold, Lois Mailou Jones and others. WT

04/05/97–05/11/97 FORT WAYNE COLLECTS — 19th & 20th-century works of art on loan from private collections in the metropolitan area of Fort Wayne will be reveal the varied tastes and interests of local collectors.

04/05/97–06/01/97 75TH ANNIVERSARY EXHIBITION (Working Title) — Works that trace the development of the permanent collection will be presented in an exhibition celebrating the 75th anniversary of the museum.

06/07/97–08/17/97 MEMORIES OF CHILDHOOD — Ten images accompanied by stories dealing with their earliest memories will be featured in this exhibition of the works and personal narratives of the 15 artists on view. WT

Indianapolis

Eiteljorg Museum of American Indians and Western Art

500 W. Washington, **Indianapolis, IN 46204**
☎ 317-636-9378
HRS: 10-5 Tu-Sa, Noon-5 S; (Open 10-5 M Jun-Aug) DAY CLOSED: M HOL: 12/25, 1/1, THGV
ADM: Y ADULT: $5.00 CHILDREN: F (4 & under) STUDENTS: $2.00 SR CIT: $4.00
♿: Y; Fully accessible; elevator; restrooms; water fountains Ⓟ Y; On site MUS/SH: Y
GR/T: Y GR/PH: CATR! 317-264-1724 DT: Y TIME: 2:00 daily H/B: Y; Landmark building featuring interior and exterior SW motif design
PERM/COLL: NAT/AM & REG: ptgs, sculp, drgs, gr, dec/art

The Eiteljorg, one of only two museums east of the Mississippi to combine the fine arts of the American West with Native American artifacts, is housed in a Southwestern-style building faced with 8,000 individually cut pieces of honey-colored Minnesota stone. **NOT TO BE MISSED:** Works by members of the original Taos Artists Colony; 4 major outdoor sculptures including a 38' totem pole by 5th generation Heida carver Lee Wallace and George Carlson's 12-foot bronze entitled "The Greeting."

ON EXHIBIT/97:

02/01/97–04/20/97 IN SEARCH OF FREDERICK REMINGTON — Long renowned for his colorful, lively paintings, sculpture and graphic images of the old West, this exhibition explores Remington's artistic process and the way in which his works have been regarded since his death.

SPRING/97 MIAMI STORY — The history of the Miami Indians of Indiana from 1780 to the present time will be traced in a long-term multi-sensory family oriented exhibition that includes hands-on activities and interactive video. Dates Tent! TENT!

05/16/97–08/17/97 BIRDS AND BEASTS OF ANCIENT LATIN AMERICA — The relationship between humans and animals in the pre-Columbian world (2,000 B.C. to the Spanish conquest of the early 16th-century) will be featured in imagery that demonstrates the interrelationships and importance of animals in the lives of the ancient peoples of Mexico and Central & South America.

08/30/97–11/09/97 LUIS JIMENEZ: WORKING CLASS HEROES: IMAGES FROM THE POPULAR CULTURE WT

11/22/97–02/15/98 CUANDO HABLAN LOS SANTOS: CONTEMPORARY SANTERO TRADITIONS FROM NORTHERN NEW MEXICO

Indianapolis

Indianapolis Museum of Art
1200 W. 38th St., **Indianapolis, IN 46208-4196**
📞 317-923-1331 Web Address: http://otisnet.com/ima
HRS: 10-5 Tu, W, F, Sa; 10 AM-8:30 PM T; Noon-5 S DAY CLOSED: M HOL: LEG/HOL!
&: Y; Wheelchairs available ℗ Y: Outdoor parking lots and parking garage of Krannert Pavilion MUS/SH: Y
�11 Y; 11 AM-1:45 PM Tu-S; (Brunch S- by reservation 926-2628); Cafe
GR/T: Y GR/PH: CATR! 317-920-2649 DT: Y TIME: 12 & 2 Tu-S; 7 PM T (other!)
PERM/COLL: AM: ptgs; EU/OM; ptgs EU/REN:ptgs; CONT; OR; AF; DEC/ART; TEXTILES

Situated in a 152 acre park as part of a cultural complex, the Indianapolis Museum is home to many outstanding collections including a large group works on paper by Turner, and world class collections of Impressionist, Chinese, and African art. PLEASE NOTE: 1. There is an admission fee for most special exhibitions. 2. The museum IS OPEN on 7/4. **NOT TO BE MISSED:** Lilly Pavilion; an 18th-century style French chateau housing American & European decorative art

ON EXHIBIT/97:

03/11/96–01/19/97	ART AND TECHNOLOGY: AFRICA AND BEYOND
09/14/96–04/27/97	KENTE: WEST AFRICAN STRIP WEAVINGS FROM THE COLLECTION — From royal garments to everyday wraps, this exhibition features 13 clothes that demonstrate the designs and motifs of the brightly colored Asante and Ewe cloth weavings of Ghana.
10/22/96–03/23/97	150 YEARS OF PHOTOGRAPHY FROM THE COLLECTION
10/25/96–08/97	DRAWINGS FROM LIFE: HOOSIER ARTISTS IN MUNICH — Created while they were students at the Royal Academy in Munich from 1880-1890, this display of 30 works on paper from the permanent collection will include portraits, figure studies, landscapes, and sketchbooks.
11/24/96–01/19/97	PAINTING IN SPAIN IN THE AGE OF ENLIGHTENMENT: GOYA AND HIS CONTEMPORARIES — During the Spanish Bourbon monarchy (1700-1808), artistic achievements flourished as the demands of the privileged class for paintings increased. This exhibition of 60 works by painters as different as Goya, Giaquinto, Tiepolo and others, explores their great artistic achievements as well as the growing challenges to authority that confronted them. CAT ADM FEE WT ⌒
02/09/97–04/20/97	IN THE AMERICAN GRAIN: ARTHUR DOVE, MARSDEN HARTLEY, JOHN MARIN, GEORGIA O'KEEFFE AND ALFRED STIEGLITZ — The development of modernism as an independent American art form will be assessed in the more than 80 works by these 5 renowned American talents. WT
04/13/97–08/03/97	BALUCHI WOVEN TREASURES: THE BOUCHER COLLECTION — Created by the Baluchi people of Iran and Afghanistan and known for their distinctive patterning, intense colors and the soft, lustrous wool from which they are woven, this collection of 65 objects (the largest and finest of its kind) was recently gifted to the museum by Colonel Jeff W. Boucher.
06/01/97–07/23/97	TURNER WATERCOLORS FROM MANCHESTER — Turner watercolors on loan from Manchester will be displayed with those in the collection of the Indianapolis Museum of Art, the largest of its kind in America, in an exhibition that forms the largest and most comprehensive presentation of its kind in a decade. WT
09/04/97–10/19/97	MASTERS OF CONTEMPORARY GLASS: SELECTIONS FROM THE GLICK COLLECTION — More than 70 works from the 1960's to the present will be included in this overview of the contemporary studio art glass movement. CAT
11/15/97–02/01/98	THE ARTS OF REFORM AND PERSUASION, 1885-1945 — Furniture, metalwork, ceramics, glass, posters and drawings will be among the 250 objects on loan from the vast collection of propaganda art at The Wolfsonian in Miami Beach, Florida. The intent of the exhibition is to explore the ways in which various elements of design from 1885-1945 functioned as key elements of propaganda and modernity in reform movements. CAT WT

INDIANA

Lafayette

Greater Lafayette Museum of Art
101 S. Ninth St., **Lafayette, IN 47901**
☎ 317-742-1128
HRS: 11-4 Tu-S DAY CLOSED: M HOL: LEG/HOL!
&: Y; Easy access sidewalk; no steps ℗ Y; Free parking lot at 10th st. entrance MUS/SH: Y GR/T: Y GR/PH: CATR!
PERM/COLL: AM: ptgs, gr, drgs 19-20; EU: ptgs, drgs, gr 19-20; REG; CONT

Art by regional Indiana artists, contemporary works by national artists of note, and a fine collection of art pottery are but three of several important collections to be found at the Greater Lafayette Museum of Art. **NOT TO BE MISSED:** Arts and crafts items by Hoosier artists at museum store; Baber Collection of contemporary art

ON EXHIBIT/97:

01/10/97–02/23/97	SAINTS AND SINNERS IN PRINTS: 1500-1900 — More than 60 prints covering 400 years of the printmakers art will be seen in images depicting Christian saints and sinners.
01/10/97–02/23/97	PAM BASTABLE: "DANCE OF FREEDOM"
01/17/97–03/16/97	WOMEN'S WORK FROM THE PERMANENT COLLECTION — Works in a variety of media by 20th-century Indiana women artists will be selected for viewing from the museum's large permanent collection of art by women.
02/26/97–03/41/97	FELLOWSHIP EXHIBITION
02/28/97–04/12/97	GLMA INDEPENDENT DRAWING GROUP EXHIBIT
03/21/97–05/18/97	PERFECT FUTURE: DRAWINGS FROM THE PERMANENT COLLECTION — American works in graphite, ink, pastel, spray paint and mixed media from the 1950's through the 1980's will be on exhibit.
04/18/97–05/18/97	BILL CROSS: PAINTINGS AND WORKS ON PAPER
05/13/97–07/13/97	ARTFORMS '97 — A biennial exhibition of contemporary artworks by artists from Indiana and Illinois.
05/16/97–07/06/97	COLLECTION SELECTIONS - RECENT ACQUISITIONS — A presentation of gifts and purchases added to the permanent collection during the past 5 years.
05/23/97–07/13/97	MARY JO CORSO: PHOTOGRAPHS
07/11/97–08/31/97	FLIGHTS OF FANCY FROM THE PERMANENT COLLECTION — Uninhibited images ranging from lyrical daydreams to surreal nightmares will be seen in the works on view.
07/18/97–09/07/97	ROADSIDE ATTRACTIONS: FOUR FOLK-ART INSPIRED SCULPTORS — A multi-media exhibition of sculptures by 4 highly individual artists whose often whimsical works are made of household objects, stones, and a variety of found media.
07/18/97–09/14/97	SUZIE COLES, LuANN LAMIE, JOANNE KUHN TITOLO: PAINTINGS, PHOTOGRAPHS AND MIXED MEDIA WORKS

Muncie

Ball State University Museum of Art
2000 University Ave., **Muncie, IN 47306**
☎ 317-285-5242
HRS: 9-4:30 Tu-F; 1:30-4:30 Sa, S HOL: EASTER, 7/4, THGV, 12/25, 1/1
&: Y; Barrier free ℗ Y; Metered street parking and metered paid garages nearby
GR/T: Y GR/PH: CATR! Nancy Huth DT: Y S/G: Y
PERM/COLL: IT/REN; EU: ptgs 17-19; AM: ptgs, gr, drgs 19-20; DEC/ART; AS; AF; OC; P/COL

5,000 years of art history are represented in the 9,500 piece collection of the Ball State University Museum of Art. In addition to wonderful explanatory wall plaques, there is a fully cataloged Art Reference Terminal of the permanent collection.

ON EXHIBIT/97:

12/22/96–02/02/97	BALDER OLRIK, PAINTINGS — Recent work by Dutch artist Olrik whose large-scale paintings are created by alternating black and white photographs through computerization and paint application.

158

Notre Dame

The Snite Museum of Art
Affiliate Institution: University of Notre Dame
Notre Dame, IN 46556
\ 219-631-5466
HRS: 10-5 Tu-F, 10-4 Sa, 1-4 S DAY CLOSED: M HOL: LEG/HOL!
VOL/CONT: Y
&: Y; Wheelchairs available; elevators to each level Ⓟ Y; Available southeast of the museum in the visitor lot
MUS/SH: Y GR/T: Y GR/PH: CATR! 219-631-4717 S/G: Y
PERM/COLL: IT/REN; FR: ptgs 19; EU: phot 19; AM: ptgs, phot; P/COL: sculp; DU: ptgs 17-18

With 17,000 objects in its permanent collection spanning the history of art from antiquity to the present, this premier university museum is a "must see" for all serious art lovers. Due to construction on a 36,000 square foot addition starting in the spring of '97, there may be no special exhibitions scheduled this year. **NOT TO BE MISSED:** AF; PR/COL & NAT/AM Collections

Richmond

Richmond Art Museum
Affiliate Institution: The Art Association of Richmond
350 Hub Etchison Pkwy, **Richmond, IN 47374**
\ 317-966-0256
HRS: 9-4 M-F, 1-4 S DAY CLOSED: Sa HOL: LEG/HOL!
&: Y; Northwest entrance wheelchair accessible Ⓟ Y: Free & handicapped accessible MUS/SH: Y
DT: Y TIME: Often available upon request
PERM/COLL: AM: Impr/ptgs; REG

Aside from its outstanding collection of American Impressionist works, the Art Association of Richmond has the unique distinction of being one of only 2 art museums in the country to be housed in an operating high school. **NOT TO BE MISSED:** Self portrait by William Merritt Chase, considered to be his most famous work

ON EXHIBIT/97:

01/19/97–04/13/97	BOBBI K. OWENS EXHIBIT — Abstract works by native Indiana artist Owens will be on view.
03/02/97–04/13/97	ART IS...JAPANESE — An annual presentation designed to introduce children to basic art elements through art and culture.
04/27/97–05/18/97	SANDRA ROWE EXHIBITION — Paintings by Rowe, a noted artist and professor will be featured.

South Bend

South Bend Regional Museum of Art
120 S. St. Joseph St., **South Bend, IN 46601**
\ 219-235-9102
HRS: 11-5 Tu-F; Noon-5 Sa, S DAY CLOSED: M HOL: LEG/HOL!
VOL/CONT: Y &: Y; Fully Accessible
P: Y; Free street parking. Also Century Center lot or other downtown parking garages. MUS/SH: Y ❙❙ Y; Cafe
GR/T: Y GR/PH: CATR!
PERM/COLL: AM: ptgs 19-20; EU: ptgs 19-20; CONT: reg

Since 1947 the South Bend Regional Museum of Art has been serving the artistic needs of its community by providing a wide variety of regional and national exhibitions year-round. This growing institution recently completed a reconstruction and expansion project adding, among other things, a Permanent Collections Gallery and a cafe. **NOT TO BE MISSED:** Permanent site-specific sculptures are situated on the grounds of Century Center of which the museum is a part.

INDIANA

South Bend Regional Museum of Art - continued
ON EXHIBIT/97:

01/11/97–02/23/97	SEAN FOELY
02/01/97	FUN GALLERY
03/01/97–04/13/97	ALAN CARTER
03/08/97–05/04/97	COTTAGE 108 REVISITED: THE PAINTINGS OF FRANK V. DUDLEY
04/19/97–06/01/97	DON VOGL
05/17/97–07/13/97	REGIONAL BIENNIAL EXHIBITION
06/07/97–07/20/97	RON MONSMA
07/20/97–09/14/97	A GRAPHIC ODYSSEY: ROMARE BEARDON AS PRINTMAKER WT
09/13/97–10/26/97	VIVIAN NUNLEY
09/25/97	OFF THE WALL
10/03/97–11/16/97	50TH ANNIVERSARY SHOW
11/01/97–12/07/97	SUSAN WINK
11/28/97–01/25/98	PHOTOGRAPHY INVITATIONAL

Terra Haute

Sheldon Swope Art Museum
25 S. 7th St., **Terra Haute, IN 47807**
☎ 812-238-1676
HRS: 10-5 Tu-F; Noon-5 Sa, S DAY CLOSED: M HOL: LEG/HOL
&: Y; Ground floor accessible ; elevator to 2nd floor Ⓟ Y; Pay lot on Ohio Blvd. MUS/SH: Y
GR/T: Y GR/PH: CATR! H/B: Y
PERM/COLL: AM: ptgs, sculp, drgs 19-20; EU 14-20; DEC/ART

The Sheldon Swope, opened in 1942 as a museum devoted to contemporary American art, has expanded from the original core collection of such great regionalist artists as Thomas Hart Benton and Edward Hopper to permanent collection works by living modern day masters. **NOT TO BE MISSED:** American Regionalist School of Art

ON EXHIBIT/97:

12/08/96–01/05/97	A VICTORIAN HOLIDAY: QUILTS AND DECORATIVE ARTS
02/01/97–03/16/97	53RD ANNUAL WABASH VALLEY EXHIBITION
06/13/97–07/27/97	A CENTURY OF WABASH VALLEY ARTISTS

West Lafayette

Purdue University Galleries
Creative Arts Bldg., #1
West Lafayette, IN 47907
☎ 317-494-3061
HRS: STEWART CENTER: 10-5 & 7-9 Tu-T, 10-5 F, 1-4 S; UNION GALLERY: 10-5 Tu-F, 1-4 S DAY CLOSED: Sa
HOL: ACAD!
&: Y
Ⓟ Y; Visitor parking in designated areas (a $3.00 daily parking permit for campus garages may be purchased at the Visitors Information Services Center); some metered street parking as well; Free parking on campus after 5 and on weekends.
PERM/COLL: AM: ptgs, drgs, gr; EU: ptgs, gr, drgs; AM: cont/cer

Purdue University Galleries - continued

In addition to a regular schedule of special exhibitions, this facility presents many student and faculty shows.

ON EXHIBIT/97:

10/16/96–12/15/97	VOICES OF COLOR — North and South American artists of multi-cultural backgrounds will present works that challenge dominant powers through the creation of art that is politically and socially relevant.
11/11/96–02/01/97	JAMES HOUSTON AND THE ART OF THE CANADIAN ARCTIC — Accompanying this display of contemporary Inuit art from 1957 to the present will be an overview of the role artist Houston played in the formation of the Cape Dorset and other Inuit art cooperatives.
01/13/97–02/08/97	ILLUSIONS, MIRAGES AND THE MIND'S EYE — A multi-media showcase of works by Purdue's Art and Design Faculty.
02/09/97–03/22/97	KENTE: CLOTH OF THE ASANTI KINGS — The meaning, culture and history of Kente cloth as an ongoing art form in Ghana will be explored in this exhibition.
03/31/97–05/04/97	THREE REALISTS — Paintings by 3 contemporary realists will be on loan from the collection of Dr. Alfred Bader, a Milwaukee resident partial to 17th-century Dutch painting.
03/31/97–05/04/97	BRUCE BEASLEY: SCULPTURE — A presentation of bronze sculptures that West Coast artist Beasley creates by conceptualizing them on his computer.
06/16/97–08/08/97	SELECTIONS FROM THE PERMANENT COLLECTION
08/25/97–09/28/97	MADHUBANI PAINTINGS: FOLK ART OF INDIA
10/06/97–11/09/97	PETER SMITH: PAINTINGS

IOWA

Cedar Falls

James & Meryl Hearst Center for the Arts
304 W. Seerly Blvd., **Cedar Falls, IA 50613**
☎ 319-273-8641
HRS: 10-9 Tu, T; 10-5 W, F; 1-4 Sa, S DAY CLOSED: M HOL: 1/1, 7/4, 12/25, THGV
&: Y; Fully accessible with elevators & wheelchairs available ℗ Y; Free public parking available
GR/T: Y GR/PH: call 319-273-8641 H/B: Y; Located in the former home of well-known farmer poet James Hearst
PERM/COLL: REG

Besides showcasing works by the region's best current artists, the Hearst Center's permanent holdings include examples of works by such well knowns as Grant Wood, Mauricio Lasansky, and Gary Kelly. **NOT TO BE MISSED:** "Man is a Shaper, a Maker," pastel by Gary Kelly; "Honorary Degree," lithograph by Grant Wood

Cedar Rapids

Cedar Rapids Museum of Art
410 Third Ave., S.E., **Cedar Rapids, IA 52401**
☎ 319-366-7503
HRS: 10-4 Tu-W & F-Sa, 10 AM-7 PM T, Noon-3 S DAY CLOSED: M HOL: LEG/HOL!
ADM: Y ADULT: $2.50 CHILDREN: F (under 7) STUDENTS: $1.50 SR CIT: $1.50
&: Y; Entrance ramp 3rd Ave.; elevator, restrooms, wheelchairs available ℗ Y: Lot behind museum building; some metered parking on street MUS/SH: Y ¶ Y
GR/T: Y GR/PH: CATR! education office DT: Y TIME: !
PERM/COLL: REG: ptgs 20; PTGS, SCULP, GR, DEC/ART, PHOT 19-20

With a focus on regionalist art by two native sons, Marvin Cone and Grant Wood, and a "Hands-On Gallery" for children, the Cedar Rapids Museum, located in the heart of the city, offers something special for visitors of every age. A recently completed expansion program connects the new facility with its original 100 year old building by the use of a colorful and welcoming Winter Garden. **NOT TO BE MISSED:** Museum includes restored 1905 Beaux Art building, formerly the Carnegie Library (free to the public); collections of Grand Wood & Marvin Cone paintings, Malvina Hoffman sculptures, & Mauricio Lasansky prints and drawings

ON EXHIBIT/97:

10/26/96–01/18/97	WORDS AND IMAGES: THE NARRATIVE WORKS OF THE PINKNEYS — The collaborative process of making books for children will be addressed in this exhibition of works by African-American father and son illustrators Pinkney and their wives.
11/02/96–01/18/97	POLLY KEMP IN IOWA — Paintings by Iowan artist Kemp in the museum's permanent collection will be displayed with those on loan from local sources.
11/23/96–02/09/97	A SPECTRUM OF INNOVATION: COLOR IN AMERICAN PRINTMAKING — On exhibit will be a major survey of printmaking in America.
12/07/96–01/19/97	PAINTINGS BY LISA INGRAM — Ingram's abstract paintings will be on exhibit.
02/01/97–03/30/97	CENTRAL IOWA WOMEN'S CAUCUS FOR ART — An exhibition of art and issues of contemporary importance to Midwestern women artists.
02/01/97–03/30/97	THREE FABLES, BY HUGH LIFSON
04/11/97–05/97	RICHARD D. PINNEY: RETROSPECTIVE — The career of local artist Pinney will be highlighted in this retrospective exhibition of his works
05/24/97–07/06/97	ANITA LAPPI — Lappi's expressive paintings of infants and small children will be featured.
05/30/97–07/27/97	PAINTING ABSTRACT: GREGORY AMENOFF, JOHN L. MOORE, KATHERINE PROTER — A traveling exhibition of works by 3 major contemporary abstract painters. WT
05/30/97–08/97	POWELL AND FRASER: TWO SCULPTORS
08/08/97–10/12/97	OF NATURE AND KNOWLEDGE: ART BY 7 FAIRFIELD ARTISTS — Various Hindu philosophies and principles as expressed in this multi-media exhibition of works by 7 well established regional artists.

Cedar Rapids Museum of Art - continued

08/15/97–10/12/97	NEW WORK BY ROBERT L. KOCHER
08/30/97–10/12/97	SARA BELL
10/18/97–11/30/97	PHOTOGRAPHS BY BOB CAMPAGNA — Presented will be Campagna's photographic portfolios of distinctive themes and subject matter.
10/24/97–01/08/98	ST. LOUIS CITY SHOW — The best works by artists in 5 Midwest cities will be on view in the first City Series exhibition.

Davenport

Davenport Museum of Art

1737 W. Twelfth St., **Davenport, IA 52804**
☎ 319-326-7804
HRS: 10-4:30 Tu-Sa, 1-4:30 S, till 8 PM T DAY CLOSED: M HOL: LEG/HOL!
SUGG/CONT: Y &: Y; Ramps, restrooms, elevator, wheelchairs available Ⓟ Y; Free MUS/SH: Y
GR/T: Y GR/PH: CATR! S/G: Y
PERM/COLL: AM/REG; AM: 19-20; EU: 16-18; OM; MEXICAN COLONIAL; HAITIAN NAIVE

Works by Grant Wood and other American Regionalists are on permanent display at the Davenport Museum, the first public art museum established in the state of Iowa (1925). **NOT TO BE MISSED:** Grant Wood's "SELF PORTRAIT," & mock ups of his house

ON EXHIBIT/97:

09/29/96–02/16/97	THE BAROQUE VISION FROM EUROPE TO NEW SPAIN: SELECTIONS FROM THE PERMANENT COLLECTION — Baroque works from the permanent collection will be on display in an exhibition that addresses Christian themes of the Counter Reformation and secular themes from the Protestant North.

Des Moines

Des Moines Art Center

4700 Grand Ave., **Des Moines, IA 50312**
☎ 515-277-4405
HRS: 11-5 Tu, W, F, Sa; 11-9 T; Noon-5 S DAY CLOSED: M HOL: LEG/HOL!
F/DAY: 11-1 daily; all day T ADM: Y ADULT: $2.00 CHILDREN: F (under 12) STUDENTS: $1.00 SR CIT: $1.00
&: Y; North door of north addition (notify info. desk prior to visit) Ⓟ Y; Free parking MUS/SH: Y
⊪ Y; 11-3 lunch Tu-Sa; dinner T (by reserv. only) GR/T: Y GR/PH: CATR! ex. 15
PERM/COLL: AM: ptgs, sculp, gr 19-20; EU: ptgs, sculp, gr 19-20; AF

Its park-like setting is a perfect complement to the magnificent structure of this museum building designed originally by Eliel Saarinen in 1948 with a south wing addition in 1968 by the noted I. M. Pei & Partners. Another spectacular wing recognized as a masterpiece of contemporary architecture was designed and built in 1985 by Richard Meier & Partners. **NOT TO BE MISSED:** "Maiastra" by Constantin Brancusi; Frank Stella's "Interlagos"

ON EXHIBIT/97:

09/21/96–01/05/97	MARY MISS: PHOTO/DRAWINGS — Miss' black and white photographic collages present a reconstruction of multiple views from a single place or thing.
10/12/96–01/12/97	CONTEMPLATIONS: FIVE INSTALLATIONS — Five artists, namely, Barbara Bloom, Ann Hamilton, Nam June Paik, Robert Ryman and James Turrell, each will create a multi-media meditative environmental installation.
02/02/97–05/04/97	THE BODY (Working Title) — A multi-media exhibition of works from the permanent collection focusing on representations of the human form.
05/17/97–09/07/97	IOWA ARTISTS 1997 — Works in all media by artists statewide will be on exhibit in the 46th annual juried exhibition which brings to the public an awareness of the diversity and breadth of the visual arts being created in Iowa.

IOWA

Des Moines Art Center - continued

05/17/97–09/14/97 GREEK MYTHOLOGY (Working Title) — From the permanent collection, this thematic exhibition explores Greek mythology.

09/27/97–01/04/98 JEFF KOONS/ROY LICHTENSTEIN (Working Title) — Works by these contemporary yet diverse artists will be on loan from the permanent collection and from Eli Broad Family Foundation, Santa Monica.

09/27/97–01/11/98 PRINT SHOW (Working Title) — Works from the museum's collection will be featured.

19/97/97–05/11/97 PEOPLE AT WORK (Working Title) — This thematic exhibition drawn from the permanent collection explores the work ethic.

Des Moines

Hoyt Sherman Place
1501 Woodland Ave., **Des Moines, IA 50309**
☎ 515-243-0913
HRS: 8-4 M-Tu & T-F; Closed on W from Oct.1-June 30 DAY CLOSED: Sa, S HOL: LEG/HOL!
♿: Y; Ramp, chairlift, elevator Ⓟ Y; Free MUS/SH: Y GR/T: Y GR/PH: CATR!
DT: Y TIME: often available upon request H/B: Y; Complex of 1877 House, 1907 Art Museum, 1923 Theater
PERM/COLL: PTGS; SCULP; DEC/ART 19; EU; sculp; B.C. ARTIFACTS

A jewel from the Victorian Era, the Hoyt Sherman Art Galleries offer an outstanding permanent collection of 19th-century American and European art complemented by antique decorative arts objects that fill its surroundings. Listed NRHP **NOT TO BE MISSED:** Major works by 19th-century American masters including Church, Innes, Moran, Frieseke and others

ON EXHIBIT/97: On continuous exhibition are artworks from the permanent collection.

Dubuque

Dubuque Museum of Art
8th & Central, **Dubuque, IA 52001**
☎ 319-557-1851
HRS: 10-5 Tu-F; 1-5 Sa, S DAY CLOSED: M HOL: 12/25, THGV, EASTER, 7/4, 1/1
♿: Y Ⓟ Y; Metered street parking MUS/SH: Y
GR/T: Y GR/PH: CATR! DT: T TIME: daily upon request H/B: Y; Housed in 1857 Egyptian Revivalist Jail
PERM/COLL: REG

Located in a rare 1857 Egyptian Revivalist style building that formerly served as a jail, the Dubuque Museum has the added distinction of being the only National Landmark building in the city. Listed NRHP

ON EXHIBIT/97: Exhibitions from the permanent collection are displayed on a rotating basis.

01/18/97–03/16/97 KING REMEMBERED: THE HISTORY OF CIVIL RIGHTS BY FLIP SHULKE — An exhibition of photographs by Shulke, Dr. Martin Luther King's personal confidant and photographer, that documents the Civil Rights movement.

03/22/97–05/18/97 FINE ART PRINT SURVEY — Works by a bevy of renowned historic and contemporary artists will be on exhibit.

03/22/97–05/18/97 WILLIAM WALMSLEY IN PRINT — Prints by Walmsley, an internationally respected master printmaker, will be seen in a major retrospective of his work.

05/24/97–07/20/97 NOTHING RUNS LIKE A DEERE: JOHN DEERE FROM MAIN STREET TO WALL STREET

07/26/97–09/21/97 SELECTIONS FROM THE PHILIP DESIND COLLECTION - WASHINGTON, DC — Realist paintings selected from more than 2,000 works in the late octogenarian Desind's collection will be seen in an exhibition that supports his adage that "the best artists in the history of America are alive and working today." Desind, who passed away just as we went to press, will be sorely missed. A mentor and friend to countless artists and clients alike, this lively and witty man did much to promote contemporary realist art in America.

09/27/97–11/23/97 DONALD SAFF: MIXED METAPHORS — A 40 year retrospective of Saff's work.

Fort Dodge

Blanden Memorial Art Museum
920 Third Ave., S., **Fort Dodge, IA 50501**
☎ 515-573-2316
HRS: 10-5 Tu-F, till 8:30 T, 1-5 Sa & S DAY CLOSED: M
&: Y; Entrance on north side of building; elevator as of spring '97
P: Y; Street parking and limited parking area behind the museum MUS/SH: Y GR/T: Y GR/PH: CATR!
PERM/COLL: AM: ptgs, sculp, gr 19-20; EU: ptgs, sculp, drgs, gr 15-20; OR: 16-20; P/COL

Established in 1930 as the first permanent art facility in the state, the Blanden's neo-classic building was based on the already existing design of the Butler Institute of American Art in Youngstown, Ohio. Listed NRHP **NOT TO BE MISSED:** "Central Park" by Maurice Prendergast, 1901; "Self-Portrait in Cap & Scarf" by Rembrandt (etching, 1663)

ON EXHIBIT/97:

01/17/97–03/16/97	IOWA PRAIRIE: SELECTED VIEWS AND VOICES — Paintings, handmade books, illustrations and photographs by a poet, printmaker, scientist, photographer and painter will be featured in an exhibition designed to increase awareness of conservation of the prairie lands and native plants of Iowa.
03/21/97–04/05/97	FOCUS ON SPAIN — Visual images of Spain expressed in the works of Goya, Dali and Picasso on view will be enhanced with a series of travelers photographs.
04/04/97–05/23/97	PERSONAL SIGHTINGS 11 — A juried exhibition of contemporary works by artists from Iowa.
06/06/97–08/03/97	THE RANGE OF POSSIBILITIES — On exhibit will be two entire bodies of work by Tilly Woodward, an artist whose involvement with people who are dying has led her to the creation of the remarkable large scale portraits on display.
09/12/97–02/11/98	WOMEN: AT WAR WITH THE MEDIA — Ten life-sized fired clay figures by Lohr reflect her connection with the classical Greek traditions of sculpture and stand as a testament to the strength and endurance of women.
12/20/97–02/08/98	MINGEI: JAPANESE FOLK ART FROM THE MONTGOMERY COLLECTION — 15th through 19th-century paintings, textiles, sculpture, woodwork, ceramics, lacquerware, metalwork, basketry, and paper objects will be presented in an exhibit of 175 objects of "Mingei" folk art (gei) for people (min) on loan from one of the world's greatest collections of its kind. WT

Grinnell

Grinnell College Print & Drawing Study Room
Affiliate Institution: Grinnell College
Burling Library, **Grinnell, IA 50112-0811**
☎ 515-269-3371
HRS: 1-5 S-F DAY CLOSED: Sa HOL: 7/4, THGV, 12/25 THROUGH 1/1
&: Y ℗ Y; Available at 6th Ave. & High St. GR/T: Y GR/PH: CATR!
PERM/COLL: WORKS ON PAPER (available for study in the Print & Drawing Study Room)

1,400 works on paper ranging from illuminated manuscripts to 16th-century European prints and drawings to 20th-century American lithographs are all part of the study group of the Grinnell College Collection that started in 1908 with an original bequest of 28 etchings by J. M. W. Turner. **NOT TO BE MISSED:** Etching: "The Artist's Mother Seated at a Table" by Rembrandt

ON EXHIBIT/97:

01/97–02/97	EASTERN EUROPEAN GRAPHIC ART
04/97	JOHN PITTMAN PAINTINGS
05/97	20TH CENTURY ART FROM THE GRINNELL COLLEGE COLLECTION
09/97	ERIC PERVUHKHIN PAINTINGS AND PRINTS
10/05/97–11/15/97	ROMARE BEARDON AS PRINTMAKER WT

IOWA

Iowa City

University of Iowa Museum of Art
North Riverside Dr., **Iowa City, IA 52242**
☎ 319-335-1727
HRS: 10-5 Tu-Sa, Noon-5 S DAY CLOSED: M HOL: 12/25, 1/1, THGV
&: Y ℗ Y; Metered lots directly across Riverside Drive & north of the museum
GR/T: Y GR/PH: CATR! 319-335-1730 S/G: Y
PERM/COLL: AM: ptgs, sculp 19-20; EU: ptgs, sculp 19-20; AF; WORKS ON PAPER

Eight thousand objects form the basis of the collection at this 25 year old university museum that features among its many strengths 19th & 20th-century American and European art and the largest group of African art in any university museum collection. **NOT TO BE MISSED:** "Karneval" by Max Beckman; "Mural, 1943" by Jackson Pollock

ON EXHIBIT/97:

11/16/96–01/26/97	DANIEL SPOERRI: "LA MÉDECINE OPÉRATOIR DESSINÉ d'APRES NATURE PAR N.H. JACOB (1839)
11/16/96–01/12/97	FRED SANDBACK
12/21/96–04/06/97	HUMANS AND ANIMALS IN MALIAN ART
01/25/97–03/16/97	PHILIP GUSTON: WORKING THROUGH THE FORTIES
01/25/97–03/16/97	ALAN SONFIST: HISTORY AND THE LANDSCAPE

Marshalltown

Central Iowa Art Association
Affiliate Institution: Fisher Community College
Marshalltown, IA 50158
☎ 515-753-9013
HRS: 11-5 M-F; 1-5 Sa, S (Apr 15-Oct 15) DAY CLOSED: Sa, S HOL: LEG/HOL!
VOL/CONT: Y &: Y; Barrier free ℗ Y; Free parking in front of building MUS/SH: Y S/G: Y
PERM/COLL: FR/IMPR: ptgs; PTGS; CER

You don't have to be a scholar to enjoy the ceramic study center of the Central Iowa Art Association, one of the highlights of this institution. 20th-century paintings and sculpture at the associated Fisher Art Gallery round out the collection. **NOT TO BE MISSED:** The Ceramic Study Collection

Mason City

Charles H. MacNider Museum
303 2nd St., S.E., **Mason City, IA 50401**
☎ 515-421-3666
HRS: 10-9 Tu, T; 10-5 W, F, Sa; 1-5 S DAY CLOSED: M HOL: LEG/HOL!, PM 12/24, PM 12/31
&: Y ℗ Y; On street parking plus a large municipal lot nearby MUS/SH: Y
GR/T: Y GR/PH: CATR! DT: Y TIME: often available upon request during museum hours
PERM/COLL: AM: ptgs, gr, drgs, cer; REG: ptgs, gr, drgs, cer;

A lovely English Tudor mansion built in 1920 complete with a modern addition is the repository of an ever-growing collection that documents American art and life. Though only a short two block walk from the heart of Mason City, the MacNider sits dramatically atop a limestone ravine surrounded by trees and other beauties of nature. **NOT TO BE MISSED:** For young and old alike, a wonderful collection of Bil Baird Marionettes; "Gateways to the Sea," by Alfred T. Bricher

Charles H. MacNider Museum - continued

ON EXHIBIT/97:

01/03/97–02/23/97	JOHN AND MARY PAPPAJOHN ENDOWMENT PRINT PURCHASE — Eight prints purchased with the Pappajohn endowment fund will be on view for the first time as a group.
01/09/97–02/09/97	CARMON SLATER: SURFACES/RE-SURFACES — An exhibition of Slater's unframed canvases full of colorful scientific imagery, which take on unusual forms and function by being draped on walls, placed on the floor, and used to upholster chairs.
02/13/97–03/23/97	AREA COLLECTORS IV — Original works of art in many media will be on loan from Mason City area collections.
02/27/97–04/13/97	THROUGH MY EYES
03/28/97–05/11/97	LIFE IS A MYSTERY: PAINTINGS BY DARREL AUSTIN — Heavily textured pallet-knife paintings of beasts, nymphs and surreal moonlight landscapes by Austin reveal his personal view of the world.
04/17/97–05/25/97	PHOTOS BY W. EUGENE SMITH — Featured will be silver prints made by Smith, one of the premier American photojournalists of the post WWII period who used the photo essay as a vehicle for social change. Many of the works are in the permanent collection of the museum but have never been previously on view.
05/16/97–07/06/97	32ND ANNUAL AREA SHOW
05/29/97–07/13/97	RECENT ADDITIONS: PERMANENT COLLECTION
07/10/97–08/24/97	QUILT NATIONAL
07/17/97–08/31/97	17TH CERRO GORDO PHOTO SHOW
08/28/97–09/28/97	BIENNIAL STAFF SHOW
10/01/97–11/09/97	RITUAL MASKS FROM PAPUA WT
11/16/97–01/04/98	IOWA CRAFTS: 30

Muscatine

Muscatine Art Center

1314 Mulberry Ave., **Muscatine, IA 52761**
✆ 319-263-8282
HRS: 10-5 Tu, W, F; 10-5 & 7-9 T; 1-5 Sa, S DAY CLOSED: M HOL: LEG/HOL!
&: Y; Fully accessible with wheelchairs available Ⓟ Y; Street and free lot nearby
GR/T: Y GR/PH: CATR! DT: Y TIME: daily when possible! H/B: Y; 1908 Edwardian Musser Mansion
PERM/COLL: AM: ptgs, sculp, gr, drgs, dec/art 19-20; NAT/AM

The original Musser Family Mansion built in Edwardian Style in 1908, has been joined since 1976 by the contemporary 3 level Stanley Gallery to form the Muscatine Art Center. In addition to its fine collection of regional and national American art, the center has recently received a bequest of 27 works by 19 important European artists including Boudin, Braque, Pissaro, Degas, Matisse and others. **NOT TO BE MISSED:** The "Great River Collection" of artworks illustrating facets of the Mississippi River from its source in Lake Itasca to its southernmost point in New Orleans.

ON EXHIBIT/97:

11/03/96–01/05/97	BOUND TO THIS LAND: SELECTED VIEWS AND SELECTED VOICES — The significance of plants and animals native to Iowa will be highlighted through a variety of perspectives and media including 24 mural size gelatine silver print photographs.
01/12/97–02/02/97	SELECTIONS FROM THE MUSCATINE ART CENTER PERMANENT COLLECTION
01/12/97–02/02/97	A TIME OF MALFEASANCE - THE PRINTS OF VIRGINIA MYERS
03/23/97–05/04/97	NATIONAL ASSOCIATION OF WOMEN ARTISTS TRAVELING EXHIBITION
05/10/97–08/17/97	NATIONAL GEOGRAPHIC: THE PHOTOGRAPHS
10/05/97–11/16/97	THE WORLD OF JAN BRETT
11/23/97–01/11/98	THE AMERICAN SOCIETY OF ARCHITECTURAL PERSPECTIVES

IOWA

Muscatine Art Center - continued

01/18/98–03/08/98 PORTRAIT PHOTOGRAPHY FROM HOLLYWOOD'S GOLDEN AGE

03/22/98–05/10/98 THE WEST IN AMERICAN ART: SELECTIONS FROM THE HARMSEN COLLECTION — Presented in five seperate thematic units will be paintings that address a continuing fascination with the American West. Works on view will range from 19th-century landscape paintings by Bierstadt, Berninghaus and others to works by the Taos Society of Artists & the Santa Fe Colony, to dramatic images that freeze a moment of tension or high drama. BROCHURE WT

04/11/98–06/27/98 THE STONEWARES OF CHARLES FERGUS BINNS - FATHER OF AMERICAN STUDIO CERAMICS

Sioux City

Sioux City Art Center
225 Nebraska St., Sioux City, IA 51101
☎ 712-279-6272
HRS: 10-5 Tu-Sa, 1-5 S HOL: LEG/HOL!
&: Y; Chair lift at front door, elevator ℗ Y; Metered street parking & city lots within walking distance of the museum
GR/T: Y GR/PH: CATR! DT: Y TIME: 2:00 1st S of the month
PERM/COLL: NAT/AM; 19-20; CONT/REG; PTGS, WORKS ON PAPER; PHOT

Begun as a WPA project in 1938, the center features a permanent collection of regional art and changing exhibitions. This facility recently moved (in 10/96) to a stunning new $9 million Art Center building designed by Skidmore, Owings and Merrill. **NOT TO BE MISSED:** In the new facility, a hands-on gallery for children featuring creative activity stations.

ON EXHIBIT/97:

11/12/96–01/15/97 IOWA FROM THE RIVER — Thirty prints, drawings and paintings depicting views of Iowa as seen from the Mississippi River will be on exhibit. Selected from the museum's "Great River Collection," the majority of works date from the mid-to-late 19th-century. WT

11/24/96–01/19/97 IOWA: A PLACE TO SEW: THE IOWA SESQUICENTENNIAL QUILTS — Contemporary quilts will be featured in an exhibition celebrating the State's Sesquicentennial. WT

01/19/97–03/16/97 SIXTEENTH TO TWENTIETH CENTURY PRINTS BY INTERNATIONAL MASTERS: AN IOWA COLLECTION — 80 spectacular prints selected from the renowned Harold Peterson Collection donated in 1988 to the Blanden Memorial Art Museum will include notable works by Rembrandt, Whistler, Manet, Lucas van Leyden, Tiepolo and Hogarth. WT

01/19/97–03/09/97 A DECADE OF MOTIVATION: IOWA AND THE FEDERAL ARTS PROJECTS, 1933-1943 — The paintings, drawings, prints and sculpture on display represent a decade of important artistic creativity in Iowa by artists working and supported by federal government initiatives. WT

02/02/97–03/23/97 ALTERED REALITIES: THE MYSTERIOUS WORLD OF GERALD GUTHRIE (Working Title) — Illinois artist Guthrie's drawings and constructions on view in this exhibition contain dreamlike imagery whose metaphoric twists play against familiar, more comfortable backgrounds.

03/23/97–05/18/97 CHAIR EXHIBITION (Working Title) — Interpretations on the image of the chair by contemporary regional artists will be presented in a thematic exhibition that results in works that are functional, thought-provoking, or just plain whimsical.

03/30/97–05/25/97 BOUND TO THIS LAND: SELECTED VIEWS AND SELECTED VOICES — The significance of plants and animals native to Iowa will be highlighted through a variety of perspectives and media including 24 mural size gelatine silver print photographs. WT

Sioux City Art Center - continued

04/06/97–06/01/97	THE LATINO PRINT: WORKS BY RENE ARCEO (Working Title) — Arceo, an artist and Art Director for the Mexican Fine Arts Center Museum in Chicago, creates the woodblock prints on view by merging the historic Mexican imagery of his culture with innovative contemporary verve and flavor.
06/08/97–08/03/97	UMEX: UPPER MIDWEST EXHIBITION — Formerly called the Annual Juried Exhibition, this multi-state regional features works in all media by established and emerging artists.

Waterloo

Waterloo Museum of Art

225 Commercial St., **Waterloo, IA 50701**
☎ 319-291-4491
HRS: 10-9 M; 10-5 Tu-F; 1-4 Sa, S HOL: LEG/HOL!
&: Y Ⓟ Y; Ample and free MUS/SH: Y
GR/T: Y GR/PH: CATR!
PERM/COLL: REG: ptgs, gr, sculp; HAITIAN: ptgs, sculp; AM: dec/art

This museum notes as its strengths its collection of Midwest art that includes works by Grant Wood, Haitian and other examples of Caribbean art, and American decorative art with particular emphasis on pottery. **NOT TO BE MISSED:** Small collection of Grant Wood paintings, lithographs, and drawings

ON EXHIBIT/97:

ONGOING	SELECTED PERMANENT COLLECTION & PERMANENTLY INSTALLED SCULPTURE ON DISPLAY IN THE GRAND FOYER
12/08/96–04/20/97	THE HAITIAN COLLECTION: 20TH ANNIVERSARY EXHIBITION
01/11/97–02/23/97	PAINTINGS BY RICHARD THOMAS
03/08/97–04/27/97	SCULPTURE AND DRAWINGS BY NINA WARD
05/03/97–06/14/97	CANINES, BOVINES & OTHER PROM THEMES: PAINTINGS BY GARY FORD
07/01/97–11/01/97	THE LEGACY OF STONE CITY

KANSAS

Garnett

The Walker Art Collection of the Garnett Public Library
125 W. 4th Ave., **Garnett, KS 66032**
☎ 913-448-5496
HRS: 10-8 M, Tu, T; 10-5:30 W, F; 10-4:30 Sa DAY CLOSED: S HOL: 1/1, MEM/DAY, 7/4, THGV, 12/25
VOL/CONT: Y
&: Y ℗ Y; Free and abundant street parking
GR/T: Y GR/PH: CATR! 913-448-3388 DT: Y TIME: upon request if available
PERM/COLL: EU & AM: ptgs: 19-20; REG

Considered one of the most outstanding collections in the state, the Walker was started with a 110 piece bequest in 1951 by its namesake, Maynard Walker, a prominent art dealer in New York during the 1930's & 40's. Brilliantly conserved works by such early 20th-century American artists as John Stuart Curry, Robert Henri, and Luigi Lucioni are displayed alongside European and Midwest regional paintings and sculpture. All works in the collection have undergone conservation in the past 5 years and are in pristine condition. **NOT TO BE MISSED:** "Lake in the Forest (Sunrise)" by Corot; "Girl in Red Tights" by Walt Kuhn; "Tobacco Plant" by John Stuart Curry

Lawrence

Spencer Museum of Art
Affiliate Institution: University of Kansas
1301 Mississippi St., **Lawrence, KS 66045**
☎ 913-864-4710
HRS: 10-5 Tu-Sa, Noon-5 S, till 9 PM T DAY CLOSED: M HOL: 1/1, 7/4, 12/24, 12/25, THGV & FOLLOWING DAY
&: Y ℗ Y; Metered spaces in lot north of museum; free 3 hour visitor permits at traffic control booth on Mississippi, just south of museum. Park anywhere when school not in session.
MUS/SH: Y
GR/T: Y GR/PH: CATR! school year only
PERM/COLL: EU: ptgs, sculp, gr 17-18; AM: phot; JAP: gr; CH: ptgs; MED: sculp

The broad and diverse collection of the Spencer Museum of Art, located in the eastern part of the state not far from Kansas City, features particular strengths in the areas of European painting and sculpture of the 17th & 18th centuries, American photographs, Japanese and Chinese works of art, and Medieval sculpture. **NOT TO BE MISSED:** "La Pia de Tolommei" by Rosetti; "The Ballad of the Jealous Lover of Lone Green Valley" by Thomas Hart Benton

ON EXHIBIT/97:

through 01/19/97	FEMININE AND FLORAL IMAGERY OF THE ART NOUVEAU
02/01/97–03/30/97	HOGARTH AND THE SHOWS OF LONDON
02/01/97–03/30/97	PICTORIALISM INTO MODERNISM: THE CLARENCE H. WHITE SCHOOL OF PHOTOGRAPHY — Rare vintage photographs by Margaret Bourke-White, Anton Bruehl, Laura Gilpin, Paul Outerbridge and others will be featured with selected works by students and faculty of the school founded by White. WT
04/12/97–05/25/97	BORIS ANISFELD AND THE THEATER
09/97–10/97	EXHIBITION IN CONJUNCTION WITH THE NINTH ANNUAL LAWRENCE INDIAN ART SHOW
11/02/97–12/28/97	SNIPER'S NEST: ART THAT HAS LIVED WITH LUCY LIPPARD

Lindsborg

Birger Sandzen Memorial Gallery
401 N. 1st St., **Lindsborg, KS 67456-0348**
☎ 913-227-2220
HRS: 1-5 W-S DAY CLOSED: M, Tu HOL: LEG/HOL!
ADM: Y ADULT: $2.00 CHILDREN: $.50 grades 1-12 SR CIT: $2.00
&: Y ⓟ Y; Free parking in front of gallery and in lot behind church across from the gallery MUS/SH: Y
PERM/COLL: REG: ptgs, gr, cer, sculp; JAP: sculp

Opened since 1957 on the campus of a small college in central Kansas about 20 miles south of Salina, this facility is an important cultural resource for the state. Named after Birger Sandzen, an artist who taught at the college for 52 years, the gallery is the repository of many of his paintings. PLEASE NOTE: There is reduced rate of $5.00 for families of 5 or more people. **NOT TO BE MISSED:** "The Little Triton" fountain by sculptor Carl Milles of Sweden located in the courtyard.

Logan

Dane G. Hansen Memorial Museum
110 W. Main, **Logan, KS 67646**
☎ 913-689-4846
HRS: 9-Noon & 1-4 M-F, 9-Noon & 1-5 Sa, 1-5 S & Holidays HOL: 12/25, 1/1, THGV
&: Y ⓟ Y; Free and abundant on all four sides of the museum
PERM/COLL: OR; REG

Part of a cultural complex completed in 1973 in the heart of downtown Logan, the Hansen Memorial Museum, a member of the Smithsonian Associates, presents 5-7 traveling exhibitions annually from the Smithsonian Institution in addition to shows by regional artists. **NOT TO BE MISSED:** Annual Hansen Arts & Craft Fair (3rd Sa of Sept) where judges select 12 artists to exhibit in the Hansen's artist corner, one for each month of the year.

ON EXHIBIT/97:

12/07/96–01/19/97	TRY THIS ON: A HISTORY OF CLOTHING, GENDER AND POWER — From corsets and bustles to blue jeans and bandannas, this exhibition examines the social history over the past 200 years of how gender, status and occupation have been intricately linked to the form and fashion of each generation.	WT
02/09/97–05/04/97	EARTH 2U, EXPLORING GEOGRAPHY	WT
05/09/97–06/19/97	TELLING TALES	WT
06/22/97–07/13/97	PAINTINGS BY MIKE BOSS	
07/11/97–08/31/97	JOSH SIMPSON: NEW WORKS, NEW WORLD — An exhibition of paperweights and vessels by Simpson, a nationally known artist from western Massachusetts.	WT
09/05/97–11/09/97	ULTRA-REALISTIC SCULPTURE BY MARK SIJAN — Sijan's incredibly lifelike polyester resin sculptures of ordinary people include such specific attention to the details of tiny hairs, veins, pores and blemishes that the works on view appear to be real human beings whose actions are suspended for a moment in time.	WT

Overland Park

Johnson County Community College Gallery of Art
Affiliate Institution: Johnson County Community College
12345 College Blvd., **Overland Park, KS 66210**
HRS: 10-5 M, T, F; 10-7 Tu, W; 1-5 Sa DAY CLOSED: S HOL: LEG/HOL!
&: Y; Fully accessible ⓟ Y; Free GR/T: Y GR/PH: 913-469-8500
PERM/COLL: AM/ CONT: ptgs, cer, phot, works on paper

KANSAS

Johnson County Community College Gallery of Art - continued

The geometric spareness of the building set among the gently rolling hills of the campus is a perfect foil for the rapidly growing permanent collection of contemporary American art. Sculptures by Jonathan Borofsky, Barry Flannagan, and Judith Shea will be joined by other contemporary works in the newly established Oppenheimer-Stein Sculpture Collection sited over the 234-acre campus.

ON EXHIBIT/97: Seven exhibitions of contemporary art are presented annually.

Salina

Salina Art Center
242 S. Santa Fe, **Salina, KS 67401**
☎ 913-827-1431
HRS: Noon-5 Tu-Sa, 1-5 S, till 7 PM T DAY CLOSED: M HOL: LEG/HOL!
♿: Y; All entrances, galleries, restrooms, & Discovery Area Ⓟ Y; Free and ample with handicapped parking at both entrances
GR/T: Y GR/PH: CATR! available school year only

Although not a collecting institution, the Salina Art Center serves its community by being the only center for the fine arts in its area. Rotating high quality traveling exhibitions and a permanent Discovery Area for children are its main features.

ON EXHIBIT/97:

11/17/96–01/26/97	18TH ANNUAL JURORED ART EXHIBITION — Works in all media including installation, kinetic sculpture, video and performance art will be selected from entries by artists from Kansas, Nebraska, Missouri and Oklahoma.
03/14/97–05/11/97	NEW ART IN CHINA, POST 1989 CAT WT
06/97–07/97	SURFACE DESIGN EXHIBITION

Topeka

Gallery of Fine Arts-Topeka & Shawnee County
1515 W. 10th, **Topeka, KS 66604**
☎ 913-231-0527
HRS: LAB/DAY-MEM/DAY: 9-9 M-F, 9-6 Sa, 2-6 S HOL: LEG/HOL!
♿: Y; Ground entry via automatic doors Ⓟ Y; Free parking in lots at the south end and to the west of the building.
GR/T: Y GR/PH: CATR!
PERM/COLL: REG: ptgs, gr 20; W/AF (Advance notice required to see any permanent collection pieces in storage)

Although the fine art permanent collection is usually not on view, this active institution presents rotating exhibitions that are mainly regional in nature. PLEASE NOTE: The museum MAY be starting construction of a 100,000 square foot addition beginning in late 1997. **NOT TO BE MISSED:** Glass paperweights; Akan gold weights from Ghana and the Ivory Coast, West Africa

ON EXHIBIT/97:

01/15/97–02/10/97	AFRICAN DECORATIVE ARTS
05/15/97–06/15/97	TOPEKA ART GUILD SUMMER SHOW
06/25/97–07/25/97	SCULPTURE - ELDON TEFT TENT!
08/97	SELECTIONS FROM THE PERMANENT COLLECTION

172

Gallery of Fine Arts-Topeka & Shawnee County - continued

09/01/97–09/23/97	BLUE IN BLACK AND WHITE: DAVID SPITZER PHOTOGRAPHS
10/97	MARJORIE SCHICK: AN INSTALLATION & OTHER SMALL WORKS TENT!
12/97	HOLIDAY MEMORIES SHOW

Topeka

Mulvane Art Museum

Affiliate Institution: Washburn University
17th & Jewell, **Topeka, KS 66621**
☎ 913-231-1010
HRS: SEP-MAY: 10-7 Tu-W, 10 & T-F, 1-4 Sa, S; SUMMER: 10-4 Tu-F, 1-4 Sa & S DAY CLOSED: M HOL: LEG/HOL!
&: Y; Wide doorways, ramps, elevators ℗ Y; Free parking including handicapped accessible spaces in lot directly across the street from the museum. MUS/SH: Y GR/T: Y GR/PH: CATR! H/B: Y; Oldest museum in State of Kansas (1925)
PERM/COLL: EU: dec/art 19-20; AM: dec/art 19-20; JAP: dec/art 19-20; REG: cont ptgs; GR; SCULP; CER

Built in 1925, the Mulvane is the oldest art museum in the state of Kansas. In addition to an ever growing collection of works by artists of Kansas and the Mountain-Plains region, the museum counts both an international and a Japanese print collection among its holdings.

ON EXHIBIT/97:

01/17/97–03/02/97	KEITH ACHEPOHL: JOURNEYS — Selections from 20 years of watercolors.
03/21/97–04/20/97	KANSAS TRIENNIAL

Wichita

Edwin A. Ulrich Museum of Art

Affiliate Institution: The Wichita State University
Box 46, The Wichita State University, **Wichita, KS 67208-0046**
☎ 316-978-3664
HRS: 12-5 Daily HOL: 1/1, EASTER, 7/4, THGV, 12/25
&: Y; Outside ramp to entrance & elevator to gallery
℗ Y; With temporary parking permits from Police Dept. (open 24 hrs). Visitor lots also available.
GR/T: Y GR/PH: CATR! H/B: Y; Marble & glass mosaic mural by Spanish artist Joan Miro on museum facade S/G: Y
PERM/COLL: AM: 19-20; EU: 19-20; PRIM; AM: gr; EU: gr; PHOT

After undergoing extensive renovation, the museum, with its extensive collection of 19th to 20th-century art, reopened in Feb. 1996. The museum, which maintains a superb outdoor sculpture garden of nearly 60 works by such greats as Rodin, Moore, Botero, Nevelson, and Chadwick, and others, is a delight to visit at any time of year in its ever changing outdoor campus setting. Advance arrangements for tours of the Outdoor Sculpture Garden (weather permitting) may be made by calling 316-978-3664. Visitors may also use free maps provided for self-guided tours. **NOT TO BE MISSED:** Sculpture collection on grounds of university; Collection of marine paintings by Frederick J. Waugh

ON EXHIBIT/97:

ONGOING	THE KOURI SCULPTURE TERRACE — Rotating presentations of works from the museum's sculpture collection.
12/29/96–03/16/97	LA GUADALUPANA: IMAGES OF FAITH AND DEVOTION
01/23/97–03/23/97	ANDRES NAGEL
01/23/97–03/23/97	ENRIQUE CHAGOYA

Edwin A. Ulrich Museum of Art - continued

03/21/97–06/15/97	RECENT ACQUISITIONS TO THE WICHITA STATE UNIVERSITY ENDOWMENT ART COLLECTION AT THE EDWIN A. ULRICH MUSEUM OF ART
04/12/97–06/29/97	MIKE GLIER: GARDEN COURT
04/12/97–06/22/97	SHELTERS
06/20/97–10/08/97	JOHN DOYLE: THE GREAT HUMAN RACE
08/17/97–10/19/97	ANITA HUFFINGTON
08/28/97–11/02/97	BETTY HAHN: PHOTOGRAPHY OR MAYBE NOT — From her early photo-fabric stitched works to her ongoing series of Lone Ranger images, Hahn who has explored the use of the photograph in contemporary culture, often employs the 19th-century processes of cyanotype, and Van Dyck in her work as well as the use of toy and pin-hole cameras.
10/26/97–01/04/98	KIMO MINTON
11/13/97–01/11/98	TARELTON BLACKWELL

Wichita

Indian Center Museum

650 N. Seneca, **Wichita, KS 67203**
☎ 316-262-5221
HRS: 10-5 Tu-Sa, 1-5 S HOL: LEG/HOL!
ADM: Y ADULT: $2.00 CHILDREN: F (6 & under) STUDENTS: $1.00
Ⓟ Y; free MUS/SH: Y GR/T: Y GR/PH: CATR!
PERM/COLL: NAT/AM

The artworks and artifacts in this museum that preserve the Native American heritage also provide non-Indian people insight into the culture and traditions of the Native American. In addition to the art, Native American food is served on Tuesday from 11-2 & 4-7. **NOT TO BE MISSED:** Blackbear Bosin's 44 foot "Keeper of the Plains" located on the grounds at the confluence of the Arkansas & Little Arkansas Rivers.

Wichita Art Museum

619 Stackman St., **Wichita, KS 67203-3296**
☎ 316-268-4921
HRS: 10-5 Tu-Sa, Noon-5 S
♿: Y; Fully accessible Ⓟ Y; Free lot at rear of building ¶ Y; Truffles Cafe open 11:30-1:30 Tu-Sa & Noon-2 S
GR/T: Y GR/PH: CATR! 316-268-4907
PERM/COLL: AM: ptgs, ge, drgs; EU: gr, drgs; P/COL; CHARLES RUSSELL: ptgs, drgs, sculp; OM: gr

Outstanding in its collection of paintings that span nearly 3 centuries of American art, the Wichita is also known for its Old Master prints and pre-Columbian art works. **NOT TO BE MISSED:** The Roland P. Murdock Collection of American Art

ON EXHIBIT/97:
THROUGH 9/97	THE TABLES — Tom Otterness's 40 foot long, four-ton monumental sculpture, composed of 3 picnic tables and more than 100 lilliputian people, fantastic animals and monsters is on long-term loan to the museum through 9/97. Though comical in appearance, this work provides allegorical commentary on such critical contemporary issues as the Cold War, environmental waste, urban crime and nuclear annihilation.

Wichita Art Museum - continued

11/25/96–01/12/97	REENCUENTROS/REENCOUNTERS: EXPRESSIONS OF LATINO IDENTITY FIVE HUNDRED YEARS AFTER COLUMBUS

02/02/97–03/30/97 SHAKER: THE ART OF CRAFTSMANSHIP — 19th-century objects and furniture of simplicity, order and fine craftsmanship from the first and most influential Shaker community (established in New Lebanon, New York in 1785), will be seen in the first major exhibition of its kind in America. WT

04/20/97–06/15/97 COMMUNITY OF CREATIVITY: A CENTURY OF MACDOWELL COLONY ARTISTS — On exhibit will be paintings and sculpture by Milton Avery, Janet Fish, Lilla Cabot Perry and others who have worked at MacDowell, one of the most prestigious and demanding art colonies in the nation. CAT

06/29/97–09/14/97 KANSAS WATERCOLOR SOCIETY 1997 SEVEN-STATE EXHIBITION — Examples of the best watercolors by artists residing in Kansas, Oklahoma, Colorado, Nebraska, Missouri, Texas and New Mexico will be featured in this annual juried exhibition.

The Wichita Center for the Arts
9112 East Central, **Wichita, KS 67206**
✆ 316-634-2787
HRS: 10-5 Tu-F; 1-5 Sa, S DAY CLOSED: M HOL: LEG/HOL! AUG
♿: Y ℗ Y; Over 200 on-site free parking spaces available.
GR/T: Y GR/PH: CATR!
PERM/COLL: DEC/ART: 20; OR; PTGS; SCULP; DRGS; CER; GR

Midwest arts, both historical and contemporary, are the focus of this vital multi-disciplinary facility. **NOT TO BE MISSED:** 1,000 piece Bruce Moore Collection

KENTUCKY

Lexington

University of Kentucky Art Museum
Rose & Euclid Ave., **Lexington, KY 40506-0241**
☏ 606-257-5716
HRS: Noon-5 Tu-S DAY CLOSED: M HOL: 12/25, 1/1, 7/4, THGV, 1/14, ACAD!
VOL/CONT: Y ♿: Y; Fully accessible Ⓟ Y; Limited parking available in the circular drive in front of the center. More extensive parking in the University lots on Euclid St. GR/T: Y GR/PH: CATR! education dept.
PERM/COLL: OM: ptgs, gr; AM: ptgs 19; EU: ptgs 19; CONT/GR; PTGS 20; AF; OR; WPA WORKS

Considered to be one of Kentucky's key cultural resources, this museum houses over 3,500 art objects that span the past 2,000 years of artistic creation.

ON EXHIBIT/97:

08/11/96–06/97	BERTIN TO RODIN: 18TH AND 19TH-CENTURY FRENCH ART FROM THE J. B. SPEED AND UNIVERSITY OF KENTUCKY ART MUSEUMS — On loan will be important paintings and sculpture that celebrate French art of the 18th and 19th centuries.
11/10/96–01/05/97	ROBERT THARSING: A RETROSPECTIVE — The evolution of Tharsing's work from abstraction to representation and back again will be seen in this 25-year retrospective, a first for one of Kentucky's most original and accomplished artists.
01/26/97–03/23/97	JACOB LAWRENCE: TOUSSAINT L' OUVERTURE SERIES — Featured will be 41 paintings by Lawrence, an internationally acclaimed African-American artist, that relate the story of the Haitain Revolution.
04/13/97–06/15/97	KENTUCKY COUNTESS: MONA BISMARCK IN ART AND FASHION — Art, letters and fashion belonging to Kentucky-born Bismarck, once voted the most elegant woman in the world will be on exhibit.
09/28/97–11/23/97	PICTORIALISM INTO MODERNISM: THE CLARENCE H. WHITE SCHOOL OF PHOTOGRAPHY — Rare vintage photographs by Margaret Bourke-White, Anton Bruehl, Laura Gilpin, Paul Outerbridge and others will be featured with selected works by students and faculty of the school founded by White. WT
10/12/97–11/30/97	THE FIGURE IN 20TH CENTURY SCULPTURE — Works by 48 internationally known sculptors Rodin, Maillol, Lachaise, Giacometti, Lipschitz, Neri and others will be included in this stunning 20th-century survey of the interpretation of the human form. BROCHURE WT

Louisville

J. B. Speed Art Museum
2035 S. Third St., **Louisville, KY 40201-2600**
☏ 502-636-2893 WEB ADDRESS: http://www.speedmuseum.org
HRS: 10-4 Tu-Sa, Noon-5 S DAY CLOSED: M HOL: LEG/HOL!, 1st weekend in March & 1st Sa in May
♿: Y; North entrance , selected restrooms & telephone Ⓟ Y; Adjacent to the museum - $2.00 fee for non-members
MUS/SH: Y ⅋ Y; Cafe, 11:30-2 Tu-Sa, Noon-3 S (Reservations suggested 637-7774)
DT: Y TIME: 2 PM Sa, 1 PM S S/G: Y
PERM/COLL: AM: dec/art; PTGS; SCULP: GR; PRIM; OR; DU: 17; FL:17; FR: ptgs 18; CONT

Founded in 1927, and located on the main campus of the University of Louisville, the J. B. Speed Art Museum is the largest (over 3,000 works) and the most comprehensive (spanning 6,000 years of art history) public art collection in Kentucky. Free "Especially For Children" tours are offered at 11:00 each Saturday. PLEASE NOTE: 1. A fee is charged for selected exhibitions. 2. Due to construction and renovation many portions of the museum will be unavailable until mid to late 1997. **NOT TO BE MISSED:** New acquisition: "Saint Jerome in the Wilderness" by Hendrick van Somer, 1651; "Head of a Ram,"a 2nd century marble Roman sculpture (recent acquisition); "Colossal Head of Medusa," polychromed fiberglass sculpture by Audry Flack (recent acquisition)

Louisville

Photographic Archives

Affiliate Institution: University of Louisville Libraries
Ekstrom Library, University of Louisville, **Louisville, KY 40292**
📞 502-852-6752 WEB ADDRESS: http./www.louisville.edu/library/ekstrom/special
HRS: 10-4 M-F, 10-8 T DAY CLOSED: Sa, S HOL: LEG/HOL!
♿: Y Ⓟ Y; Limited (for information call 502-588-6505) GR/T: Y GR/PH: call 502-588-6752
PERM/COLL: PHOT; GR

With 33 individual collections and over one million items, the Photographic Archives is one of the finest photography and research facilities in the country. **NOT TO BE MISSED:** 2,000 vintage Farm Security Administration photos; more than 1500 fine prints "from Ansel Adams to Edward Weston"

ON EXHIBIT/97:

11/18/96–02/07/97	APPALACHIAN KENTUCKY PHOTOGRAPHS FROM THE HAL COONER, CLAUDE C. MATLACK, JEAN THOMAS AND HENDERSON SETTLEMENT SCHOOL COLLECTIONS
03/03/97–04/11/97	BIRDS IN FLIGHT — Photographs by Russell C. Hansen.
03/03/97–04/11/97	HISTORICAL BIRD ILLUSTRATIONS
04/28/97–08/01/97	BASEBALL PHOTOGRAPHS FROM THE HILLERICH & BRADSBY COLLECTION, MAKERS OF THE "LOUISVILLE SLUGGER" BAT
08/18/97–10/01/97	RECENT ACQUISITIONS: FINE PRINTS AND RARE BOOKS
11/17/97–01/30/98	LOUISE ROSSKAM: PHOTOGRAPHS FROM THE OLD STANDARD OIL OF NEW JERSEY COLLECTION AND RECENT WORKS

Owensboro

Owensboro Museum of Fine Art

901 Frederica St., **Owensboro, KY 42301**
📞 502-685-3181
HRS: 10-4 M-F; 1-4 Sa, S HOL: LEG/HOL!
SUGG/CONT: Y ADULT: $2.00 CHILDREN: $1.00
♿: Y; Totally accessible Ⓟ Y; Free street parking in front of museum MUS/SH: Y
GR/T: Y GR/PH: CATR! H/B: Y; 1925 Carnegie Library Building (listed NRHP)
PERM/COLL: AM: ptgs, drgs, gr, sculp 19-20; BRIT: ptgs, drgs, gr, sculp 19-20; FR: ptgs, sculp, drgs, gr 19-20; CONT/AM; DEC/ART 14-18

The collection of the Owensboro Museum, the only fine art institution in western Kentucky, features works by important 18-20th-century American, English, and French masters. Paintings by regional artists stress the strong tradition of Kentucky landscape painting. Opened in 9/94 was a new wing of the museum which houses several new exhibition galleries, an atrium sculpture court, a restored Civil War era mansion and the John Hampdem Smith House. **NOT TO BE MISSED:** 16 turn-of-the-century stained glass windows by Emil Frei (1867-1941) permanently installed in the new wing of the museum; revolving exhibitions of the museum's collection of southeastern folk art.

ON EXHIBIT/97:

01/12/97–02/02/97	O, APPALACHIA REVISITED — Works from the O, Appalachia Collection of American Folk Art will be on exhibit.
02/09/97–06/29/97	SHARED TREASURES: MASTERWORKS FROM THE EVANSVILLE MUSEUM OF ARTS & SCIENCE — 16th & 17th-century Dutch and Flemish paintings, 19th & 20th-century American & European paintings, 18th & 19th-century Asian porcelain, and Renaissance bronzes & jewelry will be among the objects on loan for this exhibition.
05/11/97–06/29/97	DAVID BARTEN: MASTERCARVER — Both lifesize religious and American historical figures in Kentucky collections by Massachusetts sculptor Barten will be featured in this 20 year retrospective of his work.

KENTUCKY

Paducah

Yeiser Art Center
200 Broadway, **Paducah, KY 42001-0732**
📞 502-442-2453
HRS: 10-4 Tu-Sa, 1-4 S DAY CLOSED: M HOL: LEG/HOL! & JAN.
ADM: Y ADULT: $1.00 CHILDREN: F (under 12)
♿: Y; Completely accessible Ⓟ Y; Free parking across the street from the museum MUS/SH: Y
GR/T: Y GR/PH: CATR! DT: Y TIME: Usually available upon request
H/B: Y; Located in the historic Market House (1905)
PERM/COLL: ARTWORKS 19-20

The restored 1905 Market House (listed NRHP), home to the Art Center and many other community related activities, features changing exhibitions that are regional, national, and international in content. **NOT TO BE MISSED:** Annual national fiber exhibition mid Mar through Apr (call for exact dates)

ON EXHIBIT/97:

02/02/97–03/16/97	DUSK TO DAWN — Paintings and drawings by Warren Farr.
03/23/97–05/04/97	FANTASTIC FIBERS — Traditional and nontraditional fiber works by artists from across the nation will be on view in the 10th annual fiber invitational. ADM FEE
05/11/97–06/22/97	CATHY ROBINSON: FURNITURE
06/29/97–08/10/97	ART FROM THE REGIONAL GUILDS
08/17/97–09/28/97	TBA
10/05/97–11/16/97	PADUCAH '97 — A regional juried competition.

Alexandria

Alexandria Museum of Art

933 Main St., **Alexandria, LA 71301-1028**
☎ 318-443-3458
HRS: 9-5 Tu-F, 10-4 Sa DAY CLOSED: S, M HOL: LEG/HOL!
ADM: Y ADULT: $3.00 CHILDREN: $1.00 STUDENTS: $2.00 SR CIT: $2.00
&: Y ℗ Y; Free but very limited parking across the street from the museum. Some handicapped and bus parking in front of the building. GR/T: Y DT: Y TIME: often available upon request! H/B: Y; 1900 Bank Building
PERM/COLL: CONT: sculp, ptgs; REG; FOLK

Housed in a former bank building that dates back to the turn of the century, this museum features a permanent collection of contemporary art along with regional fine art and folk craft works. PLEASE NOTE: The museum will be closed for renovation and construction until at least the fall of 1997. **NOT TO BE MISSED:** Recently opened gallery of northern Louisiana folk art.

Baton Rouge

Louisiana Arts and Science Center

100 S. River Rd., **Baton Rouge, LA 70801-3373**
☎ 504-344-5272
HRS: 10-3 Tu-F, 10-4 Sa, 1-4 S DAY CLOSED: M HOL: LEG/HOL!
F/DAY: 1st S of the month ADM: Y ADULT: $3.00 CHILDREN: $2.00 (2-12) STUDENTS: $2.00 SR CIT: $2.00
&: Y; Ramp outside; elevator
℗ Y; Limited free parking in front of building and behind train; other parking areas available within walking distance
GR/T: Y GR/PH: CATR! 504-344-9463 H/B: Y; Housed in reconstructed Illinois Central Railroad Station S/G: Y
PERM/COLL: SCULP; ETH; GR; DRGS; PHOT; EGT; AM: ptgs 18-20; EU: ptgs 18-20

This museum is housed in a reconstructed Illinois Central Railroad station built on the site of the 1862 Civil War Battle of Baton Rouge. PLEASE NOTE: The admission fee on Sunday is $1.00 for all ages 2 and over except for free admission the first Sunday of each month. **NOT TO BE MISSED:** Works by John Marin, Charles Burchfield, Asher B. Durand; Baroque, Neo-Classic, & Impressionist Works

ON EXHIBIT/97:

01/07/97–03/02/97	AFRICAN AMERICAN ART IN PUBLIC AND PRIVATE COLLECTIONS IN LOUISIANA
03/04/97–05/11/97	TALKING PICTURES: PEOPLE SPEAK OUT ABOUT THE PHOTOGRAPHS THAT SPEAK TO THEM — An exhibition of 56 photographs chosen by various individuals who have been asked to highlight a single work that has impacted on their personal experience and remained as a significant memory. Remarks by these individuals that explain their choices will be accessible to the viewer through a hand-held remote receiver.

BOOK WT

Jennings

The Zigler Museum

411 Clara St., **Jennings, LA 70546**
☎ 318-824-0114
HRS: 9-5 Tu-Sa, 1-5 S DAY CLOSED: M HOL: LEG/HOL! SUGG/CONT: Y ADULT: $2.00 CHILDREN: $1.00
&: Y ℗ Y; Free street parking MUS/SH: Y GR/T: Y GR/PH: CATR! DT: Y TIME: Usually available upon request
PERM/COLL: REG; AM; EU

The gracious colonial style structure that had served as the Zigler family home since 1908 was formerly opened as a museum in 1970. Two wings added to the original building feature many works by Louisiana landscape artists in addition to those by other American and European artists. PLEASE NOTE: The museum is open every day for the Christmas festival from the first weekend in Dec. to Dec. 22. **NOT TO BE MISSED:** Largest collection of works by African-American artist, William Tolliver

ON EXHIBIT/97: Exhibitions by artists and master craftsmen are presented throughout the year.

LOUISIANA

Lafayette

University Art Museum
East Lewis & Girard Park Dr., **Lafayette, LA 70504**
☎ 318-231-5326
HRS: Fletcher Hall: 9-4 M-F, 2-5 S; Permanent Coll: 9-4 M-F DAY CLOSED: Sa HOL: 1/1, MARDI GRAS, THGV, 12/25,
EASTER ADM: Y ADULT: $2.00 SR CIT: $1.00
&: Y ℗ Y; Free
PERM/COLL: AM/REG: ptgs, sculp, drgs, phot 19-20; JAP: gr; PLEASE NOTE: Selections from the permanent collection are
on display approximately once a year (call for specifics)

This university art museum, which serves as a cultural focal point for no less than 18 southwestern Louisiana
parishes, maintains a permanent collection of primarily 19th & 20th-century Louisiana and American southern
works of art.

ON EXHIBIT/97:
06/97–08/97 TBA

09/13/97–10/31/97 LEROY ARCHULETA: A TO Z — Charming, brightly-colored wooden animals by
 Hispanic folk artist Archuleta, on loan from the Sylvia & Warren Lowe collection, will be
 arranged in a fantastical zoo-like gallery setting. CAT WT

Monroe

Masur Museum of Art
1400 S. Grand, **Monroe, LA 71201**
☎ 318-329-2237
HRS: 9-5 Tu-T, 2-5 F-S DAY CLOSED: M HOL: LEG/HOL!
&: Y; Access to first floor only ℗ Y; Free parking adjacent to the museum building GR/T: Y GR/PH: CATR! S/G: Y
PERM/COLL: AM: gr 20; REG/CONT

Twentieth-century prints by American artists and works by contemporary regional artists form the basis of the
permanent collection of this museum which is housed in a stately modified English Tudor estate situated on the
tree-lined banks of the Ouachita River.

New Orleans

The Historic New Orleans Collection
533 Royal St., **New Orleans, LA 70130**
☎ 504-523-4662
HRS: 10-4:45 Tu-Sa DAY CLOSED: M, S HOL: LEG/HOL!
ADM: Y &: Y MUS/SH: Y GR/T: Y GR/PH: CATR! DT: Y TIME: 10, 11, 2, & 3 DAILY
H/B: Y; 1792 Jean Francois Merieult House located in French Quarter
PERM/COLL: REG: ptgs, drgs, phot; MAPS; RARE BOOKS, MANUSCRIPTS

Located within a complex of historic buildings, the Historic New Orleans Collection serves the public as a museum
and research center for state and local history. Merieult House, one of the most historic buildings of this complex,
was built in 1792 during Louisiana's Spanish Colonial period. It is one of the few structures in the French Quarter
that escaped the fire of 1794. **NOT TO BE MISSED:** Tours of the LA History Galleries and Founders Residence

ON EXHIBIT/97:
01/14/97–09/06/97 A MYSTICAL BAL MASQUE: 75 YEARS OF THE MYSTIC CLUB

180

LOUISIANA

New Orleans

Louisiana State Museum
751 Chartres St., Jackson Square, **New Orleans, LA 70116**
\ 504-568-6968
HRS: 9-5 Tu-S DAY CLOSED: M HOL: LEG/HOL!
ADM: Y ADULT: $4.00 CHILDREN: F (12 & under) STUDENTS: $3.00 SR CIT: $3.00
&: Y; Presbytere, Old U.S. Mint, and Cabildo are accessible
MUS/SH: Y
GR/T: Y GR/PH: CATR! DT: Y TIME: Gallery talks on weekends - call for specifics H/B: Y
PERM/COLL: DEC/ART; FOLK; PHOT; PTGS; TEXTILES

Several historic buildings located in the famous New Orleans French Quarter are included in the Louisiana State Museum complex providing the visitor a wide array of viewing experiences that run the gamut from fine art to decorative art, textiles, Mardi Gras memorabilia, and even jazz music. The Cabildo, Presbytere, and 1850 House (all located on Jackson Square) and the Old U.S. Mint are currently open to the public. PLEASE NOTE THE FOLLOWING: (1) Although the entry fee of $4.00 is charged per building visited, a discounted rate is offered for a visit to two or more sites. (2) 1850 House features special interpretive materials for handicapped visitors. **NOT TO BE MISSED:** Considered the State Museum's crown jewel, the recently reopened Cabildo features a walk through Louisiana history from Colonial times through Reconstruction. Admission to the Arsenel, featuring changing exhibits, is included in the entry fee to the Cabildo.

New Orleans Museum of Art
1 Collins Diboll Circle, City Park, P.O. Box 19123, **New Orleans, LA 70119-0123**
\ 504-488-2631
HRS: 10-5 Tu-S DAY CLOSED: M HOL: LEG/HOL!
ADM: Y ADULT: $6.00 CHILDREN: $3.00 (3-17) SR CIT: $5.00
&: Y; Fully accessible Ⓟ Y; Ample free parking adjacent to the museum MUS/SH: Y
❙❙ Y; Courtyard Cafe 10:30-4:30 Tu-S (children's menu available)
GR/T: Y GR/PH: CATR! DT: Y TIME: 11:00 & 2:00 Tu-S
PERM/COLL: OM: ptgs; IT/REN: ptgs (Kress Collection); FR; P/COL: MEX; AF; JAP: gr; AF; OC; NAT/AM; LAT/AM; AS; DEC/ART: 1st. century A.D.-20; REG

Located in the 1,500 acre City Park, the 75 year old New Orleans Museum has recently completed a $23 million expansion and renovation program that has doubled its size. Serving the entire Gulf South as an invaluable artistic resource, the museum houses over one dozen major collections that cover a broad range of fine and decorative arts. **NOT TO BE MISSED:** Treasures by Faberge; Chinese Jades; Portrait Miniatures; new 3rd floor showcase for non-Western Art; The stARTing point, a new hands-on gallery area with interactive exhibits and 2 computer stations designed to help children and adults understand the source of artists' inspiration.

ON EXHIBIT/97:

11/04/96–01/19/97 LOST RUSSIA: PHOTOGRAPHS BY WILLIAM CRAFT BRUMFIELD

12/08/96–02/09/97 FABERGÉ IN AMERICA — Coinciding with the 150th birthday anniversary of Peter Carl Fabergé, master jeweler to the former Imperial Court of Russia, this exhibition will feature over 400 of his precious works. Accompanying 14 of the original 52 Imperial Easter Eggs created for the royal family, will be jeweled enameled picture frames, cigarette cases, miniature animal figures, and fanciful flower pots. CAT ADM FEE ATR! WT ∩

03/01/97–04/13/97 CONTEMPORARY BOTANICAL ARTISTS: THE SHIRLEY SHERWOOD COLLECTION

LOUISIANA

New Orleans Museum of Art - continued

04/26/97–06/29/97	ANDREW WYETH: THE HELGA PICTURES — Paintings, drawings and watercolors of Helga Testorf, Wyeth's neighbor and model, produced by the artist in total secrecy over a 15 year period (1971-1985) will be featured in this thought-provoking exhibition that allows the viewer to speculate on the underlying psychological possibilities of the intertwined relationship of artist to model. One of the final opportunities to see these works, as they have recently been sold to a Japanese collector. BOOK WT
07/12/97–08/31/97	HOCKNEY TO HODGKIN: BRITISH MASTER PRINTS
09/13/97–11/02/97	A CONNOISSEUR'S EYE: OLD MASTER PAINTINGS FROM THE COLLECTION OF MR. AND MRS. HENRY W. WELDON WT
09/27/97–11/23/97	ARTISTS OF THE MARDI GRAS: THE GOLDEN AGE OF CARNIVAL, 1870-1930
11/15/97–01/07/98	JAPANESE PAINTING OF THE EDO PERIOD FROM NOMA

Shreveport

Meadows Museum of Art of Centenary College

2911 Centenary Blvd., Shreveport, LA 71104-1188
☎ 318-869-5169
HRS: Noon-4 Tu-F; 1-4 Sa, S DAY CLOSED: M HOL: LEG/HOL!
♿: Y; Ramp to museum; elevator to 2nd floor Ⓟ Y; Free parking directly behind the building
GR/T: Y GR/PH: CATR! DT: Y TIME: Upon request if available
PERM/COLL: PTGS, SCULP, GR, 18-20; INDO CHINESE: ptgs, gr

This museum, opened in 1976, serves mainly as a repository for the unique collection of works in a variety of media by French artist Jean Despujols. **NOT TO BE MISSED:** The permanent collection itself which offers a rare glimpse into the people & culture of French Indochina in 1938.

ON EXHIBIT/97:

01/19/97–03/09/97	AMERICA AND THE SPANISH CIVIL WAR — Posters, photographs and paintings about the Spanish Civil War from 1936-1938 will be on display in this major multi-disciplinary exhibition. WT
04/05/97–06/01/97	FOLK ANIMALS A TO Z — Whimsical near life-size animals by Archuleta, a well known New Mexican folk artist will be on loan from the renowned folk art collection of Warren & Sylvia Lowe. WT

The R. W. Norton Art Gallery

4747 Creswell Ave., Shreveport, LA 71106
☎ 318-865-4201
HRS: 10-5 Tu-F; 1-5 Sa, S DAY CLOSED: M HOL: LEG/HOL!
♿: Y; Access ramps off street; no steps Ⓟ Y; Free parking in front of building MUS/SH: Y GR/T: Y GR/PH: CATR!
PERM/COLL: AM: ptgs, sculp (late 17-20); EU: ptgs, sculp 16-19; BRIT: cer

With its incomparable collections of American and European art, the Norton, situated in a 46 acre wooded park, has become one of the major cultural attractions in the region since its opening in 1966. Among its many attractions are the Biersdadt Gallery, the Bonheur Gallery, and the Corridor which features "The Prisons," a 16-part series of fantasy etchings by Piranesi. Those who visit the museum from early to mid April will experience the added treat of seeing 13,000 azalea plants that surround the building in full bloom. **NOT TO BE MISSED:** Outstanding collections of works by Frederic Remington & Charles M. Russell; The Wedgewood Gallery (one of the finest collections of its kind in the southern U.S.)

ON EXHIBIT/97:

03/28/97–04/06/97	ANNUAL EASTER EXHIBITION
08/24/97–10/19/97	IMPERIAL RUSSIAN PORCELAINS FROM THE RAYMOND F. PIPER COLLECTION — 90 opulent and extravagant porcelains from the Imperial Porcelain Factory in St. Petersburg, Russia, created between the reigns of Elizabeth I and Nicholas II, will be featured in this exhibition. CAT WT

Brunswick

Bowdoin College Museum of Art
Walker Art Bldg., **Brunswick, ME 04011**
☎ 207-725-3275
HRS: 10-5 Tu-Sa, 2-5 S DAY CLOSED: M HOL: LEG/HOL! CLOSED WEEK BETWEEN 12/25 & NEW YEARS DAY
VOL/CONT: Y ♿: Y; Call for assistance (207) 725-3275 ℗ Y; All along Upper Park Row MUS/SH: Y
GR/T: Y GR/PH: CATR! 207-725-3064 H/B: Y; 1894 Walker Art Building Designed by Charles Follen McKim
PERM/COLL: AN/GRK; AN/R; AN/EGT; AM: ptgs, sculp, drgs, gr, dec/art; EU: ptgs, sculp, gr, drgs, dec/art; AF: sculp;
INTERIOR MURALS BY LAFARGE, THAYER, VEDDER, COX

From the original bequest of artworks given in 1811 by James Bowdoin III, who served as Thomas Jefferson"s minister to France and Spain, the collection has grown to include important works from a broad range of nations and periods. **NOT TO BE MISSED:** Winslow Homer Collection of wood engravings, watercolors, drawings, and memorabilia (available for viewing during the summer months only).

ON EXHIBIT/97:

ONGOING	BOYD GALLERY — 14th to 20th-century European art from the permanent collection.
	BOWDOIN GALLERY — American art from the permanent collection.
	SOPHIA WALKER GALLERY — ART AND LIFE IN THE ANCIENT MEDITERRANEAN — 4th-century BC to 4th-century A.D. Assyrian, Egyptian, Cypriot, Greek and Roman objects will be featured in an installation that highlights one of the museum's great strengths.
01/30/97–03/16/07	MICHAEL MAZUR: THE INFERNO — 38 monotypes and 8 studies created by Mazur to illustrate Robert Pinsky's 1994 translation of "The Inferno of Dante" will be featured in an exhibition that reveals much of the artists's artistic process in the creation of these works.
04/01/97–06/01/97	APPEAL TO THIS AGE: PHOTOGRAPHY OF THE CIVIL RIGHTS ERA, 1954-1968 — A survey of the photography of the black-led freedom movement of the middle of our century, these are among the most inspiring images of 20th-century America. Included are 75 powerful and moving images by Gordon Parks, James Karales, Sandra Weiner, Charles Moore and others.

Lewiston

The Bates College Museum of Art
Affiliate Institution: Bates College
Olin Arts Center, Bates College, **Lewiston, ME 04240**
☎ 207-786-6158
HRS: 10-5 Tu-Sa, 1-5 S DAY CLOSED: M HOL: LEG/HOL!
♿: Y ℗ Y; Free on-street campus parking GR/T: Y GR/PH: call 207-786-6123
PERM/COLL: AM: ptgs, sculp; GR 19-20; EU: ptgs, sculp, gr; drgs:

The recently constructed building of the Museum of Art at Bates College houses a major collection of works by American artist Marsden Hartley. It also specializes in 20th-century American and European prints, drawings, and photographs, and has a small collection of 20th-century American paintings. **NOT TO BE MISSED:** Collection of Marsden Hartley drawings and memorabilia

ON EXHIBIT/97:

ONGOING	HIGHLIGHTS FROM THE PERMANENT COLLECTION
01/97–03/97	MAKING JAPANESE COLOR WOODCUTS — Prints from the museum's collection conated by Weston and Mary Naef will be on exhibit.
01/97–03/97	ELKE MORRIS: PHOTOGRAPHS

MAINE

The Bates College Museum of Art - continued

SUMMER/97	PAUL HEROUX
09/97–10/97	SIGMUND ABELES TENT!
11/97–12/97	ANTHONY PANZERA TENT!

Ogunquit

Ogunquit Museum of American Art
181 Shore Rd., **Ogunquit, ME 03907**
☎ 207-646-4909
HRS: (open 7/1 through 9/30 ONLY) 10:30-5 M-Sa, 2-5 S HOL: LAB/DAY
ADM: Y ADULT: $3.00 CHILDREN: F (under 12) STUDENTS: $2.00 SR CIT: $2.00
&: Y; Enter lower level at seaside end of bldg; wheelchairs available
Ⓟ Y; Free on museum grounds MUS/SH: Y
GR/T: Y GR/PH: CATR! DT: Y TIME: upon request if available S/G: Y
PERM/COLL: AM: ptgs, sculp 20

Situated on a rocky promontory overlooking the sea, this museum has been described as the most beautiful small museum in the world! Built in 1952, the Ogunquit houses many important 20th-century American paintings and work of sculpture in addition to site-specific sculptures are spread throughout its three acres of land. **NOT TO BE MISSED:** "Mt. Katadhin, Winter" by Marsden Hartley; "The Bowrey Drunks" by Reginald Marsh; "Pool With Four Markers" by Dozier Bell; "Sleeping Girl" by Walt Kuhn

Orono

University of Maine Museum of Art
109 Carnegie Hall, **Orono, ME 04469-5712**
☎ 207-581-3255
HRS: 9-4:30 M-F; Weekends by appointment DAY CLOSED: S HOL: STATE & LEG/HOL!
Ⓟ Y; Free with visitor permits available in director's office.
GR/T: Y GR/PH: CATR! H/B: Y; 1904 Library of Palladian Design
PERM/COLL: AM: gr, ptgs 18-20; EU: gr, ptgs 18-20; CONT; REG

Housed in a beautiful 1904 structure of classic Palladian design, this university art museum, located just to the northeast of Bangor, Maine, features American and European art of the 18th-20th centuries and works by Maine based artists of the past and present. The permanent collection is displayed throughout the whole university and in the main center-for-the-arts building,

ON EXHIBIT/97:

11/18/96–01/12/97	50TH ANNIVERSARY GALA: ART MUSEUM/ART DEPARTMENT
12/02/96–02/02/97	ARTIST'S STAMPS: OWEN SMITH
03/01/97–03/30/97	WAKE UP LITTLE SUSIE
03/01/97–03/30/97	WARNINGS
04/25/97–05/13/97	SARAH FARRAGHER: HONORS THESIS

Portland

Portland Museum of Art
Seven Congress Square, **Portland, ME 04101**
📞 207-775-6148
HRS: 10-5 Tu, W, Sa; 10-9 T, F; noon-5 S; (open 10-5 M Jul. to 10/12) DAY CLOSED: M HOL: LEG/HOL!
F/DAY: 5-9 PM F ADM: Y ADULT: $6.00 CHILDREN: $1.00 (6-12) STUDENTS: $5.00 SR CIT: $5.00
♿: Y; Galleries are wheelchair accessible
Ⓟ Y; Free on-street parking on weekends; discounted parking with validated museum ticket at nearby garages.
MUS/SH: Y 🍴 Y; Museum Cafe
GR/T: Y GR/PH: CATR! DT: Y TIME: 2:00 daily & 6 PM F
PERM/COLL: AM; ptgs, sculp 19-20; REG; DEC/ART; JAP: gr

The Joan Whitney Payson Collection is part of the oldest and finest art museum in the state of Maine. Established over 100 years ago, the outstanding museum holdings of Impressionist and American master works is housed in an award-winning building designed by renowned architect I. M. Pei & Partners. PLEASE NOTE: Admission fees change according to the season. The fees listed are in effect from June 1 - Oct 31. (Winter entry is $5). Also, there is a toll free number (1-800-639-4067) for museum information. **NOT TO BE MISSED:** The Charles Shipman Payson collection of 17 works by Winslow Homer.

ON EXHIBIT/97:

ONGOING — FROM MONET TO MATISSE: THE ORIGINS OF MODERNISM

PHILLIPE HALSMAN: A GALLERY OF STARS

11/09/96–01/12/97 — DALE CHIHULY: SEAFORMS — Over 40 exceptional glass sculptures that resemble brilliant undulating marine life created by American master Chihuly, will be on exibit with a number of his working drawings. CAT WT

12/21/96–02/23/97 — PERSPECTIVES: THE ART OF THE BOOK — The formal beauty and artistry of books will be explored in this exhibition of works by more than 15 regional artists who integrate both traditional and experimental elements into their creations.

02/01/97–03/30/97 — THE SHORES OF A DREAM: YASUO KUNIYOSHI'S EARLY WORKS IN AMERICA — 20 ink drawings and 13 oil paintings by Japanese-American artist Kuniyoshi, that reflect the influences of both Eastern (Japanese mythic symbolism) and Western (American folk art) imagery will be seen in the examples of his early works on display in this exhibition.

04/12/97–06/04/97 — IN PRINT: THE ARTISTS OF VINALHAVEN PRESS — Featured will be works created over the past decade by both established and emerging artists who have participated in the part fine-art & part artists' colony Vinalhaven Press experience.

06/19/97–09/14/97 — ALEX KATZ: UNDER THE STARS, AMERICAN LANDSCAPES — In the first retrospective of his landscapes, large-scale works by Katz, painted throughout the course of his career will include a variety of images from the woodlands and beaches of his summer home in Maine, to urban "landscapes" of New York City. CAT WT

Rockland

William A. Farnsworth Library and Art Museum
352 Main St., **Rockland, ME 04841**
📞 207-596-6457 WEB ADDRESS: htp:/www.midcoast.com/farnsworth
HRS: SUMMER: 9-5 M-Sa, Noon-5 S; WINTER: 10-5 Tu-Sa, 1-5 S HOL: LEG/HOL!
ADM: Y ADULT: $5.00 CHILDREN: $3.00 (8-18) STUDENTS: $4.00 SR CIT: $4.00
♿: Y; Wheelchair and restroom accessible Ⓟ Y; Free MUS/SH: Y GR/T: Y GR/PH: CATR! Janice Kasper
H/B: Y; 1850 Victorian Homestead on grounds adjacent to museum open seasonally! S/G: Y
PERM/COLL: AM: 18-20; REG; PHOT; GR

MAINE

William A. Farnsworth Library and Art Museum - continued

Nationally acclaimed for its collection of American Art, the Farnsworth, located in the mideastern coastal city of Rockland, counts among its important holdings the largest public collection of works (60 in all) by sculptress Louise Nevelson. Recent renovations to the museum now allow for the installation of an abbreviated survey from the permanent collection of American art with special emphasis on artists from the state of Maine. There is also an additional new gallery housing the Nevelson collection and other works of contemporary art. In 1998 the museum will add the Andrew and Betsy Wyeth Center to its complex. PLEASE NOTE: There is an additional fee of $3.00 for visiting Olson House open daily 11-4 MEM/DAY weekend to COLUMBUS DAY weekend. **NOT TO BE MISSED:** Major works by N.C., Andrew & Jamie Wyeth, Fitz Hugh Lane, John Marin, Edward Hopper, Neil Welliver, Louise Nevelson; The Olsen House, depicted by Andrew Wyeth in many of his most famous works

ON EXHIBIT/97:

ONGOING	MAINE IN AMERICA — The history of American art with a special emphasis on works related to Maine will be seen in the examples on view from the permanent collection.
	THE WYETH COLLECTION — Works by 3 generations of the Wyeth family, namely, N.C., Andrew and Jamie will be on view until they are relocated in 1988 to the planned Andrew & Betsy Wyeth Center as part of the Farnsworth complex.
11/10/96–07/06/97	HOMAGE TO LOUISE NEVELSON — In addition to the wood and terracotta sculptures for which she is noted, this exhibition will include paintings, drawings, mixed media constructions and even some personal items of jewelry and photography all gifted to the museum by the late sculptor and her family.
11/10/96–02/02/97	EARL CUNNINGHAM: PAINTING AN AMERICAN EDEN — A self taught artist Cunningham, dubbed the "Grandma Moses of Florida," created his own utopian worlds filled with symbols and visions of a peaceable kingdom. This retrospective includes 46 of his paintings created from the 1920's to his death in 1971.
01/12/97–07/06/97	NEW ACQUISITIONS: PARTS I AND II
02/16/97–04/20/97	A BRUSH WITH GREATNESS: AMERICAN WATERCOLORS FROM THE NOVEMBER COLLECTION — Masterworks in watercolor by John Marin, Edward Hopper, Winslow Homer and other American painters of note will be on loan from a private collection.
04/27/97–07/06/97	MICHAEL LOEW: NATURE INTO ABSTRACTION — Loew's watercolors and major paintings will be on exhibit.
07/13/97–10/05/97	MAINE AT WORK — 19th & 20th-century paintings, sculpture, photography, prints and drawings will be seen in an exhibition that examines the ways Maine residents have worked and shaped the character of the state from the 19th-century to the present time.

Waterville

Colby College Museum of Art

Mayflower Hill, **Waterville, ME 04901**

☎ 207-872-3228

HRS: 10-4:30 M-Sa, 2-4:30 S HOL: LEG/HOL!

&: Y ℗ Y; Free parking in front of the museum MUS/SH: Y

PERM/COLL: AM: Impr/ptgs, folk, gr; Winslow Homer: watercolors; OR: cer

Located in a modernist building on a campus dominated by neo-Georgian architecture, the museum at Colby College houses a distinctive collection of several centuries of American Art. Included among its many fine holdings is a 36 piece collection of sculpture donated to the school by Maine native, Louise Nevelson. **NOT TO BE MISSED:** 25 watercolors by John Marin; "La Reina Mora" by Robert Henri (recent acquisition)

ON EXHIBIT/97:

03/16/97–04/20/97	JUXTAPOSITION
05/11/97–07/13/97	THE WHITE HOUSE COLLECTION OF AMERICAN CRAFTS — 72 examples of some of the finest contemporary American crafts which were assembled in 1993 for the White House collection will be featured in this first time exhibition. CAT WT

Annapolis

Elizabeth Myers Mitchell Art Gallery
Affiliate Institution: St. John's College
60 College Ave., **Annapolis, MD 21404**
☎ 410-626-2556
HRS: Noon-5 Tu-S, 7 PM-8 PM F; Closed for the summer 6/21 - 8/30/96 DAY CLOSED: M HOL: LEG/HOL!
👌: Y; Barrier free entrance & restrooms; wheelchair available by appt. Ⓟ Y; Call the gallery to arrange in advance because parking is limited ⑪ Y; College Coffee Shop open 8:15-4 GR/T: Y GR/PH: Call 410-626-2556

Established in 1989 primarily as a center of learning for the visual arts in 1989, this institution, though young in years, presents a rotating schedule of high quality exhibitions containing original works by many of the greatest artists of yesterday and today.

ON EXHIBIT/97:

01/07/97–02/08/97	RED GROOMS: WHAT'S ALL THE RUCKUS ABOUT? — Lighthearted images of the city, family scenes, self-portraits, and exotic vacation locals by New York artist, Grooms, will be featured in the first comprehensive exhibition of his watercolors. WT
02/21/97–04/13/97	THE FIGURE IN 20TH CENTURY SCULPTURE — Works by 48 internationally known sculptors. Rodin, Maillol, Lachaise, Giacometti, Lipschitz, Neri and others will be included in this stunning 20th-century survey of the interpretation of the human form. BROCHURE WT
05/01/97–05/18/97	ST. JOHNS COLLEGE COMMUNITY ART EXHIBITION
09/05/97–11/16/97	NANCY GRAVES: EXCAVATIONS IN PRINT — 45 works by Graves will be on view in the first comprehensive exhibition of her innovative graphics in which the use of unconventional materials and techniques allows her to break down boundaries within and between traditional mediums. CAT WT

Baltimore

American Visionary Art Museum
800 Key Highway & Covington in the Baltimore Inner Harbor, **Baltimore, MD 21202**
☎ 410-244-1900
HRS: MEM/DAY-LAB/DAY: 10-8 S& Tu-T, 10-10 F & Sa; OTHER: 10-6 W, T, S, 10-8 F & Sa HOL: THGV, 12/25
F/DAY: M, Tu except summer ADM: Y ADULT: $6.00 CHILDREN: F (under 4) STUDENTS: $4.00 SR CIT: $4.00
👌: Y; Fully accessible with street drop-off lane Ⓟ Y; $3.00 parking in large lot across the street from the museum; many 24-hour metered spaces on Covington. MUS/SH: Y ⑪ Y; Joy America Cafe open 11:30 AM - 10 PM daily CATR!
GR/T: Y H/B: Y; 1913 eliptical brick building S/G: Y
PERM/COLL: Visionary art

Designated by congress, The American Visionary Art Museum is the nation's official repository for original self-taught (a.k.a. "outsider") visionary art. Among the many highlights of the collection are Gerlad Hawkes' one-of-a-kind matchstick sculptures, 400 original pen and ink works by postman/visionary Ted Gordon, and the entire life archive of the late Otto Billig, M.D., an expert in transcultural psychiatric art who was the last psychiatrist to Zelda Fitzgerald. **NOT TO BE MISSED:** Towering whirligig by Vollis Simpson, located in outdoor central plaza, which is like a giant playwheel during the day and a colorful firefly-like sculpture when illuminated at night; Joy America Cafe featuring ultra organic gourmet food created by four-star chef Peter Zimmer, formerly of The Inn of the Anazazi in Santa Fe, NM.; Wildflower sculpture garden complete with woven wood wedding chapel by visionary artist Ben Wilson.

ON EXHIBIT/97:

OPENING MID-'97	PERMANENT COLLECTION GALLERY
10/12/96–04/21/97	WIND IN MY HAIR — Giant whirligigs, flying machines, and art embellished automobiles will be featured in this assembly of works by visionary artists designed to explore the concept of "taking wing" that has fascinated mankind since the beginning of time.
05/30/97–LATE/97	THE END IS NEAR — This thematic exhibition of visionary works centers on man's concepts of images of apocalypse, the millennium and utopias.

MARYLAND

Baltimore

The Baltimore Museum of Art
Art Museum Drive, **Baltimore, MD 21218**
☎ 410-396-7100
HRS: 10-4 W-F; 11-6 Sa, S; 5-9 1st T of Mo. DAY CLOSED: M, Tu HOL: 7/4, THGV, 12/25; 1/1
F/DAY: 1st T ADM: Y ADULT: $5.50 CHILDREN: $1.50 (7-18) STUDENTS: $3.50 SR CIT: $3.50
&: Y
Ⓟ Y; Metered and limited; free parking on weekends at The Johns Hopkins University adjacent to the museum.
MUS/SH: Y ⅋ Y; Donna's at the BMA 410-467-3600
GR/T: Y GR/PH: CATR! 410-396-6320
H/B: Y; 1929 building designed by John Russell Pope S/G: Y
PERM/COLL: AM: ptgs 18-20; EU: ptgs, sculp 15-20; MATISSE: Cone Coll; FR: phot 19; AM: dec/art, cont; EU: dec/art, cont;
P/COL; AF; OC; NAT/AM; AN/R: mosaics

One of the undisputed jewels of this important artistic institution is the Cone Collection of works by Matisse, the
largest of its kind in the Western Hemisphere. The museum recently added a new 17 gallery wing for contemporary
art, which made it the first and largest of its kind not only for this institution but for the state of Maryland as well.
Works by Andy Warhol from the second largest permanent collection of paintings by the artist will be on regular
display in this new wing. PLEASE NOTE: The Cone Collection will be on loan to museums in Japan through 2/97.
NOT TO BE MISSED: The Cone Collection; American: dec/arts; Antioch mosaics; Sculpture gardens; American:
paintings 19; OM: paintings; the new installation (late spring 1997) of the American Wing of American Decorative
Arts and Painting.

ON EXHIBIT/97:

09/25/96–02/16/97	ANDREW WYETH: AMERICA'S PAINTER — 50 watercolor, tempra, drybrush and pencil works will be featured in a major retrospective for Wyeth, considered one of the two greatest American Realist artists of the 20th-century. All but one of the classic and rare works will be on loan from a single private collection. BOOK
11/06/96–01/19/97	JOHN McLAUGHLIN: WESTERN MODERNISM/EASTERN THOUGHT — "Abstract classicist" works by southern California artist John McLaughlin (1898-1976), will be featured in a major retrospective of his paintings which reflect the integration of facets of his fascination with Japanese, Chinese and Zen culture. CAT WT
11/20/96–01/19/97	MARYLAND BY INVITATION: CAROLYN BRADY — Baltimore-based artist Brady, one of the most distinguished watercolorists working in America today, is known for her precise, colorful, almost photo-realistic renerings of still lifes, interiors, and floral subjects. In this exhibition of her work 2 recent large-scale floral works will be among the 8 on view that form a virtual garden environment within the gallery. BOOK
01/29/97–04/13/97	ART AT THE BAGA: A DRAMA OF CULTURAL REVOLUTION — Masks, headdresses, ceremonial, household and personal items will be among the 100 Baga objects on loan from private and public sources worldwide. Though relatively isolated, the art of this small ethnic group of people from Guinea, West Africa has made an enormous impact upon 20th-century art of the West. CAT WT
02/12/97–04/13/97	THE AGE OF REMBRANDT: DISTINGUISHED PRINTS FROM THE MUSEUM'S COLLECTION — Drawn entirely from the museum's collection, this exhibition of extraordinary works explores the impact Rembrandt had on the medium of printmaking.
05/28/97–08/17/97	LAURIE SIMMONS (Working Title) — Simmons is an artist known for staging scenes for her camera with dolls, ventriloquists dummies, and human figures in order to create psychological images that critique American culture. In addition to presenting all aspects of her important bodies of work, this show will feature Simmons' site-specific installation created expressly for this exhibition. WT

The Baltimore Museum of Art - continued

06/25/97–10/12/97	CURRIER AND IVES — For 50 years, beginning in 1834, this lithography firm printed 3-4 new prints every week that helped to form America's self-imagery by documenting the life of the times. Presented in 10 sections, the 79 works on view cover a broad range of subjects including New York City life, politics & current events, technological advances, capitalist culture, family and country life, and more. **WT**
08/13/97–02/15/98	ENGLISH AND EUROPEAN NEEDLEWORK (Working Title) — Objects of 17th through 18th-century English and European "stumpwork (raised)," sampler, silk pictorial, and crewelwork textiles drawn mainly form the museum's holdings will be featured in this exhibition.
10/12/97–01/18/98	A GRAND DESIGN: THE ART OF THE VICTORIA AND ALBERT MUSEUM — In an exhibit that was 10 years in the making, 200 items from the vast Victoria & Albert Museum's collection in London will be on loan for the very first time in North America. From 17th-century Indian illuminated manuscripts, to a Leonardo Da Vinci notebook, to Boucher's Portrait of Madame de Pompadour, the paintings, sculpture, textiles, ceramics, prints, books, photographs and metalworks on view will illustrate the history of changing social and artistic taste over the last 150 years. **CAT WT**

Baltimore

The Contemporary
601 N. Howard St., **Baltimore, MD 21201**
☎ 410-333-8600 WEB ADDRESS: http://www.softaid.net/the contemporar
HRS: For administrative office only: usually 12-5 Tu-S
SUGG/CONT: Y

Considering itself an "un-museum" The Contemporary is not a permanent facility but rather an institution dedicated to the presentation of exhibitions at various venues throughout the city of Baltimore. It is suggested that visitors call ahead to verify the location (or locations) and hours of operation for each of the scheduled exhibitions.

ON EXHIBIT/97:

10/12/96–06/30/97	ABOARD THE CYBERCLIPPER: A TRANSATLANTIC TECHNOLOGICAL AD-VENTURE — An Internet art exhibition featuring new projects by telemedia artist Lee Boot and computer sculptor Frank Fietzek. Information about the venues, hours of operation and possible extention of the dates of this exhibition may be accessed by its WWW address: http://www.glows.com/cyberclipper Participating artists Boot and Fietzek may also be accessed. For Boot (http://www.glows.com/cyberclipper/webart) For Fietzek (http://www.netville.de/artware/artists/fietzek.html)
04/20/97–06/29/97	TOO JEWISH? CHALLENGING TRADITIONAL IDENTITIES — The resurgence of ethnic consiousness over the past decade and its profound effect on many Jewish artists will be explored in an exhibition featuring 45 works by 23 artists not bound to each other by stylistic homogeneity. **CAT WT**

Evergreen House
Affiliate Institution: The Johns Hopkins University
4545 N. Charles St., **Baltimore, MD 21210**
☎ 410-516-0341
HRS: 10-4 M-F, 1-4 Sa, S HOL: LEG/HOL!
ADM: Y ADULT: $6.00 CHILDREN: F (under 5) STUDENTS: $3.00 SR CIT: $5.00
&: Y Ⓟ Y; Free and ample ⅋ Y; CATR! for box lunches, high tea & continental breakfast for groups
GR/T: Y GR/PH: CATR! DT: Y TIME: call for specifics H/B: Y; 1850-1860 Evergreen House
PERM/COLL: FR: Impr, Post/Impr; EU: cer; OR: cer; JAP

MARYLAND

Evergreen House - continued
Restored to its former beauty and reopened to the public in 1990, the 48 rooms of the magnificent Italianate Evergreen House (c 1878), with classical revival additions, contain outstanding collections of French Impressionist and Post-Impressionist works of art collected by its founders, the Garrett family of Baltimore.. PLEASE NOTE: All visitors to Evergreen House are obliged to go on a 1 hour tour of the house with a docent. It is recommended that large groups call ahead to reserve. It should be noted that the last tour of the day begins at 3:00 PM. **NOT TO BE MISSED:** Japanese netsuke and inro; the only gold bathroom in Baltimore.

ON EXHIBIT/97:
10/28/96–04/01/97	TIPPECANOE & TYLER, TOO: AN EXHIBIT OF CAMPAIGN SONGS FROM THE LESTER S. LEVY COLLECTION OF SHEET MUSIC
11/01/96–04/15/97	ALICE GARRETT AND THE AMERICAN AVANT-GARDE — Alice Garrett's involvement in the politics of early 20th-century American art will be explored in the letters, paintings and works on paper selected from the Garrett archives.

Baltimore

Peale Museum
225 Holliday St., **Baltimore, MD 21202**
📞 410-396-1149
HRS: 10-5 Tu-Sa, Noon-5 S DAY CLOSED: M HOL: LEG/HOL!
F/DAY: Sa ADM: Y ADULT: $2.00 CHILDREN: $1.50 (4-18) SR CIT: $1.50
&: Y; Very limited ℗ Y; Metered street parking and pay parking in the Harbor Park Garage on Lombard St., one block from the museum. MUS/SH: Y GR/T: Y GR/PH: CATR! 410-396-3279
H/B: Y; First building built as a museum in U.S. by Rembrandt Peale, 1814 S/G: Y
PERM/COLL: REG/PHOT; SCULP; PTGS; 40 PTGS BY PEALE FAMILY ARTISTS

The Peale, erected in 1814, has the distinction of being the very first museum in the U.S. One of the several City Life Museums in Baltimore, this venue features over 40 portraits by members of the Peale Family displayed in an ongoing exhibition entitled "The Peales, An American Family of Artists in Baltimore."

ON EXHIBIT/97:
10/19/96–06/22/97	POETRY ON GLASS: THE EARLY PHOTOGRAPHS OF JIM LEWIS — An exhibition of 50 prints made from original negatives offers a rare opportunity to view the early work of this Baltimore photographer, whose thirty year career was distinguished by his keen eye for light and shadow captured in his images of ordinary working people in East Baltimore.

Walters Art Gallery
600 N. Charles St., **Baltimore, MD 21201**
📞 410-547-9000
HRS: 11-5 Tu-S DAY CLOSED: M HOL: 12/25
F/DAY: Sa 11-noon ADM: Y ADULT: $4.00 CHILDREN: F (18 & under) SR CIT: $3.00
&: Y; Wheelchair ramps at entrances, elevators to all levels ℗ Y; Ample parking on the street and nearby lots MUS/SH: Y
🍴 Y; The Pavillion 11:30-3:30 Tu-F, 11-4 Sa, S CATR! 410-727-2233 GR/T: Y GR/PH: CATR! ext. 232
DT: Y TIME: 1:00 W, (1:30 S during SEP & OCT) H/B: Y; 1904 building modeled after Ital. Ren. & Baroque palace designs
PERM/COLL: ANT; MED; DEC/ART 19; OM: ptgs; EU: ptgs & sculp

The Walters, considered one of America's most distinguished art museums, features a broad-ranging collection that spans more than 5,000 years of artistic achievement from Ancient Egypt to Art Nouveau. Remarkable collections of ancient, medieval, Islamic & Byzantine art, 19th-century paintings and sculpture, and Old Master paintings are housed within the walls of the magnificently restored original building and in a large modern wing as well. **NOT TO BE MISSED:** Hackerman House, a restored mansion adjacent to the main museum building, filled with oriental decorative arts treasures.

ON EXHIBIT/97:
ONGOING AT HACKERMAN HOUSE
JAPANESE CLOISONNÉ ENAMELS
A MEDLEY OF GERMAN DRAWINGS

Walters Art Gallery - continued

11/27/96–02/16/97	RUSSIAN ENAMELS, KIEVAN RUS TO FABERGÉ — A magnificent display of 110 Fabergé enamels from Hillwood House, the Walters and a special private collection.
11/27/96–02/16/97	MANUSCRIPT MENAGERIE — Illuminated manuscripts featuring images of animals will be seen in an exhibit designed to illustrate their symbolic and philosophical importance to the life of the times.
03/02/97–05/18/97	THE FIRST EMPEROR: TREASURES FROM ANCIENT CHINA TENT!
06/22/97–08/31/97	IMAGES IN IVORY: PRECIOUS OBJECTS OF THE GOTHIC AGE — Religious statuettes, relief diptychs & triptychs containing biblical themes, and a wide range of decorative objects will be featured in an exhibition that traces the development of medieval ivory carving.

Easton

Academy of the Arts
106 South Sts., **Easton, MD 21601**
☎ 410-822-0455
HRS: 10-4 M-Sa, until 9 W HOL: LEG/HOL! month of Aug
VOL/CONT: Y
♿: Y; Ramp ℗ Y; Free with 2 hour limit during business hours; handicapped parking available in the rear of the Academy.
GR/T: Y GR/PH: CATR! 410-822-5997 H/B: Y; Housed in Old Schoolhouse
PERM/COLL: PTGS; SCULP; GR: 19-20; PHOT

Housed in two 18th-century buildings, one of which was an old school house, the Academy's permanent collection contains an important group of original 19th & 20th-century prints. This museum serves the artistic needs of the community with a broad range of activities including concerts, exhibitions and educational workshops. **NOT TO BE MISSED:** "Slow Dancer" sculpture by Robert Cook, located in the Academy Courtyard; Works by James McNeil Whistler, Grant Wood, Bernard Buffet, Leonard Baskin, James Rosenquist, and others.

ON EXHIBIT/97:

01/08/97–01/30/97	WATERCOLOR EAST WEST II
01/24/97–03/01/97	INSPIRED BY THE PAST: CONTEMPORARY AMISH QUILTS
02/04/97–02/27/97	TIDEWATER CAMERA CLUB
02/14/97–04/17/97	SAFF TECH ARTS
03/09/97–03/29/97	WORKING ARTIST FORUM
06/13/97–07/26/97	ANNUAL MEMBERS SHOW

Hagerstown

Washington County Museum of Fine Arts
City Park, Box 423, **Hagerstown, MD 21741**
☎ 301-739-5727
HRS: 10-5 Tu-Sa, 1-5 S DAY CLOSED: M HOL: LEG/HOL!
VOL/CONT: Y ♿: Y ℗ Y; Free and ample. MUS/SH: Y GR/T: Y GR/PH: CATR! Linda Dodson
PERM/COLL: AM: 19-20; REG; OM; 16-18; EU: ptgs 18-19; OR

In addition to the permanent collection of 19th and 20th-century American art including works donated by the founders of the museum, Mr. & Mrs. William H. Singer, Jr., the museum has a fine collection of Oriental Art, African Art, American pressed glass, and European paintings, sculpture and decorative arts. Hudson River landscapes, Peale family paintings, and works by "The Eight," all from the permanent collection, are displayed throughout the year on an alternating basis with special temporary exhibitions. The museum is located in the northwest corner of the state just below the Pennsylvania border. **NOT TO BE MISSED:** "Sunset Hudson River" by Frederick Church; the new wing of the museum that more than doubled its size completed in 1995

MASSACHUSETTS

Amherst

Mead Art Museum
Affiliate Institution: Amherst College
Amherst, MA 01002
☎ 413-542-2335 WEB ADDRESS: http://www.amherst.edu/~mead
HRS: Sep-May: 10-4:30 Weekdays, 1-5 Weekends; Summer: 1-4 Tu-S HOL: LEG/HOL!; ACAD!; MEM/DAY; LAB/DAY
&: Y Ⓟ Y
GR/T: Y GR/PH: CATR! DT: Y TIME: 12:15 Tu
PERM/COLL: AM: all media; EU: all media; DU: ptgs 17; PHOT; DEC/ART; AN/GRK: cer; FR: gr 19

Surrounded by the Pelham Hills in a picture perfect New England setting, the Mead Art Museum at Amherst College houses a rich collection of 12,000 art objects dating from antiquity to the present. PLEASE NOTE: Summer hours are 1-4 Tu-S. **NOT TO BE MISSED:** American paintings and watercolors including Eakins "The Cowboy" & Homer's "The Fisher Girl"

ON EXHIBIT/97:

08/23/96–03/16/97	SELECTIONS FROM THE PERMANENT COLLECTION: MEDIEVAL TO MODERN — A selection of medieval sculpture, Renaissance altarpieces and Flemish still lifes from the permanent collection will be joined for this exhibition by the American paintings of Thomas Eakins, Winslow Homer and Robert Henri.
10/25/96–01/19/97	OF THE MOMENT: CONTEMPORARY PRINTS, PHOTOGRAPHS, MIXED MEDIA, AND SCULPTURE — Works by Richard Estes, Eric Fischl, David Hockney, Sol LeWitt, Kiki Smith and other contemporary masters will be on exhibit from the permanent collection.
11/15/96–04/27/97	VIVE LA FRANCE! ART OF THE EIGHTEENTH AND NINETEENTH CENTURIES — On view from the museum's collection will be a selection of paintings by Monet, Toulouse-Lautrec, Bouguereau, Millet, Desportes and others.
11/22/96–01/15/97	PRINTS OF STUART DAVIS — Featured will be 25 prints by Davis, one of America's leading modernist artists. WT
01/24/97–03/16/97	JOSEF BREITENBACH: PIONEERING PHOTOGRAPHER, 1924-44

Amherst

University Gallery, University of Massachusetts
Affiliate Institution: Fine Arts Center
University of Massachusetts, **Amherst, MA 01003**
☎: 413-545-3670
HRS: 11-4:30 Tu-F; 2-5 Sa, S HOL: JAN.
&: Y S/G: Y
PERM/COLL: AM: ptgs, drgs, phot 20

With a focus on the works of contemporary artists, this museum is best known as a showcase for the visual arts. It is but one of a five college complex of museums, making a trip to this area of New England a worthwhile venture for all art lovers.

ON EXHIBIT/97:

10/22/97–12/14/97	HEROIC PAINTING — Heroic acts of daily life will be one of the topics explored in this exhibition dealing with the notion of the "hero" as subject matter in art. CAT WT

Andover

Addison Gallery of American Art
Affiliate Institution: Phillips Academy
Andover, MA 01810-4166
📞: 508-749-4015
HRS: 10-5 Tu-Sa, 1-5 S DAY CLOSED: M HOL: LEG/HOL! AUG 1 through LAB/DAY; 12/24
&: Y; Fully accessible Ⓟ Y; Limited on street parking GR/T: Y GR/PH: CATR! DT: Y TIME: upon request S/G: Y
PERM/COLL: AM: ptgs, sculp, phot, works on paper 17-20

Since its inception in 1930, the Addison Gallery has been devoted exclusively to American art. The original benefactor, Thomas Cochran, donated both the core collection and the neo-classic building designed by noted architect Charles Platt. With a mature collection of more than 12,000 works, featuring major holdings from nearly every period of American art history, a visit to this museum should be high on every art lover's list. **NOT TO BE MISSED:** Marble fountain in Gallery rotunda by Paul Manship; " The West Wind" by Winslow Homer; R. Crosby Kemper Sculpture Courtyard

ON EXHIBIT/97:

ONGOING ALL YEAR	SELECTIONS FROM THE ADDISON COLLECTION
09/20/96–01/05/97	WENDY EWALD: PHOTOGRAPHIC PROJECTS — Photographs by Ewald, a recent MacArthur Fellowship award winner and artist-in-residence at the museum where she is co-organizing a retrospective exhibition of the past 25 years of her work.
09/20/96–01/05/97	CHARLES SHEELER IN ANDOVER: THE BALLARDVALE SERIES — Marking the 50th anniversary of American modernist painter Sheeler's stay as artist-in-residence at the Addison Gallery, all of his major works created during that period will be on view for the first time. BROCHURE
09/20/96–01/05/97	JUDITH JOY ROSS: PORTRAITS FROM THE HAZELTON PUBLIC SCHOOLS, 1992-1994 — A photographic display containing themes as varied as the human condition itself.
01/10/97–02/26/97	LIVING WITH BREAST CANCER — An exhibition of photographs, portraits and oral histories of Massachusetts women fighting and surviving with breast cancer.
01/17/97–03/23/97	THE CONSTRUCTED PHOTOGRAPH: JO BABCOCK, GILLIAN BROWN, MARIA MAGDALENA CAMPOS-PONS, AND DOUGLAS PRINCE — Works in which the traditional notion of straight photography is challenged by blending photographic images and sculpture will be featured in this group presentation.
01/17/97–03/02/97	REGINALD MARSH'S NEW YORK — Social realist paintings, prints and drawings by Marsh detailing the people and places of New York City street life, burlesque houses, the beaches and boardwalk of Coney Island and the forgotten corners of the city will be on exhibit from the Addison's collection joined by works on loan from important private collections.
02/22/97–05/04/97	SELECTIONS FROM THE PERMANENT COLLECTION
02/22/97–05/04/97	ROY DeCARAVA: A RETROSPECTIVE — Groundbreaking pictures of everyday life in Harlem, civil rights protests, lyrical studies of nature, and photographs of jazz legends will be among the 200 black & white photographs on view in the first comprehensive survey of DeCarava's works. CAT WT
03/30/97–05/97	DAWOULD BEY: NEW PHOTOGRAPHS — Featured will be large-scale color portraits photographs of African-Americans living in the Hartford, Connecticut area which were taken by Bey using a unique 20" x 24" Polaroid camera. WT
03/30/97–05/97	KERRY MARSHALL: NEW PAINTINGS — Recent large-scale paintings by Marshall, an artist inspired by such diverse sources as traditional African and Haitian parables, the symbolic imagery of Renaissance works, and the iconography of contemporary American media.
05/97–07/31/97	BY DESIGN: ALUMNI/AE OF PHILLIPS ACADEMY, 1962-PRESENT — An exhibit of works by alumni/ae working in the fields of architecture and design who graduated between 1962 and the present.

MASSACHUSETTS

Boston

Boston Athenaeum
10 1/2 Beacon St., **Boston, MA 02108**
✆ 617-227-0270
HRS: June-Aug: 9-5:30 M-F; Sep-May: 9-5:30 M-F, 9-4 Sa DAY CLOSED: S HOL: LEG/HOL!
&: Y MUS/SH: Y
GR/T: Y GR/PH: 3:00 Tu & T call 617-227-0270 H/B: Y; National Historic Landmark Building
PERM/COLL: AM: ptgs, sculp, gr 19

The Athenaeum, one of the oldest independent libraries in America, features an art gallery established in 1827. Most of the Athenaeum building is closed to the public EXCEPT for the 1st & 2nd floors of the building (including the Gallery). In order to gain access to many of the most interesting parts of the building, including those items in the "do not miss" column, free tours are available on Tu & T at 3 PM. Reservations must be made at least 24 hours in advance by calling The Circulation Desk, 617-227-8112. **NOT TO BE MISSED:** George Washington's private library; 2 Gilbert Stuart portraits; Houdon's busts of Benjamin Franklin, George Washington, and Lafayette from the Monticello home of Thomas Jefferson.

Boston Public Library
Copley Square, **Boston, MA 02117**
✆ 617-536-5400
HRS: Oct 1-May 22!: 5-9 M-T, 9-5 F-Sa, 1-5 S DAY CLOSED: S HOL: LEG/HOL! & 5/28
&: Y; General library only (Boylston St.); Also elevators, restrooms
GR/T: Y GR/PH: 617-536-5400 ext. 216 DT: Y TIME: 2:30 M; 6:30 Tu & W; 11 T & Sa, 2:00 S Oct1-May21
H/B: Y; Renaissance "Palace" designed in 1895 by Charles Follen McKim
PERM/COLL: AM: ptgs, sculp; FR: gr 18-19; BRIT: gr 18-19; OM: gr, drgs; AM: phot 19, gr 19-20; GER: gr; ARCH/DRGS

Architecturally a blend of the old and the new, the building that houses the Boston Public Library, designed by Charles Follen McKim, has a facade that includes noted sculptor Augustas Saint-Gauden's head of Minerva which serves as the keystone of the central arch. A wing designed by Philip Johnson was added in 1973. PLEASE NOTE: Phase I of a three-part restoration to the building has recently been completed to the first floor, lower level, grand staircase & 2nd floor gallery. **NOT TO BE MISSED:** 1500 lb. bronze entrance doors by Daniel Chester French; tours of the recently completed areas of Phase I renovation.

ON EXHIBIT/97: There are a multitude of changing exhibitions throughout the year in the many galleries of both
 buildings. Call for current information.

Boston University Art Gallery
855 Commonwealth Ave., **Boston, MA 02215**
✆ 617-353-3329
HRS: Mid Sep to mid Dec & mid Jan to mid May: 10-5 Tu-F; 1-5 Sa, S HOL: 12/25
&: Y; Limited (no wheelchair ramp and some stairs) ℗ Y; On-street metered parking; pay parking lot nearby

Several shows in addition to student exhibitions are mounted annually in this 35 year old university gallery which seeks to promote under-recognized sectors of the art world including works by a variety of ethnic artists, women artists, and those unschooled in the traditional academic system. Additional emphasis is placed on the promotion of 20th-century figurative art.

ON EXHIBIT/97:
01/17/97–02/23/97 PAINTING ABSTRACT: GREGORY AMENOFF, JOHN L. MOORE, KATHERINE
 PROTER — A traveling exhibition of works by 3 major contemporary abstract painters.
03/01/97–04/06/97 ELOQUENT GESTURE: CONTEMPORARY JAPANESE CALLIGRAPHY
09/12/97–10/19/97 JOHN WALKER
10/31/97–12/14/97 PAINTING MACHINES

Boston

The Institute of Contemporary Art
955 Boylston St., **Boston, MA 02115**
☎ 617-266-5152
HRS: Noon-5 W & F-S, Noon-9 T DAY CLOSED: M, Tu
F/DAY: 5-9 T ADM: Y ADULT: $5.25 CHILDREN: $2.25 STUDENTS: $3.25 SR CIT: $2.25
&: Y ℗ Y: Several commercial lots nearby MUS/SH: Y
GR/T: Y GR/PH: CATR! education dept
PERM/COLL: No permanent collection

Originally affiliated with the Modern Museum in New York, the ICA, founded in 1936, has the distinction of being the oldest non-collecting contemporary art institution in the country. By presenting contemporary art in a stimulating context, the ICA has, since its inception, been a leader in introducing such "unknown" artists as Braque, Kokoshka, Munch and others who have changed the course of art history.

ON EXHIBIT/97:

01/29/97–03/30/97	CILDO MEIRELES — Works by Meireles, a Brazilian artist of note, will be seen in the first North American retrospective of his work. Four large-scale installations will be among the works on view which range from those of the late 60's to the present day creations.
04/23/97–07/06/97	GOTHIC
07/23/97–09/28/97	CURRENTS 1997 ENTERPRISE (Working Title) — Of primary concern to the international group of 5 young artists participating in this multi-media show is the circumvention of conventional methods in the creation of their art. Though they focus on a diverse range of concerns, they are unified in their commitment to art as an open-ended process that strives to encourage dialogue with the viewer.
10/08/97–01/04/98	FISCHLI AND WEISS — An overview of 15 years of collaborative effort by Swiss artists Fischli and Weiss includes sculpture, film, photography and installation art that transforms everyday objects investing them with a humorous and often emotional charge. WT

Isabella Stewart Gardner Museum
280 The Fenway, **Boston, MA 02115**
☎ 617-566-1401
HRS: 11-5 Tu-S DAY CLOSED: M HOL: LEG/HOL!
ADM: Y ADULT: $8.00 CHILDREN: $3.00 (12-17) STUDENTS: $5.00 SR CIT: $6.00
&: Y; Street level access & elevator to 2nd & 3rd floor art galleries ℗ Y; Street parking plus garage two blocks away on Museum Road MUS/SH: Y ¶¶ Y; Cafe 11:30-3 Tu-F, 11:30-4 Sa, S
GR/T: Y GR/PH: CATR! 617-278-5147 DT: Y TIME: 2:30 F Gallery tour; 2:30 W Courtyard talk H/B: Y S/G: Y
PERM/COLL: PTGS; SCULP; DEC/ART; GR; OM

Located in the former home of Isabella Stewart Gardner, the collection reflects her zest for amassing this most exceptional and varied personal art treasure trove. PLEASE NOTE: The admission fee of $5.00 for college students with current I.D. is $3.00 on Wed. Children under 12 admitted free of charge. **NOT TO BE MISSED:** Rembrandt's "Self Portrait"; Italian Renaissance works of art

ON EXHIBIT/97:

01/24/97–04/06/97	BOTTICELLI'S WITNESS: CHANGING STYLE IN A CHANGING FLORENCE — Considered one of the most influential artists of the Italian Renaissance, this exhibition demonstrates how Botticelli's work was influenced by the changing politics, society and religion of 15th-century Florence.
09/18/97–01/04/98	ABELARDO MORRELL (Working Title) — Morrell, a photographer and artist in residence at the museum will create a new work for this exhibition.

MASSACHUSETTS

Boston

Museum of Fine Arts, Boston
465 Huntington Ave., **Boston, MA 02115**
📞 617-267-9300
HRS: 10-4:45 Tu & Sa, 10-9:45 W, 10-9:45 T & F(West Wing only after 5); 10-5:45 S DAY CLOSED: M!
HOL: 12/24, 12/25, THGV
F/DAY: 4-9:45 W ADM: Y ADULT: $10.00 CHILDREN: F (17 & under) STUDENTS: $8.00 SR CIT: $8.00
♿: Y; Completely wheelchair accessible ℗ Y; $3.50 first hour, $1.50 every half hour following in garage on Museum Rd. across
from West Wing entrance. MUS/SH: Y ℍ Y; Cafe, Restaurant & Cafeteria
GR/T: Y GR/PH: CATR! ext. 368 DT: Y TIME: Tu-F for 20 people or more; no summer
PERM/COLL: AN/GRK; AN/R; AN/EGT; EU: om/ptgs; FR: Impr, post/Impr; AM: ptgs 18-20; OR: cer

A world class collection of fine art with masterpieces from every continent is yours to enjoy at this great Boston
museum. Divided between two buildings the collection is housed both in the original (1918) Evans Wing with its
John Singer Sageant mural decorations above the Rotunda, and the dramatic West Wing (1981) designed by I.M.
Pei. PLEASE NOTE: 1. There is a "pay as you wish" policy from 4 PM-9:45 PM on Wed. and a $2.00 admission
fee on T & F evenings. 2. The museum will be open from 10-4:45 on Mondays from Memorial Day to Labor Day
ONLY. 3. Portable benches that can be carried into the galleries are available free of charge near the information
desk. **NOT TO BE MISSED:** Egyptian Pectoral believed to have decorated a royal sarcophagus of the Second
Intermediate Period (1784 - 1570 B.C.), part of the museum's renowned permanent collection of Egyptian art.

ON EXHIBIT/97:

ONGOING	NUBIA: ANCIENT KINDOMS OF AFRICA — 500 objects including stone sculptures, gold jewelry, household articles, clothing and tools that form this comprehensive permanent collection of Nubian art, considered the finest of its kind in the world, is on view indefinitely. CAT
	SWORDS FROM BIZEN PROVINCE
	JAPANESE BUDDHIST TEMPLE ROOM AND GALLERIES
through 05/18/97	BEYOND THE SCREEN: CHINESE FURNITURE OF THE 16TH AND 17TH CENTURIES — Known for its exquisite craftsmanship the furniture on view will offer the viewer an opportunity to admire not only its beauty but also its function and placement within a domestic setting.
07/30/96–07/97	THIS IS THE MODERN WORLD: FURNISHINGS OF THE 20TH CENTURY — From the permanent collection European furniture from the 1920's to the present will be on display with 20th-century objects of decorative art and textiles.
10/23/96–02/97	HERB RITTS: WORK — More than 200 photographs will be on view in the first full-scale exhibition devoted to the work of American photographer Ritts. WT ◠
11/13/96–03/97	FACE AND FIGURE IN CONTEMPORARY ART — Portrait works and figure studies by contemporary artists including Andy Warhol and Cindy Sherman will be on exhibit.
11/23/96–03/23/97	DRESSING UP: CHILDREN'S FASHION 1720-1920 — 18th to 20th-century clothing will be seen with portraits, dolls, furniture and toys from the museum's collection in an exhibition designed to explore how the media has changed social attitudes towards children.
01/24/97–04/20/97	THE ART OF JOHN BIGGERS: VIEW FROM THE UPPER ROOM — 127 drawings, prints, sculptures, paintings, and large-scale murals by African-American artist Biggers, created over a five decade period will be on view in his first major museum retrospective. The exhibition is the first to focus exclusively on an African-American artist whose development is tied to the southern United States. CAT WT
04/16/97–07/20/97	TALES FROM THE LAND OF DRAGONS: 1,000 YEARS OF CHINESE PAINTINGS — The museum's entire collection of 135 Chinese paintings will be on exhibit. ◠

Museum of Fine Arts, Boston - continued

05/16/97–08/24/97 IKAT: SPLENDID SILKS FROM CENTRAL ASIA — Examples of Ikat, textiles created by a method of weaving in which warp threads are tie-dyed before being set up on a loom, will be on loan from one of the most significant private collections of its kind. Traditionally woven and used by nomadic Uzbek peoples, the manufacture of these textiles has influenced the contemporary variations on display by Oscar de la Renta, Brunchwig et Fils and others.

09/97–12/97 VAN GOGH TO MONDRIAN: DUTCH WORKS ON PAPER 1885-1915 — Works by more than 40 artists will be featured in an exhibition documenting the role of the Dutch in the art world from 1885-1915.

09/10/97–01/04/98 PICASSO: THE EARLY YEARS 1892-1906 — In the first comprehensive presentation of its kind, 125 works have been selected to demonstrate the various artistic styles Picasso explored during the early years of his career. The exhibition closely examines Picasso's Blue and Rose period works along with others that reveal the artist's remarkable achievements prior to the advent of cubism. CAT WT ◯

Boston

Museum of the National Center of Afro-American Artists

300 Walnut Ave., **Boston, MA 02119**
☎ 617-442-8014
HRS: July-Aug: 1-6 Daily; Sep-June: 1-5 Tu-Sa
ADM: Y ADULT: $1.25 STUDENTS: $0.50 SR CIT: $0.50
H/B: Y; 19th century
PERM/COLL: AF/AM: ptgs; sculp; GR

Art by African-American artists is highlighted along with art from the African continent itself.

Brockton

Fuller Museum of Art

455 Oak St., **Brockton, MA 02401**
☎ 508-588-6000
HRS: Noon-5 Tu-S DAY CLOSED: M HOL: 1/1, 7/4, LAB/DAY, THGV, 12/25
&. : Y; Fully accessible ℗ Y: Free MUS/SH: Y ⑪ Y; Cafe 11:30 - 2 Tu-F GR/T: Y DT: Y S/G: Y
PERM/COLL: AM: 19-20; CONT: reg

A park-like setting surrounded by the beauty of nature is the ideal site for this charming museum that features works by artists of New England with particular emphasis on contemporary arts and cultural diversity.

Cambridge

Arthur M. Sackler Museum

Affiliate Institution: Harvard University
485 Broadway, **Cambridge, MA 02138**
☎ 617-495-9400 WEB ADDRESS: (for all 3 Harvard University Art Museums) http://fas.harvard.edu/-artmuseums
HRS: 10-5 M-Sa, 1-5 S HOL: LEG/HOL!
F/DAY: Sa AM ADM: Y ADULT: $5.00 CHILDREN: F (under 18) STUDENTS: $3.00 SR CIT: $4.00
&. : Y; Ramp at front and elevators to all floors ℗ Y; $5.00 3-hour valet parking for the museums at Harvard Inn, 1201 Mass. Ave. MUS/SH: Y GR/T: Y GR/PH: CATR! 617-496-8576 DT: Y TIME: Noon M-F
PERM/COLL: AN/ISLAMIC; AN/OR; NAT/AM

MASSACHUSETTS

Arthur M. Sackler Museum - continued

Opened in 1985, the building and its superb collection of Ancient, Asian, and Islamic art were all the generous gift of the late Dr. Arthur M. Sackler, noted research physician, medical publisher, and art collector. **NOT TO BE MISSED:** World's finest collections of ancient Chinese jades; Korean ceramics; Japanese woodblock prints; Persian miniatures

ON EXHIBIT/97:

ONGOING	SEVERAN SILVER COINAGE — 33 Severan dynasty coins (193-211 A.D.) from the Roman Imperial period will be selected for viewing from the recent gift of 276 denarii to the museum's ancient coin collection.
	COINS OF ALEXANDER THE GREAT — A display of coinage depicting varying images of Alexander that serve as a historical record of his brilliant life and accomplishments.
01/18/97–03/30/97	BUILDING THE COLLECTIVE: SOVIET GRAPHIC DESIGN 1917-1937: SELECTIONS FROM THE MERRILL C. BERMAN COLLECTION — Seen for the first time in America, the Soviet political posters on view, spanning the period from the Bolshevik rise to power in 1917 to the end of the Second Five Year Plan in 1937, reveal some of the ideological and visual strategies ruling members of the Soviet working class utilized in trying to establish a unified collective technological Communist society. CAT WT
05/10/97–07/20/97	WORLDS WITHIN WORLDS: THE RICHARD ROSENBLUM COLLECTION OF CHINESE SCHOLAR'S ROCKS — For centuries the Chinese have revered the special aesthetic and spiritual qualities of rocks used by scholars as vehicles of contemplation. The 90 rock treasures on view reveal their aesthetic merits as vehicles for meditation. CAT WT

Cambridge

Busch-Reisinger Museum

Affiliate Institution: Harvard University
32 Quincy St., **Cambridge, MA 02138**
☎ 617-495-9400 WEB ADDRESS: (for all 3 Harvard University Art Museums) http://fas.harvard.edu/-artmuseums
HRS: 10-5 M-Sa, 1-5 S HOL: LEG/HOL!
F/DAY: Sa AM ADM: Y ADULT: $5.00 CHILDREN: F (under 18) STUDENTS: $3.00 SR CIT: $4.00
&: Y; Ramp at front and elevators to all floors ⓟ Y; $5.00 3-hour valet parking for the museums at Harvard Inn, 1201 Mass. Ave. MUS/SH: Y GR/T: Y GR/PH: CATR! DT: Y TIME: 2:00 M-F
PERM/COLL: GER: ptgs, sculp 20; GR; PTGS; DEC/ART; CER 18; MED/SCULP; REN/SCULP

Founded in 1901 with a collection of plaster casts of Germanic sculpture and architectural monuments, the Busch-Reisinger lateracquired a group of modern "degenerate" artworks purged from major German museums by the Nazis. All of this has been enriched over the years with gifts from artists and designers associated with the famous Bauhaus School including the archives of artist Lyonel Feininger, and architect Walter Gropius. **NOT TO BE MISSED:** Outstanding collection of German Expressionist Art

ON EXHIBIT/97:

01/18/97–03/30/97	BUILDING THE COLLECTIVE: SOVIET GRAPHIC DESIGN 1917-1937: SELECTIONS FORM THE MERRILL C. BERMAN COLLECTION — Seen for the first time in America, the Soviet political posters on view, spanning the period from the Bolshevik rise to power in 1917 to the end of the Second Five Year Plan in 1937, reveal some of the ideological and visual strategies ruling members of the Soviet working class utilized in trying to establish a unified collective technological Communist society. CAT WT

Cambridge

Fogg Art Museum
Affiliate Institution: Harvard University
32 Quincey St., **Cambridge, MA 02138**
✆ 617-495-9400 WEB ADDRESS: (for all 3 Harvard University Art Museums) http://fas.harvard.edu/-artmuseums
HRS: 10-5 Daily HOL: LEG/HOL!
F/DAY: Sa AM ADM: Y ADULT: $5.00 CHILDREN: F (under 18) STUDENTS: $3.00 SR CIT: $4.00
&: Y; Ramp at front and elevators to all floors ℗ Y; $5.00 3 hour valet parking for the museums at Harvard Inn, 1201 Mass.
Ave. MUS/SH: Y GR/T: Y GR/PH: CATR! 617-496-8576 DT: Y TIME: 11 M-F
PERM/COLL: EU: ptgs, sculp, dec/art; AM: ptgs, sculp, dec/art; GE; PHOT, DRGS

The Fogg, the largest university museum in America, with one of the world's greatest collections, contains both European and American masterpieces from the Middle Ages to the present. Access to the galleries is off of a two story recreation of a 16th-century Italian Renaissance courtyard. **NOT TO BE MISSED:** The Maurice Wertheim Collection containing many of the finest Impressionist and Post-Impressionist paintings, sculptures and drawings in the world.

ON EXHIBIT/97:

ONGOING

INVESTIGATING THE RENAISSANCE — A reinstallation of 3 galleries of one of the most important collections of early Italian Renaissance paintings in North America.

FRANCE AND THE PORTRAIT, 1799-1870 — Changing conventions in and practices of portraiture in France between the rise of Napoleon and the fall of the Second Empire will be examined in the individual images on view from the permanent collection.

CIRCA 1874: THE EMERGENCE OF IMPRESSIONISM — Works by Bazille, Boudin, Johgkind, Monet, Degas and Renoir selected from the museum's collection reveal the variety of styles existing under the single "new painting" label of Impressionism.

THE PERSISTENCE OF MEMORY: CONTINUITY AND CHANGE IN AMERICAN CULTURES — From pre-contact Native American to African to Euro-American, the 60 works of art on exhibit reflect the personal immigrant histories and cultures of each of the artists who created them.

SUBLIMATIONS: ART AND SENSUALITY IN THE NINETEENTH CENTURY — 19th-century artworks chosen to convey the sensual will be seen in an exhibition that demonstrates how these often erotic images impacted upon the social, personal and religious lives of the times.

12/14/96–03/02/97

INVALUABLE PRINTS — This unusual exhibition features prints that are valuable as teaching tools at Harvard but have relatively little commercial monetary value.

03/29/97–06/22/97

FROM LOW LIFE TO RUSTIC IDYLL: THE PEASANT GENRE IN SEVENTEENTH-CENTURY DUTCH DRAWINGS AND PRINTS — Mannerist studies, black & red chalk figure studies, preparatory brown ink sketches, grisaille oil sketches, etchings and watercolors will be on display in an exhibit highlighting a thematic variety of peasant lowlife and festive imagery. BOOKLET

MIT-List Visual Arts Center
20 Ames Sr., Wiesner Bldg., **Cambridge, MA 02139**
✆ 617-253-4680
HRS: Noon-6 Tu, T, F; Noon-8 W; 1-5 Sa, S DAY CLOSED: M HOL: LEG/HOL!
&: Y ℗ Y; Corner of Main & Ames Sts. GR/T: Y GR/PH: CATR! DT: Y TIME: call for information
PERM/COLL: SCULP; PTGS; PHOT; DRGS; WORKS ON PAPER

Approximately 12 exhibitions are mounted annually in MIT's Wiesner Building designed by the internationally known architect I.M. Pei, a graduate of the MIT School of Architecture. **NOT TO BE MISSED:** Sculpture designed and utilized as furniture for public seating in the museum by visual artist Scott Burton

MASSACHUSETTS

MIT-List Visual Arts Center - continued

ON EXHIBIT/97:

01/25/97–03/29/97	ARTIST-IN-RESIDENCE: JILL REYNOLDS
01/25/97–03/29/97	JOSEPH KOSUTH: THE SECOND INVESTIGATION
04/19/97 06/29/97	UNDER SURVEILLANCE — A group exhibition.
04/19/97–06/29/97	KAY ROSEN: NEW WORLD ORDER

Chestnut Hill

Boston College Museum of Art

140 Commonwealth Ave., **Chestnut Hill, MA 02167-3809**
☎ 617-552-8100
HRS: SEP-MAY: 11-4 M-F; Noon-5 Sa, S; JUNE-AUG: 11-3 M-F HOL: LEG/HOL!
&: Y; Fully accessible ℗ Y; 1 hour parking on Commonwealth Ave.; in lower campus garage on weekends & as available on weekdays (call 617-552-8587 for availability) MUS/SH: Y ⅋ Y; On campus
H/B: Y
PERM/COLL: IT: ptgs 16 & 17; AM: ptgs; JAP: gr; MED & BAROQUE TAPESTRIES 15-17

Devlin Hall, the Neo-Gothic building that houses the museum, consists of two galleries featuring a display of permanent collection works one floor and special exhibitions on the other. **NOT TO BE MISSED:** "Madonna with Christ Child & John the Baptist" By Ghirlandaio, 1503-1577)

ON EXHIBIT/97:

01/97–05/97	ORIGINAL VISIONS: WOMEN, ART AND THE POLITICS OF GENDER	CAT
10/97–12/97	PAINTING HISTORY	CAT

Concord

Concord Art Association

37 Lexington Rd., **Concord, MA 01742**
☎ 508-369-2578
HRS: 10-4:30 Tu-Sa, 2-4:30 S (closed between exhibitions!) DAY CLOSED: M
HOL: LEG/HOL!; Last 2 weeks AUG.; Last week DEC.
&: Y ℗ Y; Free street parking MUS/SH: Y
H/B: Y; Housed in building dated 1720 S/G: Y
PERM/COLL: AM: ptgs, sculp, gr, dec/art

Historic fine art is appropriately featured within the walls of this historic (1720) building. The beautiful gardens are perfect for a bag lunch picnic during the warm weather months. **NOT TO BE MISSED:** Ask to see the secret room within the building which was formerly part of the underground railway.

ON EXHIBIT/97: Rotating exhibits of fine art and crafts are mounted on a monthly basis.

Cotuit

Cahoon Museum of American Art
4676 Falsmouth Rd., **Cotuit, MA 02635**
📞 508-428-7581
HRS: 10-4 Tu-Sa DAY CLOSED: M, Tu HOL: LEG/HOL!; Also closed FEB. & MAR.
VOL/CONT: Y &: Y; Limited to first floor only ℗ Y; Free MUS/SH: Y
DT: Y H/B: Y; 1775 Former Cape Cod Colonial Tavern
PERM/COLL: AM: ptgs 19-20; CONT/PRIM

Art by the donor artists of this facility, Ralph and Martha Cahoon, is shown along with works by prominent American Luminists and Impressionists. Located in a restored 1775 Colonial tavern on Cape Cod, the museum is approximately 9 miles west of Hyannis. **NOT TO BE MISSED:** Gallery of marine paintings

ON EXHIBIT/97:	The Cahoon Museum's permanent collection of American paintings is on display between special exhibitions.
05/30/97–09/27/97	ARTISTS AS ART COLLECTORS
06/27/97–07/26/97	FLORALO STILL LIFE BY SUZANNE PACKER (Working Title)
08/01/97–09/05/97	YOUNG AT ART: RECENT CRAYON SKETCHES BY MARTHA CAHOON
10/10/97–11/22/97	SALLEY MAVOR, FIBER RELIEF ILLUSTRATIONS FOR "YOU AND ME" POEMS OF FRIENDSHIP
12/05/97–01/31/98	OILS, WATERCOLORS AND SKETCHES BY LORETTA FEENEY (Working Title)

Dennis

Cape Museum of Fine Arts
Rte. 6A, **Dennis, MA 02638**
📞 508-385-4477
HRS: 10-5 Tu-Sa, 1-5 S; Call for evening hours of operation DAY CLOSED: M HOL: LEG/HOL!
ADM: Y ADULT: $2.00 CHILDREN: F SR CIT: $2.00
&: Y ℗ Y; Free and ample parking MUS/SH: Y GR/T: Y GR/PH: call 508-385-4477 DT: Y TIME: !
PERM/COLL: REG

Art by outstanding Cape Cod artists from 1900 to the present is the focus of this rapidly growing permanent collection which is housed in the restored former summer home of the family of Davenport West, one of the original benefactors of this institution.

Duxbury

Art Complex Museum
189 Alden St., **Duxbury, MA 02331**
📞 617-934-6634
HRS: 1-4 W-S DAY CLOSED: M, Tu HOL: LEG/HOL!
&: Y; Except for restrooms ℗ Y; Free GR/T: Y GR/PH: CATR! S/G: Y
PERM/COLL: OR: ptgs; EU: ptgs; AM: ptgs; gr

In a magnificent sylvan setting that compliments the naturalistic wooden structure of the building, the Art Complex houses a remarkable core collection of works on paper that includes Rembrandt's "The Descent from the Cross by Torchlight." An authentic Japanese Tea House complete with tea presentations in the summer months is another unique feature of this fine institution. The museum is located on the eastern coast of Massachusetts just above Cape Cod. **NOT TO BE MISSED:** Shaker furniture; Tiffany stained glass window

MASSACHUSETTS

Art Complex Museum - continued
ON EXHIBIT/97:

02/02/97–04/27/97	AARON FINK: HATS — Fink's images of hats executed over the last ten years continue his stylistic variations on a theme that has occupied him for most of his career.
02/02/97–04/27/97	DUXBURY ART ASSOCIATION WINTER JURIED SHOW — 100 works in all media by winning artists from New England will be on exhibit.
05/09/97–07/27/97	FRAGMENTS: A CONTEMPORARY APPROACH TO LANDSCAPE — Utilizing the landscape as subject matter, the four artists whose works are on view all attempt to reinvent reality with fragmented images.
05/09/97–07/27/97	ANIMALS IN ART — Selected from the permanent collection this exhibition of animals as subject matter will include ancient Chinese jade works, Native American amulets and an enormous 7' long wooden rhinoceros.
08/08/97–10/26/97	ATTRIBUTES OF THE ARTIST — On view will be a multi-media exhibition of works by Michael Mazur, Jessica Trraus, Gerry Bergstein, Pierre Gustafson and Ken Beck, artists who use or incorporate their tools as subject matter.
11/07/97–01/25/98	THE BOSTON PRINTMAKERS MEMBERS SHOW

Fitchburg

Fitchburg Art Museum
185 Elm St., **Fitchburg, MA 01420**
☎ 508-345-4207
HRS: 11-4:00 Tu-Sa, 1-4 S DAY CLOSED: M HOL: LEG/HOL!
ADM: Y ADULT: $3.00 CHILDREN: F (under 18) SR CIT: $2.00
&: Y; 90% handicapped accessible Ⓟ Y; Free on-site parking MUS/SH: Y
S/G: Y
PERM/COLL: AM: ptgs, gr; EU: ptgs, gr; CER; DEC/ART; SCULP;P/COL; AN/GRK; AN/R; AS; OR; ANT

Eleanor Norcross, a Fitchburg artist who lived and painted in Paris for 40 years became impressed with the number and quality of small museums that she visited in the rural areas of northern France. This led to the bequest of her collection and personal papers in 1925 to her native city of Fitchburg and marked the beginning of what is now a 40,000 square foot block long museum complex. The museum is located in north central Massachusetts near the New Hampshire border. **NOT TO BE MISSED:** "Sarah Clayton" by Joseph Wright of Derby, 1770

ON EXHIBIT/97:

09/96–03/97	OUR CENTURY IN REVIEW: PORTRAITS — This broad overview of public, private, religious, and historical portraits will also include mug shots, police sketches, and consumer celebrity images in an exhibition that documents the importance of portraiture in our lives.
01/97–03/97	RENEWAL AND METAMORPHOSIS: FROM THE LATE SOVIET ERA TO THE 1990'S — A glimpse of Russian history will be seen in the photographs on exhibit.
01/97–03/97	WILLIAM HURD: PHOTOGRAPHY
04/97–05/97	MARIE CASINDAS: PHOTOGRAPHY
06/97–08/97	62 REGIONAL EXHIBITION OF ART AND CRAFT — More than 300 works by 200 regional artists living within 25 miles of the Museum will be on view.
09/97–04/98	HIROMI TSUCHIDA AND TOSHIO SHIBATA: PHOTOGRAPHY
09/97–04/98	PRINTS: A REVIEW OF THE 20TH CENTURY — Works by printmakers and painters will be joined by works that are a collaboration of both in a survey exhibition of prints of our century.

Framingham

Danforth Museum of Art
123 Union Ave., **Framingham, MA 01701**
☎ 508-620-0050
HRS: Noon-5 W-S DAY CLOSED: M, Tu HOL: LEG/HOL! AUG!
ADM: Y ADULT: $3.00 CHILDREN: F (under 12) STUDENTS: $2.00 SR CIT: $2.00
ප: Y Ⓟ Y; Free MUS/SH: Y
GR/T: Y GR/PH: CATR! DT: Y TIME: 1:00 W (Sep-May)
PERM/COLL: PTGS; SCULP; DRGS; PHOT; GR

The Danforth, a museum that prides itself on being known as a community museum with a national reputation, offers 19th & 20th-century American and European art as the main feature of its permanent collection. **NOT TO BE MISSED:** 19th & 20th century American works with a special focus on the works of New England artists

ON EXHIBIT/97:
 12/07/96–03/16/97 THE SILK ROUTE: ANTIQUE ORIENTAL RUGS — 40 historically- significant rugs from Iran, Turkey, and other countries will be on loan for this exhibition from the collection of Arthur T. Gregorian.

 12/07/97–02/28/97 STILL LIFE AND PORTRAITS — An exhibition of paintings by Frances Gillespie, Marci Gintis and Barbara Swan.

Gloucester

Cape Ann Historical Association
27 Pleasant St., **Gloucester, MA 01930**
☎ 508-283-0455
HRS: 10-5 Tu-Sa DAY CLOSED: S, M HOL: LEG/HOL!; FEB
ADM: Y ADULT: $3.50 CHILDREN: F (under 6) STUDENTS: $2.00 SR CIT: $3.00
ප: Y; Wheelchairs available Ⓟ Y; In the lot adjacent to the museum and in the metered public lot across Pleasant St. from the museum. MUS/SH: Y
GR/T: Y GR/PH: CATR! H/B: Y; 1804 Federal period home of Captain Elias Davis is part of museum
PERM/COLL: FITZ HUGH LANE: ptgs; AM: ptgs, sculp, DEC/ART 19-20; MARITIME COLL

Within the walls of this most charming New England treasure of a museum is the largest collection of paintings (39), drawings (100), and lithographs by the great American artist, Fitz Hugh Lane. A walking tour of the town takes the visitor past many charming small art studios & galleries that have a wonderful view of the harbor as does the 1849 Fitz Hugh Lane House itself. Be sure to see the famous Fisherman's Monument overlooking Gloucester Harbor. **NOT TO BE MISSED:** The only known watercolor in existence by Fitz Hugh Lane

ON EXHIBIT/97: There are several exhibitions a year usually built around a theme that pertains in some way to the locale and its history!

Lincoln

DeCordova Museum and Sculpture Park
Sandy Pond Rd., **Lincoln, MA 01773**
☎ 617-259-8355 WEB ADDRESS: www.decordova.org
HRS: 12-5 Tu-S DAY CLOSED: M HOL: LEG/HOL!
ADM: Y ADULT: $4.00 CHILDREN: $3.00 (over 6) STUDENTS: $3.00 SR CIT: $3.00
ප: Y Ⓟ Y; free MUS/SH: Y ❙❙ Y; Terrace Cafe open 12-3 Sa, S SUMMER ONLY
GR/T: Y GR/PH: CATR! DT: Y TIME: 2:00 S & 1:00 W S/G: Y
PERM/COLL: AM: ptgs, sculp, gr, phot 20; REG

MASSACHUSETTS

DeCordova Museum and Sculpture Park - continued

In addition to its significant collection of modern and contemporary art, the DeCordova features the only permanent sculpture park of its kind in New England. While there is an admission charge for the museum, the sculpture park is always free and open to the public from 8 AM to 10 PM daily. The 35 acre park features nearly 40 site-specific sculptures. **NOT TO BE MISSED:** Annual open air arts festival first Sunday in June; summer jazz concert series from 7/4 - Labor Day

ON EXHIBIT/97:

through 05/11/97	JOHN VAN ALSTINE: VESSELS AND VOYAGES — Sculptures by Van Alstine will be on exhibit in the Museum's Sculpture Terrace.
06/14/97–09/01/97	ARTISTS/VISIONS: 1997
06/14/97–05/98	CATHERINE E.B.COX AWARD EXHIBITION — Featured in the Sculpture Terrace will be works by Dorrien. effigy vessels by Shigeru Miyamoto, the 4th recipient of the Catherine E. B. Cox Award which is generally given every other year.
09/13/97–01/03/98	CHILDREN'S BOOK ILLUSTRATION (Working Title)

Lowell

The Whistler House & Parker Gallery

243 Worthen St., **Lowell, MA 01825**
☎ 508-452-7641
HRS: 11-4 W-Sa, 1-4 S, Open Tu Jun through Aug only DAY CLOSED: M HOL: LEG/HOL! JAN. & FEB.
ADM: Y ADULT: $3.00 CHILDREN: F (under 5) STUDENTS: $2.00 SR CIT: $2.00
&: Y; Limited to first floor of museum and Parker Gallery ℗ Y; On street; commercial lots nearby MUS/SH: Y
DT: Y TIME: upon request if available
H/B: Y; 1823 Whistler Home, Birthplace of James A.M. Whistler
PERM/COLL: AM: (Including Whistler, Sargent & Gorky)

Works by James A.M. Whistler are the highlight of this collection housed in the 1823 former home of the artist. **NOT TO BE MISSED:** Collection of prints by James A.M. Whistler

ON EXHIBIT/97: Rotating exhibitions of contemporary regional art presented on a bi-monthly basis.

Medford

Tufts University Art Gallery

Affiliate Institution: Tufts University
Aidekman Arts Center, **Medford, MA 02115**
☎ 617-627-3518
HRS: Sep to mid Dec & mid Jan to May: 12-8 W-Sa, 12-5 S DAY CLOSED: M
HOL: LEG/HOL!; ACAD!; SUMMER
&: Y S/G: Y
PERM/COLL: PTGS, GR, DRGS, 19-20; PHOT 20; AN/R; AN/GRK; P/COL

Located just outside of Boston, most of the Tufts University Art Museum exhibitions feature works by undergraduate students and MFA candidates.

North Adams

Massachusetts Museum of Contemporary Art
87 Marshall St., **North Adams, MA 01247**
☎ 413-664-4481
🍴 Y: The Night Shift Cafe with jazz, blues, rock & alternative music

Though not open until 1998, the much anticipated Massachusetts Museum of Contemporary Art (MASS MoCA), created from a 27-building historic mill complex of 13 acres in the Berkshire Mountains of Western Massachusetts, promises to be an exciting multi-disciplinary center for visual, performing and visual arts. International in scope, the MASS MoCA will offer presentations of works on loan from The Solomon R. Guggenheim Museum, NYC, 2 annual exhibitions of French Impressionist and Early American artworks from The Sterling and Francine Clark Art Institute in Williamstown, MA, photographic works from the Lucien Aigner Trust, and much, much more!

Northampton

Smith College Museum of Art
Elm St. at Bedford Terrace, **Northampton, MA 01063**
☎ 413-585-2760 WEB ADDRESS: http://www.smith.edu/artmuseum
HRS: Sep-Jun: 9:30-4 F, Sa; 12-8 Tu, Noon-4 W, S; T!; Jul & Aug: Noon-4 Tu-S
DAY CLOSED: M HOL: 7/4, THGV, 12/25, 1/1
VOL/CONT: Y ♿: Y; Wheelchair accessible; wheelchairs provided upon request ℗ Y; Nearby street parking with campus parking available on evenings and weekends only; Handicapped parking behind Hillyer art building. MUS/SH: Y
GR/T: Y GR/PH: CATR!
PERM/COLL: AM: ptgs, sculp, gr, drgs, dec/art 17-20; EU: ptgs, gr, sculp, drgs, dec/art 17-20; PHOT; DU:17; ANCIENT ART

With in-depth emphasis on American and French 19th & 20th-century art, and literally thousands of superb artworks in its permanent collection, Smith College remains one of the most highly regarded college or university repositories for fine art in the nation. PLEASE NOTE: Print Room hours are 1-4 Tu-F & 1-5 T from Sep. to May - other hours by appointment only. **NOT TO BE MISSED:** "Mrs. Edith Mahon" by Thomas Eakins; "Walking Man" by Rodin

ON EXHIBIT/97:

01/16/97–03/16/97	RICHARD YARDE — Watercolors by Yarde, a well-known African-American artist will be on display.
03/97–05/97	STEPHEN ANTONAKOS — Greek-inspired icons by a contemporary neon artist.
FALL/97	UFFIZI GALLERY DRAWINGS
11/06/97–01/11/98	KINSHIPS: ALICE NEEL LOOKS AT THE FAMILY — Unconventional yet captivating and frankly honest portrait paintings by Neel (1900-1983), one of the greatest figurative artists of her day.

Words & Pictures Museum
140 Main St., **Northampton, MA 01060**
☎ 413-586-8545
HRS: Noon-5 Tu-T & S, Noon-8 F, 10-8 Sa DAY CLOSED: M HOL: 1/1, MEM/DAY, 7/4, LAB/DAY, THGV, 12/25
♿: Y; Fully accessible ℗ Y; Metered parking lots nearby MUS/SH: Y
GR/T: Y GR/PH: CATR! DT: Y TIME: Upon request if available
PERM/COLL: Original contemporary sequential/comic book art & fantasy illustration, 1970's - present

Mere words cannot describe the Words & Pictures Museum, one of only two in the country. Located in a new building opened 1/95, this museum, which follows the evolution of comic book art, intersperses traditional fine art settings with exhibits of pure fun. There are numerous interactive displays including entry into the museum through a maze and an exit-way through an area that demonstrates the history of the American comic. **NOT TO BE MISSED:** The entryway to the building featuring a life-size artist's studio built with a false perspective so that it appears to actually be viewed from above through a skylight.

MASSACHUSETTS

Pittsfield

The Berkshire Museum
39 South St., **Pittsfield, MA 01201**
☎ 413-443-7171
HRS: 10-5 Tu-Sa, 1-5 S; Open 10-5 M Jul & Aug HOL: LEG/HOL!
F/DAY: W & Sa 10-12 ADM: Y ADULT: $3.00 CHILDREN: F (12 & under) STUDENTS: $2.00 SR CIT: $2.00
&: Y; Wheelchair lift south side of building; elevator to all floors Ⓟ Y; Metered street parking; inexpensive rates at the nearby
Berkshire Hilton and municipal parking garage.
MUS/SH: Y GR/T: Y GR/PH: CATR! DT: Y TIME: 11:00 Sa "Gallery Glimpses"
PERM/COLL: AM: 19-20; EU: 15-19; AN/GRK; AN/R; DEC/ART; PHOT

Three museums in one set the stage for a varied and exciting visit to this complex in the heart of the beautiful
Berkshires. The art museum is rich in its holdings of American art of the 19th & 20th centuries and houses an
extensive collection of 2,900 objects of decorative art as well. **NOT TO BE MISSED:** "Giant Redwoods" by
Albert Bierstadt

ON EXHIBIT/97:

02/97–06/97	DIVERSE REFLECTIONS: THE PORTRAITS OF WINOLD REISS
03/01/97–05/31/97	BERKSHIRE LANDSCAPES, CONTEMPORARY AND HISTORICAL
04/26/97–04/29/97	GALLERIES IN BLOOM — A brief but beautiful presentation of floral designers' interpretations of the Museum galleries.
05/97	BERKSHIRE ART ASSOCIATION SCHOLARSHIP SHOP ANNUAL — Works by new and emerging talent in all media will be on exhibit.
11/15/97–12/07/97	13TH ANNUAL FESTIVAL OF TREES

Provincetown

Provincetown Art Association and Museum
460 Commercial St., **Provincetown, MA 02657**
☎ 508-487-1750
HRS: Summer: 12-5 & 8-10 daily; SPRING/FALL: 12-5 F, Sa, S; WINTER: 12-4 Sa, S
HOL: Open most holidays!; open weekends only Nov-Apr
SUGG/CONT: Y ADULT: $3.00 STUDENTS: $1.00 SR CIT: $1.00
&: Y MUS/SH: Y H/B: Y; 1731 Adams family house
PERM/COLL: PTGS; SCULP; GR; DEC/ART; REG

Works by regional artists is an important focus of the collection of this museum located in the former restored
vintage home (1731) of the Adams family. **NOT TO BE MISSED:** Inexpensive works of art by young artists that
are for sale in the galleries

South Hadley

Mount Holyoke College Art Museum
South Hadley, MA 01075
☎ 413-538-2245
HRS: 11-5 Tu-F, 1-5 Sa-S HOL: LEG/HOL! & ACAD!
&: Y Ⓟ Y; Free MUS/SH: Y GR/T: Y GR/PH: CATR! S/G: Y
PERM/COLL: JAP: gr; P/COL; AN/EGT; IT: med/sculp; EU: ptgs; AN/GRK; AN/CH; AM: ptgs, dec/art, gr, phot; EU: ptgs,
dec/art, gr, phot

Mount Holyoke College Art Museum - continued

A stop at this leading college art museum is a must for any art lover traveling in this area. Founded in 1876, it is one of the oldest college museums in the country. **NOT TO BE MISSED:** Albert Bierstadt's "Hetch Hetchy Canyon"; A Pinnacle from Duccio's "Maesta" Altarpiece

ON EXHIBIT/97:

01/97–03/97	SELECTIONS FROM THE COLLECTION
01/18/97–03/14/97	PHOTOGRAPHERS ON LOCATION: LANDSCAPES AND CITYSCAPES FROM THE NATIONAL MUSEUM OF AMERICAN ART — Ansel Adam's rare print portfolio "Parmelian Prints of the High Sierras," and Bernice Abbott's WPA photographs from her series entitled "Changing New York" will be among the works by 8 photographers in an exhibition designed to examine America's natural & manmade environment and its permanence or transformation. WT
02/97–06/97	NINETEENTH-CENTURY PHOTOGRAPHS OF EGYPT — Taken in the last century, these photographs by J. Pascal Sebah and Antonio Beato will be selected for viewing from a collection of vintage prints recently gifted to the Museum.
04/97–07/97	THE SPIRIT OF WEST AFRICAN TEXTILES — Examples of Kente cloth will be among the traditional African designs seen in the fabrics, costumes, textile masks, and hats on exhibit. WT

Springfield

George Walter Vincent Smith Art Museum

At the Quadrangle Corner State & Chestnut Sts., **Springfield, MA 01103**
✆ 413-263-6800 WEB ADDRESS: http://www.spfldlibmus.org/welcome.htm
HRS: Noon-4 T-S; Summer: Noon-4 W-S from late JUN-early SEP DAY CLOSED: M-W HOL: LEG/HOL!
ADM: Y ADULT: $4.00 CHILDREN: $1.00 (6-18) STUDENTS: $4.00 SR CIT: $4.00
&: Y; First floor only ℗ Y; Free on-street parking or in Springfield Library & Museum lots on State St. & Edwards St.
⑪ Y; Summertime outdoor cafe GR/T: Y GR/PH: CATR! ext. 266 H/B: Y; Built in 1896
PERM/COLL: ENTIRE COLLECTION OF 19th century AMERICAN ART OF GEORGE WALTER VINCENT SMITH; OR; DEC/ART 17-19; CH: jade; JAP: bronzes, ivories, armor, tsuba 17-19; DEC/ART: cer; AM: ptgs 19

With the largest collection of Chinese cloisonne in the western world, the G. W. V. Smith Art Museum, built in 1895 in the style of an Italian villa, is part of a four museum complex that also includes The Museum of the Fine Arts. The museum reflects its founder's special passion for collecting the arts of 17th to 19th-century Japan. **NOT TO BE MISSED:** Early 19th-century carved 9' high wooden Shinto wheel shrine

ON EXHIBIT/97:

12/04/96–02/02/97	THE PURSUIT OF BEAUTY: DISCOVERING VICTORIAN SPRINGFIELD — Japanese decorative arts, Italian watercolors, Egyptian artifacts, Victorian costumes, and recreations of Victorian interiors will be featured in an exhibition honoring the centennial of the Museum.

Museum of Fine Arts

at the Quadrangle Corner of State & Chestnut Sts., **Springfield, MA 01103**
✆ 413-263-6800 WEB ADDRESS: http://www.spfldlibmus.org/welcome.htm
HRS: Noon-4 W-S DAY CLOSED: M, Tu HOL: LEG/HOL!
ADM: Y ADULT: $4.00 CHILDREN: $1.00 (6-18) STUDENTS: $1.00
&: Y; Limited to 3 galleries at present (access renovations planned) ℗ Y; Free on-street parking and in Springfield Library & Museum lots on State St. and Edwards St. MUS/SH: Y ⑪ Y; Summertime outdoor cafe
GR/T: Y GR/PH: CATR! ext. 266
PERM/COLL: AM: 19-20; FR: 19-20

Part of a four museum complex located on The Quadrangle in Springfield, the Museum of Fine Arts, built in the 1930's Art Deco Style, offers an overview of European and American art. **NOT TO BE MISSED:** "The Historical Monument of the American Republic, 1867 & 1888 by Erastus S. Field, a monumental painting in the court of the museum

207

MASSACHUSETTS

Museum of Fine Arts - continued
ON EXHIBIT/97:

01/22/97–02/23/97	ROAD, RIVER, RAIL — Large format, black and white landscape photographs by David Torcoletti explore the entire length of the Connecticut River, a stretch of rural highway in upstate New York, and a section of the B & M Railroad in Western Massachusetts and southern Vermont.
03/15/97–06/15/97	THE AUDUBON COLLECTION — A presentation of Audubon's paintings, prints and sculptures from the Audubon Society's collection.
07/02/97–09/07/97	DOCUMENTING AMERICA, 1935-1943

Stockbridge

Chesterwood
Off Rte. 183, Glendale Section, **Stockbridge, MA 01262**
☎ 413-298-3579
HRS: 10-5 Daily (May 1-Oct 31) HOL: None during open season
ADM: Y ADULT: $7.00 CHILDREN: $1.50 (6-12) STUDENTS: $3.50 SR CIT: $7.00
&: Y; Limited ℗ Y; Ample MUS/SH: Y ⑪ Y; Snack stand
GR/T: Y GR/PH: CATR! DT: Y H/B: Y; Two Buildings (1898 studio & 1901 house) of Daniel Chester French S/G: Y
PERM/COLL: SCULP; PTGS; WORKS OF DANIEL CHESTER FRENCH; PHOT

Located on 120 wooded acres is the original studio and Colonial Revival house of Daniel Chester French, leading sculptor of the American Renaissance. Working models for the Lincoln Memorial and the Minute Man, his most famous works are on view along with many other of his sculptures, models, and preliminary drawings. PLEASE NOTE: There are reduced admission rates to see the grounds only.

The Norman Rockwell Museum at Stockbridge
Stockbridge, MA 01262
☎ 413-298 4100
HRS: May-Oct: 10-5 Daily; Nov-Apr: 11-4 M-F & 10-5 Sa, S & HOL HOL: 1/1, TGHV, 12/25
ADM: Y ADULT: $9.00 CHILDREN: $2.00 (F under 5)
&: Y; Main museum building but not studio ℗ Y; Ample free parking MUS/SH: Y
GR/T: Y GR/PH: CATR! ext. 220 DT: Y TIME: optional tours daily on the hour H/B: Y; 1800 Georgian House
PERM/COLL: NORMAN ROCKWELL ART & ARTIFACTS

The Norman Rockwell Museum displays works from all periods of the long and distinguished career of America's most beloved artist/illustrator. In addition to Rockwell's studio, moved to the new museum site in 1986, visitors may enjoy the permanent exhibition entitled "My Adventure as an Illustrator" which contains 60 paintings that span Rockwell's entire career (1910 through most of the 1970's). PLEASE NOTE: Rockwell's studio is open May through Oct. **NOT TO BE MISSED:** The "Four Freedoms" Gallery in the new museum building.

ON EXHIBIT/97:

ONGOING	A MIRROR ON AMERICA — Rockwell's images as they both influenced and depicted the American way of life is the focus of this exhibition.
	MY BEST STUDIO YET — Business, personal and social aspects of Rockwell's daily working life are revealed in this display of archival and ephemeral material. Many of the objects on view concern his relationships with his family, friends, business colleagues and even some of the models he used for his portraits of American life.
	MY ADVENTURES AS AN ILLUSTRATOR — More than 60 paintings that cover Rockwell's 60 year career from the 1910's to the 1970's will be included in this permanent installation of familiar and lesser-known works accompanied by autobiographical quotations.
11/09/96–01/26/97	THE PICTUREBOOK ART OF CHIHIRO IWASAKI — 34 original illustrations created by mixing watercolor painting with traditional Japanese techniques will be seen in the first exhibition outside of his native Japan of works by the late Iwasaki.

The Norman Rockwell Museum at Stockbridge - continued

11/09/96–01/26/97	DICK & JANE: ILLUSTRATIONS OF AN AMERICAN EDUCATION — 70 original narrative illustrations and vintage photographs will be featured in an exhibition on the book *Dick & Jane*, used to teach young school children to read from the 1920's to the last edition published in 1965.
02/15/97–05/26/97	CURRIER & IVES, PRINTMAKERS TO THE AMERICAN PEOPLE — For 50 years, beginning in 1834, this lithography firm printed 3-4 new prints every week that helped to form America's self-imagery by documenting the life of the times. Presented in 10 sections, the 79 works on view cover a broad range of subjects including New York City life, politics & current events, technological advances, capitalist culture, family and country life, and more. WT

Waltham

Rose Art Museum

Affiliate Institution: Brandeis University
415 South St., **Waltham, MA 02254**
☎ 617-736-3434
HRS: 1-5 Tu-S, 1-9 T DAY CLOSED: M HOL: LEG/HOL!
♿: Y ℗ Y; Visitor parking on campus GR/T: Y GR/PH: CATR!
PERM/COLL: AM: ptgs, sculp 19-20; EU: ptgs, sculp 19-20; CONT; OC; CER PLEASE NOTE: The permanent collection is not always on view!

The Rose Art Museum, founded in 1961, and located on the campus of Brandeis University just outside of Boston, features one of the largest collections of contemporary art in New England. Selections from the permanent collection and an exhibition of the works of Boston area artists are presented annually. PLEASE NOTE: Tours are given at 1 PM every W by advance reservation only.

Wellesley

Davis Museum and Cultural Center

Affiliate Institution: Wellesley College
106 Central St., **Wellesley, MA 02181-8257**
☎ 617-283-2051 WEB ADDRESS: http://www.wellesley.edu/DavisMuseum/davismenu.html
HRS: 11-5 Tu & F-Sa, 11-8 W & T, 1-5 S HOL: 12/25, 1/1
♿: Y ℗ Y; Free ⅋ Y; Cafe GR/T: Y GR/PH: CATR! 617-283-2081
PERM/COLL: AM: ptgs, sculp, drgs, phot; EU: ptgs, sculp, drgs, phot; AN; AF; MED; REN

Established over 100 years ago, the Davis Museum and Cultural Center, formerly the Wellesley College Museum, is located in a stunning 61,000 square foot state-of-the-art museum building. One of the first encyclopedic college art collections ever assembled in the United States, the museum is home to more than 5,000 works of art. PLEASE NOTE: The museum closes at 5 PM on W & T in January and from 6/15 to 8/15). **NOT TO BE MISSED:** "A Jesuit Missionary in Chinese Costume," a chalk on paper work by Peter Paul Rubens (recent acquisition)

ON EXHIBIT/97:

02/28/97–07/14/97	INSPIRING REFORM: BOSTON'S ARTS AND CRAFTS MOVEMENT — 150 objects will be featured in the first exhibition of its kind for the late 19th-century Arts and Crafts items created in Boston, the American city regarded as the epicenter of the Movement. Photographs, prints, furniture, metalwork, ceramics, jewelry and a myriad of other items designed as a reaction against Victorian excesses will be on exhibit. CAT WT
FALL/97	RECONFIGURING THE PICTURESQUE: PHOTOGRAPHING THE LEGACY OF FREDERICK LAW OLMSTED (Working Title) — Known as one of America's most important landscape architects and designers, this exhibition centers on 150 of Olmsted's (1822-1903) works reconfigured by the photographic interpretations of Lee Friedlander, Geoffrey James and Robert Burley. More than 30 maps and other historical documents relating to his works will accompany this presentation.

MASSACHUSETTS

Williamstown

Sterling and Francine Clark Art Institute
225 South St., **Williamstown, MA 01267**
☎ 413-458-9545
HRS: 10-5 Tu-S; also M during Jul & Aug; open MEM/DAY, LAB/DAY, COLUMBUS DAY DAY CLOSED: M!
HOL: THGV, 12/25, 1/1
&: Y; Wheelchairs available ℗ Y MUS/SH: Y ‖ Y; Outdoor cafe open in good weather (not for large groups)
GR/T: Y GR/PH: CATR! 413-458-2303 ext. 324 DT: Y TIME: 3:00 Tu-F during Jul & Aug
PERM/COLL: IT: ptgs 14-18; FL: ptgs 14-18; DU: ptgs 14-18; OM: ptgs, gr, drgs; FR: Impr/ptgs; AM: ptgs 19

More than 30 paintings by Renoir and other French Impressionist masters as well as a collection of old master paintings and a significant group of American works account for the high reputation of this recently expanded outstanding 40 year old institution. PLEASE NOTE: Recorded tours of the permanent collection and the Impressionist collection are available for a small fee. **NOT TO BE MISSED:** Impr/ptgs; works by Homer, Sargent, Remington, Cassatt; Silver coll.; Ugolino Da Siena Altarpiece; Porcelain gallery

ON EXHIBIT/97:

02/07/97–04/20/97	THE COLLECTION OF BERTRAM K. AND NINA FLETCHER LITTLE AT COGSWELL'S GRANT — Prior to its opening as a museum in 1998, Bertram K. and Nina Fletcher Little's collection of Americana, including furniture, paintings and a wide variety of decorative objects will be on exhibit. Assembled over a 60 year period, this collection is considered one of the finest of its kind in the country. WT
06/20/97–09/14/97	UNCANNY SPECTACLE: THE PUBLIC CAREER OF THE YOUNG JOHN SINGER SARGENT — On display will be early works from the 1870's and 80's that established Sargent as a major figure in the art world.
10/04/97–01/04/98	MASTERPIECES OF ENGLISH SILVER — Magnificent examples of 16th through 19th-century English silver from the renowned Clark collection will be on exhibit in this highly anticipated exhibition. CAT
10/04/97–01/04/98	THE GREAT AGE OF COUNTRY HOUSE SILVER: THE DUNHAM-MASSEY COLLECTION — From one of the finest and most complete collections of early English silver still residing in the house for which it was made will be a display of 90 groups of objects crafted in London by Huguenot silversmiths. CAT WT

Williams College Museum of Art
Main St., **Williamstown, MA 01267**
☎ 413-597-2429
HRS: 10-5 Tu-Sa, 1-5 S (open M on MEM/DAY, LAB/DAY, COLUMBUS DAY) DAY CLOSED: M!
HOL: 1/1, 12/25, THGV
&: Y; Parking, wheelchair accessible ℗ Y; Limited in front of and behind the museum, and behind the Chapel. A public lot is available at the foot of Spring St.
MUS/SH: Y GR/T: Y GR/PH: CATR! DT: Y TIME: 2:00 W & S Jul & Aug ONLY
H/B: Y; 1846 Brick Octagon by Thomas Tefft; 1983-86 additions by Chas. Moore
PERM/COLL: AM: cont & 18-19; ASIAN & OTHER NON-WESTERN CIVILIZATIONS; BRIT: ptgs 17-19; SP: ptgs 15-18; IT/REN: ptgs ; PHOT; GR/ARTS; AN/GRK; AN/ROM;

Considered one of the finest college art museums in the U.S., the Williams collection of 11,000 works that span the history of art, features particular strengths in the areas of contemporary & modern art, American art from the late 18th-century to the present, and non-Western art. The original museum building of 1846, a two-story brick octagon with a neoclassic rotunda, was joined in 1986 by a dramatic addition designed by noted architect Charles Moore. **NOT TO BE MISSED:** Works of Maurice and Charles Prendergast

ON EXHIBIT/97:

Through 5/97	AN AMERICAN IDENTITY: 19TH-CENTURY AMERICAN ART FROM THE PERMANENT COLLECTION — Works by Eakins, Harnett, Homer, Innes, Kensett, LaFarge, Whistler and others examine the ways in which creative artists helped define a national image for the new republic.

Williams College Museum of Art - continued

Through 6/97 — PAINTING CHANGES: PRENDERGAST AND HIS CONTEMPORARIES, 1850-1950 — An exhibition of American and European impressionist through modernist paintings from the permanent collection, evaluated from a late 20th-century point of view, will explore the changes in brushwork, spatial constructs, and color experimentation that defined painting as a medium.

ART OF THE ANCIENT WORLDS — From the permanent collection, a selection of ancient sculpture, vases, artifacts, and jewelry from Greece, Rome, Egypt, the Near East, Southeast Asia and the Americas.

08/24/96–06/29/97 — DREAMS AND REALITY: CHARLES PRENDERGAST AND THE ART OF THE 1940'S — From the permanent collection paintings, drawings, prints and photographs by Prendergast, an artist whose unique style was outside of the mainstream of the art of his time, will be seen in an exhibit with comparative works by Norman Rockwell, Henry Moore and others. Dates Tent!

10/26/96–02/23/97 — LESSONS FOR LOOKING AT WOMEN: SELECTIONS FROM THE PERMANENT COLLECTION — Issues of femininity, power, and powerlessness will be addressed in the 25 objects on view which were chosen for the specific purpose of stimulating conversation about women's issues.

11/30/96–02/02/97 — LIVING WITH AIDS: A PHOTOGRAPHIC JOURNAL BY SAL LOPES — Intimate yet powerful and compassionate photographs by Boston photographer Lopes, portray life with AIDS by not only showing patients, but also the people who care for them. WT

12/21/96–03/16/97 — FABRIC OF LIFE: THE PHOTOGRAPHS OF JOHN SMART — Monumental, technically brilliant, and visually stunning landscape portraits of Montana will be featured in the 75 works on view by photographer John Smart. Some of his earliest images taken in Nepal, India and the Midwest will also be shown. WT

01/11/97–SUMMER/97 — LABELTALK — 3 or 4 Williams professors will comment on and interpret 8 specially selected non-Western works from the permanent collection. Dates Tent! BROCHURE

02/01/97–LATE/97 — PEGGY DIGGS (Working Title) — A one-person show of the work of Williams professor Diggs. Dates Tent!

02/22/97–05/97 — GODS AND HEROS (Working Title) — A presentation of images from mythology in art from ancient times to the present. Dates Tent!

MID/97–06/15/97 — SPANISH ART FROM THE PERMANENT COLLECTION (Working Title)

04/05/97–06/15/97 — ARTWORKS: KATHLEEN GILJE - CONTEMPORARY RESTORATIONS — Utilizing her experience as an old master painting restorer who has worked in the conservation departments at the Met and the Prado, Gilje imbues her own works of revitalized famous imagery with elements of contemporary culture. Thus, the 25 works on view which she calls "contemporary restorations," all have surprising elements of imagery within what appear at first to be reproductions of the masters. Dates Tent!

07/01/97–11/01/97 — AMERICAN NAIVE PAINTINGS FROM THE NATIONAL GALLERY OF ART — 35 19th-century paintings featuring portraits, landscapes, and genre scenes by both unknown and well established artists from diverse backgrounds, will be on view. WT

08/97–12/97 — GRAPHIC PERSUASION: THE MECHANICAL AGE: SELECTIONS FROM THE MERRILL C. BERMAN COLLECTION — 250 posters, billboards, rare collages, paste-ups and maquettes from the 1920's & 30's (considered the golden age of design) will be featured in an exhibition that explains how these works led to the develpoment of present-day marketing tactics. Dates Tent!

08/16/97–10/26/97 — MODEL CULTURE: JAMES CASEBERE PHOTOGRAPHS 1975-1995 — In the first mid-career survey of his work, 50 two-dimensional photographic images of three-dimensional sculptures created by Casebere, that comment on the cultural stereotypes of the human environment, will be featured along with four of his light boxes of back-lit transparencies. WT

MASSACHUSETTS

Worcester

Iris & B. Gerald Cantor Art Gallery
Affiliate Institution: College of Holy Cross
1 College St., **Worcester, MA 01610**
☎ 508-793-3356
HRS: 10-4 M-F, 2-5 Sa & S; Summer hours by appointment HOL: ACAD!
&: Y ℗ Y; Free
PERM/COLL: SCULP; CONT/PHOT; 10 RODIN SCULPTURES

Five to seven exhibitions are mounted annually in this Gallery with themes that focus on contemporary art, art historical and social justice topics, and student work.

Worcester Art Museum
55 Salisbury St., **Worcester, MA 01609-3196**
☎ 508-799-4406
HRS: 11-4 W-F, 10-5 Sa, 11-5 S; Closed S JUL & AUG; CLOSED 8/18-8/31 DAY CLOSED: M, Tu HOL: 7/4, THGV, 12/25
F/DAY: 10-12 Sa ADM: Y ADULT: $6.00 CHILDREN: F (12 & under) STUDENTS: $4.00 SR CIT: $4.00
&: Y; Restrooms & some galleries; wheelchairs available on request ℗ Y; Free parking in front of museum and along side streets; handicapped parking at the Hiatt Wing entrance off Tuckerman Street. MUS/SH: Y
🍴 Y; Cafe 11:30-2 Tu-Sa (CATR! ext. 255); Closed S Jul & Aug
GR/T: Y GR/PH: CATR! ext. 3076 DT: Y TIME: 2:00 most S Sep-May; 2:00 Sa S/G: Y
PERM/COLL: AM: 17-19; JAP: gr; BRIT: 18-19; FL: 16-17; GER: 16-17; DU: 17; P/COL; AN/EGT; OR: sculp; MED: sculp; AM: dec/art

Located in central Massachusetts, The Worcester Art Museum, founded in 1896, contains more than 30,000 works of art spanning 5,000 years of creative spirit. It is the second largest art museum in New England, and was one of the first museums in the country to exhibit and collect photographs as fine art. The museum features outstanding wall text for much of its permanent collection. PLEASE NOTE: Small folding stools are available for visitors to use in the galleries. Also, hours of operation may be changing, so call ahead to verify. **NOT TO BE MISSED:** Antiochan Mosaics ; American Portrait miniatures

ON EXHIBIT/97:

11/16/96–02/12/97	AMERICA THE BEAUTIFUL, PART II — Prints by Grant Wood will be featured with those of his colleagues John Stuart Curry, Thomas Hart Benton and others.
02/01/97–04/13/97	MODERN CZECH PHOTOGRAPHY
03/16/97–08/17/97	MATT MATTUS: LURE
06/14/97–08/17/97	KEIJI SHINOHARA: INTERPRETATIONS IN WOODCUT
08/23/97–10/19/97	AFTER THE PHOTO - SECESSION: AMERICAN PICTORIAL PHOTOGRAPHY, 1910-1955 — 150 photographs documenting the social and artistic development of this pictorial medium between the World Wars will be featured in the first major exhibition to focus on this subject. WT
10/04/97–01/03/98	AMERICAN IMPRESSIONISTS

Ann Arbor

The University of Michigan Museum of Art
525 S. State St. at S. Univ., **Ann Arbor, MI 48109**
☎ 313-764-0395
HRS: 10-5 Tu-Sa, till 9 T, 12-5 S; SUMMER HOURS: 11-5 Tu-Sa, 12-5 S DAY CLOSED: M HOL: 1/1, 7/4, THGV, 12/25
&: Y; North museum entrance & all galleries; limited access to restrooms
Ⓟ Y; Limited on-street parking with commercial lots nearby MUS/SH: Y
GR/T: Y GR/PH: CATR! DT: Y TIME: 12:10-12:30 T; 2 PM S
PERM/COLL: CONT; gr, phot; OM; drgs 6-20; OR; AF; OC; IS

This museum, which houses the second largest art collection in the state of Michigan, also features a changing series of special exhibitions, family programs, and chamber music concerts. With over 12,000 works of art ranging from Italian Renaissance panel paintings to Han dynasty Tomb figures, this university museum ranks among the finest in the country. **NOT TO BE MISSED:** Works on paper by J. M. W. Whistler

ON EXHIBIT/97:

ONGOING	PERSONAL FAVORITES — Artworks from the collection chosen for viewing by Museum staff, faculty, and students and by members of the community at large.
	A CLOSER LOOK — Major recent acquisitions, newly conserved objects and recent research discoveries are highlighted in a series of featured works that change approximately every 8 weeks.
07/20/96–02/97	COMMON GROUND: AFRICAN ART AND AFFINITIES — A provocative display representing works of African, Asian and Western traditions that allows the visitor to compare and contrast one with the other.
09/21/96–01/12/97	VENICE, TRADITIONS TRANSFORMED: PAINTINGS FROM THE SARAH BLAFFER FOUNDATION AND THE UNIVERSITY OF MICHIGAN — Venice comes to life in this exhibition of 16th and 18th-century masterpieces.
11/02/96–01/05/97	IMAGES d'ÉPINAL — Enchanting 18th to 20th-century color prints from the town of Épinal, France will be on exhibit.
02/01/97–05/04/97	THE MUSEUM COLLECTS: RECENTLY ACQUIRED 20TH-CENTURY WORKS ON PAPER
02/01/97–03/16/97	ELLEN DRISCOLL — Featured will be works by Driscoll, a Boston-based sculptor and installation artist in residence at the University of Michigan.
02/08/97–04/13/97	MICHIGAN COLLECTORS — In honor of the Museum's 50th anniversary, a wonderful sampling of exceptional artworks will be on loan from private collectors, all of whom have ties to the University or the State.
03/29/97–06/01/97	FLOATING PICTURES — Japanese ukiyo-e or woodblock prints will be on exhibit.

Battle Creek

Art Center of Battle Creek
265 E. Emmett St., **Battle Creek, MI 49017-4601**
☎ 616-962-9511
HRS: 10-5 Tu-F; 1-4 Sa.S DAY CLOSED: M HOL: LEG/HOL, AUG
&: Y Ⓟ Y; 70 spaces; handicapped access at building GR/PH: CATR!
PERM/COLL: REG

This active arts institution, dedicated to the promotion of the works of artists native to Michigan, both exhibits and promotes touring exhibitions of their works.

ON EXHIBIT/97:

12/14/96–01/26/97	PUPPETS — Interesting and unusual puppets from around the world will be on view.

MICHIGAN

Art Center of Battle Creek - continued

02/01/97–03/09/97	LITTLE GEMS OF AMERICAN PAINTING FROM THE MANOOGIAN COLLECTION — On loan from one of the most distinguished collections of American art in the country will be 30 19th-century American paintings that may be small in size but are nonetheless important landscape, genre, still-life and impressionist gems by such notable artists as William Merritt Chase, Martin Heade, William Harnett, and others. WT
02/01/97–03/09/97	ARTISTS OF EVANSVILLE, INDIANA — An exhibit of paintings by Jennifer DeBlock, Carolyn Roth, and Katheryn Waters, contemporary artists from Indiana.
03/15/97–04/20/97	LESS IS MORE — Contemporary artists explore the ideal of simplicity.
03/15/97–04/20/97	KAY RANDELS RETROSPECTIVE — Paintings covering Randels' 40 year career will be on exhibit.
06/14/97–07/27/97	MICHIGAN ARTISTS THEME COMPETITION
09/03/97–10/12/97	LIVING TRADITIONS: MEXICAN FOLK ART — Historic and contemporary works will be featured in this traveling exhibition. WT
10/25/97–12/07/97	50TH MICHIGAN WATERCOLOR SOCIETY SHOW
12/17/97–01/25/98	THE MYSTICAL ART OF TIBET

Bloomfield Hills

Cranbrook Academy of Art Museum

1221 North Woodward Ave., **Bloomfield Hills, MI 48013-0801**
☎ 810-645-3323
HRS: 10-5 W-Sa, till 9 PM T, Noon-5 S DAY CLOSED: M, Tu HOL: LEG/HOL!
ADM: Y ADULT: $4.00 CHILDREN: F (under 7) STUDENTS: $2.00 SR CIT: $2.00
&: Y; Wheelchair accessible ℗ Y; Ample free parking adjacent to museum MUS/SH: Y
GR/T: Y GR/PH: CATR! (tours 1-5 W & F) DT: Y TIME: 10:30, 11, 1:30, 2, 3, 3:30, 7, 7:30 T; 1:30, 2, 3, 3:30 Sa, S
H/B: Y; Designed by noted Finnish-Amer. architect, Eliel Saarinen S/G: Y
PERM/COLL: ARCH/DRGS; CER; PTGS; SCULP; GR 19-20 ; DEC/ART 20

The newly restored Saarinen House, a building designed by noted Finnish-American architect Eliel Saarinen, is part of Cranbrook Academy, the only institution in the country devoted to graduate education in the arts. In addition to outdoor sculpture on the grounds surrounding the museum, the permanent collection includes important works of art that are influential on the contemporary trends of today. PLEASE NOTE: Call ahead for specific information on tours and admission fees for Cranbrook House, The Cranbrook Gardens, and Cranbrook Art Museum at 810-645-3149; and for Saarinen House 810-645-3323. **NOT TO BE MISSED:** Works by Eliel Saarinen; carpets by Loja Saarinen

ON EXHIBIT/97:

10/21/96–06/29/97	YOUNG CURATORS EXPLORE ART: A MUSEUM/COMMUNITY COLLABORA-TION — 4th-grade students from metropolitan Detroit schools will act as curators of works from the museum's collection in a variety of interpretative projects including writing wall text labels. This is the 3rd in a series of innovative programs designed to cultivate a working relationship between the museum and the scholastic community.
01/24/97–03/29/97	A VISUAL ESSAY BY BILL HARRIS — The second in a series, this exhibition curated by playwright/professor Harris, combines contemporary literature with works from the Art Museum's permanent collection.
01/24/97–03/29/97	BEING AND TIME: THE EMERGENCE OF VIDEO PRODUCTION — 6 room-sized installations of projected video by acknowledged masters, Gary Hill, Bruce Nauman and Bill Viola will be presented with those of 3 younger artists in an exhibition designed to challenge the limits of the medium. WT

214

Detroit

The Detroit Institute of Arts
5200 Woodward Ave., **Detroit, MI 48202**
☎ 313-833-7900 WEB ADDRESS: http://www.dia.org
HRS: 11-4 W-F; 11-5 Sa, S DAY CLOSED: M, Tu HOL: LEG/HOL!
SUGG/CONT: Y ADULT: $4.00 CHILDREN: $1.00 STUDENTS: $1.00
♿: Y; Wheelchairs available at barrier free Farnsworth Entrance! 833-9754 Ⓟ Y; Underground parking at the science center across the street (fee charged); metered street parking MUS/SH: Y
⊪ Y; Kresge Court Cafe (833-1932), American Grille (833-1857)
GR/T: Y GR/PH: CATR! 313-833-7981 DT: Y TIME: 1:00 W-Sa; 1 & 2:30 S
PERM/COLL: FR: Impr; GER: Exp; FL; ptgs; AS; EGT; EU: 20; AF; CONT; P/COL; NAT/AM; EU: ptgs, sculp, dec/art; AM: ptgs, sculp, dec/art

With holdings that survey the art of world cultures from ancient to modern times, The Detroit Institute of Arts, founded in 1885, ranks fifth among the nation's fine art museums. **NOT TO BE MISSED:** "Detroit Industry" by Diego Rivera, a 27 panel fresco located in the Rivera court.

ON EXHIBIT/97:

11/27/96–01/26/97	YOUSUR KARSH: SIXTY YEARS — 49 never before seen images of famous people for which he is best known will be among the 120 vintage photographs on view in this exhibit. WT
12/04/96–02/09/97	JEWELRY FROM THE COLLECTIONS — A presentation of jewelery from the permanent collection ranging from Bronze Age examples to present day peices.
12/11/96–02/09/97	RUTH BERNHARD AT 90: KNOWN AND UNKNOWN — A look at Bernhard's 60 year career includes vintage material from the artist's own archives and examples of the transcendent nudes for which she is best known. WT
01/18/97–03/09/97	WATERCOLOR SOCIETY 50TH ANNIVERSARY — A display of watercolors celebrating the 50th anniversary of this juried exhibition.
02/13/97–04/20/97	EARLY TWENTIETH-CENTURY GERMAN PRINTS FROM THE PERMANENT COLLECTION — Several drawings will be on view in addition to 70 prints by Emil Nolde, Kathe Kollwitz, Max Beckmann, Lovis Corinth and others.
03/01/97–04/27/97	DISCOVERING ELLIS RULEY — On view in this first-time retrospective will be over 60 folk artworks by Ruley, a self-taught African-American artist unknown in his lifetime, whose paintings were inspired by animals in the woods, and were created by using ordinary house paint on posterboard. WT
03/08/97–06/01/97	IMAGES IN IVORY: PRECIOUS OBJECTS OF THE GOTHIC AGE — Religious statuettes, relief diptychs & triptychs containing biblical themes, and a wide range of decorative objects will be featured in an exhibition that traces the development of medieval ivory carving. WT
04/27/97–07/06/97	HARRY CALLAHAN — Focusing on the exploration of photographic possibilities, this exhibition of 125 works includes innovative examples created through the manipulation of multiple images, collage, and extreme contrast by Callahan, an American artist known for his remarkable contribution to the medium. CAT WT ∩
05/01/97–07/27/97	THE PEN IS MIGHTIER...CALLIGRAPHY IN ISLAMIC ART AT THE DIA
06/15/97–09/07/97	SOL LeWITT PRINTS 1970-1995 — Intaglio woodcuts, lithographs and screen prints will be seen in an exhibition detailing how LeWitt has given his wall motifs a second life in prints. WT
11/02/97–01/11/98	JOSEF SUDEK: THE PIGMENT PRINTS 1947-1954 WT
11/16/97–01/18/98	THE WEALTH OF THE THRACIANS — More than 200 magnificent gold and silver objects dating from 1200 to 400 B.C. will be featured in an exhibition that lends credence to the life and legends of ancient Thrace. CAT WT

MICHIGAN

East Lansing

Kresge Art Museum
Affiliate Institution: Michigan State University
East Lansing, MI 48824-1119
☎ 517-355-7631
HRS: 9:30-4:30 M-W, F; Noon-8 T; 1-4 Sa, S; Summer: 11-4 M-F; 1-4 Sa, S
HOL: LEG/HOL! ACAD! CLOSED 7/28 - 9/1/97 AND 11/27 - 11/30/97
VOL/CONT: Y &: Y; Barrier free; snow melt system in sidewalk; wheelchairs available
Ⓟ Y; Small fee at designated museum visitor spaces in front of the art center. MUS/SH: Y (small)
GR/T: Y GR/PH: CATR! S/G: Y
PERM/COLL: GR 19-20; AM: cont/ab (1960'S), PHOT

Founded in 1959, the Kresge, with over 4,000 works ranging from prehistoric to contemporary, is the only fine arts museum in central Michigan. PLEASE NOTE: Due to pending revonation the museum may be closed for periods of time during 1997. Please call ahead to comfirm hours of operation and all exhibitions! **NOT TO BE MISSED:** "St. Anthony" by Francisco Zuberon; "Remorse" by Salvador Dali; Contemporary collection

ON EXHIBIT/97:

01/08/97–03/16/97	JUXTAPOSITIONS: SELECTIONS FROM THE KRESGE ART MUSEUM COLLECTION
05/11/97–07/25/97	ART AND SPORTS: IMAGES TO HERALD THE OLYMPIC GAMES — From the Amateur Athletic Foundation of Los Angeles, this exhibition features 30 Parisian posters (1900 to the present) dedicated to the art and history of Olympic posters.
05/11/97–07/25/97	ON THE ROAD: ART AND THE AUTOMOBILE — From realist and photo-realist to semi-abstract, this exhibition of over 40 prints, drawings and photos examines the impact of the revolution of the car in modern culture and artistic expression. TENT! WT
10/26/97–12/19/97	THE PRINTS OF JOHN deMARTELLY — Best known for his regionalist images, deMartelly's early and late works will be on view for the first time in this retrospective exhibition. WT
10/26/97–12/19/97	ZIMBABWE STONE SCULPTURES — 25 stone works from MSU and private collections will be on exhibit.

Flint

Flint Institute of Arts
1120 E. Kearsley St., **Flint, MI 48503**
☎ 810-234-1695
HRS: 10-5 Tu-Sa, 1-5 S DAY CLOSED: M HOL: LEG/HOL!
&: Y Ⓟ Y; Free parking adjacent to the building MUS/SH: Y GR/T: Y GR/PH: CATR! 3 weeks ahead
PERM/COLL: AM: ptgs, sculp, gr 19-20; EU: ptgs, sculp, gr 19-20; FR/REN: IT/REN: dec/art; CH; cer, sculp

In addition to the permanent collection with artworks from ancient China to modern America, visitors to this museum can enjoy the recently renovated building itself, a stunning combination of classic interior gallery space housed within the walls of a modern exterior. **NOT TO BE MISSED:** Bray Gallery of French & Italian Renaissance decorative arts

ON EXHIBIT/97:

01/19/97–03/16/97	CATHERINE SMITH: INSTALLATION ARTIST
03/31/97–05/11/97	PAINTERS OF THE GREAT LAKES SCENE: HIGHLIGHTS FROM THE INLANDER COLLECTION
05/25/97–07/13/97	ART FROM THE DRIVER'S SEAT: AMERICANS AND THEIR CARS FROM THE TERRY & EVA HERNDON COLLECTION — Paintings, drawings, photographs and etchings from the Terry and Eva Herndon Collection will be featured in an exhibition that allows the visitor to look into the rear view mirror at the history of America's relationship with the automobile. CAT WT

Grand Rapids

Calvin College Center Art Gallery
Affiliate Institution: Calvin College
Grand Rapids, MI 49546
☎ 616-957-6326
HRS: 9-9 M-T, 9-5 F, Noon-4 Sa DAY CLOSED: S HOL: ACAD!
&: Y; Barrier-free ℗ Y; Adjacent outdoor parking
GR/T: Y GR/PH: Available upon request DT: Y TIME: Available upon request
PERM/COLL: DU: ptgs, drgs 17-19; GR, PTGS, SCULP, DRGS 20

17th & 19th-century Dutch paintings are one of the highlights of the permanent collection.

ON EXHIBIT/97:

01/09/97–02/01/97	NATIVE-AMERICAN ARTIST SALLY THIELEN
02/08/97–03/08/97	OVERVOORDE KNUST FEEST — An invitational celebrating cultural diversity and honoring the retirement of Chris Stoffel Overvoorde.
03/27/97–04/12/97	SOUTHEAST ASIAN EXHIBITION

Grand Rapids Art Museum
155 N. Division, **Grand Rapids, MI 49503**
☎ 616-459-4677
HRS: 12-4 Tu, Sa, S; 10-4 W, F; 10-9 T DAY CLOSED: M HOL: LEG/HOL!
F/DAY: 5-9 T ADM: Y ADULT: $3.00 CHILDREN: F (under 5) STUDENTS: $1.00 SR CIT: $1.50
&: Y ℗ Y; Less than 1 block from the museum MUS/SH: Y
GR/T: Y GR/PH: CATR! H/B: Y; Beaux Arts Federal Building
PERM/COLL: REN: ptgs; FR: ptgs 19; AM: ptgs 19-20; GR; EXP/PTGS; PHOT; DEC/ART

Located in a renovated Federal Style Building, the Grand Rapids Art Museum, founded in 1911, exhibits paintings and prints by established and emerging artists, as well as photographs, sculpture, and a collection of furniture & decorative arts from the Grand Rapids area and beyond. **NOT TO BE MISSED:** "Harvest" by Karl Schmidt-Rottluff; "Ingleside" by Richard Diebenkorn, and other works by Alexander Calder, Childe Hassam, Max Pechstein, Grach Hartigan, and Christo.

ON EXHIBIT/97:

01/18/97–03/09/97	SIDE BY SIDE: ARTISTS AND STUDENTS SHARING VISIONS — A presentation of artwork by local African-American artists will be presented with those created by the children they mentored.
02/01/97–05/04/97	COME AND BE HEARD: VISUAL RESPONSES TO WOMEN'S ISSUES — Artworks by women that address social and political issues will be featured in this juried exhibition. Dates Tent!
02/08/97–04/27/97	IMPACT: THE PSYCHOLOGY OF COLOR — A multi-media exhibition of permanent collection works grouped according to color.
04/97–10/97	COVER THE BASES — A juried exhibition of artworks submitted for the cover of the Whitecaps minor league baseball team souvenir program.
06/06/97–08/08/97	FESTIVAL '97 — A full range of media will be seen in the 150 artworks by West Michigan artists selected for presentation in this juried exhibition. Dates Tent!
08/16/97–10/19/97	JOSEPH KINNEBREW TODAY — Famous for his "Fish Ladder on the Grand River," this exhibition presented in conjunction with the Meijer Botanic Gardens, highlights the works of sculptor Joseph Kinnebrew. Dates Tent!
09/97	FRANCOISE GILOT: WORKS FROM THE PERMANENT COLLECTION Dates Tent!
11/16/97–02/98	PERUGINO — 30 of Perugino's Renaissance masterpieces on loan from the Gallerie Nazionale in Perugia, Italy and major American museums will be featured in the only U.S. venue for this exhibition. ONLY VENUE

MICHIGAN

Kalamazoo

Kalamazoo Institute of Arts
314 South Park St., **Kalamazoo, MI 49007**
☎ 616-349-7775
HRS: SEP-MAY: 10-5 Tu-Sa, 1-5 S; JUN-JUL: 10-5 Tu-Sa DAY CLOSED: M HOL: LEG/HOL!
♿: Y Ⓟ Y; More that 100 free parking spaces MUS/SH: Y S/G: Y
PERM/COLL: AM: sculp, ptgs, drgs, cer, gr, phot 20

The Kalamazoo Institute, established in 1924, is best known for its collection of 20th-century American art. More than 2,500 objects are housed in a building that in 1979 was voted one of the most significant structures in the state. PLEASE NOTE: The galleries will be closed after 5/97 for renovation and construction. **NOT TO BE MISSED:** "La Clownesse Aussi (Mlle. Cha-U-Ka-O)" by Henri de Toulouse Lautrec; "Sleeping Woman" by Richard Diebenkorn; "Simone in a White Bonnet" by Mary Cassatt

ON EXHIBIT/97:

12/07/96–02/06/97	INLANDER COLLECTION OF REGIONAL PAINTING
12/14/96–02/06/97	SCULPTURAL FORM: MICHIGAN ARTISTS
01/04/97–LATE/97	REGIONALIST PRINTS FROM THE PERMANENT COLLECTION
02/08/97–03/30/97	HOLOGRAPHY: WORKS BY DOUG TYLER
02/14/97–03/16/97	1997 KALAMAZOO AREA SHOW
03/21/97–05/11/97	LITTLE GEMS OF AMERICAN PAINTING FROM THE MANOOGIAN COLLECTION — On loan from one of the most distinguished collections of American art in the country will be 30 19th-century American paintings that may be small in size but are nonetheless important landscape, genre, still-life and impressionist gems by such notable artists as William Merritt Chase, Martin Heade, William Harnett, and others. WT

Muskegon

Muskegon Museum of Art
296 W. Webster, **Muskegon, MI 49440**
☎ 616-722-2600
HRS: 10-5 Tu-F; Noon-5 Sa, S DAY CLOSED: M HOL: LEG/HOL!
VOL/CONT: Y
♿: Y; Fully accessible; parking, elevators, restrooms
Ⓟ Y; Limited street and adjacent mall lots; handicapped parking at rear of museum MUS/SH: Y GR/T: Y GR/PH: CATR!
PERM/COLL: AM: ptgs, gr 19-early 20; EU: ptgs; PHOT; SCULP; OM: gr; CONT: gr

The award winning Muskegon Museum, which opened in 1912, and has recently undergone major renovation, is home to a permanent collection that includes many fine examples of American and French Impressionistic paintings, Old Master through contemporary prints, photography, sculpture and glass. **NOT TO BE MISSED:** American Art Collection

ON EXHIBIT/97:

11/22/96–02/23/97	RECENT ACQUISITIONS FROM THE PERMANENT COLLECTION
01/12/97–03/02/97	IMAGES OF EVERYMAN: MICHIGAN ARTIST KIRK NEWMAN — Noted Michigan artist Newman's signature aluminum & bronze whimsical but exaggerated sculptural depictions of the human form will be on display with lithographs, etchings and photographs that reveal his artistic process.
01/12/97–03/02/97	THE NATURE OF THE PRINT: MICHIGAN ARTIST LADISLAV HANKA — An avid naturalist, Hanka combines art and biology in the creation of the prints featured in this exhibition.

Muskegon Museum of Art - continued

03/16/97–05/11/97	ACTION ADVENTURES: THE COMIC BOOK ART OF SCOTT ROSEMA — The artistic evolution of the comic book hero from inception to published image will be highlighted in the works on view by Rosema, the Museum's artist-in-residence whose inspiration in the development of such well-known characters as X-Man and Batman has been drawn from Greek mythology and the works of Hogarth and Dürer.
03/16/97–05/11/97	GLASS FROM THE PERMANENT COLLECTION — From 19th-century Tiffany lamps to 20th-century contemporary works by glass master Dale Chihuly, this eclectic exhibition showcases art glass selected from the vast holdings of the Museum.
06/01/97–08/22/97	69TH ANNUAL WEST MICHIGAN REGIONAL COMPETITION
06/01/97–08/18/97	SUSAN AARON-TAYLOR: MICHIGAN SCULPTOR

Petoskey

Crooked Tree Arts Council

461 E. Mitchell St., **Petoskey, MI 49770**
☎ 616-347-4337
HRS: 10-5 M-Sa (Spring, Fall, Winter); 10-5 M-Sa & 11-3 S (Summer) HOL: LEG/HOL!
&: Y ℗ Y; 60 parking spaces on city lot next door to museum MUS/SH: Y H/B: Y; 1890 Methodist Church
PERM/COLL: REGIONAL & FINE ART

This fine arts collection makes its home on the coast of Lake Michigan in a former Methodist church built in 1890.

Rochester

Meadow Brook Art Gallery

Affiliate Institution: Oakland University
Rochester, MI 48309-4401
☎ 810-370-3005
HRS: 1-5 W; 2-6:30 Sa, S (7-8:30 Tu-F theater performance days) DAY CLOSED: M
&: Y ℗ Y; Free S/G: Y
PERM/COLL: AF; OC; P/COL; CONT/AM: ptgs, sculp, gr; CONT/EU: ptgs, gr, sculp

Located 30 miles north of Detroit on the campus of Oakland University, the Meadow Brook Art Gallery offers four major exhibitions annually. **NOT TO BE MISSED:** African art collection, a gift from the late governor of Michigan, G. Mennen Williams

ON EXHIBIT/97:

12/08/96–02/09/97	18TH AND 19TH CENTURY EUROPEAN PAINTINGS FROM THE TADEUSZ MALINSKI COLLECTION
03/01/97–04/13/97	FAMILIAR FACES AND PLACES: RECENT PAINTINGS BY KIICHI USUI

Saginaw

Saginaw Art Museum

1126 N. Michigan Ave., **Saginaw, MI 48602**
☎ 517-754-2491
HRS: 10-5 Tu-Sa, 1-5 S DAY CLOSED: M HOL: LEG/HOL!
VOL/CONT: Y
&: Y; Ramp at front door; only first floor is accessible ℗ Y; Free
GR/T: Y GR/PH: CATR! H/B: Y; former 1904 Clark Lombard Ring Family Home
PERM/COLL: EU: ptgs, sculp 14-20; AM: ptgs sculp; OR: ptgs, gr, dec/art; JAP: GR; JOHN ROGERS SCULP; CHARLES ADAM PLATT: gr

MICHIGAN

Saginaw Art Museum - continued
The interesting and varied permanent collections of this museum that include an important group of John Rogers sculptures, are housed in a gracious 1904 Georgian-revival building designed by Charles Adam Platt. The former Clark Lombard Ring Family home is listed on the state & federal registers for historic homes. **NOT TO BE MISSED:** Full-scale model of the 28-foot tall Christ on the Cross at Indian River, Mi.

ON EXHIBIT/97:

01/08/97–01/24/97	MASTERPIECE EVENING ARTISTS — A display of artworks donated by local artists for the Museum's annual auction.
01/10/97–02/02/97	NANCY PENNELL — Featured will be paintings and prints by Pennell, winner of the All Area '95 one-person show award.
02/97	NIFTA 10TH ANNIVERSARY SHOW — A traveling exhibition of works by Michigan minority artists.
02/01/97–02/28/97	RICHARD VEENFLIET — Watercolors and postcards by Veenfliet, a 19th-century commercial artist will be featured.
03/01/97–03/31/97	ALL AREA PHOTO SHOW — Winning works by entrants from 27 mid-Michigan counties will be on exhibit.
04/04/97–05/04/97	CAROL COATS: PHOTOGRAPHS — Coats, winner of the All Area Photo '96 one-person show award, creates her photographic works by experimenting with both medium and content.
04/04/97–05/04/97	STREAMS & CHAINS — A traveling group show of works by 7 Michigan contemporary artists.
05/08/97–06/08/97	SHIG IKEDA — Ikeda, a Japanese-born photographer, focuses on ordinary objects as subject matter in order to create works intended to revive the memories and feelings of childhood.
05/08/97–06/08/97	AREA LATINO ARTISTS SHOW — Winning entries in all media by area Latino artists will be featured in the second annual juried show.
06/13/97–07/06/97	JILL EGGERS: PAINTINGS (Working Title) — Paintings and drawings of interiors and still lifes by Eggers. WT
07/11/97–08/03/97	ANSEL ADAMS — Photographs by internationally acclaimed artist Adams will be on loan to this exhibition from the collection of the University of Alabama.
08/07/97–09/21/97	ON THE ROAD: ART AND THE AUTOMOBILE — From realist and photo-realist to semi-abstract, this exhibition of over 40 prints, drawings and photos examines the impact of the revolution of the car in modern culture and artistic expression.
09/05/97–10/03/97	ROSALIE W. VASS — Mixed water media, collage and pencil are used by Vass to create the landscapes, cityscapes and human forms on exhibit.
10/01/97–12/15/97	PURR: CHILDREN'S BOOK ILLUSTRATORS BRAG ABOUT THEIR CATS — Original artworks in many media by 43 of the best known contemporary children's book illustrators. WT
10/10/97–11/02/97	TODD ZIMMERMAN — Zimmerman's watercolor interpretations of historic subjects will be on exhibit.

St. Joseph

Krasl Art Center
707 Lake Blvd., **St. Joseph, MI 49085**
☎ 616-983-0271
HRS: 10-4 M-T & Sa, 10-1 F, 1-4 S DAY CLOSED: F PM HOL: LEG/HOL! & Sa of Blossomtime Parade in early May
&: Y; Ramp, restrooms, elevator Ⓟ Y; Free and ample MUS/SH: Y GR/PH: CATR!
PERM/COLL: SCULP; FOLK

Located on the shores of Lake Michigan, site-specific sculptures are placed in and around the area of the center. Maps showing locations and best positions for viewing are provided for the convenience of the visitor. The center is also noted for hosting one of the Midwest's finest art fairs each July. **NOT TO BE MISSED:** "Three Lines Diagonal Jointed-Wall" by George Rickey

Krasl Art Center - continued
ON EXHIBIT/97:

03/07/97–04/20/97 FLORIBUNDA: ABOUNDING IN BLOSSOMS — Works by outstanding Illinois artists who use flowers as their subject matter will be selected for viewing by Guest Curator Winifred Godfrey.

07/31/97–09/14/97 THE FIGURE IN 20TH CENTURY SCULPTURE — Works by 48 internationally known sculptors Rodin, Maillol, Lachaise, Giacometti, Lipschitz, Neri and others will be included in this stunning 20th-century survey of the interpretation of the human form.
BROCHURE WT

11/20/97–12/30/97 TEMPLE AND VILLAGE: PATTERNS AND PRINTS OF INDIA — On loan from the collection at Iowa State University will be 50 traditionally designed hand-printed, dyed and embroidered Indian textiles that reveal their rich regional diversity. WT

Traverse City

Dennos Museum Center
Affiliate Institution: Northwestern Michigan College
1701 East Front St., **Traverse City, MI 49686**
☎ 616-922-1055
HRS: 10-5 M-Sa, 1-5 S HOL: LEG/HOL!
ADM: Y ADULT: $2.00 CHILDREN: $1.00 STUDENTS: $1.00 SR CIT: $2.00
&. : Y Ⓟ Y; Reserved area for museum visitors adjacent to the museum. MUS/SH: Y
GR/T: Y GR/PH: CATR! S/G: Y
PERM/COLL: Inuit art; CONT: Canadian Indian graphics; AM; EU; NAT/AM

With a collection of more than 575 works, the Dennos Museum Center houses one of the largest and most historically complete collections of Inuit art from the peoples of the Canadian Arctic. The museum also features a "hands-on" Discovery Gallery. **NOT TO BE MISSED:** The Power Family Inuit Gallery with over 860 Inuit sculptures and prints; The Thomas A. Rutkowski interactive "Discovery Gallery"

ON EXHIBIT/97:

12/14/96–03/02/97 ART AND THE AUTOMOBILE — This unusual and exciting four part exhibition consists of paintings by Jay Constantine that explore the freeway and its impact on culture and the landscape, super realist images on paper by Bruce McCombe of classic cars and car parts, a variety of sculptural automobile hood ornaments, and a 1929 fully restored Dussenberg car.

03/08/97–06/01/97 PAPER AS MEDIUM — Works of cast paper, dyed and hand-made paper and artist's books will be seen in an exhibition designed to explore the use of paper as the medium for creating a work of art. TENT!

06/08/97–08/31/97 THE 50TH ANNIVERSARY MICHIGAN WATERCOLOR SOCIETY EXHIBITION

06/08/97–08/31/97 QAMINITTUAQ: WHERE THE RIVER WIDENS - DRAWINGS BY BAKER LAKE ARTISTS

MINNESOTA

Duluth

Tweed Museum of Art

Affiliate Institution: Univ. of Minn.
10 University Dr., **Duluth, MN 55812**
☎ 218-726-8222
HRS: 9-8 Tu, 9-4:30 W-F, 1-5 Sa & S DAY CLOSED: M HOL: ACAD!
SUGG/CONT: Y ADULT: $2.00 CHILDREN: F (under 6) STUDENTS: $1.00 SR CIT: $1.00
&: Y; Barrier free Ⓟ Y MUS/SH: Y
GR/T: Y GR/PH: CATR! 218-726-8222 S/G: Y
PERM/COLL: OM: ptgs; EU: ptgs 17-19; AM 19-20; CONT

Endowed with gifts of American and European paintings by industrialist George Tweed, for whom this museum is named, this fine institution also has an important growing permanent collection of contemporary art. One-person exhibitions by living American artists are often presented to promote national recognition of their work. PLEASE NOTE: The museum offers a reduced suggested contribution of $5.00 per family. **NOT TO BE MISSED:** "The Scourging of St. Blaise," a 16th-century Italian painting by a follower of Caravaggio

ON EXHIBIT/97:

02/02/97–03/29/97	MINNESOTA MASTERS: WOMEN ARTISTS OF THE REGION: SOLVIG JOHNSON, JULIA MARSHALL, VIOLA HART, MILDRED LOESCHER, GENE RITCHIE MONAHAN, GLADYS KOSKI-HOLMES, ELLA LABOVITZ CAT
05/31/97–07/13/97	TWEED CONTEMPORARY ARTISTS SERIES: A REGIONAL SURVEY — Highlighted will be mixed media works by 15-20 regional artists. BROCHURE
07/13/97–09/25/97	ARISTIDE PAPPAS: PAINTINGS AND WORKS ON PAPER — 56 drawings and paintings donated by Greek American artist Pappas to the museum before his death will be on view in an exhibit that features his signature style of elements of formal abstraction combined with highly personal and symbolic content. CAT
08/12/97–11/02/97	ORIENTAL ART: A CONCISE HISTORICAL SURVEY
08/12/97–09/28/97	SUMI-E SOCIETY OF AMERICA ANNUAL EXHIBITION — Works by members of the Sumi-e Society of America, a group dedicated to fostering an appreciation and understanding of Oriental brush painting and calligraphy, will be featured in this juried competition.
10/07/97–12/07/97	ETCHINGS BY ANNA MARIE PAVLIK: FABLES FOR THESE TIMES — Personal family stories and the myths & stories of other cultures will be seen in this series of copperplate etchings by Pavlik.
10/14/97–12/21/97	I ASK YOU: ARTISTS RESPOND TO QUESTIONS ABOUT THE FUTURE OF ELECTRONIC MEDIA — An exhibition concerned with the issues of computers & art, electronic information and new technology.

Minneapolis

Frederick R. Weisman Art Museum at the University of Minnesota

Affiliate Institution: University of Minnesota
333 East River Road, **Minneapolis, MN 55455**
☎ 612-625-9494
HRS: 10-5 Tu, W, F; 10-8 T; 11-5 Sa, S DAY CLOSED: M HOL: ACAD!; LEG/HOL!
&: Y; Fully accessible Ⓟ Y; Paid parking in the building MUS/SH: Y
GR/T: Y GR/PH: CATR! 612-625-9656 H/B: Y; Terra-cotta brick & stainless steel bldg. (1993) by Frank O. Ghery
PERM/COLL: AM: ptgs, sculp, gr 20; KOREAN: furniture 18-19; Worlds largest coll of works by Marsden Hartley & Alfred Maurer (plus major works by their contemporaries such as Feininger & O'Keeffe)

Frederick R. Weisman Art Museum at the University of Minnesota - continued

In 1993, this university museum became the recipient of the new Frederick R. Weisman Art Museum. Mr. Weisman gererously donated the funds for the stunning fantasy building designed by noted architect Frank Ghery, as well as the art from his own outstanding collection. All of the permanent holdings of the University Museum are now housed in this facility. PLEASE NOTE: Walk-in self guided tours entitled "Get It" are always available. **NOT TO BE MISSED:** "Oriental Poppies," by Georgia O'Keeffe

ON EXHIBIT/97:

10/19/96–02/02/97	WORKS FROM THE COLLECTION OF THE FREDERICK R. WEISMAN ART FOUNDATION
11/17/96–01/26/97	DOUBLE VISION: FORTY NORTH AMERICAN METALS ARTISTS — Jewelry created by artists and atrisans working in teams will be featured in this exhibition.
11/17/96–01/26/97	TEXTUS: AN EXHIBITION OF 20TH-CENTURY CALLIGRAPHY — Presented will be contemporary calligraphic works that are unique variations on an ancient art form.
01/24/97–03/16/97	UNIVERSITY OF MINNESOTA DEPARTMENT OF ARCHITECTURE FACULTY JURIED EXHIBITION
01/24/97–03/16/97	BUILDINGS CELEBRATED - CELEBRATED BUILDINGS: FROM THE PERMANENT COLLECTION OF THE WEISMAN ART MUSEUM — Photographs by Bernice Abbott and paintings by Lyonel Feininger & Ernest Lawson will be among the works on view in an exhibition designed to illustrate the built environment.
02/14/97–04/13/97	MASTERPIECEWORK: THE LOUIS SULLIVAN OWATONNA BANK — Presented will be a comprehensive overview of the development and construction of one of this legendary architect's most celebrated buildings located the Minnesota town of Owatonna.
04/04/97–05/25/97	CRITIQUES OF PURE ABSTRACTION — 32 paintings, sculptures, prints, photographs and videos will be featured in an exhibition by 20 artists including Richard Artschwager, John Baldessari, Ross Bleckner, Jonathan Borofsky and others who respond to the ideals of pure abstraction in their works and yet seek to reform it in order to address the demands of contemporary issues. CAT WT
04/25/97–06/18/97	CHINESE PAINTINGS FROM THE COLLECTION OF Y.T. BAY — Examples of Chinese painting and calligraphy from this remarkable collection dating from 1800-1950 will be on view in this student-curated exhibition.
05/01/97–06/01/09	ORGANIC MATTERS: AN INSTALLATION AND RESIDENCY BY IKEBANA MASTER KOSEN OHTSUBO — A major installation of radical, organic sculptures will be created by Ohtsubo based on some of the traditional aesthetics of Ikebana floral arranging.
05/24/97–/98	THE REINSTALLATION OF THE PERMANENT COLLECTION
06/04/97–09/08/97	MARSDEN HARTLEY: THE COLLECTION OF HUDSON AND IONE WALKER — Drawn entirely from the museum's collection which was gifted to them by the Walker's, this retrospective exhibition presents works Hartley, one of the key members of America's first (early 20th-century) avant-garde.
07/11/97–10/06/97	THE WEISMAN SCULPTURE PROJECT: ARTIST KAVEH SHAKIKHAN — Working models, drawings and works related to the installation of Shakikhan's site-specific sculpture for the museum's plaza will be on exhibit.

MINNESOTA

Minneapolis

The Minneapolis Institute of Arts
2400 Third Ave.So., **Minneapolis, MN 55404**
✆ 612-870-3000 WEB ADDRESS: http://www.artsmia.org
HRS: 10-5 Tu-Sa, 10-9 T, Noon-5 S DAY CLOSED: M HOL: THGV, 12/25, 7/4
&: Y ℗ Y; Free and ample MUS/SH: Y ❚❙ Y; Restaurant 11:30-2:30 Tu-S
GR/T: Y GR/PH: CATR! 612-870-3140 DT: Y TIME: 2:00 Tu-S, 1:00 Sa & S, 7 PM T
H/B: Y; 1915 NEO-CLASSIC BUILDING BY McKIM MEAD & WHITE
PERM/COLL: AM: ptgs, sculp; EU: ptgs, sculp; DEC/ART; OR; P/COL; AF; OC; ISLAMIC; PHOT; GR; DRGS; JAP: gr

Distinguished by a broad-ranging 80,000 object collection housed within the walls of a landmark building that combines a 1915 neo-classic structure with 1974 Japanese inspired additions. With the recent completion of a 50 million dollar renovation project, the museum has reinstalled its redesigned 20th-century galleries on the 1st & 2nd floors of the East Wing. PLEASE NOTE: There is a charge for some special exhibitions. **NOT TO BE MISSED:** Rembrandt's "Lucretia"

ON EXHIBIT/97:

10/27/96–01/19/97	POETIC HORIZONS: THE LANDSCAPE TRADITION IN BRITAIN, 1750-1850 (Working Title) — Etchings, mezzotints, preliminary drawings, and watercolors by Turner and other printmakers who were part of, or whose work relates directly to, Turner's "Liber Studiorum" will be seen in this exhibition. Published in groups of five and divided into the specific categories of historical, mountainous, pastoral, marine and architectural, the prints on view may be accompanied by several important paintings by Turner, Constable and Gainsborough on loan from major museums in England and France. ADM FEE
11/08/96–06/29/97	A "GLOVE" AND "INTERMEZZI": MAX KLINGER'S PRINTS OF FANTASY — Portfolios of German artist Klinger's "A Glove" and "Intermezzi" prints of 1881 enable the viewer to realize how these works anticipated the dream-like imagery and macabre themes of future 20th-century surrealism.
11/09/96–06/29/97	THE SCHOLAR'S STUDY: CHINESE ART IN THE LITERATI TRADITION — 50 Ming dynasty (1368-1655) works from the peramnent collection will be on view in an exhibition consisting of objects used by the scholar to create works of art, works produced by literati artists, and works collected by literati artists.
11/23/96–02/23/97	THE COLOR RED: MESSAGES IN TEXTILE ART — Diverse cultural preferences and the meanings of a single color will be explored in an exhibition of textiles on view from the permanent collection.
12/06/96–01/05/97	HOLIDAY TRADITIONS IN THE PERIOD ROOMS
12/13/96–02/02/97	LINDA ROSSI (Working Title) — Illuminated sculpture, video, sound, and still photography by Minnesota artist Rossi, will be installed in her "room of the season" presentation.
01/25/97–04/06/97	LANDMARKS IN PRINT COLLECTING: CONNOISSEURS AND DONORS AT THE BRITISH MUSEUM SINCE 1753 — Drawn entirely from the British Museum's holdings, 100 outstanding prints spanning the history of Western printmaking from rare 15th-century German woodcuts to 20th-century American etchings will be on loan to the U.S. for the very first time. CAT WT
02/08/97–05/04/97	AFTER THE PHOTO - SECESSION: AMERICAN PICTORIAL PHOTOGRAPHY, 1910-1955 — 150 photographs documenting the social and artistic development of this pictorial medium between the World Wars will be featured in the first major exhibition to focus on this subject. CAT WT
03/02/97–05/11/97	DALE CHIHULY: INSTALLATIONS 1964-1995 — In the most comprehensive presentation of his work to date, over 100 fantastic glass creations by this modern American master of the medium will be featured in a spectacular installation that includes "Sea Forms," "Chandelier," and "Floats," 3 of the largest glass spheres ever blown. TENT! CAT WT
04/05/97–08/24/97	"A ROSE WOULD SMELL AS SWEET..." - FLORAL IMAGERY IN TEXTILE ART — From visual abstraction to realistic imagery, this exhibition of textiles focuses on the image of flowers as a color source and as vehicles for symbolism. Dates Tent!

The Minneapolis Institute of Arts - continued

05/10/97–08/10/97 CHRISTOPHER BROWN: WORKS ON PAPER (Working Title) — Paintings and pastels by Brown, a preeminent West Coast artist of national and international stature, will be seen in the first comprehensive survey of his works.

05/31/97–08/24/97 PHOTOGRAPHY PERMANENT COLLECTION EXHIBITION

09/13/97–LATE/97 DYING TO PLEASE: FROM SURFACE APPLICATION TO TOTAL IMMERSION — Textiles selected from the museum's collection will be shown in an exhibition that focuses on the technology of the application of the dye, and its effects on economics, labor and international trade. Dates Tent!

09/20/97–01/98 PHOTOGRAPHS FROM THE COLLECTION OF HARRY DRAKE (Working Title) — 75 photographs by 25 major 20th-century artists will be featured in an exhibition highlighting Drake's personal eye as a collector. More than half of the images on view are by Minor White and represent the most significant collection of his works in private hands. CAT

11/16/97–01/25/98 A PASSION FOR THE PAST: THE COLLECTION OF BERTRAM K. AND NINA FLETCHER LITTLE AT COGSWELL'S GRANT — This superb assemblage of 18th and 19th-century furnishings is being shown for the first, and probably only time, outside rural New England. Collected for their Massachusetts home, these rare objects of remarkable quality reflect the Littles' extraordinary contribution to the study of American decorative arts. ADM FEE WT

11/23/97–02/01/98 THE ARTS OF REFORM AND PERSUASION, 1885-1945 — Furniture, metalwork, ceramics, glass, posters and drawings will be among the 250 objects on loan from the vast collection of propaganda art at The Wolfsonian in Miami Beach, Florida. The intent of the exhibition is to explore the ways in which various elements of design from 1885-1945 functioned as key elements of propaganda and modernity in reform movements. WT

Minneapolis

Walker Art Center

Vineland Place, **Minneapolis, MN 55403**
☎ 612-375-7622 WEB ADDRESS: http://www.walkerart.org/
HRS: Gallery: 10-5 Tu-Sa, 11-5 S, till 8 PM T DAY CLOSED: M HOL: LEG/HOL!
F/DAY: T& 1st Sa ADM: Y ADULT: $4.00 CHILDREN: F (under 12)) STUDENTS: $3.00 SR CIT: $3.00
♿: Y Ⓟ Y; Hourly metered on-street parking & pay parking at nearby Parade Stadium lot MUS/SH: Y ❙❙ Y; Sculpture Garden 11:20-3 Tu-S; Gallery 8 Restaurant 11:30-3, till 8 W GR/T: Y GR/PH: CATR! DT: Y TIME: 1 PM Sa, S (Free) S/G: Y
PERM/COLL: AM & EU CONT: ptgs, sculp; GR; DRGS

Housed in a beautifully designed building by noted architect Edward Larabee Barnes, the Walker Art Center, with its superb 7,000 piece permanent collection, is particularly well known for its major exhibitions of 20th-century art. PLEASE NOTE: 1. The sculpture garden is open free to all from 6 AM to midnight daily. There is a self-guided audio tour of the Garden available for rent at the Walker lobby desk. 2. It is suggested that you call ahead (612-375-7693) for information on the various guided group tours of the Museum and Sculpture Garden. **NOT TO BE MISSED:** Minneapolis Sculpture Garden at Walker Art Center (open 6- Midnight daily; ADM F); "Standing Glass Fish" by F. Gehry at Cowles Conservatory (open 10 -8 Tu-Sa, 10-5 S; ADM F)

ON EXHIBIT/97:

10/20/96–02/02/97 THE PHOTOMONTAGES OF HANNAH HÖCH (Working Title) — On view will be a full retrospective of the work of German artist Höch, a pioneer in the field of photocollage. CAT WT

12/08/96–04/04/99 SELECTIONS FROM THE PERMANENT COLLECTION — Drawn from the permanent collection this museum-wide exhibition traces the progression of 20th-century art from early modernist works by Georgia O'Keeffe and Franz Marc, to works of the 40'5 and 50's by Rothko, Still and Noguchi, followed by abstract minimalist works by Donald Judd & Sol Lewitt, pop art by Andy Warhol & Claes Oldenburg, and art of the Italian Arte Povera artists. Representing the aftermath of the high modernist movement in the final portion of the show will be works by Polke, Nauman, members of the Fluxes group, and new & emerging talents.

MINNESOTA

Walker Art Center - continued

02/02/97–04/29/97	MARK LUYTEN — In celebration of the completion of Belgian artist Luyton's project linking the Minneapolis Sculpture Garden to the Walker's indoor spaces, the exhibition will include a full range of the artist's drawings, photographs, video, and other objects that summarize this 2 year project. CAT
03/09/97–06/08/97	NO PLACE (LIKE HOME) — With the modern world becoming increasingly more mobile, the notion of "home" is no longer linked to national and cultural boundaries. This exhibition by eight contemporary artists from across the globe expresses in their found-object sculptural creations their subverted reactions to their new sense of place.
05/18/97–08/24/97	FRANK STELLA AND KENNETH TYLER: A UNIQUE COLLABORATION (Working Title) — Marking the 30th anniversary collaboration between Stella and master printer Tyler, this exhibition examines the technological innovations produced as the result of their close working relationship. In addition to a "case study" of the stages in making a single print, collages, large-scale paintings and templates for new three-dimensional works will be on view. ONLY VENUE CAT
09/21/97–12/21/97	JOSEPH BEUYS MULTIPLES (Working Title) — 250 multiples created by Beuys from 1965-1985 will be on view in their first public presentation. Organized in thematic sections the works reveal key concepts in his work of Nature, Communication, and Teaching & Learning. An in-gallery Information Office for this exhibition will allow the visitor to participate in discussions, watch videos on the artist, read catalogs, or attend gallery talks. CAT WT
10/29/97–01/18/98	THE ARCHITECTURE OF REASSURANCE: DESIGNING DISNEY'S THEME PARKS — Plans, posters, models, drawings and paintings from Walt Disney's "Imagineering" department, used by them since the 1950's in the development of their theme parks will be seen in an exhibition that reveals how their idealized architecture acted as a harbinger that gave rise to the culture of the modern American shopping center and its inherent impact on the nature of consumerism. CAT

Moorehead

Plains Art Museum
521 Main St., **Moorehead, MN 56560**
📞 701-293-0903
HRS: 10-5 Tu-Sa, Noon-5 S, till 9 PM T DAY CLOSED: M HOL: 12/25, 1/1, 7/4, MEM/DAY, LAB/DAY, THGV
♿: Y; Elevator Ⓟ Y; Free on-street parking in front of the museum MUS/SH: Y
GR/T: Y GR/PH: call 218-236-7383 H/B: Y; 1915 Old Post Office Building (member NRHP)
PERM/COLL: AM/REG; NAT/AM; AF; PHOT 20

Located on the western border of the state near Fargo, North Dakota, the 1915 Classical Revival style building that houses the Plains Museum was used, until 1958, as a Federal Post Office building.

St. Paul

Minnesota Museum of American Art
Landmark Center-Fifth & Market, **St. Paul, MN 55102-1486**
📞 612-292-4355
HRS: 11-4 Tu-Sa, 11-7:30 T, 1-5 S DAY CLOSED: M HOL: LEG/HOL!
SUGG/CONT: Y ADULT: $2.00
♿: Y; Elevator; restroom; special entrance Ⓟ Y; Street parking and nearby parking facilities
MUS/SH: Y ‖ Y; 11:30-1:30 Tu-F; 11-1 S
GR/T: Y GR/PH: CATR! 612-292-4369 DT: Y TIME: selected Sundays at 1:30! H/B: Y S/G: Y
PERM/COLL: AM; OC; AS; AF

Minnesota Museum of American Art - continued

Begun in 1927 as the St. Paul School of Art, the Minnesota Museum is one of the oldest visual arts institutions in the area. Housed in two historic buildings, the museum's exhibitions focus of the multi-cultural diversity of the Upper Midwest as expressed through the artists of the region. PLEASE NOTE: The museum is usually closed between exhibitions.

ON EXHIBIT/97:

11/10/96–02/02/97 NORWEGIAN FOLK ART: THE MIGRATION OF A TRADITION — From bedroom furniture to ceramic folklore characters, more than 400 years of folk art within the Norwegian cultural tradition will be featured in an exhibition that highlights the continuity of that tradition between the people of Norway and their compatriots who emigrated to the U.S. and settled in the Upper Midwest. WT

02/22/97–05/18/97 TOWARD DIVERSITY: A DECADE OF COLLECTING BY THE MINNESOTA MUSEUM OF AMERICAN ART

02/22/97–05/18/97 AMERICAN PAINTING FROM THE TWEED MUSEUM OF ART — Hudson River School, Luminist, and Impressionist art works from the permanent collection will be seen in a survey highlighting their unique American characteristics.

06/01/97–08/17/97 SHARED STORIES: EXPLORING CULTURAL DIVERSITY — Original illustrations and manuscripts from the growing field of ethnic children's books by authors of African-American, Asian American, Latin American and Native American descent. Shared Stories promotes cross-cultural understanding and demonstrates diverse cultural identities.

06/01/97–08/17/97 OLD TURTLE: WATERCOLORS BY CHENG-KHEE CHEE — Old Turtle watercolor illustrations that center on the theme of peace on earth.

09/97–10/97 GALLERIES CLOSED FOR RENOVATION AND REINSTALLATION OF THE PERMANENT COLLECTION

09/15/97 CELEBRATING 70 YEARS OF ART IN SAINT PAUL — Selections from the Museum's 4,000 work collection will be presented in an exhibition celebrating the opening of the new Permanent Collection galleries.

11/15/97–02/15/98 REGIONAL INVITATIONAL

MISSISSIPPI

Biloxi

George E. Ohr Arts and Cultural Center
136 George E. Ohr St., **Biloxi, MS 39530**
☏ 601-374-5547
HRS: 9 AM-8 PM M-W, 9-5 T-Sa HOL: 12/25, 1/1, 7/4, THGV
&: Y Ⓟ Y; Free parking in the lot across the street from the museum.
MUS/SH: Y GR/T: Y GR/PH: call ahead to reserve
PERM/COLL: George Ohr pottery

This museum, formerly one of three divisions of the Mississippi Museum of Art, now operates as an independent entity. **NOT TO BE MISSED:** 100 piece collection of pottery by George Ohr, often referred to as the mad potter of Biloxi

Jackson

Mississippi Museum of Art
201 E. Pascagoula St., **Jackson, MS 39201**
☏ 601-960-1515
HRS: 10-5 M-Sa, Noon-5 S DAY CLOSED: S, M HOL: LEG/HOL
F/DAY: Tu & T students only ADM: Y ADULT: $3.00 CHILDREN: $2.00 (F under 3) STUDENTS: $2.00 SR CIT: $2.00
&: Y Ⓟ Y; Pay lot behind museum MUS/SH: Y ⁝⁝ Y; Palette Restaurant (open for lunch 11:30-1:30 M-F)
GR/T: Y GR/PH: CATR!
DT: Y TIME: upon request if available S/G: Y
PERM/COLL: AM: 19-20; REG: 19-20; BRIT: ptgs, dec/art mid 18-early 19; P/COL: cer; JAP: gr

Begun as art association in 1911, the Mississippi Museum now has more than 5,000 works of art in a collection that spans more than 30 centuries. **NOT TO BE MISSED:** "hands -on" Impressions Gallery, housed in a unique stimulating architectural environment

ON EXHIBIT/97:

ONGOING	SELECTIONS FROM THE PERMANENT COLLECTION — A rotating selection of works from all aspects of the permanent collection.
11/09/96–01/11/97	MARY KATHERINE LOYACONO McCRAVEY — A presentation of poetic figure, landscape and still life paintings by Mississippi artist and teacher McCravey. CAT
11/09/96–01/11/97	LEROY ARCHULETA: A TO Z — Charming, brightly colored wooden animals by Hispanic folk artist Archuleta, on loan from the Sylvia & Warren Lowe collection, will be arranged in a fantastical zoo-like gallery setting. CAT WT
01/25/97–04/06/97	A COMMUNION OF THE SPIRITS: AFRICAN AMERICAN QUILTERS, QUILT COLLECTORS AND THEIR STORIES — 100 of Roland L. Freeman's photographs will be featured in an exhibition of his images of quilt makers and quilt collectors, providing an intimate look into the environment in which quilts are created and used. CAT
04/19/97–07/06/97	MISSISSIPPI INVITATIONAL — Art in all media will be seen in an exhibition of works by some of the State's most significant contemporary artists. CAT
07/19/97–09/28/97	HEROIC PAINTING — Heroic acts of daily life will be one of the topics explored in this exhibition dealing with the notion of the "hero" as subject matter in art. CAT WT

Laurel

Lauren Rogers Museum of Art
5th Ave. at 7th St., **Laurel, MS 39440**
☎ 601-649-6374
HRS: 10-4:45 Tu-Sa, 1-4 S DAY CLOSED: M HOL: LEG/HOL!
&: Y; Wheelchair accessible, elevator, restrooms ℗ Y; New lot at rear of museum and along side of the museum on 7th Street
MUS/SH: Y GR/T: T GR/PH: call 601-649-6374 DT: Y TIME: 10-12 & 1-3 Tu-F
PERM/COLL: AM:19-20; EU: 19-20; NAT/AM; JAP: gr 18-19; NAT/AM: baskets; ENG: silver

Located among the trees in Laurel's Historic District, the Lauren Rogers, the first museum to be established in the state, has grown rapidly since its inception in 1922. While the original Georgian Revival building still stands, the new adjoining galleries are perfect for the display of the fine art collection of American and European masterworks. **NOT TO BE MISSED:** Largest collection of Native American Indian baskets in the U.S.; Gibbons English Georgian Silver Collection

Meridian

Meridian Museum of Art
25th Ave. & 7th St., **Meridian, MS 39301**
☎ 601-693-1501
HRS: 1-5 Tu-S DAY CLOSED: M HOL: LEG/HOL!
℗ Y; Free but very limited GR/T: Y GR/PH: CATR! DT: Y TIME: Upon request, if available
PERM/COLL: AM: phot, sculp, dec/art; REG; WORKS ON PAPER 20; EU: portraits 19-20

Housed in the landmark Old Carnegie Library Building built in 1912-13, the Meridian Museum, began in 1933 as an art association, serves the cultural needs of the people of East Mississippi and Western Alabama. **NOT TO BE MISSED:** 18th-century collection of European portraits

ON EXHIBIT/97:

01/04/97–02/01/97	TY DIMIG — Sculpture and ceramics by Dimig, the 1996 Bi-State Best of Show winner.
01/04/97–02/01/97	MARTHA STENNIS — Watercolors
01/04/97–02/01/97	LES THOMPSON — An exhibition of prints & paintings by Thompson, a Mobile, AL artist.
02/08/97–03/15/97	24TH ANNUAL BI-STATE ART COMPETITION
04/26/97–04/19/97	VALERY KOSORUKOV — A presentation of landscapes and ballet-themed paintings by Russian expatriot Kosorukov.
04/26/97–05/31/97	CLAUDIA CARTEE — Cartee's objects of stoneware and raku will be on display.
06/07/97–07/12/97	1997 PEOPLE'S CHOICE ART COMPETITION
07/19/97–08/23/97	ROBIN SMITH NANCE — Watercolors and mixed media works by Nance, a Gulf Coast artist.
08/30/97–10/04/97	MERIDIAN CAMERA CLUB — Outstanding photographs of the year.
08/30/97–10/04/97	ANNABELLE MEACHAM — Meachem's surrealist paintings and prints will be on view.
10/25/97–11/22/97	MISSISSIPPI ART COLONY
10/25/97–11/22/97	BOB DEEN — Featured will be a retrospective of works by Deen, an award-winning photographer.
11/29/97–12/27/97	MUSEUM MEMBERS SHOW

MISSISSIPPI

Ocean Springs

Walter Anderson Museum of Art
510 Washington Ave. P.O Box 328, **Ocean Springs, MS 39566**
☎ 601-872-3164
HRS: 10-5 M-Sa, 1-5 S HOL: 12/25, 1/1, EASTER, THGV
ADM: Y ADULT: $3.00 CHILDREN: F (under 6) STUDENTS: $1.00 SR CIT: $3.00
&: Y; Wheelchair accessible (also available at museum)
Ⓟ Y; Limited free parking at the adjacent Community Center and on the street. MUS/SH: Y
PERM/COLL: Works by Walter Inglis Anderson (1903-1965), in a variety of media and from all periods of his work.

This museum celebrates the works of Walter Inglis Anderson, whose vibrant and energetic images of plants and animals of Florida's Gulf Coast have placed him among the forefront of American painters of the 20th-century. **NOT TO BE MISSED:** "The Little Room," a room with private murals seen only by Anderson until after his death when it was moved in its entirety to the museum.

ON EXHIBIT/97:

11/15/96–02/97	A SYMPHONY OF ANIMALS — On exhibit will be drawings and paintings done throughout the career of Walter Anderson that explore his fascination with the world of animals. BOOK
03/97–05/97	PEOPLE OF WALTER ANDERSON: AN EXPLORATION — The early drawings and later works in oil on masonite, watercolor and pen & ink on view in this exhibition will feature a rarely seen side of Anderson's interpretation of friends and family.
06/97–08/97	A SUCCESSION OF FLOWERS — Anderson's concern for the environment will be addressed in this exhibition of wild flowers and other vegetation rendered in watercolor and graphite.
09/97–11/97	GIFTS OF AN AUSTERE MOTHER — Evidence of nature's bounty will be expressed in Anderson's still life watercolors on view in this exhibition.
12/97–02/98	BETWEEN THE BLADES OF GRASS — 60 of Anderson's watercolors of insects, frogs, turtles, lizards and snakes will be featured with his drawings and prints on the same subject.

Tupelo

Mississippi Museum of Art, Tupelo
211 W. Main St., **Tupelo, MS 38801**
☎ 601-844-2787
HRS: 10-4 Tu-T, 1-4 F HOL: 1/1, 7/4, THGV, 12/25
&: Y Ⓟ Y; Non metered street parking
GR/T: Y GR/PH: Call ahead to reserve DT: Y TIME: Upon request if available

Housed in the former original People's Bank Building (1904-05) this small but effective non-collecting institution is dedicated to bringing traveling exhibitions from all areas of the country to the people of the community and its visitors.

Columbia

Museum of Art and Archaeology
Affiliate Institution: University Of Missouri
1 Pickard Hall, **Columbia, MO 65211**
☎ 573-882-3591
HRS: 9-5 Tu, W, F; Noon-5 Sa, S; 9-5 & 6-9 T DAY CLOSED: M HOL: LEG/HOL!; 12/25, 1/1
VOL/CONT: Y
&: Y Ⓟ Y; Parking is available at the university visitors' garage on University Avenue; metered parking spaces on Ninth St.
MUS/SH: Y
PERM/COLL: AN/EGT; AN/GRK; AN/R; AN/PER; BYZ; DRGS 15-20; GR 15-20; AF; OC; P/COL; CH; JAP; OR

Ancient art and archaeology from Egypt, Palestine, Iran, Cyprus, Greece, Etruria and Rome as well as early Christian and Byzantine art, the Kress study collection, and 15th-20th-century European and American artworks are among the treasures from six continents and five millennia that are housed in this museum.

ON EXHIBIT/97:

THROUGH 1997	THE KRESS STUDY COLLECTION	
	ISMS AND OTHERS IN THE TWENTIETH CENTURY	
	EXPRESSIONS OF AFRICA: SELECTIONS FROM THE PERMANENT COLLECTION	
02/01/97–03/30/97	ROMARE BEARDON AS PRINTMAKER	WT
10/18/97–12/14/97	COMMITMENT: FATHERHOOD IN BLACK AMERICA	

Kansas City

Kemper Museum of Contemporary Art & Design
4420 Warwick Blvd., **Kansas City, MO 64111-1821**
☎ 816-753 5784 Web Address: www.kemperart.org
HRS: 10-4 Tu-F, 10-5 Sa, 11-5 S DAY CLOSED: M HOL: 1/1, 7/4, TGV, 12/24, 12/25
&: Y; accessible ramp in front of museum - handicapped parking available Ⓟ Y; Free MUS/SH: Y
❙❙ Y; Café Sebastienne 11-3 Tu-S GR/T: Y GR/PH: CATR! DT: Y TIME: call for specifics S/G: Y
PERM/COLL: WORKS BY CONTEMPORARY EMERGING AND ESTABLISHED ARTISTS

Designed by architect Gunnar Birkerts, the stunning ultra-modern tripartite building of the Kemper Museum of Contemporary Art & Design (a work of art in itself) features up-turned ribbons of glass along the high walls in the exhibition wings that permit natural light to illuminate the galleries. Works by living artists, designers and craftsmen form the nucleus of the collection. **NOT TO BE MISSED:** "Ahulani," bronze sculpture by Deborah Butterfield; Frank Stella's "The Prophet"; Donald Sultan's "Spike Acantha July 5"; Robert Graham's "Source Figure"; Keith Sonnier's neon sculpture "New Orleans Dyad"

ON EXHIBIT/97:

11/23/96–01/19/97	RAYMUNDO SESMA: EPIPHANEIA (EPIPHANY) — The irrational nature of aggression and violence for its own sake will be addressed in this video installation involving the viewer whose presence becomes a hope for the future.
12/15/96–03/16/97	DALE CHIHULY OVER VENICE — Ten glass chandeliers designed to hang from bridges over the canals of Venice will be hung in the Museum's main gallery and atrium along with one specially commissioned work that will be installed in a permanent site within the Museum. WT
01/25/97–04/13/97	AKIN & LUDWIG: THE WOMAN SERIES — This exhibition consists of an installation of 200 black & white photographs of varying sizes comprised of women's faces within black oval frames. Most of the mainly anonymous images, found in flea markets and junk shops were rephotographed before being integrated within the composition.
04/05/97–07/06/97	MICHAEL LUCERO: SCULPTURE '76 -'95 — Lucero's glazed ceramic, bronze and mixed media sculptures reflecting reworked European, Native American, Afro-Carolinian, and ancient Mayan forms will be featured in a display detailing 2 decades of change in his works. CAT WT

MISSOURI

Kemper Museum of Contemporary Art & Design

| 04/19/97–06/15/97 | JUNICHI ARAI: GLISTENING FABRICS — Arai, a Japanese textile artist who combines the ancient history of Japanese textile traditions with contemporary technology, will create an installation that completely fills an entire gallery of the Museum. |

06/21/97–08/31/97 CARMEN LOMAS GARZA — Celebrations, myths, healing ceremonies, family stories and everyday life are the dominant themes of the visual narrative paintings on view which are reflective the Chicana/o life Garza experienced growing up in rural Kingsville, Texas.

07/26/97–08/12/97 TOYS IN CONTEMPORARY ART — Featured will be an exhibition which utilizes the theme of toys to embody adult social, political and economic ideologies.

09/13/97–11/30/97 JIM CAMPBELL — Recent works by San Francisco-based video artist Campbell will be on view in this solo exhibit.

11/22/97–01/25/98 MICHAEL REES — On view will be imaginary human organs and animal life created by Rees, a sculptor/designer who uses computer modeling software and cutting-edge industrial design methods in the formation of his unique life-forms.

Kansas City

The Nelson-Atkins Museum of Art

4525 Oak St., **Kansas City, MO 64111-1873**

☎ 816-561-4000

HRS: 10-4 Tu-T, 10-9 F, 10-5 Sa, 1-5 S DAY CLOSED: M HOL: 12/25, 1/1, 7/4, THGV
F/DAY: Sa ADM: Y ADULT: $4.00 CHILDREN: F (under 5) STUDENTS: $1.00 SR CIT: $4.00
&: Y; Elevators & ramps ℗ Y; Free lot on 45th St; parking lot for visitors with disabilities at Oak St. Business Entrance on west side of the Museum MUS/SH: Y ❢Y; Restaurant 10-3:30 Tu-Sa, 1-4 S
GR/T: Y GR/PH: CATR! 816-751-1238 DT: Y TIME: 10:30, 11, 1 & 2 Tu-Sa; 1:30, 2, 2:20, 3 S S/G: Y
PERM/COLL: AM: all media; EU: all media; PER/RMS; NAT/AM; OC; P/COL; OR

Among the many fine art treasures in this outstanding 60 year old museum is their world famous collection of Oriental art and artifacts that includes the Chinese Temple Room with its furnishings, a gallery displaying delicate scroll paintings, and a sculpture gallery with glazed T'ang dynasty tomb figures. **NOT TO BE MISSED:** Largest collection of works by Thomas Hart Benton; Henry Moore Sculpture Garden; "Shuttlecocks," a four-part sculptural installation by Claes Oldenburg and Coosje van Bruggen located in the grounds of the museum

ON EXHIBIT/97:

01/26/97–03/16/97 ALBERT BLOCK

04/06/97–05/18/97 THE PRINTS OF JOHN S. deMARTELLY, 1903-1979 — Best known for his regionalist images, deMartelly's early and late works will be on view for the first time in this retrospective exhibition. WT

04/27/97–06/15/97 UNIVERSAL LIMITED ART EDITIONS: FORTY YEARS, 1957-1997 — On display will be 160 prints, books, portfolios, and 3 dimensional objects by 24 artists such as Helen Frankenthaler, Jasper Johns, Robert Rauchenberg, and Larry Rivers, all of whom have created art at this Long-Island workshop at some point in their careers. CAT WT

07/13/97–09/14/97 ELECTRONIC SUPER HIGHWAY: NAM JUNE PAIK IN THE '90'S — Paik's monumental multi-television monitor installation addresses the significance of the electronic media on modern culture. CAT WT

10/26/97–01/04/98 INVENTING THE SOUTHWEST: THE FRED HARVEY COMPANY AND NATIVE AMERICAN ART — Baskets, pottery, jewelry, paintings, and other art objects from this renowned collection will be displayed in an exhibit designed to tell the story of early American railroad travel and its effect on Native American people and their art. WT

Poplar Bluff

Margaret Harwell Art Museum

421 N. Main St., **Poplar Bluff, MO 63901**
☎ 537-686-8002
HRS: 1-4 W-S DAY CLOSED: M, T, S HOL: LEG/HOL!
VOL/CONT: Y ♿: Y MUS/SH: Y GR/T: Y GR/PH: CATR! H/B: Y; Located in 1883 mansion
PERM/COLL: DEC/ART; REG; CONT

The 1880's mansion in which this museum is housed is a perfect foil for the museum's permanent collection of contemporary art. Located in the south-eastern part of the state just above the Arkansas border, the museum features monthly exhibitions showcasing the works of both regional and nationally known artists.

ON EXHIBIT/97:

01/04/97–02/02/97	JANE CARROLL — Featured will be Carroll's large colorful canvases of mixed media.
02/08/97–03/02/97	CELEBRATING AFRICAN AMERICAN MONTH — Ceramics and contemporary sculpture will be on exhibit.
03/08/97–03/30/97	KAREN PATTON & CAROL INMAN — Portraits by Patton, Inman and others will be featured.
04/05/97–04/27/97	BARBARA WILLIAMS — Mixed media works.
05/03/97–06/01/97	12TH ANNUAL MAIL-IN SHOW
06/07/97–07/19/97	MHAM's ANTIQUE CLOTHING COLLECTION: "PARISIAN TROUSSEAU FOR A MISSOURI BRIDE"
07/26/97–08/24/97	10TH ANNUAL PICTURES BY THE PEOPLE — A annual regional photography exhibit by residents living within a 100 mile radius of Pine Bluff.
09/06/97–10/25/97	PAUL JACKSON WATERCOLORS — A selection of watercolors by Jackson, an internationally acclaimed artist will be on exhibit.
11/01/97–11/23/97	THE MARGARET HARWELL ART MUSEUM PERMANENT COLLECTION
12/05/97–01/04/98	VICTORIAN CHRISTMAS AT THE MHAM

Saint Joseph

The Albrecht-Kemper Museum of Art

2818 Frederick Blvd., **Saint Joseph, MO 64506**
☎ 816-233-7003
HRS: 10-4 Tu-Sa, 1-4 S DAY CLOSED: M HOL: 1/1, EASTER, 7/4, THGV, 12/25
F/DAY: S ADM: Y ADULT: $3.00 CHILDREN: F (under 12) STUDENTS: $1.00
♿: Y; Fully wheelchair accessible (doors, lifts, restrooms, theater) Ⓟ Y; Free on-site parking MUS/SH: Y ⑪ Y; Daily Tu-F
GR/T: Y GR/PH: CATR! S/G: Y
PERM/COLL: AM: ldscp ptgs, Impr ptgs, gr, drgs 18-20

Considered to have the region's finest collection of 18th through 20th-century American art, the Albrecht-Kemper Museum of Art is housed in the expanded and transformed 1935 Georgian-style mansion of William Albrecht. PLEASE NOTE: As of press time all exhibitions after 7/20/97 are TBA. **NOT TO BE MISSED:** North American Indian Portfolio by Catlin: illustrated books by Audubon; Thomas Hart Benton collection

ON EXHIBIT/97:

05/97 - 05/98	ROBERT STACKHOUSE: LARGE-SCALE OUTDOOR SCULPTURE INSTALLATION	
12/09/96–02/16/97	BILL SCHENCK: WESTERN LANDSCAPES	WT
01/30/97–03/02/97	23RD ANNUAL MEMBERSHIP EXHIBITION	
02/21/97–03/23/97	TBA	
04/01/97–06/01/97	SARAH BALBIN	
04/17/97–06/29/97	THOMAS KING BAKER	
06/12/97–07/20/97	PHOTOGRAPHS BY LEW SHADY	

MISSOURI

Springfield

Springfield Art Museum
1111 E. Brookside Dr., **Springfield, MO 65807-1899**
📞 417-837-5700
HRS: 9-5 Tu, W, F, Sa; 1-5 S; till 8 PM T DAY CLOSED: M HOL: LOCAL & LEG/HOL!
VOL/CONT: Y &: Y ℗ Y; West parking lot with 55 handicapped spaces; limited on-street parking north of the museum
GR/T: Y GR/PH: CATR!
PERM/COLL: AM: ptgs, sculp, drgs, gr, phot 18-20; EU: ptgs, sculp, gr, drgs, phot 18-20; DEC/ART; NAT/AM; OC; P/COL

Watercolor U.S.A., an annual national competition is but one of the features of the Springfield Museum, the oldest cultural institution in the city. **NOT TO BE MISSED:** New Jeannette L. Musgrave Wing for the permanent collection; John Henry's "Sun Target," 1974, a painted steel sculpture situated on the grounds directly east of the museum; paintings and prints by Thomas Hart Benton

ON EXHIBIT/97:

ONGOING	WORKS FROM THE PERMANENT COLLECTION
06/07/97–08/03/97	WATERCOLOR U.S.A. 1997 — One of the most prestigious national juried exhibitions in America.
09/13/97–11/02/97	THE PAINTINGS OF PETER HOLBROOK — Works by Holbrook, one of the the most accomplished watercolor artists in America, will be on exhibit.

St. Louis

Forum for Contemporary Art
3540 Washington St., **St. Louis, MO 63103**
📞 314-535-4660 WEB ADDRESS: http/www.jpcom.com/arts/index.html
HRS: 10-5 Tu-Sa DAY CLOSED: S, M HOL: LEG/HOL! & INSTALLATIONS
SUGG/CONT: Y ADULT: $2.00
&: Y; First floor accessible; elevator to third floor gallery
℗ Y; Street or public parking (nominal fee) at the Third Baptist Church parking lot on Washington.
¶ Y; Cafe & Bookstore GR/T: Y GR/PH: CATR!
PERM/COLL: No permanent collection. Please call for current exhibition information not listed below.

Experimental cutting-edge art of the new is the focus of The Forum which presents exhibitions of important recent national and international art enhanced by educational programming and public discussions.

ON EXHIBIT/97:

01/24/97–03/15/97	THE MEDIATED OBJECT: SELECTIONS FROM THE ELI BROAD COLLECTION — This installation of 14 works from the Eli Broad Collection explores various meanings of the terms "media" and "object" as they pertain to three specific artistic issues. WT
04/04/97–05/31/97	CARROLL DUNHAM: PAINTINGS AND DRAWINGS 1983-1995 — 12 major paintings and 20 drawings will be included in the first concentrated show of work by Dunham, one of America's foremost exponents of contemporary abstraction. WT
04/04/97–05/31/97	KEN LITTLE: NEW WORKS — A retrospective of diverse works from the past will be presented with new works in bronze by Little, a Texas-based artist who incorporates his wry sense of humor into his Western influenced creations. WT
09/05/97–10/25/97	DAWOUD BEY: PORTRAITS 1975-1995 — Featured will be large-scale color portrait photographs of African-Americans living in the Hartford, Connecticut area which were taken by Bey using a unique 20" x 24" Polaroid camera. CAT WT
11/07/97–01/03/98	SABINA OTT: PAINTINGS

St. Louis

Laumeier Sculpture Park & Gallery
12580 Rott Rd., **St. Louis, MO 63127**
☎ 314-821-1209
HRS: Park: 8:30-5; Gallery: 10-5 Tu-Sa & Noon-5 S
♿: Y; Paved trails; ramps to museum & restrooms ℗ Y; Free and ample MUS/SH: Y ⵌ Picnic Area
GR/T: Y GR/PH: CATR! ext. 21 ($6.00 per group) DT: Y TIME: 2 PM S (May - Oct) S/G: Y
PERM/COLL: CONT/AM; sculp: 40 WORKS BY ERNEST TROVA; SITE SPECIFIC SCULP

Internationally acclaimed site-specific sculptures that complement their natural surroundings are the focus of this institution whose goal is to promote greater public involvement and understanding of contemporary sculpture. Audio cassettes are available for self-guided tours. **NOT TO BE MISSED:** Works by Alexander Liberman, Beverly Pepper, Dan Graham, Jackie Ferrara

ON EXHIBIT/97:

10/12/96–01/31/97	SUZE LINDSAY: SELECTED CERAMICS
10/19/96–01/31/97	ARTESAO BRASILERIO: FOLK ART OF BRAZIL — On exhibit will be colorful carved and painted, wooden and ceramic figures created by Brazilian folk artists living in a remote mining and farming region of the country.
03/15/97–05/26/97	TIM CURTIS: SCULPTURE INSTALLATION
03/15/97–05/25/97	GINA BOBROWSKI: CERAMICS — Life-sized human and animal ceramic figures by avant-garde American ceramic artist Bobrowski will be featured.
06/14/97–08/31/97	ALISON SAAR — Saar imbues her powerful rough-hewn figurative sculptures with elements of spiritual identity, and fragments of myth & legend that address the humanity in all of us.
06/14/97–08/31/97	DEBORAH MASUOKA — Masuoka's 5' to 7' giant sized rabbet head sculptures will be on exhibit. Dates Tent!
10/97–01/98	LINDA CHRISTIANSON: CERAMICS

The Saint Louis Art Museum
1 Fine Arts Park, Forest Park, **St. Louis, MO 63110-1380**
☎ 314-721-0072
HRS: 1:30-8:30 Tu, 10-5 W-S DAY CLOSED: M HOL: 1/1, 12/25, THGV
♿: Y ℗ Y; Free parking in small lot on south side of building; also street parking availble. MUS/SH: Y ⵌ Y; Cafe 11-3:30 & 5-8 Tu; 11-3:30 W-S; 10-2 S (brunch); Snack Bar also GR/T: Y GR/PH: CATR! ext. 484
DT: Y TIME: 1:30 W-F (30 min.); 1:30 Sa, S (60 min.) H/B: Y; Located in 1904 World's Fair Exhibition Building S/G: Y
PERM/COLL: AN/EGT; AN/CH; JAP; IND; OC; AF; P/COL; NAT/AM; REN; PTGS:18-CONT; SCULP: 18-CONT

Just 10 minutes from the heart of downtown St. Louis, this museum is home to one of the most important permanent collections of art in the country. A global museum featuring pre-Columbian and German Expressionist works that are ranked among the best in the best in the world, this institution is also known for its Renaissance, Impressionist, American, and Asian collections. PLEASE NOTE: Although there is an admission fee for special exhibitions of $3.50 adults, $2.50 students & seniors, and $1.50 for children 6-12, a free tour of these exhibitions is offered at 6 PM on Tuesday evenings. **NOT TO BE MISSED:** The Sculpture Terrace with works by Anthony Caro, Pierre Auguste Renoir, Henry Moore, Alexander Calder, and Aristide Maillol; Reinstalled galleries of Oceanic art

ON EXHIBIT/97:

11/14/96–01/26/97	LOVIS CORINTH RETROSPECTIVE — 70 paintings, 40 watercolors and drawings and 30 prints by Corinth (1858-1925), one of the most acclaimed German artists of his day, will be seen in the first ever major retrospective of his work in America. Each of Corinth's various painterly roles as a Realist, Impressionist and Expressionist will be highlighted. ONLY VENUE CAT ◯
12/03/96–02/02/97	CURRENTS 68: PER KIRKEBY — On exhibit will be 7 large canvases by Kirkeby, considered the leading contemporary abstract painter in Europe.

MISSOURI

The Saint Louis Art Museum - continued

01/23/97–04/13/97	THE HUGUENOT LEGACY: ENGLISH SILVER 1680-1760 FROM THE ALAN & SIMONE HARTMAN COLLECTION WT
02/21/97–05/18/97	IN THE LIGHT OF ITALY: COROT AND EARLY OPEN-AIR PAINTING — Twenty of Corot's finest Italian sketches and small finished paintings will be among those seen in this exhibition of 120 works that trace the achievements of an international group of European painters working in Italy (late 18th to early 19th-century), who, though committed to classical artistic traditions, were pioneers in the development of the new open-air or plein-air school of painting. PLEASE NOTE: There will be an admission fee of $5.00 adults, $4.00 students &seniors, and $3.00 children 6-12, with Tuesday designated as a free day. ADM FEE CAT WT
02/25/97–04/27/97	MEN, WOMEN AND GOD: GERMAN RENAISSANCE PRINTS — Works by Albrecht Durer will be among the 80 outstanding Old Master woodcuts and etchings on loan from public and private collections.
04/29/97–07/06/97	CERAMIC GESTURES: NEW VESSELS BY MAGDALENE ODUNDO — On exhibit will be 15 elegant handbuilt vessels by noted contemporary Kenyan ceramist, Odundo, that act as expressions of form rather than utility. CAT WT
04/29/97–10/14/97	HARK HERALDRY! WT
06/03/97–08/24/97	RUTH THORNE-THOMSEN: SONGS OF THE SEA (Working Title) — Thorne-Tomsen, a photographic artist who utilizes a hand-made pinhole camera with various miniature props and cutouts, creates the works on view by melding art historical and classical influences into mysterious and beautiful scenes.
06/15/97–08/09/97	ROY DeCARAVA: A RETROSPECTIVE — Groundbreaking pictures of everyday life in Harlem, civil rights protests, lyrical studies of nature, and photographs of jazz legends will be among the 200 black & white photographs on view in the first comprehensive survey of DeCarava's works. CAT WT
06/27/97–09/07/97	BRITISH ART FROM THE HERMITAGE — Coinciding with the bicentennial of the death of Catherine the Great, British masterworks (including paintings by Van Dyck, Reynolds, Lawrence, and Wright of Derby, sculptures, silver, ceramics and gems) from the collection of the State Hermitage Museum in St. Petersburg, Russia will be seen in the first major traveling exhibition of its kind. CAT WT
09/23/97–01/98	WOMEN PHOTOGRAPHERS: A PRIVATE COLLECTION (Working Title) — Twentieth-century works by 60 women photographers worldwide will be featured in an exhibition that documents their accomplishments and offers the viewer their unique perspectives on life and our relationships to one another.

St. Louis

Washington University Gallery of Art, Steinberg Hall

One Brookings Drive, **St. Louis, MO 63130-4899**
☎ 314-935-5490
HRS: SEP-MAY: 10-5 M-F & 1-5 Sa, S; CLOSED MEM/DAY-LAB/DAY
HOL: LEG/HOL! Occasionally closed for major installations; Call (314-935-4523)
♿: Y; Elevator recently installed ⓟ Y; Free visitor parking on the North side of the building MUS/SH: Y
GR/T: Y GR/PH: call 314-935-5490
PERM/COLL: EU: ptgs, sculp 16-20; OM: 16-20; CONT/GR; AM: ptgs, sculp 19-20; DEC/ART; FR: academic; AB/EXP; CUBISTS

With a well-deserved reputation for being one of the premier university art museums in the nation, the more than 100 year old Gallery of Art at Washington University features outstanding examples of works by Picasso (25 in all) and a myriad of history's artistic greats. **NOT TO BE MISSED:** Hudson River School Collection

ON EXHIBIT/97:

through 05/97	SELECTIONS FROM THE WASHINGTON UNIVERSITY ART COLLECTIONS
01/17/97–04/06/97	URBAN RESEARCH & DESIGN CENTER
01/17/97–04/06/97	WORKING TITLE: ABSTRACT EXPRESSIONISM
01/17/97–04/06/97	HERVÉ'S PHOTOGRAPHS OF LE CORBUSIER'S RONCHAMP
03/07/97–04/06/97	VISIONARIES IN EXILE

Billings

Yellowstone Art Center
410 N. 27th St., **Billings, MT 59101**
☎ 406-256-6804
HRS: 11-5 Tu-Sa, Noon-5 S, till 8 PM T; Open one hour earlier in summer DAY CLOSED: M HOL: LEG/HOL!
&: Y; Ramp ℗ Y; Pay lot next to building is free on weekends MUS/SH: Y
GR/T: Y GR/PH: CATR! H/B: Y; Located in 1916 Building
PERM/COLL: CONT/HISTORICAL: ptgs, sculp, cer, phot, drgs, gr

Situated in the heart of downtown Billings, the focus of the museum is on displaying the works of contemporary regional artists and on showcasing artists who have achieved significant regional or national acclaim. With 2,400 works in its permanent collection, the museum is well-known for its Montana Collection" dedicated to the preservation of Western art as a living artistic heritage. It is also the recipient of 90 Abstract Expressionist paintings from the George Poindexter family of New York. PLEASE NOTE: The museum will be closed for renovation and expansion until the fall of 1997.

Great Falls

C. M. Russell Museum
400 13th St. North, **Great Falls, MT 59401-1498**
☎ 406-727-8787
HRS: MAY 1-SEPT 30: 9-6 M-Sa & 1-5 S; WINTER: 10-5 Tu-Sa & 1-5 S HOL: 1/1, EASTER, THGV, 12/25
F/DAY: M (OCT-APR) ADM: Y ADULT: $4.00 CHILDREN: F (under 6) STUDENTS: $2.00 SR CIT: $3.00
&: Y ℗ Y; Free parking on grounds of museum MUS/SH: Y
GR/T: Y GR/PH: CATR! DT: Y TIME: 1:00 M-F (June through Aug) H/B: Y
PERM/COLL: REG; CONT; CER

Constructed mainly of telephone poles the log cabin studio of the great cowboy artist C.M. Russell still contains the original cowboy gear and Indian artifacts that were used as the artist's models. Adjoining the cabin and in contrast to it is the the fine art museum with its modern facade. It houses more than 7,000 works of art that capture the flavor of the old west and its bygone way of life. **NOT TO BE MISSED:** Collection of Western Art by many of the American greats

ON EXHIBIT/97:

MID/96–EARLY/97	C.M. RUSSELL CHRISTMAS SHOW
12/07/96–02/16/97	E. E. HEIKKA: SCULPTURE EXHIBITION
01/97–/	C. M. RUSSELL AUCTION ART EXHIBITION
04/03/97–07/06/97	FOCUS OF WATERCOLOR: JOE BOHLER AND GERALD FRITZKER
06/14/97–09/01/97	RUSSELL'S CIRCLE EXHIBITION
09/15/97–11/30/97	EDWARD BOREIN (ROCKWELL MUSEUM) EXHIBITION
11/97–01/98	C. M. RUSSELL CHRISTMAS EXHIBITION
12/06/97–02/15/98	BLACKFEET SUNDANCE SERIES: PAINTINGS BY GARY SCHILDT

MONTANA

Great Falls

Paris Gibson Square Museum of Art
1400 1st Ave., North, **Great Falls, MT 59401-3299**
☎ 406-727-8255
HRS: 10-5 Tu-F; Noon-5 Sa, S; 7-9 T; Also open M MEM/DAY to LAB/DAY DAY CLOSED: M HOL: LEG/HOL!
&: Y; Wheelchair accessible; elevators ℗ Y; Free and ample MUS/SH: Y ¶ Y; Lunch Tu-F
GR/T: Y GR/PH: CATR! H/B: Y; 19th century Romanesque structure built in 1895 as a high school S/G: Y
PERM/COLL: REG: ptgs, sculp, drgs, gr

Contemporary arts are featured within the walls of this 19th-century Romanesque building which was originally used as a high school.

ON EXHIBIT/97:

11/13/96–02/03/97	DREAMING OF THE WEST: SURREALISM REVISITED — A survey of regional artists working in the surreal vein. TENT!
02/15/97–03/30/97	RICHARD SWANSON — This exhibition features Swanson's installation of hay.
02/15/97–03/30/97	JENEESE HILTON — Works by Hilton, a Native American painter from St. Ignatius, Montana.
02/15/97–03/30/97	SOLES OF THE WEST - WESTERN SOUL — From walking boot to fancy showbiz boot, this traveling exhibition of cowboy boots will even have boots custom-made for this exhibition. WT
05/07/97–06/21/97	HUMAN VESSELS: REINTERPRETATIONS OF TRIBAL ARTS — A display of modern figurative baskets created by David Powers, artist-in-residence last year in the Great Falls Public School.
05/07/97–06/21/97	TALKING QUILTS: POSSIBILITIES IN RESPONSE — 9 quilts and 9 original musical compositions will be featured in this multi-media exhibition.
07/01/97–08/30/97	MONTANA FOUND — A survey of the best "found object" art in the State. TENT!
07/01/97–08/30/97	SIGNS OF SPRING — Husband and wife artists Sarah Mast & Terry Karson will present a multi-media installation based on the theme of the garden.
09/08/97–11/09/97	THE ART EQUINOX — The Museum's 4th biennial juried exhibition of art from the western states.

Kalispell

Hockaday Center for the Arts
Second Ave E. & Third St, **Kalispell, MT 59901**
☎ 406-755-5268
HRS: 10-5 Tu-F, 10-3 Sa DAY CLOSED: S, M HOL: LEG/HOL!
&: Y ℗ Y; Free 2 hour street parking MUS/SH: Y GR/T: Y GR/PH: CATR! DT: Y TIME: Upon request if available
PERM/COLL: CONT/NORTHWEST: ptgs, sculp, gr, port, cer

The Hockaday Center which places strong emphasis on contemporary art is housed in the renovated Carnegie Library built in 1903. A program of rotating regional, national, or international exhibitions is presented approximately every 6 weeks.

ON EXHIBIT/97:

01/15/97–03/01/97	THE ART OF HENRY MELOY — Meloy's watercolors and drawings describe many of his life experiences from teaching in New York to summers in his native state of Montana. This exhibition surveys the late artist's (d. 1951) connections to modernism and its impact on Montana.

Hockaday Center for the Arts - continued

01/15/97–03/01/97	TALKING QUILTS: POSSIBILITIES IN RESPONSE — 9 quilts and 9 original musical compositions will be featured in this multi-media exhibition. WT
03/15/97–05/01/97	PORTRAITS OF PRINTMAKERS: WOOD ENGRAVINGS BY JIM TODD — On loan from the University of Montana, the prints by Dürer, Rembrandt, Hogarth, Goya, Daumier, Picasso and other artistic luminaries will displayed in a thematic exhibition of artists' representations of other printmakers.
08/01/97–09/01/97	SOLES OF THE WEST: THE ART AND HISTORY OF COWBOY BOOTS — From walking boot to fancy showbiz boot, this traveling exhibition of cowboy boots will even have boots custom-made for this exhibition. WT
09/12/97–10/22/97	WATERMEDIA 97 — Montana Watercolor Society's 15th annual show.

Miles City

Custer County Art Center

Water Plant Rd., **Miles City, MT 59301**
✆ 406-232-0635
HRS: 1-5 Tu-S DAY CLOSED: M HOL: 1/1, EASTER, THGV, 12/25
VOL/CONT: Y
♿: Y; Inquire at front desk Ⓟ Y MUS/SH: Y
GR/T: Y
H/B: Y; Located in the old holding tanks of the water plant (member NRHP)
PERM/COLL: CONT/REG; 126 EDWARD S. CURTIS PHOTOGRAVURES; 81 WILLIAM HENRY JACKSON PHOTOCHROMES

The old holding tanks of the water plant (c. 1914) provide an unusual location for the Custer Art Center. Situated in the middle eastern part of the state in a park-land setting overlooking the Yellowstone River, this facility features 20th-century Western and contemporary art. The gift shop is worthy of mention due to the emphasis placed on available works for sale by regional artists. **NOT TO BE MISSED:** Annual Art Roundup & Quick Draw Art Auction, Sat., May 15, 1993, at 11 AM

ON EXHIBIT/97:

02/02/97–03/10/97	18TH ANNUAL JURIED EXHIBITION — An exhibition of 150 entries from Montana and surrounding states.
03/15/97–04/20/97	TALKING QUILTS: POSSIBILITIES IN RESPONSE — 9 quilts and 9 original musical compositions will be featured in this multi-media exhibition.
04/24/97–07/07/97	WESTERN ART ROUNDUP — The best in historical, traditional and contemporary Western art will be on display.
07/10/97–08/28/97	JANET FISH PAINTINGS — Fish's lush, colorful and exquisitely rendered paintings demonstrate why she is considered among the finest realist painters of our time.
08/31/97–09/26/97	ART AUCTION EXHIBIT
09/28/97–11/09/97	3RD BIENNIAL MINIATURE SHOW "SIGNS OF SPRING"
11/16/97–12/31/97	QUILT SHOW

MONTANA

Missoula

Missoula Museum of the Arts
335 N. Pattee, **Missoula, MT 59802**
☎ 406-728-0447
HRS: Noon-6 Tu-S, till 8 PM Tu DAY CLOSED: M HOL: LEG/HOL!.
F/DAY: Tu ADM: Y ADULT: $2.00 CHILDREN: F (under 18) STUDENTS: $2.00 SR CIT: $2.00
&: Y Ⓟ Y; Limited metered on-street parking MUS/SH: Y
GR/T: Y GR/PH: CATR! H/B: Y
PERM/COLL: REG: 19-20

Regional art of Montana and other Western states is featured in this lively community-based museum which is housed in the early 20th-century Old Carnegie Library building in downtown Missoula.

Missoula

Museum of Fine Arts
Affiliate Institution: School of Fine Arts, University of Montana
Missoula, MT 59812
☎ 406-243-4970
HRS: 9-12 & 1-4 M-F DAY CLOSED: S, M HOL: STATE/HOL & LEG/HOL!
&: Y Ⓟ Y; Free parking with visitor pass obtained in the security office.
PERM/COLL: REG

Great American artists are well represented in this University museum with special emphasis on Western painters and prints by such contemporary artists as Motherwell and Krasner. The permanent collection rotates with exhibitions of a temporary nature.

Kearney

Museum of Nebraska Art
Affiliate Institution: University of Nebraska at Kearney
24th & Central, **Kearney, NE 68848**
✆ 308-865-8559
HRS: 11-5 Tu-S, 1-5 S HOL: LEG/HOL!
&: Y ⓟ Y MUS/SH: Y GR/T: Y GR/PH: CATR! H/B: Y S/G: Y
PERM/COLL: REG: Nebraskan 19-present

The museum building, listed in the National Register of Historic Places, has been remodeled and expanded with new gallery spaces and a sculpture garden. Featured is the Nebraska Art Collection-artwork by Nebraskans from the Artist-Explorers to the contemporary scene. **NOT TO BE MISSED:** "The Bride", by Robert Henri

Lincoln

Great Plains Art Collection
Affiliate Institution: University of Nebraska
215-217 Love Library, **Lincoln, NE 68588-0475**
✆ 402-472-6220
HRS: 9:30-5 M-F, 10-5 Sa, 1:30-5 S HOL: LEG/HOL!
&: Y ⓟ Y; Limited metered parking GR/T: Y GR/PH: CATR!
PERM/COLL: WESTERN: ptgs, sculp 19, 20; NAT/AM

This collection of western art which emphasizes the Great Plains features sculptures by such outstanding artists as Charles Russell & Frederic Remington, and paintings by Albert Bierstadt, John Clymer, Olaf Wieghorst, Mel Gerhold and others. **NOT TO BE MISSED:** William de la Montagne Cary, (1840-1922), "Buffalo Throwing the Hunter," bronze

ON EXHIBIT/97:

01/20/97–02/28/97	VISIONS OF NEW MEXICO: FSA PHOTOGRAPHERS	WT
03/97–05/97	UNTITLED (DEPICTIONS OF NARRATIVE SUBJECTS BY ILLUSTRATOR-ARTISTS)	Tent. Name
05/97–08/97	UNTITLED (IMAGES OF AMERICAN INDIANS FROM THE PERMANENT COLLECTION)	Tent. Name

Sheldon Memorial Art Gallery and Sculpture Garden
Affiliate Institution: University of Nebraska
12th and R Sts., **Lincoln, NE 68588-0300**
✆ 402-472-2461
HRS: 10-5 Tu-Sa, 7-9 T-Sa, 2-9 S DAY CLOSED: M HOL: LEG/HOL!
&: Y ⓟ Y MUS/SH: Y; Tu-Sa 10-5 ¶ Y; The New Cafe open 9:30-3:30 Tu-F
GR/T: Y GR/PH: CATR! H/B: Y S/G: Y
PERM/COLL: AM: Impr, phot, sculp, ldscp ptgs 19, 20

This highly regarded collection is housed in a beautiful Italian marble building designed by internationally acclaimed architect Philip Johnson. It is located on the University of Nebraska-Lincoln campus and surrounded by a 25 acre sculpture garden consisting of over 30 key examples by artists of renown including di Suvero, Lachaise, David Smith, Heiser, Shea and Serra. **NOT TO BE MISSED:** "Toro Notebook," a new 22 foot monumental sculpture by Claes Oldenburg and Coosje van Bruggen, 3 pieces.

ON EXHIBIT/97:

11/96–02/97	EUROPEAN MASTER SCULPTURE

NEBRASKA

Sheldon Memorial Art Gallery and Sculpture Garden - continued

11/96–02/97	WEARABLE ART: CONTEMPORARY ARTISTS' JEWELRY
12/96–02/97	IRWIN KREMEN: COLLAGE AND SCULPTURE — 75 collages and 15 sculptures by artist and clinical psychologist Kremen who has been on the faculty of Duke University since 1963, will be featured in an exhibition honoring his 70th birthday.
12/96–02/97	PROUD POSSESSIONS: SELECTED ACQUISITIONS
02/97–03/97	FORMER FACULTY WORK FROM THE PERMANENT COLLECTION
02/97–03/97	UNL STUDIO FACULTY BIENNIAL
03/97–06/97	MARK ROTHKO: THE SPIRIT OF MYTH, EARLY PAINTINGS FROM THE 1930'S AND 1940'S — 26 landscape, figurative and portrait expressionist paintings will be seen in an exhibition that provides an important understanding of his later more familiar atmospheric color-field works.
04/97–06/97	THE QUEST FOR THE ABSOLUTE
06/97–07/97	SHELDON SOLO: FREDERICK BROWN
06/97–07/97	CHARLES RAIN
06/97–08/97	FLETCHER BENTON: SOLID GEOMETRY
07/97–09/97	4 SOLOS, 4 PAINTERS
08/97–10/97	MANUEL NERI: THE SCULPTOR'S DRAWINGS
09/97–10/97	PRINTS OF STUART DAVIS
11/97–01/98	CHRISTO

Omaha

Joslyn Art Museum
2200 Dodge St., **Omaha, NE 68102-3300**
☎ 402-342-3300
HRS: 10-5 Tu, W, F, Sa; 10-8 T; 12-5 S DAY CLOSED: M HOL: LEG/HOL!
F/DAY: 10-12Sa ADM: Y ADULT: $4.00 CHILDREN: F (under 5) STUDENTS: $2.00 SR CIT: $2.00
&: Y; At atrium entrance Ⓟ Y; Free MUS/SH: Y ⑪ Y
GR/T: Y GR/PH: CATR! DT: Y TIME: W, 1 PM; Sa 11AM H/B: Y S/G: Y
PERM/COLL: AM: ptgs 19, 20; WESTERN ART; EU: 19, 20

Housing works from antiquity to the present the Joslyn, Nebraska's only art museum with an encyclopedic collection, has recently completed a major $16 million expansion and renovation program. **NOT TO BE MISSED:** World-renowned collection of watercolors and prints by Swiss artist Karl Bodmer that document his journey to the American West 1832-34; Noted collection of American Western art including works by Catlin, Remington, and Leigh.

ON EXHIBIT/97:

11/02/96–01/12/97	WORKERS, AN ARCHEOLOGY OF THE INDUSTRIAL AGE: PHOTOGRAPHS BY SEBASTIAO SALGADO — This Brazilian born photojournalist's powerful images chronicle the diverse activities that have defined labor from the Iron Age, through the Industrial Revolution, to the present. WT
12/14/96–02/16/97	VOYAGES AND VISIONS: NINETEENTH CENTURY EUROPEAN IMAGES OF THE MIDDLE EAST, FROM THE VICTORIA AND ALBERT MUSEUM WT
02/01/97–04/06/97	BEYOND BELIEF: CONTEMPORARY ART FROM EAST CENTRAL EUROPE WT
03/01/97–04/27/97	WILLIAM H. JOHNSON: A RETROSPECTIVE FROM THE NATIONAL MUSEUM OF AMERICAN ART WT

Joslyn Art Museum - continued

| 04/19/97–07/27/97 | PLAIN PICTURES: IMAGES OF THE AMERICAN PRAIRIE | WT |

04/25/97–07/13/97 PLAINS INDIAN DRAWINGS, 1865-1935: PAGES OF A LIVING HISTORY — Presented will be an exhibition of Ledger art developed from the Native American tradition of painting on buffalo hides. The drawings on view depict current events and personal narratives, and in their experimentation with pictorial conventions, anticipate some of the concerns of twentieth-century artists. WT

05/10/97–07/08/97 MERET OPPENHEIM: BEYOND THE TEACUP — Works on loan from his family, private lenders, and Eurpoean museums will be featured in the first retrospective exhibition in America for Oppenheim (1913-1985), an artist who is considered an icon of 20th-century art and the Surrealist movement and who is best recognized as the creator of a fur-lined tea cup entitled "Déjuner en Fourrure," 1936.

07/19/97–08/31/97 JOHN MCLAUGHLIN: WESTERN MODERNISM/EASTERN THOUGHT

08/09/97–10/05/97 TURNER WATERCOLORS FROM MANCHESTER — Turner watercolors on loan from Manchester will be displayed with those in the collection of the Indianapolis Museum of Art, the largest of its kind in America, in an exhibition that forms the largest and most comprehensive presentation of its kind in a decade. CAT WT

09/13/97–11/02/97 HOT DRY MEN, COLD WET WOMEN: THE THEORY OF HUMORS AND DEPICTIONS OF MEN AND WOMEN — A diverse group of western European works from the late 16th and 17th centuries exploring the representation of gender and its basis in the prevailing assumptions about human physiology founded on humoral theory.

NEVADA

Reno

Nevada Museum of Art/E. L. Weigand Gallery
160 W. Liberty Street, **Reno, NV 89501**
☎ 702-329-3333
HRS: 10-4 Tu-Sa, 12-4 S DAY CLOSED: M HOL: LEG/HOL!
ADM: Y ADULT: $3.00 CHILDREN: $.50 (6-12) STUDENTS: $1.50 SR CIT: $1.50
&: Y ⓅY MUS/SH: Y
GR/T: Y GR/PH: CATR! DT: Y TIME: Res. Req 2 weeks in advance
PERM/COLL: AM: ptgs 19, 20, NAT/AM; REG

As "the only collecting fine art museum in the state of Nevada," this 60 year old institution has made art and artists of the Great Basin & the American West its primary focus. PLEASE NOTE: The permanent collection is on display only during specific exhibitions. Call for specifics. **NOT TO BE MISSED:** A 'welcome' collage of neon tubes and fragmented glass placed over the entryway to the museum

ON EXHIBIT/97:
 12/07/96–01/19/97 ART QUILTS: PLAYING WITH A FULL DECK

Cornish

Saint-Gaudens National Historic Site
St. Gaudens Rd, **Cornish, NH 03745-9704**
☎ 603-675-2175
HRS: 8:30-4:30 Daily last weekend May-last weekend Oct
ADM: Y ADULT: $2.00 STUDENTS: $2.00 SR CIT: $2.00
Ⓟ Y GR/T: Y GR/PH: CATR! H/B: Y S/G: Y
PERM/COLL: AUGUSTUS SAINT GAUDENS: sculp

The house, the studios, and 150 acres of the gardens of Augustus Saint-Gaudens (1848-1907), one of America's greatest sculptors.

ON EXHIBIT/97: Exhibits of contemporary art throughout the season. Concert Series Sundays at 2 PM, July and August.

Durham

The Art Gallery, University of New Hampshire
Paul Creative Arts Center, 30 College Road, **Durham, NH 03824-3538**
☎ 603-862-3712
HRS: 10-4 M-W, 10-8 T, 1-5 Sa-S (Sep-May) DAY CLOSED: F HOL: ACAD!
&: Y; Limited Ⓟ Y; Metered or at Visitors Center
GR/T: Y GR/PH: CATR!
PERM/COLL: JAP: gr 19; EU & AM: drgs 17-20; PHOT; EU: works on paper 19, 20

Each academic year The Art Gallery of the University of New Hampshire presents exhibitions ranging from historical eras to the contemporary art scene and featuring works in a variety of media.

ON EXHIBIT/97:
01/28/97–04/10/97 PORTFOLIOS: CONTEMPORARY PRINT SERIES FROM THE PERMANENT COLLECTION — Included in this exhibition from the rich permanent collection are works by Josef Albers, Pierre Alechinsky, Karel Appel, Ilya Bolotowsky, Cornelius Corneille, Jacques-Henri Lartique, Roberto Matta, Michael Rothenstein and Ben Shahn.

Hanover

Hood Museum of Art
Affiliate Institution: Dartmouth College
Wheelock Street, **Hanover, NH 03755**
☎ 603-646-2808
HRS: 10-5 Tu, T, F, Sa; 10-9 W; 12-5 S DAY CLOSED: M HOL: LEG/HOL!
&: Y Ⓟ Y MUS/SH: Y ⑪Y
PERM/COLL: AM: ptgs 19, 20; GR; PICASSO; EU: ptgs

One of the oldest and finest college collections in the country is housed in an award-winning post-modern building designed by Charles Moore and Chad Floyd. **NOT TO BE MISSED:** Panathenaic Amphora by the Berlin Painter 5th century BC.

ON EXHIBIT/97: The museum will be closed for renovations 6/22/97-9/97. Call for exact date.
10/12/96–03/02/97 CORRESPONDENCES: AFRICAN SCULPTURE AT THE HOOD MUSEUM OF ART

03/25/97–06/22/97 DARTMOUTH COLLEGE MEDICAL SCHOOL BICENTENNIAL EXHIBITION

245

NEW HAMPSHIRE

Hood Museum of Art - continued

04/11/97–06/22/97	REALMS OF HEROISM: INDIAN PAINTINGS FROM THE BROOKLYN MUSEUM
	CAT WT
10/04/97–01/04/98	INTIMATE ENCOUNTERS: LOVE AND DOMESTICITY IN EIGHTEENTH-CENTURY FRANCE
	WT

Keene

Thorne-Sagendorph Art Gallery

Affiliate Institution: Keene State College
229 Main St, **Keene, NH 03431**
✆ 603-358-2720
HRS: 12-4 M-W; 12-7 T-F; 1-4 Sa, S HOL: ACAD!
&: Y ℗ Y; Free parking adjacent to the museum
GR/T: Y GR/PH: CATR!
PERM/COLL: REG: 19; AM & EU: cont, gr

Changing exhibitions as well as selections from the permanent collection are featured in the contemporary space of this art gallery.

Manchester

The Currier Gallery of Art

201 Myrtle Way, **Manchester, NH 03104**
✆ 603-669-6144
HRS: 11-5 M, W, T, S; 11-9 F; 10-5 Sa DAY CLOSED: Tu HOL: LEG/HOL!
ADM: Y ADULT: $5.00 CHILDREN: F (under 18) STUDENTS: $4.00 SR CIT: $4.00
&: Y ℗ Y; Adjacent on-street parking
MUS/SH: Y ⅋ Y
GR/T: Y GR/PH: CATR! H/B: Y; Registered in National Landmark of historic places (Circa 1929)
PERM/COLL: AM & EU: sculp 13-20; AM: furniture, dec/art

Set on beautifully landscaped grounds, The Gallery is housed in a elegant, newly renovated 1929 Beaux Arts building reminiscent of an Italian Renaissance villa. **NOT TO BE MISSED:** Zimmerman House (separate admission: Adults $6, Seniors and Students $4) designed in 1950 by Frank Lloyd Wright. It is one of five Wright houses in the Northeast and the only Wright designed residence in New England that is open to the public.

ON EXHIBIT/97:

12/20/96–01/20/97	50TH ANNUAL NEW HAMPSHIRE ART ASSOCIATION EXHIBITION Dates Tent!
07/17/97–09/09/97	TONE VIGELAND — The first retrospective of the jewelry of Norway's foremost designer to travel throughout North America, Vigeland is acclaimed for her original and striking designs in precious and non-precious metals. CAT WT
09/26/97–12/01/97	AMERICAN VIEWS: OIL SKETCHES BY THOMAS HILL — 60 small landscape oil paintings by 19th-century artist Hill include scenes he painted of the White Mountains, Mount Shasta, Lake Tahoe, Yosemite, Yellowstone, the Columbia River and Alaska.

Camden

Stedman Art Gallery
Affiliate Institution: The State Univ of NJ
Rutgers Fine Arts Center, **Camden, NJ 08102**
☎ 609-225-6245
HRS: 10-4 M-Sa DAY CLOSED: S HOL: MEM/DAY, 7/4, LAB/DAY, THGV, 12/24-1/2
&: Y ⓟ Y
PERM/COLL: AM & EU: Cont works on paper

Located in southern New Jersey, the gallery brings visual arts into focus as an integral part of the human story.

Jersey City

Jersey City Museum
472 Jersey Ave, **Jersey City, NJ 07302**
☎ 201-547-4514
HRS: 10:30-5 Tu, T-Sa; 10:30-8 W; closed Sa in summer DAY CLOSED: S, M HOL: LEG/HOL!, 12/24, 12/31
5 steps into building, small elevator ⓟ Y; Street MUS/SH: Y
GR/T: Y GR/PH: CATR! 201-547-4380 H/B: Y
PERM/COLL: AUGUST WILL COLLECTION: views of Jersey City, 19; AM: ptgs, drgs, gr, phot; HIST: dec/art; JERSEY CITY INDUSTRIAL DESIGN

Established in 1901, the museum is located in the historic Van Vorst Park neighborhood of Jersey City in the 100-year old public library building. In addition to showcasing the works of established and emerging contemporary regional artists, the museum presents exhibitions from the permanent collection documenting regional history.

ON EXHIBIT/97:

12/11/96–02/15/97	SUBVERSIONS/AFFIRMATIONS: JAUNE QUICK-TO-SEE SMITH, A TEN YEAR SURVEY — The first important survey of this major painter in mid-career. WT
03/05/97–05/17/97	SHEBA SHARROW: DRAWINGS — 11 acrylic drawings by this artist whose work is a synthesis of expressionism and humanism.
03/05/97–05/17/97	ESTHER PODEMSKI: PAINTINGS — Small, subtle, painterly works that evoke the natural world.
03/29/97–06/01/97	DAWOUD BEY: PORTRAITS 1975-1995 — Featured will be large-scale color portraits photographs of African-Americans living in the Hartford, Connecticut area which were taken by Bey using a unique 20" x 24" Polariod camera. WT
06/11/97–08/22/97	CHRIS GRIFFIN: AN INSTALLATION — A sculptural installation representing the female gender from the points of view of Catholicism and the culture at large.
06/11/97–08/22/97	ANCIENT PROBLEMS: CONTEMPORARY SIGNIFIERS — Four contemporary sculptors draw inspiration from ancient cultures in their quest to give meaning to contemporary phenomena.
09/17/97–11/22/97	JERSEY CITY: SHAPING AMERICA'S POTTERY INDUSTRY
09/17/97–11/22/97	RECENT ACQUISITIONS
12/10/97–02/14/98	SHARI ZOLLA: PAINTINGS
12/10/97–02/14/98	MIRIAM BEERMAN: ARTIST'S BOOKS
12/17/97–02/14/98	ROBERT PIRMELIN: GRAPHIC WORK

NEW JERSEY

Millville

Museum of American Glass at Wheaton Village
Affiliate Institution: 998-4552
1501 Glasstown Road, **Millville, NJ 08332-1566**
☎ 609-825-6800
HRS: 10-5 daily(Apr-Dec); 10-5 W-S (Jan-Mar) HOL: EASTER, THGV, 12/25
ADM: Y ADULT: $6.50, Fam $12 STUDENTS: $3.50 SR CIT: $5.50
&: Y ℗ Y; Free MUS/SH: Y ❡ Y; 7am-11 PM, PaperWaiter Restaurant and Pub, adjacent to Village
GR/T: Y GR/PH: CATR! DT: Y H/B: Y S/G: Y
PERM/COLL: GLASS

Wheaton Village focuses on American glass, craft and art. It features the beautiful Museum of American Glass plus a fully operational glass factory with daily, narrated demonstrations. See ongoing demonstrations also in pottery, woodworking, glass lampworking and stained glass. Also featured are Crafts and Trades Row, Folklife Center, a Stained Glass Studio, unique museum stores, a train ride and picnic area.

ON EXHIBIT/97:

	THE GALLERY OF AMERICAN CRAFT — 5 untitled exhibitions are planned. Call for information.
04/05/97–10/19/97	ANNUAL EXHIBITION Tent. Name
11/28/97–02/04/98	GRAND CHRISTMAS EXHIBITION Tent. Name

Montclair

The Montclair Art Museum
3 South Mountain Ave, **Montclair, NJ 07042**
☎ 201-746-5555
HRS: 11-5 Tu, W, F, Sa; 1-5 T, S; Summer hours 12-5 W-S DAY CLOSED: M HOL: LEG/HOL!
F/DAY: Sa, 11-2 SUGG/CONT: Y ADULT: $4.00 CHILDREN: F (under 12) STUDENTS: $3.00 SR CIT: $3.00
&: Y; Main floor and restroom ℗ Y; Free on-site parking MUS/SH: Y ❡ Y; nearby restaurants
GR/T: Y GR/PH: CATR! DT: Y TIME: call 201-746-5555 for specifics
PERM/COLL: NAT/AM: art 18-20; AM: ldscp, portraits 19; AM: dec/art; Hudson River School: Am Impressionists

Located just 12 miles west of midtown Manhattan and housed in a Greek Revival style building, this museum, founded in 1914, features an impressive American art collection of a quality not usually expected in a small suburb.

ON EXHIBIT/97:

01/28/97–04/13/97	SEAGRAMS PHOTOGRAPHY COLLECTION
02/04/97–04/13/97	JANET TAYLOR PICKETT
02/04/97–04/13/97	THE MONTCLAIR ART COLONY: PAST AND PRESENT
04/09/97–04/12/97	ART IN BLOOM — Floral interpretations based on selected works in the Museum.
04/27/97–07/27/97	GUY ROSE: AMERICAN IMPRESSIONIST — A retrospective survey of the work of this American impressionist ranges from picturesque scenes of the French countryside to views of the California coast. Many of these paintings are from private collections and have not been seen before. WT
05/04/97–07/27/97	HANANIAH HARARI — In the first retrospective of the work of this 82 year old artist who was among the original members of the American Abstract Artists, approximately 60 paintings, prints and drawings will demonstrate the variety of styles in which he worked ranging from Cubism, Constructivism and Expressionism to a trompe l'oeil realism.
WINTER/97–SPRING/98	GRACE NICHOLSON Dates Tent!

New Brunswick

Jane Voorhees Zimmerli Art Museum

Affiliate Institution: Rutgers, The State University of New Jersey
Corner George & Hamilton Streets, **New Brunswick, NJ 08903**
☎ 908-932-7237
HRS: 10-4:30 Tu-F; Noon-5 Sa, S DAY CLOSED: M HOL: LEG/HOL! 12/25 through 1/1; Month of August, Sa in July
&: Y Ⓟ Y; Nearby or metered MUS/SH: Y GR/T: Y $5.00pp! GR/PH: CATR! H/B: Y
PERM/COLL: FR: gr 19; AM: 20; EU: 15-20; P/COL: cer; CONT/AM: gr; THE NORTON AND NANCY DODGE
COLLECTION OF NON-CONFORMIST ART FROM THE SOVIET UNION

Housing the Rutgers University Collection of more than 50,000 works, this museum also incorporates the
International Center for Japonisme which features related art in the Kusakabe-Griffis Japonisme Gallery. **NOT
TO BE MISSED:** The George Riabov Collection of Russian Art; The Norton and Nancy Dodge Collection of
Nonconformist Russian Art from the Soviet Union.

ON EXHIBIT/97:

09/03/96–11/17/97	ITALIAN RELIGIOUS ART FROM THE COLLECTION
09/03/96–02/16/97	ANCIENT ART FROM THE COLLECTION
09/03/96–02/16/97	FOUR CENTURIES OF PRINTS: SELECTIONS FROM THE PERMANENT COLLECTION
11/24/96–02/16/97	LIT FROM WITHIN: AMISH QUILTS OF LANCASTER COUNTY — A selection of quilts created between 1860 and 1950. In their fine craftsmanship, bold colors, and simple designs, the examples of female creativity in this medium reflect the values of a unique American social group.
12/02/96–02/16/97	BEARS ALL AROUND
03/22/97–07/31/97	RUTGERS ARCHIVES FOR PRINTMAKING STUDIOS: PRINTS BY EMILY MASON
03/22/97–07/31/97	NARRATIVE SEQUENCES FROM THE NORTON AND NANCY DODGE COLLECTION
03/23/97–07/31/97	ASIAN TRADITIONS/MODERN EXPRESSION: ASIAN AMERICAN ARTISTS AND ABSTRACTION, 1945-1970 — The achievements of Asian American artists and how they were able to make use of traditional Asian art techniques and philosophies to develop a creative blending of Eastern and Western art.
09/97–11/07/97	ART OF THE BALKANS TENT!
11/22/97–02/22/98	THE GREAT AMERICAN POP STORE: MULTIPLES OF THE SIXTIES — A selection of objects including 3-D multiples, artists sketches, plans, and maquettes by major figures of the Pop Art movement. TENT!

Newark

The Newark Museum

49 Washington Street, **Newark, NJ 07101-0540**
☎ 201-596-6550
HRS: 12-5 W-S DAY CLOSED: M, Tu HOL: 1/1, 7/4, THGV, 12/25
&: Y; Ramp entrance, elevators, wheelchair accessible, restrooms Ⓟ Y; $1.00 in the museum's adjacent parking lot
MUS/SH: Y; 2 ⅋ Y; Cafe in Engelhard Court open noon-3:30 W-S (wheelchair accessible)
GR/T: Y GR/PH: CATR! 201-596-6614 H/B: Y, Ballantine House
PERM/COLL: AM: ptgs 17-20; AM: folk; AF/AM; DEC/ARTS; GLASS; JAP; CONT; AM: Hudson River School ptgs; AF;
AN/GRK; AN/R; EGT

Established in 1909 as a museum of art, the Newark features one of the finest collections of Tibetan art in the
world. Several connected structures of the museum consist of the historic late Victorian Ballantine House, a
contemporary and recently renovated museum building, a Mini Zoo, Planetarium, and a 1784 Schoolhouse. **NOT
TO BE MISSED:** "The Voice of the City of New York Interpreted,"by Joseph Stella 1920-22; One of the most
highly regarded collections of 19th-century American furniture

The Newark Museum - continued
ON EXHIBIT/97:

ONGOING	HOUSE AND HOME: BALLANTINE HOUSE EXHIBITION — The Victorian origins of today's concept of "home" is explored through the restored rooms and new thematic galleries that showcase the Museum's extensive decorative arts collection. This 1885 national landmark building is the only urban Victorian mansion open to the public in the Tri-state area. Included is an interactive computer game allowing the players to chose items for their own fantasy house.
Through 06/97	AFRICAN DESIGN: HEIRS TO THE TRANS-SAHARAN TRADE — The history of trade routes and the pool of shared designs in North and Sub-Saharan African arts during the last hundred years are studied in ceramics, amulets, weapons jewelry, textiles, pottery, leatherwork and more.
SPRING/97	THE PRINTED POT: TRANSFER-PRINTED POTTERY 1750-1990 — Through 100 pieces of pottery and porcelain in Museum's collection the history of printed decoration on tableware is traced from its perfection by Josiah Wedgewood in the middle of the 18th-century to its most recent use by designer Dorothy Hafner for German porcelain maker Rosenthal.
11/15/96–11/98	CRAFTSMEN OF ANCIENT ROME — For the first time the Roman collection will be shown in one gallery incorporating a unified theme and offering a historical and cultural background. Many of the objects have never been on view.
11/27/96–01/05/97	QUILT MASTERPIECES FROM THE NEWARK MUSEUM COLLECTION — Complex patterns and brilliant colors are the highlights of the 12 beautifully ornate quilts illustrating the art and tradition of quilting through the 18th-20th centuries.

Newark

The Newark Public Library
5 Washington Street, **Newark, NJ 07101**
📞 201-733-7800
HRS: 9-5:30 M, F, Sa; 9-8:30 Tu, W, T HOL: LEG/HOL!
&: Y; Ramp H/B: Y
PERM/COLL: AM & EU: gr

Since 1903 the library can be counted on for exhibitions which are of rare quality and well documented.

Oceanville

The Noyes Museum
Lily Lake Rd, **Oceanville, NJ 08231**
📞 609-652-8848 WEB ADDRESS: http://users.aol.com/noyesnews
HRS: 11-4 W-S DAY CLOSED: M, T HOL: LEG/HOL! 12/24-1/2
F/DAY: F ADM: Y ADULT: $3.00 CHILDREN: F, under 18 STUDENTS: $2.00 SR CIT: $2.00
&: Y Ⓟ Y; Free MUS/SH: Y GR/T: Y GR/PH: CATR!
PERM/COLL: AM: cont, craft, folk; NJ: reg; VINTAGE BIRD DECOYS

Nestled in a peaceful lakeside setting, the Museum displays rotating exhibitions of American art and craft. southern New Jersey's only fine art museum, it is a hidden treasure worth discovering and is located only 15 minutes from Atlantic City.

The Noyes Museum - continued
ON EXHIBIT/97:

through 01/12/97 AN INNER JOURNEY: PAINTINGS BY MICHAEL RYAN — The works of this Hoboken artist reflect the poignant memories and emotions he encountered working with the homeless and downtrodden in Philadelphia. They speak of his own personal experiences before he was treated for manic depression.

10/27/96–02/23/97 THE NEW JERSEY OYSTER: RELICS OF A FADING INDUSTRY — This once booming industry on the Delaware Bay is remembered with artifacts from a private collection.

11/10/96–01/05/97 ANGELS, CHERUBS AND PUTTI: THE ARTISTS' MUSES — Works by regional artists, some self-taught, in a variety of media inspired by and featuring images of guiding spirits.

01/05/97–03/23/97 A FANTASY WORLD: DRAWINGS BY PATRICIA O'MAILLE — These fantasy-like scenes evoke a world of daydream which the artist describes as "a continuous conversation" with herself.

01/26/97–03/23/97 DUST SHAPED HEARTS: PHOTOGRAPHIC PORTRAITS BY DON CAMP — Full face portraits of African-American men by an award winning conceptual and experimental photographer. The exhibition is named in honor of poet Robert Hayden's publication "Heart Shapes in the Dust."

01/26/97–04/13/97 TRAMP ART AND WHIMSIES FROM THE CIARDELLI COLLECTION — Whimsies, seemingly impossible carvings such as balls inside of cages and interlocked chain links, all carved from a single block of wood, are a folk art transplanted to America by European and Asian settlers and slaves from Africa. Techniques were handed down from father to son, traded among neighbors, and learned from hobos.

03/09/97–/ DECOYS FROM THE NOYES MUSEUM PERMANENT COLLECTION — A survey of the best 19th and 20th-century decoys in the collection including those by notable New Jersey carvers.

04/06/97–06/22/97 RECENT WORKS BY DAVID AMBROSE — Paintings by Ambrose, an artist with two primary inspirations: human anatomy and gothic architecture.

04/06/97–06/15/97 TREASURES OF ART HISTORY FROM THE NEW JERSEY STATE MUSEUM — Treasures such as a linoleum cut by Picasso or an engraving by Toulouse-Lautrec provide insight into 19th and 20th-century art movements. Ancient works from Egypt, Greece, India and Ethiopia demonstrate the enduring desire for artistic expression.

04/27/97–08/17/97 EASY ACCESS: HIGHLIGHTS FROM THE NOYES MUSEUM'S COLLECTION OF CONTEMPORARY ART — The best of the collection presented in ways which allow the sight or hearing impaired to transcend the barriers and experience art.

06/29/97–09/21/97 FOR THE LOVE OF ART: CARVINGS AND PAINTINGS BY SOUTH JERSEY FOLK ARTIST ALBERT HOFFMAN — The work of this self-taught artist reflects his interest in Old Testament narratives, Native American life, fishing and the undersea world.

08/31/97–12/07/97 THE ART OF BEAUTY: ARTISTS CAPTURE MISS AMERICA IN ART — Artists view the pageant and its contestants from unique perspectives.

09/14/97–01/04/98 ART OF THE ABSURD: SURREALISM IN CONTEMPORARY AND SELF-TAUGHT ART — In two galleries, the museum explores surreal expression. One features trained contemporary artists, the other self-taught artists.

NEW JERSEY

Oradell

The Hiram Blauvelt Art Museum
705 Kinderkamack Road, **Oradell, NJ 07649**
☎ 201-261-0012
HRS: 10-4 W-F; 2-4 Sa, S DAY CLOSED: M, T HOL: LEG/HOL
VOL/CONT: Y ♿: Y ℗ Y, F MUS/SH: Y GR/T: Y GR/PH: CATR! DT: Y TIME: by appt H/B: Y S/G: Y
PERM/COLL: WILDLIFE ART; AUDUBON FOLIO; IVORY GALLERY; BIG GAME ANIMALS, EXTINCT BIRDS, REPTILES

Founded in 1957 the museum is dedicated to bringing awareness to issues facing the natural world and to showcasing the artists who are inspired by it. It is located in an 1893 shingle and turret style carriage house. The 1679 Demarest House in River Edge, NJ is also owned by the Blauvelt-Demarest Foundation. **NOT TO BE MISSED:** Carl Rungius oil

ON EXHIBIT/97:

01/15/97–04/15/97	JOHN SCHOENHERR
05/03/97–06/02/97	SOCIETY OF ANIMAL ARTISTS EXHIBITION AND SALE
06/15/97–08/15/97	HIRAM BLAUVELT MUSEUM AND SOCIETY OF ANIMAL ARTISTS EDUCATIONAL CONFERENCE
09/15/97–12/15/97	DWAYNE HARTY

Princeton

The Art Museum
Affiliate Institution: Princeton University
Nassau Street, **Princeton, NJ 08544-1018**
☎ 609-258-3788
HRS: 10-5 T-Sa, 1-5 S DAY CLOSED: M HOL: LEG/HOL!
♿: Y ℗ Y; On-street or nearby garages; special parking arrangements for the handicapped are available (call ahead for information) MUS/SH: Y GR/T: Y GR/PH: CATR! DT: Y TIME: 2:00 Sa
PERM/COLL: AN/GRK; AN/R+Mosaics; EU: sculp, ptgs 15-20; CH: sculp, ptgs; GR; P/COL; OM: ptgs, drgs; AF

An outstanding collection of Greek and Roman antiquities including Roman mosaics from Princeton University's excavations in Antioch is but one of the features of this highly regarded eclectic collection housed in a modern building on the lovely Princeton University campus. **NOT TO BE MISSED:** Picasso sculpture, "Head of a Woman"

ON EXHIBIT/97:

02/22/97–06/08/97	IN CELEBRATION: WORKS OF ART FROM THE COLLECTIONS OF PRINCETON ALUMNI AND FRIENDS OF THE ART MUSEUM

Summit

New Jersey Center for Visual Arts
68 Elm Street, **Summit, NJ 07901**
☎ 908-273-9121
HRS: 12-4 M-F; 7:30-10 T; 2-4 Sa, S HOL: LEG/HOL! & last 2 weeks in August
ADM: Y ADULT: $1.00 CHILDREN: F (under 12) STUDENTS: $1.00
♿: Y; Elevator, ramps, etc. ℗ Y; Free MUS/SH: Y GR/T: Y GR/PH: CATR! DT: Y TIME: ! S/G: Y
PERM/COLL: non-collecting institution

The Center presents exhibitions of contemporary art by artists of national and international reputation as well as classes for people of all ages and levels of ability.

Tenafly

The African Art Museum of the S. M. A. Fathers
23 Bliss Ave, **Tenafly, NJ 07670**
📞 201-567-0450
HRS: 10-5 M-Sa, f2-5 S HOL: LEG/HOL!
&: Y ℗ Y, F GR/T: Y GR/PH: CATR!
PERM/COLL: AF; sculp, dec/art

Located in a cloistered monastery with beautiful gardens in the gracious old town of Tenafly, this museum features changing collection and loan exhibitions.

ON EXHIBIT/97:
02/09/97–03/30/97	MASKS AND HEADDRESSES AS AGENTS OF SOCIAL CONTROL AND NIGERIAN IMAGES FROM THE LEONARD AND JUDY KAHAN COLLECTION
05/04/97–06/29/97	AFRICAN TEXTILES AS SYMBOLS OF POWER AND PRESTIGE
10/12/97–01/11/98	MASTERWORKS OF AFRICAN ART FROM THE M. BERGER COLLECTION

Trenton

New Jersey State Museum
205 West State Street, CN530, **Trenton, NJ 08625-0530**
📞 609-292-6464
HRS: 9-4:45 Tu-Sa, 12-5 S DAY CLOSED: M HOL: LEG/HOL!
ADULT: Planetarium $1.00 CHILDREN: Planetarium $1.00
&: Y ℗ Y; Free parking available in garage near museum MUS/SH: Y GR/T: Y GR/PH: CATR!
PERM/COLL: AM: cont, gr; AF/AM

The museum is located in the Capitol Complex in downtown Trenton. The fine art collections cover broad areas of interest with a special focus on New Jersey and culturally diverse artists. **NOT TO BE MISSED:** Ben Shahn Graphics Collection

ON EXHIBIT/97:
through 02/07/97	SELECTIONS FROM THE AFRICAN-AMERICAN COLLECTION OF THE NEW JERSEY STATE MUSEUM	
01/09/97–03/09/97	WORKS BY ANN STARKEY	
01/12/97–03/02/97	THE BUFFALO SOLDIER: THE AFRICAN-AMERICAN SOLDIER IN THE US ARMY, 1866-1912 FROM THE COLLECTION OF ANTHONY L. POWELL	TENT!
01/18/97–03/23/97	PHOTOGRAPHS BY WILLIAM TRENT	TENT!

NEW MEXICO

Abiquiu

The Georgia O'Keeffe Home and Studio
Affiliate Institution: The Georgia O'Keeffe Foundation
Abiquiu, NM 87510
☎ 505-685-4539
HRS: open by reservation only! 1 hr Tours seasonally on Tu, T, F HOL: LEG/HOL
ADM: Y ADULT: $20 interior $15 ext
&: exterior only ⓟ Y
GR/T: Y GR/PH: CATR! H/B: Y
PERM/COLL: Home and studio of artist Georgia O'Keeffe

To the extent possible the house remains as it was left by O'Keeffe in 1984 when she moved to Santa Fe. O'Keeffe Foundation President, Elizabeth Glassman says" Few places exist in America where one can see how an artist lived and worked. To experience the spaces created by O'Keeffe and to see the places she so often painted allows the visitor a new glimpse of the artist." No photographs or tape recorders are permitted. Visitors are required to wear soft rubber-soled shoes to protect the traditional adobe floors.

Albuquerque

University Art Museum and Jonson Gallery
Affiliate Institution: The University of New Mexico
Fine Arts Center, **Albuquerque, NM 87131**
☎ 505-277-4001
HRS: 9-4 Tu-F, 5-8 Tu, 1-4 Sa, S; Jonson Gallery closed on weekends DAY CLOSED: M, Sa HOL: LEG/HOL!
&: Y ⓟ Y; Limited free parking MUS/SH: Y
GR/T: Y GR/PH: CATR! DT: Y TIME: 2nd, 3rd and 4th Tu, 5:30 PM ! S/G: Y
PERM/COLL: MEX RETABLOS 19; CONT; GR; PHOT

Works of art in all media by artists whose work is relevant to contemporary art issues are featured in this gallery. The Museum has opened a branch gallery-516: University Art Gallery Downtown. Open from 11-4 Tu-Sa, the new space offers a sampling of the rich diversity and strengths of the Museum's collection. **NOT TO BE MISSED:** An early Richard Diebenkorn painting

ON EXHIBIT/97:

Fine Arts Center:	505-277-4001
Jonson Gallery: 1909 LAS LOMAS, NE	505-277-4967

12/06/96–01/31/97	CHROMATIC CONTRASTS: THE SENSATION OF COLOR MOVEMENT — In a series of paintings started in the 1930's Raymond Johnson explored color compositions and developed a mode in which to express dissonant color relationships. The result produced a sensation of color movement.
12/17/96–01/17/97	FRANK WALKER-ENIGMATIC FORMS — For Walker, each work is a visual adventure bringing new form, color or texture at every turn. Each imaginative construction is a feast for the eyes and a subject unto itself.

Los Alamos

Fuller Lodge Art Center and Gallery
2132 Central Avenue, **Los Alamos, NM 87544**
☎ 505-662-9331
HRS: 10-4 M-Sa, 1-4 S (Nov-Mar, closed S) HOL: LEG/HOL!
♿: Y ⓟ Y MUS/SH: Y showcase member artists H/B: Y
PERM/COLL: under development

Located in historic Fuller Lodge, this art center, nationally recognized for its juried Biennial 6-State Exhibition, also presents monthly changing exhibitions.

ON EXHIBIT/97:

01/10/97–02/08/97	PIECEMAKERS
02/14/97–03/15/97	QUE PASA
03/21/97–04/27/97	LOS ALAMOS ARTISTS STUDIO TOUR
05/02/97–06/01/97	FLIGHTS OF FANCY
06/06/97–07/13/97	BIENNIAL FINE ARTS JURIED EXHIBITION
07/18/97–08/17/97	FLAC CELEBRATES 20 YEARS
08/22/97–09/21/97	NEW MEXICO SCULPTURE GUILD
09/26/97–10/20/97	SOUTHWEST FIBER AND FABRIC
10/31/97–11/29/97	MAKING FACES

Roswell

Roswell Museum and Art Center
100 West 11th, **Roswell, NM 88201**
☎ 505-624-6744
HRS: 9-5 M-Sa, 1-5 S & HOL HOL: 1/1, THGV, 12/25
VOL/CONT: Y
♿: Y ⓟ Y GR/T: Y GR/PH: CATR!
PERM/COLL: SW/ART; HISTORY; SCIENCE; NM/ART; NAT/AM

16 galleries featuring works by Santa Fe and Taos masters and a wide range of historic and contemporary art in its impressive permanent collection make this museum one of the premier cultural attractions of the Southwest. Temporary exhibitions of Native American, Hispanic, and Anglo art are often featured. **NOT TO BE MISSED:** Rogers Aston Collection of Native American and Western Art

ON EXHIBIT/97:

01/31/97–04/27/97	THE LIFE AND ART OF PATROCINO BARELA		
02/14/97–05/11/97	BERNADETTE VIGIL:PAINTINGS		
02/21/97–04/20/97	KAREN AQUA:FILM AND DRAWING		
05/97–06/97	DEBORAH BRACKENBURG: MIXED MEDIA	Dates Tent!	TENT!
05/09/97–07/06/97	BEATRICE MANDELMANN: PAINTINGS		
05/23/97–08/31/97	MARY PECK: CHACO CANYON		
06/97–07/97	LAUREL FARRIN: MIXED MEDIA	Dates Tent!	TENT!
09/12/97–11/30/97	1997 INVITATIONAL: JIM WAGNER		

255

NEW MEXICO

Santa Fe

Institute of American Indian Arts Museum
108 Cathedral Place, **Santa Fe, NM 87504**
☎ 505-988-6281
HRS: 10-5 M-Sa, 12-5 S (closed M, Tu Jan & Feb) HOL: LEG/HOL!
ADM: Y ADULT: $4.00; F NAT/AM CHILDREN: F (under 16) STUDENTS: $2.00 SR CIT: $2.00
&: Y MUS/SH: Y GR/T: Y GR/PH: CATR!
PERM/COLL: NAT/AM: artifacts; CONT NAT/AM: arts and crafts

Contemporary Native American arts and crafts and Alaskan native arts are featured in this museum which also houses an outstanding archive of Native American video tapes.

Museum of New Mexico
113 Lincoln Ave., **Santa Fe, NM 87501**
☎ 505-827-6451
HRS: All Museums 10-5 Tu-S! Monuments, 8:30-5 daily DAY CLOSED: M HOL: 1/1, EASTER , THGV, 12/25
ADM: Y ADULT: $8, 4 day pass all CHILDREN: F (under 17) STUDENTS: $4.00 SR CIT: $4.00
&: Y; In most buildings ℗ Y MUS/SH: Y
GR/T: Y GR/PH: CATR! H/B: Y
PERM/COLL: (4 Museums with varied collections): TAOS & SANTA FE MASTERS; PHOT; SW/REG ;NAT/AM; FOLK; 5 State Monuments

In 1917 when it opened, the Museum of Fine Arts set the Santa Fe standard in pueblo-revival architecture. The Palace of the Governors, built by Spanish Colonial and Mexican governors, has the distinction of being the oldest public building in the US. **NOT TO BE MISSED:** The entire complex

ON EXHIBIT/97:
PALACE OF THE GOVERNORS ON THE PLAZA

Permanent · ANOTHER MEXICO: SPANISH LIFE ON THE UPPER RIO GRANDE — An overview of life in New Mexico from the Colonial period with the Spanish presence in 1540 to the present.

SOCIETY DEFINED: THE HISPANIC RESIDENTS OF NEW MEXICO, 1790 — Artifacts and documents related to the detailed census of New Mexico taken in 1790 by order of the Spanish crown.

PERIOD ROOMS: 1893: Governor Bradford L. Prince Parlor, The 1846 Mexican Governor's Office, Northern New Mexico Chapel a Composite of Items From 1820 - 1880

MUSEUM OF INTERNATIONAL FOLK ART

Permanent · MULTIPLE VISIONS: A COMMON BOND — A collection of approximately 10,000 pieces from the Girard Collection representing folk art of more than 100 nations.

FAMILIA Y FE/FAMILY AND FAITH — An exhibition that spotlights the importance of family and faith to the New Mexican Hispanic culture.

MUSEUM OF INDIAN ARTS AND CULTURE

Continuing: · FROM THIS EARTH: POTTERY OF THE SOUTHWEST — A survey of archeological, historical and contemporary Southwest Indian pottery examines techniques, styles, materials and regions.

PEOPLE OF THE MIMBRES — A comprehensive examination of these ancient people whose civilization is being reconstructed by archeologists despite destruction of cultural sites by pothunters and fortune seekers.

DANCING SPIRITS: JOSE REY TOLEDO, TOWA ARTIST — The paintings of this late artist whose many careers included health educator, actor and lecturer, are witness to his love of the traditions and ceremonies of his people.

256

Museum of New Mexico - continued
NEW MEXICO STATE MONUMENTS

FORT SELDEN — (505-526-8911) A 19th-century adobe fort.

FORT SUMNER — (505-355-2573) closed Tu, W — Site of the internment of 9500 Apaches and Navajos in the 1860's. Billy the Kid was killed here by Sheriff Pat Garrett.

JEMEZ — (505-829-3530) The ruins of Giusewa, an ancient Indian settlement near present-day Jemez Pueblo and San Jose de los Jemez, a 17th-century Spanish mission church.

LINCOLN — (505-653-4372) This well preserved old west town was the site of the Lincoln County War and of Billy the Kid's capture and escape.

CORONADO

(505-867-5351) Site of the ruins of the ancient Tiwa Pueblo of Kuaua.

ONGOING

MULTIPLE VISIONS: A COMMON BOND — A collection of approximately 10,000 pieces from the Girard Collection represents folk art of more than 100 nations.

FAMILIA y FE/ FAMILY AND FAITH — Textiles, jewelry, religious objects, period chapel and family rooms illuminate the importance of the family in New Mexican Hispanic culture.

Through 02/02/97

NATURAL BELONGINGS: CLASSIC ART TRADITIONS FROM THE SOUTHWEST — Utilitarian and ceremonial Native American artifacts will be on exhibit.

Through 08/22/98

RECYCLED, RE-SEEN: FOLK ART FROM THE GOSPEL SCRAP HEAP — Featured will be 700 works by visionary and folk artists from around the world who transform discarded industrial byproducts into renewed objects of meaning and beauty.

FROM THIS EARTH: POTTERY OF THE SOUTHWEST — A survey of archeological, historical and contemporary Southwest Indian pottery details techniques, styles, materials and regions of origin.

10/18/96–02/03/97

STEINA AND WOODY VASULKA: MACHINE MEDIA — Video art pertaining to communications technology and shifting cultural contexts.

10/25/96

GEORGIA O'KEEFFE – FROM LAKE GEORGE TO NEW MEXICO: ALFRED STIEGLITZ, PAUL STRAND AND FRIENDS

10/26/96–03/17/97

WILLIARD VAN DYKE: THE EARLY WORK 1930-1937 AND THE WILLIAM VAN DYKE MEMORIAL REWARD — On exhibit will be a cross section of photographs by van Dyck, founder of Group f-64 at the Pinewood Foundation Collection.

11/17/96–08/09/97

THE STORIES WOVEN IN: DIYOGI HANÉ BIL NIDAHAASTIQ — Navajo weaving and oral traditions are combined in the symbolism used to communicate stories, songs and traditions into the 35-50 rug designs and other weavings on display.

12/13/96–06/02/97

SPECIAL COLLECTORS, SPECIAL COLLECTIONS IN PHOTOGRAPHY: JANE REESE WILLIAMS, ROBERTA COKE DeGOLYER, GILBERT HITCHCOCK

01/26/97–01/04/98

MARIA HESCH: A KIND AND GENTLE LIFE — Paintings by Hesch (1913-1994), a lifelong New Mexico resident who filled her canvases with narrative recollections of the daily life of Hispanic society in the early 20th-century.

02/22/97

CONTEMPORARY PAINTINGS (Working Title) — Contemporary Native American artistic visions will be showcased in the paintings on view.

03/21/97–09/15/97

FLORENCE MILLER PIERCE (Working Title) — Abstract paintings of personal visions by Pierce, one of New Mexico's foremost artists for 60 years.

06/20/97–11/10/97

ALCOVE SHOW — A presentation of works by promising new and emerging New Mexico artists.

08/08/97

HERE, NOW AND ALWAYS — A display of 1,500 objects imbued with aspects of the culture of native Southwestern peoples.

08/30/97–01/05/98

SAM SCOTT: A RETROSPECTIVE (Working Title) — Emphasis on Scott's large, vibrant abstract paintings will be featured in this retrospective exhibition of his works.

10/10/97–02/09/98

THREADS OF TWO CULTURES: THE WEAVING TRADITIONS OF THE NAVAJO AND THE BERBER — Hands-on looms, weaving tools and a children's component will be part of this comparative exhibition of rural Moroccan and Southwest American weavings and other artworks. WT

NEW MEXICO

Santa Fe

Wheelwright Museum of the American Indian
704 Camino Lejo, **Santa Fe, NM 87502**
📞 505-982-4636
HRS: 10-5 M-Sa, 1-5 S HOL: 1/1, 12/25, THGV
&: Y, Main Gallery only; rest rooms and gift shop downstairs Ⓟ Y, in front of building
MUS/SH: Y GR/T: Y GR/PH: CATR! DT: Y TIME: 2 PM Tu, F S/G: Y
PERM/COLL: NAT/AM, Navajo; SW Ind (not always on view)

Inside this eight sided building, shaped like a Navajo 'hogan' or home, on a hillside with vast views, you will find breathtaking American Indian art. **NOT TO BE MISSED:** Sandpainting reproductions and Hastiin Klah's sandpainting textiles (not usually on display !).

ON EXHIBIT/97:
 SKYLIGHT GALLERY: CHANGING EXHIBITS OF EMERGING NATIVE AMERICAN ARTISTS

 10/13/96–01/22/97 TBA

Taos

The Harwood Museum of the University of New Mexico
Affiliate Institution: University of New Mexico
238 Ledoux St, **Taos, NM 87571**
📞 505-758-9826
HRS: 10-5 M-F, 10-4 Sa DAY CLOSED: S HOL: LEG/HOL!
ADM: Y ADULT: $2.00
&: Y; Partial! Ⓟ Y; Limited parking with parking lots nearby MUS/SH: Y GR/T: Y GR/PH: CATR! H/B: Y
PERM/COLL: HISPANIC: 19; TAOS ARTISTS: 20

Many of the finest artists who have worked in Taos are represented in this collection. The building housing the museum is one of the first twentieth-century buildings that set the architectural style which became popular in northern New Mexico. **NOT TO BE MISSED:** "Winter Funeral," By Victor Higgins

ON EXHIBIT/97: The Harwood Museum is closed for renovation until late Spring 1997. Until then there is a satellite location in the old Taos County Courthouse on Taos Plaza. Admission fees and hours may change when the original building reopens. Call!

Millicent Rogers Museum of Northern New Mexico
Museum Road, 4 miles N of Taos, **Taos, NM ff571**
📞 505-758-2462
HRS: 10-5 Daily Apr-Oct; closed M Apr-Mar HOL: 1/1, EASTER, 9/30, THGV, 12/25
ADM: Y ADULT: $4.00 CHILDREN: $2.00 (6-16) STUDENTS: $3.00 SR CIT: $3.00
&: Y Ⓟ Y MUS/SH: Y GR/T: Y GR/PH: CATR! H/B: Y S/G: Y
PERM/COLL: NAT/AM & HISP: textiles, basketry, pottery, jewelry

Dedicated to the display and interpretation of the art and material of Native American and Hispanic peoples of the Southwest, the Millicent Rogers Museum places particular focus on works from Northern New Mexican.

ON EXHIBIT/97:
 01/18/97–05/04/97 ANIMAL FRIENDS — Drawn entirely from the permanent collection this exhibition focuses on the artistic, cultural and symbolic significance of wild and domestic animals in northern New Mexico.
 05/17/97–10/05/97 NATIVE AMERICAN BIENNIAL — A comprehensive survey of Native American art, craft, and design in all media includes Pueblo, Apache, Navajo, Zuni, and Hopi artists from New Mexico and Arizona. The exhibition theme "Relationships" examines personal, social, cultural, historical, and environmental concerns as they relate to contemporary Native American life and culture.

258

Albany

Albany Institute of History & Art
125 Washington Ave, **Albany, NY 12210**
☎ 518-463-4478
HRS: 10-5 Tu-F; 12-5 Sa, S DAY CLOSED: M HOL: LEG/HOL!
VOL/CONT: Y
&: Y ⓟ Y; Nearby pay garage MUS/SH: Y ¶ Y; 11:30-1:30 Tu-F (Sep-May) GR/T: Y GR/PH: CATR! H/B: Y
PERM/COLL: PTGS: Hudson River School & Limner; AM: portraits 19; CAST IRON STOVES; DEC/ARTS: 19

Founded in 1791, this museum, one of the oldest in the nation, presents changing exhibitions throughout the year. There are over 15,000 objects in the permanent collection. **NOT TO BE MISSED:** Hudson River School Ptgs by Cole, Durand, Church, Kensett, Casilear and the Hart Brothers

ON EXHIBIT/97:

12/21/96–06/01/97	THE CAPITOL COMES TO ALBANY — People, events and issues surrounding the 1797 decision to establish Albany as the capital are examined in the paintings, documents and objects on view in an exhibition that also highlights the 1897 centennial celebration.
01/18/97–02/16/97	MARBLE DUST AND MAGIC LAKES — A major folk art exhibition focusing exclusively on 19th-century charcoal and pastel drawings on sandpaper includes biblical, historical, memorial, allegorical, portrait and still life themes.
01/25/97–06/97	MARION WEEBER: INDUSTRIAL DESIGNER — Included are jewelry, sterling silver decorative arts, stainless steel flatware, and other works created in New York City between 1940-1980.
02/28/97–06/08/97	FAIRFIELD PORTER: AN AMERICAN PAINTER — The works in this exhibition by Porter, an important American realist painter, are from his most productive years (1945-1974) and are drawn from the collection of the Parrish Art Museum in Southampton, NY, a town where he lived and worked for many years.
06/97–12/97	HUDSON RIVER SCHOOL DRAWINGS — An exhibition of drawings and sketchbooks by Thomas Cole, Asher B. Durand, Frederic Church, Jasper Cropsey, James Hart, William Hart and others.
06/19/97–09/07/97	BEST OF BOTH WORLDS: ETHNIC RESORTS OF THE CATSKILLS — Featured will be contemporary and historic looks at a dozen ethnic communities developed after World War II.
09/26/97–11/09/97	IS IT ART?: TRANSGRESSIONS IN CONTEMPORARY ART — This exhibition enables the viewer to respond to the works of 15 of today's most cutting edge artists, many of whom have been at the center of controversies that have created contemporary art history.

University Art Museum
Affiliate Institution: University At Albany, State University of NY
1400 Washington Ave, **Albany, NY 12222**
☎ 518-442-4035
HRS: 10-5 Tu-F; 12-4 Sa, S DAY CLOSED: M HOL: LEG/HOL!
&: Y ⓟ Y; Collins Circle on Washington Ave entrance to campus ¶ Y; In Campus Center
PERM/COLL: AM: gr, ptgs, drgs 20

This museum, the largest of its kind among the State University campuses and one of the major galleries of the Capitol District, features work from student and mid-career to established artists of national reputation. **NOT TO BE MISSED:** Richard Diebenkorn, "Seated Woman," 1966, (drawing)

ON EXHIBIT/97:

01/21/97–03/02/97	THE UNIVERSITY AT ALBANY ART DEPARTMENT FACULTY EXHIBITION — In conjunction with the celebration of the University Uptown campus 30th anniversary this exhibition will feature paintings, sculpture, prints, photographs and drawings by the world renowned art department faculty.

University Art Museum - continued

03/15/97–04/30/97 ONCE UPON A DRAWING: THE PICTURE BOOK ILLUSTRATIONS OF MARCIA BROWN — The artist's collection of notes, journals, illustrations, and correspondence will be featured. Marcia Brown is a three-time winner of the Caldecott Award for children's book illustration.

06/17/97–07/27/97 ARTISTS OF THE MOHAWK HUDSON REGION JURIED EXHIBITION

09/20/97–11/09/97 SHARED CULTURAL EXPERIENCE: MEMORY AND MOURNING — The exhibition will include, among other works, "A Day Of The Dead" installation by Antonio Martorell of Puerto Rico.

Annandale on Hudson

The Center for Curatorial Studies and Art in Contemporary Culture

Bard College, **Annandale on Hudson, NY 12504**
☎ 914-758-2424
HRS: 1-5 W-S DAY CLOSED: M, Tu HOL: ACAD!
&: Y ℗ Y GR/T: Y GR/PH: CATR!
PERM/COLL: CONT: all media; VIDEO: installation 1960-present

Housed in a new facility which opened in 1992, the Rivendell Collection, a systematic collection of art from the mid 1960's to the present, will continue to grow with the addition of works through the end of this century. **NOT TO BE MISSED:** Sol Lewitt "Double Assymetrical Pyramids," 1986, india ink wash on wall

Astoria

American Museum of The Moving Image

35th Ave at 36th St, **Astoria, NY 11106**
☎ 718-784-0077
HRS: 12-5 Tu-F, 11-6 Sa-S DAY CLOSED: M HOL: 12/25, 1/1
ADM: Y ADULT: $7.00 CHILDREN: $4.00; F (under 4) STUDENTS: $4.00 SR CIT: $4.00
&: Y ℗ Y; Nearby pay garage MUS/SH: Y ¶Y; Cafe GR/T: Y GR/PH: CATR! 718-784-4520 H/B: Y
PERM/COLL: BEHIND THE SCREEN, combination of artifacts, interactive experiences, live demonstrations and video screenings to tell the story of the making, marketing and exhibiting of film, television and digital media. Especially popular are Automated Dialogue Replacement where visitors can dub their own voices into a scene from a movie and Video Flipbook where visitors can create a flipbook of themselves that they can pick up at the gift shop as a memento.

The only Museum in the US devoted exclusively to film, television, video and interactive media and their impact on 20th-century American life. **NOT TO BE MISSED:** "Tut's Fever Movie Palace," Red Grooms and Lysiane Luongs interpretation of a 1920's neo-Egyptian movie palace showing screenings of classic movie serials daily.

Auburn

Schweinfurth Memorial Art Center

205 Genesee St, **Auburn, NY 13021**
☎ 315-255-1553
HRS: 12-5 Tu-F, 10-5 Sa, 1-5 S DAY CLOSED: M HOL: 12/25, THGV
ADM: Y ADULT: $1.00 CHILDREN: F (under 12) SR CIT: $1.00
&: Y ℗ Y MUS/SH: Y
PERM/COLL: Non collecting institution

Regional fine art, folk art and crafts are featured in changing exhibitions at this cultural center located in central New York State.

Bayside

QCC Art Gallery
Affiliate Institution: Queensborough Community College
222-05 56th Ave., **Bayside, NY 11364-1497**
☎ 718-631-6396
HRS: 9-5 M-F and by appt. DAY CLOSED: Sa, S HOL: ACAD!
ᕫ: Y GR/T: Y GR/PH: CATR!
PERM/COLL: AM: after 1950; WOMEN ARTISTS

The Gallery which reflects the ethnic diversity of Queensborough Community College and its regional residents also highlights the role art plays in the cultural history of people.

Binghamton

Roberson Center for the Arts and Sciences
30 Front St., **Binghamton, NY 13905**
☎ 607-772-0660
HRS: 10-5 Tu, T, Sa; 10-9 F; 12-5 S DAY CLOSED: M HOL: LEG/HOL!
ADM: Y ADULT: $3.00 CHILDREN: $1.50 (5-16) STUDENTS: $3.00 SR CIT: $2.00
ᕫ: Y ℗ Y MUS/SH: Y GR/T: Y GR/PH: CATR!
PERM/COLL: TEXTILES; PHOT; PTGS; DEC/ART: late 19, 20

This regional museum and science center features the history of Broome County spanning 10,000 years, Edward A. Link's accomplishments in aviation and oceanography, and the Lee J. Loomis Wildlife Collection. **NOT TO BE MISSED:** "Blue Box" trainer circa 1942 by Edward Link

Blue Mountain Lake

Adirondack Museum
Blue Mountain Lake, NY 12812
☎ 518-352-7311
HRS: 9:30-5:30 M-S; MEM/DAY weekend to 10/97! HOL: None
ADM: Y ADULT: $10.00 CHILDREN: $6.00 (7-15) SR CIT: $9.00
ᕫ: Y ℗ Y MUS/SH: Y ¶ Y H/B: Y
PERM/COLL: An excellent small collection of paintings entirely related to the Adirondacks

Perched on the shoulder of Blue Mountain overlooking Mountain Lake, this regional museum of art and history features a small but fine collection of paintings related entirely to the Adirondacks. A luxurious private railroad car, the Bill Gates Diner, a trolley eatery from Bolton Landing, and other buildings that tell the history of the largest wilderness area in the East are also part of this complex.

ON EXHIBIT/97:

ONGOING OF THE ADIRONDACKS AND FOR THE ADIRONDACKS: A MUSEUM IN MOTION (Working Title) — An explanation of why and how the Museum was developed and built, how it has developed over the past 40 years and its plans for the future.

THESE GLORIOUS MOUNTAINS: MASTERWORKS OF THE ADIRONDACKS — An exhibit celebrating the 40th anniversary of the Museum and the creative responses of major artists to the Adirondack wilderness. In addition to the best works in the collection, art will be borrowed for the occasion.

AN ADIRONDACK SAMPLER (Working Title) — The Museum's collections will be used to illustrate and interpret its educational mission and delight the public with the broad range of unusual, provocative and rarely exhibited objects.

NEW YORK

Bronx

The Bronx Museum of the Arts
1040 Grand Concourse, **Bronx, NY 10456**
☎ 718-681-6000
HRS: 3-9 W; 10-5 T, F; 1-6 Sa, S DAY CLOSED: M, Tu HOL: THGV, 12/25
F/DAY: S ADM: Y ADULT: $3.00 CHILDREN: F (under 12) STUDENTS: $2.00 SR CIT: $1.00
&: Y ℗ Y, Nearby garage MUS/SH: Y
PERM/COLL: AF: LAT/AM: SE/ASIAN: works on paper 20; CONT/AM: eth

Noted for its reflection of the multi-ethnicity of this "borough of neighborhoods," this is the only fine arts museum in the Bronx. The collection and exhibitions are a fresh perspective on the urban experience.

ON EXHIBIT/97:

11/08/96–02/16/97	PETRONA MORRISON AND VERONICA RYAN: SCULPTURAL WORKS — Evocative, meditative assemblages which traverse realms through varying approaches to sculptural form. BROCHURE
11/08/96–02/16/97	XVI ANNUAL ARTIST IN THE MARKETPLACE EXHIBITION — Works in all media by 36 emerging artists living in the New York metropolitan area. CAT
12/18/96–02/16/97	TALK BACK: THE COMMUNITY RESPONDS TO THE PERMANENT COLLECTION PART I (Working Title) — This three part exhibition celebrates a decade of collecting. Members of the community will help to develop exhibition related interpretive materials. Part I will function as an experimental space in which works will be displayed in a more informal environment allowing visitors to respond directly to the art work.
03/14/97–06/22/97	TALK BACK: THE COMMUNITY RESPONDS TO THE PERMANENT COLLECTION PART II (Working Title) — Part II will exhibit over 100 works from the permanent collection and incorporate written and oral responses obtained during community workshops.
07/18/97–08/24/97	TALK BACK: THE COMMUNITY RESPONDS TO THE PERMANENT COLLECTION PART III (Working Title) — Part III will consist of 40-50 new works from the collection and incorporate the interpretive models proposed in Parts I and II.
07/18/97–08/24/97	XVII ARTIST IN THE MARKETPLACE ANNUAL EXHIBITION CAT

Bronx

The Hall of Fame for Great Americans
Affiliate Institution: Bronx Community College
University Ave and W. 181 St, **Bronx, NY 10453**
☎ 718-220-6003
HRS: 10-5 Daily HOL: None
&: Y; Ground level entrance to Colonnade ℗ Y
GR/T: Y GR/PH: CATR! DT: Y TIME: ! H/B: Y S/G: Y
PERM/COLL: COLONNADE OF 97 BRONZE BUSTS OF AMERICANS ELECTED TO THE HALL OF FAME SINCE 1900
(includes works by Daniel Chester French, James Earle Fraser, Frederick MacMonnies, August Saint-Gaudens

Overlooking the Bronx & Harlem Rivers, this beautiful Beaux arts style architectural complex, once a Revolutionary War fort, contains a Stanford White designed library modeled after the Pantheon in Rome. 97 restored bronze portrait busts of famous Americans elected to the Hall of Fame since 1900 and placed within the niches of the 'Men of Renown' classical colonnade allow the visitor to come face-to-face with history through art.

Brooklyn

The Brooklyn Museum of Art
200 Eastern Parkway, **Brooklyn, NY 11238**
☏ 718-638-5000
HRS: 10-5 W-S DAY CLOSED: M, T HOL: THGV, 12/25, 1/1
VOL/CONT: Y ADULT: $4.00 CHILDREN: F (under 12) SR CIT: $1.50
&: Y Ⓟ Y; Pay parking on site
MUS/SH: Y ❙❙ Y; Open until 4 weekdays, 10:30-4:30 Weekends and holidays
GR/T: Y GR/PH: CATR! ext 221 DT: Y TIME: !W-F, 2 PM; Sa, S, 1 & 2 PM H/B: Y S/G: Y
PERM/COLL: EGT; AM: ptgs, scupl, dec/art 18-20; AF; OC; NW/AM; W/COL

The Brooklyn Museum is one of the nation's premier art institutions. Housed in a Beaux-Arts structure designed in 1893 by McKim, Mead & White, its collections represent virtually the entire history of art from Egyptian artifacts to modern American paintings. **NOT TO BE MISSED:** Newly renovated and brilliantly installed Charles A. Wilbur Egyptian Collection

ON EXHIBIT/97:

RE-INSTALLATIONS	THE BROOKLYN MUSEUM — Permanent and Long-term reinstallations opening in late 1996 include EUROPEAN PAINTINGS 10/11/96, MAGIC CARPETS/THE ISLAMIC GALLERY 11/06/96, THE ARTS OF CHINA 11/08/96, THE ARTS OF THE PACIFIC 11/25/96, ANDEAN REINSTALLATION 12/07/96.
07/17/96–06/29/97	18TH AND 19TH- CENTURY AMERICAN PAINTINGS — Highlights from the Museum's superb collection including Winslow Homer's "In the Mountains," George Caleb Bingham's "Shooting for the Beef" and "A Ride for Liberty-The Fugitive Slaves" by Eastman Johnson.
09/12/96–01/19/97	PHOTOGRAPHY IN LATIN AMERICA: A SPIRITUAL JOURNEY — The uniqueness of Latin American culture will be explored in these photographs from the Museum collection by photographers including Manuel Alvarez Bravo, Graciela Iturbide, and Mariana Yampolsky. Religion, death, mysticism and tradition are among the common themes explored. Also included art very early ethnographic and archeological photographs of Latin America.
09/21/96–01/19/97	WORKING IN BROOKLYN: GLENN LIGON — The "Working in Brooklyn" exhibition series is being revived with works on paper by Ligon, a Brooklyn resident whose densely worked drawings use words, phrases and bodies of text as a formal device to examine the depth and complexity of the African-American identity and its relationship to other cultures.
10/11/96–01/12/97	IN THE LIGHT OF ITALY: COROT AND EARLY PLEIN-AIR PAINTING — Twenty of Corot's finest Italian sketches and small finished paintings will be among those seen in this exhibition of 120 works that trace the achievements of an international group of European painters working in Italy (late 18th to early 19th century), who, though committed to classical artistic traditions, were pioneers in the development of the new open-air or plein-air school of painting. CAT WT
10/11/96–06/29/97	INSTALLATION OF LATE 19TH CENTURY AMERICAN PAINTINGS — Selections from the Museum collection including works by William Merritt Chase, Childe Hassam, John Singer Sargent, Theodore Robinson and Mary Cassatt.
02/07/97–05/04/97	SYMBOLIST PRINTS (Working Title) — More than 60 prints from the collection in a range of style and media including Aubrey Beardsley, Paul Gauguin, Edvard Munch and Odilon Redon.
02/07/97–05/04/97	RECENT ACQUISITIONS: THE JAMES BROOKS GIFT — The preparatory drawings, gouache, and tempera studies for the WPA mural "Flight" will be exhibited in the context of the Museum's collection of American figurative art from the 1930's.

The Brooklyn Museum of Art - continued

02/21/97–05/18/97	MISTRESS OF THE HOUSE, MISTRESS OF HEAVEN: WOMEN IN ANCIENT EGYPT/ A CENTENNIAL EXHIBITION — Women's roles in family, court and temple; queens and female royalty; and the myths and beliefs surrounding female deities and women in the afterlife will be examined through more than 200 objects, including 20 rarely seen objects from the Brooklyn Museum's collection. CAT WT
03/01/97–06/29/97	AMERICAN PAINTINGS: ASHCAN AND MODERNIST/ A CENTENNIAL EXHIBITION — Works from the Museum's collection from the first half of the 20th-century including artists Florine Stettheimer, Marsden Hartley and Georgia O'Keeffe.
03/29/97–06/22/97	OLD BAGS: HANDBAGS FROM THE PERMANENT COLLECTION (Working Title) — A selection of pockets, reticules, miser's bags and handbags from the 17th through the 20th-century demonstrating the diversity of detail and design.
10/17/97–01/04/98	MONET AND THE MEDITERRANEAN — Paintings by Monet created on his trips to the Italian Riviera (1884), French Riviera (1888) and Venice (1908) will be assembled for the first time in an exhibition that demonstrates how the artist thrived in the powerful light and sunshine of southern Europe. His unique contribution to the development of Post-Impressionism will also be addressed. CAT WT
11/17/97–02/01/98	INVENTION AND INNOVATION IN THE 19TH CENTURY: THE FURNITURE OF GEORGE HUNZINGER/ A CENTENNIAL EXHIBITION — The first in a series of monographic exhibitions devoted to the leading furniture designers of the late 19th-century focuses on works by Hunzinger (1835-1898), one of the most innovative and idiosyncratic furniture makers in the US.

Brooklyn

The Rotunda Gallery

33 Clinton Street, **Brooklyn, NY 11201**
☎ 718-875-4047
HRS: 12-5 Tu-F, 11-4 Sa DAY CLOSED: S, M HOL: LEG/HOL!
&: Y; Wheelchair lift ⓟ Y; Metered street parking; nearby pay garage
GR/T: Y GR/PH: CATR! DT: Y TIME: 10-11:30 AM M-F
PERM/COLL: non-collecting institution

The Gallery's facility is an architecturally distinguished space designed for exhibition of all forms of contemporary art. It is located in Brooklyn Heights which is well known for its shops, restaurants and historic brownstone district.

ON EXHIBIT/97:

01/23/97–03/08/97	UNTITLED GROUP EXHIBITION
03/20/97–05/03/97	ABSTRACTION — The exhibition will consider contemporary abstraction in all media from work that springs from classic "isms" such as expressionism and minimalism to time-based process and installation art.

The Rubelle & Norman Schafler Gallery

Affiliate Institution: Pratt Institute
200 Willoughby Ave, **Brooklyn, NY 11205**
☎ 718-636-3517
HRS: 9-5 M-F DAY CLOSED: Sa, S HOL: LEG/HOL!
&: Y ⓟ Y; on street parking only
PERM/COLL: Currently building a collection of Art and Design Works by Pratt Alumni, Faculty and Students

Varied programs of thematic, solo, and group exhibitions of contemporary art, design and architecture are presented in this gallery.

Buffalo

Albright-Knox Art Gallery
1285 Elmwood Ave, **Buffalo, NY 14222**
✆ 716-882-8700
HRS: 11-5 Tu-Sa, 12-5 S DAY CLOSED: M HOL: 1/1, THGV, 12/25
ADM: Y ADULT: $4.00 CHILDREN: F (under 12) STUDENTS: $3.00 SR CIT: $3.00
&: Y ℗ Y MUS/SH: Y ⑪ Y
GR/T: Y GR/PH: CATR! DT: Y TIME: ! H/B: Y S/G: Y
PERM/COLL: AB/EXP; CONT: 70's & 80's; POST/IMPR; POP; OP; CUBIST; AM & EU: 18-19

With one of the world's top international surveys of twentieth-century painting and sculpture, the Albright-Knox is especially rich in American and European art of the past fifty years. The permanent collection which also offers a panorama of art through the centuries dating from 3000 BC., is housed in a 1905 Greek Revival style building designed by Edward B. Green with a 1962 addition by Gordon Bunshaft of Skidmore, Owings and Merrill.

ON EXHIBIT/97:

01/11/97–03/02/97	MASTER WORKS: ITALIAN DESIGN, 1960-1994 — A large scale examination of furniture, glass, ceramics, metalwork, stonework and lighting produced in Italy 1960-1994. WT
03/15/97–05/11/97	TBA
05/31/97–10/05/97	IN WESTERN NEW YORK — Works by artists living in the eight counties of Western New York.
05/31/97–10/05/97	CASTELLANI GIFT TO WESTERN NEW YORK — Works by Cy Twombly, Susan Rothanberg and Jess representing Armand Castellani's gifts of contemporary art to the Albright Knox and to the Castellani Art Museum, Niagara University will be showcased in this exhibition. WT
07/26/97–10/05/97	MEMORY: VISUAL REPRESENTATIONS AND LUBA HISTORY — The art and culture of the Luba people of Zaire are presented via art objects created to guide and stimulate memory. Dating from the late 18th to the 20th centuries are memory boards, beaded emblems, staffs, figures, divination objects and works in metal. WT
10/25/97–01/04/98	DALE CHIHULY: INSTALLATIONS 1964-1995 — In the most comprehensive presentation of his work to date, over 100 fantastic glass creations by this modern American master of the medium will be featured in a spectacular installation that includes "Sea Forms," "Chandelier," and "Floats," 3 of the largest glass spheres ever blown. CAT WT

Burchfield-Penney Art Center
Affiliate Institution: Buffalo State College
1300 Elmwood Ave, **Buffalo, NY 14222-6003**
✆ 716-878-6011
HRS: 10-5 Tu-Sa, 1-5 S, till 7:30 PM W DAY CLOSED: M HOL: LEG/HOL!
SUGG/CONT: Y ADULT: $3.00
&: Y; Elevator access, wheelchairs available ℗ Y; Some on campus and metered parking.
MUS/SH: Y ⑪ Y GR/T: Y GR/PH: CATR! DT: Y TIME: usually available 10-5 Sa, 1-5 S
PERM/COLL: AM; WEST/NY: 19, 20

The Burchfield-Penney Art Center is dedicated to the art and artists of Western New York. Particular emphasis is given to the works of renowned American watercolorist Charles E. Burchfield. The museum holds the largest archives and collection in the world of his works. **NOT TO BE MISSED:** Burchfield's "Appalachian Evening"; and "Oncoming Spring," hand crafted objects by Roycroft Arts and Crafts community artists, and sculpture by Charles Cary Rumsey.

ON EXHIBIT/97:

11/02/96–04/20/97	NANCY DWYER — Dwyer's site specific installation addresses contemporary issues via the use of puns and irony via computer generated imagery.

Burchfield-Penney Art Center - continued

11/16/96–01/26/97	EMERGING ARTISTS: THE ARTISTS LANDSCAPE — The third in a series presenting emerging or under-recognized artists working in a variety of media who draw their inspiration from the landscape.
02/08/97–04/06/97	E. B. GREEN: BUFFALO'S ARCHITECT
04/19/97–06/01/97	JAMES K. Y. KUO — The influence of nature and philosophical thought on this Chinese-American artist will be investigated in this retrospective.
06/14/97–08/17/97	THE PAINTINGS OF CHARLES BURCHFIELD: NORTH BY MIDWEST — A comprehensive survey of Burchfield's work. WT

Canajoharie

Canajoharie Library and Art Gallery
2 Erie Blvd, **Canajoharie, NY 13317**
☎ 518-673-2314
HRS: 10-4:45 M-W, F; 10-8:30 T; 10-1:30 Sa; Summer Only 1-3:45 S DAY CLOSED: Tu, S HOL: LEG/HOL!
&: Y ℗ Y
GR/T: Y GR/PH: CATR! S/G: Y
PERM/COLL: WINSLOW HOMER; AMERICAN IMPRESSIONISTS; 'The Eight'

Located in downtown Canjoharie, the gallery's spectacular American art collection includes 21 Winslow Homers.

ON EXHIBIT/97:

01/01/97–02/20/97	BLAKELOCK AND RYDER
02/23/97–03/14/97	HOMER WATERCOLORS
03/16/97–04/17/97	JOHN VAN ORSEO
04/20/97–05/15/97	CENTRAL NEW YORK WATERCOLOR SHOW
05/18/97–09/04/97	20TH CENTURY WATERCOLORS
09/07/97–10/09/97	RUTH LIPOWITZ
10/12/97–11/06/97	CANAJOHARIE INVITATIONAL
11/10/97–02/19/98	WORKS BY THE EIGHT

Catskill

Thomas Cole Foundation
218 Spring St., **Catskill, NY 12414**
☎ 518-943-6533
HRS: 11-4 W-Sa; 1-5 S (Jul-Lab/Day); by appt rest of year HOL: LEG/HOL!
℗ Y
PERM/COLL: AM: ptgs 19

The Residence and Studio of Thomas Cole is a 1815 building with paintings relating to the development of the Hudson River School and the works of Cole himself, a leading American master painter and influential teacher of his day.

Clinton

Emerson Gallery

Affiliate Institution: Hamilton College
198 College Hill Road, **Clinton, NY 13323**
☎ 315-859-4396
HRS: 12-5 M-F; 1-5 Sa, S; closed weekends June, Jul & Aug HOL: LEG/HOL! ᴥ: Y ℗ Y
PERM/COLL: NAT/AM; AM & EU: ptgs, gr 19, 20; WEST INDIES ART

While its ultimate purpose is to increase the educational scope and opportunity for appreciation of the fine arts by Hamilton students, the gallery also seeks to enrich campus cultural life in general, as well as to contribute to the cultural enrichment of the surrounding community. **NOT TO BE MISSED:** Outstanding collection of works by Graham Sutherland

ON EXHIBIT/97:

01/13/97–02/09/97	WAKE UP LITTLE SUZY/WARNINGS: PREGNANCY AND POWER BEFORE ROE VS. WADE — Included in this exhibition is a three dimensional, mixed-media installation that explores the theme of single pregnancy and race in postwar, pre Roe vs. Wade America. WT
02/17/97–04/06/97	PRIVATE ART/PUBLIC ART — A survey of the history of photography made up of "gems" from a range of illustrious photographers. Many of these works have never been seen by the general public. WT
05/30/97–08/22/97	WILLIAM SALZILLO RETROSPECTIVE

Corning

The Corning Museum of Glass

1 Museum Way, **Corning, NY 14830-2253**
☎ 607-937-5371
HRS: 9-5 daily, till 8 PM July & Aug HOL: LEG/HOL!
ADM: Y ADULT: $6.00 CHILDREN: $4 (6-17) SR CIT: $5.00
ᴥ: Y ℗ Y MUS/SH: Y ‖Y GR/T: Y! GR/PH: CATR! DT: Y
PERM/COLL: GLASS: worldwide 1500 BC - present

The Museum houses the world's premier glass collection – more than 26,000 objects representing 3500 years of achievements in glass design and craftsmanship. It is part of the Corning Glass Center complex, which also includes the Hall of Science and Industry and the Steuben factory, where visitors can watch artisans make world-famous Steuben crystal. New in 1996 is a hot-glass studio presenting workshops, classes and demonstrations. **NOT TO BE MISSED:** Visit the Steuben Factory where Steuben Glass is made.

ON EXHIBIT/97:

04/19/97–10/26/97	ITALIAN GLASS, 1930-1970: MASTERPIECES OF DESIGN FROM MURANO AND MILAN

The Rockwell Museum

111 Cedar St. at Denison Parkway, **Corning, NY 14830**
☎ 607-937-5386
HRS: 9-5 M-Sa, 12-5 S; July & Aug: 9-7 M-F, 9-5 Sa, 12-5 S HOL: 1/1, THGV, 12/24, 12/25
ADM: Y ADULT: $4.00, family $ CHILDREN: $2.00 (6-17) SR CIT: $3.50
ᴥ: Y ℗ Y; Municipal lot across Cedar St. MUS/SH: Y
GR/T: Y! GR/PH: CATR! DT: Y! TIME: 10am & 2 PM F (Jun, Jul, Aug) H/B: Y; 1893 City Hall, Corning, NY
PERM/COLL: PTGS & SCULP: by Western Artists including Bierstadt, Remington and Russell 1830-1920; FREDERICK CARDER STEUBEN GLASS; ANT: toys

Located in the 1893 City Hall of Corning, NY, and nestled in the lovely Finger Lake Region of NY State is the finest collection of American Western Art in the Eastern U.S. The Romanesque revival style museum building served as a City Hall, firehouse and jail until the 1970's. It is home to the world's most comprehensive collection of Frederick Carder Steuben glass. **NOT TO BE MISSED:** Model of Cyrus E. Dallin's famous image, "Appeal to the Great Spirit."

NEW YORK

Cortland

Dowd Fine Arts Gallery
Affiliate Institution: State University of New York College at Cortland
Suny Cortland, **Cortland, NY 13045**
℡ 607-753-4216
HRS: 11-4 Tu-Sa DAY CLOSED: S, M HOL: ACAD!
VOL/CONT: Y &: Y Ⓟ Y; Adjacent to building S/G: Y
PERM/COLL: Am & EU: gr, drgs 20; CONT: art books

Temporary exhibitions of contemporary and historic art which are treated thematically are presented in this university gallery.

East Hampton

Guild Hall Museum
158 Main Street, **East Hampton, NY 11937**
℡ 516-324-0806
HRS: SUMMER: 11-5 daily; WINTER: 11-5 W-Sa, 12-5 S HOL: THGV, 12/25, 1/1
&: Y Ⓟ Y MUS/SH: Y H/B: Y S/G: Y
PERM/COLL: AM: 19, 20

Located in one of America's foremost art colonies this cultural center combines a fine art museum and a 400 seat professional theater.

East Islip

Islip Art Museum
50 Irish Lane, **East Islip, NY 11730**
℡ 516-224-5402
HRS: 10-4 W-Sa, 2-4:30 S HOL: LEG/HOL!
F/DAY: FF VOL/CONT: Y &: Y MUS/SH: Y H/B: Y
PERM/COLL: AM/REG: ptgs, sculp, cont

The Islip Museum, the leading exhibition space for contemporary and Avant Garde Art on LI. The Carnegie House Project Space, open in the summer and fall, features cutting-edge installations and site-specific work. A satellite gallery called the Anthony Giordano Gallery is located at Dowling College in Oakdale, LI.

Elmira

Arnot Art Museum
235 Lake St, **Elmira, NY 14901-3191**
℡ 607-734-3697
HRS: 10-5 Tu-Sa, 1-5 S DAY CLOSED: M HOL: THGV, 12/25, 1/1
ADM: Y ADULT: $2.00 CHILDREN: $.50 (6-12) STUDENTS: $1.00 SR CIT: $1.00
&: Y Ⓟ Y; Free MUS/SH: Y GR/T: Y GR/PH: CATR! DT: Y HB: Y
PERM/COLL: AM: salon ptgs 19, 20; AM: sculp 19

The original building, a neo-classical mansion built in 1833 in downtown Elmira, also incorporates a modern addition designed by Graham Gund. **NOT TO BE MISSED:** Matthias Arnot Collection; one of last extant private collections housed intact in its original showcase

Flushing

Frances Godwin & Joseph Ternbach Museum
Affiliate Institution: Queens College
65-30 Kissena Blvd, **Flushing, NY 11367**
☎ 718-997-5000
HRS: 11-7 M-T, 11-5 F; Call to confirm! DAY CLOSED: Sa, S HOL: ACAD!
&: Not at present ℗ Y; On campus
PERM/COLL: GR: 20; ANT: glass; AN/EGT; AN/GRK; PTGS; SCULP

This is the only museum in Queens with a broad and comprehensive permanent collection which includes a large collection of WPA/FAP prints.

Glens Falls

The Hyde Collection
161 Warren St, **Glens Falls, NY 12801**
☎ 518-792-1761
HRS: 10-5 Tu-S; Till 9 PM T (5/1-8/31 only) DAY CLOSED: M HOL: LEG/HOL!
F/DAY: S ADM: Y ADULT: $4.50 CHILDREN: F (under 5) STUDENTS: $3.50 SR CIT: $3.50
&: Y ℗ Y
MUS/SH: Y
GR/T: Y GR/PH: CATR! H/B: Y S/G: Y
PERM/COLL: O/M: ptgs; AM: ptgs; ANT; IT/REN; FR: 18

The central focus of this museum complex is an Italian Renaissance style villa which houses an exceptional collection of noted European Old Master and American works of art displayed among an important collection of Renaissance and French 18th-century furniture. Since 1985 contemporary collections have been shown in the Edward Larabee Barnes Education Wing.

Hamilton

The Picker Art Gallery
Affiliate Institution: Colgate University
Charles A Dana Center for the Creative Arts, **Hamilton, NY 13346-1398**
☎ 315-824-7634
HRS: 10-5 Daily HOL: ACAD!; (also open by request!)
&: Y ℗ Y; 2 large lots nearby
GR/T: Y GR/PH: CATR!
PERM/COLL: ANT; PTGS & SCULP 20; AS; AF

Located on Colgate University campus, the setting of the Charles A. Dana Art Center is one of expansive lawns and tranquility.

NEW YORK

Hempstead

Hofstra Museum
Affiliate Institution: Hofstra University
Hempstead, NY 11550
☏ 516-463-5672
HRS: 10-9 Tu; 10-5 W-F; 1-5 Sa, S !varying hours in galleries HOL: EASTER WEEKEND, ! closed some holidays
&: Y ℗ Y MUS/SH: Y �‼Y H/B: Y S/G: Y
PERM/COLL: SCULP: Henry Moore, H. J. Seward Johnson, Jr, Tony Rosenthal

Hofstra University is a living museum consisting of five exhibition areas located throughout the 238-acre campus on grounds that are also a national arboretum. **NOT TO BE MISSED:** Sondra Rudin Mack Garden designed by Oehme, Van Sweden and Assoc. Henry Moore's "Upright Motive No. 9," and "Hitchhiker," and Tony Rosenthal's "T"s.

ON EXHIBIT/97:

11/11/96–01/19/97	GEORGE SAND: BOOKS, MANUSCRIPTS AND PHOTOGRAPHS
01/26/97–03/16/97	PEOPLE AND PLACES: HUNGARIAN ETCHINGS
02/02/97–03/23/97	ENDLESS IS THE WAY LEADING HOME: THE ART OF STEPHEN CSOKA
03/24/97–05/18/97	THE GEORGE BUSH PRESIDENCY, 1989-1992: DOCUMENTING THE BUSH-QUAYLE YEARS
04/06/97–05/25/97	NATIVE AMERICA: CONFRONTING CONTEMPORARY REALITIES
06/02/97–08/10/97	BETWEEN UNIFORMITY AND UNIQUENESS: CONTEMPORARY RUSSIAN ART
06/09/97–07/31/97	WAKE UP LITTLE SUZY/WARNINGS: PREGNANCY AND POWER BEFORE ROE VS. WADE— Included in this exhibition is a three dimensional, mixed-media installation that explores the theme of single pregnancy and race in postwar, pre Roe vs. Wade America. WT

Howes Cave

Iroquois Indian Museum
Caverns Road, **Howes Cave, NY 12092**
☏ 518-296-8949
HRS: 10-5 daily April 1-Dec 30 HOL: THGV, 12/24, 12/25
ADM: Y ADULT: $5.00 CHILDREN: $2.50 (7-12) STUDENTS: $4.00 SR CIT: $4.00
&: Y ℗ Y, F MUS/SH: Y GR/T: Y GR/PH: CATR!
PERM/COLL: Cont IROQUOIS art; local archeology

The Museum sees arts as a window into the Iroquois culture. Exhibits and demonstrations focus on the visual and performing arts of contemporary Iroquois people and the creativity and tradition of their ancestors as expressed in historic and archeological artifacts. **NOT TO BE MISSED:** "Corn Spirit" by Stanley Hill

Hudson

Olana State Historic Site
State Route 9G, **Hudson, NY 12534**
☏ 518-828-0135
HRS: 10-4 W-Sa & 12-4 S (4/15-Lab/Day); 12-4 W-S (Lab/Day-10/31) DAY CLOSED: M, T
HOL: MEM/DAY, 7/4, LAB/DAY, COLUMBUS DAY
ADM: Y ADULT: $3.00 CHILDREN: $1.00 (5-11) STUDENTS: $3.00 SR CIT: $3.00
&: Y! ℗ Y; Limited MUS/SH: Y GR/T: Y GR/PH: CATR! H/B: Y
PERM/COLL: FREDERIC CHURCH: ptgs, drgs; PHOT COLL; CORRESPONDENCE

Olana, the magnificent home of Hudson River School artist Frederic Edwin Church, was designed by him in the Persian style, and furnished in the Aesthetic style. He also designed the picturesque landscaped grounds. Many of Church's paintings are on view throughout the house.

270

Huntington

Heckscher Museum of Art
2 Prime Ave, **Huntington, NY 11743**
☎ 516-351-3250
HRS: 10-5 Tu-F; 1-5 Sa, S; till 8:30 1st F DAY CLOSED: M HOL: !
SUGG/CONT: Y ADULT: $2.00 CHILDREN: $1 STUDENTS: $1.00 SR CIT: $1.00
&: Y; Steps to restrooms Ⓟ Y MUS/SH: Y
GR/T: Y GR/PH: CATR! DT: Y TIME: 2:30 & 3:30 S; 1 & 3 W H/B: Y;
PERM/COLL: AM: ldscp ptg 19; AM: Modernist ptgs, drgs, works on paper

Located in a 18.5 acre park, the museum, whose collection numbers more than 900 works, was presented as a gift to the people of Huntington by philanthropist August Heckscher. **NOT TO BE MISSED:** "Eclipse of the Sun," by George Grosz (not always on view!)

ON EXHIBIT/97: The Museum closes for several days for installation of an exhibition. Call!

| 12/07/96–02/02/97 | WILLIAM H. JOHNSON | WT |

03/01/97–04/06/97 ALLI'S 42ND ANNUAL LONG ISLAND EXHIBITION — A juried exhibition by contemporary artists of the region.

04/19/97–06/29/97 THE STUDIO MUSEUM IN HARLEM: 25 YEARS OF AFRICAN-AMERICAN ART — In celebration of the Studio Museum's 25th anniversary, this traveling exhibition will highlight paintings, sculpture, and works on paper created by noted African-American artists between 1968-1993. CAT WT

07/12/97–09/07/97 BETTY PARSONS: HER ART AND HER ARTISTS — Betty Parsons was both an artist and an illustrious art dealer whose work will be explored along with the work of some of the artists she represented.

09/13/97–11/16/97 IMAGES OF THE NATIVE AMERICAN IN 19TH-CENTURY AMERICAN ART — A survey of depictions of Native-American life from idealistic glorification to stark realism, from Remington's bronzes to Blakelock's paintings of Indian encampments.

11/22/97–02/01/98 SEAFORMS — "Seaforms," creations by America's glass master Dale Chihuly, will be seen in the sole New York area exhibition of this group of his works. WT

Ithaca

Herbert F. Johnson Museum of Art
Affiliate Institution: Cornell University
Cornell University, **Ithaca, NY 14853-4001**
☎ 607-255-6464
HRS: 10-5 Tu-S DAY CLOSED: M HOL: MEM/DAY, 7/4, THGV + F
&: Y Ⓟ Y; Metered GR/T: Y GR/PH: CATR! DT: Y TIME: 12 noon every other T; 1 Sa, S! S/G: Y
PERM/COLL: AS; AM: gr 19, 20

The Gallery, with a view of Cayuga Lake, is located on the Cornell Campus in Ithaca, NY. **NOT TO BE MISSED:** "Fields in the Month of June," by Daubigny

ON EXHIBIT/97:
12/21/96–03/09/97 THINGS OF THIS WORLD: DUTCH PRINTS AND DRAWINGS OF THE 17TH CENTURY — Drawn from the Museum's holdings and private collections, this exhibition makes clear the Dutch artist's interest in illustrating the truth in everyday things whether a horse-drawn carriage or farm animals in a familiar landscape.

01/11/97–03/16/97 PAULA CHAMLEE AMD MICHAEL SMITH PHOTOGRAPHS — Landscape photographs of the south and west by Chamlee and Smith will be on exhibit.

Herbert F. Johnson Museum of Art - continued

01/11/97–02/09/97	CORNELL COUNCIL FOR THE ARTS — An invitational exhibition for students and staff of the University.
01/25/97–03/09/97	GENDERED VISIONS: ART BY FIVE CONTEMPORARY AFRICAN WOMEN ARTISTS
02/15/97–03/30/97	ASAFO! AFRICAN FLAGS OF THE FANTE — European military and ancient African oral traditions are combined in the patchwork, applied and embroidered flags of the Fante people of Ghana created from the time of their European colonialization in 1850 to Ghanaian independence in 1957. WT
03/22/97–05/25/97	JOSEPH NORMAN PRINTS
03/29/97–06/15/97	THE TALE OF GENJI: SPLENDOR AND INNOVATION IN EDO CULTURE
04/05/97–06/15/97	MOTHERWELL PRINTS FROM THE ANBINDER COLLECTION
05/29/97–06/07/97	PHYLLIS COHEN WOODCUT PRINTS

Katonah

Caramoor Center for Music and the Arts

149 Girdle Ridge Road, **Katonah, NY 10536**
☎ 914-232-5035
HRS: 11-4 Tu-Sa, 1-4 S (Jun-Sep); 11-4 Tu-F (by appt Oct-May) DAY CLOSED: M HOL: LEG/HOL!
ADM: Y ADULT: $5.00 CHILDREN: $4.00
&: Y Ⓟ Y; Free MUS/SH: Y ¶ Picnic facilities and snack bar
GR/T: Y GR/PH: CATR! DT: Y TIME: W-F, S 1-4-last tour at 3; Sa 1-5, last tour at 4
H/B: Y S/G: Y
PERM/COLL: FURNITURE; PTGS; SCULP; DEC/ART; REN; OR: all media

Built in the 1930's by Walter Rosen as a country home, this 54 room Italianate mansion is a treasure trove of splendid collections spanning 2000 years. There are six unusual gardens including the Marjorie Carr Sense Circle (for sight-impaired individuals). Tours of the gardens are available by appointment in the spring and fall and every weekend during the festival at 2:30 PM. Caramoor also presents a festival of outstanding concerts each summer in addition to many other programs throughout the year. **NOT TO BE MISSED:** Extraordinary house-museum with entire rooms from European villas and palaces

The Katonah Museum of Art

Route 22 at Jay Street, **Katonah, NY 10536**
☎ 914-232-9555 WEB ADDRESS: www.katonah-museum.org
HRS: 1-5 Tu-F, S; 10-5 Sa DAY CLOSED: M HOL: 1/1, MEM/DAY; PRESIDENTS/DAY, 7/4, THGV, 12/25
VOL/CONT: Y &: Y Ⓟ Y; Free on-site parking MUS/SH: Y ¶ Y; Snack bar
GR/T: Y GR/PH: CATR! DT: Y; T, Th, S TIME: 2 PM S/G: Y
PERM/COLL: No Permanent Collection

Moved to a building designed by Edward Larabee Barnes in 1990, the museum has a commitment to outstanding special exhibitions which bring to the community art of all periods, cultures and mediums.

ON EXHIBIT/97:

01/12/97–03/16/97	REVISITING AMERICAN ART: WORKS FROM BLACK COLLEGES AND UNIVERSITIES — A survey of major figures in African-American art through objects created during the 20th-century.

The Katonah Museum of Art - continued

03/23/97–05/18/97 MASTERPIECES FROM KATONAH COLLECTIONS and FACES OF KATONAH — An exhibition timed to coincide with the Katonah centennial celebration.

06/15/97–09/14/97 CRAFT EXHIBITION — Works in fiber, jewelry, and glass from the collection of the American Craft Museum in New York City.

09/28/97–01/04/98 ARCHITECTURAL TOYS — 100 building toys manufactured in the US and Europe from the early 1800's to the present will be seen in this presentation. Consisting of modular parts requiring assembly, these toys, designed to teach through play, were also conveyers of architectural style and benchmarks of technological progress.

Long Island City

Isamu Noguchi Garden Museum

32-37 Vernon Blvd, **Long Island City, NY 11106**
☏ 718-545-8842
HRS: 10-5 W-F; 11-6 Sa, S (Apr-Oct only)
SUGG/CONT: Y ADULT: $4.00 CHILDREN: $2.00 STUDENTS: $2.00 SR CIT: $2.00
♿: Y; 1/3 of the collection is accessible Ⓟ Y; Street parking
MUS/SH: Y GR/T: Y GR/PH: CATR! H/B: Y S/G: Y
PERM/COLL: WORKS OF ISAMU NOGUCI

Designed by Isamu Noguchi, (1904-1988), this museum offers visitors the opportunity to explore the work of the artist on the site of his Long Island City studio. The centerpiece of the collection is a tranquil outdoor sculpture garden. PLEASE NOTE: A shuttle bus runs to the museum on Sat. & Sun. every hour on the half hour starting at 11:30 AM from the corner of Park Ave. & 70th St, NYC, and returns on the hour every hour till 5 PM. The round trip fare is $5.00 and DOES NOT include the price of museum admission. **NOT TO BE MISSED:** Permanent exhibition of over 250 sculptures as well as models, drawings, and photo-documentation of works of Noguchi; stage sets designed for Martha Graham; paper light sculptures called Akari

Mountainville

Storm King Art Center

Old Pleasant Hill Rd, **Mountainville, NY 10953**
☏ 914-534-311590
HRS: 11-5:30 Daily (Apr-Nov.15); Special eve hours Sa, June, July, Aug HOL: closed 11/16-3/31
ADM: Y ADULT: $7.00 CHILDREN: F (under 5) STUDENTS: $3.00 SR CIT: $5.00
♿: Y; Partial, 1st floor of building and portions of 500 acres Ⓟ Y
MUS/SH: Y
GR/T: Y GR/PH: CATR! DT: Y TIME: 2 PM daily H/B: Y S/G: Y
PERM/COLL: SCULP: David Smith, Alexander Calder, Isamu Noguchi, Louise Nevelson, Alice Aycock, Mark di Suvero

America's leading open-air sculpture museum features over 120 masterworks on view amid 500 acres of lawns, fields and woodlands. Works are also on view in a 1935 Norman style mansion that has been converted to museum galleries. **NOT TO BE MISSED:** "Momo Taro," a 40 ton, nine-part sculpture by Isamu Noguchi designed for seating and based on a Japanese Folk tale

ON EXHIBIT/97:

04/01/97–11/15/97 AN EXHIBITION CELEBRATING THE 30TH ANNIVERSARY OF THE ART CENTER'S PURCHASE OF 13 SCULPTURES BY DAVID SMITH

NEW YORK

Mumford

Genesee Country Museum
Flint Hill Road, **Mumford, NY 14511**
☎ 716-538-6822
HRS: 10-5 Tu-S Jul-Aug; 10-4 Tu-F, 10-5 Sa, S Spring and Fall; Season May-Oct DAY CLOSED: M HOL: open LEG/HOL
ADM: Y ADULT: $10.00 CHILDREN: 4-16 $6.00;F under 6 SR CIT: $8.50
&: Y:partial ℗ Y, F MUS/SH: Y ⅋Y H/B: Y S/G: Y
PERM/COLL: AM: ptgs, sculp; AM/SW: late 19; NAT/AM: sculp; WILDLIFE:art; EU & AM:
sport art 17-20

The outstanding John F. Wehle collection of sporting art is housed in the only museum in New York specializing in sport, hunting and wildlife subjects. The collection and carriage museum are part of an assembled village of 19th-century shops, homes and farm buildings.

New Paltz

College Art Gallery
Affiliate Institution: State University of New York at New Paltz
New Paltz, NY 12561
☎ 914-257-3844
HRS: 10-4 M-T, 7-9 Tu, 1-4 Sa & S; Summer: 10-4 M-T, 7-9 PM Sa DAY CLOSED: F HOL: 1/1, EASTER, THGV, 12/25,
ACAD! &: Y; Wheelchair ramp ℗ Y GR/T: Y GR/PH: CATR!
PERM/COLL: AM; gr, ptgs 19, 20; JAP: gr; CH: gr; P/COL; CONT: phot

A major cultural resource for the mid-Hudson Valley region.

ON EXHIBIT/97:
02/01/97–02/20/97	ALUMNI ART — A biennial, multi-media invitational exhibition.
03/04/97–03/20/97	THE ART AND DESIGN OF THE TIN CAN — Jewelry, sculpture and wall pieces by more than 24 artists created from found and recycled tin cans.
07/97	HUDSON VALLEY/CATSKILL MOUNTAIN ARTISTS — An invitational exhibition featuring regional artists.
10/97	SPECIAL EXHIBITION TBA

NEW YORK CITY - See Astoria, Bayside, Bronx, Brooklyn, Flushing, Long Island City, New York, Queens and Staten Island

New York

Alternative Museum
594 Broadway, **New York, NY 10012**
☎ 212-966-4444
HRS: 11-6 Tu-Sa DAY CLOSED: S, M HOL: 12/25
SUGG/CONT: Y ADULT: $3.00
&: Y; Elevator access ℗ Y; Nearby pay garage only
PERM/COLL: CONT

This contemporary arts institution is devoted to the exploration and dissemination of new avenues of thought on contemporary art and culture.

274

Alternative Museum - continued

ON EXHIBIT/97:

01/21/97–02/15/97 NEA EXPANSION ART EXHIBITION — Incorporating video and video installations, digitally generated images, electronic installations and photography, the exhibition highlights the work of a number of mid-career and emerging artists.

03/04/97–03/29/97 AFTER NATURE: A WORLD OF OUR MAKING — The first in The Alternative Museum's new "DeNatured Series" will explore the profound change in the way society interprets and understands the world today. Earlier notions of nature as a "divine wilderness" will be compared with the current perception that nature should be "tamed and harnessed to the service of mankind." WT

04/15/97–05/24/97 LIM OK-SANG — This is the first American exhibition of the work of Korean artist Lim who is a leader of the Minjoong movement which arose in 1980 in response to the brutal suppression of political and artistic freedom by Korea's military dictatorship. Included are both his Minjoong work and more recent pressed paper work.

06/10/97–07/19/97 ANNUAL NATIONAL SHOWCASE EXHIBITION — A part of the Museum's continuing commitment to showcase emerging artists from widely diverse backgrounds, representing nearly every region of the country.

New York

Americas Society

680 Park Avenue, **New York, NY 10021**
☎ 212-249-8950
HRS: 12-6 Tu-S HOL: 7/4, THGV, 12/24, 12/25
SUGG/CONT: Y
♿: Y Ⓟ Y; Nearby pay Garage
MUS/SH: Y
GR/T: Y GR/PH: CATR! H/B: Y
PERM/COLL: No permanent collection

Located in a historic neo federal townhouse built in 1909, the goal of the Americas Society is to increase public awareness of the rich cultural heritage of our geographic neighbors.

ON EXHIBIT/97:

01/16/97–03/16/97 THREE ABSTRACT ARTISTS: LAURA ANDERSON BARBATA, LINDA MATALON, AND RICARDO MAZAI — Compelling and thoughtful works by three significant young artists who live and work in New York City who find in tradition a usable past which they subtly adopt in their aesthetic, cultural and personal investigations of contemporary concerns. CAT WT

05/01/97–07/20/97 MARIA IZQUIERDO: A RETROSPECTIVE — Izquierdo, a major painter in Mexican art history (1902-1955) is little known outside of Mexico. Her career, which developed alongside those of artists identified with the post-Revolutionary mural movement, includes such diverse themes as the circus, portraiture, mythical allegories, and melancholic landscapes drawn both from her own artistic milieu and from such European movements as Surrealism. WT

FALL/97 THE COLONIAL ART OF POTOSI — Fine arts, decorative arts, liturgical objects, maps, prints, and other documents relating to Potosi, the great Bolivian mining city are presented in an exploration of the diverse facets of Bolivian art, culture and society in the colonial period. CAT

NEW YORK

New York

The Asia Society
725 Park Ave, New York, NY 10021
☎ 212-517-ASIA
HRS: 11-6 Tu-Sa, 11-8 T, 12-5 S DAY CLOSED: M HOL: LEG/HOL!
F/DAY: T, 6-8 PM ADM: Y ADULT: $3.00 CHILDREN: $1.00; F under 12 STUDENTS: $1.00 SR CIT: $1.00
&: Y ℗ Y; Nearby pay garages MUS/SH: Y GR/T: Y GR/PH: CATR!
PERM/COLL: The Mr. and Mrs. John D. Rockefeller III Collection of Asian Art

The Asia Society is America's leading institution dedicated to fostering understanding of Asia and communication between Americans and the peoples of Asia and the Pacific.

ON EXHIBIT/97:

02/05/97–04/13/97	KOTAH: ITS GODS, PRINCES AND TIGERS	CAT WT
09/24/97–01/04/98	MANDALA: THE ARCHITECTURE OF ENLIGHTENMENT — The first exhibition to be devoted to this important art form is structured to help viewers both enjoy the stunning artistry and diversity of the images and to understand the ways these images work both as visual forms and as guides to the Buddhist practitioner. CAT WT	

The Chaim Gross Studio Museum
526 LaGuardia Place, New York, NY 10012
☎ 212-529-4906
HRS: 12-6 Sa & by appt. HOL: LEG/HOL
&: Y ℗ Nearby pay parking
GR/T: Y GR/PH: CATR! 212-473-3341
PERM/COLL: Sculp, wood, stone, bronze; sketches, w/c

A seventy sculpture collection of Chaim Gross (1904-1991) work housed in the three floor Greenwich Village building which was the artist's home and studio for thirty-five years. **NOT TO BE MISSED:** "Roosevelt and Hoover in a Fistfight" 1932, Mahogany 72x20x1½. The 1932 cubist inspired wood sculptures were done in the only year when Gross submitted to modernist influences.

China Institute Gallery, China Institute In America
125 East 65th Street, New York, NY 10021=7088
212-744-8181
HRS: 10-5 M & W-Sa, 1-5 S, 10-8 Tu DAY CLOSED: S HOL: LEG/HOL!, CHINESE NEW YEAR
SUGG/CONT: Y ADULT: $5.00 STUDENTS: $3.00 SR CIT: $3.00
℗ Y; Pay garage nearby, limited street parking MUS/SH: Y DT: Y TIME: Varies! H/B: Y
PERM/COLL: Non-collecting institution

The only museum in New York and one of five in the entire country specializing in exhibitions of Chinese art and civilization. The Gallery reaches out to people interested in learning about and staying connected to China.

ON EXHIBIT/97:

02/08/97–06/14/97	ADORNMENT FOR ETERNITY: STATUS AND RANK IN CHINESE ORNAMENT — Using over 100 objects from the Mengdiexuan Collection, the exhibition examines the imagery, technique and materials of adornment in China as well as the influence of China's northern neighbors on metal technology. These symbols of status and rank in gold, silver, bronze and jade date from the Eastern Zhou period (770-221 B.C.) to the Quing dynasty (1644-1911). WT	
09/97–12/97	POWER AND VIRTUE: IMAGES OF HORSES IN CHINESE ART — The image of the horse, through Chinese history, is linked with a reflection of imperial power as a symbol of moral virtue. Some of the most important early Chinese equestrian paintings in the world will be featured here along with three dimensional objects. CAT WT	

New York

The Cloisters

Affiliate Institution: The Metropolitan Museum of Art
Fort Tryon Park, **New York, NY 10040**
☎ 212-923-3700
HRS: 6:30-5:15 Tu-S (3/1-10/30); 9:30-4:45 Tu-S (11/1-2/28) DAY CLOSED: M HOL: 1/1, THGV, 12/25
SUGG/CONT: Y ADULT: $8 CHILDREN: F (under12) STUDENTS: $4.00 SR CIT: $4.00
&: Y; Limited, several half-floors are not accessible to wheelchairs ℗ Y; Free limited street parking in Fort Tryon Park
MUS/SH: Y GR/T: Y GR/PH: CATR! DT: Y TIME: !
H/B: Y, 1938 bldg resembling med monastery, incorporates actual med arch elements
PERM/COLL: ARCH: Med/Eu; TAPESTRIES; ILLUMINATED MANUSCRIPTS; STAINED GLASS; SCULP; LITURGICAL OBJECTS

This unique 1938 building set on a high bluff in a tranquil park overlooking the Hudson River recreates a medieval monastery in both architecture and atmosphere. Actual 12th - 15th-century medieval architectural elements are incorporated within various elements of the structure which is filled with impressive art and artifacts of the era. **NOT TO BE MISSED:** "The Unicorn Tapestries"; "The Campin Room"; Gardens; Treasury; the "Belles Heures" illuminated manuscript of Jean, Duke of Breey

Cooper-Hewitt, National Museum of Design, Smithsonian Institution

2 East 91st Street, **New York, NY 10128**
☎ 212-860-6868 WEB ADDRESS: http://www.si.edu/ndm
HRS: 10-9 Tu, 10-5 W-Sa, Noon-5 S DAY CLOSED: M HOL: LEG/HOL!
F/DAY: T 5-9 ADM: Y ADULT: $3.00 CHILDREN: F (under 12) STUDENTS: $1.50 SR CIT: $1.50
&: Y ℗ Y: Nearby pay garages MUS/SH: Y
GR/T: Y GR/PH: CATR! DT: Y TIME: times vary; call 212-860-6868 H/B: Y S/G: Y
PERM/COLL: DRGS; TEXTILES; DEC/ART; CER

Cooper Hewitt, housed in the landmark Andrew Carnegie Mansion, has more than 165,000 objects which represent 3000 years of design history from cultures around the world.

ON EXHIBIT/97:	EXHIBITIONS WILL BE SUSPENDED UNTIL FALL 1996 FOR A MAJOR RENOVATION. Off site exhibitions, educational programs and the library will continue.
09/17/96–02/16/97	MIXING MESSAGES: GRAPHIC DESIGN IN CONTEMPORARY CULTURE — The opening exhibition of the centennial year of the National Design Museum celebrates the innovation of U.S. graphic design from 1980 to 1995. This period of revolutionary changes gave rise to changes in communication affecting all of society. Cable television, desktop publishing, interactive media, the proliferation of small-circulation magazines and the growing visibility of minorities and women have encouraged greater diversity in the styles and images, media and messages, makers and users of public information. Included will be a video documenting typography and the moving image, an interactive computer program allowing visitors to experiment with type, and a CD-ROM display allowing an experience with publications in sequence. PLEASE NOTE: The following WEB ADDRESS may be accessed for this specific exhibition: http://mixingmessages.si.edu
02/11/97–05/18/97	DISEGNO: ITALIAN RENAISSANCE DRAWINGS FOR THE DECORATIVE ARTS — In Renaissance Italy, drawing and design became so linked that they were referred to by the same term: disegno. Works of this nature will be on view from the Museum's collection.
03/18/97–08/17/97	HENRY DREYFUSS: DIRECTING DESIGN — On exhibit will be sketches, working drawings, scale models, prototypes, and finished products designed by this first consultant industrial designer whose priority was comfort, safety and convenience for the consumer.
04/29/97–06/22/97	THE JEWELRY OF TONE VIGELAND — The first retrospective of the jewelry of Norway's foremost designer to travel throughout North America, Vigeland is acclaimed for her original and striking designs in precious and non-precious metals. CAT WT

Cooper-Hewitt, National Museum of Design, Smithsonian Institution - continued

06/03/97–09/21/97	TODD OLDHAM — Drawing on the rich and far ranging holdings of the Museum to look at this renowned fashion designers work, the exhibition studies his iconoclastic view of design and the collection's inherent diversity.
06/21/97–09/22/97	UNDER THE SUN: AN OUTDOOR EXHIBITION OF LIGHT — The power of the sun as a catalyst for design both practical and visionary will be explored in illumination, reflection, focus, diffusion, pattern, shade, and shadow in this season long celebration. It will be phased into the garden in stages beginning on the vernal equinox, culminating on the summer solstice, and ending with the autumnal equinox
07/09/97–08/31/97	HELEN DRUTT — The Helen Williams Drutt Collection features jewelry dating from the mid-1960's through 1997, made by artists from North America, Europe, Australia, New Zealand, and Japan. The unique collection featured in this exhibition includes experiments in gold, gemstones, and other precious materials as well as wearable art constructed of plastic, feathers, and common found objects.
09/16/97–01/11/98	CELEBRATING DESIGN: COOPER HEWITT, NATIONAL DESIGN MUSEUM AT 100 — Marking the centennial of the only museum in the US devoted exclusively to historical and contemporary design, "Celebrating Design" underscores the significance and value of the Collection which spans three thousand years of the products and processes of design.
10/14/97–01/05/98	ARQUITECTONICA — In their first solo exhibition in New York, this display of photographs. models and drawings will introduce to the public the work of this Miami-based firm. Their vision for a new, dynamic, multi-story hotel, entertainment, and retail complex in Times Square will be included in the works on exhibit.

New York

Dahesh Museum

601 Fifth Avenue, New York, NY 10017
☎ 212-759-0606
HRS: 11-6 Tu-Sa HOL: LEG/HOL! ℗ Y pay parking nearby GR/T: Y GR/PH: CATR! DT: Y TIME: lunchtime daily
PERM/COLL: Acad pntg; 19, 20

More than 2000 works collected by writer, philosopher Salim Achi who was known as Dr. Dahesh form the collection of this new museum housed on the second floor of a commercial building built in 1911. Included are works by Auguste Bonheur, Luc-Olivier Merson, Henri Picou, Constant Troyon.

ON EXHIBIT/97:

10/22/96–02/97	JEAN-LÉON GÉROME AND THE CLASSICAL IMAGINATION — The museum's exceptional recently acquired painting by French master Gérome entitled "Le Travail du Marbre" or "L'Artiste Sculptante Tanagra" will be shown with an outstanding collection of 19th century photographs on loan from the Berkshire Museum in Pittsfield, MA.
03/04/97–06/07/97	RELIGION AND THE RUSTIC IMAGE IN LATE 19TH CENTURY ART

Dia Center for the Arts

548 West 22nd Street, New York, NY 10011
☎ 212-431-9232 WEB ADDRESS: http://www.diacenter.org
HRS: 12-6 T-S Sep-Jun DAY CLOSED: M-W HOL: LEG/HOL!
SUGG/CONT: Y ADULT: $3.00
&: Y MUS/SH: Y
PERM/COLL: not permanently on view

With several facilities and collaborations Dia has committed itself to working with artists to determine optimum environments for their most ambitious and uncompromising works which are usually on view for extended exhibition periods. **NOT TO BE MISSED:** Two Walter De Maria extended exhibitions, THE NEW YORK EARTH ROOM at the gallery at 141 Wooster Street and THE BROKEN KILOMETER at 393 Broadway. Both are open 12-6 W-Sa, closed July and August, adm F

ON EXHIBIT/97:

Extended exhibition:	DAN GRAHAM: ROOFTOP URBAN PARK PROJECT — A roof transformed into a park for the Chelsea neighborhood and the greater New York community.

New York

The Drawing Center
35 Wooster Street, New York, NY 10013
☎ 212-219-2166
HRS: 10-6 Tu-F; 10-8 W; 11-6 Sa, S DAY CLOSED: M HOL: 12/25, 1/1, all of AUG
&: Y; Lift ℗ Y; Nearby pay garages MUS/SH: Y H/B: Y
PERM/COLL: non collecting institution

Featured at The Drawing Center are contemporary and historical drawings and works on paper both by internationally known and emerging artists.

El Museo Del Barrio
1230 Fifth Ave, New York, NY 10029-4496
☎ 212-831-7272
HRS: 11-5 W-S; SUMMER (6/6-9/26) open till 8 PM T DAY CLOSED: M-Tu HOL: LEG/HOL!
SUGG/CONT: Y ADULT: $4.00 CHILDREN: F (under 12) STUDENTS: $2.00 SR CIT: $2.00
&: Y ℗ Y; Discount at Merit Parking Corp 12-14 E 107 St.
PERM/COLL: LAT/AM: P/COL; CONT: drgs, phot, sculp

One of the foremost Latin American cultural institutions in the United States, this museum is also the only one in the country that specializes in the arts and culture of Puerto Rico. **NOT TO BE MISSED:** Juan Sanchez: "Bleeding Reality: Asi Estamos"

ON EXHIBIT/97:

09/26/96–01/12/97	THE LIBERATED PRINT: THE PORTFOLIO IN PUERTO RICAN GRAPHICS — 265 prints and posters produced over the last five decades by Puerto Rican artists active in the portfolio movement will be seen in this exhibition. This was the first national art movement devoted to the political and cultural history of the island where artists joined together to establish a series of collective workshops in which extraordinary print portfolios were produced.
11/01/96–1998	SANTOS: SCULPTURES BETWEEN HEAVEN AND EARTH — A new permanent installation from the Museum's outstanding collection of Santos, colorful polychromed wood sculptures created by self-taught artists.
12/01/96–04/13/97	CONTEMOPORANEA: AN INSTALLATION BY MARIA ELENA GONZALEZ — A first Manhattan museum installation by this Cuban-born artist who proposes to create an evocative space in which the viewer will be encouraged to contemplate the loss of loved ones as well as the loss of ones' own physical or spiritual resources.
02/06/97–04/13/97	ALICIA CREUS — Argentine artist Alicia Creus has lived in the US since 1977. Several years ago she abandoned oil on canvas and began to produce the intensely sensual textile collages on view in this exhibition.
02/06/97–04/13/97	THE CONCEPTUAL TREND: SIX ARTISTS FROM MEXICO CITY — Some of the most energetic and innovative works produced in Mexico today will be presented in an exhibition that challenges existing stereotypes associated with "Mexican art." Artworks by Rodrigo Aldana, Marco Arce, Silvia Gruner, Yishai Judisman, Pablo Varga, and Daniela Rossell will be included..
05/06/97–08/31/97	RE-ALIGNING VISIONS: SOUTH AMERICAN DRAWING (1960-1990) — 90 drawings by 75 leading Latin American artists will be on loan from public and private sources in an exhibition of works ranging from the contemporary interpretation 16th & 17th-century old master techniques, to photographic realism, expressive figuration and abstraction. WT

279

El Museo Del Barrio - continued

05/06/97–09/07/97 CONTEMPORANEA: RECURRENT MEMORIES BY DIAMANTINA GONZALEZ — A Mexican artist currently living in New York, Gonzalez's installation will deal with the phenomenon of memory which for her become sharp at one moment and fade into the recesses of consciousness at the next.

09/25/97–03/29/98 THE TAINO LEGACY — Rare pieces of pre-Columbian art and artifacts of the Tainos, an Arawak people who populated the Caribbean from 800-1500 A.D. will be selected from various public collections in New York, Puerto Rico and the Dominican Republic. They will be chosen both for artistic merit and for their potential to sustain a discussion regarding the cultural and historical context in which they were created.

New York

The Equitable Gallery
787 Seventh Avenue, **New York, NY 10019**
☎ 212-554-4818
HRS: 11-6 M-F, 12-5 Sa DAY CLOSED: S HOL: LEG/HOL, 12/24
♿: Y ℗ Y, nearby pay MUS/SH: Y, branch ❛❜ Y; 3 fine restaurants located in the space overlooking the Galleria
PERM/COLL: `PUBLIC ART IN LOBBY OF EQUITABLE TOWER: THOMAS HART BENTON "AMERICA TODAY" MURAL SERIES

The gallery presents works from all fields of the visual arts that would not otherwise have a presence in New York City.

The Frick Collection
1 East 70th Street, **New York, NY 10021**
☎ 212-288-0700
HRS: 10-6 Tu-Sa, 1-6 S; Also open 2/12, Election Day, 11/11 DAY CLOSED: M HOL: 1/1, 7/4, THGV, 12/24, 12/25
ADM: Y ADULT: $5 CHILDREN: under 10 not adm STUDENTS: $3.00 SR CIT: $3.00
♿: Y ℗ Y; Pay garages nearby MUS/SH: Y H/B: Y S/G: Y
PERM/COLL: PTGS; SCULP; FURNITURE; DEC/ART; Eur, Or, PORCELAINS

The beautiful Henry Clay Frick mansion built in 1913-14, houses this exceptional collection while preserving the ambiance of the original house. In addition to the many treasures to be found here, the interior of the house offers the visitor a tranquil respite from the busy pace of city life outside of its doors. PLEASE NOTE: Children under 10 are not permitted in the museum and those from 11-16 must be accompanied by an adult. **NOT TO BE MISSED:** Boucher Room; Fragonard Room; Paintings by Rembrandt, El Greco, Holbein and Van Dyck

ON EXHIBIT/97:

12/09/96–03/03/97 16TH THROUGH 18TH CENTURY DRAWINGS FROM THE RATJEN FOUNDATION

04/01/97–08/06/97 THE PROUD REPUBLIC: DUTCH PORTRAIT MEDALS OF THE 17TH CENTURY
Dates Tent! TENT!

George Gustav Heye Center of the National Museum of the American Indian
Affiliate Institution: Smithsonian Institution
One Bowling Green, **New York, NY 10004**
☎ 212-668-6624
HRS: 10-5 daily, 10-8 T HOL: 12/25
℗ Y; Nearby pay MUS/SH: Y-2 GR/T: Y GR/PH: CATR! 212-825-8096 DT: Y TIME: daily H/B: Y
PERM/COLL: NAT/AM; Iroq silver, jewelry, NW Coast masks

George Gustav Heye Center of the National Museum of the American Indian - continued

The Heye Foundation collection contains more than 1,000,000 works which span the entire Western Hemisphere and present a new look at Native American peoples and cultures. Newly opened in the historic Alexander Hamilton Customs House it presents masterworks from the collection and contemporary Indian art.

ON EXHIBIT/97:

Inaugural Exhibitions

CREATION'S JOURNEY: MASTERWORKS OF NATIVE AMERICAN IDENTITY AND BELIEF — Objects of beauty and historical significance, representing numerous cultures throughout the Americas, ranging from 3200 B.C. to the present will be on display.
CAT

ALL ROADS ARE GOOD: NATIVE VOICES ON LIFE AND CULTURE — Artifacts chosen by 23 Indian selectors.
CAT

THIS PATH WE TRAVEL: CELEBRATIONS OF CONTEMPORARY NATIVE AMERICAN CREATIVITY — Collaborative exhibition featuring works by 15 contemporary Indian artists.
CAT

10/98/97–01/08/98

NATIVE AMERICAN QUILTS (Working Title) — The 60 quilts shown demonstrate the cultural and economic significance of quiltmaking in tribal communities.
WT

New York

The Grey Art Gallery and Study Center

Affiliate Institution: New York University Art Collection
100 Washington Square East, **New York, NY 10003-6619**
☎ 212-998-6780
HRS: 11-6 Tu, T, F; 11-8:30 W; 11-5 Sa DAY CLOSED: S, M HOL: LEG/HOL!
SUGG/CONT: Y ADULT: $2.00
&: Y
Ⓟ Y; Nearby pay garages
PERM/COLL: AM: ptgs 1940-present; CONT; AS; MID/EAST

Located at Washington Square Park and adjacent to Soho, the Grey Art Gallery, established by Samuel F. B. Morse in 1835, occupies the site of the first academic fine arts department in America.

ON EXHIBIT/97:

02/97–03/97

LE MOVEMENT QUOTIDIEN: ASPECTS OF FRENCH ART IN THE NINETIES — It has been a perception in the US that contemporary French art either did not exist or was of inferior quality. This exhibition puts this notion to rest. Contemporary French artists are choosing to concentrate on the minutia of everyday life depicting the nitty-gritty requirements of the urban city dweller.

04/97–05/97

LANGLANDS AND BELL — The art of Ben Langlands and Nikki Bell treats architecture as a literal embodiment of ideas, beliefs, and values. Their appropriations of architectural models, plans, and cross-sectional drawings suggest metaphors for the systems and structures that ultimately shape us all.

06/97–07/97

NAHUM ZENIL: WITNESS TO THE SELF — An outstanding Mexican artist, this is his first comprehensive exhibition in an American museum. It will provide greater understanding of his collages, mixed media on paper and oils on canvas as well as of social, political and psychological circumstances of life in Mexico in the 20th-century.

New York

Guggenheim Museum Soho
575 Broadway at Prince St, New York, NY 10012
☎ 212-423-3500
HRS: 11-6 S & W-F, 11-8 Sa DAY CLOSED: M, Tu HOL: 1/1, 12/25
ADM: Y ADULT: $5.00 CHILDREN: F (under 12) STUDENTS: $3.00 SR CIT: $3.00
&: Y; Wheelchairs and folding chairs available in coatroom ℗ Y; Nearby pay garages
MUS/SH: Y ¶Y GR/T: Y GR/PH: CATR! H/B: Y
PERM/COLL: INTERNATIONAL CONT ART

As a branch of the main museum uptown, this facility, located in a historic building in Soho, was designed as a museum by Arata Isozaki.

ON EXHIBIT/97:

ONGOING	ENEL — Electronic reading room
	ENEL — Virtual Reality Gallery
11/19/96–01/19/97	1996: THE HUGO BOSS PRIZE Dates Tent!
01/30/97–04/13/97	ARAKAWA/GINS: THE MECHANISM OF MEANING AND REVERSIBLE DESTINY ARCHITECTURE Dates Tent!

The Hispanic Society of America
155th Street and Broadway, New York, NY 10032
☎ 212-926-2234
HRS: 10-4:15 Tu-Sa, 1-4 S DAY CLOSED: M HOL: LEG/HOL!
VOL/CONT: Y
&: Y; Limited, exterior & interior stairs ℗ Y; Nearby pay garage MUS/SH: Y
GR/T: Y GR/PH: CATR! H/B: Y S/G: Y
PERM/COLL: SP: ptgs, sculp; arch; HISPANIC

Representing the culture of Hispanic peoples from prehistory to the present, this facility is one of several diverse museums located within the same complex on Audubon Terrace in NYC. **NOT TO BE MISSED:** Paintings by El Greco, Goya, Velazquez

ON EXHIBIT/97:

ONGOING	HISPANIC SOCIETY GALLERIES OF NINETEENTH AND EARLY TWENTIETH CENTURY ART — These newly opened galleries include works by Sorolla, Fortuny, Rusinol, Zuloaga, Casas and Sala, among others, many of which have not been on display for 25 years. This selection offers a comprehensive survey of a long neglected period and an opportunity to study works by artists better known in Spain. The Galleries will be open 10:30-4:15 Sa.

International Center of Photography
Midtown, 1133 Avenue of the Americas and 1130 Fifth Avenue, 10128, New York, NY 10036
☎ 212-860-1777
HRS: 11-8 Tu, 11-6 W-S DAY CLOSED: M HOL: 1/1, 7/4, THGV, 12/25
F/DAY: Tu, 6-8 ADM: Y ADULT: $4.00 STUDENTS: $2.50 SR CIT: $2.50
&: Y! ℗ Y; Nearby pay garages MUS/SH: Y ¶Y; Nearby GR/T: Y GR/PH: CATR! H/B: Y
PERM/COLL: DOCUMENTARY PHOT: 20

The ICP was established in 1974 to present exhibitions of photography, to promote photographic education at all levels, and to study 20th-century images. The uptown museum is housed in a 1915 Neo-Georgian building designed by Delano and Aldrich.

ON EXHIBIT/97:

11/08/96–02/09/97	ROADWORKS: PHOTOGRAPHS BY LINDA McCARTNEY — At 1133 Avenue of the Americas.

International Center of Photography - continued

11/08/96–02/09/97 ALL ZONES OFF PEAK: PHOTOGRAPHS OF LIVERPOOL BY TOM WOOD — At 1133 Avenue of the Americas.

11/15/96–01/12/97 PICTORIALISM INTO MODERNISM: THE CLARENCE H. WHITE SCHOOL OF PHOTOGRAPHY — At 1130 5th Avenue: This exhibition provides a wider public knowledge and appreciation of an aspect of modern photographic history previously overshadowed by Stieglitz. WT

11/15/96–01/12/97 LABYRINTH: PHOTOGRAPHS OF HONG KONG BY MASAHIKO YAMASHIKO — At 1130 Fifth Avenue

New York

Japan Society Gallery

333 E. 47th Street, New York, NY 10017
☎ 212-832-1155
HRS: 11-5 Tu-S (CLOSED FOR RENOVATIONS 5/96-5/97) DAY CLOSED: M HOL: LEG/HOL!
SUGG/CONT: Y ADULT: $3.00 CHILDREN: $3.00 STUDENTS: $3.00 SR CIT: $3.00
&. : Y ℗ Y; Nearby pay garages MUS/SH: Book Shop GR/T: Y GR/PH: CATR! H/B: Y S/G: Y
PERM/COLL: JAPANESE ART

Exhibitions of the fine arts of Japan are presented along with performing and film arts at the Japan Society Gallery which attempts to promote better understanding and cultural enlightenment between the peoples of the U.S. and Japan.

ON EXHIBIT/97:

05/97 BUDDHIST SCULPTURE

10/97 HISTORY OF THEATER IN JAPAN FROM PRE-BUDDHIST TO TODAY: AN EXAMINATION AND ILLUSTRATION

The Jewish Museum

1109 5th Ave., New York, NY 10128
☎ 212-423-3200
HRS: 11-5:45 S, M, W & T; 11-8 Tu DAY CLOSED: F, Sa HOL: LEG/HOL!; JEWISH/HOL!
F/DAY: Tu after 5 ADM: Y ADULT: $7.00 CHILDREN: F (under 12) STUDENTS: $5.00 SR CIT: $5.00
&. : Y! ℗ Y; Nearby pay garages
MUS/SH: Y
�11 Y; Cafe Weissman, kosher cuisine
GR/T: Y GR/PH: CATR! 212-423-3225 DT: Y TIME: Noon & 2:30 M-T H/B: Y
PERM/COLL: JUDAICA: ptgs by Jewish and Israeli artists; ARCH; ARTIFACTS

27,000 works of art and artifacts covering 4000 years of Jewish history created by Jewish artists or illuminating the Jewish experience are displayed in the original building (the 1907 Felix Warburg Mansion), and in the new addition added in 1993. The collection is the largest of its kind outside of Israel. **NOT TO BE MISSED:** "The Holocaust," by George Segal

ON EXHIBIT/97:

09/08/96–01/19/97 FROM COURT JEWS TO THE ROTHSCHILDS: ART, PATRONAGE AND POWER 1600-1800 — The first exhibition to examine the cultural life of Court Jews in Germanic lands, these 275 works in all media will tell their dramatic story within the politics, art and culture of their time. Specific individuals and families will be highlighted and the show's epilogue will discuss the history of the Rothschilds, the "last Court Jews" and the first entrepreneurs to build an unprecedented financial and industrial network that helped to usher in a new economic age. CAT

The Jewish Museum - continued

01/19/97–04/13/97 MORRIS LOUIS: THE CHARRED JOURNAL SERIES — A series of paintings by this great American abstract painter which deals with Nazi book burnings in terms of black and white abstract forms.

01/19/97–04/13/97 RICO LEBRUN: THE HOLOCAUST PAINTINGS — Horrified yet fascinated by photographs of concentration camp victims, Italian-American painter Lebrun created these monumental paintings which, with the preliminary drawings, provide a powerful realistic statement of one artist's response to historic events.

02/23/97–05/27/97 CHANTAL AKERMAN: D'EST — A major installation of film and video by Belgian filmmaker Akerman is a documentary of her visit to her parents' homeland in Eastern Europe and Russia.

05/18/97–08/17/97 POINTS OF ENTRY — Three major photographic exhibition which have been traveling among their organizing institutions are now brought together under this single title. The approximately 200 photographs on view in this venue which deal with the immigration experience in America, were part of separate exhibitions entitled: "A Nation of Strangers" from the Museum of Photographic Arts in San Diego; "Reframing America" from the Center for Creative Photography in Tucson; and "Tracing Cultures" from the Friends of Photography/Ansel Adams Center in San Francisco. WT

07/01/97–10/13/97 FACING THE NEW WORLD: JEWISH PORTRAITS IN COLONIAL AND FEDERAL AMERICA — Painted representations of American Jews during the Colonial Period will be explored in an exhibition that includes works by such artistic notables as Gilbert Stuart, John Wesley Jarvis, Thomas Sully and Charles Wilson Peale.

New York

The Metropolitan Museum of Art
5th Ave at 82nd Street, New York, NY 10028
☎ 212-879-5500 WEB ADDRESS: http://www.metmuseum.org
HRS: 9:30-5:15 Tu-T, S; 9:30-9 PM F, Sa DAY CLOSED: M HOL: 12/25, 1/1
SUGG/CONT: Y ADULT: $8.00 CHILDREN: F (under 12) STUDENTS: $4.00 SR CIT: $4.00
&: Y Ⓟ Y; Pay garage MUS/SH: Y ❡Y GR/T: Y GR/PH: CATR! H/B: Y S/G: Y
PERM/COLL: EU: all media; GR & DRGS: Ren-20; MED; GR; PHOT; AM: all media; DEC/ART: all media; AS: all media; AF; ISLAMIC; CONT; AN/EGT; AN/R; AN/AGR; AN/ASSYRIAN

The Metropolitan is the largest world class museum of art in the Western Hemisphere. It's comprehensive collections includes more than 2 million works from the earliest historical artworks through those of modern times and from all areas of the world. Just recently, the museum opened the Florence & Herbert Irving Galleries for the Arts of South & Southeast Asia, one of the best and largest collections of its kind in the world. **NOT TO BE MISSED:** Temple of Dendur; The recently renovated 19th-century European Beaux-Arts painting & sculpture galleries (21 in all), designed to present the permanent collection in chronological order and to accommodate the promised Walter Annenberg collection now on view approximately 6 months annually.

ON EXHIBIT/97:

10/08/96–02/02/97 QUEEN NEFERTITI AND THE ROYAL WOMEN: IMAGES OF BEAUTY IN ANCIENT EGYPT — Coinciding with the opening of a new installation of the Museum's own collection of Amarna (c.1353-1336 BC) the exhibition will display loans from the Louvre, Agyptisches Museum, Berlin and other foreign and US museums. At the center are a dozen masterpiece sculptures of Queen Nefertiti, her daughters and other women of the royal family which demonstrate a remarkable transformation of the ancient Egyptian ideal of female beauty which emerged in this period. CAT

10/10/96–01/12/97 AMERICAN ART IN THE EDITH AND MILTON LOWENTHAL COLLECTION — The 50-20th Century works reunited here celebrate the Lowenthal's pioneering efforts to promote a wider appreciation of contemporary American art in the 1940's and 1950's. The works, mostly paintings, are by artists including Milton Avery, Romare Bearden, Stuart Davis, Arthur Dove, Jacob Lawrence, Georgia O'Keeffe, and Max Weber and range in date from 1914-1952. BROCHURE

The Metropolitan Museum of Art - continued

10/29/96–01/19/97 COROT — This 200th anniversary retrospective, the first in the US in 35 years, traces the entire career of Camille Corot (1796-1875). The 160 paintings on exhibit chart his evolution as an artist from the acute observations of the real landscape that define his early works to the imaginary idylls of his later years. CAT ◠

10/29/96–02/02/97 IMAGES OF WOMEN: NINETEENTH-CENTURY AMERICAN DRAWINGS AND WATERCOLORS — Watercolors and drawings from the permanent collection including 19th and early 20th-century works by Thomas Eakins, Winslow Homer, John Singer Sargent, Arthur B. Davies and others will be seen in an exhibition whose diverse theme reflects the range of expression offered to artists by female forms and personae.

11/01/96–10/05/97 NO ORDINARY MORTALS: THE HUMAN (AND NOT-SO-HUMAN) FIGURE IN JAPANESE ART — Paintings, sculpture, ceramics, textiles, lacquers, and prints dating from prehistoric times to the 19th-century will be seen in an exhibition designed to take a "new look at who's who in Japanese art."

11/05/96–01/05/97 MASTERPIECES IN LITTLE: PORTRAIT MINIATURES FROM THE COLLECTION OF HER MAJESTY THE QUEEN WT

11/05/96–01/05/97 EUROPEAN MINIATURES IN THE METROPOLITAN MUSEUM OF ART — Some 250 portrait miniatures and 50 gold boxes from the Museum collection complement those from the British Royal Collection. CAT

11/18/96–03/01/97 FLOWERS UNDERFOOT: INDIAN CARPETS OF THE MUGHAL ERA — A major international exhibition of classic Indian carpets designed by the Metropolitan Museum that pays tribute to India's half century of independence. CAT

11/21/96–02/16/97 CHARLES RENNIE MACKINTOSH — This survey affords a rare opportunity to experience firsthand the scope and brilliance of the oeuvre of one of the most celebrated architects and designers of the early 20th-century. Included is the Ladies' Luncheon Room from Miss Cranston's Ingram Street Tea Rooms which has not been seen since it was dismantled in 1971 and fully restored for this exhibition featuring furnishings and decorative gesso panels by Mackintosh and Margaret MacDonald, his wife and artistic collaborator. CAT ◠

12/06/96–04/06/97 LATE KLEE — Rarely shown large-scale works that are heavy in line will be seen in a presentation that focuses on paintings from the last 15 years of Klee's life.

12/10/96–FALL/97 THE GODS OF WAR: SACRED IMAGERY AND THE DECORATION OF ARMS AND ARMOR — Depictions of saints, deities, spirits and religious imagery on armor from the Middle East, India. Southeast Asia, Tibet, China and Japan will be seen in a display of objects selected from the Museum's encyclopedic collection of arms and armor.

12/12/96–03/23/97 CHRISTIAN DIOR — A presentation of the achievements of Dior, a designer who in the ten years from 1947 to 1957 created the foundation of post-war fashion beginning with the New Look, a style symbolic of renewal and optimism.

01/22/97–04/27/97 VENETIAN EIGHTEENTH CENTURY PRINTS AND BOOKS FROM THE COLLECTION OF THE METROPOLITAN MUSEUM OF ART — Approximately 100 prints and books chosen to represent the astoundingly varied and abundant production of Venetian presses in the last century of the Republic.

01/23/97–04/27/97 GIAMBATTISTA TIEPOLO — Celebrating the 300th anniversary of Tiepolo's birth, this monographic exhibition of major works by the greatest Venetian painter of the 18th-century coincides with an exhibition at the Pierpont Morgan Library entitled "Drawings by Giambattista Tiepolo and His Circle in the North American Collections." CAT ◠

01/23/97–04/27/97 DOMENICO TIEPOLO: DRAWINGS, PRINTS AND PAINTINGS IN THE METROPOLITAN MUSEUM OF ART — Works by the son and collaborator of Giambattista Tiepolo, a gifted artist in his own right, will be seen in this display from the Museum's collection, one of the greatest concentrations of his work in the world. BOOKLET

01/30/97–05/04/97 MASTERPIECES FROM A EUROPEAN FOUNDATION — An exceptional group of some 65 masterpieces from one of the world's finest private collections will be on public view for the first time. Ranging from El Greco to Warhol, this presentation includes a dozen major canvases by van Gogh and exceptional groups of works by Renoir, Gauguin, Cézanne, Matisse, Picasso and other artistic luminaries. CAT WT

03/11/97–07/06/97 THE GLORY OF BYZANTIUM — On exhibit will be art of the middle period of the Byzantine Empire (mid-9th through mid-13th centuries) when Byzantium set a standard of imperial elegance and quality for both contemporary Western Europe and the Islamic east. CAT ◠

NEW YORK

The Metropolitan Museum of Art - continued

04/02/97–08/03/97	CARTIER: 1900-1939 — The progression of styles from the opulent display of the turn of the century pieces through the innovative geometrics and exoticisms of the 1920's and 30's will be traced in the more than 200 examples of jewelry, clocks, watches and boxes on view in this exhibition. Design drawings and plaster models will also be on exhibit. CAT ◯
04/04/97–08/17/97	THE FOUR SEASONS — An exhibition of costume's variations throughout the year includes wardrobe changes for social and recreational seasons, and for accommodation to climate.
MID/97–MID/97	THE HUMAN FIGURE IN TRANSITION: AMERICAN SCULPTURE FROM THE MUSEUM'S COLLECTION, 1900-1945 — On exhibit will be small-scale sculptures by American and European artists.
05/97–10/97	THE IRIS AND B. GERALD CANTOR ROOF GARDEN — Weather permitting, a selection of 20th-century sculpture from the permanent collection may be seen in the Museum's open-air rooftop garden setting.
05/06/97–07/13/97	THE PRINT IN THE NORTH: THE AGE OF ALBRECHT DÜRER AND LUCAS VAN LEYDEN — Masterpieces of etching, engravings, woodcuts and illustrated books from the Museum's outstanding collection of German and Netherlands prints from 1470 to 1550. BROCHURE
06/10/97–09/07/97	IVAN ALBRIGHT — A retrospective of this American artist (1897-1983) whose style of sharp-focus painting is so exacting in its depiction of detail that it transcends reality. WT
09/23/97–01/04/98	HEROIC ARMOR OF THE ITALIAN RENAISSANCE: THE NEGROLI AND THEIR CONTEMPORARIES — Paintings, drawings and engravings will accompany this marvelous display of highly decorated military costumes fashioned between 1530-50 at the Milanese workshop of Renaissance master Filippo Negroli. Created mainly for royalty, Filippo transformed the armor seen here into artworks of sculptured steel. CAT
10/28/97–01/11/98	FILIPPINO LIPPI AND HIS CIRCLE — On loan from museums worldwide, this major exhibition of 110 drawings, more than 80 of which are by 15th-century master Lippi, will include superb examples by Botticelli, Piero di Cosimo, and other notable Florentine artists working in Filippino's circle.
11/97–03/98	RICHARD POUSETTE-DART IN THE METROPOLITAN MUSEUM OF ART: WORKS FROM THE ARTIST'S ESTATE — 30 paintings by Abstract-Expressionist Pousette-Dart (1916-1992) will be seen with a selection of his works on paper. CAT
11/18/97–02/08/98	PADSHAHNAMA — On loan from the Royal Library at Windsor Castle, "The Padshahnama" (History of the Emperor) is regarded as one of the greatest - and most rarely exhibited - volumes made for the Mughal emperor who was the builder of the Taj Mahal. This priceless publication documenting the first 10 years of the emperor's rule, consists of 44 illustrations and two elaborate illuminations. CAT WT

New York

Miriam and Ira D. Wallach Art Gallery
Affiliate Institution: Columbia University
Schermerhorn Hall, 8th Fl.116th St. and Broadway, **New York, NY 10027**
☎ 212-854-7288
HRS: 1-5 W-Sa (The gallery is open only when there is an exhibition!) DAY CLOSED: S, M, Tu
HOL: 1/1, week of THGV, 12/25, 6/3-10/10/95
&: Y; Enter on Amsterdam Avenue ⓟ Y; Nearby pay garages H/B: Y
PERM/COLL: non-collecting institution

Operated under the auspices of Columbia University and situated on its wonderful campus, the gallery functions to complement the educational goals of the University.

ON EXHIBIT/97:

01/28/97–03/97	ROBERT MOTHERWELL ON PAPER: GESTURE, VARIATION, CONTINUITY Dates Tent!
03/97–04/97	VISUAL ARTS, MFA WORK Dates Tent!
10/97–12/97	COLUMBIA'S MASTER PLAN ENTERS ITS SECOND CENTURY Dates Tent!

New York

The Museum for African Art
593 Broadway, **New York, NY 10012**
☎ 212-966-1313
HRS: 10:30-5:30 Tu-F; 12-6 Sa, S DAY CLOSED: M HOL: LEG/HOL!
ADM: Y ADULT: $4.00 CHILDREN: $2.00 STUDENTS: $2.00 SR CIT: $2.00
&: Y ℗ Y; Nearby pay garages MUS/SH: Y GR/T: Y GR/PH: CATR! DT: Y TIME: call for specifics H/B: Y
PERM/COLL: AF: all media

Located in a historic building with a cast iron facade, this museum was designed by Maya Lin, architect of the Vietnam Memorial in Washington, D.C. Her conception of the space is "less institutional, more personal and idiosyncratic." She is using "color in ways that other museums do not, there will be no white walls here." **NOT TO BE MISSED:** Sub-Saharan art

ON EXHIBIT/97:

02/07/97–08/31/97	ART THAT HEALS: THE IMAGE AS MEDICINE IN ETHIOPIA — The exhibition traces the historically shifting relationship between religion as practiced by the Ethiopian Christians, art and healing in the Ethiopian context and the African use of art as an essential therapeutic tool. CAT
02/07/97–08/31/97	TO PROTECT AND CURE: SICKNESS AND HEALTH IN AFRICAN ART — The ways in which sub-Saharan cultures have depicted health and sickness in works of art will be shown in the objects on view that are used to identify, cure and prevent disease.

Museum of American Folk Art
Two Lincoln Square, **New York, NY 10023-6214**
☎ 212-595-9533
HRS: 11:30 -7:30 Tu-S DAY CLOSED: M HOL: LEG/HOL!
&: Y ℗ Y, pay garage nearby MUS/SH: Y, also at 62 W. 50th St.
GR/T: Y GR/PH: CATR!
PERM/COLL: FOLK: ptgs, sculp, quilts, textiles, dec/art

The museum is known both nationally and internationally for its leading role in bringing quilts and other folk art to a broad public audience. **NOT TO BE MISSED:** "Girl in Red with Cat and Dog," by Ammi Phillips; major works in all areas of folk art

ON EXHIBIT/97:

ONGOING	AMERICA'S HERITAGE — Major works from the permanent collection shown on a rotating basis.
01/11/97–02/25/97	HENRY DARGER: THE UNREALITY OF BEING — In 15,000 pages created over 40 years Henry Darger (1892-1973) created a turbulent and powerful cosmic world in his epic narrative, "The Realms of the Unreal." This is the first museum retrospective of this artist's complex oeuvre.
02/15/97–04/13/97	SIGN SCULPTURE: SHOP AND CIGAR STORE FIGURES IN AMERICA — The origins, sources and practice of shop figure carving are traced here from the earliest English and American examples through those made in urban workshops by shipcarvers in the 1840's to 1880's, the height of their popularity, to their decline in the early 20th-century. WT
05/03/97–07/06/97	A PASSION FOR THE PAST: THE COLLECTION OF BERTRAM K. AND NINA FLETCHER LITTLE AT COGSWELL'S GRANT — This superb assemblage of 18th and 19th-century furnishings is being shown for the first, and probably only time, outside rural New England. Collected for their Massachusetts home these rare objects of remarkable quality reflect the Little's extraordinary contribution to the study of American decorative arts. WT
07/12/97–09/07/97	QUILT REVIVAL: 1910-1950 — A reassessment of the quilts of the first half of the 20th-century will be viewed within the context of such contemporary design movements as colonial revival and art deco.

NEW YORK

New York

The Museum of Modern Art
11 West 53rd Street, **New York, NY 10019-5498**
✆ 212-708-9400 WEB ADDRESS: http://www.moma.org
HRS: 11-6 Sa-Tu; 12-8:30 T, F DAY CLOSED: W HOL: THGV, 12/25
F/DAY: T, F 5:30-8 vol contr
ADM: Y ADULT: $8.50 CHILDREN: F under 16 with adult STUDENTS: $5.50 SR CIT: $5.50
&: Y Ⓟ Y:Pay nearby MUS/SH: Y ♟ Y; Garden Cafe and Sette Moma (open for dinner exc W & S)
GR/T: Y GR/PH: CATR! 212-708-0400 DT: Y TIME: ! 212-708-9795 Weekdays, Sa, S 1 & 3p H/B: Y;1939 Bldg by
Goodwin&Stone considered one of first examples of Int. Style S/G: Y
PERM/COLL: WORKS BY PICASSO, MATISSE, BRANCUSI; AB/IMP; PHOT & DESIGN 20

The MOMA offers the world's most comprehensive survey of 20th-century art in all media as well as an exceptional film library. **NOT TO BE MISSED:** Outstanding collection of 20th-century photography, film and design.

ON EXHIBIT/97:

10/18/96–01/21/97	JASPER JOHNS: A RETROSPECTIVE — A full retrospective of works in all media surveys the career (b.1930) of Johns, arguably most influential artist of the last three decades. Both his imagery and his way of working – in drawings, prints and sculpture as well as in painting – have had a profound impact on the style and creative imagination of generations of artists worldwide. CAT
10/20/96–01/21/97	JASPER JOHNS: PROCESS AND PRINTMAKING
01/18/97–04/29/97	AFTER ARTAUD — A selection of works illustrating the influence of Artaud in contemporary culture.
01/23/97–05/25/97	PROJECTS: CHIA MATSUE AND BUI LEE — A painting installation by these artists from Osaka and Seoul explores Asian cultural conventions, focusing on the role of women.
01/24/97–03/31/97	RAINER WERNER FASSBINDER
01/28/97–04/29/97	DEKOONING IN THE EIGHTIES — Approximately 40 paintings made during the artist's final creative years, demonstrate his striking range, from spare to animated to richly hued works. CAT ⌒
02/20/97–05/18/97	MANUEL ALVAREZ BRAVO
02/27/97–05/20/97	HANNAH HÖCH (Working Title) — On view will be a full retrospective of the work of German artist Höch, a pioneer in the field of photocollage. CAT WT
05/15/97–09/02/97	OBJECTS OF DESIRE: THE MODERN STILL LIFE ⌒

Museum of the City of New York
Fifth Ave. at 103rd Street, **New York, NY 10029**
✆ 212-534-1672
HRS: 10-5 W-Sa, 1-5 S, 10-2 Tu for pre-registered groups only DAY CLOSED: M, Tu HOL: LEG/HOL!
SUGG/CONT: Y ADM: Y ADULT: $5, Family $10 CHILDREN: $4.00 STUDENTS: $4.00 SR CIT: $4.00
&: Y; 104th St Entrance Ⓟ Y; Nearby pay garages MUS/SH: Y GR/T: Y GR/PH: CATR! TIME: ! H/B: Y
PERM/COLL: NEW YORK: silver 1678-1910; INTERIORS: 17-20; THE ALEXANDER HAMILTON COLLECTION; PORT
OF THE NEW WORLD MARINE GALLERY

Founded in 1933 this was the first American museum dedicated to the history of a major city. The museum's collections encompass the City's heritage, from its exploration and settlement to the NY of today. **NOT TO BE MISSED:** Period Rooms

Museum of the City of New York - continued

ONGOING

BROADWAY — A survey of the magical Broadway comedies, dramas and musicals from 1866 to the present.

BROADWAY CAVALCADE — The history of the street known as Broadway from its origins as a footpath in Colonial New York to its development into the City's most dynamic, diverse and renowned boulevard.

FAMILY TREASURES: TOYS AND THEIR TALES — Toys from the Museum's renowned collection present a history of New York City through their individual stories.

ISADORA DUNCAN — A display focusing on the provocative life of the dancer who transformed the concept of dance into an art form.

02/02/96–03/23/97

BACK IN THE DAYS: EAST HARLEM OLD AND YOUNG — East Harlem's history is traced through the eyes of young people and senior citizens engaged in an inter-generational program under the auspices of Union Settlement Association. Included are memorabilia, photographs, video-tapes and oral histories.

05/03/96–02/16/97

REVISITING THE SCENE: NEW RESEARCH, NEW DISCOVERIES — 25 recently re-examined, intriguing 19th and 20th-century paintings from the museum's extensive collection of urban scenes.

08/21/96–01/19/97

DRAWING THE FUTURE: DESIGN DRAWINGS FOR THE NEW YORK WORLD'S FAIR — The original architectural renderings and illustrations on view focus on futuristic drawings that provided the vision for the 1939 Fair. CAT

10/01/96–06/29/97

A MUSEUM FOR A NEW CENTURY: THE MUSEUM OF THE CITY OF NEW YORK IN THE 21ST CENTURY — Drawings and interior renderings by James Stewart Polshek and Ralph Appelbaum Associates of the new six-story wing which will complete the 1930 landmark building and double the size of the exhibition galleries.

11/02/96–04/06/97

THE ART OF POLITICS: POLITICAL CARTOONS BY CASSEL. KIRBY AND ARLT — The political cartoons, made between 1910 and 1959, drawn from the Museum's collection were seen as editorials in cartoon form when they appeared in *The World*, *The New York World Telegram*, and *The Brooklyn Eagle*.

11/27/96–04/27/96

NEW YORK TOY STORIES — A display of 18th to 20th-century toys from the collection many of which have origins of manufacture and connection to New York City in diverse ways.

02/05/97–06/08/97

THE STREETS AND BEYOND: NEW YORK PHOTOGRAPHS, 1900-1960

04/16/97–08/31/97

OF THEE WE SING: GEORGE AND IRA GERSHWIN CENTENNIAL — Featured will be an assortment of the Gershwin brothers original art work, caricatures of them by Auerbach-Levy, Fruhauf, and Rosenberg, personal items and memorabilia from shows they created together.

05/21/97–09/21/97

NEW YORK GETS MARRIED — A celebration of a variety of wedding rituals seen through the display of clothing, memorabilia, works-on-paper and decorative arts objects will feature some of New York City's most noteworthy wedding events.

10/15/97–01/11/98

BERENICE ABBOTT AT WORK: THE MAKING OF CHANGING NEW YORK — On view will be 125 of her New York City photographs which have come to define Depression-era New York in the popular imagination. These are from the benchmark "Changing New York" project of 1935-1939.

New York

National Academy of Design
1083 Fifth Avenue, **New York, NY 10128**
✆ 212-369-4880
HRS: 12-5 W-S, 12-8 F DAY CLOSED: M, Tu HOL: LEG/HOL!
F/DAY: F, 5-8 ADM: Y ADULT: $5.00 STUDENTS: $3.50 SR CIT: $3.50
&: Y ℗ Y; Nearby pay garage
PERM/COLL: AM: all media 19-20

With outstanding special exhibitions as well as rotating exhibits of the permanent collection, this facility is a school as well as a resource for American Art. **NOT TO BE MISSED:** The oldest juried annual art exhibition in the nation is held in spring or summer with National Academy members only exhibiting in the odd-numbered years and works by all U.S. artists considered for inclusion in even-numbered years.

ON EXHIBIT/97:

01/12/97–03/09/97	THEODORE CLEMENT STEELE: AN AMERICAN MASTER OF LIFE — The Impressionist works of Indiana born Steele, painted from the 1880's through the early part of the 20th-century reveal a command of varied subject matter including landscapes, figure paintings, still lifes, and portraits. CAT WT
02/12/97–05/04/97	LOUIS REMY MIGNOT — In the first major retrospective of works by this extraordinary and important landscape painter of the Hudson River School, emphasis will be placed on his years in New York (1855-62), his most creative and influential period. BOOK WT
SPRING/97	WINSLOW HOMER WOOD ENGRAVINGS — One of America's most important artists of the second half of the 19th-century, Homer began his career as an illustrator and designer of wood engravings for periodicals such as *Harpers* and *Ballou's*. These laid the foundation for his later development as a painter.

New York

National Arts Club
15 Gramercy Park South, **New York, NY 10024**
✆ 212-475-3424
HRS: 1-6 daily HOL: LEG/HOL! ℗ Y; Nearby pay garage, some metered street parking MUS/SH: Y � Y; For members
PERM/COLL: AM: ptgs, sculp, works on paper, dec/art 19, 20; Ch: dec/art

The building which houses this private club and collection was the 1840's mansion of former Governor Samuel Tilden. The personal library of Robert Henri which is housed here is available for study on request.

The New Museum of Contemporary Art
583 Broadway, **New York, NY 10012**
✆ 212-219-1355
HRS: 12-6 W-F, S; 12-8 Sa DAY CLOSED: M, TU HOL: 12/25, NYD
F/DAY: Sa, 6-8 ADM: Y ADULT: $4.00, ARTISTS $3.00 CHILDREN: F (under 12) STUDENTS: $3.00 SR CIT: $3.00
&: Y ℗ Y; Nearby pay garages MUS/SH: Y GR/T: Y GR/PH: CATR! H/B: Y; Astor Building
PERM/COLL: CONT

Featuring a unique semi-permanent collection, this museum purchases artworks on a ongoing basis and sells older works before they are retained for a maximum of 20 years.

The New Museum of Contemporary Art - continued

ON EXHIBIT/97:

11/24/96–01/26/97	ENCLOSURES: INSTALLATIONS BY TERESITA FERNANDEZ, NEDKO SOLAKOV, AND HALE TENGER — Each artist's project involves transforming the space viewers enter. All three have recently attracted international attention.
11/24/96–01/26/97	CAROLEE SCHNEEMANN: UP TO AND INCLUDING HER LIMITS — The first US museum exhibition devoted to Schneemann, a key figure since the early 1960's in the development of both performance and body-based art. A pioneer installation and video artist, this multi-talented woman is also a highly accomplished painter, filmmaker, photographer, assemblagist, writer and graphic artist. CAT
1997–1998	FAITH RINGGOLD: THE FRENCH COLLECTION/THE AMERICAN COLLECTION — On display will be recent quilt-paintings by Ringgold, an artist who has received significant attention for blending historical and autobiographical narratives in her art, and for her introduction of quiltmaking and other craft-identified practices into the artistic mainstream.
1997–1998	MONA HATOUM — The first museum survey in the US of the mixed media work of this Palestinian artist, born in Beirut, who has lived in the UK since the mid-1970's. WT
02/12/97–04/20/97	EUGENIO DITTBORN: REMOTA AIRMAIL PAINTINGS — In the mid 1970's this Chilean artist began sending his paintings abroad through international airmail service. Constructing his works by printing, stamping, painting and sewing directly onto unprimed cloth, he ensured they could be removed from the wall in sections, folded to the size of a large envelope, and mailed to a foreign destination. CAT

New York

The New-York Historical Society

170 Central Park West, **New York, NY 10024**
☎ 212-873-3400
HRS: 11-5 W-S DAY CLOSED: M, Tu HOL: LEG/HOL!
ADM: Y ADULT: $3.00 STUDENTS: $1.00 SR CIT: $1.00
&: Y; Limited! Ⓟ Y; Pay garages nearby MUS/SH: Y GR/T: Y GR/PH: CATR! H/B: Y
PERM/COLL: AM: Ptgs 17-20; HUDSON RIVER SCHOOL; AM: gr, phot 18-20; TIFFANY GLASS; CIRCUS & THEATER: post early 20; COLONIAL: portraits (includes Governor of NY dressed as a woman)

Housed in an elegant turn of the century neoclassical building is a collection of all but 2 of the 435 "Birds of America" watercolors by John James Audubon. In addition there are 150 works from Tiffany Studios. **NOT TO BE MISSED:** 435 original watercolors by John James Audubon

ON EXHIBIT/97:

02/03/97–05/04/97	TAKING FLIGHT: JOHN JAMES AUDUBON AND THE WATERCOLORS FOR "THE BIRDS OF AMERICA" — More than 85 original watercolors and a dozen engravings will return to their museum home to be shown in this rare exhibition of Audubon's work. CAT WT*
02/03/97–05/04/97	THE PASSING OF A SPRING: JAMES REUEL SMITH AND "THE SPRINGS AND WELLS OF MANHATTAN AND THE BRONX" — A display of photographs by Smith, a naturalist who documented all known natural water sources in Manhattan and the Bronx at the turn of the century.
06/04/97–09/08/97	NINETEENTH CENTURY AMERICAN PRINTS FROM THE COLLECTION OF REBA AND DAVE WILLIAMS — The prints selected for this exhibition focus on those made between the Civil War and the turn of the century, a period that embraced the New York-centered etching revival. WT

291

NEW YORK

New York

The Pierpont Morgan Library
29 East 36th Street, **New York, NY 10016-3490**
☎ 212-685-0008
HRS: 10:30-5 M-F, 10:30-6 Sa, noon-6 S HOL: LEG/HOL!
ADM: Y ADULT: $5.00 CHILDREN: F (under 12) STUDENTS: $3.00 SR CIT: $3.00
&: Y; except original Library ℗ Y; Nearby pay garage
MUS/SH: Y ⊓ Y; Cafe open daily for luncheon and afternoon tea 212-685-0008
GR/T: Y GR/PH: CATR! DT: Y TIME: Exh, W&F 2:30; Hist rooms, Tu & T 2:30 H/B: Y
PERM/COLL: MED: drgs, books, ptgs, manuscripts, obj d'art

The Morgan Library is a perfect Renaissance style gem both inside and out. Set in the heart of prosaic NY, this monument comes to the city as a carefully thought out contribution to the domain of the intellect and of the spirit. PLEASE NOTE: Due to renovation, the McKim Building, which houses the historic East and West rooms, will be closed from mid 9/96 to mid 4/97. **NOT TO BE MISSED:** Stavelot Triptych, a jeweled 12th-century reliquary regarded as one of the finest medieval objects in America.

ON EXHIBIT/97:

01/17/97–04/13/97	TIEPOLO AND HIS CIRCLE: DRAWINGS IN AMERICAN COLLECTIONS	∩
01/17/97–04/13/97	18TH CENTURY VENETIAN DRAWINGS IN THE PIERPONT MORGAN LIBRARY COLLECTION	
06/97–08/97	MEDIEVAL BEST-SELLER: THE BOOK OF HOURS	

Pratt Manhattan Gallery
295 Lafayette Street, 2nd floor, **New York, NY 10012**
☎ 718-636-3517
HRS: 10-5 M-Sa DAY CLOSED: S HOL: LEG/HOL!
&: Y; Possible but difficult ℗ Y; Nearby pay garage
H/B: Y; Puck Building
PERM/COLL: Not continuously on view.

Pratt Manhattan and Schaffler Galleries in Brooklyn present a program of exhibitions of contemporary art, design, and architecture in thematic exhibitions as well as solo and group shows of work by faculty, students and alumni.

Salmagundi Museum of American Art
47 Fifth Avenue, **New York, NY 10003**
☎ 212-255-7740
HRS: 1-5 daily HOL: LEG/HOL!
℗ Y; Nearby pay garage
⊓ Members Only
H/B: Y
PERM/COLL: AM: Realist ptgs 19, 20

An organization of artists and art lovers in a splendid landmark building on lower 5th Avenue.

New York

Sidney Mishkin Gallery of Baruch College
135 East 22nd Street, New York, NY 10010
☎ 212-387-1006
HRS: 12-5 M-W, F; 12-7 T ACAD DAY CLOSED: Sa, S HOL: ACAD!
&: Y Ⓟ Y; Nearby pay garages H/B: Y
PERM/COLL: GR; PHOT 20

The building housing this gallery was a 1939 Federal Courthouse erected under the auspices of the WPA. **NOT TO BE MISSED:** Marsden Hartley's "Mount Katadin, Snowstorm," 1942

Society of Illustrators Museum of American Illustration
128 East 63rd St, New York, NY 10021
☎ 212-838-2560
HRS: 10-5 W-F, 10-8 Tu, 12-4 Sa DAY CLOSED: S, M HOL: LEG/HOL!
&: Y Ⓟ Y; Nearby pay garages MUS/SH: Y
PERM/COLL: NORMAN ROCKWELL

A very specialized collection of illustrations familiar to everyone.

ON EXHIBIT/97:

01/08/97–02/01/97	PAPERBACK '97
02/08/97–03/08/97	ILLUSTRATORS 39: BOOK AND EDITORIAL
03/15/97–04/12/97	ILLUSTRATORS 39: ADVERT. AND INST.
04/22/97–05/10/97	STUDENT SCHOLARSHIP
05/14/97–06/14/97	TBA
06/18/97–07/12/97	TBA
09/03/97–09/27/97	AIR FORCE
10/01/97–10/25/97	OUR OWN SHOW
10/29/97–11/26/97	THE ORIGINAL ART '97

Solomon R. Guggenheim Museum
1071 Fifth Ave, New York, NY 10128
☎ 212-423-3500 WEB ADDRESS: http//math240.lehman.cuny.edu/gugg
HRS: 10-6 S-W, 10-8 F & Sa DAY CLOSED: T HOL: 12/25, 1/1
F/DAY: F 6-8 ADM: Y ADULT: $7.00 CHILDREN: F (W/ADULT) SR CIT: $4.00
&: Y; wheelchairs and folding chairs available in coatroom Ⓟ Y; Nearby pay garages MUS/SH: Y ⑪ Y
GR/T: Y GR/PH: CATR! DT: Y H/B: Y S/G: Y
PERM/COLL: AM & EU: ptgs, sculp; PEGGY GUGGENHEIM COLL: cubist, surrealist, & ab/exp artworks; PANZA diBIUMO COLL: minimalist art 1960's -70's

Designed by Frank Lloyd Wright in 1950, and designated a landmark building by New York City, the museum was recently restored and expanded. Originally called the Museum of Non-Objective Painting, the Guggenheim houses one of the world's largest collections of paintings by Kandinsky as well as prime examples of works by such modern masters as Picasso, Giacometti, Mondrian and others. **NOT TO BE MISSED:** Kandinsky's "Blue Mountain"

ON EXHIBIT/97:

01/30/97–04/30/97	MASTERWORKS OF MODERN SCULPTURE FROM THE NASHER COLLECTION — 60 works on loan from the world's most important private collection of modern sculpture will be featured. CAT WT

NEW YORK

New York

The Studio Museum in Harlem
144 West 125th Street, New York, NY 10027
☎ 212-864-4500
HRS: 10-5 W-F; 1-6 Sa, S DAY CLOSED: M, Tu HOL: LEG/HOL!
ADULT: $5.00 CHILDREN: $1.00 (under 12) STUDENTS: $3.00 SR CIT: $3.00
&: Y ℗ Yes, pay garages nearby MUS/SH: Y S/G: Y
PERM/COLL: AF/AM; CARIBEAN; LATINO

This is the premier center for the collection, interpretation and exhibition of the art of Black America and the African Diaspora. The five-story building is located on 125th Street, Harlem's busiest thoroughfare and hub of it's commercial rebirth and redevelopment.

ON EXHIBIT/97:
12/15/96–06/29/97	GROWING FORWARD: PRINTS, DRAWINGS, SCULPTURE, AND PUBLIC ART BY RICHARD HUNT, 1986-1996 — The influences of modern sculpture, African-American history and culture, biology, the urban-industrial environment, and metal fabricating technology which inform Hunt's work are studied and interpreted in the exhibition. CAT WT

Whitney Museum of American Art
945 Madison Ave, New York, NY 10021
☎ 212-570-3676 WEB ADDRESS: http://mosaic.echoinyc.com/~whitney
HRS: 11-6 W, 1-8 T, 11-6 F-S DAY CLOSED: M, Tu HOL: 12/25, 1/1, 7/4, THGV
F/DAY: 6-8 T ADM: Y ADULT: $8.00 CHILDREN: F (under 12) STUDENTS: $6.00 SR CIT: $6.00
&: Y ℗ Y; Nearby pay parking lots MUS/SH: Y ⫸ Y
GR/T: Y GR/PH: CATR! DT: Y TIME: W-S & T eve 212-570-3652 H/B: Y S/G: Y
PERM/COLL: AM: all media, 20

Founded by leading art patron Gertrude Vanderbilt Whitney in 1930, the Whitney is housed in an award winning building designed by Marcel Breuer. The museum's mandate, to devote itself solely to the art of the US, is reflected in its significant holdings of the works of Edward Hopper (2,500 in all), and more than 850 works by Reginald Marsh. New directions and developments in art are featured every 2 years in the often cutting edge and controversial 'Whitney Biennial'. **NOT TO BE MISSED:** Alexander Calder's "Circus"

ON EXHIBIT/97:
11/21/96–02/23/97	MAKING MISCHIEF: DADA INVADES NEW YORK — Works by Marcel Duchamp, Florine Stettheimer, Jean Crotti, Man Ray and others will be featured in a landmark exhibition, the first to offer a comprehensive overview of this group of New York-based artists who comprised the American branch of the Dadist Art Movement.
03/12/97–06/22/97	THE 1997 BIENNIAL EXHIBITION — For more than 60 years the Biennial, and its predecessor, the Whitney Annual, has been the Whitney's signature exhibition and the premier showcase for the most important developments in recent American art.

Yeshiva University Museum
2520 Amsterdam Avenue, New York, NY 10033
☎ 212-960-5390
HRS: 10:30-5 Tu-T, 12-6 S DAY CLOSED: Sa, M HOL: LEG/HOL!, JEWISH/HOL!
ADM: Y ADULT: $3.00 CHILDREN: $2.00 (4-16) STUDENTS: $2.00 SR CIT: $2.00
&: Y; 4th floor accessible, main floor partially accessible ℗ Y, neighboring streets and pay lots
MUS/SH: Y ⫸ Y; Cafeteria on campus GR/T: Y GR/PH: CATR!
PERM/COLL: JEWISH: ptgs, gr, textiles, ritual objects, cer

Major historical and contemporary exhibitions of Jewish life and ceremony are featured in this museum. **NOT TO BE MISSED:** Architectural models of historic synagogues

Yeshiva University Museum - continued
ON EXHIBIT/97:

09/03/96–02/97 IN SEARCH OF THE ARKS: SYNAGOGUE PHOTOGRAPHS BY JOEL BERKOWITZ — From Marrakesh to Szczebrzeszyn in Poland, Berkowitz captures the interiors and exteriors of hundreds of historic synagogues of an incredible range of architecture and style.

10/13/96–02/97 HOLY TRANSMITTERS: PORTRAITS OF THE MEKUBALIM (JEWISH MYSTICS) BY B.J.GOLDBERG — Images and quotations are combined to create images and portraits of the spiritual nature of the holy teachers of Jewish mysticism as living, dynamic beings.

10/13/96–02/97 "UNGRAVEN" IMAGES: SCULPTURE BY HAROLD KAHN — Minimalist sculptures of wood, metal, clay and wax suggesting spirituality and mysticism are titled for Talmudic centers in Babylonia and Palestine, the Levites, Kings of Israel, Judah, and the Judges of Israel.

10/13/96–11/97 THE TEACHING OF ISAAC LURIA: PAINTINGS AND WORKS ON PAPER BY ARTHUR YANOFF — Expressionistic paintings and watercolors inspired by the writings of the 16th-century Kabbalist, "Ha-Ari," ("The Sacred Lion") Rabbi Isaac Luria of Israel.

02/97–04/97 KIDS BRIDGE — A hands on, interactive exhibition for children and their families exploring issues of identity, ethnicity, and prejudice. **WT**

02/97–07/97 THEODOR HERZL: IF YOU WILL IT, IT IS NOT A DREAM

03/97–07/31/97 MYSTERY OF A PRAYER SHAWL: WORKS BY HARVEY BREVERMAN — Oils and pastels

03/97–07/31/97 CONFRONTATIONS: PAINTINGS BY CHAIM SHERFF — The work of this Canadian painter deals with the conflicts in religious life.

03/97–07/31/97 LAYERINGS: GAIL COHEN EDELMAN Tent. Name — The layers of archeological fragments that are the bases for the State of Israel are uncovered and reflect the sacrifice of human life that occurred during the Holocaust.

Niagara Falls

Castellani Art Museum-Niagara University
Niagara Falls, NY 14109
☎ 716-286-8200
HRS: 11-5 W-Sa, 1-5 S DAY CLOSED: M, Tu HOL: ACAD!
♿: Y Ⓟ Y
PERM/COLL: AM: ldscp 19; CONT: all media; WORKS ON PAPER: 19-20; PHOT: 20

Minutes away from Niagara Falls, Artpark, and the New York State Power Vista, the Castellani Art Museum features an exciting collection of contemporary art and a permanent folk arts program in a beautiful grey marble facility. **NOT TO BE MISSED:** "Begonia," 1982, by Joan Mitchell

ON EXHIBIT/97:

10/06/96–02/02/97 MUTUAL AFFINITIES: THE AARON MILRAD COLLECTION — Contemporary painting and ceramics

02/21/97–04/06/97 CROSSING BORDERS: WORKS FROM CANADIAN AND U.S. FINE ARTS PROGRAMS

03/09/97–04/20/97 CARL CHIARENZA — Photographic installation

09/21/97–11/02/97 ANIMATING DESTINIES: VIDEO WORKS BY JOHN KNECHT

NEW YORK

North Salem

Hammond Museum
Deveau Rd. Off Route 124, **North Salem, NY 10560**
☎ 914-669-5033
HRS: 12-4 W-S DAY CLOSED: M, Tu HOL: 12/25, 1/1
ADM: Y ADULT: $4.00 CHILDREN: F (under 5) STUDENTS: $3.00 SR CIT: $3.00 ᵫ: Y Ⓟ Y ⊪ Y; Apr-Oct
PERM/COLL: Changing exhibitions

The Hammond Museum and Japanese Stroll Garden provide a place of natural beauty and tranquility to delight the senses and refresh the spirit.

Ogdensburg

Frederic Remington Art Museum
303/311 Washington Street, **Ogdensburg, NY 13669**
☎ 315-393-2425
HRS: 10-5 M-Sa, 1-5 S (5/1-10/31); 10-5 Tu-Sa (11/1-4/30) HOL: LEG/HOL!
ADM: Y ADULT: $3.00 CHILDREN: F (under 13) STUDENTS: $2.00 SR CIT: $2.00
ᵫ: Y; Back entrance of museum MUS/SH: Y GR/T: Y GR/PH: CATR! H/B: Y
PERM/COLL: REMINGTON: ptgs, w/col, sculp, works on paper

The library, memorabilia, and finest single collections of Frederic Remington originals are housed in a 1809-10 mansion with a modern gallery addition. **NOT TO BE MISSED:** "Charge of the Rough Riders at San Juan Hill"

Oneonta

The Museums at Hartwick
Affiliate Institution: Hartwick College
Oneonta, NY 13820
☎ 607-431-4480
HRS: 10-4 M-Sa, 1-4 S HOL: LEG/HOL!
ᵫ: Y Ⓟ Y MUS/SH: Y
PERM/COLL: NAT/AM: artifacts; P/COL: pottery; VAN ESS COLLECTION OF REN, BAROQUE & AM (ptgs 19); masks; shells; botanical specimens

An excellent college museum with community involvement and traveling exhibitions.

Plattsburgh

SUNY Plattsburgh Art Museum
Affiliate Institution: State University Of New York
State University of New York, **Plattsburgh, NY 12901**
☎ 518-564-2474
HRS: 12-4 daily HOL: LEG/HOL! ᵫ: Y; Elevator Ⓟ Y; Free MUS/SH: Y GR/T: Y GR/PH: CATR! S/G: Y
PERM/COLL: ROCKWELL KENT: ptgs, gr, cer; LARGEST COLLECTION OF NINA WINKEL SCULPTURE

This University Gallery features a 'museum without walls' with artworks displayed throughout its campus. **NOT TO BE MISSED:** Largest collection of Rockwell Kent works

ON EXHIBIT/97:

11/22/96–02/09/97	ABSTRACT ILLUSIONISM — A gift of large paintings from the Louis Meisel Gallery
02/15/97–04/06/97	TBA

Potsdam

Roland Gibson Gallery
Affiliate Institution: State University College
State University College at Potsdam, **Potsdam, NY 13676-2294**
☎ 315-267-2250
HRS: 12-5 M-F; 12-4 Sa, S; 7-9:30 M-T eve HOL: LEG/HOL!
&: Y ℗ Y GR/T: Y GR/PH: CATR! S/G: Y
PERM/COLL: CONT: sculp; WORKS ON PAPER; JAP: ptgs

Based on the New York State University campus in Potsdam, this is the only museum in northern New York that presents a regular schedule of exhibitions. **NOT TO BE MISSED:** "Untitled," by Miro

Poughkeepsie

The Frances Lehman Loeb Art Center at Vassar College
Affiliate Institution: Vassar College
124 Raymond Ave., **Poughkeepsie, NY 12601**
☎ 914-437-5235
HRS: 10-5 Tu-Sa, 1-5 S DAY CLOSED: M HOL: EASTER, THGV, 12/25-1/1
&: Y ℗ Y MUS/SH: Y
GR/T: Y GR/PH: CATR!
PERM/COLL: AM, EU: ptgs, sculp; AN/GR & AN/R: sculp; GR: old Master to modern

Housed in a newly built facility, this is the only museum between Westchester County and Albany exhibiting art of all periods. **NOT TO BE MISSED:** Magoon Collection of Hudson River Paintings

ON EXHIBIT/97:

01/17/97–03/16/97	ART OF INDIA — Drawn from the collection are miniatures and other works from the painting schools of northern and central India, this is the first time that many of them have been exhibited.
04/04/97–06/08/97	MAN RAY'S MAN RAY — These 45 photographs and 6 objects document the extraordinary career of inventive and enigmatic American-born, avant-garde artist Man Ray, providing an overview of six decades of his virtuosity and creativity. WT
07/25/97–09/07/97	MODERN MASTERS FROM THE COLLECTION OF ALEXANDER E. AND DINA RACOLIN — In collaboration with The Neuberger Museum, the Racolin gifts, including works by Picasso, Kirchner, Braque, Bonnard and Giacometti will be on exhibit. WT

Purchase

The Donald M. Kendall Sculpture Gardens at Pepsico
700 Anderson Hill Road, **Purchase, NY 10577**
☎ 914-253-2900
HRS: 9-5 daily HOL: LEG/HOL!
&: Y ℗ Y; Free and ample S/G: Y
PERM/COLL: 44 SITE-SPECIFIC SCULPTURES BY 20TH CENTURY ARTISTS

42 site-specific sculptures are located throughout the 168 magnificently planted acres that house the headquarters of Pepsico, designed in 1970 by noted architect Edward Durrell Stone. A large man-made lake and wandering ribbons of pathway invite the visitor to enjoy the sculptures within the ever-changing seasonal nature of the landscape. The garden, located in Westchester County about 30 miles outside of NYC, is an art lover's delight.

NEW YORK

Purchase

Neuberger Museum of Art
Affiliate Institution: Purchase College, SUNY
735 Anderson Hill Rd, **Purchase, NY 10577-1400**
☏ 914-251-6113
HRS: 10-4 Tu-F; 11-5 Sa, S DAY CLOSED: M HOL: LEG/HOL!
ADM: Y ADULT: $4.00 CHILDREN: F (under 12) STUDENTS: $2.00 SR CIT: $2.00
&: Y ℗ Y; Free and ample MUS/SH: Y ¶ Y; Museum Cafe 11:30-2:30, Tu-F; 12-4, Sa, S
GR/T: Y! GR/PH: CATR! 914-251-6110 DT: Y TIME: 1 PM, Tu-F; 2 and 3 PM, S
PERM/COLL: PTGS, SCULP, DRGS 20; ROY R. NEUBERGER COLLECTION; EDITH AND GEORGE RICKEY COLLECTION OF CONSTRUCTIVIST ART; AIMEE HIRSHBERG COLLECTION OF AFRICAN ART; HANS RICHTER BEQUEST OF DADA AND SURREALIST OBJECTS; ANC GRK, ETR VASES GIFT OF NELSON A. ROCKEFELLER

On the campus of Purchase College, SUNY, the Neuberger Museum of Art houses a prestigious collection of 20th-century art.

ON EXHIBIT/97:

ONGOING	ROY R. NEUBERGER COLLECTION — More than sixty works from the permanent collection displayed on a rotating basis form the heart and soul of the Museum's collection and include major works by Romare Bearden, Jackson Pollack, Edward Hopper, Georgia O'Keeffe and others.
	OBJECT AND INTELLECT: AFRICAN ART FROM THE PERMANENT COLLECTION — Over forty objects created in the 19th and 20th-century reflect African tradition, rites and religious beliefs. The exhibition presents the African view of the universe as being composed of two inseparable realms: a visible, tangible world of the living and an invisible world of the sacred.
	INTERACTIVE LEARNING CENTER — Interactive video program enables visitors to delve into the style, history and artistic vocabulary of 200 works of art from the Roy R. Neuberger Collection of 20th-century paintings and sculpture.
09/22/96–01/19/97	URBAN SUBURBAN: THE ARCHITECTURE OF PURCHASE COLLEGE — The unique architectural origins of the campus which was conceived as a unit with its parts to be designed by prominent American architects, is examined as an architectural milestone of design drawing on collegial needs to establish an academic communal habitat.
01/19/97–03/23/97	REVELATIONS: CHAKAIA BOOKER/CAROL HAMOY — This series focuses on artists of ability who have not received due exposure to the public. One of them, Chakaia Booker, calls herself a "narrative environmental sculptor." She works with recycled tires forming objects which she describes as "abstractly African" because of their blackness and patterns. Another, Carol Hamoy, has completed extensive research on female and child immigrants to America, using Ellis Island archives and oral history techniques. Each individual she selected is represented via a simple garment sewn from a gauze-like scrim.
01/26/97–03/30/97	HANANIAH HARARI — In the first retrospective of the work of this 82 year old artist who was among the original members of the American Abstract Artists, approximately 60 paintings, prints and drawings will demonstrate the variety of styles in which he worked ranging from Cubism, Constructivism and Expressionism to a trompe l'oeil realism. WT
02/02/97–04/06/97	AFFINITIES AND INFLUENCES: NATIVE AMERICAN ART AND AMERICAN MODERNISM — A view of the influences that Native American traditional art has had on American modern art through Native American artifacts, American paintings from the late 1940's and works from the permanent collection of the Montclair Art Museum. WT
04/06/97–05/18/97	REVELATIONS: ROBERT VALDES/DAVID MERENO — Robert Valdes is a watercolorist whose work with traditional themes of landscape and still life have lyrical, and at times humorous overtones. His works will be on view with those of David Mereno whose conceptually based paintings, drawings and mixed media works use sound as their subject in order to ingeniously convey sensations of oral communication.
04/20/97–06/22/97	JUNE WAYNE: A 50 YEAR RETROSPECTIVE — An exhibition of paintings, drawings, tapestries and lithographs by Wayne, a Los Angeles artist whose work is an investigation of time & space, genetic codes, molecular energy, stellar winds and magnetic fields, all of which reflect her concerns with texture, surface and color. BOOKLET

Neuberger Museum of Art - continued

05/11/97–10/05/97 THE NEUBERGER MUSEUM OF ART BIENNIAL FOR PUBLIC ART — A first biennial juried exhibition devoted to Public Art.

06/01/97–07/06/97 MODERN MASTERS FROM THE COLLECTION OF ALEXANDER E. AND DINA RACOLIN — In collaboration with Vassar College, the Racolin gifts, including works by Picasso, Kirchner, Braque, Bonnard and Giacometti will be on exhibit. WT

07/06/97–09/14/97 SMART GLASS — Conceptual glass work

09/07/97–01/11/98 FAIRFIELD PORTER: AN AMERICAN PAINTER — The works in this exhibition by Porter, an important American realist painter, are from his most productive years (1945-1974) and are drawn from the collection of the Parrish Art Museum in Southampton, NY, a town where he lived and worked for many years.

10/05/97–01/04/98 ELIZABETH CATLETT — A retrospective look at the sculpture of this respected African-American artist. WT

Queens

The Queens Museum of Art

New York City Building, Flushing Meadows Corona Park, **Queens, NY 11368-3393**
📞 718-592-9700
HRS: 10-5 W-F; 12-5 Sa, S; Tu groups by appt DAY CLOSED: M, Tu HOL: 1/1, THGV, 12/25
SUGG/CONT: Y ADULT: $3.00 CHILDREN: F (under 5) STUDENTS: $1.50 SR CIT: $1.50
&.: Y ℗ Y; Free MUS/SH: Y GR/T: Y GR/PH: CATR! H/B: Y
PERM/COLL: CHANGING EXHIBITIONS OF 20TH CENTURY ART AND CONTEMPORARY ART

The Panorama is where all of NYC fits inside one city block. You will feel like Gulliver when you experience it for the first time. The building was built for the 1939 World's Fair and was later used for United Nations meetings. Satellite Gallery at Bulova Corporate Center, Jackson Heights, Queens. **NOT TO BE MISSED:** 'The Panorama of NYC', largest architectural scale model of an Urban Area. Tiffany lamps, globes and windows on long term loan from the Egon and Hildegard Neustadt Museum of Tiffany Art.

Rochester

George Eastman House, International Museum of Photography and Film

900 East Ave, **Rochester, NY 14607**
📞 716-271-3361
HRS: 10-4:30 Tu-Sa, 1-4:30 S DAY CLOSED: M HOL: LEG/HOL!
ADM: Y ADULT: $6.50 CHILDREN: $2.50 (5-12) STUDENTS: $5.00 SR CIT: $5.00
&.: Y ℗ Y MUS/SH: Y; two ⑪ Y GR/T: Y GR/PH: CATR! DT: Y TIME: 10:30 & 2, Tu-Sa; 2, S H/B: Y
PERM/COLL: PHOT: prints; MOTION PICTURES; MOTION PICTURE STILLS; CAMERAS; BOOKS

The historic home of George Eastman, founder of Eastman Kodak Co. includes a museum that contains an enormous and comprehensive collection of over 500,000 photographic prints, 15,000 motion pictures, 15,000 cameras, 38,000 books and 3,000,000 motion picture stills. **NOT TO BE MISSED:** Discovery room for children

ON EXHIBIT/97:

SEMI PERMANENT THROUGH THE LENS: SELECTIONS FROM THE PERMANENT COLLECTION

AN HISTORICAL TIMELINE OF PHOTO IMAGING

A PICTURE-PERFECT RESTORATION: GEORGE EASTMAN'S HOUSE AND GARDEN

ENHANCING THE ILLUSION: THE ORIGINS AND PROGRESS OF PHOTOGRAPHY

GEORGE EASTMAN IN FOCUS

10/05/96–03/15/98 EAST MEETS WEST: INDONESIAN FILM POSTERS FROM THE JOHN PFAHL COLLECTION — The posters shown here comprise a unique form of movie advertising, still widespread in Southeast Asia. "Robin Hood," "Prince of Thieves" (1981), and "The Presidio" (1988) posters will be among those included in this presentation..

George Eastman House, International Museum of Photography and Film - continued

11/09/96–02/09/97	FINDING YOU: WORKS BY DAVID KEATING — Drawing on his own life experiences in his multi-media work, contemporary artist Keating poignantly illuminates the impact of HIV and AIDS on all of us. Included in this presentation are photographs, photo-related installations, and sculpture.
01/18/97–03/16/97	THE NATURE OF HOLOGRAPHY — An introduction to the unique characteristics of holography, this presentation reveals how it differs from other media, what techniques are employed to produce special effects, and how holographic technology is used in science and industry.
02/08/97–06/01/97	GWINN: A PORTRAIT OF THE GARDEN — Contemporary works by noted landscape photographer Carol Betsch combined with archival photographs document the landscape of the Lake Erie estate, Gwinn.
02/15/97–05/04/97	MODOTTI AND WESTON: MEXICANIDAD — The life and work of Tina Modotti (American, 1896-1942) was shaped by the fervent politics of 1920's Mexico. Traveling to Mexico with Edward Weston (American, 1886-1958), she developed a style which is a tenuous balance of pure formal beauty with political intent. Her works on view in this exhibit will be accompanied by some of Weston's images.
03/29/97–09/28/97	BLINKITY BLANK: NORMAN MCLAREN, THE GENIUS OF ANIMATION — The first major retrospective of the life and career of McLaren (1914-1987), one of the most revolutionary personalities in the history of film animation, embraces the full range of his talents. Included will be examples of his photography, stereography, animation, film, and music accompanied by a film series of his work.
05/10/97–10/19/97	MAJOR LEAGUE/MINOR LEAGUE — Jim Dows photographs of 60 American baseball stadiums capture the nostalgia evoked by baseball about American life and the values of working hard and winning.
06/07/97–10/12/97	NORTHWEST PASSAGE — During a 3500 mile voyage on the first private yacht to cross the Northwest Passage, Robert Glenn Ketchum took the breathtaking photos of the beauty and grandeur of the natural world on view in this exhibition.
10/11/97–01/04/98	MAGNUM CINEMA: 50 YEARS OF PHOTOGRAPHY — For fifty years photographers of the Magnum Photo Agency have been observing the world of cinema. They have mounted this extraordinary exhibition which documents the history, taste, fashion, vision, and the creation of some of the major icons of international popular culture.

Rochester

Memorial Art Gallery

Affiliate Institution: University of Rochester
500 University Ave, **Rochester, NY 14607**
☎ 716-473-7720
HRS: 12-9 Tu, 10-4 W-F, 10-5 Sa, 12-5 S DAY CLOSED: M HOL: LEG/HOL!
ADM: Y ADULT: $5.00, (Tu, 5-9 PM $2.00) CHILDREN: $3.00 (6-8) STUDENTS: $4.00 SR CIT: $4.00
&: Y ℗ Y MUS/SH: Y ‖ Y GR/T: Y GR/PH: CATR! DT: Y TIME: 2 PM, F, S; 7:30 PM Tu H/B: Y S/G: Y
PERM/COLL: MED; DU: 17; FR: 19; AM: ptgs, sculp 19, 20; FOLK

The Gallery's permanent collection of 10,000 works spans 50 centuries of world art and includes masterworks by artists such as Monet, Cézanne, Matisse, Homer and Cassatt. A new interactive learning center has been added focusing on Learning to look. Also added is an interactive CD-ROM "tour" of the Gallery. **NOT TO BE MISSED:** "Waterloo Bridge, Veiled Sun" 1903, by Monet

ON EXHIBIT/97:

11/03/96–02/09/97	WEAVING A LEGEND: ROYAL FRENCH TAPESTRIES — Ten monumental tapestries telling the story of Queen Artemesia, woven in Paris between 1610 and 1627, are displayed in 17th-century fashion and are accompanied by a multi-media installation describing the development of their story line and the design and weaving process.

Memorial Art Gallery - continued

02/06/97–04/06/97	THE STUDIO MUSEUM IN HARLEM: 25 YEARS OF AFRICAN-AMERICAN ART — In celebration of the Studio Museum's 25th anniversary, this traveling exhibition will highlight paintings, sculpture, and works on paper created by noted African-American artists between 1968-1993. WT
05/02/97–06/15/97	SACRED SAND PAINTINGS OF TIBET: CREATING A CIRCLE OF PEACE — For more than 1000 years Tibetan Buddhist monks have created intricate circular sand paintings or mandalas that symbolize the essential teachings of Buddhism. For this exhibition three monks will create the Kalachakra (Wheel of Time) mandala in the gallery and will answer questions. In addition, 42 of Heinrich Harrar's black and white photographs, taken in the 1940's of the forbidden Tibetan city of Lhasa, will be on view.
07/13/97–09/07/97	56TH ROCHESTER-FINGER LAKES EXHIBITION — A juried exhibition of works in all media by emerging artists from the 23 upstate New York counties.
09/27/97–11/16/97	REDISCOVERING THE LANDSCAPE OF THE AMERICAS — Approximately 80 paintings by contemporary artists including Rackstraw Downes, Janet Fish and Wolf Kahn, depict artists' responses to the particular places they call home; namely, Mexico, the United States, Canada.
12/13/97–01/25/98	NEW RUSSIAN ART: PAINTINGS FROM THE CHRISTIAN KEESEE COLLECTION — On view will be 45 paintings by artists who have chosen to remain in Russia and respond to life in a post-communist society. The largely figurative works, full of irony, fantasy and subversive humor, reflect the new freedom granted to contemporary artists and contain influences ranging from Constructivism to Pop. WT

Roslyn Harbor

Nassau County Museum of Fine Art

Northern Blvd & Museum Dr, **Roslyn Harbor, NY 11576**
☎ 516-484-9338
HRS: 11-5 Tu-S DAY CLOSED: M HOL: LEG/HOL!
F/DAY: F ADM: Y ADULT: $4.00 CHILDREN: $2.00 STUDENTS: $2.00 SR CIT: $3.00
&: Y ℗ Y: F MUS/SH: Y
GR/T: Y GR/PH: CATR! H/B: Y S/G: Y
PERM/COLL: AM: gr, sculp

Situated on 145 acres of formal gardens, rolling lawns and meadows, the museum presents four major exhibitions annually and is home to one of the east coasts' largest publicly accessible outdoor sculpture gardens.

ON EXHIBIT/97:

11/17/96–01/26/97	PICASSO: PAINTINGS, CERAMICS, PRINTS
02/08/97–02/16/97	JURIED EXHIBITION
02/22/97–05/18/97	THE FEMININE IMAGE — This exhibition explores the image of Woman as defined by both men and women artists from the 1960's through the 1980's contrasted with earlier artists of the 20th-century. Contemporary art by Roy Lichtenstein, Richard Diebenkorn, Cindy Sherman, Kiki Smith, James Rosenquist and many others will be shown with historical works by Salvador Dali, William deKooning, Edvard Munch and Freud.
06/07/97–09/01/97	POETS AND PAINTERS
09/28/97–01/04/98	PORTRAITS: FRENCH AND AMERICAN

NEW YORK

Saratoga Springs

The Schick Art Gallery
Affiliate Institution: Skidmore College
Skidmore Campus North Broadway, **Saratoga Springs, NY 12866-1632**
☎ 518-584-5000
HRS: 9-5 M-F; 1-3:30 Sa, S HOL: LEG/HOL!, ACAD!
&: Y; Elevator Ⓟ Y; On campus ⅋ Y GR/T: Y GR/PH: CATR!
PERM/COLL: non-collecting institution

Theme oriented or one person exhibitions that are often historically significant are featured in this gallery located on the beautiful Skidmore Campus.

Southampton

The Parrish Art Museum
25 Job's Lane, **Southampton, NY 11968**
☎ 516-283-2118
HRS: 11-5 Tu-Sa, 1-5 S (Jun 15-Sep 14); 11-5 W-M (Sep 14-Jun 14) HOL: 1/1, EASTER, 7/4, THGV, 12/25
SUGG/CONT: Y ADULT: $2.00
&: Y;! Ⓟ Y MUS/SH: Y GR/T: Y GR/PH: CATR! H/B: Y S/G: Y
PERM/COLL: AM: ptgs, gr 19; WILLIAM MERRITT CHASE; FAIRFIELD PORTER

Situated in a fashionable summer community. this Museum is a 'don't miss' when one is near the Eastern tip of Long Island. It is located in an 1898 building designed by Grosvenor Atterbury.

ON EXHIBIT/97:

11/23/96–01/04/98	COLLECTION IN CONTEXT: HENRY M. BUHL
04/06/97–06/01/97	THE KIMONO INSPIRATION: ART AND ART-TO-WEAR IN AMERICA
06/08/97–08/10/97	PAINTINGS AND PATRONAGE: THE TENTH STREET STUDIOS
08/17/97–09/28/97	ALFONSO OSORIO
10/05/97–11/16/97	FAIRFIELD PORTER: AN AMERICAN PAINTER — The works in this exhibition by Porter, an important American realist painter, are from his most productive years (1945-1974) and are drawn from the collection of the Parrish Art Museum in Southampton, NY, a town where he lived and worked for many years. WT

Staten Island

Jacques Marchais Museum of Tibetan Art
338 Lighthouse Ave., **Staten Island, NY 10306**
☎ 718-987-3500
HRS: 1-5 W-S (Apr-mid Nov or by appt.Dec-Mar) DAY CLOSED: M, Tu HOL: EASTER, 7/4, LAB/DAY, THGV & day after
ADM: Y ADULT: $3.00 CHILDREN: $1.00 (under 12) STUDENTS: $3.00 SR CIT: $2.50
MUS/SH: Y GR/T: Y GR/PH: CATR! S/G: Y
PERM/COLL: TIBET; OR: arch; GARDEN

This unique museum of Himalayan art within a Tibetan setting consists of two stone buildings resembling a Buddhist temple. A quiet garden and a goldfish pond help to create an atmosphere of serenity and beauty. It is the only museum in this country devoted primarily to Tibetan art.

Staten Island

The John A. Noble Collection at Snug Harbor

Affiliate Institution: Snug Harbor Cultural Center
270 Richmond Terrace, **Staten Island, NY 10301**
📞 718-447-6490
HRS: 9-2 M-F and by appt. DAY CLOSED: Sa, S HOL: LEG/HOL!
SUGG/CONT: Y
♿: Y Ⓟ Y MUS/SH: Y ¶ Y
GR/T: Y GR/PH: CATR! H/B: Y
PERM/COLL: PTGS; LITHOGRAPHS; DOCUMENTS AND ARTIFACTS; SALOON HOUSEBOAT OF JOHN A. NOBLE

John Noble wrote "My life's work is to make a rounded picture of American Maritime endeavor of modern times." He is widely regarded as America's premier marine lithographer. The collection, in a new site at historic Snug Harbor Cultural Center, is only partially on view as renovation continues.

Snug Harbor Cultural Center

Affiliate Institution: Newhouse Center for Contemporary Art
1000 Richmond Terrace, **Staten Island, NY 10301**
📞 718-448-2500
HRS: 12-5 W-S DAY CLOSED: M, T HOL: LEG/HOL!
SUGG/CONT: Y ADULT: $2.00 Ⓟ Y; Free
MUS/SH: Y ¶ Y
GR/T: Y GR/PH: CATR! S/G: Y
PERM/COLL: Non-collecting institution

Once a 19th-century home for retired sailors Snug Harbor is a land-marked 83 acre, 28 building complex being preserved and adapted for the visual and performing arts. The Newhouse Center for Contemporary art provides a forum for regional and international design and art. **NOT TO BE MISSED:** The award winning newly restored 1884 fresco ceiling in the Main Hall.

ON EXHIBIT/97:

03/97–06/97	AFTER THE FALL: ASPECTS OF ABSTRACT PAINTING SINCE 1970 — Some of the guises abstract painting has assumed from the 1970's to the present will be examined in the works of over 75 artists. Divided into 6 categories, the exhibition will consist of the following: Planar and Structural Abstraction, Material Abstraction, Gestural/Expressive Abstraction, Geometric Abstraction, Minimalist Abstraction and Conceptual Abstraction.
07/97–10/97	1997 OUTDOOR SCULPTURE EXHIBITION — An annual exhibition of site-specific works. (Open from dawn to dusk)
07/97–09/97	1997 SNUG HARBOR STUDIO ARTISTS EXHIBITION
10/97–01/98	NEW ISLAND VIEWS — An juried exhibition of Staten Island artists.
11/07/97–01/28/97	ARTISTS IN ACTION: BAM'S VISUAL ARTS INITIATIVE — Artists Jane Highstein and Hanna Tierney will collaborate on a performance installation entitled "Flatland: A Romance of Many Dimensions."

NEW YORK

Staten Island

Staten Island Institute of Arts and Sciences
75 Stuyvesant Place, **Staten Island, NY 10301**
☎ 718-727-1135
HRS: 9-5 M-Sa, 1-5 S HOL: LEG/HOL!
SUGG/CONT: Y ADULT: $2.50 STUDENTS: $1.50 SR CIT: $1.50
&: Y; Limited MUS/SH: Y GR/T: Y GR/PH: CATR!
PERM/COLL: PTGS; DEC/ART; SCULP; STATEN ISLAND: arch

One of Staten Island's oldest and most diverse cultural institutions, this facility explores and interprets the art, natural resources and cultural history of Staten Island. **NOT TO BE MISSED:** Ferry Collection on permanent exhibition. This exhibition on the history of the world-famous ferry service is located in the Staten Island Ferry terminal.

ON EXHIBIT/97:

ONGOING	THE STATEN ISLAND FERRY COLLECTION OF SIIAS The history of the world's most famous Ferry Line is explored in an exhibition in the Staten Island Ferry waiting room, St. George. open daily 9-2 Suggested donation: adults $1.00; children under 12 $.25
09/27/96–03/09/97	STATEN ISLAND BIENNIAL JURIED ART EXHIBITION — Artists are selected from entries local, regional and national.
11/22/96–05/04/97	ORCHIDS AND ORIOLES: BIODIVERSITY OF STATEN ISLAND — The natural history of Staten Island is explored through the Institute's extensive holdings.
01/31/97–07/06/97	HISTORY IN THE BALANCE: WEIGHING DEVICES FROM THE COLLECTION OF DR. JACK BENDER — Unique and exquisite scales will be displayed.
03/23/97–09/07/97	CONTEMPORARY ART OF P. BUCKLEY AND JACK DEMYAN — A display of works by two Staten Island Artists of national and regional renown.
07/25/97–01/04/98	1997 STATEN ISLAND BIENNIAL JURIED CRAFT EXHIBITION
09/26/97–03/08/98	FIVE STATEN ISLAND ILLUSTRATORS (Working Title)

Stony Brook

The Museums at Stony Brook
1208 Rte. 25A, **Stony Brook, NY 11790-1992**
☎ 516-751-0066
HRS: 10-5 W-Sa, 12-5 S DAY CLOSED: M, Tu HOL: THGV, 12/24, 12/25, 1/1
ADM: Y ADULT: $4.00 CHILDREN: $2.00 (6-17) SR CIT: $3.00
&: Y Ⓟ Y MUS/SH: Y GR/T: Y GR/PH: CATR!
PERM/COLL: AM: ptgs; HORSE DRAWN CARRIAGES; MINIATURE ROOMS; ANT: decoys; COSTUMES; TOYS

The finest collection of American horse-drawn carriages in the world (90 on permanent display) as well as master works by American genre artist William Sidney Mount (1807-1868) are to be found here.

ON EXHIBIT/97:

09/14/96–02/02/97	MORE THAN MOUNT: SELECTIONS FROM THE PERMANENT COLLECTION — Selected works from the major collection of William Sidney Mount (1807-1868) will be shown with works by other Long Island and American artists.
10/12/96–03/16/97	NINETEENTH-CENTURY CHILDREN IN PORTRAITS AND PLAY — The life of children during the 19th-century depicted in a variety of portraits and genre scenes by William Sidney Mount and others form the focus of this presentation.
01/18/97–04/20/97	POSTERS OF THE WORLD WARS — From recruitment to propaganda, this exhibition includes posters from the U.S., England, France and Russia.
01/18/97–04/20/97	THE ANNE FRANK STORY — Anne's life will be explored through 17 panels of photographs and text.

The Museums at Stony Brook - continued

02/15/97–06/15/97 JOSEPH REBOLI RETROSPECTIVE — A retrospective exhibition of the works of Reboli, a well-known Long Island artist, with a career spanning three decades includes images of his favorite subjects: Long Island landscapes, seascapes and architectural studies.

05/04/97–08/17/97 SHAKEN, NOT STIRRED: COCKTAIL SHAKERS AND DESIGN — Nearly 100 vintage cocktail shakers defining Art Deco design are included in this unique exhibition on loan from a private collection. WT

06/28/97–09/21/97 WHIRLIGIGS AND WEATHERVANES: CONTEMPORARY SCULPTURE — Bringing together professional and amateur artists to highlight their talent, ingenuity and wit, these wind-powered sculptures sometimes make biting social commentary, create dynamic sculptural statements and build upon the humorous aspects of modern life. WT

08/30/97–01/98 HOLIDAY CELEBRATION (to mid-Dec.) and DOLLS AND DOLLHOUSES (Working Title)

10/04/97–11/11/98 OUT OF THE ORDINARY: COMMUNITY TASTES AND VALUES IN CONTEMPORARY FOLK ART — The diversity of American culture is apparent in this investigation of the lives, work, community contexts and (particularly) the shared group aesthetics and values of a significant cross section of folk arts.

Syracuse

Everson Museum of Art

401 Harrison Street, **Syracuse, NY 13202**

📞 315-474-6064

HRS: 12-5 Tu-F, 10-5 Sa, 12-5 S DAY CLOSED: M HOL: 1/1, 7/4, THGV, 12/25

VOL/CONT: Y

&.: Y ℗ Y; Nearby pay garages, limited metered on street MUS/SH: Y 🍴 Y

GR/T: Y GR/PH: CATR! DT: Y TIME: ! H/B: Y S/G: Y

PERM/COLL: AM: cer; AM: ptgs 19, 20; AM: Arts/Crafts Movement Objects

When it was built, the first museum building designed by I. M. Pei was called "a work of Art for Works of Art." The Everson's Syracuse China Center for the Study of Ceramics is one of the nation's most comprehensive, ever increasing collection of America's ceramics housed in an open-storage gallery. The installation is arranged chronologically by culture and includes samples from the ancient classical world, the Americas, Asia and Europe. **NOT TO BE MISSED:** One of the largest, most comprehensive permanent exhibitions of American and world ceramics

ON EXHIBIT/97:

ONGOING ONE HUNDRED FIFTY YEARS OF AMERICAN ART — An overview of American art featuring turn of the century portraits and genre paintings, late 19th-century landscapes and American modernism through the 1950's, including American Scene painting by some of America's best known artists.

INTERNATIONAL CONTEMPORARY CERAMICS

SYRACUSE CHINA CENTER FOR THE STUDY OF AMERICAN CERAMICS

through 10/13/97 THE JOHN F. MARSELLUS COLLECTION OF FEDERAL DUCK STAMP PRINTS AND DUCK STAMPS — The duck stamp program was founded in 1934 to raise funds for wetland conservation. This collection is especially significant as a historical document- one of the few groupings to include every design created in the 61 years of the program's existence.

03/07/97–04/27/97 JOSEPH DIGIORGIO: THE PROSPECT PARK SERIES

03/07/97–04/27/97 RAYMOND HAN: STILL LIFE PAINTINGS — Paintings by Han, a contemporary American realist, will be showcased.

05/16/97–07/13/97 LIFE CYCLES: THE CHARLES E. BURCHFIELD COLLECTION — On view will be 62 paintings by Burchfield (1893-1967), a man whose original style helped to inspire several generations of artists. His works reflected strong concerns for the dwindling of America's virginal landscape, the passage of time, and memories of childhood. WT

09/19/97–11/09/97 DALE CHIHULY: SEAFORMS — Over 40 exceptional glass sculptures that resemble brilliant undulating marine life created by American master Chihuly, will be on exibit with a number of his working drawings. CAT WT

NEW YORK

Tarrytown

Kykuit

Affiliate Institution: Historic Hudson Valley
150 White Plains Road, **Tarrytown, NY 10591**
📞 914-631-9491 WEB ADDRESS: www.hudsonvalley.org
HRS: DAY CLOSED: Tu HOL: Open mid-April through October
ADM: Y ADULT: $18.00 CHILDREN: not rec under 12 SR CIT: $16.00
&: Y ℗ Y, F at Visitor's Center MUS/SH: Y
GR/T: Y GR/PH: CATR! H/B: Y S/G: Y

The six story stone house which was the Rockefeller home for four generations is filled with English and American furnishings, portraits and extraordinary collections of Asian ceramics. Paintings and sculpture by Andy Warhol, George Segal, Alexander Calder, Robert Motherwell and many others are featured in the art galleries. Visitors may also view the enclosed gardens and terraces with their collections of classical and 20th-century sculpture and stunning river views. Another building, The Coach Barn, contains horse-drawn carriages and classic automobiles. The property's manicured Beaux-Arts gardens, designed by William Welles Bosworth, are filled with an extraordinary collection of modern sculpture.

ON EXHIBIT/97: Reservations are strongly recommended and will be accepted after January 1997. The site is open 04/18/97-11/02/97. Reservations are assigned to groups of 18. There will be two tours in 1997: the House and Galleries Tour and the new Garden and Sculpture Tour which includes areas of the estate never before open to the public. Tours are 1-1½ hours. There is also a N.Y. Waterway Tour which leaves NYC or NJ for a cruise to Tarrytown and then boards a bus to the Philipsburg Manor Visitors Center which is the point of departure for all tours. For reservations via the ferry call 1-800-53-ferry.

Utica

Munson-Williams-Proctor Institute Museum of Art

310 Genesee Street, **Utica, NY 13502**
📞 315-797-0
HRS: 10-5 Tu-Sa, 1-5 S Fountain Elm is closed 1/1-2/12/96 DAY CLOSED: M HOL: LEG/HOL!
SUGG/CONT: Y
&: Y ℗ Y MUS/SH: Y GR/T: Y GR/PH: CATR! H/B: Y S/G: Y
PERM/COLL: AM: ptgs, dec/art; EU: manuscripts, gr, drgs

The Museum is a combination of the first art museum designed by renowned architect Philip Johnson (1960) and Fountain Elms, an 1850 historic house museum which was the home of the museum's founders.

ON EXHIBIT/97:

11/09/96–02/02/97	THE ART OF COLLECTING: RECENT ACQUISITIONS FOR THE PERMANENT COLLECTION OF THE MUNSON-WILLIAMS-PROCTOR MUSEUM OF ART — A distinguished collection of paintings, sculptures, drawings, prints, furniture and decorative arts provides an overview of the Museum's ongoing efforts to enhance its collection.
11/16/96–01/26/97	HIROSHIGE — An exhibition 25 works from the collection by Ando Hiroshige, one of the most important printmakers of Japan in the first half of the 19th-century.
02/15/97–04/27/97	DRAWN TO SCULPTURE — Works from the collection by Calder, Lippold, Monti, Oppenheim, Zorach, and others, including related drawings, will highlight the expressive potential and limitations of two and three dimensional media.
03/01/97–04/27/97	THE 57TH EXHIBITION OF CENTRAL NEW YORK ARTISTS
05/17/97–07/13/97	SHAKER: THE ART OF CRAFTSMANSHIP — 19th-century objects and furniture of simplicity, order and fine craftsmanship from the first and most influential Shaker community (established in New Lebanon, New York in 1785), will be seen in the first major exhibition of its kind in America. WT

Yonkers

The Hudson River Museum of Westchester

511 Warburton Ave, **Yonkers, NY 10701-1899**

☏ 914-963-4550

HRS: Oct-Apr: 12-5 W-S, 12-5 S; May-Sept: 12-5 W, T, Sa, S & 12-9 F DAY CLOSED: M, Tu HOL: LEG/HOL!

ADM: Y ADULT: $3.00 CHILDREN: $1.50 (12-under) SR CIT: $1.50

&: Y; Entire building; also, a "Touch Gallery" for visually-impaired ℗ Y; Free

MUS/SH: Y ⑪ Y

GR/T: Y GR/PH: CATR! H/B: Y S/G: Y

PERM/COLL: AM: ldscp/ptgs 19, 20; DEC/ART; GR: 19, 20; COSTUMES; PHOT: 19, 20.

The Hudson River Museum of Westchester, overlooking the Palisades, provides a dramatic setting for changing exhibitions of art, architecture, design, history and science. Discover the Hudson River's special place in American life as you enjoy the art. **NOT TO BE MISSED:** Hiram Powers' "Eve Disconsolate," marble statue, 1871, (gift of Berol family in memory of Mrs. Gella Berolzheimer, 1951). Also, woodwork and stencils in the decorated period rooms of the 1876 Glenview Mansion.

ON EXHIBIT/97:

ONGOING

GLENVIEW MANSION — Completed in 1877 and overlooking the Hudson and the Palisades, four period rooms of the Mansion have been restored to reflect the lifestyle of its turn-of-the-century inhabitants, the John Trevor Bond family. This building is considered one of the finest examples of an Eastlake interior open to the public.

THE ANDRUS PLANETARIUM — Star shows Sa, S 1:30, 2:30 and 3:30 PM; F 7, F

01/97–04/97

JULIANA FREE: HAIR BRAIDING Tent. Name — This exhibition of hair braiding by Juliana Free is rooted in African tradition where the various styles reveal information about the ethnic group, royalty or social status of both the male and female wearer. Dates Tent!

02/07/97–08/31/97

OUT OF THE ORDINARY: COMMUNITY TASTES AND VALUES IN CONTEMPORARY FOLK ART — The diversity of American culture is apparent in this investigation of the lives, work, community contexts and (particularly) the shared group aesthetics and values of a significant cross section of folk arts. WT

NORTH CAROLINA

Asheville

Asheville Art Museum
2 S. Pack Square, **Asheville, NC 28801**
☎ 704-253-3227
HRS: 10-5 Tu-F; 1-5 Sa, S DAY CLOSED: M HOL: 1/1, 7/4, LAB/DAY, THGV, 12/25
ADM: Y ADULT: $3.00 CHILDREN: 4-14 $2.50 STUDENTS: $2.50 SR CIT: $2.50
&: Y ℗ Y, on street MUS/SH: Y
GR/T: Y GR/PH: CATR! H/B: Y
PERM/COLL: AM/REG:ptgs, sculp, crafts 20

The Museum is housed in the splendidly restored Old Pack Memorial Library, a 1920 Beaux Arts Building. **NOT TO BE MISSED:** ART IS...The Museum's collection of 20th-century art asks this question and there are historical and contemporary responses by noted artists.

ON EXHIBIT/97:

02/06/97–05/03/97 QUIET LIGHT: ISAMU NOGUCHI'S AKARI LIGHT SCULPTURES — Noguchi considered Akari to be "light sculpture," sculpture that used light as a material "inextricably connecting the necessity and beauty of light." With utopian spirit, infused with an informal modernism, he focused on the creation of spatial environments. This exhibition shows his expanded conception of sculpture.

04/22/97–06/30/97 RAY JOHNSON: BLACK MOUNTAIN COLLEGE TO NEW YORK CORRESPON-DENCE SCHOOL — Ray Johnson was a student at Black Mountain College. When he moved to New York he began to mail art works to friends, colleagues, and even total strangers. Calling this body of work the "New York Correspondence School," these painted, sanded and collaged creations, that often included poetry and were filled with humor and irony, came to be known as Mail Art. As an adjunct to this exhibition the Museum will set aside a temporary "Response Gallery" for visitors to respond the the works with writing and imagery. CAT

08/21/97–10/11/97 THE VELVET YEARS, 1965-1967: WARHOL'S FACTORY, PHOTOGRAPHS BY STEPHEN SHORE — Paul Shore's photographs, taken in Andy Warhol's studio, focus attention on the intersection of visual art, performance art and music. Warhol helped to organize the Velvet Underground, a group including musicians Lou Reed, John Cage, Sterling Morrison, Maureen "Moe" Tucker and Nico for whom he designed their first album cover. Working within the documentary tradition, Shore's work in the 1970's helped lay the groundwork for the acceptance of color photography as a legitimate photographic art form.

Chapel Hill

The Ackland Art Museum
Columbia & Franklin Sts-Univ. Of North Carolina, **Chapel Hill, NC 27599**
☎ 919-966-5736
HRS: 10-5 W-Sa; 1-5 S DAY CLOSED: M HOL: 12/25
&: Y ℗ Y
GR/T: Y
PERM/COLL: EU & AM: ptgs, gr 15-20; PHOT; REG

The Ackland, with a collection of more than 12,000 works of art ranging from ancient times to the present, includes a wide variety of categories conveying the breadth of mankind's achievements.

Charlotte

Mint Museum of Art
2730 Randolph Road, **Charlotte, NC 28207**
☎ 704-337-2000
HRS: 10-10 Tu; 10-5 W-Sa; 12-5 S DAY CLOSED: M HOL: LEG/HOL!
F/DAY: Tu 5-10 ADM: Y ADULT: $4.00 CHILDREN: under 12 F STUDENTS: $2.00 SR CIT: $3.00
&: Y ℗ Y; Free and ample MUS/SH: Y GR/T: Y H/B: Y
PERM/COLL: EU & AM: ptgs; REN; CONT; CH; DEC/ART; AM: pottery, glass; BRIT: cer

The building, erected in 1836 as the first branch of the US Mint, produced 5 million dollars in gold coins before the Civil war. In 1936 it opened as the first art museum in North Carolina. When the museum was moved to its present parkland setting the facade of the original building was integrated into the design of the new building. **NOT TO BE MISSED:** Extensive Delhom collection of English pottery beautifully displayed.

ON EXHIBIT/97:

01/11/97–03/16/97	ARTCURRENTS 22: TBA
02/08/97–08/24/97	THE CERAMIC ART OF NORTH CAROLINA — From the production of early agrarian utilitarian wares of the 19th-century, to the art wares of the 1920's, and to the individual artistic creativity of the contemporary studio potter, nothing speaks more eloquently of North Carolina's artistic heritage than does its ceramics.
03/22/97–06/01/97	ARTCURRENTS 23: MARTHA STRAWN — Strawn's compelling photographic survey demonstrates the generational connection between alligators and residents of the rural Gulf coast of the southeastern US.
08/10/96–02/09/97	MEISSEN PORCELAIN 1710-1750 — An introductory survey of the 'Golden Age' of production including pieces from the collection not publically shown until now.
10/26/96–01/05/97	ANIMALS IN AFRICAN ART — This exhibition of more than 90 representations of animals, both domestic and wild, minuscule and mammoth, from the 11th through 20th centuries is visually stunning, possessing great aesthetic power and charm. CAT WT
11/02/96–01/05/97	IMPRESSIONS: PRINTS BY JAMES MCNEIL WHISTLER — Whistler's skill as a printmaker, his sensitive line and concern for light created softly focused images of rare subtlety and variety. WT

Charlotte

Spirit Square Center for Arts and Education
345 N. College Street, **Charlotte, NC 28202**
☎ 704-372-9664
HRS: 12-6 M-Sa DAY CLOSED: S HOL: LEG/HOL!
&: Y ℗ Y MUS/SH: Y H/B: Y
PERM/COLL: non-collecting institution

At Spirit Square, the performing arts, the visual arts, and art education are combined in a remarkable atmosphere of exploration and creativity.

ON EXHIBIT/97:	Spirit Square, as it currently exists, will close permanently on June 30, 1997.
11/08/96–01/25/97	A SLAVE SLAVE SHIP SPEAKS:THE WRECK OF THE HENRIETTA MARIE — Artifacts and reproductions from the only slave ship salvaged and conserved in the western hemisphere. WT
11/08/96–02/08/97	TRAGIC WAKE: THE LEGEND OF SLAVERY AND THE AFRICAN DIASPORA IN CONTEMPORARY AMERICAN ART
03/07/97–04/18/97	FREEDOM OF EXPRESSION — A no-holds-barred exhibition open to the public. WT

NORTH CAROLINA

Dallas

Gaston County Museum of Art and History
131 W. Main Street, **Dallas, NC 28034**
☎ 704-922-7681
HRS: 10-5 Tu-F; 1-5 Sa; 2-5 S HOL: LEG/HOL!
&: Y; Ramps, elevators Ⓟ Y MUS/SH: Y
GR/T: Y H/B: Y S/G: Y
PERM/COLL: CONT; ARTIFACTS RELATING TO THE US, N.C., & THE SOUTHEAST

The museum, housed in the 1852 Hoffman Hotel located in historic Court Square, contains period rooms and contemporary galleries which were renovated in 1984. **NOT TO BE MISSED:** Carriage exhibit, the largest in the Southeast

ON EXHIBIT/97:

11/96–01/97 A SLAVE SHIP SPEAKS: THE WRECK OF THE HENRIETTA MARIE — Artifacts and
 reproductions from the only slave ship salvaged and conserved in the western hemisphere.
 Dates Tent!

03/97–04/97 FREEDOM OF EXPRESSION — A no holds barred exhibition open to the public.
 Dates Tent!

Davidson

William H. Van Every Gallery/Edward M. Smith Gallery
Davidson College, Visual Arts Center, **Davidson, NC 28036**
☎ 704-892-2344
HRS: 10-4 M-F; Sa, S 2-5 (Jan-May, Sep-Dec) HOL: LEG/HOL!
Ⓟ Y
PERM/COLL: WORKS ON PAPER

In the fall of 1993 the Gallery moved to a new building designed by Graham Gund where selections from the 2,500 piece permanent collection are displayed at least once during the year. The Gallery also presents a varied roster of both traveling and student exhibitions. **NOT TO BE MISSED:** Auguste Rodin's 'Jean d'Aire, bronze

Durham

Duke University Museum of Art
Affiliate Institution: Duke University
Buchanan Blvd at Trinity, **Durham, NC 27701**
☎ 919-684-5135
HRS: 9-5 Tu-F; 11-2 Sa; 2-5 S DAY CLOSED: M HOL: LEG/HOL!
&: Y Ⓟ Y MUS/SH: Y
GR/T: Y
PERM/COLL: MED: sculp; DEC/ART; AF: sculp; AM & EU: all media

Duke University Art Museum, with its impressive collection ranging from ancient to modern works includes the Breumner collection of Medieval art, widely regarded as a one of a kind in the US, a large pre-Columbian collection from Central and South America, and a collection of contemporary Russian art.

310

Fayetteville

Fayetteville Museum of Art
839 Stamper Road, **Fayetteville, NC 28303**
☎ 910-485-5121
HRS: 10-5 Tu-F; 1-5 Sa, S DAY CLOSED: M HOL: 1/1, EASTER, 7/4, THGV, 12/23-12/31
&: Y ℗ Y MUS/SH: Y S/G: Y
PERM/COLL: CONT: North Carolina art; PTGS, SCULP, CER

The museum, whose building was the first in the state designed and built as an art museum, also features an impressive collection of outdoor sculpture on its landscaped grounds. **NOT TO BE MISSED:** 'Celestial Star Chart', by Tom Guibb

Greensboro

Weatherspoon Art Gallery
Affiliate Institution: The University of North Carolina
Spring Garden & Tate Street, **Greensboro, NC 27412-5001**
☎ 910-334-5770 WEB ADDRESS: http://www.uneg.edu/wag/
HRS: 10-5 Tu, T, F; 1-5 Sa-S; 10-8 W DAY CLOSED: M HOL: ACAD! and vacations
&: Y ℗ Y MUS/SH: Y ¶ Many restaurants nearby
GR/T: Y DT: Y TIME: 1st S 2 PM ! H/B: Y S/G: Y
PERM/COLL: AM: 20; MATISSE LITHOGRAPHS; OR

Designed by renowned architect, Romaldo Giurgola, the Weatherspoon Art Gallery features six galleries showcasing special exhibitions and a predominantly 20th-century collection of American art with works by Willem de Kooning, Alex Katz, Louise Nevelson, David Smith, and Robert Rauschenberg. **NOT TO BE MISSED:** The Cone Collection of Matisse lithographs and bronzes

ON EXHIBIT/97:

10/06/96–03/16/97	FROM A CURATOR'S POINT OF VIEW: MAKING SELECTIONS AND FORGING CONNECTIONS — Works from the Weatherspoon Collection by Eva Hesse, Robert Smithson, Lee Bontecou, Ronald Bladen, Sol LeWitt, Robert Morris and Donald Judd will form the basis of an exhibition that surveys Minimalism and Post-Minimalism during the 1960's and 1970's. CAT
10/20/96–01/19/97	FALK VISITING ARTIST: KEITH CARTER — A photographer now living in Texas, Keith Carter brings elegant vision to his photographs of the South. His works embody contradictions and his compositional sense and manipulation of scale bring a quiet yet insightful eye to his subjects.
10/20/96–01/19/97	FALK VISITING ARTIST: MARK LERE — Born in North Dakota and living in California, sculptor Mark Lere uses industrial materials – aluminum, fiberglass, bronze and steel – to create a variety of forms which are essentially abstract but suggest multiple associations. Included will be works on paper as well as sculpture.
01/26/97–03/16/97	BETH B — A site specific installation will be created by this original member of the New York collective "Colab. B." She focuses on themes of social injustice, abuses of institutional and domestic power, racism and censorship.
02/09/97–04/13/97	FALK VISITING ARTIST: JOHN WALKER — The work of abstract painter and printmaker John Walker has changed considerably over the last fifteen years as it incorporates various influences of Spanish painting to the Aboriginal art of Australia.
04/06/97–09/21/97	MARSDEN HARTLEY: SELECTED WORKS — The Weisman Art Museum at the University of Minnesota holds the largest collection of the work of this American modernist (1877-1943) including paintings and works on paper. A selection will be shown here. It will run concurrently with Tobi Kahn's exhibition with its strong affinity to Hartley's spiritual orientation and reductive abstraction.

Weatherspoon Art Gallery - continued

04/06/97–07/13/97	THE LIBERATED IMAGE: PHOTOGRAPHY SINCE 1970 FROM THE TAMPA MUSEUM OF ART'S PERMANENT COLLECTION — A strength of this collection is its postmodern work with representation of John Baldessari, Cindi Sherman, Joel-Peter Witkin, William Wegman, Sandy Skoglund, and Nancy Burson to name a few. It constitutes an impressive survey of contemporary photographic practices. BROCHURE
08/03/97–10/26/97	TOBI KAHN: DREAMS OF TRANSFORMATION — Paintings, sculptural shrines and an installation of smaller paintings will show how Kahn uses the language of abstraction to transform natural forms into meditative landscapes and mindscapes. CAT BROCHURE
10/13/97–03/01/98	WEATHERSPOON COLLECTION EXHIBITION
10/26/97–01/11/98	UNCG ART FACULTY BIENNIAL EXHIBITION — A wide range of media are represented in this opportunity to observe new stylistic developments in contemporary art and to view faculty members' work together.
11/16/97–01/18/98	ART ON PAPER — The 32nd annual exhibition which showcases a large variety of nationally known, regional and faculty artists who create works on paper. CAT BROCHURE

Greenville

Greenville Museum of Art, Inc

802 Evans Street, **Greenville, NC 27834**
☎ 919-758-1946
HRS: 10-4:30 T-F; 1-4 S HOL: LEG/HOL!
&: Y ℗ Y
GR/T: Y
PERM/COLL: AM: all media 20

Founded in 1939 as a WPA Gallery, the Greenville Museum of Art focuses primarily on the achievements of 20th-century American art. Many North Carolina artists are represented in its collection which also includes works by George Bellows, Thomas Hart Benton, Robert Henri, Louise Nevelson, and George Segal, to name but a few. **NOT TO BE MISSED:** Major collection of Jugtown pottery

ON EXHIBIT/97:

01/97 -03/97	WORKS BY HENRYK FANTASOS	Tent. Name	Dates Tent!
04/97–05/97	WORKS BY MARY VIRGINIA LANGSTON	Tent. Name	Dates Tent!
09/97–10/97	WORKS BY WARREN DENNIS	Tent. Name	Dates Tent!
11/97–12/97	PICASSO POSTERS: A STUDY IN DESIGN		Dates Tent!

Wellington B. Gray Gallery

Affiliate Institution: East Carolina University
Jenkins Fine Arts Center, **Greenville, NC 27858**
☎ 919-757-6336
HRS: 10-5 M-W, F & Sa; 10-8 T HOL: LEG/HOL!
&: Y; Ramp, elevators ℗ Y; Limited metered S/G: Y
PERM/COLL: CONT

One of the largest contemporary art galleries in North Carolina. **NOT TO BE MISSED:** Print portfolio, Larry Rivers 'The Boston Massacre'

Hickory

The Hickory Museum of Art
243 Third Ave. NE, **Hickory, NC 28601**
☎ 704-327-8576
HRS: 10-5 Tu-F; 1-4 Sa, S DAY CLOSED: M HOL: LEG/HOL!
&: Y ℗ Y MUS/SH: Y
GR/T: Y H/B: Y
PERM/COLL: AM: all media 19, 20 ; ART POTTERY; AM: Impr

Located in one of Hickory's finest examples of neo-classic revival architecture, the museum is giving new life to the old Claremont Central High School, now renovated as the Arts and Science Center of Catawba Valley. **NOT TO BE MISSED:** William Merritt Chase painting (untitled)

ON EXHIBIT/97:

12/01/96–02/01/97	GREGORY IVE: WATERCOLORS 1939-1949 — A decade of work by the man who brought modern art to North Carolina. His works are as modern today as they were when he produced them.
05/17/97–06/26/97	SHARED STORIES: EXPLORING CULTURAL DIVERSITY — Original illustrations and manuscripts from the growing field of ethnic children's books by authors of African-American, Asian American, Latin American and Native American descent. Shared Stories promotes cross-cultural understanding and demonstrates diverse cultural identities. BROCHURE

North Wilkesboro

Wilkes Art Gallery
800 Elizabeth Street, **North Wilkesboro, NC 28659**
☎ 910-667-2841
HRS: 10-5 Tu-F; 12-4 Sa DAY CLOSED: M, S HOL: 1/1, EASTER, EASTER MONDAY, 7/4, 12/25
&: Y; Entrance ways & bathrooms ℗ Y MUS/SH: Y, craft
PERM/COLL: REG & CONT: all media

This 80 year old neighborhood facility which was formerly the Black Cat Restaurant presents monthly changing exhibitions often featuring minority artists.

ON EXHIBIT/97:

01/09/97–02/01/97	MARINA MATTHEWS, STU CASPER AND JACKIE HELMS
02/06/97–02/22/97	KIMBERLI JOHNSON AND JAMES BRANNOCK
04/10/97–05/03/97	NORTHWEST ARTISTS LEAGUE COMPETITION
05/05/97–08/09/97	STUDIO ART ROBERT BOGUE
08/17/97–09/13/97	QUILT SHOW
09/18/97–10/08/97	JOSEPH YORK AND STEVEN FORBES DE SOULE
09/18/97–10/18/97	BETH GOLDSTON
10/23/97–11/15/97	19TH ANNUAL BLUE RIDGE OVERVIEW JURIED PHOTOGRAPHY COMPETITION
11/20/97–12/31/97	NORTH CAROLINA CHRISTMAS SHOW

NORTH CAROLINA

Raleigh

North Carolina Museum of Art
2110 Blue Ridge Boulevard, **Raleigh, NC 27607-6494**
☎ 919-839-6262
HRS: 9-5 Tu-T, Sa; 9-9 F; 11-6 S DAY CLOSED: M HOL: LEG/HOL!
&: Y ℗ Y MUS/SH: Y ⑪ Y; Cafe serves lunch daily & dinner Fri 5:30-8:45
GR/T: Y DT: Y TIME: 1:30 daily
PERM/COLL: EU/OM: ptgs; AM: ptgs 19; ANCIENT ART; AF; REG; JEWISH CEREMONIAL ART

The Kress Foundation, in 1960, added to the museum's existing permanent collection of 139 prime examples of American and European artworks, a donation of 71 masterworks. This gift was second in scope and importance only to the Kress bequest to the National Gallery in Washington, D.C. **NOT TO BE MISSED:** Kress Collection

ON EXHIBIT/97:

10/20/96–01/19/97	LOUIS REMY MIGNOT — In the first major retrospective of works by this extraordinary and important landscape painter of the Hudson River School, emphasis will be placed on his years in New York (1855-62), his most creative and influential period. BOOK WT
11/17/96–06/01/97	SEPPHORIS IN GALILEE: CROSSCURRENTS OF CULTURE — Once an important city in Roman Palestine, archeologists have uncovered significant works of art, architectural remains and other artifacts that dramatically illuminate the history and everyday life of this once vibrant urban center. The exhibition will include a large mosaic, sculptures, sarcophagi, ceramic and glass vessels, maps, photomurals and scale models of buildings.
04/06/97–06/15/97	I CLAUDIA: WOMEN IN ANCIENT ROME CAT WT

North Carolina State University Visual Arts Center
Cates Ave.-Room 4110-University Student Center, **Raleigh, NC 27695**
☎ 919-515-3503
HRS: 12-8 Tu-F; 2-8 Sa, S DAY CLOSED: M HOL: ACAD!
&: Y ℗ Y ⑪ Y
PERM/COLL: AM: cont, dec/art, phot

The Center hosts exhibitions of contemporary arts and design of regional and national significance and houses research collections of photography, ceramics and textiles.

Tarboro

Blount Bridgers House/Hobson Pittman Memorial Gallery
130 Bridgers Street, **Tarboro, NC 27886**
☎ 919-823-4159
HRS: 10-4 M-F; 2-4 Sa, S HOL: LEG/HOL!
ADM: Y ADULT: $2.00
&: Y ℗ Y; Street GR/T: Y H/B: Y
PERM/COLL: AM: 20; DEC/ART

In a beautiful North Carolina town, the 1808 Plantation House and former home of Thomas Blount houses decorative arts of the 19th Century and the Hobson Pittman (American, 1899-1972) Collections of paintings and memorabilia. **NOT TO BE MISSED:** "The Roses," oil, by Hobson Pittman

314

Wilmington

St. John's Museum of Art
114 Orange Street, **Wilmington, NC 28401**
☎ 910-763-0281
HRS: 10-5 Tu-Sa; 12-4 S DAY CLOSED: M HOL: LEG/HOL!
VOL/CONT: Y ADULT: $2.00 CHILDREN: $1.00 (under 18)
&: Y; Ramp, elevators Ⓟ Y MUS/SH: Y H/B: Y
PERM/COLL: AM: ptgs, sculp

Housed in three architecturally distinctive buildings dating back to 1804, the museum is the primary visual arts center in Southeastern North Carolina. **NOT TO BE MISSED:** Mary Cassatt color prints

ON EXHIBIT/97:

01/16/97–03/09/97	ARTISTS OF BLACK MOUNTAIN COLLEGE — These works on paper from the collection of Juan Logan include works by Jasper Johns, Robert Rauschenberg, Jacob Lawrence, Joseph and Annie Albers. Dates Tent!
03/20/97–05/26/97	THE FIGURE IN NORTH CAROLINA CRAFT — Functional and non-functional artwork in glass, metal, wood and fiber are all inspired by the animate figure found in nature in this invitational exhibition. Dates Tent!
03/20/97–05/26/97	CONTEMPORARY NORTH CAROLINA FURNITURE — Works highlighting the leading artists and craftspeople of today including Al Frega, Chad Voorhees and Bob Trotman. Dates Tent!
06/05/97–06/30/97	ARTISTS OF SOUTHEASTERN NORTH CAROLINA: A JURIED EXHIBITION — Two and three-dimensional artwork created by artists from the seven county region. Dates Tent!
01/06/96–03/09/97	JUAN LOGAN: NOT SEPARATE AND APART FROM Dates Tent!

Winston-Salem

Reynolda House, Museum of American Art
Reynolda Road, **Winston-Salem, NC 27106**
☎ 910-725-5325
HRS: 9:30-4:30 Tu-Sa; 1:30-4:30 S DAY CLOSED: M HOL: 1/1, THGV, 12/25
ADM: Y ADULT: $6.00 STUDENTS: $3.00 SR CIT: $5.00
&: Y Ⓟ Y MUS/SH: Y GR/T: Y H/B: Y
PERM/COLL: AM: ptgs 18-present; HUDSON RIVER SCHOOL; DOUGHTY BIRDS

Reynolda House, an historic home designed by Charles Barton Keen, was built between 1914 and 1917 by Richard Joshua Reynolds, founder of R. J. Reynolds Tobacco Company, and his wife, Katherine Smith Reynolds.

The Southeastern Center for Contemporary Art
750 Marguerite Drive, **Winston-Salem, NC 27106**
☎ 910-725-1904
HRS: 10-5 Tu-Sa; 2-5 S DAY CLOSED: M HOL: LEG/HOL!
ADM: Y ADULT: $3.00 CHILDREN: F (under 12) STUDENTS: $2.00 SR CIT: $2.00
&: Y; Main floor in the galleries only. Not accessible to 2nd floor Ⓟ Y; Free MUS/SH: Y GR/T: Y H/B: Y S/G: Y
PERM/COLL: Non-collecting institution

Outstanding contemporary art being produced throughout the nation is showcased at the Southeastern Center for Contemporary Art, a cultural resource for the community and its visitors.

NORTH CAROLINA

The Southeastern Center for Contemporary Art - continued

01/97–05/97	JEAM TINGUELY		TENT!
01/18/97–03/30/97	NATIONAL ENDOWMENT FOR THE ARTS/SOUTHERN ARTS FEDERATION FELLOWSHIP WINNERS		
01/28/97–03/30/97	TIM HAWKINSON		
04/05/97–06/27/97	TRIAD ARTISTS		
04/12/97–07/06/97	NORTH CAROLINA ARTISTS EXHIBITION 1996 — This provocative triennial showcases the most recent art being created in North Carolina.		
04/12/97–07/06/97	ARTIST AND THE COMMUNITY: MAYA LIN		
07/97–09/97	PAINTING: ROLE OF WOMEN	DatesTent!	TENT!
FALL/97–/98	WILLIAM CHRISTENBERRY	Dates Tent!	TENT!
10/19/96–01/05/97	SUE MOORE		
10/19/96–01/05/97	PICTURED IN MY MIND: CONTEMPORARY SELF-TAUGHT ART		

Grand Forks

North Dakota Museum of Art
Affiliate Institution: University of North Dakota
Centennial Drive, **Grand Forks, ND 58202**
📞 701-777-4195
HRS: 9-5, M-F; 1-5, Sa, S; 12-9, T Sept-May HOL: THGV, 12/25
♿: Y Ⓟ Y; Metered on street
MUS/SH: Y 🍴 Y; Coffee bar
GR/T: Y H/B: Y S/G: Y
PERM/COLL: CONT: Nat/Am; CONT: reg ptgs, sculp; REG HIST (not always on display)

In *ARTPAPER 1991* Patrice Clark Koelsch said of this museum "In the sparsely populated state that was the very last of all the US to build an art museum,...(The North Dakota Museum of Art) is a jewel of a museum that presents serious contemporary art, produces shows that travel internationally, and succeeds in engaging the plain people of North Dakota." **NOT TO BE MISSED:** Collection of paintings on paper by Winnipeg artists: The work is autobiographical and includes script and image; the subject is child abuse.

OHIO

Akron

Akron Art Museum

70 East Market Street, **Akron, OH 44308-2084**
\ 330-376-9185
HRS: 11-5 Tu-F, 10-5 Sa, 12-5 S, open 11-9 T (6/27-8/29) DAY CLOSED: M HOL: LEG/HOL!
&: Y ℗ Y; $2 for 2 1/2 hrs; $5 for over 2 1/2 hrs
GR/T: Y GR/PH: CATR!
H/B: Y; 1899 Italian Renaissance Revival structure. listed NRHP S/G: Y
PERM/COLL: EDWIN C. SHAW COLLECTION; AM: ptgs, sculp, phot 20

Three new regional, national, or international temporary exhibitions are presented every 10 weeks at the Akron.
NOT TO BE MISSED: Claus Oldenburg's "Soft Inverted Q," 1976; The Myers Sculpture Courtyard

ON EXHIBIT/97:

04/19/97–06/15/97	FAME AND MISFORTUNE: ANDY WARHOL'S PORTRAITS — Warhol transformed the understanding of art, revealing the role that wealth, commercialism, fame and taste play in creating our visual culture. This is the first exhibition to explore the range of Warhol's involvement with portraiture of the rich and famous.
06/28/97–08/24/97	CREATIVE COMMUNITIES: ART FROM AKRON'S NEIGHBORHOODS — This project represents an effort to bring together artists and individuals living in different neighborhoods to create art projects that reflect the diversity of the city and its artistic, ethnic and religious heritage.
09/06/97–11/02/97	A HISTORY OF WOMEN PHOTOGRAPHERS — Over 200 vintage photographs from around the world survey the contributions of women to photography as a fine art from 1839 to the 1980's. Using the premise that photography, unlike any other art form, has had major input from women from its beginning and that women have had a much more major role in its history than previously acknowledged. CAT
11/15/97–01/11/98	SEVENTY-FIFTH ANNIVERSARY CELEBRATION OF THE COLLECTION — 100 of the finest paintings, sculpture and photographs created by regional, national and international artists from the 1860's to the present, will be featured in this exhibition. BOOK

Athens

Kennedy Museum of American Art

Affiliate Institution: Ohio University
Lin Hall, **Athens, OH 45701-2979**
\ 614-593-1304
HRS: Hours to be Announced, Call! HOL: LEG/HOL!
℗ Y
GR/T: Y GR/PH: CATR! H/B: Y
PERM/COLL: GR: 20; NAT/AM; AF; textiles, jewelry

Housed in the newly renovated 19th-century Lin Hall, the Museum collections include the Edwin L and Ruth Kennedy Southwest Native American collection, the Contemporary American Print Collection and the Martha and Foster Harmon Collection.

Canton

The Canton Museum of Art
1001 Market Ave., N., **Canton, OH 44702**
☎ 330-453-7666
HRS: 10-5 & 7-9 Tu-T; 10-5 F, Sa; 1-5 S DAY CLOSED: M HOL: 1/1, THGV, 12/25
&: Y ℗ Y MUS/SH: Y GR/T: Y GR/PH: CATR! S/G: Y
PERM/COLL: WORKS ON PAPER; AM & EU: ptgs 19-20; CER: after 1950

Located in the Cultural Center for the Arts, the Canton Museum of Art is the only visual arts museum in Stark County whose mix of permanent with traveling exhibitions creates a showcase for a spectrum of visual art. **NOT TO BE MISSED:** Painting by Frank Duveneck "Canal Scene with Washer Women, Venice"

ON EXHIBIT/97:

11/22/96–02/23/97	PERMANENT COLLECTION EXHIBITION/FACULTY EXHIBITION	
1997	ROCKWELL'S 322 SATURDAY EVENING POST COVERS	WT
02/02/97–03/97	OHIO CERAMIC SHOWCASE	
04/06/97–05/04/97	TIBETAN ARTS FESTIVAL	
05/19/97–07/13/97	IN TOUCH WITH FIBERS — An exhibition mounted in conjunction with the Midwest Weaver's Association Conference.	

Cincinnati

Cincinnati Art Museum
Eden Park, **Cincinnati, OH 45202-1596**
☎ 513-721-5204
HRS: 10-5 Tu-Sa, 11-6 S DAY CLOSED: M HOL: 1/1, THGV, 12/25
F/DAY: Sa ADM: Y ADULT: $5.00 CHILDREN: F (under 18) STUDENTS: $4.00 SR CIT: $4.00
&: Y ℗ Y; Free MUS/SH: Y ⅋ Y GR/T: Y GR/PH: CATR! S/G: Y
PERM/COLL: AS; AF; NAT/AM: costumes, textiles; AM & EU: ptgs, dec/art, gr, drgs, phot

One of the oldest museums west of the Alleghenies, The Cincinnati Art Museum's collection includes the visual arts of the past 5,000 years of almost every major civilization in the world. **NOT TO BE MISSED:** 'Undergrowth with Two Figures,' Vincent van Gogh, 1890

ON EXHIBIT/97:

through 04/20/97	ISSAYE MIYAKE — Garments from the 1996 fall collection of fashion designers Miyake.	
02/14/97–05/25/97	THE LURE OF THE WEST-HENRY FARNY — Romanticized views of the wild, wild west include Farny's depictions of Native American life and his illustrations for the McGuffy Reader.	WT
03/01/97–04/27/97	RUTH BERNHARD AT 90: KNOWN AND UNKNOWN — A look at Bernhard's 60 year career includes vintage material from the artist's own archives and examples of the transcendent nudes for which she is best known.	WT
03/21/97–03/15/98	ONE HUNDRED YEARS OF MODERN ART — A reinstallation of the 20th-century collection with loans from private collections give a new perspective on modern art.	
05/10/97–09/01/97	THOMAS SHOTTER BOYS' PICTURESQUE VIEWS — Images of London, Paris and the French provinces created by Boys through the then new technique of lithography.	
05/10/97–09/01/97	AFRICAN-AMERICAN QUILTS — Works by local African-American quilters will be shown with those from the permanent collection.	
05/10/97–09/01/97	THE PHOTOGRAPHER IN FOCUS	
05/17/97–07/27/97	VIEW FROM THE UPPER ROOM: THE ART OF JOHN BIGGERS — 127 drawings, prints, sculptures, paintings, and large-scale murals by African-American artist Biggers, created over a five decade period will be on view in his first major museum retrospective. The exhibition is the first to focus exclusively on an African-American artist whose development is tied to the southern United States.	WT

OHIO

Cincinnati Art Museum - continued

08/08/97–11/30/97	TRIBES OF THE BUFFALO: A SWISS ARTIST ON THE AMERICAN FRONTIER — Celebrate the art and culture of the Plains Indians with artifacts and Karl Boddmer's illustrated views from the 1830's.
12/09/97–03/01/98	CHARLES SHEELER IN DOYLESTOWN: MODERNISM AND THE PENNSYLVANIA TRADITION — American modernist's Sheeler's approach to the vernacular of Pennsylvania architecture and artifacts will be addressed in this exhibition. WT

Cincinnati

The Contemporary Arts Center

115 E. 5th St., **Cincinnati, OH 45202-3998**
☎ 513-721-0390
HRS: 10-6 M-Sa, 12-5 S HOL: LEG/HOL!
F/DAY: M ADM: Y ADULT: $3.50 CHILDREN: F (under 12) STUDENTS: $2.00 SR CIT: $2.00
&: Y ℗ Y; Pay garage 1 block away under Fountain Square MUS/SH: Y GR/T: Y GR/PH: CATR!
PERM/COLL: NONE

Founded in 1939, this is one of the first contemporary art museums in the United States where the art of today in all media, including video, is presented.

ON EXHIBIT/97:

01/25/97–03/23/97	FRED TOMASELLI: THE URGE TO BE TRANSPORTED CAT WT
01/25/97–03/23/97	HEROIC PAINTING — Heroic acts of daily life will be one of the topics explored in this exhibition dealing with the notion of the "hero" as subject matter in art. CAT WT
04/05/97–06/08/97	PHOTO-OP: TIM BURTON. DENNIS HOPPER, DAVID LYNCH, JOHN WATERS (Working Title) — Four movie directors who are also photographers have agreed to exhibit together giving an unprecedented opportunity to see the personal expressions of people who are known for their collaborative spectacles.
04/05/97–06/08/97	ODE DE MA MERE: WORKS ON A THEME BY LOUISE BOURGEOIS — For the first time an American art museum will bring together a new body of work on spiders created by this 84 year old French born American artist. Cast in bronze or formed from welded steel, these monumental sculptures possess a new level of emotional intensity for Bourgeois while other smaller ones creep and dwell on gallery walls. A portfolio of etchings that accompanies this exhibition reveals small arachnids.
06/28/97–08/31/97	SCULPTURE BY ROBERT THERRIEN — Therrien's monumental sculptures take familiar objects and renders them foreign as in "Under the Table," and "Stacked Plates."

The Taft Museum

316 Pike Street, **Cincinnati, OH 45202-4293**
☎ 513-241-0343
HRS: 10-5 M-Sa, 1-5 S & Hol! HOL: 1/1, THGV, 12/25
ADM: Y ADULT: $3.00 CHILDREN: F (under 12) STUDENTS: $2.00 SR CIT: $2.00
&: Y ℗ Y; Limited free parking MUS/SH: Y GR/T: Y GR/PH: CATR! H/B: Y
PERM/COLL: PTGS; CH: Kangzi-period cer; FR/REN: Limoges enamels; EU & AM: furniture 19

Collections include masterpieces by Rembrandt, Hals, Gainsborough, Turner and Corot, arranged within the intimate atmosphere of the 1820 Baum-Taft house, a restored Federal-period residence. **NOT TO BE MISSED:** French Gothic ivory Virgin and Child from the Abbey Church of St. Denis, ca. 1260.

ON EXHIBIT/97:

12/13/96–02/09/97	ROMANCE AND CHIVALRY: HISTORY AND LITERATURE REFLECTED IN EARLY 19TH CENTURY FRENCH PAINTING
02/21/97–04/20/97	CINCINNATI COLLECTS CHINESE ART

The Taft Museum - continued

06/13/97–08/17/97	HENRY F. FARNY — Romanticized views of the wild, wild west include Farny's depictions of Native American life and his illustrations for the McGuffy Reader. WT
09/12/97–11/09/97	SEEKING IMMORTALITY: CHINESE TOMB SCULPTURE FROM THE SCHLOSS COLLECTION — On exhibit will be 150 2nd century BC to 8th-century AD ceramic objects which recreated life in ancient China and were placed in buriel tombs to be used in the afterlife of the deceased. TENT!

Cleveland

The Cleveland Museum of Art

11150 East Blvd, Cleveland, OH 44106
☏ 216-421-7340
HRS: 10-5:45 Tu-T, F; 10-9:45 W; 9-5:45 Sa; 1-5:45 S DAY CLOSED: M HOL: 1/1, 7/4, THGV, 12/25
&: Y ℗ Y; Pay MUS/SH: Y 🍴 Y
GR/T: Y GR/PH: CATR! DT: Y TIME: ! H/B: Y S/G: Y
PERM/COLL: ANCIENT: Med, Egt, Gr, R; EU; ΛM; AF; P/COL; OR; phot, gr, text, drgs

One of the world's major art museums, The Cleveland Museum of Art is located in the University Circle area of Cleveland, the largest concentration of cultural, educational and medical institutions in the nation. A portion of the museum includes a wing designed in 1970 by Marcel Breuer. **NOT TO BE MISSED:** Guelph Treasure, especially the Portable Altar of Countess Gertrude (Germany, Lower Saxony, Brunswick, circa 1040; gold, red porphyry, cloisonne, enamel, niello, gems, glass, pearls

ON EXHIBIT/97:

11/24/96–02/02/97	LEGACY OF LIGHT: MASTER PHOTOGRAPHS FROM THE CLEVELAND MUSEUM OF ART — Capitalizing on 150 key works from the Museum's especially strong holdings the photographs on view span the history of 19th-century French and English photography. Extraordinary techniques and aesthetic milestones will be documented in the historic images in this exhibition accompanied by a number of 20th-century and contemporary works.
02/02/97–03/23/97	SOL LEWITT PRINTS 1970-1995 — Intaglio woodcuts, lithographs and screen prints will be on seen in an exhibition detailing how LeWitt has given his wall motifs a second life in prints. WT
02/19/97–05/15/97	THOMAS EAKINS: THE ROWING PICTURES — 9 oil paintings and 14 works on paper created early in Eakins' career and crucial to the understanding of the artist's subsequent creative process will be on view for the first time as a group in an exhibition that explores every aspect of the artist's favorite sport. CAT WT
03/09/97–05/11/97	FABERGÉ IN AMERICA AND THE LILLIAN THOMAS PRATT COLLECTION OF FABERGÉ — The first national tour to focus on great American collections of the work of the Russian imperial jeweler. WT ◠
03/10/97–01/04/98	THREE IMPRESSIONIST MASTERPIECES (Working Title) — On loan will be Claude Monet's "La Japonaise," Edouard Manet's "Street Singer," and J.A.M. Whistler's "The White Girl."
04/15/97–07/06/97	EAST MEETS WEST: INDONESIAN FILM POSTERS FROM THE JOHN PFAHL COLLECTION — The posters shown here comprise a unique form of movie advertising, still widespread in Southeast Asia. "Robin Hood," "Prince of Thieves" (1981), and "The Presidio" (1988) posters will be among those included in this presentation.. CAT WT
04/22/97–07/06/97	ALONE IN A CROWD: PRINTS BY AFRICAN-AMERICAN ARTISTS OF THE 1930'S- 1940'S FROM THE COLLECTION OF REBA AND DAVE WILLIAMS — A gallery of 20th-century works from the Museum's permanent African-American collection will accompany this exhibition of 100 rare prints by African-American artists working (many under the auspices of the WPA) in a wide variety of styles and techniques during the Depression decades. WT
06/22/97–09/14/97	CONTEMPORARY EXHIBITION TBA

OHIO

The Cleveland Museum of Art - continued

07/05/97–09/07/97	FOCUS: FIBER — Am annual juried exhibition of diverse fiber techniques by members of The Textile Alliance.
08/03/97–03/01/98	GLASS TODAY: RECENT AMERICAN STUDIO GLASS FROM CLEVELAND COLLECTIONS — An overview of trends in glass making during the last 35 years.
08/17/97–10/26/97	JACQUES BELLANGE: PRINTMAKER OF LORRAINE (ca. 1575-1616) (Working Title) — Etchings by Bellange, a 17th-century French painter, printmaker and decorator who worked at the court of Nancy, the capital of the independent duchy of Lorraine.
08/22/97–10/5/97	OLGA DE AMARAL: NINE STELAE AND OTHER LANDSCAPES WT
10/19/97–01/04/98	WHEN SILK WAS GOLD: CENTRAL ASIAN AND CHINESE TEXTILES FROM THE CLEVELAND AND THE METROPOLITAN MUSEUMS OF ART — The textiles in the collections of these two museums together form the largest group of this material outside of China. Most have only come to light within the past decade and provide important new evidence for textile production, particularly in the 10th-14th centuries. They will only be shown at these two museums. WT
11/16/97–03/01/98	LEE FRIEDLANDER PHOTOGRAPHS: PEOPLE WORKING — The fifty photographic images by Friedlander included in this exhibition present a penetrating reflection on the diversity of Cleveland's people at work.

Columbus

Columbus Museum of Art

480 East Broad Street, **Columbus, OH 43215**
☎ 614-221-6801
HRS: 10-5:30 Tu, W, F-S; 10-8:30 T DAY CLOSED: M HOL: LEG/HOL!
F/DAY: T 5:30-8:30 SUGG/CONT: Y ADULT: $3.00 CHILDREN: F (Under 12) STUDENTS: $2.00 SR CIT: $2.00
&: Y ℗ Y; $2.00 MUS/SH: Y ⫶ Y GR/T: Y GR/PH: CATR! H/B: Y S/G: Y
PERM/COLL: EU & AM: ptgs 20

Located in a 1931 Italian Renaissance style building, this museum houses the largest single collection of George Bellows paintings.

ON EXHIBIT/97:

ONGOING	GREAT COLLECTORS AND GREAT COLLECTIONS — A re-installation of 20th-century paintings given to the Museum by Ferdinand Howald, The Frederick Schumacher Collection of Old Masters and modern American paintings, and the Sirak Collection of Impressionist, Post-impressionist and Expressionist.
02/97–04/97	DIALOGUES OF THE LAND: PHOTOGRAPHS OF MICHAEL SMITH AND PAULA CHAMLEE — While traveling across the country Smith & Chamlee took the photographs seen here by focusing on the same subjects, primarily landscapes, from different points of view.
03/23/97–05/18/97	THE PAINTINGS OF CHARLES BURCHFIELD: NORTH BY MIDWEST — A comprehensive survey of Burchfield's work. WT
05/15/97–09/14/97	AFRICAN INFLUENCES IN CONTEMPORARY ART: ARTISTS OF THE KWANZAA PLAYGROUND — Images by seven artists commissioned to create works influenced and inspired by traditional art forms will be juxtaposed in this display with traditional art objects.
06/08/97–09/14/97	CARLTON WATKINS: THE YOSEMITE VALLEY PORTFOLIOS — An exhibition of more than 40 photographic prints depicting the pristine beauty of the Yosemite Valley in the 1800's.
10/97–01/98	ORIENTAL ART FROM THE COLUMBUS MUSEUM OF ART (Working Title)

Columbus

The Schumacher Gallery

Affiliate Institution: Capital University
2199 East Main Street, **Columbus, OH 43209-2394**
☎ 614-236-6319
HRS: 1-5 M-F; 2-5 Sa, S; Closed May through August HOL: LEG/HOL!; ACAD!
&: Y Ⓟ Y MUS/SH: Y GR/T: Y GR/PH: CATR!
PERM/COLL: ETH; AS; REG; CONT; PTGS, SCULP, GR 16-19

In addition to its diverse 1200 object collection, the gallery, located on the 4th floor of the University's library building, hosts exhibitions which bring to the area artworks of historical and contemporary significance.

ON EXHIBIT/97:

01/10/97–02/02/97	EXPANDED VISIONS: ART AND TECHNOLOGY — A joint project between the Gallery and Ohio State University's Advanced Computing Center for the Arts and Design features bold experiments in computer graphics, computer animation and multi-media design.
02/07/97–03/06/97	ART NOUVEAU: 1890-1910 — Turn-of-the-century artworks from a private collection include examples by artists Alphonse Mucha, Louis Comfort Tiffany and Emile Galle.
03/16/97–04/13/97	THE LITURGICAL ART GUILD OF OHIO BIENNIAL EXHIBITION — A juried exhibition brings together liturgical, religious, and spiritual works by noted regional artists.

Wexner Center for the Arts

Affiliate Institution: The Ohio State University
North High Street at 15th Avenue, **Columbus, OH 43210-1393**
☎ 614-292-0330
HRS: 10-6 Tu, T, F; 10-8 W & Sa; 12-5 S DAY CLOSED: M HOL: LEG/HOL!
&: Y Ⓟ Y MUS/SH: Y ⑪Y GR/T: Y GR/PH: CATR! DT: Y TIME: 1:00 T & Sa H/B: Y
PERM/COLL: ART OF THE 70's

Located on the campus of The Ohio State University, in the first public building designed by theoretician Peter Eisenman, the Wexner is a multi-disciplinary contemporary arts center dedicated to the visual, performing and media arts.

ON EXHIBIT/97:

02/01/97–04/13/97	EVIDENCE (Working Title) — Featured are eight internationally recognized contemporary photographers who, in different ways, use the camera to track evidence of human activity against the backdrop of the built environment.
02/08/97–04/13/97	PETER FISCHLI AND DAVID WEISS: IN A RESTLESS WORLD — These Swiss artists participate in a collaborative art practice that engages the most humble of everyday objects in a display of spectacle and bravura. Their presentations which include sculpture, photography, film, video and installations, create a dialogue between the opposites of order and chaos, work and play, and the mundane and the sublime. WT
05/10/97–08/10/97	MARK DION: CURIOSITY CABINETS (Working Title) — Dion's first major American installation outside a commercial gallery will be a stunning series of "curiosity cabinets" – the centuries old tradition whereby a collector would display within tall cabinets an array of natural and artistic objects presumed to edify and astonish the viewer. Dion will fill the shelves of nine cabinets with objects resulting in a panoramic demonstration of both the logic of classifying systems and the biases of historical knowledge and memory. CAT
05/10/97–08/10/97	BEVERLY SEMMES — Known throughout the world for her dramatic installations that address psychological and sculptural aspects of clothing, Semmes will create a new installation in response to the building as well as to the concurrent exhibitions, "Viewing Olmstead" and "Inside." WT
05/10/97–08/10/97	INSIDE (Working Title) — Contemporary artists who engage and explore prevailing notions about interiors often use wallpaper as a medium or presentation format. Here the completed installations will convey witty and wry visual narratives that comment on issues of art and architecture as well as the culture within which we live.

OHIO

Wexner Center for the Arts - continued

05/10/97–08/10/97 VIEWING OLMSTED: PHOTOGRAPHS BY ROBERT BURLEY, LEE FRIEDLANDER AND GEOFFREY JAMES — Commissioned to record and interpret the varied work of Frederick Law Olmsted (1822-1903), North America's most important landscape architect, these three leading photographers produced more than 900 images from which the 150 in the exhibition were selected.

Dayton

The Dayton Art Institute

456 Belmonte Park North, **Dayton, OH 45405**
✆ 513-223-5277
HRS: 9-5 daily ♿: Y ℗ Y MUS/SH: Y GR/T: Y GR/PH: CATR! H/B: Y S/G: Y
PERM/COLL: AM; EU; AS; OCEANIC; AF; CONT

The Dayton Art Institute is located at the corner of Riverview Avenue and Belmonte Park North in a Edward B. Green designed Italian Renaissance style building built in 1930. The 1982 Propylaeum (entry) was designed by Levin Porter Smith, Inc. PLEASE NOTE: The museum galleries will be closed until 6/97 for renovation and construction. **NOT TO BE MISSED:** "Water Lilies," by Monet; "Two Study Heads of an Old Man" by Rubens; "St. Catherine of Alexandria in Prison," by Preti; "High Noon," by Hopper

ON EXHIBIT/97: The museum is scheduled to reopen in June 1997 after a major renovation and expansion. Call to confirm hours, etc.

06/30/97–08/03/97 THE SOUL UNBOUND: PHOTOGRAPHS BY JANE REECE (1868-1961)

06/30/97–08/03/97 AMERICAN CLASSICS: THE THE JIM DICKE COLLECTION Tent. Name

09/06/97–11/30/97 ANCIENT SPLENDOR: QIN AND HAN SCULPTURE FROM XIAN, CHINA Tent. Name

12/06/97–02/01/98 IN THE SPIRIT OF RESISTANCE: AFRICAN-AMERICAN MODERNISTS AND THE MEXICAN MURALIST SCHOOOL — Influences of the Mexican Muralist movement on African-American modernist artists will be explored in the works on view by Rivera, Orozco, Catlett, Lawrence, Woodruff and others. CAT WT

Wright State University Galleries

Affiliate Institution: Wright State University
A 128 CAC Colonel Glenn Highway, **Dayton, OH 45435**
✆ 513-873-2978
HRS: 10-4 Tu-F; 12-5 Sa, S HOL: ACAD!
♿: Y ℗ Y
PERM/COLL: PTGS, WORKS ON PAPER, SCULP 20

The Museum is located on the Wright State University campus. **NOT TO BE MISSED:** Aimee Rankin Morgana's "The Dream," 1988

ON EXHIBIT/97:

02/16/97–03/23/97 SPIRITS RISING: HERITAGE AND CONTEMPORANEITY IN FIGURATIVE AFRICAN-AMERICAN ART — Three contemporary artists (Valerie Maynard, Pheoria West, Jon Lockard) pursue a positive representation of the figure, while incorporating traditional patterning and visual rhythms.

04/06/97–05/11/97 THE DEMOCRATIC PRINT: A NATIONAL RELIEF PRINT EXHIBITION AND HISTORICAL SURVEY — A national juried exhibition accompanied by a survey of relief prints from various Ohio museums.

09/97–10/07 WSU FACULTY EXHIBITION TENT!

11/97–12/97 ROBERT BERLIND — A survey of paintings oil sketches and preparatory drawings by Berlind, a SUNY Purchase educator.

Granville

Denison University Gallery
Burke Hall of Music & Art, **Granville, OH 43023**
☎ 614-587-6296
HRS: 1:00-4 daily HOL: ACAD!
&: Y; Includes parking on ground level ℗ Y
PERM/COLL: BURMESE & SE/ASIAN; EU & AM: 19; NAT/AM

Located on the Denison University campus.

ON EXHIBIT/97:
01/17/97–02/21/97 FACULTY DRAWING SHOW

03/01/97–03/29/97 ORLANDO PELLICIA: SCULPTURE/ANDA DUBINSKIS: PAINTING-MIXED MEDIA

Kent

Kent State University Art Galleries
Affiliate Institution: Kent State University
Kent State University, School of Art, **Kent, OH 44242**
☎ 330-672-7853
HRS: 10-4 M-F, 2-5 S DAY CLOSED: Sa HOL: ACAD!
&: Y MUS/SH: Y
GR/T: Y GR/PH: CATR!
PERM/COLL: GR & PTGS: Michener coll; IGE COLL: Olson photographs; GROPPER PRINTS: (political prints)

Operated by the School of Art Gallery at Kent State University since its establishment in 1972, the gallery consists of two exhibition spaces both exhibiting Western and non-Western 20th-century art and craft.

ON EXHIBIT/97:
02/05/97–02/28/97 TBA

04/09/97–05/09/97 THE AFRICAN ESSENCE OF ROMARE BEARDEN

Lakewood

Beck Center for the Cultural Arts
17801 Detroit Ave, **Lakewood, OH 44107**
☎ 216-521-2540
HRS: 12-6 T-Sa HOL: LEG/HOL!
&: Y ℗ Y; Free
PERM/COLL: KENNETH BECK WATERCOLORS

A multi-arts facility featuring an art gallery, Main Stage Theater, Studio Theater, etc., this Gallery is home to a cooperative of local, highly acclaimed artists whose works are on display throughout the year.

OHIO

Oberlin

Allen Memorial Art Museum

Affiliate Institution: Oberlin College
87 North Main Street, **Oberlin, OH 44074**
☎ 216-775-8665
HRS: 10-5 Tu-Sa, 1-5 S DAY CLOSED: M HOL: LEG/HOL!
♿: Y; Through courtyard entrance ℗ Y; Free MUS/SH: Y GR/T: Y GR/PH: CATR! 216-775-8046 H/B: Y S/G: Y
PERM/COLL: DU & FL: ptgs; CONT/AM: gr; JAP: gr; ISLAMIC: carpets

Long ranked as one of the finest college or university art collections in the nation, the Allen continues to grow in size and distinction. The museum's landmark building designed by Cass Gilbert was opened in 1917. A recent addition, the Weitzheimer/Johnson House, is one of Frank Lloyd Wright's Usonian designs. PLEASE NOTE: The museum is open on the first Sunday and third Saturday of the month from 1-5 PM with tours on the hour. Admission is $5.00 pp with tickets available at the Museum. **NOT TO BE MISSED:** Hendrick Terbrugghen's 'St. Sebastian Attended by St. Irene', 1625

ON EXHIBIT/97:

01/07/97–03/06/97	RHETORICS OF THE REAL: CONTEMPORARY AND MODERN PHOTOGRAPHY
01/31/97–03/10/97	THE WHOLE IS GREATER THAN THE SUM OF THE PARTS: INTERCULTURAL EXCHANGES IN THE VISUAL ARTS
03/28/97–05/11/97	CONTEMPORARY ART FROM MIAMI
07/97–09/97	CONTEMPORARY WESTERN ARTISTS WORKING IN JAPAN
07/97–10/97	THE GRAND TOUR OF ITALY: 1750-1850,

Oxford

Miami University Art Museum

Affiliate Institution: Miami University
Patterson Ave, **Oxford, OH 45056**
☎ 513-529-2232
HRS: 11-5 Tu-S DAY CLOSED: M HOL: LEG/HOL! ACAD!
♿: Y ℗ Y MUS/SH: Y GR/T: Y GR/PH: CATR!
PERM/COLL: AM: ptgs, sculp; FR: 16-20; NAT/AM; Ghandharan, sculp

Designed by Walter A. Netsch, the museum building is located in an outstanding natural setting featuring outdoor sculpture.

ON EXHIBIT/97:

08/27/96–07/20/97	REVIVALS OF ANCIENT ART — In a wide range of media from terra cotta to marble to photographs to prints this exhibition presents both classical works as well as contemporary examples influenced by the classical.
08/27/96–12/12/97	ARTS LONGA, VITA BREVIS: ANCIENT ART FROM THE PERMANENT COLLECTION — Highlights from the unique and significant Egyptian, Greek, Near Eastern, Etruscan and Roman sculpture, ceramics and glass collection. CAT
01/21/97–03/18/97	ART AND THE LAW — The 21st annual invitational exhibition of work by contemporary artists interprets the relationship between society and the law. WT
01/21/97–12/12/97	CHANGING IMAGES FROM THE AMERICAS: LATIN AMERICAN ART — As part of a university-wide Latin American Festival the exhibition will highlight works of our southern neighbors drawn from the Museum's collection.
04/01/97–07/13/97	ROY CARTWRIGHT: CERAMIC SCULPTURE — Often containing decorative painted images, the ceramic mosaic sculptures on view use botanical forms as their primary design reference.

326

Portsmouth

Southern Ohio Museum and Cultural Center

825 Gallia Street, **Portsmouth, OH 45662**
☎ 614-354-5629
HRS: 10-5 Tu-F; 1-5 Sa, S DAY CLOSED: M HOL: LEG/HOL!
F/DAY: F ADM: Y ADULT: $1.00 CHILDREN: $.75 STUDENTS: $0.75 SR CIT: $1.00
⑤: Y ⑫ Y; F on street and municipal lot MUS/SH: Y H/B: Y
PERM/COLL: PORTMOUTH NATIVE ARTIST CLARENCE CARTER; ANT: doll heads

Constructed in 1918, this beaux art design building is located in the heart of Portsmouth.

ON EXHIBIT/97:

ONGOING	CLARENCE HOLBROOK CARTER: THE PERMANENT COLLECTION
02/01/97–03/15/97	LASTING IMPRESSIONS — Contemporary and historic prints from the Ohio University print collection and from the Huntington Museum of Art.
03/22/97–05/03/97	ARTICLES OF FAITH — Religious themes in contemporary art.
07/05/97–08/17/97	BEST OF SHOW: OHIO DESIGNER CRAFTSMEN — The finest work from Ohio's professional craftspeople.
11/04/97–01/07/98	WILLARD READER RETROSPECTIVE — Oil paintings and watercolors by a highly acclaimed local artist.

Springfield

Springfield Museum of Art

107 Cliff Park Road, **Springfield, OH 45501**
☎ 513-325-4673
HRS: 9-5 Tu, T, F; 9-9 W; 9-3 Sa; 2-4 S DAY CLOSED: M HOL: GOOD FRI, THGV WEEKEND, 12/24-1/1
⑤: Y ⑫ Y MUS/SH: Y
GR/T: Y GR/PH: CATR!
PERM/COLL: AM & EU: 19, 20; ROOKWOOD POTTERY; REG: ptgs, works on paper

Located in Cliff Park along Buck Creek in downtown Springfield, this nearly 50 year old institution is a major and growing arts resource for the people or Southwest Ohio. Its 1,000 piece permanent collection attempts to provide a comprehensive survey of American art enhanced by works that represent all of the key movements in the development of Western art during the past two centuries. **NOT TO BE MISSED:** Gilbert Stuart's "Portrait of William Miller," 1795

ON EXHIBIT/97:

01/11/97–02/23/97	KEVIN EVERSON: PHOTOGRAPHS AND CONSTRUCTIONS
01/11/97–02/23/97	RALPH BELL: FOLK ARTIST
03/01/97–04/06/97	BUKANG KIM: RECENT PAINTINGS
04/19/97–05/25/97	HOW GREAT THOU ART
04/19/97–05/25/97	SAM MARTINEAU: RECENT PAINTINGS
06/07/97–08/17/97	DANIEL KANIESS: PAINTINGS AND DRAWINGS
07/97–08/17/97	ANNUAL MEMBER'S JURIED EXHIBITION
08/23/97–10/05/97	DEBORAH MORRISEY MCGOFF: PAINTINGS
10/11/97–11/30/97	HISTORIC OHIO QUILTS FROM THE MINA WHITE COLLECTION
12/06/97–01/11/98	THE WESTERN OHIO WATERCOLOR SOCIETY JURIED EXHIBITION

OHIO

Toledo

The Toledo Museum of Art
2445 Monroe Street, Toledo, OH 43697
☎ 419-255-8000
HRS: 10-4 Tu-T, Sa; 10-9 F; 1-5 S DAY CLOSED: M HOL: 1/1, 7/4, THGV, 12/25
&: Y ℗ Y; $1.00 in lot on Grove St. MUS/SH: Y ⊪ Y
GR/T: Y GR/PH: CATR! H/B: Y
PERM/COLL: EU: glass, ptgs, sculp, dec/art; AM: ptgs

Founded in 1901 by Edward Drummond Libbey who brought the glass industry to Toledo, the museum is internationally known for its broad ranging collections. Edward Green, who designed the perfectly proportioned neo-classical building in the early 1900's, added symmetrical wings to his own design in the 20's and 30's. Celebrated architect Frank Gehry designed the adjacent Center for the Visual Arts which opened early in 1993. **NOT TO BE MISSED:** "The Crowning of St. Catherine," Peter Paul Rubens, 1633.

ON EXHIBIT/97:

01/23/97–04/27/97	RUSSIA AFTER THE TEARS: PRINTS, PHOTOGRAPHS AND BOOKS
02/16/97–05/11/97	BRITISH ART TREASURES FROM RUSSIAN IMPERIAL COLLECTIONS IN THE HERMITAGE — Coinciding with the bicentennial of the death of Catherine the Great, British masterworks (including paintings by Van Dyck, Reynolds, Lawrence, and Wright of Derby, sculptures, silver, ceramics and gems) from the collection of the State Hermitage Museum in St. Petersburg, Russia will be seen in the first major traveling exhibition of its kind. CAT WT
04/15/97–07/20/97	YOSHIDA HIROSHI: MASTER PRINTMAKER
07/13/97–09/07/97	TOLEDO AREA ARTISTS: 79TH ANNUAL EXHIBITION

Youngstown

The Butler Institute of American Art
524 Wick Ave, Youngstown, OH 44502
☎ 330-743-1711 WEB ADDRESS: http://www.butlerart.com
HRS: 11-4 Tu, T-Sa; 11-8 W; 12-4 S DAY CLOSED: M HOL: 1/1, EASTER, 7/4, THGV, 12/25
&: Y; Parking, ramps, restrooms, elevators ℗ Y; Adjacent MUS/SH: Y ⊪ Y
GR/T: Y GR/PH: CATR! H/B: Y S/G: Y
PERM/COLL: AM: ptgs 19, 20; EARLY/AM: marine coll; AM/IMPR; WESTERN ART; AM: sports art

Dedicated exclusively to American Art, this exceptional museum, containing numerous national artistic treasures, is often referred to as "America's Museum." housed in a McKim, Mead and White building this was the first structure erected in the United States to house a collection of American art. **NOT TO BE MISSED:** Winslow Homer's "Snap the Whip," 1872, oil on canvas

ON EXHIBIT/97:

BUTLER INSTITUTE OF AMERICAN ART/SALEM, 343 East State St. Salem, Oh 44460, 330-332-8213

BUTLER INSTITUTE OF AMERICAN ART/TRUMBULL, 9350 East Market Street Howland, OH 44484, 330-609-9900

Both satellite museums have hours 11-4 T, F; 10-3 Sa; 12-4 S, Closed Leg/Hols

02/16/97–08/20/97	WOLF KAHN
03/16/97–06/08/97	ROBERT NATKIN
05/04/97–06/15/97	HERB OLDS
06/22/97–09/17/97	BEN SCHONZEIT

Zanesville

Zanesville Art Center
620 Military Road, **Zanesville, OH 43701**
☎ 614-452-0741
HRS: 1-5 Tu-S DAY CLOSED: M HOL: LEG/HOL!
&: Y Ⓟ Y MUS/SH: Y
GR/T: Y GR/PH: CATR!
PERM/COLL: ZANESVILLE: cer; HAND BLOWN EARLY GLASS; CONT; EU

In addition to the largest public display of Zanesville pottery (Weller, Rosedale & J. B. Owens), the Art Center also has a generally eclectic collection including Old and Modern Masters, African, Oriental and European art. **NOT TO BE MISSED:** Rare areas (unique) hand blown glass & art pottery

OKLAHOMA

Ardmore

Charles B. Goddard Center for Visual and Performing Arts
First Ave & D Street SW, **Ardmore, OK 73401**
📞 405-226-0909
HRS: 9-4 M-F; 1-4 Sa, S HOL: LEG/HOL!
&: Y; North parking and entrance ℗ Y
GR/T: Y GR/PH: CATR!
PERM/COLL: PTGS, SCULP, GR, CONT 20; AM: West/art; NAT/AM

Works of art by Oklahoma artists as well as those from across the United States & Europe are featured in this multi-cultural center.

Bartlesville

Woolaroc Museum
Affiliate Institution: The Frank Phillips Foundation, Inc
State Highway, 123, **Bartlesville, OK 74003**
📞 918-336-0307
HRS: 10-5 Tu-S; Mem day-Lab day 10-5 daily DAY CLOSED: M HOL: THGV, 12/25
ADM: Y ADULT: $4.00 CHILDREN: F (under 16) SR CIT: $3.00
&: Y; Wheelchair access in public areas and restrooms ℗ Y
MUS/SH: Y
🍴 Y; Snack bar w/sandwiches, etc. H/B: Y
PERM/COLL: WEST: ptgs; sculp

Brilliant mosaics surround the doors of this museum situated in a wildlife preserve. The large Western art collection includes works by Remington, Russell, Leigh and others. In addition to the completely restored original country home of oilman Frank Phillips called his Lodge (built in 1926-27), the Woolaroc monoplane, winner of the 1927 race across the Pacific to Hawaii is another of the attractions at this facility.

Muskogee

The Five Civilized Tribes Museum
Agency Hill, Honor Heights Drive, **Muskogee, OK 74401**
📞 918-683-1701
HRS: 10-5 M-Sa, 1-5 S HOL: 1/1, THGV, 12/25
ADM: Y ADULT: $2.00 CHILDREN: F (under 6) STUDENTS: $1.00
&: Y ℗ Y
MUS/SH: Y
GR/T: Y GR/PH: CATR!
H/B: Y
PERM/COLL: NAT/AM

Built in 1875 by the US Government as the Union Indian Agency, this museum was the first structure ever erected to house the Superintendency of the Cherokee, Chickasaw, Choctaw, Creek and Seminole Tribes.

Norman

The Fred Jones Jr. Museum of Art

Affiliate Institution: University of Oklahoma
410 West Boyd Street, **Norman, OK 73019**
☎ 405-325-3272
HRS: 10-4:30 Tu, W, F; 10-9 T; 1-4:30 Sa, S: Summer 12-4:30 Tu-S DAY CLOSED: M
HOL: LEG/HOL!; ACAD!; HOME FOOTBALL GAMES 10-kickoff
&: Y ℗ Y; Free passes available at admission desk MUS/SH: Y GR/T: Y GR/PH: CATR!
PERM/COLL: AM: cont/ptgs; PRIM; OR; gr; PHOT; NAT/AM

Considered one of the finest university museums in the country with a diverse permanent collection of nearly 6000 objects, this facility also hosts the state's most challenging exhibitions of contemporary art. **NOT TO BE MISSED:** Dame Barbara Hepworth's "Two Figures" bronze, 1968

ON EXHIBIT/97: Exhibition schedule unavailable because of renovations. Call for information!
 01/12/97–02/16/97 TBA

 03/01/97–04/08/97 THROUGH AN OPEN DOOR: SELECTIONS FROM THE ROBERT A HEFNER
 COLLECTION OF CONTEMPORARY CHINESE OIL PAINTING

Oklahoma City

National Cowboy Hall of Fame and Western Heritage Center

1700 N.E. 63rd Street, **Oklahoma City, OK 73111**
☎ 405-478-2250
HRS: 9-5 daily (Lab/Day-Mem/Day); 8:30-6 daily (Mem/Day-Lab/Day) HOL: 1/1, THGV, 12/25
ADM: Y ADULT: $6.50 CHILDREN: $3.25 (under 18) SR CIT: $5.50
&: Y MUS/SH: Y GR/T: Y GR/PH: CATR!
PERM/COLL: WEST/ART

Housing the largest collection of contemporary Western art available for public view, this unusual and unique museum features work by Frederic Remington, Charles M. Russell, Charles Schreyvogel, Nicolai Fechin, and examples from the Taos School. Many cowboy and American Indian historical exhibits are mounted with works from the Museum's impressive permanent holdings.

Oklahoma City Art Museum

3113 Pershing Blvd, **Oklahoma City, OK 73107**
☎ 405-946-4477
HRS: 10-5 Tu-Sa, 1-5 S; Fairgrounds 10-8 T; Artsplace 10-5 DAY CLOSED: M HOL: LEG/HOL!
ADM: Y ADULT: $3.50 CHILDREN: F (under 12) STUDENTS: $2.50 SR CIT: $2.50
&: Y ℗ Y MUS/SH: Y & First National Center ⑪ Lobby Bistro GR/T: Y GR/PH: CATR! S/G: Y
PERM/COLL: AM: ptgs, gr 19, 20; ASHCAN SCHOOL COLLECTION

The Museum complex includes the Oklahoma City Art Museum at the Fairgrounds built in 1958, (where the design of the building is a perfect circle with the sculpture court in the middle), and the Oklahoma City Museum in the 1937 Buttram Mansion. **NOT TO BE MISSED:** Works by Washington color school painters and area figurative artists are included in the collection of modern art from the former Washington Gallery.

ON EXHIBIT/97:
 09/13/97–01/10/98 BRITISH DELFT FROM COLONIAL WILLIAMSBURG — Though offering a rude
 simulation of the Chinese porcelain that it imitated, British Delft soon took on a character
 and style all its own. The objects on view demonstrate that what began as a simple imitation
 evolved into an art form in its own right. WT

331

OKLAHOMA

Oklahoma City

Omniplex
2100 NE 52nd, **Oklahoma City, OK 73111**
☎ 405-427-5461
HRS: 9-6 M-Sa, 11-6 S (Mem/Day-Lab/Day); 9:00-5 M-F, 9-6 Sa, 11-6 S(Winter months) HOL: THGV, 12/25
ADM: Y ADULT: $6.50 + tax CHILDREN: $4.00 + tax (3-12) STUDENTS: $6.50 SR CIT: $4.00
&: Y ℗ Y; Free MUS/SH: Y ⏸ Y; Limited GR/T: Y GR/PH: CATR! 405-424-0066
PERM/COLL: VARIED; REG; AF; AS

In addition to numerous exhibition galleries the former Kirkpatrick center, now Omniplex, includes the Kirkpatrick Science and Air Space Museum, the International Photography Hall of Fame and Museum, Red Earth Indian Center, the Kirkpatrick Planetarium, and the Conservatory and Botanical Garden. **NOT TO BE MISSED:** Sections of the Berlin Wall

Shawnee

Mabee-Gerrer Museum of Art
1900 West MacArthur Drive, **Shawnee, OK 74801**
☎ 405-878-5300
HRS: 1-4 Tu-S HOL: 1/1, GOOD FRI, HOLY SAT, EASTER, THGV, 12/25
&: Y; Ground level ramp access from parking ℗ Y; Free ⏸ Y
GR/T: Y GR/PH: CATR! S/G: Y
PERM/COLL: EU: ptgs (Med-20); AN/EGT; NAT/AM; GRECO/ROMAN; AM: ptgs

The oldest museum collection in Oklahoma is housed in the newest built facility, featuring earth derm technology and a pyramid roof. **NOT TO BE MISSED:** Mummy of the Egyptian Princess Henne, 32nd Dynasty (1332 BC)

Tulsa

Gilcrease Museum
1400 Gilcrease Museum Road, **Tulsa, OK 74127-2100**
☎ 918-596-2700
HRS: 9-5 Tu-Sa; 1-5 S and Holidays; Mem Day-Lab Day open M DAY CLOSED: M Sept HOL: 12/25
ADM: Y ADULT: $3.00 (Fam $5) CHILDREN: F (under 18)
&: Y ℗ Y; Free
MUS/SH: Y ⏸ Y
GR/T: Y GR/PH: CATR! DT: Y TIME: 2 PM daily
PERM/COLL: THOMAS MORAN, FREDERIC REMINGTON, C.M. RUSSELL, ALBERT BIERSTADT, ALFRED JACOB MILLER, GEORGE CATLIN, THOMAS EAKINS

Virtually every item in the Gilcrease Collection relates to the discovery, expansion and settlement of North America, with special emphasis on the Old West and the American Indian. The Museum's 440 acre grounds include historic theme gardens. **NOT TO BE MISSED:** 'Acoma', by Thomas Moran

ON EXHIBIT/97:

03/16/97–05/04/97	ART FROM THE DRIVER'S SEAT: AMERICANS AND THEIR CARS — Paintings, drawings, photographs and etchings from the Terry and Eva Herndon Collection will be featured in an exhibition that allows the visitor to look into the rear view mirror at the history of America's relationship with the automobile. CAT WT
04/25/97–07/06/97	GILCREASE RENDEZVOUS 1997 — Retrospective as well as new works by featured artists, painter Clyde Aspevig and sculptor Steve Kestrell.

Tulsa

The Philbrook Museum of Art Inc
2727 South Rockford Road, **Tulsa, OK 74114**
☎ 918-749-7941
HRS: 10-5 Tu-Sa, 10-8 T, 11-5 S DAY CLOSED: M HOL: 1/1, THGV, 12/25
ADM: Y ADULT: $4.00 CHILDREN: F (under 12) STUDENTS: $2.00 SR CIT: $2.00
&: Y ℗ Y; Free
MUS/SH: Y ⅋ Y; 11-2 Tu-S;
GR/T: Y GR/PH: CATR! 918-749-5309 H/B: Y S/G: Y
PERM/COLL: NAT/AM; IT/REN: ptgs, sculp; EU & AM: ptgs 19-20;

An Italian Renaissance style villa built in 1927 on 23 acres of formal and informal gardens and grounds houses a collection of more than 8000 works from around the world more than half of which are by Native-Americans. Visitors enter a 75,000 square foot addition via a striking rotunda which was completed in 1990 and is used for special exhibitions, a shop, a restaurant, and a school.

ON EXHIBIT/97:

09/29/96–01/19/97	TWENTIETH CENTURY DRAWINGS FROM THE PHILBROOK COLLECTION — Ranging from impressionistic sketches to highly finished drawings, this exhibition features a wide range of styles and media and includes works by Doel Reed, Alexandre Hogue, Rackstraw Downs, Reginald Marsh and others.
10/31/96–04/13/97	NATIVE AMERICAN PRINTS AND DRAWINGS
01/01/97–05/12/97	PRINTS AND DRAWINGS FROM THE NATIVE AMERICAN COLLECTION
01/12/97–05/04/97	OKLAHOMA PRINTMAKERS: A SELECTION OF PRINTS FROM THE 1930'S AND 1940'S
01/19/97–03/09/97	AMERICA SEEN: PEOPLE AND PLACE — The American experience of the 1920's through the 1950's is explored through 78 paintings, prints and photographs. Included are works by Grant Wood, Norman Rockwell, John Stuart Curry, Thomas Hart Benton and others who document two world wars, the Great Depression, the New Deal, the growth of the American city and the nostalgia for simple rural life.
01/26/97–05/11/97	OKLAHOMA PORTRAIT: PHOTOGRAPHS BY RUSSELL LEE — One of America's most esteemed photographers documents the hardships and strength of Oklahomans during the Great Depression.
02/01/97–/98	PEOPLE OF THE PRAIRIE Dates Tent!
04/13/97–05/25/97	JANET FISH PAINTINGS — The large scale watercolors and oil paintings completed in the last decade by one of America's foremost realists are showcased here. Included are still lifes for which the artist is best known as well as landscape and figurative paintings.
04/17/97–06/01/97	OKLAHOMA INDIAN ART COMPETITION
05/11/97–09/21/97	PORTRAITURE IN PRINT — A survey of portraits in etchings, lithographs and engravings spanning the 18th through the 20th centuries includes some of the greatest names in that field – Nanteuil, Manet, Whistler, Bellows, and Kollwitz.
05/18/97–09/28/97	SELECTIONS FROM THE STANDARD OIL COMPANY COLLECTION — Showcased in this major corporate collection gifted to the Philbrook in the 1950's will be major works by Benton, Dehn, Hurd, Doris Lee and others.
06/08/97–/98	PAINTINGS FROM THE BACONE SCHOOL Dates Tent!
06/22/97–08/17/97	CONTEMPORARY VENEZUELAN ART Dates Tent!
09/14/97–11/09/97	AMERICAN STILL LIFE AND INTERIORS, 1915-1994: SELECTIONS FROM THE METROPOLITAN MUSEUM OF ART — The vitality of still-life painting in the 20th-century is celebrated in this exhibition of 62 works by 57 artists including Stuart Davis, Jim Dine, Marsden Hartley, Georgia O'Keeffe, Rosenquist and Warhol.
09/28/97–01/18/98	THE BRITISH ETCHING REVIVAL — The 19th-century in Britain saw renewed appreciation for etching. Artists, who consciously sought to emulate the Old Masters, extended this nostalgia well into the 20th-century as will be seen in the etchings on exhibit.
10/05/97–01/11/98	CONTEMPORARY PRINTS FROM THE PHILBROOK COLLECTION

OREGON

Coos Bay

Coos Art Museum
235 Anderson, **Coos Bay, OR 97420**
☎ 541-267-3901
HRS: 11-5 Tu-F, 1-4 Sa DAY CLOSED: S, M HOL: LEG/HOL!
&: Y; Complete facilities Ⓟ Y; Free MUS/SH: Y H/B: Y
PERM/COLL: CONT: ptgs, sculp, gr; AM; REG

This cultural center of Southwestern Oregon is the only art museum on the Oregon coast. It's collection includes work by Robert Rauschenberg, Red Grooms, Larry Rivers, Frank Boyden, Henk Pander and Manuel Izquierdo. Newly added is the Prefontaine Room, a special memorial to the late Olympic track star who was a native of Coos Bay. **NOT TO BE MISSED:** "Mango, Mango," by Red Grooms

ON EXHIBIT/97:

01/24/97–03/01/97	PUBLIC HANGING
04/04/97–05/10/97	ARTISAN SHOWCASE/SOUTH SLOUGH NATIONAL RESERVE CENTER'S PHOTOGRAPHY EXHIBIT
07/11/97–09/06/97	MARITIME SHOW
09/12/97–10/25/97	JERRY BARON/EARL HAMILTON/MICHAEL HOUGH

Eugene

University of Oregon Museum of Art
Affiliate Institution: University of Oregon
1430 Johnson Lane, **Eugene, OR 97403**
☎ 541-346-3027
HRS: 12-5 W-S DAY CLOSED: M, Tu HOL: ACAD!, 1/1, 7/4, THGV, 12/25
&: Y MUS/SH: Y GR/T: Y GR/PH: CATR! H/B: Y S/G: Y
PERM/COLL: CONT: ptgs, phot, gr, cer; NAT/AM

Visitors may enjoy one of the premier art experiences in the Pacific Northwest at this university museum whose collection features more than 12,500 objects from throughout the world as well as contemporary Northwest art and photography.

ON EXHIBIT/97:

09/08/96–06/97	SCULPTURE BY AUGUSTE RODIN — A reinstallation of the 27 bronzes on loan from the Stanford University Museum of Art.
01/10/97–03/09/97	FRAGRANCE OF INK: KOREAN LITERATI PAINTINGS OF THE CHOSEN DYNASTY — On loan from the Korea University Museum in Seoul, these 62 rare works including ink paintings, hanging scrolls, album leaves, fans and screens are examples of some of the most significant painters of the Choson period and have never before been on view outside Korea. They encompass some of the most prominent stylistic developments of Korean painting, including the 17th century "true view" landscape style. WT
01/10/97–02/28/97	TREASURES FROM THE KOREAN COLLECTION
03/07/97–04/26/97	LONG LIFE! AUSPICIOUS WISHES IN EAST ASIAN ART — Drawn from the collection, this exhibition of Chinese, Japanese, and Korean art centers on the theme of longevity and suspiciousness.
06/14/97–10/10/97	GERTRUDE BASS WARNER AND THE FOUNDING OF THE UOMA — In celebration of the Museum's 65th Anniversary, this exhibition focuses on the contribution of Warner to the Museum, University and State of Oregon.

Klamath Falls

Favell Museum of Western Art and Indian Artifacts
125 West Main Street, **Klamath Falls, OR 97601**
☎ 541-882-9996
HRS: 9:30-5:30 M-Sa DAY CLOSED: S HOL: LEG/HOL!
ADM: Y ADULT: $4.00 CHILDREN: $2.00 (5-16) SR CIT: $3.00
&: Y ℗ Y MUS/SH: Y
PERM/COLL: CONT/WEST: art; NAT/AM; ARTIFACTS; MINI FIREARMS

The museum, built on an historic campsite of the Klamath Indians, contains numerous artifacts – some of which have been incorporated into the stone walls of the museum building itself.

Portland

The Douglas F. Cooley Memorial Art Gallery
Affiliate Institution: Reed College
3203 S.E. Woodstock Blvd., **Portland, OR 97202-8199**
☎ 503-777-7790
HRS: 12-5 Tu-S HOL: LEG/HOL!
&: Y ℗ Y; Adjacent
PERM/COLL: AM: 20; EU: 19

The gallery is committed to a program that fosters a spirit of inquiry and questions the status quo.

Portland Art Museum
1219 S.W. Park Ave., **Portland, OR 97205**
☎ 503-226-2811
HRS: 10-5 Tu-S, 10-9 W & 1st T DAY CLOSED: M HOL: LEG/HOL!
ADM: Y ADULT: $6.00 CHILDREN: F (under 5) STUDENTS: $2.50 SR CIT: $4.50
&: Y; Ramp to main lobby, elevator to all floors MUS/SH: Y GR/T: Y GR/PH: CATR! H/B: Y
PERM/COLL: NAT/AM; P/COL; AS; GR; EU & AM: ptgs; CONT: ptgs

Designed by Pietro Belluschi, the Portland Art Museum, with a permanent collection that spans 35 centuries of international art, is the region's oldest and largest visual arts and media center. The museum also hosts a Jazz series, Museum After Hours, and presents Art/On the Edge performance art programs.

ON EXHIBIT/97:

11/26/96–01/26/97	DISCOVERING ELLIS RULEY — On view in this first-time retrospective will be over 60 folk artworks by Ruley, a self-taught African-American artist unknown in his lifetime, whose paintings were inspired by animals in the woods, and were created by using ordinary house paint on posterboard. WT
01/27/97–03/30/97	VENETIAN PAINTINGS FROM THE SARAH CAMPBELL BLAFFER FOUNDATION — Italian Old Master paintings by Tintoretto, Veronese, Tiepolo, Guardi and others explore mythological, religious, allegorical and secular themes. WT
02/15/97–05/11/97	INTERNATIONAL PRINT EXHIBITION — An invitational and juried exhibition.
MID/97–MID/97	HOSPICE: A PHOTOGRAPHIC INQUIRY — The photographs of Jim Goldberg, Nan Goldin, Sally Mann, Jack Radcliffe and Kathy Vargas detailing the emotional and collaborative experience of living and working in hospices in different regions of the country will be seen in this exhibition specially commissioned by the Corcoran. Their works will touch upon every aspect of hospice care revealing the spiritual, emotional and physical needs of the terminally ill and their families. WT

OREGON

Portland Art Museum -continued

04/05/97–06/01/97 MUNCH AND WOMEN: IMAGE AND MYTH — Nearly 74 prints by Munch, considered one of the pioneers of European Modernism, will be seen in an exhibition that reveals some of the artist's more positive images of women. CAT WT

04/05/97–06/01/97 GOLD, JADE, AND FORESTS: PRE-COLUMBIAN TREASURES OF COSTA RICA — 140 precious objects that reflect traditional cultural pre-Columbian Costa Rican depictions of human and animal figures will be highlighted in an exhibit that features objects of gold, jade, stone, and pottery. WT

05/24/97–07/27/97 BEING AND TIME: THE EMERGENCE OF VIDEO PRODUCTION — 6 room-sized installations of projected video by acknowledged masters, Gary Hill, Bruce Nauman and Bill Viola will be presented with those of 3 younger artists in an exhibition designed to challenge the limits of the medium. WT

Warm Springs

The Museum at Warm Springs Oregon
Affiliate Institution: Confederated Tribes of the Warm Springs Reservation
Warm Springs, OR 97761
✆ 541-553-3331
HRS: 10-5 daily HOL: 12/25, 1/1, THGV
ADM: Y ADULT: $6.00 CHILDREN: $3.00 (5-12) SR CIT: $5.00
♿: Y; Fully wheelchair accessible Ⓟ Y
MUS/SH: Y
GR/T: Y GR/PH: CATR!
PERM/COLL: NAT/AM: art, phot, artifacts

The Museum at Warm Springs draws from a rich collection of native artwork, photographs and stories that tell the long history of the three tribes (Wasco, Warm Springs and Paiute) comprising the Confederated Tribes of Warm Springs. The unusual building is architecturally designed to evoke a creekside encampment among a stand of cottonwoods. **NOT TO BE MISSED:** A trio of traditional buildings built by tribal members; the tule mat wickiup, or house of the Paiutes, the Warm Springs summer teepee, and the Wasco wooden plank house.

ON EXHIBIT/97:

09/27/96–01/17/97 ARTIFACTS AND PICTURE COLLECTIONS FROM THE MUSEUM

01/29/97–03/07/97 INDIAN HUMOR

03/13/97–04/25/97 4TH WARM SPRINGS COMMUNITY ART SHOW

05/02/97–06/27/97 4TH TRIBAL MEMBER ART SHOW

07/02/97–09/02/97 GLASS TAPESTRY: PLATEAU BEADED BAGS FROM THE ELAINE HORWITCH COLLECTION — The history of beaded bags and the cultures of the Columbia Plateau region will be seen in a display of 240 late 19th to early 20th-century woven root bags accompanied by a small number of gloves. WT

09/12/97–12/15/97 PARFLETCH'S AND ABSTRACT PAINTINGS

Allentown

Allentown Art Museum
Fifth & Court Street, **Allentown, PA 18105**
☎ 610-432-4333
HRS: 10-5 Tu-Sa, 12-5 S DAY CLOSED: M HOL: LEG/HOL!
ADM: Y ADULT: $3.50 CHILDREN: F (under 12) STUDENTS: $2.00 SR CIT: $3.00
&: Y MUS/SH: Y GR/T: Y GR/PH: CATR!
PERM/COLL: EU: Kress Coll; AM; FRANK LLOYD WRIGHT: library; OM: gr

Discover the intricate and visual riches of the Allentown, one of the finest small art museums in the country. **NOT TO BE MISSED:** "Piazetti in Venice," by Canaletto

ON EXHIBIT/97:	All dates subject to change !
11/22/96–02/02/97	MASTERWORKS IN METAL: 20TH CENTURY SCULPTURE — An exploration of the historical context and process innovation of major modern sculptors including Baskin, Calder, Hepworth, Lipton and Zorach.
12/06/96–02/23/97	WINTER IN JAPANESE PRINTS — Twenty color wood-block prints from the Museum's collection.
01/19/97–03/23/97	PENNSYLVANIA PHOTOGRAPHERS 10 — A biennial reviewing the best work done in the two year period by artists living or working in Pennsylvania.
01/19/97–03/23/97	THE PHOTOGRAPHY COLLECTION IN REVIEW — Presented will be twenty years of photographic works collected by the Museum directly from the selected artists in the "Pennsylvania Photographers" biennial series.
02/07/97–05/11/97	NEEDLE ART OF THE LEHIGH VALLEY — Textiles survey a visual and geneological record of German and Scottish women who settled in the Lehigh Valley during the 18th and 19th centuries.
02/28/97–05/18/97	DAN MASSAD — Works in pastels Massad creates deep, peaceful moments in pictures usually referred to as still lifes.
04/06/97–06/22/97	JUDITH JOY ROSS — A mid-career retrospective of 8 x 10 photographs organized in conjunction with the publication of Ross's first monograph by MOMA.
04/06/97–06/22/97	CHARLES SHEELER IN DOYLESTOWN: AMERICAN MODERNISM AND THE PENNSYLVANIA TRADITION — American modernist's Sheeler's approach to the vernacular of Pennsylvania architecture and artifacts will be addressed in this exhibition. WT
05/16/97–08/16/97	WINDS OF THE AEGEAN: GREEK EMBROIDERY FROM THE COLLECTION — A display of needlework traditions from the Greek islands and mainland.

Audubon

Mill Grove, the Audubon Wildlife Sanctuary
Paulings and Audubon Roads, **Audubon, PA 19407-7125**
☎ 610-666-5593
HRS: 10-4 Tu-Sa, 1-4 S; grounds open dawn to dusk HOL: 1/1, EASTER, THGV, 12/25
VOL/CONT: Y
Ⓟ Y MUS/SH: Y GR/T: Y GR/PH: CATR! H/B: Y
PERM/COLL: JOHN JAMES AUDUBON: all major published artwork (complete 19th century editions)

Housed in the 1762 National Historic Landmark building which was the first American home of John James Audubon, this site is also a wildlife sanctuary complete with nature trails and feeding stations.

PENNSYLVANIA

Bethlehem

Lehigh University Art Galleries
17 Memorial Drive East, **Bethlehem, PA 18015-3007**
☎ 610-758-3615
HRS: 9-5 M-F, 9-12 Sa, 2-5 S; Some galleries are open late, others closed weekend HOL: LEG/HOL!
&: Y ℗ Y; Limited ⵏⵏ Y; In Iacocca Bldg. open until 2 PM
GR/T: Y GR/PH: CATR! S/G: Y
PERM/COLL: EU & AM: ptgs; JAP: gr; PHOT

More than 20 temporary exhibitions a year in five campus galleries introduce students and the community to current topics in art, architecture, history, science and technology. PLEASE NOTE: The Galleries do not permanently exhibit the important works in its collections. Call to inquire.

ON EXHIBIT/97: More than 20 temporary exhibitions a year in five campus galleries introduce students and the community to current topics in art, architecture, history, science and technology.

Bryn Athyn

Glencairn Museum: Academy of the New Church
1001 Cathedral Road, **Bryn Athyn, PA 19009**
☎ 215-947-9919
HRS: 9-5 M-F by appt, 2-5 second S each month (except Jul & Aug) DAY CLOSED: Sa HOL: LEG/HOL!
ADM: Y ADULT: $4.00 CHILDREN: $2.00 STUDENTS: $2.00 SR CIT: $3.00
&: Y ℗ Y GR/T: Y GR/PH: CATR!
PERM/COLL: MED, GOTHIC & ROMANESQUE: sculp; STAINED GLASS; EGT, GRK & ROMAN: cer, sculp; NAT/AM

Glencairn, the former home of Raymond and Mildred Pitcarin, is a unique structure built in the Romanesque style using building processes unknown since the middle ages. **NOT TO BE MISSED:** French Medieval stained glass and sculpture

Carlisle

Trout Art Gallery
Affiliate Institution: Dickinson College
High Street, **Carlisle, PA 17013**
☎ 717-245-1344
HRS: 10-4 Tu-S HOL: LEG/HOL!; ACAD!
&: Y ℗ Y
GR/T: Y GR/PH: CATR!
PERM/COLL: GR; 19, 20; AF

The exhibitions and collections here emphasize all periods of art history. **NOT TO BE MISSED:** Gerofsky Collection of African Art and the Carnegie Collection of prints. Rodin's "St. John the Baptist" and other gifts from Meyer P. and Vivian Potamkin.

ON EXHIBIT/97:
01/31/97–03/15/97 ART HISTORICAL METHODS EXHIBITION (portraits from the permanent collection)

04/04/97–06/14/97 FAMILIAR PLACES: AMERICAN IMPRESSIONISTS'VIEWS OF HOME AND LAND IN THE AMERICAN SUBURB, COUNTRYSIDE AND SUMMER RESORT TOWN

Chadds Ford

Brandywine River Museum
U.S. Route 1, **Chadds Ford, PA 19317**
☎ 610-388-2700
HRS: 9:30-4:30 Daily HOL: 12/25
ADM: Y ADULT: $5.00 CHILDREN: F (under 6) STUDENTS: $2.50 SR CIT: $2.50
&: Y Ⓟ Y MUS/SH: Y ⑪ Y; 11-3 (Closed M and Tu Jan through Mar)
GR/T: Y GR/PH: CATR! H/B: Y
PERM/COLL: AM: ptgs by three generations of the Wyeth Family

Situated in a pastoral setting in a charming converted 19th-century grist mill, this museum is devoted to displaying the works of three generations of the Wyeth family and other Brandywine River School artists. Particular focus is also placed on 19th century American still-life & landscape paintings and on works of American illustration.

ON EXHIBIT/97:

01/18/97–03/16/97	OF THE BEST SORT, BUT PLAIN: DELAWARE VALLEY QUAKER QUILTS
03/22/97–05/18/97	THE SHIP PORTRAITS AND MARINE PAINTINGS OF ALEXANDER CHARLES STUART
05/24/97–08/10/97	EARLY ENGLISH WINE GLASSES AND DECANTERS
05/31/97–09/01/97	TBA
09/07/97–11/23/97	THE BEN EISENSTAT COLLECTION: AN OUTGROWTH OF TEACHING AMERICAN ILLUSTRATION
11/28/97–01/04/98	IMAGES OF SNOW WHITE — Concurrently with "Snow White" will be the annual "BRANDYWINE CHRISTMAS" featuring this year's addition of the " DONALD PYWELL JEWELRY FROM THE COLLECTION OF BETSY JAMES WYETH."

Chester

Widener University Art Museum
Affiliate Institution: Widener University
1300 Potter Street, **Chester, PA 19013**
☎ 610-499-1189
HRS: 10-4 Tu-Sa; Closed July DAY CLOSED: S, M HOL: LEG/HOL!, Month of July
MUS/SH: Y
GR/T: Y GR/PH: CATR!
PERM/COLL: AM & EU: ptgs 19, 20

A Georgian style building on the main campus of Widener University is the home of this museum, which includes in its holdings the Widener University Collection of American Impressionist paintings and the Alfred O. Deshong Collection of 19th and 20th-century European and American painting. PLEASE NOTE: Children under 16 must be accompanied by an adult.

ON EXHIBIT/97:

01/14/97–02/15/97	PAINTINGS BY DAVID SHEVLINO
02/25/97–03/27/97	PAINTINGS BY JAMES WILLIAMS

PENNSYLVANIA

Collegeville

Philip and Muriel Berman Museum of Art
Affiliate Institution: Ursinus College
Main Street, **Collegeville, PA 19426-1000**
☎ 610-409-3500
HRS: 10-4 Tu-F; Noon-4:30 Sa, S HOL: LEG/HOL!
&: Y ℗ Y; On campus adjacent to Museum GR/T: Y GR/PH: CATR! DT: Y TIME: ! H/B: Y S/G: Y
PERM/COLL: AM: ptgs 19, 20; EU: ptgs 18; JAP: ptgs; PENNSYLVANIA GERMAN ART: cont outdoor sculp

With 145 works from 1956-1986, the Berman Museum of Art holds the largest private collection of sculpture by Lynn Chadwick in the U.S., all housed in the original Georgian Style stone facade college library built in 1921. **NOT TO BE MISSED:** 'Seated Couple on a Bench' (1986 bronze), by Lynn Chadwick (English b. 1914)

ON EXHIBIT/97:

12/15/96–04/05/97	PHILADELPHIA WATERCOLOR CLUB 96TH ANNIVERSARY — National juried competition.
01/24/97–04/06/97	THE CONTEMPORARY LANDSCAPE — Paintings and sculpture by 8 artists based in the Philadelphia area focusing on the landscape genre.　　　WT
04/97–05/97	EAST ASIAN ART AND ARTIFACTS
06/97–08/97	SPOTLIGHT: TRACY PEDERSON — Wildlife and botanical illustrations on themes from the South American rain forest.
09/25/97–11/30/97	CHALLENGE VI: LATHE-TURNED OBJECTS
11/01/97–01/12/98	LANDSCAPE PHOTOGRAPHY BY JOAN Z. ROUGH

Doylestown

James A. Michener Art Museum
138 South Pine Street, **Doylestown, PA 18901**
☎ 215-340-9800
HRS: 10-4:30 Tu-F; 10-5 Sa, S DAY CLOSED: M HOL: LEG/HOL!
ADM: Y ADULT: $5.00 CHILDREN: F (under 12) STUDENTS: $1.50 SR CIT: $4.50
&: Y ℗ Y; Free MUS/SH: Y ⑪ Y: Expresso Cafe GR/T: Y GR/PH: CATR! DT: Y TIME: 2 PM S H/B: Y S/G: Y
PERM/COLL: AM: Impr/ptgs 19-20; BUCKS CO: 18-20; AM: Exp 20; SCULP 20; NAKASHIMA READING ROOM

Situated in the handsomely reconstructed buildings of the antiquated Bucks County prison, the Museum, with its recent addition, provides an invigorating environment for viewing a wonderful collection of twentieth-century American art. **NOT TO BE MISSED:** Redfield, Garber & New Hope School

ON EXHIBIT/97:

Permanent installations	CREATIVE BUCKS COUNTY: A CELEBRATION OF ART AND ARTISTS — A multimedia exhibition in the new Mari Sabusawa Michener Wing which tells the story of Bucks County's rich artistic tradition. Included are individual displays on 12 of the country's best known artists, a video theater, and a comprehensive database containing information on hundreds of Bucks County artists, both living and deceased. The featured artists are Pearl S. Buck, Daniel Garber, Oscar Hammerstein II, Moss Hart, Edward Hicks, George S. Kaufman, Henry Chapman Mercer, Dorothy Parker, S. J. Perelman, Charles Sheeler, Edward Redfield, and Jean Toomer.
	JAMES A MICHENER: A LIVING LEGACY — Michener's Bucks County office is installed at the Museum and included are a video, the Presidential Medal of Freedom and the original manuscript of 'The Novel'.
	NAKASHIMA READING ROOM — Classic furniture from the studio of internationally known woodworker George Nakashima.
	VISUAL HERITAGE OF BUCKS COUNTY — A comprehensive exhibition based on the permanent collection which traces art in the region from Colonial times through to the present.

James A. Michener Art Museum - continued

INSIDE OUR VAULT: SELECTIONS FROM THE COLLECTION — A small-scale exhibition of delights and surprises in the Museum's rapidly expanding collection.

10/27/96–01/26/97 NEWMAN'S GIFT: 50 YEARS OF PHOTOGRAPHY — Internationally acclaimed photographer Arnold Newman created "environmental portraits" of prominent post-World War II figures, 100 of which will be featured in this exhibition. WT

12/21/96–03/16/97 THE TACTILE VESSEL — Basketry, a dynamic contemporary art form utilizing a wide range of materials will be showcased in an exhibition of works from the 1980's, all of which demonstrate the continuing vitality of this ancient craft.

02/01/97–05/04/97 BUCKS COUNTY INVITATIONAL — Works by six contemporary regional artists represent the lively and diverse artistic scene.

03/22/97–06/09/97 THE CONTEMPORARY MUSE III: ABSTRACT PAINTING — Several mid-career painters who create evocative, symbolic abstractions will be featured in this ongoing series bringing to Bucks County the best work in the major genres of contemporary art.

05/10/97–08/10/97 FRED STALOFF: 40 YEARS IN RETROSPECT — Staloff's landscape, still life and figurative paintings reveal his poetic and structural approach to color. WT

06/14/97–09/07/97 TWENTIETH ANNIVERSARY BUCKS COUNTY SCULPTURE SHOW — One of the few annual juried exhibitions in the region devoted exclusively to sculpture features both emerging and established artists.

Easton

Lafayette College Art Gallery, Williams Center for the Arts
Hamilton and High Streets, **Easton, PA 18042-1768**
☎ 610-250-5361
HRS: 10-5 Tu-F, 2-5 S Sep-Jun DAY CLOSED: M, Sa HOL: ACAD!
♿: Y Ⓟ Y; On-street
PERM/COLL: AM: ptgs, portraits, gr

Located in Easton, Pennsylvania, on the Delaware River, the collection is spread throughout the campus. **NOT TO BE MISSED:** 19th century American history paintings and portraits

Erie

Erie Art Museum
411 State Street, **Erie, PA 16501**
☎ 814-459-5477
HRS: 11-5 Tu-Sa, 1-5 S DAY CLOSED: M HOL: LEG/HOL!
F/DAY: W ADM: Y ADULT: $1.50 CHILDREN: $.50 (under 12) STUDENTS: $0.75 SR CIT: $0.75
♿: Y Ⓟ Y; Street parking available MUS/SH: Y GR/T: Y GR/PH: CATR! DT: Y TIME: F H/B: Y
PERM/COLL: IND: sculp; OR; AM & EU: ptgs, drgs, sculp gr; PHOT

The museum is located in the 1839 Greek Revival Old Customs House built as the U. S. Bank of PA. Building plans are underway to provide more gallery space in order to exhibit works from the 4,000 piece permanent collection. **NOT TO BE MISSED:** Soft Sculpture installation "The Avalon Restaurant"

ON EXHIBIT/97:

12/31/96–03/09/97 TECHNOLOGY'S SHADOW — An exploration of works created with and about modern technology.

03/15/97–04/17/97 NAKED TRUTH: JOHN SILK DECKARD, SCULPTURES AND PAINTINGS

03/30/97–05/97 FROM THE COLLECTION OF TOM CARAVAGLIA — Photographs of jazz artists.

04/97–06/97 74TH ANNUAL SPRING SHOW: JURIED, MIXED MEDIA

06/97–08/97 HIMALAYAN MEDITATIONS — Outstanding examples from the Museum's collection of thankgas and sculpture.

06/97–08/97 ALFRED STEIGLITZ: CAMERA WORK WT

PENNSYLVANIA

Greensburg

Westmoreland Museum of American Art
221 North Main Street, **Greensburg, PA 15601-1898**
☎ 412-837-1500
HRS: 11-5 W-S, 11-9 T DAY CLOSED: M, Tu HOL: LEG/HOL!
&: Y ℗ Y; Free MUS/SH: Y GR/T: Y GR/PH: CATR! DT: Y TIME: !
PERM/COLL: AM: ptgs (18-20), sculp, drgs, gr, furniture, dec/art

This important collection of American art is located in a beautiful Georgian style building situated on a hill overlooking the city. **NOT TO BE MISSED:** Portraits by William Merritt Chase and Cecilia Beaux; Largest known collection of paintings by 19th-century southwestern Pennsylvania artists.

ON EXHIBIT/97:

02/06/97–03/29/97	THE ANIMAL KINGDOM: CARVED AND CRAFTED CRITTERS AND CREATURES — Unique sculptures by self-taught artists from the Museum collection will be seen with those on loan from private collections in Pennsylvania.
02/16/97–03/29/97	EARL CUNNINGHAM: PAINTING AN AMERICAN EDEN — A self taught artist Cunningham, dubbed the "Grandma Moses of Florida," created his own utopian worlds filled with symbols and visions of a peaceable kingdom. This retrospective includes 46 of his paintings created from the 1920's to his death in 1971.
04/13/97–07/13/97	AN AMERICAN TRADITION: THE PENNSYLVANIA IMPRESSIONISTS — An exploration of the individual stylistic preferences of the premier artists of Bucks County and its environs where a particular brand of American Impressionism flourished in the first decades of the 20th-century.
08/10/97–10/19/97	THE WPA (Works Progress Administration) AND ITS IMPACT ON WESTERN PENNSYLVANIA ARTISTS OF THE 1930'S AND 1940'S — Artists include Roy Hilton, Johanna K. W. Hailman, Philip Elliott, Dorothy Lauer, and others.
11/28/97–01/11/98	HOLIDAY TRAIN AND TOY EXHIBITION: CHRISTMAS PAST, PRESENT AND FUTURE

Harrisburg

The State Museum of Pennsylvania
3rd and North Streets, **Harrisburg, PA 17108-1026**
☎ 717-787-7789
HRS: 9-5 Tu-Sa, 12-5 S DAY CLOSED: M HOL: LEG/HOLS
&: Y MUS/SH: Y
GR/T: Y GR/PH: CATR! 717-772-6997 DT: Y TIME: !
PERM/COLL: VIOLET OAKLEY COLL; PETER ROTHERMEL MILITARY SERIES; PA: cont

A newly renovated Art Gallery collecting, preserving, and interpreting contemporary art & historical works relating to Pennsylvania's history, culture and natural heritage is the main focus of this museum whose collection includes 4000 works of art from 1650 to the present produced by residents/natives of Pennsylvania. **NOT TO BE MISSED:** The 16' x 32' "Battle of Gettysburg: Pickett's Charge," by P. F. Rothermel (the largest battle scene on canvas in North America)

ON EXHIBIT/97:

PERMANENT	COELOPHYSIS DINOSAUR DIORAMA opening 10/97
	DUNKLEOSTEUS EXHIBIT opening fall 96/early 97
01/15/97–04/30/97	CONTEMPORARY ARTIST SERIES
06/97–09/97	ART OF THE STATE '97

Indiana

The University Museum
Affiliate Institution: Indiana University
John Sutton Hall, Indiana University of Penn, **Indiana, PA 15705-1087**
☎ 412-357-7930
HRS: 11-4 Tu-F; 7-9 T; 1-4 Sa, S DAY CLOSED: M HOL: ACAD!
ADULT: $3.00 CHILDREN: F (under 12) STUDENTS: $3.00 SR CIT: $3.00
&: Y ℗ Y GR/T: Y GR/PH: CATR!
PERM/COLL: AM: 19, 20; NAT/AM; MILTON BANCROFT: ptgs & drgs; INUIT: sculp

ON EXHIBIT/97:
01/17/97–02/02/97	GRADUATE ART ASSOCIATION JURIED EXHIBITION
02/04/97–03/28/97	MILTON BANCROFT: EARLY 20TH CENTURY ARTIST — The largest collection in the Museum, Bancroft's works, created in the World War I era, captured the early 1900's both artistically and historically. They will be seen in this exhibition with works on loan from private collections. PLEASE NOTE: The Museum will be closed from 3/3 to 3/10 for Spring Break.
04/01/97–05/07/97	TBA
06/05/97–07/04/97	ANNUAL ARTIST/ALUMNI EXHIBITION

Lewisburg

Center Gallery of Bucknell University
Affiliate Institution: Bucknell University
Seventh Street and Moore Ave, **Lewisburg, PA 17837**
☎ 717-524-3792
HRS: 11-5 M-F; 1-4 Sa, S HOL: LEG/HOL!
&: Y ℗ Y; Free MUS/SH: Y ¶ Y; Not in museum but in bldg.
PERM/COLL: IT/REN: ptgs; AM: ptgs 19, 20; JAP

NOT TO BE MISSED: "Cupid Apollo," by Pontormo

Loretto

Southern Alleghenies Museum of Art
Affiliate Institution: Saint Francis College
Saint Francis College Mall, **Loretto, PA 15940**
☎ 814-472-6400
HRS: 10-4 M-F; 1:30-4:30 Sa, S HOL: LEG/HOL!
&: Y; 1st floor only (not 2nd floor) ℗ Y ¶ Y; Nearby on college campus S/G: Y
PERM/COLL: AM: ptgs 19, 20; PHOT

This multi-cultural museum seeks to promote an appreciation of America's cultural legacy and the specially rich tradition of Pennsylvania art. Southern Alleghenies Museum of Art, Brett Bldg, 1210 11th Ave, Altoona, PA 16602 and Southern Alleghenies Museum of Art at Pasquerilla Performing Arts Center, University of Pittsburgh at Johnstown, PA 15904 (814-946-4464) are part of this facility. **NOT TO BE MISSED:** John Sloan's "Bright Rocks"

PENNSYLVANIA

Merion Station

Barnes Foundation
300 North Latch's Lane, **Merion Station, PA 19066**
☎ 610-667-0290
HRS: 12:30-5 T, 9:30-5 F-S (subject to change !) DAY CLOSED: M-W
ADM: Y ADULT: $5.00, $4 for audio
ⓟ Y; Free on-street parking MUS/SH: Y
GR/T: Y GR/PH: CATR! for groups of 10 or more
PERM/COLL: FR: Impr, post/Impr; EARLY FR MODERN; AF; AM: ptgs, sculp 20

The core of the collection includes numerous Impressionist and Post-Impressionist works by Renoir, Cézanne, and Matisse, in addition to major examples of work by Picasso, van Gogh, Seurat, Braque, Modigliani, Soutine, Monet and Manet and others displayed among outstanding examples of American antique furniture, ironworks, ceramics and crafts. Collected by Alfred Barnes, a highly astute but quirky connoisseur, these wide ranging works are still displayed in his recently renovated former home just as they were in his lifetime. **NOT TO BE MISSED:** This outstanding collection should not be missed.

Mill Run

Fallingwater
Rt. 381, **Mill Run, PA 15464**
☎ 412-329-8501
HRS: 10-4 Tu-S (4/1 until 11/1); weekends only 11/1-4/1; open most Leg/Hol DAY CLOSED: M HOL: Some LEG/HOLS!
ADM: Y ADULT: $8.00 Tu-F
⌖: Y ⓟ Y; Free MUS/SH: Y ⏸ Y; Open 5/1 - 11/1
GR/T: Y GR/PH: CATR! H/B: Y; National Historic Landmark S/G: Y
PERM/COLL: ARCH; PTGS; JAP: gr; SCULP; NAT/AM

Magnificent is the word for this structure, one of Frank Lloyd Wrights most widely acclaimed works. The key to the setting of the house is the waterfall over which it is built. PLEASE NOTE: The admission fee is $12.00 on weekends and holidays. **NOT TO BE MISSED:** The Frank Lloyd Wright designed building.

Paoli

The Wharton Esherick Museum
Horseshoe Trail, **Paoli, PA 19301**
☎ 610-644-5822
HRS: 10-4 M-F, 10-5 Sa, 1-5 S (Mar-Dec) HOL: LEG/HOL!
ADM: Y ADULT: $6.00 CHILDREN: $3.00 (under 12) SR CIT: $5.00
⌖: Y MUS/SH: Y
GR/T: Y GR/PH: CATR! DT: Y TIME: Hourly, (reservations required) H/B: Y
PERM/COLL: WOOD SCULP; FURNITURE; WOODCUTS; PTGS

Over 200 works in all media, produced between 1920-1970 which display the progression of Esherick's work are housed in his historic studio and residence. **NOT TO BE MISSED:** Oak spiral stairs

344

Philadelphia

Afro-American Historical and Cultural Museum
701 Arch Street, **Philadelphia, PA 19106**
☎ 215-574-0380
HRS: 10-5 Tu-Sa, 12-6 S DAY CLOSED: M HOL: LEG/HOL!
ADM: Y ADULT: $4.00 CHILDREN: $2.00 STUDENTS: $2.00 SR CIT: $2.00
&: Y ℗ Yes; Pay parking nearby MUS/SH: Y GR/T: Y GR/PH: CATR!
PERM/COLL: JACK FRANK COLL: phot; PEARL JONES COLL: phot drgs, dec/art: JOSEPH C. COLEMAN personal papers, photos and awards

A diverse and unique showplace, this is the first museum built by a major city to house and interpret collections of African-American art, history, and culture primarily in, but not limited to the Commonwealth of Pennsylvania.

ON EXHIBIT/97:
ONGOING INTRODUCTION TO THE MUSEUM AND ITS COLLECTION

through 03/30/97 MOMENTS WITHOUT PROPER NAMES — A collaborative event of the West Philadelphia Cultural Alliance. the Community Education Center, and the Philadelphia Museum of Art celebrating African-American documentary photography through multi-disciplinary presentation of the work of Gordon Parks.

01/97–06/97 SELECTIONS FROM THE PERMANENT COLLECTION: AFRICAN AMERICANS IN THE PERFORMING ARTS

01/24/97–05/06/97 HOME STORIES AND OTHER FABLES-AFRICAN ARTISTS IN PHILADELPHIA

07/97–12/97 SELECTIONS FROM THE PERMANENT COLLECTION: CIVIL RIGHTS AND POLITICS IN PHILADELPHIA

The Curtis Center Museum of Norman Rockwell Art
601 Walnut Street, **Philadelphia, PA 19106**
☎ 215-922-4345
HRS: 10-4 M-Sa, 11-4 S HOL: 1/1, EASTER, THGV, 12/25
ADM: Y ADULT: $2.00 CHILDREN: F (under 12) STUDENTS: $1.50 SR CIT: $1.50
&: Y ℗ Y, pay parking in building MUS/SH: Y, also mail order dept. GR/T: Y GR/PH: CATR! H/B: Y
PERM/COLL: Complete collection of Saturday Evening Post cover illustrations

In the historic Curtis Publishing Building which published the *Saturday Evening Post* is housed the largest collection of art and Post covers by Norman Rockwell.

Institute of Contemporary Art
Affiliate Institution: University of Pennsylvania
118 South 36th Street at Sansom, **Philadelphia, PA 19104-3289**
☎ 215-898-7108
HRS: 10-5 W, F-S; 10-7 T HOL: 12/25
F/DAY: S, 10-12 ADM: Y ADULT: $3.00 CHILDREN: $1.00; F under 12 STUDENTS: $1.00 SR CIT: $1.00
&: Y nearby meters and pay garages GR/T: Y GR/PH: CATR! DT: Y TIME: T, 5:15; S, 1
PERM/COLL: non-collecting institution

The Museum, founded in 1963, is one of the premier institutions dedicated solely to the art of our time.

ON EXHIBIT/97:
11/16/96–01/19/97 PETER FISCHLI AND DAVID WEISS: IN A RESTLESS WORLD — These Swiss artists participate in a collaborative art practice that engages the most humble of everyday objects in a display of spectacle and bravura. Their presentations which include sculpture, photography, film, video and installations, create a dialogue between the opposites of order and chaos, work and play, and the mundane and the sublime. WT

Institute of Contemporary Art - continued

02/08/97–04/20/97	WINIFRED LUTZ/TONY OURSLER AND MAUREEN CONNOR — Winifred Lutz creates commanding sculptural installations which deal with light and space. For this presentation she will create a work which takes advantage of the soaring height of the Tuttleman Gallery space. Tony Oursler and Maureen Connor are video artists. Tony Oursler's featured work "Judy," which refers to a multiple personality disorder case, is comprised of multiple objects, video projections and an exterior surveillance camera which can be controlled by viewers inside the gallery. Maureen Connor also involves sculptural objects and interaction with the viewer. In "Narrow Escape" she has replaced the decorative panels of a Neo-Rococo wardrobe with video monitors in an effort to contrast 18th-century hedonism with the controls and compulsions of the 20th-century obsession with slimness.
05/17/97–07/06/97	JOHN KINDNESS — In this exhibition from his series "Treasures of New York," Irish artist John Kindness depicts a character from a Grecian urn tableau performing the daily ritual of using a pooper-scooper, a trash can resembling the generic paper coffee cup with its blue and white design of a decaying coliseum, and a discus thrower transformed into the New York Stock Exchange. Also on view will be a colorful fragmentary fresco painted in the authentic tradition on wet plaster, portraying an autobiography of his childhood in the Belfast of the 1950's.
09/06/97–11/23/97	PHOTOGRAPHY AFTER PHOTOGRAPHY — The impact of digital machinery such as computer-generated imagery, Cyberspace, the Internet. and Virtual Reality on photography as well as pornographic photography in the computer network is reflected upon in the exhibition. It brings together artistic trends in and reflections on digital pictorial culture in the field of photography and related media art by 30 international artists. WT

Philadelphia

La Salle University Art Museum

Affiliate Institution: LaSalle University
20th and Olney Ave, **Philadelphia, PA 19141**
☎ 215-951-1221
HRS: 11-4 Tu-F, 2-4 S, Sep-Jul DAY CLOSED: Sa HOL: ACAD! ♿: Y Ⓟ Y; Campus lot
PERM/COLL: EU: ptgs, sculp, gr 15-20; AM: ptgs

Many of the major themes and styles of Western art since the Middle ages are documented in the museum's comprehensive collection of paintings, prints, drawings and sculpture.

Museum of American Art of the Pennsylvania Academy of the Fine Arts

118 N. Broad Street at Cherry Street, **Philadelphia, PA 19102**
☎ 215-972-7600
HRS: 10-5 M-Sa, 11-5 S HOL: LEG/HOL!
ADM: Y ADULT: $5.95 CHILDREN: $3.95; F under 5 STUDENTS: $4.95 SR CIT: $4.95
♿: Y Ⓟ Y; Public parking lots nearby ($2.00 discount at Parkway Corp. lots at Broad & Cherry and 15th & Cherry); some street parking MUS/SH: Y GR/T: Y GR/PH: CATR! DT: Y TIME: weekends, ! H/B: Y
PERM/COLL: AM: ptgs, sculp 18-20

The Pennsylvania Academy is located in the heart of downtown Philadelphia in a building recently restored to its original splendor. Its roster of past students includes some of the most renowned American artists of the 19th & 20th centuries.

ON EXHIBIT/97:

01/17/97–04/13/97	THE SARTAIN FAMILY AND THEIR PHILADELPHIA CIRCLE — A combination of paintings, works on paper and archival material commemorate the 100th anniversary of patriarch John Sartain's death and the contributions of the family to Philadelphia's cultural life from 1830-1930.

346

Museum of American Art of the Pennsylvania Academy of the Fine Arts - continued

01/25/97–04/13/97	MARK MCCULLEN — Works by McCullen, a contemporary abstract painter.
03/08/97–94/20/97	ARNOLDO ROCHE-RABELL: THE UNCOMMON WEALTH WT
06/13/97–09/07/97	PAFA AT PONT-AVON — Works from the permanent collection and loans examine the late 19th-century artists' colony in Brittany. Artists include Thomas Hovenden, Hugh Bolton-Jones, Anna Klumpke, Daniel Ridgeway Knight and others.
06/21/97–08/31/97	RECONSTRUCTION: WILLIAM CHRISTENBERRY'S ART — A retrospective of the work of this multi-media artist whose work explores the home culture of the Deep South and related issues of American migration and regionalism. WT
09/19/97–11/30/97	THE UNBROKEN LINE: 100 YEARS OF THE FELLOWSHIP, 1887-1997 — Curated and juried alumni work, both historic and contemporary, celebrating the centennial of the Fellowship of PAFA.

Philadelphia

Philadelphia Museum of Art

26th Street & Benjamin Franklin Parkway, **Philadelphia, PA 19130**
☎ 215-763-8100 WEB ADDRESS: http://pma.libertynet.org
HRS: 10-5 Tu, T-S; 10-8:45 W DAY CLOSED: M HOL: LEG/HOL!
F/DAY: S, 10-1 ADM: Y ADULT: $7.00 CHILDREN: $4.00 STUDENTS: $4.00 SR CIT: $4.00
&.: Y ℗ Y; Free MUS/SH: Y ❙❙ Y; 11:45-2:15
GR/T: Y GR/PH: CATR! DT: Y TIME: Free-on the hour 11-3 H/B: Y S/G: Y
PERM/COLL: EU: ptgs 19-20; CONT; DEC/ART; GR; AM: ptgs, sculp 17-20

With more than 400,000 works in the permanent collection the Philadelphia Art Museum is the 3rd largest art museum in the country. Housed within its more than 200 galleries are a myriad of artistic treasures from many continents and cultures. **NOT TO BE MISSED:** Van Gogh's "Sunflowers"; Newly re-opened Medieval & Early Renaissance Galleries (25 in all) which include a Romanesque cloister, a Gothic chapel, and a world-class collection of early Italian & Northern paintings.

ON EXHIBIT/97:

11/03/96–02/02/97	THE CADWALADER FAMILY: ART AND STYLE IN EARLY PHILADELPHIA — In conjunction with "The Peale Family" exhibition, this presentation of paintings and decorative arts relates the commissioning of portraits and collectings of four generations of the Cadwalader family.
11/22/96–03/16/97	"IN THE MANNER OF...": IMITATION, EMULATION, AND FORGERY IN OLD MASTER PRINTMAKING — 60 old master prints from the Museum's collection including works by Dürer, Rembrandt and Lucas van Leyden will be shown beside later generations' imitations and interpretations of them.
12/14/96–03/02/97	SUSAN BARRON: LABYRINTH OF TIME
12/31/96–02/23/97	UP CLOSE AND PERSONAL — New and recent work by an international selection of younger women performance artists including Cheryl Donegan, Vanessa Beecroft, Alix Lambert, Sadie Benning and others.
03/02/97–05/11/97	ENCOUNTERS WITH MODERN ART: WORKS FROM THE ROTHSCHILD FAMILY COLLECTIONS — Outstanding works from many of the major schools of modern European art (including futurism, cubism, constructivism, and de Stijl) will be seen in the works on loan from the Herbert and Nannette Rothschild collection. Motivated by the fact that they were friends of Braque, Arp, Brancusi, Severini, Léger and many other members of the French art community of their day, the Rothschild's collection reflects their personal enthusiasm in acquiring the works on view. CAT WT ◠
03/30/97–06/22/97	MICHELANGELO AND RODIN
04/19/97–06/15/97	THE INGENIOUS MACHINE OF NATURE: FOUR CENTURIES OF ART AND ANATOMY WT
07/97–08/97	INDIA: 50 YEARS OF INDEPENDENCE (photos) TENT!
09/97–11/97	EARL HORTER: THE ARTIST AS COLLECTOR OF EARLY MODERN MASTER-PIECES — Works by Picasso, Matisse, Braque, etc. TENT!
10/97–12/97	TREASURES OF COSTUME AND TEXTILES TENT!

PENNSYLVANIA

Philadelphia

The Rodin Museum
Benjamin Franklin Parkway at 22nd Street, **Philadelphia, PA 19101**
📞 215-763-8100
HRS: 10-5 Tu-S DAY CLOSED: M HOL: LEG/HOL!
VOL/CONT: Y &: Y Ⓟ Y; Free on-street parking MUS/SH: Y
GR/T: Y GR/PH: CATR! DT: Y TIME: Free/twice a month- check schedule H/B: Y S/G: Y
PERM/COLL: RODIN: sculp, drgs

The largest collection of Rodin's sculptures and drawings outside of Paris is located in a charming and intimate building designed by architects Paul Cret and Jacques Greber. **NOT TO BE MISSED:** 'The Thinker', by Rodin

The Rosenbach Museum & Library
2010 DeLancey Place, **Philadelphia, PA 19103**
📞 215-732-1600
HRS: 11-4 Tu-S DAY CLOSED: M HOL: LEG/HOL! August through Labor Day
ADM: Y ADULT: $3.50 incl guid CHILDREN: $2.50 STUDENTS: $2.50 SR CIT: $2.50
MUS/SH: Y GR/T: Y GR/PH: CATR!
PERM/COLL: BRIT & AM: ptgs; MINI SCALE DEC/ARTS; BOOK ILLUSTRATIONS

In the warm and intimate setting of a 19th-century townhouse, the Rosenbach Museum & Library retains an atmosphere of an age when great collectors lived among their treasures. It is the only collection of its kind open to the public in Philadelphia. **NOT TO BE MISSED:** Maurice Sendak drawings

ON EXHIBIT/97:

11/24/96–03/30/97	MAKING IT NEW: MARIANNE MOORE AND THE VISUAL ARTISTS — An exploration of the interaction of writers, painters and photographers who made up the American avant-garde during the early decades of this century includes works by Charles Sheeler, Charles Demuth, Marsden Hartley and William Zorach, Alfred Stieglitz, Doris Ullman, Lotte Jacobi and George Platt Lynes.
04/24/97–11/02/97	DRACULA CENTENNIAL EXHIBITION — Bram Stoker published his literary classic, "Dracula" in 1897. This centennial exhibition traces the development of that legend from its first appearance in 15th-century folklore to its enduring role today.

Rosenwald-Wolf Gallery, the University of the Arts
Broad and Pine Streets, **Philadelphia, PA 19102**
📞 215-875-1116
HRS: 10-5 M-Tu & T-F; 10-9 W; 12-5 Sa, S; (10-5 weekdays Jun & Jul) HOL: ACAD!
&: Y Ⓟ Y; Pay garages and metered parking nearby GR/T: Y GR/PH: CATR!
PERM/COLL: non-collecting institution

This is the only university in the nation devoted exclusively to education and professional training in the visual and performing arts.

ON EXHIBIT/97:

01/11/97–02/14/97	FACULTY EXHIBITION
02/28/97–04/16/97	JON KESSLER: UNPLUGGED
04/25/97–05/08/97	ALUMNI DESIGN AWARDS: AFTERWARDS
09/06/97–10/26/97	RICHARD REINHARDT: FULL CIRCLE, A LEGACY OF METALWORK
11/01/97–12/15/97	OBJECTS AND SOUVENIRS: ARTISTS MULTIPLES

Philadelphia

The University of Pennsylvania Museum of Archaeology and Anthropology
Affiliate Institution: University of Pennsylvania
33rd and Spruce Streets, **Philadelphia, PA 19104**
☎ 215-898-4000 WEB ADDRESS: http://www.upenn.edu/museum
HRS: 10-4:30 Tu-Sa, 1-5 S, closed S Mem day-Lab day DAY CLOSED: M HOL: LEG/HOL!
ADM: Y ADULT: $5.00 CHILDREN: F (under 6) STUDENTS: $2.50 SR CIT: $2.50
&: Y ℗ Y MUS/SH: Y ¶ Y
GR/T: Y GR/PH: CATR!
DT: Y TIME: 1:15 Sa, S (mid Sep-mid May)! S/G: Y
PERM/COLL: GRECO/ROMAN; AF; AN/EGT; ASIA; MESOPOTAMIA; MESO AMERICA; POLYNESIAN; AMERICAS

Dedicated to the understanding of the history and cultural heritage of humankind, the museum's galleries include objects from China, Ancient Egypt, Mesoamerica, South America, North America (Plains Indians), Polynesia, Africa, and the Greco Roman world. **NOT TO BE MISSED:** Bull headed lyre, gold, lapis lazuli, shell on wooden construction; Ur, Iraq ca. 2650-2550 B.C.

ON EXHIBIT/97:

LONG TERM EXHIBITIONS	TIME AND RULERS AT TIKAL: ARCHITECTURAL SCULPTURE OF THE MAYA
	ANCIENT MESOPOTAMIA: THE ROYAL TOMBS OF UR
	THE EGYPTIAN MUMMY: SECRETS AND SCIENCE
	RAVEN'S JOURNEY: THE WORLD OF ALASKA'S NATIVE PEOPLE
	BUDDHISM: HISTORY AND DIVERSITY OF A GREAT TRADITION
	TIME AND RULERS AT TIKAL: ARCHITECTURAL SCULPTURE OF THE MAYA — With a 15 foot hand crafted wood model of Tikal's Great Plaza as the centerpiece, the exhibition shows how the Museum's historical excavations of 1956-1970 provided the evidence on which new theories about Maya civilization are being developed.
	THE ANCIENT GREEK WORLD — A complete reinstallation of the Museum's Ancient Greek gallery.
	LIVING IN BALANCE: THE UNIVERSE OF THE HOPI, ZUNI, NAVAJO AND APACHE — An Apache 'tipi', Navajo 'hogan' framework and walk in sky dome as well as about 300 artifacts look at the connection these Native Americans have with their environment.
01/18/97–04/20/97	LIFE ON THE MONGOLIAN STEPPES: PHOTOGRAPHS BY ROBERT MCCRACKEN PECK
01/25/97–04/27/97	FORT MOSE: COLONIAL AMERICA'S BLACK FORTRESS OF FREEDOM
04/26/97–08/23/97	THE AFGHAN FOLIO: PHOTOGRAPHS BY LUKE POWELL
09/13/97–12/07/97	EGGY'S VILLAGE: LIFE AMONG THE MINANGKABAU OF INDONESIA
09/27/97–06/98	ROMAN GLASS: REFLECTIONS OF CULTURAL CHANGE — More than 200 spectacular examples of glass and associated materials dating from the 1st century B.C. through the 7th-century A.D. will be on display. Dates Tent!

PENNSYLVANIA

Philadelphia

The Woodmere Art Museum
9201 Germantown Ave, **Philadelphia, PA 19118**
☎ 215-247-0476
HRS: 10-5 Tu-Sa, 1-5 S DAY CLOSED: M HOL: LEG/HOL!
SUGG/CONT: Y ADULT: $3.00 CHILDREN: F (under 12) STUDENTS: $2.00 SR CIT: $2.00
&: Y ℗ Y; free parking adjacent to building MUS/SH: Y GR/T: Y GR/PH: CATR!
PERM/COLL: AM: ptgs 19, 20, prints, gr, drgs; EU (not always on view()

The Woodmere Art Museum, located in a mid 1850's eclectic Victorian house, includes a large rotunda gallery which is the largest exhibit space in the city. **NOT TO BE MISSED:** Benjamin West's "The Death of Sir Phillip Sydney"

ON EXHIBIT/97:

02/16/96–04/13/97	WOODMERE ART MUSEUM ANNUAL JURIED EXHIBITION
12/06/96–03/16/97	THE FELL COLLECTION — The Fell Collection, which was on extended loan to the Museum since 1986 and has now been given as a gift, includes splendid examples of works by renowned European masters including Boudin, Corot, Renoir, Daumier, Rouault, and many others.
12/14/96–02/01/97	THE 99TH ANNUAL EXHIBITION OF THE PENNSYLVANIA ACADEMY OF FINE ARTS FELLOWSHIP
02/23/97–04/28/97	LIFE LINES: AMERICAN MASTER DRAWINGS, 1788-1962 — Showcasing the extraordinary drawing collection of the Munson-Williams-Proctor Institute in Utica, NY. will be works that date from the late 18th-century to the present. WT*
04/20/97–05/18/97	THE ART OF FRANK ROOT
05/25/97–06/22/97	C. MOLLER, INC
07/06/97–08/24/97	ANNUAL MEMBERS EXHIBITION
09/13/97–10/26/97	THE PHILADELPHIA CHAPTER OF ARTIST EQUITY ANNUAL EXHIBITION

Pittsburgh

The Andy Warhol Museum
417 Sandusky Street, **Pittsburgh, PA 15212-5890**
☎ 412-237-8300 WEB ADDRESS: http://www.warhol.org/warhol
HRS: 11-6 W & S, 11-8 T-Sa DAY CLOSED: M, Tu
ADM: Y ADULT: $5.00 CHILDREN: $3.00 STUDENTS: $3.00 SR CIT: $4.00
&: Y; Ramp, elevators, restrooms ℗ Y; 2 pay lots adjacent to the museum (nominal fee charged); other pay lots nearby
MUS/SH: Y ‖ Y; Cafe
GR/T: Y GR/PH: CATR! H/B: Y; Former Vokwein building renovated by Richard Gluckman Architects
PERM/COLL: ANDY WARHOL ARTWORKS

The most comprehensive single-artist museum in the world, this 7 story museum with over 40,000 square feet of exhibition space permanently highlights artworks spanning every aspect of Warhol's career. A unique feature of this museum is a photo booth where visitors can take cheap multiple pictures of themselves in keeping with the Warhol tradition. **NOT TO BE MISSED:** Rain Machine, a 'daisy waterfall' measuring 132' by 240'; "Last Supper" paintings; 10' tall "Big Sculls" series

Pittsburgh

The Carnegie Museum of Art
4400 Forbes Ave, **Pittsburgh, PA 15213**
☎ 412-622-3131 WEB ADDRESS: http://www.clpgh.org
HRS: 10-5 Tu-T, Sa; 10-9 F; 1-5 S; Open 10-5 M July 8-Aug 26 DAY CLOSED: M HOL: LEG/HOL!
ADM: Y ADULT: $5.00 CHILDREN: $3.00 STUDENTS: $3.00 SR CIT: $4.00
&: Y ℗ Y; Pay garage MUS/SH: Y ⑪ Y: Cafe open weekdays; cafeteria daily
GR/T: Y GR/PH: CATR! 412-622-3289
DT: Y TIME: 1:30, Tu-Sa; 3, S H/B: Y S/G: Y
PERM/COLL: FR/IMPR: ptgs; POST/IMPR: ptgs; AM: ptgs 19, 20; AB/IMPR; VIDEO ART

The original 1895 Carnegie Institute, created in the spirit of opulence by architects Longfellow, Alden and Harlowe, was designed to house a library with art galleries, the museum itself, and a concert hall. A stunning light filled modern addition offers a spare purity that enhances the enjoyment of the art on the walls. **NOT TO BE MISSED:** Claude Monet's 'Nympheas' (Water Lilies)

ON EXHIBIT/97:

08/03/96–02/23/97	DRAWINGS BY SAMUEL ROSENBERG FROM THE PERMANENT COLLECTION — A selection of drawings by Pittsburgh's leading social realist painter and most influential art teacher of the 1930's-1960's.
02/22/97–05/18/97	DESIGN 1885-1945: THE ARTS OF REFORM AND PERSUASION — Approximately 280 objects from the Wolfsonian Foundation which demonstrate how designs of this period functioned as an agent of modernity, reflecting society's opinions and values. WT
06/07/97–08/03/97	REMBRANDT ETCHINGS: SELECTIONS FROM THE CARNEGIE MUSEUM OF ART
06/07/97–08/03/97	BELLANGE EXHIBITION
11/08/97–01/25/98	PITTSBURGH REVEALED: PHOTOGRAPHS SINCE 1850 — 450 vintage photographs by more than 150 photographers will be seen in the first full-scale study of photography in Western Pennsylvania, one of the most ambitions photographic journals of any American city.

Hunt Institute for Botanical Documentation
Affiliate Institution: Carnegie Mellon University
Pittsburgh, PA 15213-3890
☎ 412-268-2434
HRS: 9-12 & 1-5 M-F HOL: LEG/HOL!; 12/24-1/1
&: Y ℗ Y; Pay parking nearby MUS/SH: Y
PERM/COLL: BOTANICAL W/COL 15-20; DRGS; GR

Botanical imagery from the Renaissance onward is well represented in this collection.

ON EXHIBIT/97:

SPRING/97	IN THE REALM OF EDEN — Watercolors of the Costa Rican rainforest by Ohio artist John Matyas.
FALL/97	PANDORA SELLARS: WATERCOLORS

351

PENNSYLVANIA

Pittsburgh

Mattress Factory, Ltd
500 Sampsonia Way, satellite bldg at 1414 Monterey, **Pittsburgh, PA 15212**
☎ 412-231-3169 WEB ADDRESS: www.mattress.org
HRS: 10-5 Tu-Sa & 1-5 S (Sep-Jul or by appt) DAY CLOSED: M HOL: 1/1, EASTER, MEM/DAY, THGV, 12/25
&: Y ℗ Y MUS/SH: Y; rep. artists in coll GR/T: Y GR/PH: CATR! H/B: Y S/G: Y
PERM/COLL: Site-specific art installations completed in residency

This museum of contemporary art that commissions, collects and exhibits site-specific art installations, was founded in 1977 in a six story warehouse in the historic Mexican War Streets of Pittsburgh's North Side. 1997 exhibitions include John Latham, Yayoi Kusama, Greer Lankton and Andre Walker. **NOT TO BE MISSED:** "Danae," by James Turrell

The Frick Art Museum
7227 Reynolds Street, **Pittsburgh, PA 1520821**
☎ 412-371-0600
HRS: 10-5:30 Tu-Sa, 12-6 S DAY CLOSED: M HOL: LEG/HOL!
&: Y ℗ Y; Free MUS/SH: Y GR/T: Y GR/PH: CATR! DT: Y!
PERM/COLL: EARLY IT/REN: ptgs; FR & FLEM: 17; BRIT: ptgs; DEC/ART

The Frick Art Museum features a permanent collection of European paintings, sculptures and decorative objects in addition to temporary exhibitions from around the world.

ON EXHIBIT/97:

04/03/97–06/29/97	IN THE GILDED AGE: PITTSBURGH ART COLLECTORS AND THEIR COLLECTIONS: 1890-1910 — Pittsburgh collectors will be put on a par with collectors of the period elsewhere in the US and Europe with works by Alma-Tadema, Bouguereau, Corot, Gerome, Dagnan-Bouveret and Friant. Period photographs of the interiors of the collector's houses will also be included.
08/07/97–10/19/97	PLAINS INDIAN DRAWINGS, 1865-1935: PAGES OF A LIVING HISTORY — Presented will be an exhibition of Ledger art developed from the Native American tradition of painting on buffalo hides. The drawings on view depict current events and personal narratives, and in their experimentation with pictorial conventions, anticipate some of the concerns of twentieth-century artists. WT
11/13/97–01/25/98	TREASURES OF ASIAN ART: MASTERPIECES FROM THE MR. AND MRS. JOHN D. ROCKEFELLER 3RD COLLECTION — The seventy objects from this collection include works from thirteen different nations ranging from India, Cambodia and Indonesia to China, Korea and Japan and span over a millennium-from eleventh-century B.C. Chinese bronze vessels to eighteenth-century paintings and ceramics. They explore the many ways in which cultural links between different parts of Asia are recorded in the visual arts. WT

Reading

Freedman Gallery
Affiliate Institution: Albright College
13th & Bern Streets, **Reading, PA 19604**
☎ 610-921-2381
HRS: 12-6 Tu, W & F; 12-8 T; 12-4 Sa, S; Summer 12-4 Tu-S HOL: LEG/HOL!, ACAD!
&: Y ℗ Y GR/T: Y GR/PH: CATR! 610-921-7541
PERM/COLL: CONT: gr, ptgs

The Freedman is the only gallery in Southeastern Pennsylvania outside of Philadelphia that presents an on-going program of provocative work by today's leading artists. **NOT TO BE MISSED:** Mary Miss Sculpture creates an outdoor plaza which is part of the building

Scranton

Everhart Museum
Nay Aug Park, **Scranton, PA 18510**
☎ 717-346-7186
HRS: 10-5 M-F; 12-5 Sa, S HOL: LEG/HOL!
&: Y ℗ Y MUS/SH: Y
PERM/COLL: AM: early 19; WORKS ON PAPER; AM: folk, gr; AF; NAT/AM NAT/AM

This art, science, and natural history museum which includes a 40 seat planetarium is the only wide-ranging museum of its type in Northeastern Pennsylvania.

University Park

Palmer Museum of Art
Affiliate Institution: The Pennsylvania State University
Curtin Road, **University Park, PA 16802-2507**
☎ 814-865-7672
HRS: 10-4:30 Tu-Sa, 12-4 S DAY CLOSED: M HOL: LEG/HOL!, 12/25-1/1
&: Y ℗ Y; Limited meter, nearby pay MUS/SH: Y
GR/T: Y GR/PH: CATR! DT: Y TIME: ! S/G: Y
PERM/COLL: AM; EU; AS; S/AM: ptgs, sculp, works on paper, ceramics

A dramatic and exciting new facility now houses this collection of 35 centuries of artworks. **NOT TO BE MISSED:** The new building by Charles Moore, a fine example of post-modern architecture

ON EXHIBIT/97:

through 01/26/97	THE WOOD ENGRAVINGS OF WARREN MACK
01/14/97–03/16/97	DISMAL SCIENCE: PHOTOWORKS BY ALLAN SEKULA, 1972-1992 — The first exhibition to survey Sekula's work, a photographer who has transformed the discourse of photographic criticism and our perception of the medium and its role in society.
04/08/97–06/29/97	EXOTIC ILLUSIONS: ART, ROMANCE, AND THE MARKETPLACE — "Exotic Illusions" explores how the desires of early travelers and collectors, and the demands of the marketplace today, have shaped the artistic production of native people.

Wilkes-Barre

Sordoni Art Gallery
Affiliate Institution: Wilkes University
150 S. River Street, **Wilkes-Barre, PA 18766-0001**
☎ 717-831-4325
HRS: 12-5 M-S, 12-9 T HOL: LEG/HOL!
&: Y ℗ Y
PERM/COLL: AM: ptgs 19, 20; WORKS ON PAPER

Located on the grounds of Wilkes University, in the historic district of downtown Wilkes-Barre, this facility is best known for mounting both historical and contemporary exhibitions.

RHODE ISLAND

Kingston

Fine Arts Center Galleries, University of Rhode Island
105 Upper College Road, Suite 1, **Kingston, RI 02881-0820**
☎ 401-874-2131
HRS: Main Gallery:12-4 & 7:30-9:30 Tu-F, 1-4 Sa; Phot Gallery: 12-4 Tu-F & 1-4 Sa HOL: LEG/HOL!; ACAD!
&: Y ℗ Y
MUS/SH: Y
GR/T: Y GR/PH: CATR! DT: Y TIME: !
PERM/COLL: non-collecting institution

A university affiliated 'kunsthalle' distinguished for the activity of its programming (20-25 exhibitions annually) features contemporary exhibitions in all media as well as film and video presentations. The Corridor Gallery is open from 9-9 daily.

ON EXHIBIT/97:

01/17/97–04/27/97 THOMAS EAKINS AND THE SWIMMING PICTURE — Studies that relate to "Swimming" and "The Pathetic Song" and his work in Arcadia are seen in this revealing exhibition. CAT WT

Newport

Newport Art Museum
76 Bellevue Avenue, **Newport, RI 02840**
☎ 401-848-8200
HRS: 10-4 Tu-Sa, 12-4 S DAY CLOSED: M HOL: THGV, 12/25, 1/1
ADM: Y ADULT: $5.00 CHILDREN: F (under 12) STUDENTS: $4.00 SR CIT: $4.00
&: Y ℗ Y
MUS/SH: Y
H/B: Y
PERM/COLL: AM: w/col 19, 20

Historic J. N. A. Griswold House in which the museum is located was designed by Richard Morris Hunt in 1862-1864.

Redwood Library and Athenaeum
50 Bellevue Avenue, **Newport, RI 02840**
☎ 401-847-0292
HRS: 9:30-5:30 M-S HOL: LEG/HOL! ℗ Y
H/B: Y
PERM/COLL: AM: gr, drgs, phot, portraits, furniture, dec/art 18, 19

Established in 1747, this facility serves as the oldest circulating library in the country. Designed by Peter Harrison, considered America's first architect, it is the most significant surviving public building from the Colonial period. **NOT TO BE MISSED:** Paintings by Gilbert Stuart and Charles Bird King

354

Providence

David Winton Bell Gallery

Affiliate Institution: Brown University
List Art Center, 64 College Street, **Providence, RI 02912**
☎ 401-863-2932
HRS: 11-4 M-F & 1-4 Sa-S (Sept-May) HOL: 1/1, THGV, 12/25
&: Y Ⓟ Y; On-street H/B: Y
PERM/COLL: GR & PHOT 20; WORKS ON PAPER 16-20; CONT: ptgs

Located in the List Art Center, an imposing modern structure designed by Philip Johnson, the Gallery presents exhibitions which focus on the arts and issues of our time.

ON EXHIBIT/97:

12/07/96–01/19/97	BRODSKY AND UTKIN TENT!
02/01/97–03/09/97	STILL TIME: PHOTOGRAPHS BY SALLY MANN, 1971-91 WT
04/19/97–06/01/97	RUDOLF KOPPITZ, 1884-1936: VIENNESE "MASTER OF THE CAMERA"
08/97–10/97	KOREAN ART FROM THE CHO WON-KYONG COLLECTION
10/97–11/97	CONTEMPORARY PORTUGUESE ART FROM THE COLLECTION OF THE LUSO-AMERICAN FOUNDATION, LISBON
10/24/98–11/29/98	HOSPICE: A PHOTOGRAPHIC INQUIRY — The photographs of Jim Goldberg, Nan Goldin, Sally Mann, Jack Radcliffe and Kathy Vargas detailing the emotional and collaborative experience of living and working in hospices in different regions of the country will be seen in this exhibition specially commissioned by the Corcoran. Their works will touch upon every aspect of hospice care revealing the spiritual, emotional and physical needs of the terminally ill and their families. WT

Museum of Art

Affiliate Institution: Rhode Island School Of Design
224 Benefit Street, **Providence, RI 02903**
☎ 401-454-6100
HRS: 10:30-5 Tu, W, F, Sa; 12-8 T; 2-5 S, Hol; 12-5 W-Sa (6/30-Lab day) HOL: LEG/HOL!
F/DAY: Sa ADM: Y ADULT: $2.00 CHILDREN: $.50 (5-18) STUDENTS: $0.50 SR CIT: $1.00
&: Y Ⓟ Y; Nearby pay, 1/2 price with museum adm MUS/SH: Y GR/T: Y GR/PH: CATR! S/G: Y
PERM/COLL: AM: ptgs, dec/art; JAP: gr, cer; LAT/AM

The museum's outstanding collections are housed on three levels: in a Georgian style building completed in 1926, in Pendleton House, completed in 1906, and in The Daphne Farago Wing, a center dedicated to the display and interpretation of contemporary art in all media. **NOT TO BE MISSED:** "Buddha Dainichi Nyorai" ca. 1150

ON EXHIBIT/97:

11/22/96–03/97	20TH CENTURY ART FROM THE ALBERT PILAVIN COLLECTION — This remarkable collection, purchased for the Museum between 1970 and 1984, celebrates the development of American painting from Abstract Expressionism and Color Filled painting to Pop Minimalism, Photo Realism, and beyond. Included are works by Andy Warhol, Helen Frankenthaler, Robert Mangold, Cy Twombly, and Don Eddy.
12/13/96–03/02/97	KASHMIR SHAWLS — Many of these fine tapestry shawls are from the Museum's collection and exhibit a wide range of intricately detailed pattern.
12/13/96–03/02/97	PINES IN SNOW: IMAGES OF WINTER IN JAPANESE WOODBLOCK PRINTS — The image of the pine withstanding winter's harshness conveys the theme of endurance which dominates this exhibition.
12/19/96–04/27/97	THOMAS EAKINS AND THE SWIMMING PICTURE — Studies that relate to "Swimming" and "The Pathetic Song" and his work in Arcadia are seen in this revealing exhibition. CAT WT

Museum of Art - continued

02/07/97–04/27/97	RHODE ISLAND COLLECTS CERAMICS — Important historical works from the Museum's collection as well as pieces loaned by members of the Pottery and Porcelain Club celebrate the breadth and depth of ceramic collections in Rhode Island.
03/07/97–05/08/97	INDONESIAN TEXTILES — An exploration of the role of textiles in Indonesian society and the techniques of their production.
05/23/97–09/21/97	THE JAPANESE KIMONO — Examples of various styles of kimonos —uchikake, furisode, and the katabira – each of which has a specific place in Japanese dress.

Providence

Rhode Island Black Heritage Society

One Hilton Street, **Providence, RI 02905**
☎ 401-751-3490
HRS: 9-4:30 M-F HOL: LEG/HOL!
♿: Y ⓟ Y MUS/SH: Y
PERM/COLL: PHOT; AF: historical collection

The Society collects documents and preserves the history of African-Americans in the state of Rhode Island with an archival collection which includes photos, rare books, and records dating back to the 18th-century. **NOT TO BE MISSED:** Polychrome relief wood carvings by Elizabeth N. Prophet

Charleston

City Hall Council Chamber Gallery
Broad & Meeting Streets, **Charleston, SC 29401**
☎ 803-724-3799
HRS: 9-5 M-F; closed 12-1 DAY CLOSED: Sa, S HOL: LEG/HOL!
♿: Y
GR/T: Y GR/PH: CATR! H/B: Y
PERM/COLL: AM: ptgs 18, 19

What is today Charleston's City Hall was erected in 1801 in Adamsesque style to be the Charleston branch of the First Bank of the United States. **NOT TO BE MISSED:** 'George Washington', by John Trumbull is unlike any other and is considered one of the best portraits ever done of him.

Gibbes Museum of Art
135 Meeting Street, **Charleston, SC 29401**
☎ 803-722-2706
HRS: 10-5 Tu-Sa, 1-5 S-M HOL: LEG/HOL!
ADM: Y ADULT: $5.00 CHILDREN: $3.00 STUDENTS: $4.00 SR CIT: $4.00
♿: Y; Right side of museum Ⓟ Y; Municipal
MUS/SH: Y
GR/T: Y GR/PH: CATR! DT: Y TIME: 1st W of mo at 2:30 PM
S/G: Y
PERM/COLL: AM: reg portraits, miniature portraits; JAP: gr

Charleston's only fine arts museum offers a nationally significant collection of American art, American Renaissance period (1920's-40's) room interiors done in miniature scale, and a miniature portrait collection, the oldest and finest in the country. **NOT TO BE MISSED:** 'The Green Gown', by Childe Hassam (1859-1935)

ON EXHIBIT/97:

08/16/96–03/09/97	HOLLYWOOD GLAMOUR PHOTOGRAPHY — Works from the collection by photographers who helped create the screen images of the Hollywood star and developed a glamourous and sophisticated form of photographic art. Included are images by Carl Van Vechten, Keith Bernard, Larry Barbier, Jr. and Peter Gowland.
09/27/96–01/05/97	CALIFORNIA IMPRESSIONISTS — On exhibit will be nearly 65 works, painted between 1895 and the beginning of WWII, that define the California Impressionist style. WT
01/04/97–04/06/97	ECHOES OF HISTORY — Photographs by Tillman Crane showcase the many processes that have been used during the history of photography in portraits, landscapes, still lifes and architectural work.
01/17/97–03/02/97	CONTEMPORARY BOTANICAL ARTISTS: THE SHIRLEY SHERWOOD COLLECTION — A celebration of the renaissance of botanical art with works collected during the past five years from more than 100 artists living in 17 different countries.
02/01/97–04/27/97	JOHN DREYFUSS: SCULPTOR — These sculptures, hugely simplified forms with clean lines and smooth details, are contemplative and evocative.
03/14/97–05/04/97	CHAMPIONS OF MODERNISM: THE ART OF TOMORROW AND TODAY WT

SOUTH CAROLINA

Columbia

Columbia Museum of Arts & Gibbes Planetarium
1112 Bull Street, Columbia, SC 29201
℡ 803-799-2810 WEB ADDRESS: http://www.scsn.net/users/cma
HRS: 10-5 Tu-F, 12:30-5 Sa-S DAY CLOSED: M HOL: 1/1, 7/4, LAB/DAY, THGV, 12/24, 12/25
F/DAY: W ADM: Y ADULT: $2.00 CHILDREN: F (under 6) STUDENTS: $1.50 SR CIT: $1.50
&: Y ℗ Y MUS/SH: Y GR/T: Y GR/PH: CATR! H/B: Y
PERM/COLL: KRESS COLL OF MED, BAROQUE & REN; AS; REG

The Thomas Taylor Mansion, built in 1908, functions as the museum, while the Horry-Guignard House, one of the oldest in Columbia, is used as office space on the site. The Gibbes Planetarium, open weekends only, is inside the museum building.

ON EXHIBIT/97:

10/11/96–01/05/97	ROYCROFT DESKTOP — An exhibition of objects made by Elbert Hubbard's Roycofters focuses on the application of the aesthetic of the American Craft movement to objects such as books, furniture and metalwork used for work and study. WT
01/24/97–04/06/97	THE SOUTH BY ITS PHOTOGRAPHERS — Works by more than 45 artists.
05/97–07/97	DREAMS AND TRADITIONS: BRITISH AND IRISH PAINTING FROM THE ULSTER MUSEUM, BELFAST — The development of English and Irish painting from 1670 to 1993 is traced in the 45 works presented. WT

Florence

Florence Museum of Art, Science & History
558 Spruce Street, Florence, SC 29501
℡ 803-662-3351
HRS: 10-5 Tu-Sa, 2-5 S DAY CLOSED: M HOL: LEG/HOL!
&: Y; Limited, not all areas accessible ℗ Y
H/B: Y
PERM/COLL: AM/REG: ptgs; SW NAT/AM; pottery; CER

Founded to promote the arts and sciences, this museum, located in a 1939 art deco style building originally constructed as a private home, is surrounded by the grounds of Timrod Park. **NOT TO BE MISSED:** 'Francis Marion Crossing to Pee Dee', by Edward Arnold

Greenville

Bob Jones University Collection of Sacred Art
Jones University, Greenville, SC 29614
℡ 864-242-5100
HRS: 2-5 Tu-S HOL: 1/1, 7/4, 12/20 through 12/25, Commencement Day (early May)
&: Y ℗ Y; Nearby MUS/SH: Y
GR/T: Y GR/PH: CATR!
PERM/COLL: EU: ptgs including Rembrandt, Tintoretto, Titian, Veronese, Sebastiano del Piombo

One of the finest collections of religious art in America.

Greenville

Greenville County Museum of Art
420 College Street, **Greenville, SC 29601**
✆ 864-271-7570
HRS: 10-5 Tu-Sa, 1-5 S DAY CLOSED: M HOL: LEG/HOL!
&: Y MUS/SH: Y GR/T: Y GR/PH: CATR!
PERM/COLL: AM: ptgs, sculp, gr; REG

The Southern Collection, nationally recognized as one of the countries best regional collections, provides a survey of both American history and American art history from 1726 to World War II.

ON EXHIBIT/97:

11/20/96–10/05/97	THEMATIC INSTALLATIONS FROM THE PERMANENT COLLECTION — In this re-installation of the Museum's Southern Collection, dating from the early 1700's through the present, paintings are grouped thematically rather than chronologically. All have a tie to the South, through artist or subject matter.
12/04/96–01/19/97	GUY ROSE: AMERICAN IMPRESSIONIST — A retrospective survey of the work of this American impressionist ranges from picturesque scenes of the French countryside to views of the California coast. Many of these paintings are from private collections and have not been seen before. WT
01/10/97–02/23/97	ELENA SISTO — Cartoon imagery is employed by this contemporary painter to address issues such as power, history and sexuality.
02/05/97–03/30/97	JACOB LAWRENCE: THE FREDERICK DOUGLASS AND HARRIET TUBMAN SERIES OF NARRATIVE PAINTINGS — The 63 paintings (1938-40) exhibited tell the story of the two abolitionists who lived around the Civil War. Each depicts a significant event in the life of its hero. WT
02/28/97–04/13/97	REFLECTION AND REDEMPTION: THE SURREALIST ART OF ALFONSO OSSORIO, 1939-1949
04/16/97–06/15/97	STILL TIME: PHOTOGRAPHS BY SALLY MANN, 1971-91 WT

Murrells Inlet

Brookgreen Gardens
1931 Brookgreen Gardens Drive, **Murrells Inlet, SC 29576**
✆ 803-237-4218
HRS: 9:30-4:45 daily HOL: 12/25
ADM: Y ADULT: $7.50 CHILDREN: $3.00 (6-12)
&: Y ℗ Y MUS/SH: Y ⊩ Y; Terrace Cafe open year round
GR/T: Y GR/PH: catr! H/B: Y S/G: Y
PERM/COLL: AM: sculp 19, 20

The first public sculpture garden created in America is located on the grounds of a 200-year old rice plantation. It is the largest permanent outdoor collection of American Figurative Sculpture in the world with 542 works by 240 American sculptors on permanent display. **NOT TO BE MISSED:** "Fountain of the Muses," by Carl Milles

ON EXHIBIT/97:

through LATE 07/97	AMERICAN MASTER SCULPTURE FROM BROOKGREEN GARDENS — 42 works by America's master sculptors.

SOUTH CAROLINA

Spartanburg

The Spartanburg County Museum of Art
385 South Spring Street, **Spartanburg, SC 29306**
☎ 864-582-7616
HRS: 9-5 M-F, 10-2 Sa, 2-5 S HOL: LEG/HOL!, EASTER, 12/24
&: Y ℗ Y; Adjacent to the building MUS/SH: Y
PERM/COLL: AM/REG: ptgs, gr, dec/art

A multi-cultural Arts Center that presents 20 exhibits of regional art each year. **NOT TO BE MISSED:** "Girl With The Red Hair," by Robert Henri

ON EXHIBIT/97:

01/13/97–02/23/97	JIM COLLINS: MIXED MEDIA/SCULPTURE; H. STEINBERG: PHOTOGRAPHS; K. JARDINE: PAINTINGS
03/03/97–04/13/97	PRINT SHOW INVITATIONAL/ LEANN BEAVERS/ PATRICIA CARTER: MINT MUSEUM PRINT SHOW (tent): RESA ARONSON/JEWELRY
04/21/97–05/25/97	ARTISTS GUILD SHOW; R. SCHWARZCHILD/PHOTOS
06/02/97–07/06/97	NEIL JUSSILLA: FIGURATIVE PAINTINGS; B.PARRIS: PAINTINGS; SHEPHERD'S CENTER
07/14/97–08/17/97	A. ANTONIOU: PHOTOGRAPHS; MINT MUSEUM ANSEL ADAMS SHOW (tent); C.O.L.O.R.S.
08/25/97–10/05/97	MARK MESSERSMITH: PAINTINGS (COMPLEX); DANIEL FERRATO: PAINTINGS (SOMBER) (tent); MIKE CORBIN: PHOTOS-PEACH FARM
10/13/97–11/23/97	LIZ QUIZGARD: DECORATIVE SCULPTURE/PAINTINGS
12/19/97–01/04/98	DECEMBERFEST

Brookings

South Dakota Art Museum
Medary Ave at Harvey Dunn Street, **Brookings, SD 57007-0899**
\ 605-688-5423
HRS: 8-5 M-F, 5-9:30 T, 10-5 Sa, 1-5 S & holidays HOL: 1/1, THGV, 12/25
&: Y; Elevator service to all 3 levels from west entrance ℗ Y
MUS/SH: Y GR/T: Y GR/PH: CATR! S/G: Y
PERM/COLL: HARVEY DUNN: ptgs; OSCAR HOWE: ptgs; NAT/AM; REG 19, 20

Many of the state's art treasures including the paintings by Harvey Dunn of pioneer life on the prairie, a complete set of Marghab embroidery from Madeira, outstanding paintings by regional artist Oscar Howe, and masterpieces from all the Sioux tribes are displayed in the 6 galleries of this museum established in 1970.

ON EXHIBIT/97:

12/14/96–01/19/97	CARL GRUPP: DRAWINGS, PAINTINGS, PRINTS
01/25/97–02/23/97	CARLENE ROETERS: PAINTINGS, MONOPRINTS, CERAMICS
03/01/97–04/13/97	RAVAE MARSH-LUCKHART: RECENT WORKS
04/19/97–06/01/97	DAN PACKARD: CONSTRUCTIONS

Mitchell

Friends of the Middle Border Museum of American Indian and Pioneer Life
1311 S. Duff St., PO Box 1071, **Mitchell, SD 57301**
\ 605-996-2122
HRS: 8-6 M-Sa & 10-6 S (Jun-Aug); 9-5 M-F & 1-5 Sa, S (May-Sep); by appt(Oct-Apr) HOL: 1/1, THGV, 12/25
ADM: Y ADULT: $3.00 CHILDREN: F (under 12) SR CIT: $2.00
&: Y; Partially, the art gallery is not wheelchair accessible ℗ Y MUS/SH: Y
GR/T: Y GR/PH: CATR! H/B: Y
PERM/COLL: AM: ptgs 19, 20; NAT/AM

This Museum of American Indian and Pioneer life also has an eclectic art collection in the Case Art Gallery, the oldest regional art gallery including works by Harvey Dunn, James Earle Fraser, Gutzon Borglum, Oscar Howe, Childe Hassam, Elihu Vedder, Anna Hyatt Huntington and many others. **NOT TO BE MISSED:** Fraser's "End of the Trail" and Lewis and Clark Statues

Oscar Howe Art Center
119 W. Third, **Mitchell, SD 57301**
\ 605-996-4111
HRS: Winter: 10-5 W-Sa; Summer: 10-5 daily HOL: LEG/HOL!
&: Y ℗ Y; On-street
MUS/SH: Y GR/T: Y GR/PH: CATR! H/B: Y
PERM/COLL: OSCAR HOWE: ptgs, gr

Oscar Howe paintings and lithographs that document his career from his Santa Fe Indian School years through his mature work on a 1902 Carnegie Library are featured in the permanent collection of this art center that bears his name. **NOT TO BE MISSED:** "Sun and Rain Clouds Over Hills," dome painted by Oscar Howe in 1940 as a WPA project (Works Progress Administration)

SOUTH DAKOTA

Pine Ridge

The Heritage Center, Inc
Affiliate Institution: Red Cloud Indian School
Pine Ridge, SD 57770
☎ 605-867-5491
HRS: 9-5 M-F HOL: EASTER, THGV, 12/25
♿: Y ⓟ Y MUS/SH: Y GR/T: Y GR/PH: CATR! H/B: Y
PERM/COLL: CONT NAT/AM; GR; NW COAST; ESKIMO: 19, 20

The Center is located on the Red Cloud Indian school campus in an historic 1888 building built by the Sioux and operated by them with the Franciscan sisters. The Holy Rosary Mission church features a Gothic interior with designs by the Sioux.

Rapid City

Dahl Fine Arts Center
713 Seventh Street, **Rapid City, SD 57701**
☎ 605-394-4101
HRS: Winter: 9-5 M-Sa, 1-5 S; Summer: 9-8 M-T, 9-5 F & Sa, 1-5 S HOL: LEG/HOL!
♿: Y ⓟ Y; Metered MUS/SH: Y GR/T: Y GR/PH: CATR!
PERM/COLL: CONT; REG: ptgs; gr 20

The Dahl presents a forum for all types of fine arts: visual, theatre, and music, that serve the Black Hills region, eastern Wyoming, Montana, and Western Nebraska. **NOT TO BE MISSED:** 200 foot cyclorama depicting the history of the US.

Sioux Indian Museum and Crafts Center
Rapid City, SD 57701
☎ 605-348-0557
HRS: HOL: 1/1, THGV, 12/25
♿: Y ⓟ Y MUS/SH: Y GR/T: Y GR/PH: CATR!
PERM/COLL: SIOUX ARTS

Displays of the rich diversity of historic and contemporary Sioux art may be enjoyed at this museum and native crafts center with rotating exhibitions. PLEASE NOTE: A new building is under construction and tentatively scheduled to open in May 1997. Call for address and hours!

Sioux Falls

Civic Fine Arts Center
235 West Tenth Street, **Sioux Falls, SD 57102**
☎ 605-336-1167
HRS: 9-5 M-F, 10-5 Sa, 1-5 S & Hol HOL: 1/1, THGV, 12/25
♿: Y ⓟ Y H/B: Y
PERM/COLL: REG/ART: all media

The building was originally the 1902 Carnegie Library.

Sisseton

Tekakwitha Fine Arts Center
401 South 8th Street W., **Sisseton, SD 57262**
☎ 605-698-7058
HRS: 10-4 daily (Mem day-Lab day); 10-4 Tu-F & 12:30-4 Sa-S (mid Sep-mid May) HOL: LEG/HOL!
☧: Y ℗ Y MUS/SH: Y GR/T: Y GR/PH: CATR!
PERM/COLL: TWO DIMENSIONAL ART OF LAKE TRAVERSE DAKOTA SIOUX RESERVATION

Vermillion

University Art Galleries
Affiliate Institution: University of South Dakota
Warren M. Lee Center, 414 E. Clark Street, **Vermillion, SD 57069-2390**
☎ 605-677-5481
HRS: 10-4 M-F; 1-5 Sa, S HOL: ACAD!
☧: Y ℗.Y
PERM/COLL: Sioux artist OSCAR HOWE; HIST REG/ART

ON EXHIBIT/97:

01/08/97–01/28/97	LAWRENCE ANDERSON: SABBATICAL EXHIBITION
02/26/97–03/16/97	VIEWS OF JORDAN: PHOTOGRAPHS BY JOHN BANASIAK
03/19/97–04/08/97	DAKOTAS INTERNATIONAL: WORKS ON AND OF PAPER
05/15/97–06/10/97	THE CLEARING: AN INSTALLATION BY CONNIE HERRING
06/08/97–08/03/97	SUMMER ARTS XIX: REGIONAL COMPETITION
06/13/97–07/03/97	ROBERT FREEMAN RETROSPECTIVE EXHIBITION
08/10/97–08/30/97	THE AKELEY GIFT TO THE UNIVERSITY OF SOUTH DAKOTA PERMANENT COLLECTION
09/08/97–09/28/97	ROBERT ALDERN RETROSPECTIVE EXHIBITION
10/02/97–10/22/97	PAINTING INVITATIONAL EXHIBITION CURATED BY JEFF FREEMAN
10/26/97–11/15/97	FURNITURE AS ART

TENNESSEE

Chattanooga

Hunter Museum of American Art
10 Bluff View, **Chattanooga, TN 37403**
℡ 423-267-0968
HRS: 10-4:30 Tu-Sa, 1-4:30 S DAY CLOSED: M HOL: LEG/HOL!
ADM: Y ADULT: $5.00 CHILDREN: $2.50 (3-12) STUDENTS: $3.00 SR CIT: $4.00
&: Y Ⓟ Y MUS/SH: Y GR/T: Y GR/PH: CATR! H/B: Y
PERM/COLL: AM: ptgs, gr, sculp, 18-20

Blending the old and the new, the Hunter Museum consists of a 1904 mansion with a 1975 contemporary addition.

ON EXHIBIT/97:

10/18/97–11/22/97	STEVE LEWINTER
12/06/97–01/25/98	MARY FERRIS KELLEY — Kelly's exuberant paintings often focus on the human figure and on angels.
12/07/97–01/24/98	ART FROM THE DRIVER'S SEAT: AMERICANS AND THEIR CARS — Paintings, drawings, photographs and etchings from the Terry and Eva Herndon Collection will be featured in an exhibition that allows the visitor to look into the rear view mirror at the history of America's relationship with the automobile. WT

Knoxville

Knoxville Museum of Art
1050 World's Fair Park Drive, **Knoxville, TN 37916-1653**
℡ 423-525-6101 WEB ADDRESS: http://www.esper.com/KMA
HRS: 10-5 Tu-T, S; 10-9 F; 11:30-5 S DAY CLOSED: M HOL: LEG/HOL!
&: Y Ⓟ Y; Free parking across the street MUS/SH: Y ¶ Y GR/T: Y GR/PH: CATR!
PERM/COLL: CONT; GR ; AM: 19

Begun in 1961 as the Dulin Gallery of Art located in an ante bellum mansion, the Knoxville Museum, because of its rapidly expanding collection of contemporary American art, then moved to the historic Candy Factory prior to settling into its new facility in 1990. **NOT TO BE MISSED:** Historic Candy Factory next door; the nearby Sunsphere, trademark building of the Knoxville Worlds Fair

ON EXHIBIT/97:

08/16/96–07/27/97	SELECTIONS FROM THE KNOXVILLE MUSEUM OF ART'S PERMANENT COLLECTION (Working Title) — This group of paintings and works on paper representing the strength of the Museum's collection of contemporary art is notable for its range of styles and imagery. Works on view include those by Frederick Brosen, Janet Fish, John Kelley and Robert Longo as well as Robert Rauschenberg, Bessie Harvey, Robert Van Vranken and others.
08/16/96–04/06/97	OLD MASTER PAINTINGS FROM THE BLAFFER FOUNDATION — An exhibition of approximately 40 works by Rubens, Hals, Breughel the Younger, Cranach, Van Dyck and others represents one of the richest and most diversified periods in Western painting. WT
10/11/96–01/12/97	HEROIC PAINTING — Heroic acts of daily life will be one of the topics explored in this exhibition dealing with the notion of the "hero" as subject matter in art. WT
04/04/97–07/27/97	AWAKENING THE SPIRITS: SCULPTURE BY BESSIE HARVEY — The first retrospective of the work of Harvey, a self-taught artist who extracted historical and imaginary characters from gnarled roots, branches, paint and cloth and is in the forefront of American folk art. WT
05/03/97–08/17/97	RED GROOMS INSTALLATION — Grooms' major site-specific installation allows visitors to walk through his whimsical and colorful visions of urban life in America. ADM FEE

Memphis

The Dixon Gallery & Gardens
4339 Park Ave, **Memphis, TN 38117**
☎ 901-761-5250
HRS: 10-5 Tu-Sa, 1-5 S, Gardens only M 1/2 price DAY CLOSED: M HOL: LEG/HOL!
F/DAY: T, Seniors only ADM: Y ADULT: $5.00 CHILDREN: $1.00 (under 12) STUDENTS: $3.00 SR CIT: $4.00
& : Y ⓟ Y; Free MUS/SH: Y GR/T: Y GR/PH: CATR! DT: Y TIME: ! H/B: Y S/G: Y
PERM/COLL: FR: Impr, 19; GER: cer

Located on 17 acres of woodlands and formal gardens, the Dixon was formerly the home of Hugo and Margaret Dixon, collectors and philanthropists.

ON EXHIBIT/97:

11/24/96–01/19/97	THE KIMONO INSPIRATION: ART AND ART-TO-WEAR IN AMERICA	WT
01/05/97–06/01/97	MASTERWORKS FROM THE CHEEKWOOD COLLECTION	
05/04/97–06/01/97	MEMPHIS IN MAY EXHIBITION: SALUTE TO BRAZIL	
06/22/97–09/14/97	DALE CHIHULY: INSTALLATIONS 1964-1995 — In the most comprehensive presentation of his work to date, over 100 fantastic glass creations by this modern American master of the medium will be featured in a spectacular installation that includes "Sea Forms," "Chandelier," and "Floats," 3 of the largest glass spheres ever blown. CAT WT	

Memphis Brooks Museum of Art
Overton Park, 1934 Poplar Ave., **Memphis, TN 38104-2765**
☎ 901-722-3500
HRS: 9-4 Tu, W, F; 11-8 T; 9-5 Sa; 11:30-5 S DAY CLOSED: M HOL: 1/1, 7/4, THGV (open 10-1), 12/25
& : Y MUS/SH: Y ❙❙ Y; Brushmark Restaurant; Lunch 11:30-2:30; Cocktails and dinner T. to r
GR/T: Y GR/PH: CATR! 901-722-3515 DT: Y TIME: 10:30, 1:30 Sa; 1:30 S
PERM/COLL: IT/REN, NORTHERN/REN, & BAROQUE: ptgs; BRIT & AM: portraits 18, 19; FR/IMPR; AM: modernist

Founded in 1916, this is the mid-south's largest and most encyclopedic fine arts museum. Works in the collection range from those of antiquity to present day creations. **NOT TO BE MISSED:** Global Survey Galleries

ON EXHIBIT/97:

through 02/09/97	DAVID SMITH AND ITALY: VOLTRI LANDSCAPES AND SPRAYS — A survey of Smith's drawings and paintings on paper created for the Spoleto festival in 1962 will be displayed with subsequent Italian-influenced work completed before his death in 1965.	
11/03/96–01/06/97	MYTHS, MAGIC AND MYSTERY: ONE HUNDRED YEARS OF AMERICAN CHILDREN'S BOOK ILLUSTRATION — Illustrations by Beatrix Potter, Edward Lear and others.	CAT WT
11/28/96–01/26/97	REMBRANDT! PRINTS FROM THE PERMANENT COLLECTION — Landscapes, portraits, religious and genre scenes from different stages of Rembrandt's career offer an opportunity to appreciate his development as a printmaker.	
02/21/97–05/04/97	NANCY GRAVES: EXCAVATIONS IN PRINT — 45 works by Graves will be on view in the first comprehensive exhibition of her innovative graphics in which the use of unconventional materials and techniques allows her to break down boundaries within and between traditional mediums.	CAT WT
03/16/97–05/11/97	TURNER WATERCOLORS FROM MANCHESTER — Turner watercolors on loan from Manchester will be displayed with those in the collection of the Indianapolis Museum of Art, the largest of its kind in America, in an exhibition that forms the largest and most comprehensive presentation of its kind in a decade.	WT
06/08/97–08/31/97	STITCHES IN TIME: TEXTILES FROM THE BROOKS COLLECTION	
11/16/97–01/11/98	LASTING IMPRESSIONS: THE DRAWINGS OF THOMAS HART BENTON — Approximately 70 drawings and watercolors from the artist's working studio collection provide an amazingly rich visual record of the artist's experiences of a lifetime.	WT

TENNESSEE

Murfreesboro

Middle Tennessee State University Photographic Gallery
Affiliate Institution: Middle Tennessee State University
Learning Resources Center, **Murfreesboro, TN 37132**
☎ 615-898-5628
HRS: 8-4:30 M-F, 8-noon Sa, 6-10 PM S HOL: EASTER, THGV, 12/25
&: Y; 1st floor complete with special electric door ℗ Y; Free parking 50 yards from gallery
PERM/COLL: CONT: phot

A college museum with major rotating photographic exhibitions.

Nashville

Cheekwood - Nashville's Home of Art and Gardens
1200 Forrest Park Drive, **Nashville, TN 37205-4242**
☎ 615-356-8000
HRS: 9-5 M-Sa, 12-5 S (Grounds open 11-5 S) Facility renovation in 1997-call! HOL: 1/1, THGV, 12/24, 12/25, 12/31
ADM: Y ADULT: $5.00 CHILDREN: $2.00 (7-17) STUDENTS: $4.00 SR CIT: $4.00
&: Y ℗ Y MUS/SH: Y GR/T: Y GR/PH: CATR! H/B: Y S/G: Y
PERM/COLL: AM: ptgs, sculp, dec/art 19-20

One of the leading cultural centers in the South, the Museum of Art, housed in a former 1920's mansion that retains its charming homelike quality, is located in a luxuriant botanical garden.

The Parthenon
Centennial Park, **Nashville, TN 37201**
☎ 615-862-8431
HRS: 9-4:30 Tu-Sa, 12:30-4:30 S, For summer hours! DAY CLOSED: M HOL: LEG/HOL!
ADM: Y ADULT: $2.50 CHILDREN: $1.25 (4-17) SR CIT: $1.25
&: Y ℗ Y; Free MUS/SH: Y GR/T: Y GR/PH: CATR! H/B: Y
PERM/COLL: AM: 19, 20; The Cowan Collection

First constructed as the Art Pavillion for the Tennessee Centennial Exposition in 1897, The Parthenon is the world's only full size reproduction of the original 5th-century B.C. Greek building complete with the statue of Athena Parthenos. **NOT TO BE MISSED:** "Mt. Tamalpais," by Albert Bierstadt

ON EXHIBIT/97:

01/25/97–03/08/97	LINDA DUROSSETT
03/01/97–04/12/97	CENTENNIAL CENTENNIAL
03/15/97–04/26/97	DENNIS SWEENEY
04/19/97–05/31/97	BOB HEAD
05/03/97–05/31/97	TRAVIS CHILDERS
06/07/97–07/19/97	CENTRAL-SOUTH EXHIBITION
07/26/97–09/06/97	LIBBY BAILEY
08/02/97–09/13/97	ANA ALVIRA
09/13/97–10/25/97	PAUL HARMON
11/01/97–01/03/98	TENNESSEE ALL STATE EXHIBITION

Nashville

The University Galleries
Affiliate Institution: Fisk University
D.B. Todd Blvd and Jackson Street, N., **Nashville, TN 37208-3051**
☎ 615-329-8543
HRS: 10-5 Tu-F, 1-5 Sa-S; Summer: 10-4 Tu-F DAY CLOSED: M HOL: ACAD!
VOL/CONT: Y &: Y ℗ Y MUS/SH: Y GR/T: Y GR/PH: CATR! H/B: Y
PERM/COLL: EU; AM; AF/AM: ptgs; AF: sculp

The museum is housed both in an historic (1888) building and in the University library. **NOT TO BE MISSED:** The Alfred Stieglitz Collection of modern art

Vanderbilt University Fine Arts Gallery
23rd at West End Ave, **Nashville, TN 37203**
☎ 615-322-0600
HRS: 1-4 M-F; 1-5 Sa, S; Summer: 1-4 M-F HOL: ACAD!
℗ Y H/B: Y
PERM/COLL: OR: Harold P. Stern Coll; OM & MODERN: gr (Anna C. Hoyt Coll); CONTINI-VOLTERRA PHOT ARCHIVE; EU: om/ptgs (Kress Study Coll)

The history of world art may be seen in the more than 7,000 works from over 40 countries housed in this museum. Rich in old masterworks and Oriental art, this historical collection is the only one of its kind in the immediate region. **NOT TO BE MISSED:** 'St. Sebastian', 15th-century Central Italian tempera on wood

ON EXHIBIT/97:

01/09/97–02/09/97	DEANNA AUGSBURGER: THE 1995 MARGARET STONEWALL WOOLDRIDGE HAMBLET AWARD EXHIBITION — A juried invitational by the winning graduating Senior of the previous year.
02/20/97–03/30/97	THE ARTS OF ASIA: HIGHLIGHTS FROM THE VANDERBILT UNIVERSITY FINE ARTS GALLERY COLLECTIONS — The first comprehensive survey of the fine, folk and applied arts of countries includes works from Japan, People's Republic of China, Thailand, Cambodia, Korea, Vietnam, Taiwan, and India.
04/11/97–06/08/97	CAPITOL CULTURES — This exhibition, held in conjunction with the meeting of the American Society for Eighteenth-Century Studies, explores the different characteristics of visual culture as well as documentary culture in diverse world capitals during the 18th-century.
06/23/97–08/15/97	FAUX POST: ARTIST'S POSTAGE STAMPS FOR THE INTERNATIONAL MAIL NETWORK — A unique contemporary art form, Artstamps, mimics the look of postage stamps. Stamp production, until now a medium exclusive to governments, can be seen as an ideal expressive tool for artists interested in commentary on the way these governments have utilized art imagery for its own purposes. WT

Oak Ridge

Oak Ridge Arts Center
201 Badger Avenue, **Oak Ridge, TN 37830**
☎ 615-482-1441
HRS: 9-5 Tu-F, 1-4 Sa-M HOL: LEG/HOL!
&: Y ℗ Y
PERM/COLL: AB/EXP: Post WW II; REG

NOT TO BE MISSED: Gomez Collection of Post WW II art

TEXAS

Abilene

Museums of Abilene, Inc.
102 Cypress, **Abilene, TX 79601**
☎ 915-673-4587
HRS: 10-5 Tu, W, F, Sa; 5-8:30 T; 1-5 S DAY CLOSED: M HOL: LEG/HOL!
F/DAY: T-Eve ADM: Y ADULT: $2.00 CHILDREN: $1.00 (3-12) STUDENTS: $2.00 SR CIT: $2.00
&: Y Ⓟ Y MUS/SH: Y
GR/T: Y GR/PH: CATR! H/B: Y
PERM/COLL: TEXAS/REG; AM: gr, CONT: gr; ABILENE, TX, & PACIFIC RAILWAY: 18-20

The museums are housed in the 1909 Mission Revival Style Railroad Hotel.

Albany

The Old Jail Art Center
Hwy 6 South, **Albany, TX 76430**
☎ 915-762-2269
HRS: 10-5 Tu-Sa, 2-5 S DAY CLOSED: M HOL: LEG/HOL!
&: Y; Except 2 story original jail building Ⓟ Y
GR/T: Y GR/PH: CATR! 915-762-2269 H/B: Y S/G: Y
PERM/COLL: AS, EU, BRIT cont, Mod;

The Old Jail Art Center is housed partly in a restored 1878 historic jail building, with a small annex opened in 1980, and in a new wing added in 1984, featuring a courtyard and sculpture garden. **NOT TO BE MISSED:** 'Young Girl With Braids', by Modigliani; 37 Chinese terra cotta tomb figures

ON EXHIBIT/97:

12/06/96–02/01/97	GRAND OPENING OF NEW WING/ THE COLLECTOR II — This sequel to the exhibition which celebrated the 1984 opening of the then new addition is based on the same premise – CENTURIES OF ART FROM TEXAS COLLECTORS. This segment will focus on the 'joys and fun of collecting' by looking at art through the eyes of our lenders. Dates Tent!
02/09/97–03/16/97	ANA MARIA PACHECO: MAN AND HIS SHEEP — A life size sculpture of 8 figures by Pacheco, a British artist, will be complemented by a series of her prints.
03/22/97–05/10/97	EMERGING ARTIST EXHIBITION
05/24/97–07/31/97	KEN DIXON: ORDER AND DISORDER: FAMOUS AND LEGENDARY HORSES OF WEST TEXAS — Dixon's large scale paintings on wood are constructions of puzzle shapes, sculptural elements and narrative texts.
06/07/97–08/03/97	JOE ED BARRINGTON, OUTDOOR SCULPTURE AND STEVE MURPHY, RECENT SCULPTURE TENT!
08/10/97–09/28/97	SELECTIONS FROM THE OLD JAIL CENTER'S PERMANENT COLLECTION
10/04/97–12/07/97	GROUP PHOTOGRAPHY EXHIBITION TENT!
12/15/97–01/19/98	TURN, TURNING, TURNED — On exhibit will be 35 wood works by both formally trained and self-taught artists that explore techniques ranging from the strictly traditional to computer generated forms turned on a computer driven lathe. WT

Amarillo

Amarillo Museum of Art
2200 S. Van Buren, **Amarillo, TX 79109**
☎ 806-371-5050
HRS: 10-5 Tu-F; 1-5 Sa, S DAY CLOSED: M HOL: LEG/HOL! ♿: Y Ⓟ Y S/G: Y
PERM/COLL: CONT AM; ptgs, gr, phot, sculp; JAP gr; SE ASIA sculp

Opened in 1972, the Amarillo Museum of Art is a visual arts museum featuring exhibitions, art classes, tours and educational programs.

ON EXHIBIT/97:

01/18/97–03/02/97	TREASURES FROM AFRICA
03/08/97–04/27/97	PATRICK FAULHABER: THE PANHANDLE AND BEYOND
06/28/97–08/17/97	HUDSON RIVER SCHOOL
06/28/97–08/17/97	KEN LITTLE: NATIVE SON

Arlington

Arlington Museum of Art
201 West Main St., **Arlington, TX 76010**
☎ 817-275-4600
HRS: 10-5 W-Sa DAY CLOSED: S, M, Tu HOL: LEG/HOLS, 12/25-1/2!
♿: Y; Partial with ramp on side of building, & restrooms Ⓟ Y; Free parking directly in front of the building with handicapped spaces; parking also at side of building MUS/SH: Y GR/T: Y GR/PH: CATR! DT: Y TIME: Occasional
PERM/COLL: Non-collecting institution

Texas contemporary art by both emerging and mature talents is featured in this North Texas museum located between the art-rich cities of Fort Worth and Dallas. This institution has gained a solid reputation for showcasing contemporary art in the eight exhibitions it presents annually.

The Center for Research in Contemporary Arts
Fine Arts Bldg, Cooper Street, **Arlington, TX 76019**
☎ 817-273-2790
HRS: 10-3 M-T, 1-4 Sa-S HOL: ACAD! Ⓟ Y
PERM/COLL: Non-collecting institution

A University gallery with varied special exhibitions.

Austin

Archer M. Huntington Art Gallery
Affiliate Institution: University of Texas at Austin
Art Bldg, 23rd & San Jacinto Streets, **Austin, TX 78712-1205**
☎ 512-471-7324 WEB ADDRESS: http://www.utexas.edu/cofa/hag
HRS: 9-5 M-Sa, 1-5 S HOL: MEM/DAY, LAB/DAY, THGV, XMAS WEEK
♿: Y Ⓟ Y MUS/SH: Y GR/T: Y GR/PH: CATR! S/G: Y
PERM/COLL: LAT/AM; CONT; GR; DRGS,

The encyclopedic collection of this university gallery, one of the finest and most balanced in the southern United States, features a superb collection of medieval art. The permanent collection is located in the Harry Ransom Humanities Research Center at 21st and Guadelupe Streets.

TEXAS

Austin

Austin Museum of Art at Laguna Gloria
3809 W. 35th Street, **Austin, TX 78703**
✆ 512-458-8191 WEB ADDRESS: http://www.amoa.org
HRS: 10-5 Tu-Sa, 1-5 S DAY CLOSED: M HOL: LEG/HOL!
F/DAY: T ADM: Y ADULT: $2.00 CHILDREN: F (under 16) STUDENTS: $1.00 SR CIT: $1.00
&: Y ℗ Y; Free MUS/SH: Y GR/T: Y GR/PH: CATR! H/B: Y S/G: Y
PERM/COLL: AM: ptgs 19, 20; WORKS ON PAPER

The Museum is Located on the 1916 Driscoll Estate which is listed in the National Register of Historic Places.

ON EXHIBIT/97:
 AUSTIN MUSEUM OF ART DOWNTOWN, 823 Congress Ave. Austin, TX 78701, 512-495-9224

01/18-04/13/97	FRESH INK: AUSTIN PRINT WORKSHOP
04/26-07/20/97	HAITIAN ART
08/02-10/12/97	SUBVERSIONS/AFFIRMATIONS: JAUNE QUICK TO SEE SMITH, A SURVEY

 AUSTIN MUSEUM OF ART AT LAGUNA GLORIA

01/12/97–01/26/97	ART GUYS INSTALLATION
02/08/97–05/04/97	ART PATTERNS: ANNUAL FAMILY EXHIBITION
05/17/97–08/10/97	CHICANO EXHIBITION
08/23/97–11/16/97	TEXAS VERNACULAR

Beaumont

The Art Museum of Southeast Texas
500 Main Street, **Beaumont, TX 77701**
✆ 409-832-3432
HRS: 9-5 M-Sa, 12-5 S HOL: LEG/HOL!
&: Y ℗ Y MUS/SH: Y ¶ Y
GR/T: Y GR/PH: CATR! DT: Y TIME: W, noon S/G: Y
PERM/COLL: AM: ptgs, sculp, dec/art, FOLK: 19, 20

This new spacious art museum with 4 major galleries and 2 sculpture courtyards is located in downtown Beaumont.

ON EXHIBIT/97:
12/08/96–01/20/97	THE FIGURE IN 20TH CENTURY SCULPTURE — Works by 48 internationally known sculptors Rodin, Maillol, Lachaise, Giacometti, Lipschitz, Neri and others will be included in this stunning 20th-century survey of the interpretation of the human form. WT
02/14/97–06/15/97	KEITH CARTER: RECENT WORK
02/14/97–06/22/97	HELEN ALTMAN SCULPTURE
06/28/97–08/31/97	LEROY ARCHULETA: A TO Z — Charming, brightly colored wooden animals by Hispanic folk artist Archuleta, on loan from the Sylvia & Warren Lowe collection, will be arranged in a fantastical zoo-like gallery setting. WT
09/06/97–01/27/98	SOUTHEAST TEXAS COLLECTS

College Station

MSC Forsyth Center Galleries

Affiliate Institution: Texas A & M University
Memorial Student Center, Joe Routt Blvd, **College Station, TX 77844-9081**
📞 409-845-9251
HRS: 9-8 M-F, 12-6 Sa-S HOL: 7/4, THGV, 12/25-1/1
&: Y ℗ Y; Underground GR/T: Y GR/PH: CATR!
PERM/COLL: EU, BRIT & AM; glass; AM: western ptgs

The Gallery, particularly rich in its collection of American Art glass, has one of the finest collections of English Cameo Glass in the world. **NOT TO BE MISSED:** Works by Grandma Moses

ON EXHIBIT/97:

01/13/97–05/11/97	LOOK FOR THE LABEL: FIFTY YEARS OF THE LIBBEY GLASS COMPANY
01/13/97–05/11/97	LIFE, LOVE AND DEATH IN WINSLOW HOMER'S "WINDING THE CLOCK"

Texas A&M University/J. Wayne Stark University Center Galleries

Mem Student Ctr. Joe Routt Blvd, **College Station, TX 77844-9083**
📞 409-845-8501
HRS: 9-8 Tu-F, 12-6 Sa-S DAY CLOSED: M HOL: ACAD!
&: Y ℗ Y GR/T: Y GR/PH: CATR!
PERM/COLL: REG; GER 19

A University gallery featuring works by 20th-century Texas artists

ON EXHIBIT/97:

01/16/97–03/19/97	PIECES, PARTS AND PASSION: QUILTS
01/23/97–03/12/97	FACULTY ART EXHIBITION Tent. Name
03/20/97–05/19/97	CRAFTSMEN TO THE KINGS: RURAL MAYA STONE TECHNOLOGY AT COLHA, BELIZE WT
03/24/97–05/04/97	SPANISH CIVIL WAR POSTERS
05/08/97–06/29/97	PERSPECTIVE 97: FLORAL INTERPRETATIONS OF UNIVERSITY ART WORKS
05/22/97–07/03/97	EDWARD CURTIS PHOTOGRAPHS
09/02/97–10/12/97	PICASSO POSTERS: A STUDY IN DESIGN
09/04/97–10/19/97	NORMAN ROCKWELL LITHOGRAPHS

Corpus Christi

Art Museum of South Texas

1902 N. Shoreline, **Corpus Christi, TX 78401**
📞 210-884-3844
HRS: 10-5 Tu-Sa, 1-5 S DAY CLOSED: M HOL: 1/1, 7/4, THGV, 12/25
F/DAY: T ADM: Y ADULT: $3.00 CHILDREN: $1.00 (2-12) STUDENTS: $2.00 SR CIT: $2.00
&: Y ℗ Y; Free MUS/SH: Y ⑪ Y S/G: Y
PERM/COLL: AM; REG

The award winning building, designed by Philip Johnson, has vast expanses of glass which provide natural light for objects of art in addition to breathtaking views of Corpus Christi Bay.

Art Museum of South Texas - continued

ON EXHIBIT/97:

01/03/97–03/02/97	FRENCH PAINTINGS FROM THE SARAH CAMPBELL BLAFFER FOUNDATION — Masterpieces from the 16th to 18th-century.
01/10/97–03/30/97	REDISCOVERING THE LANDSCAPE OF THE AMERICAS — Approximately 80 paintings by contemporary artists including Rackstraw Downes, Janet Fish and Wolf Kahn, depict artists' responses to the particular places they call home; namely, Mexico, the United States, Canada. WT
04/04/97–05/11/97	CHARLES MARY KUBRICHT AND TERRELL JAMES — Works by two Houston artists who address the subject of nature and the environment using very different styles of painting.
05/16/97–07/13/97	CHARLES SCHORRE: A RETROSPECTIVE — Highlights of the long career and varied output of Schorre, an artist who has worked in all media.
07/18/97–09/14/97	THE HISPANIC VOICE: FROM THE PERMANENT COLLECTION OF THE ART MUSEUM OF SOUTH TEXAS — The story of the Hispanic community told through paint, photography, printmaking, and sculpture.
07/18/97–09/14/97	THE FOUNDATION SHOW — A juried biennial competition for South Texas artists.

Corpus Christi

Asian Cultures Museum and Educational Center

Upper Level, Sunrise Mall, 5858 SPID #66, **Corpus Christi, TX 78412**
☎ 512-993-3963
HRS: 12-6 Tu-Sa DAY CLOSED: S, M HOL: LEG/HOL!, EASTER
VOL/CONT: Y
&: Y ⓟ Y; Street MUS/SH: Y GR/T: Y GR/PH: CATR! H/B: Y
PERM/COLL: JAP

An oasis of peace and tranquility, this museum's holdings are comprised predominately of one private Hakata Doll collection. **NOT TO BE MISSED:** Cast bronze Buddha weighing over 1500 lb

Dallas

African American Museum

1111 First Avenue, **Dallas, TX 75215**
☎ 214-565-9026
HRS: 10-5 T-Sa, 1-5 S HOL: LEG/HOL!
&: Y ⓟ Y MUS/SH: Y ⅃⅃ Y GR/T: Y GR/PH: CATR! S/G: Y
PERM/COLL: AF/AM: folk

The African American Museum collects, preserves, exhibits and researches artistic expressions and historic documents which represent the African-American heritage. Its mission is to educate and give a truer understanding of African-American culture to all.

ON EXHIBIT/97:

01/03/97–03/02/97	IN THE SPIRIT OF RESISTANCE: AFRICAN-AMERICAN MODERNISTS AND THE MEXICAN MURALIST SCHOOOL — Influences of the Mexican Muralist movement on African-American modernist artists will be explored in the works on view by Rivera, Orozco, Catlett, Lawrence, Woodruff and others. CAT WT
01/10/97–03/23/97	SELECTIONS FROM THE PERMANENT COLLECTION

African American Museum - continued

02/07/97–04/20/97	PARADOXICAL SCULPTORS: THREE GENERATIONS OF AFRICAN AMERICAN WOMEN SCULPTORS
02/28/97–05/18/97	WILLIAM EDMONDSON
04/11/97–07/15/97	ISAAC SMIT
05/10/97–07/06/97	WADE IN THE WATER
05/30/97–08/31/97	18TH SOUTHWEST BLACK ART FESTIVAL
06/19/97–08/31/97	BLACK POLITICAL ARCHIVES
08/08/97–10/11/97	JOHNNY BANKS
09/12/97–12/28/97	DISCOVER GREATNESS
10/24/97–12/31/97	ALMA GUNTER

Dallas

Biblical Arts Center
7500 Park Lane, **Dallas, TX 75225**
☎ 214-691-4661
HRS: 10-5 Tu-Sa, 1-5 S DAY CLOSED: M HOL: 1/1, THGV, 12/24, 12/25
ADM: Y ADULT: $3.75 CHILDREN: $2.00 (6-12) SR CIT: $3.00
&: Y ℗ Y MUS/SH: Y H/B: Y
PERM/COLL: BIBLICAL ART

The sole purpose of this museum is to utilize the arts as a means of helping people of all faiths to more clearly envision the places, events, and people of the Bible. The building, in the style of Romanesque architecture, features early Christian era architectural details. **NOT TO BE MISSED:** 'Miracle at Pentecost', painting with light and sound presentation

Dallas Museum of Art
1717 N. Harwood, **Dallas, TX 75201**
☎ 214-922-1200 WEB ADDRESS: http://www.unt.edu/dfw/dma.htm
HRS: 11-4 Tu, W, F; 11-9 T; 11-5 Sa, S & Hols DAY CLOSED: M HOL: 1/1, THGV, 12/25
&: Y ℗ Y; Large underground parking facility MUS/SH: Y ⅃Y GR/T: Y GR/PH: CATR! S/G: Y
PERM/COLL: P/COL; AF; AM: furniture; EUR: ptgs, sculp, Post War AM; AF; AS; CONT

Designed by Edward Larabee Barnes, the new Nancy and Jake Hamon Building is a $30 million dollar 140 square foot addition to the museum. Housing a 14,000 square foot exhibition gallery, it is billed as the first museum to focus on the art of the Americas from the pre-contact period (which includes a spectacular pre-Columbian gold Treasury of more than 1,000 works) through the mid-20th-century. **NOT TO BE MISSED:** 'The Icebergs' by Frederick Church; 750 piece Bybee Collection of early American furniture; Education Resource Center with computer information on items in the core collection; contemporary art collection in Museum of Contemporary Art opened 11/21/93.

ON EXHIBIT/97:	The J.E.R. Chilton Galleries (Special Exhibition Galleries) have an admission charge: Adults $8.00; Students/Seniors $6.00; Children under 12 $2.00. Audio tour is included. Thursday after 5 adm is free-audio tour $4.00.
ONGOING	ETERNAL EGYPT — A three part installation on long term loan containing funerary art, sculptures of kings and gods, and other objects from tombs and temples in ancient Egypt. Views of everyday life and the afterlife are seen through vessels, jewelry and religious objects. Art of Nubia includes fine examples of blue faience vessels, weapons, lamps, etc., as well as a large group of 'shabti' tomb figures.

TEXAS

Dallas Museum of Art - continued

ONGOING	SOUTH ASIAN SCULPTURE — Exceptionally fine sculptures representing the artistic traditions of India, Nepal, Tibet, Thailand and Indonesia.
12/15/96–02/16/97	FOCUS ON SIR EDWARD COLEY BURNE-JONES'S 'THE PILGRIM AT THE GATE OF IDLENESS' — The exhibition places this important new acquisition in the context of the artist's fascination with medieval themes and his work in the Aesthetic Movement of the 1880's with artist-designers William Morris and John Ruskin. ADM FEE
02/02/97–04/27/97	ANIMALS IN AFRICAN ART: FROM THE FAMILIAR TO THE MARVELOUS — This exhibition of more than 90 representations of animals, both domestic and wild, minuscule and mammoth, from the 11th through 20th centuries is visually stunning, possessing great aesthetic power and charm. CAT WT
02/16/97–04/22/97	PENNSYLVANIA QUILTS: SELECTIONS FROM THE LANDES DOWRY — The first in a series of exhibitions at the museum sponsored by the Quilter's Guild of Dallas is drawn from a rare dowry of textiles assembled in the 19th-century.
05/18/97–08/02/97	LUIS JIMINEZ: WORKING CLASS HEROES, IMAGES FROM THE POPULAR CULTURE — The Dallas Museum of Art will augment the exhibition with loans from regional public and private collections which will only be shown at this venue. WT
06/01/97–08/24/97	PIONEER IN ABSTRACTION: FRANTISEK KUPKA: PAINTING THE UNIVERSE — Modernist works by this Czech artist, a contemporary of Mondrian and Kandinsky, are fascinating for their sumptuous colors, daring form and creative evolution from 19th-century symbolism to pure abstraction. ADM FEE WT
06/01/97–08/24/97	WHAT IS ART? RUSSIAN WORKS FROM THE PERMANENT COLLECTION, 1910-1940 — Complementing the Frantisek Kupka exhibition are these 100 works from the museum's collection of graphic art by the Russian avant-garde.

Dallas

The Meadows Museum
Affiliate Institution: SMU School of the Arts
Bishop Blvd. at Binkley Ave., **Dallas, TX 75275-0356**
☎ 214-768-2516
HRS: 10-5 M, Tu, F, Sa; 10-8 T; 1-5 S DAY CLOSED: W HOL: 1/1, EASTER, 7/4, THGV, 12/25
VOL/CONT: Y &: Y Ⓟ Y MUS/SH: Y
GR/T: Y GR/PH: CATR! 214-823-7644 DT: Y TIME: 2 PM, S, Sept-May S/G: Y
PERM/COLL: SP; ptgs, sculp, gr, drgs; AM: sculp 20,

The collection of Spanish Art, with works from the last years of the 15th-century through the 20th-century, is the most comprehensive in the US.

ON EXHIBIT/97:

02/14/97–03/30/97	LOVE CONQUERS WAR: RENAISSANCE EVOCATIONS BY LINDEE CLIMO — Paintings by Climo, a Canadian artist whose compositions use sheep to evoke, through earlier artist's style and mood, artistic masterpieces of the European tradition. WT
04/18/97–06/22/97	JERRY BYWATERS: A FORCE IN TEXAS ART — A survey, through paintings and works on paper, of the life work of this renowned Texas artist.

El Paso

El Paso Museum of Art
1211 Montana Ave, **El Paso, TX 79902-5588**
☎ 915-541-4040
HRS: 9-5 Tu, W, F, Sa; 9-9 T; 1-5 S DAY CLOSED: M HOL: LEG/HOL!
&: Y Ⓟ Y; Free MUS/SH: Y GR/T: Y GR/PH: CATR!
PERM/COLL: EU: Kress Coll 13-18; AM; MEX: 18, 19; MEX SANTOS: 20; REG

Fort Worth

Amon Carter Museum
3501 Camp Bowie Blvd, **Fort Worth, TX 76107-2631**
☎ 817-738-1933
HRS: 10-5 Tu-Sa, 12-5 S DAY CLOSED: M HOL: 1/1, 7/4, THGV, 12/24, 12/25
♿: Y; Side entrance Ⓟ Y; Free MUS/SH: Y GR/T: Y GR/PH: CATR!
PERM/COLL: AM: ptgs, sculp, gr, phot 19, 20; WESTERN ART

One of the foremost museums of American Art, the Amon Carter, located in Fort Worth's cultural district, represents the Western experience and embraces the history of 19th and 20th-century American Art. **NOT TO BE MISSED:** "The Swimming Hole," by Thomas Eakins

ON EXHIBIT/97:

	MASTERWORKS OF THE PHOTOGRAPHY COLLECTION is an ongoing reinstallation. Dates are 1/11-5/11/97, 5/17-9/17/97, and 9/13/97-2/8/98	
11/23/96–02/23/97	PLAIN PICTURES: IMAGES OF THE AMERICAN PRAIRIE	WT
03/01/97–06/01/97	LIKENESS AND LANDSCAPE: THE DAGUERREOTYPE ART OF THOMAS M. EASTERLY	
06/07/97–08/17/97	SELECTIONS FROM THE AMON CARTER MUSEUM COLLECTIONS	
08/23/97–11/02/97	CHARLES SHEELER IN DOYLESTOWN: AMERICAN MODERNISM AND THE PENNSYLVANIA TARDITION — American modernist's Sheeler's approach to the vernacular of Pennsylvania architecture and artifacts will be addressed in this exhibition. WT	

Kimbell Art Museum
3333 Camp Bowie Blvd, **Fort Worth, TX 76107-2792**
☎ 817-332-8451
HRS: 10-5 Tu-T, Sa; 12-8 F; 12-5 S HOL: 1/1, 7/4, THGV, 12/25
ADM: Y ADULT: $6.00 CHILDREN: $2.00 (6-12) STUDENTS: $4.00 SR CIT: $4.00
♿: Y Ⓟ Y MUS/SH: Y ⊪ Y GR/T: Y GR/PH: CATR! DT: Y! TIME: 2 PM Tu-F, S; 2 PM S; 3:00 S S/G: Y
PERM/COLL: EU: ptgs, sculp 14-20; AS; AF; Med/Ant

Designed by Louis I. Kahn, this classic museum building is perhaps his finest creation and a work of art in its own right. The last building completed under his personal supervision, it is often called 'America's best small museum'. **NOT TO BE MISSED:** Newly acquired "The Stonecutters," by Jean Baptiste Camille Corot, 1872-74 and "After the Bath, Woman Drying Her Hair" by Edgar Degas, about 1895.

ON EXHIBIT/97:

01/19/97–03/30/97	MICHELANGELO AND HIS INFLUENCE: DRAWINGS FROM WINDSOR CASTLE — The great impact Michelangelo's work had on the imagination, technique, style, and imagery of his contemporaries and followers will be seen in an exhibition of 18 of the master's drawings on view with 55 sheets and a small number of engravings created by the artists he influenced. CAT WT
02/02/97–05/11/97	GEORGES DE LA TOUR: MASTERPIECES IN FOCUS — 40 major paintings by La Tour, one of the greatest and most original French artists of the 17th-century, will be featured with works by his contemporaries Caravaggio, Bellange, Vouet, Terbruggen and others in this extraordinary exhibition designed to illustrate their iconography and the meaning of La Tour's art within the context of 17th-century culture. CAT WT ◯
06/08/97–09/07/97	MONET AND THE MEDITERRANEAN — Paintings by Monet created on his trips to the Italian Riviera (1884), French Riviera (1888) and Venice (1908) will be assembled for the first time in an exhibition that demonstrates how the artist thrived in the powerful light and sunshine of southern Europe. His unique contribution to the development of Post-Impressionism will also be addressed. CAT WT ◯

TEXAS

Kimbell Art Museum - continued

11/09/97–01/25/98 TREASURES OF THE TERVUREN MUSEUM: THE ROYAL MUSEUM OF CENTRAL AFRICA, TERVUREN, BELGIUM — An exhibition of 125 magnificent and specially selected objects will be on loan from the world's greatest collection of central African art.
 WT

12/07/97–03/01/98 QING PORCELAIN FROM THE PERCIVAL DAVID FOUNDATION OF CHINESE ART — The first exhibition of the Foundation's renowned collection of 17th and 18th-century porcelains to travel to the U.S. is particularly admired for its technical peerfection and artistic inspiration. WT

Fort Worth

Modern Art Museum of Fort Worth

1309 Montgomery Street, **Fort Worth, TX 76107**
☎ 817-738-9215 WEB ADDRESS: http://www.ago.on.ca/AAMDO/FTWext.htm
HRS: 10-5 Tu-F; 11-5 Sa; 12-5 S DAY CLOSED: M HOL: LEG/HOL!
&.: Y ℗ Y MUS/SH: Y ⊪ Y; Weekdays GR/T: Y GR/PH: CATR!
PERM/COLL: CONT; ptgs, sculp, works on paper, photo

Chartered in 1892 (making it one of the oldest museums in the western U.S.), this museum has evolved into a celebrated and vital showcase for works of modern and contemporary art. Great emphasis at the Modern is placed on the presentation of exceptional traveling exhibitions making a trip to this facility and others in this 'museum rich' city a rewarding experience for art lovers. **NOT TO BE MISSED:** Important collections of works by Robert Motherwell, Jackson Pollock, Morris Louis and Milton Avery as well as contemporary photography.

ON EXHIBIT/97:

01/12/97–03/23/97 EXPLORATIONS IN THE CITY OF LIGHT: AFRICAN-AMERICAN ARTISTS IN PARIS, 1945-1965 CAT WT

04/06/97–09/07/97 KIKI SMITH: PRINTS AND MULTIPLES, 1985-1993

The Modern at Sundance Square

Affiliate Institution: The Modern Art Museum
410 Houston Street, **Fort Worth, TX 76102**
☎ 817-335-9215
HRS: 11-6 M-W; 11-8 T-Sa; 1-5 S HOL: LEG/HOL &.: Y MUS/SH: Y GR/T: Y GR/PH: CATR! H/B: Y
PERM/COLL: ptg, sculp, works on paper, CONT photo

Opened in 1995 in the historic Sanger Building in downtown Fort Worth, this facility acts as an annex for both the permanent collections and temporary exhibitions of the Modern Art Museum.

Sid Richardson Collection of Western Art

309 Main Street, **Fort Worth, TX 76102**
☎ 817-332-6554
HRS: 10-5 Tu, W; 10-8 T, F; 11-8 Sa; 1-5 S DAY CLOSED: M HOL: LEG/HOL!
&.: Y ℗ Y; 3 hours free at Chisholm Trail Lot-4th and Main with ticket validation. MUS/SH: Y
GR/T: Y GR/PH: CATR! H/B: Y
PERM/COLL: AM/WEST: ptgs

Dedicated to Western Art, this museum is located in historic Sundance Square in a reconstructed 1890's building. The area, in downtown Fort Worth, features restored turn-of-the-century buildings. **NOT TO BE MISSED:** 52 Remington and Russell paintings on permanent display

Houston

Contemporary Arts Museum
5216 Montrose Boulevard, **Houston, TX 77006-6598**
✆ 713-526-0773 WEB ADDRESS: http://riceinfo.rice.edu/projects/cam/
HRS: 10-5 Tu-W, F, Sa; 10-9 T; 12-5 S DAY CLOSED: M HOL: 1/1, 7/4, THGV, 12/25
&: Y Ⓟ Y; On-street parking MUS/SH: Y
GR/T: Y GR/PH: CATR! S/G: Y
PERM/COLL: Non-Collecting Institution

Located in a metal building in the shape of a parallelogram this museum is dedicated to presenting the art of our time to the public.

ON EXHIBIT/97: The Contemporary Arts Museum will be closed for renovation from 1/1/97-5/1/97.

05/97–08/97 OPENING EXHIBITION TBA (Working Title) — Planned to celebrate the reopening of the Museum's refurbished building and grounds, this exhibition commemorates the Museum's 50 year commitment to bringing the most important and exciting new art to Houston and the SW. CAT

The Menil Collection
1515 Sul Ross, **Houston, TX 77006**
✆ 713-525-9400
HRS: 11-7 W-S DAY CLOSED: M, Tu HOL: LEG/HOL!
&: Y Ⓟ Y MUS/SH: Y
GR/T: Y GR/PH: CATR! S/G: Y
PERM/COLL: PTGS, DRGS, & SCULP 20; ANT; TRIBAL CULTURES; MED; BYZ

The Menil Collection houses an internationally-recognized art collection that spans mans' creative efforts from paleolithic times to the modern era. The four primary areas of interest are antiquities, Byzantine and medieval, art of tribal cultures (African, Oceanic, American Pacific Northwest) and 20th-century art. **NOT TO BE MISSED:** The new Cy Twombly Gallery designed by Renzo Piano featuring works in all media created between 1954 and 1994.

ON EXHIBIT/97:
12/12/96–03/30/97 MARK ROTHKO: THE CHAPEL COMMISSION — In celebration of the 25th anniversary of the Rothko Chapel, the exhibition examines the evolution of the Chapel paintings and brings together for the first time the more than 20 full scale paintings, drawings and sketches done in preparation for the final 14 works in the Chapel today.

05/03/97–08/31/97 BRAQUE FROM THE MENIL COLLECTION

05/03/97–08/31/97 LATE BRAQUE — Devoted to the last 25 years of Braque's career, a less familiar period than his cubist era, the exhibition will include works from the great cycles such as "Interiors," the "Billiard Tables," the "Studios" and the "Birds."

09/18/97–01/04/98 THEOPHILE BRA — A 19th-century sculptor of some renown, Bra was also the creator of thousands of unknown, visionary drawings expressing his dreams and mystical experiences. CAT

09/18/97–01/04/98 JOSEPH CORNELL: BOXES AND COLLAGES — More than 40 of Cornell's boxes and collages filled with associations of home, family, childhood, and allusions to literature will be seen in the works on loan from the Cornell Foundation.

TEXAS

Houston

The Museum of Fine Arts, Houston
1001 Bissonnet, Houston, TX 77005
☎ 713-639-7300 WEB ADDRESS: www.mfah.org
HRS: 10-5 Tu-Sa; 5-9 PM T; 12:15-6 S DAY CLOSED: M HOL: 1/1, 7/4, LAB/DAY, THGV, 12/25
F/DAY: T ADM: Y ADULT: $3.00 CHILDREN: F(und 5);6-18 $1.50 STUDENTS: $1.50 SR CIT: $1.50
&: Y ⓟ Y; Free MUS/SH: Y ¶ Y GR/T: Y GR/PH: CATR! 713-639-7324 S/G: Y
PERM/COLL: STRAUS COLL OF REN & 18TH century WORKS; BECK COLL: Impr; GLASSELL COLL: Af gold

Over 31,000 works are housed in the largest and most outstanding museum in the southwest. **NOT TO BE MISSED:** Bayou Bend, a 28 room former residence with 14 acres of gardens, built in 1927 and redesigned and reopened as a museum in 1966. More than 4800 works, fine and decorative arts from colonial period to the mid 19th-century. Separate admission and hours. !713-639-7750 Adults, $10.00; Seniors and students, $8.50; children 10-18, $5.00. Gardens, Adults, $3.00; Children, F

ON EXHIBIT/97:

ONGOING	AFRICAN GOLD: SELECTIONS FROM THE GLASSELL COLLECTION — Objects created by the Akan peoples of the Ivory Coast and Ghana as well as works from the Fulani of Mali and the Swahili of Kenya dating from the late 19th and 20th centuries are featured in this exhibition.
	BAYOU BEND COLLECTION AND GARDENS — One of the nation's premier collections of decorative arts.
09/22/96–03/30/97	SPLENDORS OF ANCIENT EGYPT CAT WT
10/27/96–01/19/97	AN ENDURING LEGACY: MASTERPIECES FROM THE MR. AND MRS. JOHN D. ROCKEFELLER III COLLECTION — Selected Pan-Asian sculpture, ceramic and painting masterpieces (11th-century B.C.E. to the 18th-century) from 13 different nations will be on view in an exhibition on loan from the most highly regarded public collection of Asian art in the country. WT
12/13/96–02/16/97	SCHEMATA: DRAWING BY SCULPTORS — A look at regional contemporary sculptors, both well known and emerging who might conceive their three dimensional works in two dimensional format. These may be notes of initial thoughts, emotions, or gestures of the form that will follow and are an intimate glimpse of the artist's creative process.
02/09/97–04/20/97	JOHN MCLAUGHLIN: WESTERN MODERNISM/EASTERN THOUGHT WT
02/23/97–04/20/97	FABRICATIONS — Trend setting names in French fashion over a 100 year period are showcased in the examples on view by Jeanne Lanvin, Madeleine Vionnet, Yves St Laurent, Chanel, Givenchy, Bohan and Balenciaga.
05/18/97–07/13/97	MATISSE, PICASSO, AND FRIENDS: MASTERWORKS ON PAPER FROM THE CONE COLLECTION WT
08/03/97–11/02/97	MARK CATESBY: THE NATURAL HISTORY OF AMERICA WITH THE WATERCOLORS FROM THE ROYAL LIBRARY, WINDSOR CAT WT
09/07/97–11/16/97	ROY DECARAVA: A RETROSPECTIVE — Groundbreaking pictures of everyday life in Harlem, civil rights protests, lyrical studies of nature, and photographs of jazz legends will be among the 200 black & white photographs on view in the first comprehensive survey of DeCarava's works. WT
09/07/97–11/30/97	PICASSO AND PHOTOGRAPHY — Many of the Picasso photographs in this exhibition which will only be shown at the Museum of Fine Arts and in Tokyo, have never been displayed before. Included will be early photographs made between 1901-16, works that combine various processes, and photographs and the paintings inspired by those photographs. ONLY VENUE
12/14/97–04/12/98	THE BODY OF CHRIST IN THE ART OF EUROPE AND NEW SPAIN, 1150-1800 — European painting, printmaking, and decorative arts that focus on the figure of Christ are divided into three broad areas: The Word Incarnate; The Passion and Resurrection of Christ; and The Mystical Body. Included are works by Botticelli, Tintoretto, Veronese, Dürer and Zurburan.

378

Houston

Rice University Art Gallery
Sewall Hall 6100 S. Main Street, **Houston, TX 77005**
☎ 713-527-6069
HRS: 11-5 M-Sa, 11-9 T DAY CLOSED: S HOL: ACAD! & SUMMER
&: Y ℗ Y
PERM/COLL: Rotating Exhibitions, collection not on permanent display

Since its founding in 1968 the gallery has provided a rich and diverse cultural experience for both Rice University and the Houston Community.

Kerrville

Cowboy Artists of America Museum
1550 Bandera Hwy, **Kerrville, TX 78028**
☎ 210-896-2553
HRS: 9-5 M-Sa, 1-5 S DAY CLOSED: M HOL: 1/1, EASTER, THGV, 12/25
ADM: Y ADULT: $3.00 CHILDREN: $1.00 (6-18) SR CIT: $2.50
&: Y ℗ Y; Free MUS/SH: Y
GR/T: Y GR/PH: CATR! DT: Y; daily H/B: Y S/G: Y
PERM/COLL: AM/WESTERN: ptgs, sculp

Located on a hilltop site just west of the Guadalupe River, the museum is dedicated to perpetuating America's western heritage

Longview

Longview Art Museum
102 W. College Ave., **Longview, TX 75601**
☎ 903-753-8103
HRS: 10-5 Tu-T; 10-4 F, Sa DAY CLOSED: M HOL: 12/25, 1/1
&: Y ℗ Y; Adjacent to the building MUS/SH: Y H/B: Y
PERM/COLL: CONT TEXAS ART (1958-1992)

Located in a residential neighborhood, this renovated home was used to house many of the city's 'oil boomers' who came to East Texas to invest in the great East Texas Oil Boom.

ON EXHIBIT/97:

01/11/97–02/22/97	FRANK REAUGH
01/11/97–02/22/97	ALISTAIR ROSS AND WILLIAM CADENHEAD (FROM SCOTLAND)
03/01/97–03/29/97	PHOTOVIEW WINNERS/CERAMIC SHOW
04/05/97–05/31/97	TOYOHARU MIYAZAKI: JAPANESE GARDEN SCULPTURE
05/07/97–06/21/97	DARRYL HOWARD
06/07/97–08/23/97	YOURS, MINE AND OURS: FAMILIES WITH AN ARTISTIC BENT
09/06/97–10/25/97	INVITATIONAL

TEXAS

Lufkin

The Museum of East Texas
503 N. Second Street, **Lufkin, TX 75901**
☎ 409-639-4434
HRS: 10-5 Tu-F, 1-5 Sa-S DAY CLOSED: M HOL: LEG/HOL!
&: Y ℗ Y MUS/SH: Y GR/T: Y GR/PH: CATR! H/B: Y
PERM/COLL: AM, EU, & REG: ptgs

The Museum is housed in St. Cyprians Church, whose original Chapel was built in 1906. **NOT TO BE MISSED:** Historic photographic collection covering a period of over 90 years of Lufkin's history

Marshall

Michelson Museum of Art
216 N. Bolivar, **Marshall, TX 75670**
☎ 903-935-9480
HRS: 12-5 Tu-F, 1-4 Sa-S DAY CLOSED: M HOL: EASTER, 7/4, THGV, 12/25
VOL/CONT: Y
&: Y ℗ Y GR/T: Y GR/PH: CATR! H/B: Y
PERM/COLL: WORKS OF RUSSIAN AMERICAN ARTIST LEO MICHELSON, 1887-1978

The historic Southwestern Bell Telephone Corporation building in downtown Marshall is home to this extensive collection.

ON EXHIBIT/97:

01/22/97–05/27/97	TRUE REDD PHOTOGRAPHY — A varied exhibition of color and black and white photos by Redd, an internationally recognized photographer.
05/01/97–05/30/97	AMERICAN WATERCOLOR EXHIBIT — A major national juried exhibition.

McAllen

McAllen International Museum
1900 Nolana, **McAllen, TX 78504**
☎ 210-682-1564 Web: http://www.hiline.net/mim
HRS: 9-5 Tu-Sa, 1-5 S DAY CLOSED: M HOL: THGV, 12/25
ADM: Y ADULT: $1:00 CHILDREN: $.25 STUDENTS: $0.25 SR CIT: $1.00
&: Y ℗ Y MUS/SH: Y GR/T: Y GR/PH: CATR!
PERM/COLL: LAT/AM: folk; AM; EU: gr 20

The museum caters to art & science on an equal level.

ON EXHIBIT/97:

PERMANENT EXHIBITS	METEOROLOGY — Includes a working weather station and related exhibits
	THE TOUCH BASE — Investigation tables and curiosity drawers all dealing with Earth Science and Ethnography.
01/15/97–03/02/97	SCULPTURE BY MARK SIJAN — Sijan's incredibly lifelike polyester resin sculptures of ordinary people include such specific attention to the details of tiny hairs, veins, pores and blemishes that the works on view appear to be real human beings whose actions are suspended for a moment in time. WT

McAllen International Museum - continued

01/18/97–12/31/97	CERAMICS OF MEXICO — Ceramics from the Museum's collection which show the diversity of Mexican pottery.
01/22/97–06/04/97	BACKYARD MONSTERS: THE WORLD OF INSECTS — Several robotic insects thousands of times larger than life will "invade" the Museum in a blockbuster exhibition that also features lots of hands-on activities. ADM FEE
03/04/97–06/01/97	PAINTINGS BY HEIDI TAILLEFER — Witty watercolors by an artist who renders animals as if they were man made machines.
06/04/97–08/03/97	KARSCH: PORTRAITS OF GREATNESS — Black and white images by legendary photographer Karsch depict portraits of some of the immortal personalities of the 20th-century.
06/06/97–08/17/97	TOUCHABLE SCULPTURE — Hands on opportunities for all ages to thoroughly investigate the art of sculpture.
10/07/97–12/31/97	BORN OF WOOD: THE WORNICK COLLECTION — An amazing variety of fine art made of wood by major artists from many parts of the world.

Midland

Museum of the Southwest

1705 W. Missouri Ave, **Midland, TX 79701-6516**
☎ 915-683-2882
HRS: 10-5 Tu-Sa, 2-5 S DAY CLOSED: M HOL: LEG/HOL!
&.: Y ℗ Y S/G: Y
PERM/COLL: REG; GR; SW: archeological artifacts

The Museum of the Southwest is an educational resource in art and archeology focusing on the Southwest. Housed in a 1934 mansion and stables, the collection also features the Hogan Collection of works by founder members of the Taos Society of Artists. **NOT TO BE MISSED:** "The Sacred Pipe," by Alan Houser, bronze

ON EXHIBIT/97:

ONGOING	THE SEARCH FOR ANCIENT PLAINSMEN: AN ARCHEOLOGICAL EXPERIENCE
	THE COLLECTION — Selections including paintings, sculptures, graphics and photographs.
	UNDER STARRY SKIES: DEFINING THE SOUTHWEST — An interpretive installation using loan and collection works by culturally diverse artists.
01/17/97–03/02/97	ANSEL ADAMS: AN AMERICAN PHOTOGRAPHER WT
03/07/97–04/13/97	MIDLAND ARTS ASSOCIATION SPRING SHOW — Juried exhibition of art in all media.
05/17/97–06/29/97	TEXAS WATERCOLOR SOCIETY 48TH ANNUAL NATIONAL EXHIBITION — Juried exhibition of watercolors from across the nation.
07/10/97–08/24/97	TEXAS ABSTRACT: NEW PAINTING IN THE NINETIES — Works by 12 Texas artists whose work investigates non-objective form. WT
09/04/97–09/28/97	WANDERLUST: WORKS BY EIGHT CONTEMPORARY PHOTOGRAPHERS — Photographs of people and places from exotic locations.
10/02/97–11/16/97	WHIRLIGIGS AND WEATHERVANES: CONTEMPORARY SCULPTURE — Bringing together professional and amateur artists to highlight their talent, ingenuity and wit, these wind-powered sculptures sometimes make biting social commentary, create dynamic sculptural statements and build upon the humorous aspects of modern life. WT
12/04/97–01/01/98	NATIVITIES AND MENORAHS: OBJECTS OF REVERENCE AND CEREMONY

TEXAS

Orange

Stark Museum of Art
712 Green Ave, **Orange, TX 77630**
📞 409-883-6661
HRS: 10-5 W-Sa, 1-5 S DAY CLOSED: M & T HOL: 1/1, EASTER, 7/4, THGV, 12/25
&: Y ℗ Y MUS/SH: Y GR/T: Y GR/PH: CATR!
PERM/COLL: AM: 1830-1950; STEUBEN GLASS; NAT/AM

In addition to Great Plains and SW Indian crafts, the Stark houses one of the finest collections of Western American art in the country. The museum also features the only complete Steuben Glass collection of "The US in Crystal." **NOT TO BE MISSED:** Paul Kane Collection of Western American Art

San Angelo

San Angelo Museum of Fine Arts
704 Burgess, **San Angelo, TX 76903**
📞 915-658-4084
HRS: 10-4 Tu-Sa, 1-4 S DAY CLOSED: M HOL: LEG/HOL!
ADM: Y ADULT: $2.00 CHILDREN: Free (under 6) SR CIT: $1.00
&: Y ℗ Y; On-site MUS/SH: Y
GR/T: Y GR/PH: CATR! H/B: Y S/G: Y
PERM/COLL: AM: cont cer; REG; MEX: 1945-present

The completely renovated museum building was originally the 1868 quartermaster's storehouse on the grounds of Fort Concho, a National Historic Landmark. It is currently undergoing a major Capitol Building Campaign to construct a new museum to be started in the spring of 1997. **NOT TO BE MISSED:** "Figuora Accoccolata," by Emilio Greco

ON EXHIBIT/97:

12/05/96–12/21/97	THE HERO IN WORLD ART	WT

San Antonio

McNay Art Museum
6000 N. New Braunfels Ave, **San Antonio, TX 78209-0069**
📞 210-824-5368
HRS: 10-5 Tu-Sa, 12-5 S DAY CLOSED: M HOL: 1/1, 7/4, THGV, 12/25
&: Y ℗ Y MUS/SH: Y GR/T: Y GR/PH: CATR! DT: Y! H/B: Y S/G: Y
PERM/COLL: FR & AM: sculp 19, 20; SW: folk ; GR & DRGS: 19, 20; THEATER ARTS

Devoted to the French Post-Impressionist and early School of Paris artists, the McNay Art Museum also has an outstanding theatre arts collection containing over 20,000 books and drawings as well as models of stage sets. It is located on beautifully landscaped grounds in a classic mediterranean style mansion.

ON EXHIBIT/97:

11/22/96–01/19/97	THE ST. PETERSBURG MURAKKA: A ROYAL ALBUM — The album is one of the greatest of Islamic painting in the world. Well known to Islamic scholars, it has never before been shown or even accessible prior to this.	
12/10/96–02/09/97	RAY METZKER — A selective retrospective of the work, from a private collection, of this major American photographer.	
02/03/97–04/13/97	RED GROOMS' "RUCKUS RODEO"	WT

McNay Art Museum - continued

02/03/97–04/13/97	RED GROOMS' DRAWINGS AND PRINTS
SPRING/97–/	CONTEMPORARY PRINTS FROM THE MCNAY COLLECTION Dates Tent!
SPRING/97–/	SELECTIONS FROM THE MARY AND SYLVAN LANG COLLECTION — This collection represents a valuable aspect of the McNay's permanent collection. Dates Tent!
04/21/97–06/15/97	TWENTY FAVORITE OPERAS — A selection of theatre and costume designs of the Metropolitan Opera's most frequently produced operas.
05/31/97–07/27/97	JOSEPH SUDEK: THE PIGMENT PRINTS (LES TIRAGE PIGMENTAIRES), 1947-1954 — Tinted vintage photographs of Sudek's native Czechoslovakia include still life views from the windows of his studio, portraits, and architectural spaces in Prague. WT
SUMMER/97–/	JONES MEILZINER AND LEE Dates Tent!
SUMMER/97–/	NO.2 IN SERIES OF RETROSPECTIVES ON CONTEMPORARY SAN ANTONIO-SOUTH TEXAS ARTISTS
SUMMER/97–/	BERMAN-WORKS IN PROGRESS Dates Tent!
09/20/97–11/16/97	RECYCLING REALITY-SURREALIST SCULPTURE — A major survey of surrealist sculpture including works by Salvador Dali, Rene Magritte, Joseph Cornell, and others. WT
10/97–12/97	THE NIGHTMARE BEFORE CHRISTMAS
11/97–12/97	THE EYE OF CHILDHOOD
11/97–01/98	THE ART OF ENCHANTMENT: CHILDREN'S BOOK ILLUSTRATORS
12/19/97–02/15/98	SMALL PAINTINGS BY ARTHUR DOVE: 1942-43 — This small gem of an exhibition focuses on Dove's late abstractions which relate directly to the McNay's important painting "The Brothers" as well as the Museum's ten studies for the picture.

San Antonio

San Antonio Museum of Art
200 West Jones Street, San Antonio, TX 78215
☎ 210-978-8100
HRS: 10-5 M, W, F, Sa; 10-9 Tu; 12-5 S HOL: THGV, 12/25
F/DAY: Tu, 3-9 ADM: Y ADULT: $4.00 CHILDREN: $1.75 (4-11) STUDENTS: $2.00 SR CIT: $2.00
♿: Y ⓟ Y; Free MUS/SH: Y GR/T: Y GR/PH: CATR! 210-978-8138 H/B: Y S/G: Y
PERM/COLL: AN/GRK; AN/R; EGT; CONT: ptgs, sculp

The San Antonio Museum of Art is located in the restored turn-of-the-century former Lone Star Brewery. In addition to its other varied and rich holdings it features the most comprehensive collection of ancient art in the southwest. **NOT TO BE MISSED:** The spectacular Ewing Halsell Wing for Ancient Art.

ON EXHIBIT/97:

11/01/96–01/19/97	THE PEACEABLE KINGDOM: ANIMAL STORIES AND ART — The storyteller's approach to animals, real and imagined, over time will be explored as will the role of storytelling in different cultures.
01/04/97–03/09/97	I CLAUDIA: WOMEN IN ANCIENT ROME CAT WT
04/01/97–06/30/97	TISSOT RELIGIOUS PAINTINGS
05/01/97–07/31/97	TURKOMAN RUGS AND TEXTILES
07/01/97–09/30/97	CONTEMPORARY ARTS MONTH
08/01/97–09/30/97	AUBREY KEATING
10/17/97–12/31/97	SOUL OF SPAIN
11/01/97	GALLE AND ART NOUVEAU Dates Tent!

TEXAS

Tyler

Tyler Museum of Art
1300 S. Mahon Ave, **Tyler, TX 75701**
☎ 903-595-1001
HRS: 10-5 Tu-Sa, 1-5 S DAY CLOSED: M HOL: LEG/HOL!
₺: Y ℗ Y MUS/SH: Y ￤￤ Y; Cafe open Tu-F 11-2 GR/T: Y GR/PH: CATR! H/B: Y
PERM/COLL: PHOT; REG 20

The Museum is located in an architecturally award winning building.

ON EXHIBIT/97:

11/07/96–02/02/97	THE CITY: ETCHINGS AND ENGRAVINGS BY REGINALD MARSH, 1930-1940. A PORTFOLIO FROM THE UNIVERSITY OF WYOMING ART MUSEUM PERMANENT COLLECTION — This selection of images from a 30 print portfolio created later in Marsh's life, typify the graphic vitality and dynamism of his work.
11/09/96–01/12/97	RECYCLED RESOURCES (Working Title) — Rick Ladd and other artists (Art Guys a.o.) use assemblage techniques to create "art" from recycled and non-traditional materials.
11/09/96–01/12/97	TEXAS INVITATIONAL (Working Title) — The exhibition functions as an ongoing survey of Texas painters and sculptors by introducing new artists and featuring well known ones whose work has taken on a different direction from their more familiar style.
01/18/97–03/02/97	JAKE GILSON — Large paintings on paper, austere in tone, have shapes that are perceived as abstract but have their origins in Gilson's metaphors for life and death.
01/18/97–03/02/97	TRE ARNEZ — These sculptures by Arnez are fired ceramic pieces that are sometimes combined with found objects. The works derive from her interest in "samenesses and differences between individuals, cultures, and nations."
02/08/97–04/06/97	JAPANESE WOODBLOCK PRINTS (UKIYO-E) — Ukiyo-e, called "Floating World Pictures," refers to Japanese woodblock prints originating as early as the 17th-century. It was this "new" art form, first noticed in Europe in the mid 1800's, that greatly influenced the development of Impressionism in France with its elements of unusual perspective, color and subject matter.
03/08/97–04/13/97	RICHARD THOMPSON — Recent canvases and works on paper depict the artist's love of trout fishing and the out-of-doors.
03/08/97–04/13/97	US INVITATIONAL — A selection of artists from outside of Texas whose works act as a survey of different regions and recent trends in American art.
05/03/97–07/06/97	ALAIN GALAUP: SISTER CITY ARTIST (METZ) — This French painter displays playful abstraction with surrealist influences.
05/03/97–07/06/97	TYLER MUSEUM OF ART-PERMANENT COLLECTION
05/03/97–07/06/97	VIDEO ART SURVEY — The display traces the "coming-of-age" of video art, showcasing 60 of the most accomplished works produced from the late 1960's to the early 1990's. WT
09/01/97–10/05/97	ARTISTS OF THE AMERICAN WEST WT

Waco

The Art Center
1300 College Drive, **Waco, TX 76708**
☎ 817-752-4371
HRS: 10-5 Tu-Sa, 1-5 S DAY CLOSED: M HOL: LEG/HOL!
₺: Y; 1st floor ℗ Y MUS/SH: Y GR/T: Y GR/PH: CATR! S/G: Y
PERM/COLL: CONT; REG

Housed in the Cameron Home, The Art Center, located on the McLellan Community College campus, features an exhibit of sculpture on the grounds. **NOT TO BE MISSED:** "Square in Black," by Gio Pomodoro

Wichita Falls

Wichita Falls Museum and Art Center
Two Eureka Circle, **Wichita Falls, TX 76308**
☎ 817-692-0923
HRS: 10-5 Tu-Sa, 1-5 S DAY CLOSED: M HOL: LEG/HOL!
ADM: Y ADULT: $3.00 CHILDREN: $2.00; F (under 3) STUDENTS: $2.00 SR CIT: $2.00
&: Y Ⓟ Y MUS/SH: Y
GR/T: Y GR/PH: CATR!
PERM/COLL: AM: gr; CONT

The art collection has the singular focus of representing the history of American art through the medium of print making. **NOT TO BE MISSED:** The 'Magic Touch Gallery' featuring hands-on science and the 'Discovery Gallery' emphasizing family programming. Also high energy, high tech laser programs and planet shows in the planetarium.

UTAH

Logan

Nora Eccles Harrison Museum of Art
Affiliate Institution: Utah State University
650 N. 1100 E., **Logan, UT 84322-4020**
☎ 801-797-0163
HRS: 10:30-4:30 Tu, T, F; 10:30-9 W; 2-5 Sa-S HOL: LEG/HOL!
&: Y ℗ Y; Within one block ¶ Y
GR/T: Y GR/PH: CATR! S/G: Y
PERM/COLL: NAT/AM; AM: cont art, cer 20

NOT TO BE MISSED: 'Untitled' (Standing Woman), 1959, by Manuel Neri

ON EXHIBIT/97:

04/08/97–06/08/97	BEATRICE MANDELMAN: TAOS MODERNIST — Mandelman, who began her artistic career as a WPA social realist painter, later progressed to abstraction and collage. The works on exhibit reflect her connection to the landscape of Taos, her long time residence, Mexico, and many other lands she visited during her lifetime. WT

Salt Lake City

Salt Lake Art Center
20 S.W. Temple, **Salt Lake City, UT 84101**
☎ 801-328-4201
HRS: 8-5 Tu-T, 8-9 F, 10-5 Sa, 1-5 S DAY CLOSED: M HOL: LEG/HOL!
VOL/CONT: Y
&: Y ℗ Y; Paid on street parking MUS/SH: Y ¶ Y
GR/T: Y GR/PH: CATR!
PERM/COLL: REG: all media

The 60 year old art center is located in the Bicentennial complex in the heart of downtown Salt Lake City.

ON EXHIBIT/97:

01/10/97–03/09/97	FLETCHER BOOTH
01/17/97–03/16/97	UTAH ARTS COUNCIL FELLOWSHIP
03/14/97–05/04/97	ANTONIA HEDRICK INSTALLATION
03/21/97–05/11/97	SHARON KOPRIVA
05/09/97–07/06/97	JOSEPH OSTRAFF
05/16/97–07/16/97	TREVOR SOUTHEY RETROSPECTIVE
07/18/97–09/14/97	THREE SCULPTORS
09/12/97–11/09/97	MARY FISH INSTALLATION TENT!
09/19/97–11/16/97	100 YEARS OF CENSORSHIP AND CONTROVERSY IN UTAH

Salt Lake City

Utah Museum of Fine Arts
101 AAC, University of Utah, **Salt Lake City, UT 84112**
☎ 801-581-7332
HRS: 10-5 M-F; 2-5 Sa, S HOL: LEG/HOL!
♿: Y ⓟ Y; Free on campus parking Sa & S; metered parking on weekdays
MUS/SH: Y GR/T: Y GR/PH: CATR! S/G: Y
PERM/COLL: EU & AM: ptgs 17-19; AF; AS; EGT

With a permanent collection of over 10,000 works spanning a broad spectrum of the world's art history, this major Utah cultural institution is a virtual artistic treasure house containing the only comprehensive collection of art in the state or the surrounding region. **NOT TO BE MISSED:** "Dance Around The Maypole" by Pieter Breughel, The Younger

Springville

Springville Museum of Art
126 E. 400 S., **Springville, UT 84663**
☎ 801-489-2727
HRS: 10-5 Tu-Sa, 2-5 S, 10-9 W DAY CLOSED: M HOL: 1/1, 12/25
♿: Y ⓟ Y MUS/SH: Y
GR/T: Y GR/PH: CATR!
PERM/COLL: UTAH: ptgs, sculp

The museum, housed in a Spanish colonial revival style building, features a collection noted for the art of Utah dating from pioneer days to the present.

VERMONT

Bennington

The Bennington Museum
W. Main Street, **Bennington, VT 05201**
☎ 802-447-1571
HRS: 9-5 daily; Weekends 9-7 MEM/DAY-LAB?DAY HOL: THGV
ADM: Y ADULT: $5.00 CHILDREN: F (under 12) STUDENTS: $3.50 SR CIT: $4.50
&: Y; Partial first floor only ℗ Y MUS/SH: Y GR/T: Y GR/PH: CATR! H/B: Y
PERM/COLL: AM: dec/art; MILITARY HIST; AM: ptgs

Visitors can imagine days gone by while gazing at a favorite Grandma Moses painting at The Bennington, one of the finest regional art and history museums in New England. The original museum building is the 1855 St. Francis de Sales church.

Burlington

Robert Hull Fleming Museum
Affiliate Institution: University of Vermont
61 Colchester Ave., **Burlington, VT 05405**
☎ 802-656-0750
HRS: 9-4 Tu-F; 1-5 Sa, S; call for summer hours DAY CLOSED: M HOL: LEG/HOL!, ACAD!
SUGG/CONT: Y ADULT: $2.00 STUDENTS: $2.00 SR CIT: $2.00
&: Y ℗ Y MUS/SH: Y GR/T: Y GR/PH: CATR! H/B: Y
PERM/COLL: NAT/AM; AN/EGT; CONT: Eu & Am

Vermont's primary art and anthropology museum is located in a 1931 McKim, Mead and White building. **NOT TO BE MISSED:** Assyrian Relief

ON EXHIBIT/97:

through 01/26/97	FINE PRESS ARTISTS' BOOKS IN THE 20TH CENTURY
through 03/02/97	DAVID BETHUEL JAMIESON
01/21/97–04/13/97	RE: FAB PAINTINGS ABSTRACTED, FABRICATED AND REVISED

Manchester

Southern Vermont Art Center
West Road, **Manchester, VT 05254**
☎ 802-362-1405
HRS: 10-5 Tu-Sa, 12-5 S DAY CLOSED: M HOL: COLUMBUS DAY only
F/DAY: Sa, 10-1 ADM: Y ADULT: $3.00 CHILDREN: F (under 13) STUDENTS: $0.50 SR CIT: $3.00
&: Y ℗ Y MUS/SH: Y ⑪ YGR/T: Y GR/PH: CATR! H/B: Y S/G: Y
PERM/COLL: PTGS, SCULP, PHOT, GR; CONT: 20

Built in 1917, by Mr. & Mrs. W.M. Ritter of Washington D.C., the Art Center is housed in a Georgian Colonial Mansion located on 450 acres on the eastern slope of Mt. Equinox. **NOT TO BE MISSED:** Works by Winslow Homer and Ogden Pleissner

ON EXHIBIT/97:

01/11/97–02/12/97	FIFTH ANNUAL WINTER SHOW — Artist members from across New England display recent works in all media in this juried exhibition.
02/05/97–03/12/97	FINAL SOLO AND GROUP EXHIBITION — Artists include Luc Denys, Melissa Pell Loughlin, Russ Housman, Matthew Perry and Drusa Heidle.

Middlebury

Middlebury College Museum of Art
Middlebury College, **Middlebury, VT 05753**
☎ 802-388-3711 ext5007
HRS: 10-5 Tu-F; 12-5 Sa, S DAY CLOSED: M HOL: ACAD!, 12/18-1/1
&: Y ℗ Y; Free MUS/SH: Y ⫪Y
GR/T: Y GR/PH: CATR! 802-443-5007
PERM/COLL: CYPRIOT: pottery; EU & AM : sculp 19; CONT: GR

Designed by the New York firm of Hardy Holzman Pfeiffer Associates, the new (1992) Center for the Arts also includes a theater, concert hall, music library and dance studios. It is located midway between Rutland and Burlington. **NOT TO BE MISSED:** "Bimbo Malado (Sick Child)," 1893 by Menardo Rosso (wax over plaster)

ON EXHIBIT/97:

ONGOING	19TH CENTURY PAINTING FROM THE PERMANENT COLLECTION
	20TH CENTURY PAINTING FROM THE PERMANENT COLLECTION
10/22/96–01/26/97	AMERICAN PHOTOGRAPHY: 1910-1990 — A continuation of the survey of American photography extending into the 20th-century.
01/11/97–03/09/97	CARIBBEAN VISIONS: CONTEMPORARY PAINTING AND SCULPTURE — A presentation of 92 paintings and sculptures by 56 Carribean artists whose works reflect the traditions of their native lands. WT
02/13/97–06/01/97	THE COLLABORATIVE PROCESS: THE ART OF THEATER DESIGN — Using several past productions and one in progress the work of the College Theater Department will illustrate the "behind the scenes" development of a production.
04/17/97–08/03/97	DALE CHIHULY: SEAFORMS — Over 40 exceptional glass sculptures that resemble brilliant undulating marine life created by American master Chihuly, will be on exhibit with a number of his working drawings. CAT WT
12/12/97–02/22/98	NANCY GRAVES: EXCAVATIONS IN PRINT — 45 works by Graves will be on view in the first comprehensive exhibition of her innovative graphics in which the use of unconventional materials and techniques allows her to break down boundaries within and between traditional mediums. CAT WT

The Sheldon Art Museum, Archeological and Historical Society
1 Park Street, **Middlebury, VT 05753**
☎ 802-388-2117
HRS: 10-5 M-F, 10-4 Sa; Special Hol Hours in Dec. DAY CLOSED: S HOL: LEG/HOL!
ADM: Y · ADULT: $3.50; $7.00 family CHILDREN: $.50 (under 12) STUDENTS: $3.00 SR CIT: $3.00
&: Y
GR/T: Y GR/PH: CATR! H/B: Y
PERM/COLL: DEC/ART; PER/RMS; ARTIFACTS

Vermont's exciting and interesting history is interpreted in this century old museum located in the 1829 Judd Harris house. **NOT TO BE MISSED:** Collection of locally made 18th-century Windsor chairs

ON EXHIBIT/97: Special Holiday exhibition in December each year!

VERMONT

Montpelier

T. W. Wood Gallery and Arts Center
Affiliate Institution: Vermont College
College Hall, **Montpelier, VT 05602**
☎ 802-828-8743
HRS: 12-4 Tu-S DAY CLOSED: M HOL: LEG/HOL!
ADM: Y ADULT: $2.00 CHILDREN: F (under 12) SR CIT: $2.00
&: Y MUS/SH: Y
GR/T: Y GR/PH: CATR! H/B: Y
PERM/COLL: THOMAS WATERMAN WOOD: ptgs; PORTRAITS; WPA WORKS

Included in the more than 200 oils and watercolors in this collection are the works of Thomas W. Wood and his American contemporaries of the 1920's and 30's including A. H. Wyant and Asher B. Durand. **NOT TO BE MISSED:** "American Citizen to the Poles," by Thomas Wood

Shelburne

Shelburne Museum
U.S.Route 7, **Shelburne, VT 05482**
☎ 802-985-3346
HRS: 10-5 M-S Late-May through Late-Oct HOL: open all Hols
ADM: Y ADULT: $17.50 CHILDREN: $7.00 (6-14)
&: Y; Limited (certain buildings are handicapped accessible) Ⓟ Y; Free
MUS/SH: Y ⅋ Y
GR/T: Y GR/PH: CATR! DT: Y TIME: 1 PM late-Oct - late-May H/B: Y
PERM/COLL: FOLK; DEC/ART; HAVERMEYER COLL

37 historic and exhibition buildings on 45 scenic acres combine to form this nationally celebrated collection of American folk art, artifacts, and architecture. **NOT TO BE MISSED:** Steamboat Ticonderoga

St. Johnsbury

St. Johnsbury Athenaeum
30 Main Street, **St. Johnsbury, VT 05819**
☎ 802-748-8291
HRS: 10:00-8:00 M, W; 10:00-5:30 Tu, F; 9:30-4 Sa DAY CLOSED: S HOL: LEG/HOL!
&: Y Ⓟ Y; Limited
H/B: Y
PERM/COLL: AM: ptgs 19; Hudson River School

The Athenaeum was built as a public library and presented to the townspeople of St. Johnsbury by Horace Fairbanks in 1871. In 1873 an art gallery, which today is an authentic Victorian period piece, was added to the main building. The collection of American landscapes and genre paintings is shown as it was in 1890 in the oldest unaltered art gallery in the US. **NOT TO BE MISSED:** "Domes of The Yosemite," by Albert Bierstadt

Charlottesville

Bayly Art Museum of the University of Virginia

Rugby Road, Thomas H. Bayly Memorial Bldg, **Charlottesville, VA 22903-2427**
☎ 804-924-3592
HRS: 1-5 Tu-S HOL: 12/25-1/1
&: Y Ⓟ Y; Limited parking behind the museum MUS/SH: Y
GR/T: Y GR/PH: CATR! 804-924-7458
PERM/COLL: NAT/AM; MESO/AM; AF; DEC/ART 18; OM: gr; AM: ptgs, sculp, works on paper, phot 20; P/COL,

This handsome Palladian-inspired building is located on the grounds of Jefferson's University of Virginia. With its wide ranging collection it serves as a museum for all ages and interests, for art lovers and scholars alike.

ON EXHIBIT/97:

06/29/96–01/19/97	FOCUS ON COLLECTORS: NATIVE AMERICAN ART OF THE SOUTHWEST — Highlights of three collections represent diverse types of Native American art.
01/03/97–03/16/97	ITALO SCANGA: SCULPTURE AND PRINTS (Arts Board 1997 Exhibition) — Totemic, large scale sculptures constructed of wood, metal and a variety of found objects, make witty commentary on both the history of art and contemporary issues.
01/11/97–03/09/97	BLAMING THE MIRROR: PORTRAIT AND ANTI-PORTRAIT IN PHOTOGRAPHY — Chosen mostly from the Museum's collection, works range from those of 19th-century photographer Nadar, to contemporary photographs by Sally Mann.
03/28/97–05/25/97	SHAPING THE LANDSCAPE IMAGE, 1865-1910: JOHN DOUGLAS WOODWARD — Watercolors, drawings and oil paintings of landscapes in America and abroad, made on-site and published as wood engravings in the popular magazines of the day.
06/07/97–10/12/97	THE TRANSFORMATION OF AMERICA: PHOTOGRAPHS BY DAVID PLOWDEN
10/24/97–01/04/98	REALMS OF HEROISM: INDIAN PAINTINGS FROM THE BROOKLYN MUSEUM CAT WT

Second Street Gallery

201 2nd Street, NW, **Charlottesville, VA 22902**
☎ 804-977-7284
HRS: 10-5 T-Sa, 1-5 S HOL: LEG/HOL!
&: Y Ⓟ Y; On-street parking H/B: Y
PERM/COLL: Non-collecting Contemporary art space

Nationally known for its innovative programming, Second Street Gallery presents work of talented local, regional, and national artists working in a variety of media from painting and photography, to sculpture and site-specific installations. The McGuffey Art Center which houses the Gallery is a historic former primary school building and is now an artist cooperative with open studios.

ON EXHIBIT/97:	Season may be interrupted because of facility renovations. Call!
01/03/97–02/02/97	M.P.LANDIS (PROVINCETOWN, MA):PAINTINGS
02/07/97–03/02/97	TBA
03/07/97–03/30/97	CONTEMPORARY AFRICAN AMERICAN ARTISTS: MIXED MEDIA GROUP SHOW
04/04/97–04/27/97	JEANETTE MONTGOMERY BARRON (NEW YORK, NY) PHOTOGRAPHS
05/02/97–06/01/97	DAVID BORAWSKI (EAST HARTFORD, CT) MIXED MEDIA INSTALLATION
06/06/97–06/29/97	CONTEMPORARY CRAFTS (VARIOUS)

VIRGINIA

Clifton Forge

Allegheny Highlands Arts and Crafts Center
439 East Ridgeway Street, **Clifton Forge, VA 24422**
☎ 703-862-4447
HRS: 10:30-4:30 M-Sa May-Jul; 10:30-4:30 Tu-Sa Aug-Apr HOL: THGV, 12/25 &: Y ℗ Y MUS/SH: Y
PERM/COLL: Non-collecting institution

Housed in an early 1900's building, the galleries' changing exhibits feature works produced by Highlands and other artists.

ON EXHIBIT/97:
01/07/97–02/01/97	MARY ELLEN PLITT: PRINTMAKING AND MIXED MEDIA
02/04/97–03/01/97	VIRGINIA POLYTECHNIC INSTITUTE AND STATE UNIVERSITY ART DEPARTMENT FACULTY
03/04/97–03/29/97	DAVID DOOLEY: OILS AND PASTELS
04/01/97–04/26/97	PHILLIP BRANCH: ACRYLICS AND MURALS
04/29/97–05/24/97	RUTH FREDRICK: PASTELS
05/26/97–06/21/97	MARGARET DUBOIS:ENAMELS/AGNES CARBREY: OILS
06/23/97–08/16/97	FROM RAILS TO GALLERY: THE C&O'S AFFAIR WITH ART — A collection of art and design work from the Chesapeake and Ohio Railroad Archives and from private collectors.
08/18/97–09/13/97	AMERIND GALLERY: MULTIPLE MEDIA BY TRADITIONAL AND CONTEMPORARY NATIVE AMERICAN ARTISTS
09/15/97–10/11/97	ASSOCIATION OF VIRGINIA ARTISANS: MULTI-MEDIA — Fine craft works by some of the state's most accomplished artisans.
10/17/97–11/08/97	FALL FESTIVAL ART SHOW — Works in all media by more than 30 local and regional artists.

Danville

Danville Museum of Fine Arts & History
975 Main Street, **Danville, VA 24541**
☎ 804-793-5644
HRS: 10-5 Tu-F; 2-5 Sa, S DAY CLOSED: M HOL: LEG/HOL!
&: Y ℗ Y MUS/SH: Y H/B: Y
PERM/COLL: REG: portraits, works on paper, dec/art, furniture, textiles; SOUTHERN PORTRAITS

The museum, in Sutherlin House built about 1857, is often referred to as the last capitol of the confederacy. **NOT TO BE MISSED:** Restored Victorian Parlor

Fredericksburg

Belmont, the Gari Melchers Estate and Memorial Gallery
224 Washington St., **Fredericksburg, VA 22405**
☎ 540-654-1015
HRS: 10-5 M-Sa, 1-5 S, 10-7 F !for winter hours HOL: 12/31, 1/1, THGV, 12/24, 12/25
ADM: Y ADULT: $4.00 CHILDREN: F (under 6) STUDENTS: $1.00 SR CIT: $3.00
&: Y; Very limited (with prior notice assistance will be provided) ℗ Y MUS/SH: Y GR/T: Y GR/PH: CATR! H/B: Y
PERM/COLL: EU & AM: ptgs (mostly by Gari Melchers)

This 18th-century estate features many paintings by Gari Melchers (its former resident). Also on view are works by his American and European contemporaries as well as some old masters.

Hampton

Hampton University Museum
Hampton University, **Hampton, VA 23668**
☎ 804-727-5308
HRS: 8-5 M-F; 12-4 Sa, S Sept-May HOL: LEG/HOL!, ACAD!
&: Y Ⓟ Y MUS/SH: Y GR/T: Y GR/PH: CATR! H/B: Y
PERM/COLL: AF; NAT/AM: AM: ptgs 20

In a 1881 building on the Hampton Campus founded in 1868 for the education of newly freed African-Americans is this remarkable museum containing art & artifacts from cultures around the world. **NOT TO BE MISSED:** "The Banjo Lesson," by Henry O. Tanner

ON EXHIBIT/97:

08/23/96–02/03/97	GROWING INTO THE 21ST CENTURY: ACQUISITIONS 1990-1996 — Recent additions to the collection of Native American, African and African-American art, as well as the University History collection.
01/19/97–03/23/97	COME DANCE WITH US — Fifty paintings about Native American dance by Native American artists cover a wide variety from the social dances of the Northern Plains to the religious dances of the southwest. WT
04/06/97–07/27/97	LILLIAN T. BURWELL: A RETROSPECTIVE EXHIBITION — This thirty year retrospective documents in a site specific installation the evolution of this Washington, D.C. based abstract artist from two dimensional painting to the three dimensional, sculptural form which she describes as "environmental."

Lynchburg

Maier Museum of Art
Affiliate Institution: Randolph-Macon Woman's College
1 Quinlan Street, **Lynchburg, VA 24503**
☎ 804-947-8136
HRS: 1-5 Tu-S Sep-May DAY CLOSED: M HOL: ACAD!; 6/1-8/31
&: Y; Limited (no handicap bathroom) Ⓟ Y; Limited MUS/SH: Y
GR/T: Y GR/PH: CATR! DT: Y TIME: call 804-924-8136 for specifics
PERM/COLL: AM: ptgs 19, 20

19th and 20th-century American paintings including works by Gilbert Stuart, Winslow Homer, Thomas Eakins, Thomas Cole, George Bellows, Mary Cassatt, Georgia O'Keeffe, and Jamie Wyeth, are among the many highlights of the Maier Museum of Art. **NOT TO BE MISSED:** George Bellows' "Men of the Docks"

ON EXHIBIT/97:

01/18/97–03/02/97	REACTION AND REBELLION: AMERICAN ART OF THE 1930's: SELECTIONS FROM THE PERMANENT COLLECTION
03/15/97–04/27/97	PAINTING ABSTRACT: 86TH ANNUAL EDITION

Newport News

Peninsula Fine Arts Center
101 Museum Drive, **Newport News, VA 23606**
☎ 804-596-8175
HRS: 10-5 Tu-Sa, 1-5 S HOL: 1/1, 7/4, 12/25
&: Y; Limited as only exhibition wing is wheelchair accessible Ⓟ Y MUS/SH: Y GR/T: Y GR/PH: CATR! S/G: Y
PERM/COLL: Non-collecting institution

Changing exhibitions of primarily contemporary art by emerging artists that often contrast with exhibitions of historical significance are featured at this fine arts center.

VIRGINIA

Norfolk

The Chrysler Museum
245 Olney Road at Mowbray Arch, **Norfolk, VA 23510-1587**
☏ 804-664-6200
HRS: 10-4 Tu-Sa, 1-5 S DAY CLOSED: M HOL: 1/1, 7/4, THGV, 12/25
&: Y ⑫ Y; Free MUS/SH: Y ⫴Y
GR/T: Y GR/PH: CATR!
PERM/COLL: GLASS; IT/BAROQUE: ptgs; FR: 19; AN/EGT; AM: sculp, ptgs

Named one of the top 20 museums in the nation, The Chrysler Museum offers visitors an encyclopedic view of 30,000 works of art in an Italianate-Style structure built on the picturesque Hague of the Elizabeth River. **NOT TO BE MISSED:** Gianlorenzo Bernini's "Bust of the Savior"

ON EXHIBIT/97:

11/22/96–07/20/97	THE ART OF LOUIS COMFORT TIFFANY FROM THE COLLECTION OF THE CHRYSLER MUSEUM OF ART — The Chrysler Museum's holdings of Tiffany glass and pottery are among the largest in the United States. Rarely seen bronze desk sets, ashtrays, jewel boxes and candlesticks will be among the items featured in this exhibition.
12/21/96–02/23/97	APPEAL TO THIS AGE: PHOTOGRAPHY OF THE CIVIL RIGHTS ERA, 1954-1968 — A survey of the photography of the black-led freedom movement of the middle of our century, these are among the most inspiring images of 20th-century America. Included are 75 powerful and moving images by Gordon Parks, James Karales, Sandra Weiner, Charles Moore and others. WT
03/02/97–05/11/97	AN ALLIANCE OF ART, DESIGN AND INDUSTRY: THE BRILLIANCE OF SWEDISH GLASS, 1918-1939 — This examination of landmark developments of the Swedish glass industry during the inter-war years provides a rare opportunity for American audiences to learn about a major chapter in the history of 20th-century design and to view outstanding examples of Swedish glass, many never before seen in this country. CAT WT
03/15/97–06/01/97	LAND OF PARADOX: CONTEMPORARY PHOTOGRAPHS BY YUJI SAIGA, NAOYA HATAKEYAMA, NORIO KOBAYASHI, AND TOSHIO YAMANE — Featured will be images of Japan's constructed landscape captured by the lens of 4 contemporary Japanese photographers.
06/27/97–09/07/97	TOULOUSE-LAUTREC

Hermitage Foundation Museum
7637 North Shore Road, **Norfolk, VA 23505**
☏ 804-423-2052
HRS: 10-5 M-Sa, 1-5 S HOL: 1/1, THGV, 12/25
ADM: Y ADULT: $4.00 CHILDREN: $1.00 SR CIT: $4.00
&: Y ⑫ Y H/B: Y
PERM/COLL: OR; EU; AS; 16, 17

Nestled in a lush setting along the Lafayette River is the 12 acre estate of the Hermitage Foundation Museum whose turn-of-the-century English Tudor home appears to have been frozen in time. It is, however, alive with treasures from the past. **NOT TO BE MISSED:** 1,400 year old Buddha

Radford

Radford University Galleries
200 Powell Hall, **Radford, VA 24142**
📞 703-831-5754
HRS: 10-4 Tu-F, 6-9 T, 12-4 S (9/1-5/30) DAY CLOSED: Sa, M
HOL: LEG/HOL!, JUL & AUG &: Y Ⓟ Y S/G: Y
PERM/COLL: Cont works in all media

Located in the New River Valley, the gallery is noted for the diversity of its special exhibitions.

ON EXHIBIT/97:
 ONGOING NIGERIAN ART

 RADFORD UNIVERSITY LIVING COLLECTION — (placed throughout the campus)

Richmond

Anderson Gallery, School of the Arts
Affiliate Institution: Virginia Commonwealth University
907 1/2 W. Franklin Street, **Richmond, VA 23284-2514**
📞 804-828-1522
HRS: 10-5 Tu-F; 1-5 Sa, S DAY CLOSED: M HOL: LEG/HOL! ACAD!
&N; no elevator; museum has 3 floors Ⓟ Y; Metered on-street parking MUS/SH: Y GR/T: Y GR/PH: CATR!
PERM/COLL: CONT: gr, phot, ptgs, sculp

The gallery is well known in the US and Europe for exhibiting work of nationally and internationally renowned artists.

ON EXHIBIT/97:
01/17/97–03/02/97 ARNALDO ROCHE-RABELL: THE UNCOMMON WEALTH — A fifteen year retrospective of this important contemporary Puerto Rican artist whose paintings draw on the traditions of expressionism, performance art, and the Chicago imagists to construct a complex dialogue in political, religious and social issues.

06/06/97–08/03/97 NEW WORK BY VIRGINIA ARTISTS

08/29/97–10/05/97 GREGORY CREWDSON — Large-scale photographs which examine landscapes as a heightened blend of nature and artifice.

08/29/97–10/03/97 PRESUMED INNOCENCE — Expressions of innocence as undermined by technology
 • and changing social attitudes will be seen n the work of an international selection of artists.

Virginia Museum of Fine Arts
2800 Grove Ave, **Richmond, VA 23221-2466**
📞 804-367-0844
HRS: 11-5 Tu, W, F-S; 11-8 T DAY CLOSED: M HOL: 1/1, 7/4, THGV, 12/25
SUGG/CONT: Y ADULT: $4.00
&: Y Ⓟ Y; Free and ample MUS/SH: Y ⊪ Y
GR/T: Y GR/PH: CATR! DT: Y TIME: 2:30 Tu-S; 6 PM T except summer S/G: Y
PERM/COLL: AM: ptgs, sculp; LILLIAN THOMAS PRATT COLL OF JEWELS BY PETER CARL FABERGÉ; EU: all media
(Ren to cont)

Diverse collections and outstanding special exhibits abound in the internationally prominent Virginia Museum which houses one of the largest collections in the world of Indian, Nepalese, and Tibetan art. It also holds the Mellon Collection of British sporting art and the Sydney and Francis Lewis Collection of late 19th and early 20th-century decorative arts, contemporary American paintings and sculpture. **NOT TO BE MISSED:** 'Caligula', Roman, AD 38-40 marble 80 ' high. Also the largest public collection of Faberge Imperial Easter eggs in the West.

VIRGINIA

Virginia Museum of Fine Arts - continued

ON EXHIBIT/97:

07/16/96–02/16/97	A SAMPLER FROM INDIA: MASTERPIECES OF PAINTING FROM THE VIRGINIA MUSEUM — More than 20 masterworks from the permanent collection present an overview of Indian painting from the 13th to the late 19th-century.
10/01/96–02/02/97	I SING FOR THE ANIMALS: PRINTS AND DRAWINGS FROM THE PAUL MELLON COLLECTION — Previous exhibitions of sporting drawings and prints from the Paul Mellon Collection have examined various aspects to enlarge on particular sporting themes. This exhibition has less of a sociological function and more of a naturalistic ideal.
03/04/97–05/25/97	CARRIE MAE WEEMS: AFRICA SERIES — In this compelling narrative of search and discovery Carrie Mae Weems creates poetic ensembles of photographs and text that draw upon personal and family histories as well as African-American history and folklore. The photographs on view were taken on her recent trip to Ghana, Mali and Senegal. BROCHURE
03/04/97–05/25/97	RECENT ACQUISITIONS IN AMERICAN PHOTOGRAPHY
08/12/97–11/09/97	ADORNMENT FOR ETERNITY: STATUS AND RANK IN CHINESE ORNAMENT — Using over 100 objects from the Mengdiexuan Collection, the exhibition examines the imagery, technique and materials of adornment in China as well as the influence of China's northern neighbors on metal technology. These symbols of status and rank in gold, silver, bronze and jade date from the Eastern Zhou period (770-221 B.C.) to the Quing dynasty (1644-1911). CAT WT
09/23/97–12/07/97	AN AMERICAN DREAM: THE WARNER COLLECTION (Working Title) — Jack W. Warner's collection, one of the most preeminent in the United States, gives a glimpse of American art through a very astute and private eye. The works cover Hudson River School, American Impressionism, and early 20th-century realism.
11/04/97–01/11/98	WILLIAM BLAKE: THE BOOK OF JOB — "The Book Of Job"(1825) is the most important set of line engravings executed by Blake. To highlight this major work, 60 watercolors, drawings and engravings have been assembled to investigate the position, aesthetic and spiritual implications of this work in Blake's career.
11/16/97–01/31/98	WIT AND DELIGHT IN TWENTIETH CENTURY ART AND DESIGN CAT

Roanoke

The Art Museum of Western Virginia

One Market Square, **Roanoke, VA 24011**
☎ 703-342-5760
HRS: 10-5 Tu-Sa, 1-5 S, (10-2 12/24 - 12/31) DAY CLOSED: M HOL: 1/1, 12/25
&: Y ℗ Y; Pay MUS/SH: Y GR/T: Y GR/PH: CATR! S/G: Y
PERM/COLL: AM & EU: ptgs 20; AM: folk, gr, phot

Located in the Blue Ridge Mountains of Western Virginia, the collection reflects all cultures formerly and presently found there. **NOT TO BE MISSED:** Outsider Art and regional artist exhibitions

ON EXHIBIT/97:

10/01/96–06/14/97	PLASTIC FANTASTIC: TOYS IN ART — Sculptures, photographs and paintings inspired by the symbolism and whimsey of children's toys.
02/07/97–05/05/97	JUDITH GODWIN — A retrospective which will examine the evolution of Godwin's abstract paintings from the mid-1950's to the present.
06/13/97–09/14/97	CHARLIE BROUWER — Constructed sculptures and drawings on themes of spirituality, memory, and biography.
07/11/97–09/26/97	ROANOKE CITY ART SHOW — Annual juried regional exhibition.
09/05/97–11/16/97	ELI REED: BLACK IN AMERICA WT
09/26/97–11/17/97	KOREAN EXCHANGE EXHIBITION Dates Tent!
10/15/97–12/21/97	DOROTHY GILLESPIE

Sweet Briar

Sweet Briar College Art Gallery
Sweet Briar College, **Sweet Briar, VA 24595**
☎ 804-381-6248
HRS: Pannell: 12-9:30 M-T, 12-5 F-S; Babcock: 9-9 daily DAY CLOSED: M HOL: ACAD!
&: Y; Ramp & elevator ℗ Y MUS/SH: Y ‼ Y; On campus GR/T: Y GR/PH: CATR! H/B: Y S/G: Y
PERM/COLL: JAP: woodblock prints; EU: gr, drgs 19; AM: ptgs 20

Th exterior design of the 1901 building is a rare collegiate example of Ralph Adams Cram Georgian Revival Style architecture. **NOT TO BE MISSED:** "Daisies and Anemones," by William Glackens

ON EXHIBIT/97:
09/19/96–02/04/97	THE CLASSICAL WORLD
02/13/97–04/20/97	MEDIEVAL MANUSCRIPTS FROM THE WALTERS ART GALLERY AND THE WALTON COLLECTION

Virginia Beach

Virginia Beach Center for the Arts
2200 Parks Avenue, **Virginia Beach, VA 23451**
☎ 804-425-0
HRS: 10-4 Tu-Sa, 12-4 S HOL: LEG/HOL!
&: Y ℗ Y MUS/SH: Y S/G: Y
PERM/COLL: Non-collecting institution

Rotating exhibits of locally, nationally and internationally acclaimed artists are featured at this center for the arts.

Williamsburg

Abby Aldrich Rockefeller Folk Art Center
307 S. England Street, **Williamsburg, VA 23185**
☎ 804-220-7698
HRS: 10-6 M-S
ADM: Y ADULT: $10.00!
&: Y ℗ Y; Free MUS/SH: Y GR/T: Y GR/PH: CATR! H/B: Y
PERM/COLL: AM: folk

Historic Williamsburg is the site of the country's premier showcase for American folk art. The museum, originally built in 1957 and reopened in its new building in 1992, demonstrates folk arts' remarkable range and inventiveness in textiles, paintings, and decorative arts.

ON EXHIBIT/97:
	THE DEWITT WALLACE DECORATIVE ARTS GALLERY (entered through the Public Hospital Building) — The gallery offers exhibitions of decorative arts, firearms, textiles and costumes.
through 05/97	MAPPING COLONIAL AMERICA
09/27/96-12/97	REVOLUTION IN TASTE — Features consumer choices in ceramics and metals during the 18th-century.

VIRGINIA

Abby Aldrich Rockefeller Folk Art Center - continued

through 05/97	VIRGINIA FURNITURE 1690-1820
10/97-09/98	VIRGINIA NEEDLEWORK
10/97-12/98	SOUTHERN FURNITURE
11/02/96–04/06/97	TAKE JOY: THE WORLD OF TASHA TUDOR — Toys and 19th-century textiles as well as original artwork from the collection of author/illustrator Tudor.
05/08/97–11/97	FOLK ART FROM THE COLLECTION OF BARON AND ELLIN GORDON
12/97–04/98	KING GEORGE III AND AMERICAN NATURAL HISTORY: MARK CATESBY'S WATERCOLORS FROM THE ROYAL LIBRARY, WINDSOR CASTLE WT

Williamsburg

Muscarelle Museum of Art
College of William and Mary, **Williamsburg, VA 23185**
✆ 804-221-2700
HRS: 10-4:45 M-F, 12-4 Sa-S HOL: LEG/HOL!
&: Y ℗ Y MUS/SH: Y
GR/T: Y GR/PH: CATR! 804-221-2703 H/B: Y
PERM/COLL: BRIT & AM: portraits 17-19; O/M: drgs; CONT: gr; AB; EU & AM: ptgs

The "worlds' first solar painting" by Gene Davis, transforms the south facade of the Museum into a dramatic and innovative visual statement when monumental tubes, filled with colored water are lit from behind. **NOT TO BE MISSED:** Early Renaissance fresco fragment, "St. Mary Magdalene and Donor," attributed to The Master of the Cappella di San Giorgio, Italian (Assisi), 1300-1350.

ON EXHIBIT/97:

01/11/97–03/09/97	AN ARTISTIC FRIENDSHIP: IN RELIEF — Prints by Will Barnet and Bob Blackburn from the Cochran Collection.
03/15/97–05/25/97	MEMORIES OF CHILDHOOD, 1995: SO WE'RE NOT THE CLEAVERS OR THE BRADY BUNCH
06/06/97–08/17/97	INTIMATE NATURE: ANSEL ADAMS AND THE CLOSE VIEW

Bellevue

Bellevue Art Museum
301 Bellevue Square, **Bellevue, WA 98004**
✆ 206-454-6021
HRS: 10-6 M, W, T, Sa; 10-8 Tu, F; 11-5 S: THE MUSEUM IS CLOSED BETWEEN EXHIBITIONS
HOL: EASTER, 7/4, THGVG, 12/25
F/DAY: Tu ADM: Y ADULT: $3.00 CHILDREN: F (under 12) SR CIT: $2.00
&: Y MUS/SH: Y GR/T: Y GR/PH: CATR! DT: Y TIME: 2:00 daily
PERM/COLL: Non-collecting institution

Located across Lake Washington about 10 minutes drive from Seattle, the museum is a place to see, explore and make art.

Bellingham

Whatcom Museum of History and Art
121 Prospect Street, **Bellingham, WA 98225**
✆ 360-676-6981
HRS: 12-5 Tu-S DAY CLOSED: M HOL: LEG/HOL!
&: Y MUS/SH: Y GR/T: Y GR/PH: CATR! H/B: Y S/G: Y
PERM/COLL: KINSEY: phot coll; HANSON: Naval arch drgs; NW/COAST: ethnography; VICTORIANA

An architectural and historic landmark, this museum building is situated in a 1892 former City Hall on a bluff with a commanding view of Bellingham Bay.

ON EXHIBIT/97:

11/09/96–03/02/97	PHYSICS OF TOYS	
01/11/97–05/11/97	FRANK OKADA	
01/25/97–02/08/97	HEARTWORKS	
03/29/97–06/22/97	TRASHFORMATIONS: RECYCLED MATERIALS IN CONTEMPORARY AMERICAN ART AND DESIGN	
05/10/97–08/31/97	VIEWS OF THE KLONDIKE	
05/17/97–09/07/97	ROSS PALMER BEECHER	
07/19/97–10/12/97	17TH ANNUAL NORTHWEST INTERNATIONAL ART COMPETITION	
11/08/97–03/01/98	ED YOUNG	Dates Tent!

Clarkston

Valley Art Center, Inc
842-6th Street, **Clarkston, WA 99403**
✆ 509-758-8331
HRS: 9-4 M-F; by appt other times DAY CLOSED: Sa, S HOL: 7/4, THGV, 12/25-1/1
&: Y; Building accessible EXCEPT for restrooms Ⓟ Y MUS/SH: Y
GR/T: Y GR/PH: CATR! H/B: Y
PERM/COLL: REG; NAT/AM

Valley Art Center is located in Southeast Washington at the Snake and Clearwater Rivers in the heart of the city's historic district made famous by Lewis and Clarke. **NOT TO BE MISSED:** Beadwork, Piute Cradle Board Tatouche

WASHINGTON

Ellensburg

The Clymer Museum
416 North Pearl Street, **Ellensburg, WA 98926**
\ 509-962-6416
HRS: 10-5 M-F; 12-5 Sa, S HOL: 1/1, EASTER, 7/4, THGV, 12/25
ADM: Y ADULT: $3.00 CHILDREN: $1.50 STUDENTS: $2.00 SR CIT: $2.00
&: Y Ⓟ Y; Street
MUS/SH: Y
GR/T: Y GR/PH: CATR!
H/B: Y
PERM/COLL: WORKS OF ELLENSBURG ARTIST, JOHN FORD CLYMER FOR THE SATURDAY EVENING POST COVER; drgs, sketches; WESTERN ART

The 1901 building with lintels from the Chicago Music Hall (and an upstairs ballroom!) is an unusual setting for the diverse work of John Clymer, an artist whose work adorned more than 80 *Saturday Evening Post* covers. He was equally well known as an outstanding western and wildlife artist.

Goldendale

Maryhill Museum of Art
35 Maryhill Museum Drive, **Goldendale, WA 98620**
\ 509-773-3733
HRS: 9-5 Daily Mar 15-Nov 15. HOL: Open HOL
ADM: Y ADULT: $5.00 CHILDREN: F (under 6) STUDENTS: $1.50 SR CIT: $4.50
&: Y Ⓟ Y
MUS/SH: Y
⑪ Y; Cafe, picnic grounds H/B: Y
PERM/COLL: SCULP; ORTHODOX ICONS: 18; BRIT: ptgs; NAT/AM: baskets, dec/art; FURNISHINGS OF QUEEN MARIE of ROMANIA; INTERNATIONAL CHESS SETS

Serving the Pacific Northwest, the Maryhill Museum is a major cultural resource in the Columbia River Gorge region. **NOT TO BE MISSED:** Theatre de la Mode: 1946 French fashion collection

Longview

The Art Gallery, Lower Columbia College Fine Arts Gallery
1600 Maple Street, **Longview, WA 98632**
\ 360-577-2300
HRS: 10-4 M, Tu, F; 10-8 W & T DAY CLOSED: Sa, S HOL: Open SEP through JUN
&: Y Ⓟ Y
GR/T: Y GR/PH: CATR!
PERM/COLL: Non-collecting institution

A College gallery that features temporary exhibitions by local, regional, and national artists.

Olympia

Washington State Capital Museum
211 West 21st Avenue, **Olympia, WA 98501**
📞 360-753-2580
HRS: 10-4 Tu-F, 12-4 Sa-S DAY CLOSED: M HOL: LEG/HOL!
ADM: Y ADULT: $2.00 STUDENTS: $1.00 SR CIT: $1.75
&: Y Ⓟ Y MUS/SH: Y H/B: Y
PERM/COLL: REG: NAT/AM: 18, 19

The Museum is housed in the Lord Mansion, a 1924 Italian Renaissance Revival Style building. It also features a permanent exhibit on the history of Washington State government and culture. **NOT TO BE MISSED:** Southern Puget Sound American Indian exhibit welcome healing totem pole figure.

ON EXHIBIT/97:

11/96–06/97	REMEMBERING MEDICINE CREEK — The events leading up to the Medicine Creek Council of 1854 and the ongoing consequences of the Treaty's provisions.
01/97	HER PRESENT PROUD POSITION: OLYMPIA AS WASHINGTON'S STATE CAPITAL
01/97	DEMOCRACY DRESSED UP: CULTURAL AND SOCIAL MEANING OF GOWNS AT WASHINGTON'S INAUGURAL BALLS
01/97	TRADITIONS AND TRANSITIONS: AMERICAN INDIANS OF SOUTHERN PUGET SOUND

Pullman

Museum of Art
Washington State University, **Pullman, WA 99164**
📞 509-335-1910
HRS: 10-4 M-F, 7-10 Tu, 1-5 Sa-S HOL: ACAD!
&: Y Ⓟ Y; Parking permits may be purchased at Parking Services, adjacent to the Fine Arts Center GR/T: Y GR/PH: CATR!
PERM/COLL: NW: art; CONT/AM & CONT/EU: gr 19

The WSU Museum of Art, in the university community of Pullman, presents a diverse program of changing exhibitions, including paintings, prints, photography, and crafts. The Museum is located in a beautiful agricultural area between the university communities of Pullman and Moscow.

ON EXHIBIT/97:

01/14/97–02/23/97	FAY JONES: A TWENTY-YEAR RETROSPECTIVE	WT
03/03/97–03/30/97	THE ELECTRONIC MUSE: ARTISTS IN THE INFORMATION AGE — Work by several artists including Nam June Paik, Jenny Holzer, and Lynn Hershman, who use new technologies as a fitting and exciting way to express their ideas. Featured also will be computer stations at which visitors will interact with digital art shows and other on-line presentations.	
05/27/97–08/01/97	AMERICAN PHOTOGRAPHS 1970-1980 — Richard Avedon, Diane Arbus, Duane Michals, Robert Heinecken, Richard Misrach, and Eve Sonneman are among the 33 photographers in this exhibition of works owned by the WSU Museum of Art in partnership with other museums of the Washington Art Consortium. TENT!	
10/06/97–11/09/97	PETLAND: KATHRYN A. GLOVER — An unusual and innovative installation using the personal effects and business archives of a recently deceased 101 year old woman who owned the Spokane pet store with that name.	
12/01/97–02/01/98	SILENT SCREAMS FROM THE RUSSIAN UNDERGROUND — Works by Russian artists from the 60's through the 90's examine the role of the artist as a voice for dissidents in a totalitarian society.	

WASHINGTON

Seattle

Henry Art Gallery
Affiliate Institution: University of Washington
15th Ave. NE & NE 41st Street, **Seattle, WA 98195-3070**
📞 206-543-2280
HRS: 11-5 Tu-W & F-S, 11-9 T DAY CLOSED: M HOL: LEG/HOL!
F/DAY: T ADM: Y ADULT: $3.50 CHILDREN: F (under 12) STUDENTS: $2.00 SR CIT: $2.00
&: Y ℗ Y; Pay MUS/SH: Y ⅡY
GR/T: Y GR/PH: CATR! H/B: Y
PERM/COLL: PTGS: 19, 20; PHOT; CER; ETH: textiles & W./Coast

The major renovation designed by Charles Gwathmey of Carl F. Gould's 1927 building will reopen in March 1997. The expansion adds 10,000 square feet of galleries and additional visitor amenities and educational facilities.

ON EXHIBIT/97:	The Gallery will be closed until March 1997 for major renovations. Included in the expansion will be a Media Gallery fully wired to permit presentation of media-based art works, from single channel video to Internet and other network-linked projects.
03/97–05/97	CHRIS BURDEN: SCULPTURE — Six of Burden's major works of the last 20 years will be featured along with drawings for these and other works in the first major exhibition in nearly a decade to contain a significant group of his large scale sculpture.
03/97–02/98	COLLECTIONS EXHIBITION — The Gallery's permanent collection will be celebrated in a year long exhibition revealing the highlights through changing components. Thematic selections will reveal its range of artistic media, historic period, and cultural diversity.

Seattle Art Museum
100 University Street, **Seattle, WA 98101-2902**
📞 206-625-8900 WEB ADDRESS: http://www.pan.ci.seattle.wa.us/sam/home.htm
HRS: 10-5 Tu-S, 10-9 T, Open M on holidays DAY CLOSED: M HOL: THGV, 12/25, 1/1
F/DAY: 1st T;(1st F sr/cit) ADM: Y ADULT: $6.00 CHILDREN: F (under 12) STUDENTS: $4.00 SR CIT: $4.00
&: Y ℗ Y; Limited pay parking MUS/SH: Y ⅡY
GR/T: Y GR/PH: CATR! DT: Y TIME: 2 Tu-S, 7 T; Sp exh: 1 Tu-S, 6 T S/G: Y
PERM/COLL: AS; AF; NW NAT/AM; CONT; PHOT; EU: dec/art; NW/CONT

Designed by Robert Venturi, architect of the new wing of the National Gallery in London, this stunning five story building is but one of the reasons for visiting the outstanding Seattle Art Museum. The downtown location is conveniently located within walking distance of many of Seattle's most interesting landmarks including Pike Place Market, and Historic Pioneer Square. The Museum features 2 complete educational resource centers with interactive computer systems. **NOT TO BE MISSED:** NW Coast Native American Houseposts; 48' kinetic painted steel sculpture "Hammering Man" by Jonathan Borovsky

ON EXHIBIT/97:

ONGOING	CONTEMPORARY NORTHWEST COAST BASKETRY — From the collection, a new case installation of masterworks by today's outstanding native weavers.
	DISTANT THUNDER BY ANDREW WYETH
07/96-05/98	PIER TABLE BY CHARLES-HONORE LANNULER
through 02/28/97	ABORIGINAL AUSTRALIAN ART — Symbolic bark paintings, dramatic acrylic canvases, and wood sculptures represent complex cultural tales from age-old Aboriginal history and law.
08/22/96–03/02/97	DOCUMENTS NORTHWEST, THE PONCHO SERIES-LIZ BIRKHOLZ AND STEVEN BERARDELLI: MANNERS AND GESTURES — Two contemporary Seattle artists who utilize the essential characteristics of photography while investigating new formats for its use.

Seattle Art Museum - continued

08/22/96–03/02/97	GUY ANDERSON — A retrospective honoring the artist's 90th birthday drawn from the Museum's and local collections.
08/30/96–07/14/97	THE SPIRAL PATH: THE ART OF CONTEMPORARY NORTHWEST COAST BASKETRY AND WEAVING — Baskets, hats and small treasures such as basket pendants and earrings from weavers from Haida, Nuu-chah-nulth, Wishxam, Tlingit and Puget Sound traditions will be highlighted.
10/24/96–01/12/97	THE ARTS OF REFORM AND PERSUASION: DESIGN 1885-1945 — Approximately 280 objects from the Wolfsonian Foundation which demonstrate how designs of this period functioned as an agent of modernity, reflecting society's opinions and values.　　WT
03/20/97–07/22/97	DOCUMENTS NORTHWEST: THE PONCHO SERIES: FAY JONES RETROSPECTIVE　　WT
08/14/97–12/14/97	DOCUMENTS NORTHWEST: THE PONCHO SERIES: KUMI YAMASHITA

Seattle

Seattle Asian Art Museum

Volunteer Park, 1400 East Prospect Street, **Seattle, WA**
☎ 206-625-8900
HRS: 10-5 Tu-S, 10-9 T　DAY CLOSED: M　HOL: LEG/HOLS
F/DAY: 1st T, Sr 1st F　ADM: Y　ADULT: $6.00　CHILDREN: F (under 12)　STUDENTS: $4.00　SR CIT: $4.00
&: Y　MUS/SH: Y
⑪ Tea Garden ! for hours
GR/T: Y　GR/PH: CATR!　H/B: Y
PERM/COLL: CH;JAP;SE/AS;IND;KOR

The historical preservation of the Carl Gould designed 1932 building (the first Art-Deco style art museum in the world) involved uniting all areas of the structure including additions of 1947, 1954, and 1955. Now a 'jewel box' its plush but tasteful interiors perfectly complement the art of each nation. 900 of the 7000 objects in the collection are on view.

ON EXHIBIT/97:

08/01/96–03/02/97	VIETNAMESE CERAMICS: A SEPARATE TRADITION — This groundbreaking exhibition of 40 ceramics from northern Vietnam, dating from the second to the 16th centuries, demonstrates the uniqueness of Vietnamese ceramic tradition.
11/21/96–03/23/97	ABSTRACTION AND EXPRESSION IN CHINESE CALLIGRAPHY — 24 hanging scrolls and hand scrolls dating from the 15th to 20th centuries are presented to illustrate not only their beauty, but the comparisons between this art form and modern Western art.
03/29/97–03/98	MUGHAL ART FROM THE SAM COLLECTION
04/10/97–08/17/97	NANGA: JAPANESE PAINTINGS AND SCREENS
09/05/97–11/16/97	WORLDS WITHIN WORLDS: THE RICHARD ROSENBLUM COLLECTION OF CHINESE SCHOLAR'S ROCKS — For centuries the Chinese have revered the special aesthetic and spiritual qualities of rocks used by scholars as vehicles of contemplation. The 90 rock treasures on view reveal their aesthetic merits as vehicles for meditation.

WASHINGTON

Seattle

Nordic Heritage Museum
3014 N.W. 67th Street, **Seattle, WA 98117**
☎ 206-789-5707
HRS: 10-4 Tu-Sa, 12-4 S DAY CLOSED: M HOL: 12/24, 12/25, 1/1
ADM: Y ADULT: $4.00 CHILDREN: $2.00 (6-16) STUDENTS: $3.00 SR CIT: $3.00
&: Y ℗ Y; Free MUS/SH: Y GR/T: Y GR/PH: CATR!
PERM/COLL: SCANDINAVIAN/AM: folk; PHOT

Follow the immigrants journey across America in this museum located in Ballard north of the Ballard Locks.

ON EXHIBIT/97:
01/12/97–03/06/97	LIN SEREBRIN
02/28/97–05/31/97	NORWEGIAN FOLK ART
03/28/97–05/18/97	GUNVOR BYE
05/23/97–06/29/97	LAURA MYNTTI
07/11/97–08/31/97	IIERA OWEN
07/11/97–08/31/97	LOUISA MATTHIASDOTTIR
07/11/97–09/14/97	FAROESE ARTISTS
09/10/97–10/12/97	ULLA WACHMEISTER
09/10/97–10/12/97	JEAN DERNBERGER
10/01/97–11/16/97	HEIKE ARNDT
10/01/97–11/16/97	WESTERN ROSEMALERS
10/01/97–11/16/97	CONSTANTIA SMULOVITZ
12/02/97–01/04/98	REA NURMI
12/02/97–01/04/98	CAROLE QUAM

Spokane

Cheney Cowles Museum
2316 W. First Avenue, **Spokane, WA 99204**
☎ 509-456-3931
HRS: 10-5 Tu-Sa, 10-9 W, 1-5 S DAY CLOSED: M HOL: LEG/HOL!
F/DAY: 1/2 price W ADM: Y ADULT: $4.00; $10 family CHILDREN: $2.50 (6-16) STUDENTS: $2.50 SR CIT: $3.00
&: Y ℗ Y MUS/SH: Y GR/T: Y GR/PH: CATR! H/B: Y
PERM/COLL: NW NAT/AM; REG; DEC/ART

The mission of the Cheney Cowles Museum is to actively engage the people of the Inland Northwest in life-long learning about regional history, visual arts, and American Indian and other cultures especially those specific to the region.

ON EXHIBIT/97:
01/17/97–03/30/97	NORTHWEST NEON - ART/HISTORY
03/27/97–06/01/97	THE RADIANT OBJECT: SELF-TAUGHT ARTISTS FROM THE VOLKERSZ COLLECTION
04/10/97–06/15/97	THE ESTELLE BEEL COLLECTION
06/15/97–09/07/97	REMEMBERING NATATORIUM PARK
06/28/97–09/07/97	SPOKANE COLLECTS

Cheney Cowles Museum - continued

09/18/97–12/14/97	SOUP TO NUTS: POP ART AND ITS LEGACY
09/29/97–12/31/97	TREASURES OF ANTIQUITY: GREEK AND ROMAN ART FROM THE MUSEUM OF FINE ARTS, BOSTON WT
12/14/97–02/15/98	SPOKANE SAMPLER

Tacoma

Tacoma Art Museum
12th & Pacific (downtown Tacoma), **Tacoma, WA 98402**
☎ 206-272-4258
HRS: 10-5 Tu-Sa, 10-7 T, 12-5 S DAY CLOSED: M HOL: 1/1, THGV, 12/25
F/DAY: Tu ADM: Y ADULT: $3.00 CHILDREN: F (under 12) STUDENTS: $2.00 SR CIT: $2.00
&: Y ℗ Y; Street parking MUS/SH: Y GR/T: Y GR/PH: CATR!
PERM/COLL: CONT/NW; AM: ptgs

The only comprehensive collection of the stained glass of Dale Chihuly in a public institution. **NOT TO BE MISSED:** Chihuly Retrospective Glass Collection

ON EXHIBIT/97:

ONGOING	CHIHULY AT UNION STATION, 1717 Pacific Avenue, Tacoma.

Tacoma

Tacoma Public Library/Thomas Handforth Gallery
1102 Tacoma Avenue South, **Tacoma, WA 98402**
☎ 206-591-5666
HRS: 9-9 M-T, 9-6 F-Sa DAY CLOSED: S HOL: LEG/HOL!
&: Y ℗ Y H/B: Y
PERM/COLL: HISTORICAL; PHOT; ARTIFACTS

Built in 1903 as an original Andrew Carnegie Library, the Gallery has been serving the public since then with rotating exhibits by Pacific Northwest artists. **NOT TO BE MISSED:** Rare book room containing 750 prints including "North American Indian," by Edward S. Curtice

Walla Walla

Donald Sheehan Art Gallery
900 Isaacs- Olin Hall, **Walla Walla, WA 99362**
☎ 509-527-5249
HRS: 10-5 Tu-F, 1-4 Sa-S DAY CLOSED: M HOL: ACAD!
&: Y; Enter from parking lot ℗ Y; On campus
GR/T: Y GR/PH: CATR!
PERM/COLL: SCROLLS; SCREENS; BUNRAKY PUPPETS; CER

The Sheehan Gallery administrates the Davis Collection of Oriental Art which is not on permanent display. !

WEST VIRGINIA

Charleston

Sunrise Museums
746 Myrtle Road, **Charleston, WV 25314**
☎ 304-344-8035
HRS: 11-5 W-Sa, 2-5 S DAY CLOSED: M HOL: LEG/HOL!
ADM: Y ADULT: $3.50 CHILDREN: $ STUDENTS: $2.50 SR CIT: $2.50
&: Y ℗ Y MUS/SH: Y GR/T: Y GR/PH: CATR! H/B: Y S/G: Y
PERM/COLL: AM: ptgs, sculp, gr; SCI COLL

This multi-media center which occupies two historic mansions overlooking downtown Charleston, features a Science Hall, Planetarium, and an art museum.

ON EXHIBIT/97:

01/18/97–03/25/97	THE ART OF WEST VIRGINIA WOMEN ARTISTS — Contemporary West Virginia women artists, their artistic style and contributions to the cultural heritage of the state are celebrated here. WT
04/05/97–05/25/97	AN INSTALLATION BY DAVID RIFFLE — A multi-media installation by this West Virginia Artist.
04/05/97–05/25/97	BEYOND TRADITION: AMERICANS IN GLASS — An exploration of the contributions of the champions and pioneers of the Studio Glass Movement and the continued experimentation and innovation emanating from today's American Glass artists.
06/07/97–08/03/97	AMERICAN SCENE: PEOPLE AND PLACES — A comprehensive exploration of American pictorial art from the late 1920's through the late 1940's, includes paintings, prints and photographs by Grant Wood, Edward Hopper, Norman Rockwell and Thomas Hart Benton.
09/97–11/97	TBA
11/28/97–12/31/97	CHRISTMAS AT SUNRISE

Huntington

Huntington Museum of Art, Inc
2033 McCoy Road, **Huntington, WV 25701-4999**
☎ 304-529-2701
HRS: 10-5 Tu-Sa, 12-5 S DAY CLOSED: M HOL: 1/1, 7/4, THGV, 12/25
&: Y ℗ Y MUS/SH: Y GR/T: Y GR/PH: CATR! H/B: Y S/G: Y
PERM/COLL: AM: ptgs, dec/art 18-20; GLASS

The serene beauty of the museum complex on a lovely hilltop surrounded by nature trails, herb gardens, an outdoor amphitheater and a sculpture courtyard is enhanced by an extensive addition designed by the great architect Walter Gropius.

ON EXHIBIT/97:

10/20/96–06/98	ARCHITECTURAL ACHIEVEMENTS: PASSAGES THROUGH TIME — Visitors will move through a three-dimensional historical time line perceiving architectural space and mass simultaneously. Theme areas will include architecture as it relates to humans, an area where visitors can alter the exterior design of a home to reflect the style of another time period, a comparison of entertainment arenas past and present, and a presentation of how architects solve problems.
11/17/96–02/02/97	WITNESS: ENDANGERED SPECIES OF NORTH AMERICA — This exhibition is the culmination of an extraordinary project that bridges art and science to raise awareness about endangered species. The electrifying photographic portraits of plants and animals on view possess the power to inspire lasting appreciation for these creatures and for their threatened habitats.
03/09/97–06/08/97	DRAWN ON STONE — A wide range of distinguished works from the Collection marks the 200th anniversary, in 1996, of the accidental discovery of lithography by German Aloys Senefelder.
03/16/97–06/08/97	THE REGIONAL ART SCENE — A juried selection of contemporary art from the surrounding region.

Beloit

Wright Museum of Art
Affiliate Institution: Beloit College
Prospect at Bushnell, **Beloit, WI 53511**
☎ 608-363-2677
HRS: 9-5 M-F; 11-4 Sa, S HOL: ACAD!
♿: Y ⓟ Y GR/T: Y GR/PH: CATR!
PERM/COLL: AS; KOREAN: dec/art, ptgs, gr; HIST & CONT: phot

Madison

Elvehjem Museum of Art
Affiliate Institution: University of Wisconsin-Madison
800 University Ave, **Madison, WI 53706**
☎ 608-263-2246
HRS: 9-5 Tu-F; 11-5 Sa, S HOL: 1/1, THGV, 12/24, 12/25
♿: Y; Use Murray St. entrance, elevator requires security assistance
ⓟ Y; University lots 46 and 83 on Lake Street and City Lake St and Madison ramps. MUS/SH: Y
GR/T: Y GR/PH: CATR! DT: Y TIME: !
PERM/COLL: AN/GRK: vases & coins; MIN.IND PTGS: Earnest C. & Jane Werner Watson Coll; JAP: gr (Van Vleck Coll); OR: dec/arts); RUSS & SOVIET: ptgs (Joseph E. Davies Coll)

More than 15,000 objects that date from 2,300 B.C. to the present are contained in this unique university museum collection.

ON EXHIBIT/97:

11/09/96–01/19/97	HARE'S FUR, TORTOISESHELL, AND PARTRIDGE FEATHERS: CHINESE BROWN-AND-BLACK GLAZED CERAMICS, 400-1400 WT
02/08/97–04/06/97	WORKERS, AN ARCHEOLOGY OF THE INDUSTRIAL AGE: PHOTOGRAPHS BY SEBASTIAO SALGADO — This Brazilian born photojournalist's powerful images chronicle the diverse activities that have defined labor from the Iron Age, through the Industrial Revolution, to the present. WT
04/26/97–06/29/97	HOGARTH AND THE SHOWS OF LONDON

Madison Art Center
211 State Street, **Madison, WI 53703**
☎ 608-257-0158
HRS: 11-5 Tu-T, 11-9 F, 10-9 Sa, 1-5 S DAY CLOSED: M HOL: LEG/HOL!
♿: Y ⓟ Y; Pay MUS/SH: Y
GR/T: Y GR/PH: CATR! H/B: Y
PERM/COLL: AM: works on paper, ptgs, sculp; JAP; MEX; CONT

Located in the Old Capitol theatre, the Madison Art Center offers modern and contemporary art exhibitions and highlights from its permanent collections. **NOT TO BE MISSED:** "Serenade" by Romare Bearden

ON EXHIBIT/97:

12/08/96–02/02/97	H. C. WESTERMAN — Sculptures, drawings, prints, illustrated letters.
02/16/97–04/13/97	DANE COUNTY COLLECTS — Artwork in all media from private and corporate collections in Dane County.

WISCONSIN

Madison Art Center - continued

04/27/97–07/17/97	CLAES OLDENBURG: PRINTED STUFF — A first in-depth survey of Oldenburg's printed material, covers more than three decades and features 135 works.
08/23/97–11/16/97	PROJECTIONS: THE PHOTOMONTAGE OF ROMARE BEARDEN — Collaged images chronicle the African-American experience during the Civil Rights movement and celebrate jazz of the Harlem Renaissance.
12/97–02/98	MARTIN KERSELS — Photographs and sculptures incorporating video, sound and movement.

Manitowoc

Rahr-West Art Museum

Park Street at North Eighth, **Manitowoc, WI 54220**
☎ 414-683-4501
HRS: 10-4 M, Tu, T, F; 10-8 W; 11-4 Sa-S HOL: LEG/HOL!
&: Y ℗ Y: Free MUS/SH: Y GR/T: Y GR/PH: CATR! H/B: Y
PERM/COLL: AM: ptgs, dec/art 19; OR: ivory, glass; CONT: ptgs

Built between 1891 & 1893, this Victorian mansion with its former parlors and bed chambers, carved woodwork and beamed ceiling provides an elegant setting for its fine collection. **NOT TO BE MISSED:** "Birch and Pine Tree No 2" by Georgia O'Keeffe

ON EXHIBIT/97:

11/10/96–01/19/97	ROBERT VICKREY: IMAGINARY REALITIES — 16 paintings in oil and egg tempera explore the subjects this artist has memorialized in his work during his 45 year career. He represents the energy and appeal of creating a three dimensional world on a two dimensional plane. WT
02/02/97–03/30/97	THE ART OF TABLESETTING — An annual exhibition of tableware and wall hangings.
04/13/97–05/11/97	SEASCAPES BY AUGUST HOLLAND — Paintings of ships and seas by this renowned Midwestern realist.
07/27/97–09/07/97	MANITOWOC COUNTY ARTISTS — A non-juried exhibition of work by more than 80 artists.
08/24/97–09/28/97	CHARLES PARNESS: A DIFFERENT VIEW OF THE WORLD — The wit and humor of these works, all self portrait interpretations of the artist himself, makes one smile. At a deeper level the paintings are a reflection of Parness' good humor, tolerance and understanding that reveal his insights into the human condition. BROCHURE WT
11/23/97–01/11/98	CHRISTMAS IN THE MANSION — An annual holiday exhibition in an historic Victorian setting.

Milwaukee

Charles Allis Art Museum

1801 North Prospect Avenue, **Milwaukee, WI 53202**
☎ 414-278-8295
HRS: 1-5 & 7-9 W, 1-5 T-S HOL: LEG/HOL!
ADM: Y ADULT: $2.00
GR/T: Y GR/PH: CATR! H/B: Y
PERM/COLL: CH: porcelains; OR: AN/GRK; AN/R; FR: ptgs 19

With its diverse collection this museum is housed in a 1909 Tudor style house.

Milwaukee

Milwaukee Art Museum

750 North Lincoln Memorial Drive, **Milwaukee, WI 53202**
☎ 414-224-3200
HRS: 10-5 Tu, W, F, Sa; 12-9 T; 12-5 S DAY CLOSED: M HOL: 1/1, THGV, 12/25
ADM: Y ADULT: $5.00 CHILDREN: F (under 12) STUDENTS: $3.00 SR CIT: $3.00
&: Y ℗ Y MUS/SH: Y ⅋Y
GR/T: Y GR/PH: CATR! 414-224-3825 H/B: Y S/G: Y
PERM/COLL: CONT: ptgs, sculp; GER; AM: folk art

The Milwaukee Museum features an exceptional collection housed in a 1957 landmark building by Eero Saarinen, which is cantilevered over the Lake Michigan shoreline. **NOT TO BE MISSED:** Zurburan's "St. Francis"

ON EXHIBIT/97:

07/11/97-continuing	THE MICHAEL AND JULIE HALL COLLECTION OF AMERICAN FOLK ART — After a cross country tour the renowned collection acquired by the Museum in 1989 will be presented in an ongoing exhibition.
12/06/96–03/02/97	TBA
01/17/97–04/06/97	CONTEMPORARY WOMEN PRINTMAKERS — About 35 works by prominent American women printmakers made from the 1970's to today will reflect the artists' perspectives on politics and social experiences and their prolific experimentation with technique, material and subject matter. WT
01/31/97–03/30/97	PLAINS INDIAN DRAWINGS, 1865-1935: PAGES OF A LIVING HISTORY — Presented will be an exhibition of Ledger art developed from the Native American tradition of painting on buffalo hides. The drawings on view depict current events and personal narratives, and in their experimentation with pictorial conventions, anticipate some of the concerns of twentieth-century artists. CAT WT
02/07/97–05/11/97	ANOTHER HISTORY OF PHOTOGRAPHY — Photographs from the Museum collection and locally owned collections attempt to thematically illustrate photography.
03/07/97–05/11/97	CURRENTS 26: ED RUSCHA — All new works will be shown in this first Midwest one-man show in more than a decade. The exhibition is part of a series dedicated to international developments in contemporary art. BROCHURE
03/21/97–06/15/97	WISCONSIN ART SINCE 1990: SELECTIONS FROM THE PERMANENT COLLECTION
04/11/97–06/01/97	EXPLORATIONS IN THE CITY OF LIGHT: AFRICAN-AMERICAN ARTISTS IN PARIS, 1945-1965 CAT WT
04/18/97–06/29/97	OLD MASTER DRAWINGS FROM THE PERMANENT COLLECTION
05/23/97–06/29/97	RECENT ACQUISITIONS — An annual exhibition highlighting new acquisitions in all collecting areas.
05/30/97–08/31/97	SINCE NOW: CONTEMPORARY PHOTOGRAPHS FROM THE PERMANENT COLLECTION
07/01/97–09/28/97	PUBLIC POLITICS: ROSS LEWIS AND WILLIAM GROPPER — The turbulent American political climate was lampooned by these two artists from the 1930's through the 1970's, from bootleg liquor to the McCarthy years.

WISCONSIN

Milwaukee

The Patrick & Beatrice Haggerty Museum of Art
Affiliate Institution: Marquette University
13th & Clybourn, **Milwaukee, WI 53233-1881**
☎ 414-288-1669 WEB ADDRESS: http://www.mu.edu/haggerty
HRS: 10-4:30 M-Sa, 12-5 S, 10-8 T HOL: 1/1, EASTER, THGVG, 12/25
&: Y ℗ Y, F, lot J off 11th and Wisconsin Ave.
MUS/SH: Y
GR/T: Y GR/PH: CATR! 414-288-5915 S/G: Y
PERM/COLL: PTGS, DRWG, GR, SCULP, PHOT, DEC/ART 16-20; ASIAN, TRIBAL

Selections from the Old Master and modern collections are on exhibition continuously.

ON EXHIBIT/97:

PERMANENT	MODERN GALLERY —20th-century art from the collections including work by Dali, Lawrence, Man Ray and Nam June Paik.
	THE GREEN ROOM — Salon-style gallery hung with art from 16th-19th centuries by European Old Masters.
10/03/96–01/12/97	ADOLPH ROSENBLATT: MILWAUKEE IN SCULPTURE — Large scale wall and free-standing sculptures depicting the Milwaukee experience.
11/07/96–01/26/97	MASTERPIECES FROM THE ROJTMAN FOUNDATION COLLECTION — The Haggerty's Old Master painting and print collection originated with a gift from the Rojtmans. This exhibition brings together additional works never before seen at the Museum including those by Rubens, Maes and Van Dyck.
11/07/96–01/26/97	RECENT GIFTS — Selected gifts received in 1995-96 include Jacob Lawrence's " Birth," 1948; Carpeau's "Figaro," and works on paper by Nevelson, Miro, Bearden, and others.
01/30/97–03/30/97	DANCE FINDINGS: ROBERT DUNN VIDEO DANCE INSTALLATION — A video dance designed to transform human movement into a visual display, resulting in kinetic sculpture.
02/07/97–04/06/97	SARAH BACHRODT: RECENT PAINTINGS — Bachrodt's recent work examines the relationship between art and machines, whereby patterns of clothing are turned into urban roadways which in turn become prehistoric graffiti.
04/17/97–06/01/97	DRAWINGS FROM THE O'NEAL COLLECTION — Included in this presentation of 57 Old Master and modern 16th - 20th-century drawings by Continental and British artists will be examples of architectural and stage designs along with British Victorian and Pre-Raphaelite drawings. WT
04/17/97–06/01/97	GARY SCHNEIDER: RECENT PHOTOGRAPHS — These large scale photographs by South African born New York photographer Schneider offer an interpretation of the subject pictured, not a static snapshot.
06/13/97–08/31/97	RUDOLF KOPPITZ, 1884-1936: VIENNESE "MASTER OF THE CAMERA" WT
09/12/97–11/30/97	MATTA: SURREALIST ART 1940-1990 — An exhibition of 70 works in all media surveys the entire career of Chilean artist Matta, one of the most significant artists of the 20th-century.
12/12/97–01/31/98	CONTEMPORARY PRINTS FROM THE COLLECTION OF MICHAEL AND SUSAN TATALOVICH — This collection of prints reveals the depth and breadth of contemporary American printmaking. Artists include Jennifer Bartlett, Jim Dine, and Robert Indiana.

Milwaukee

UWM Art Museum
3253 N. Downer Avenue, **Milwaukee, WI 53211**
☎ 414-226-6509
HRS: 10-4 Tu-F, 12-8 W, 1-5 Sa-S DAY CLOSED: M HOL: LEG/HOL!
&: Y; Automatic doors in front and elevators inside ℗ Y; Meters in front of building.
PERM/COLL: AM & EU: works on paper, gr; RUSS: icons; REG: 20

The museum works to provide its audience with an artistic cultural and historical experience unlike that offered by other art institutions in Milwaukee. Its three spaces on the campus provide the flexibility of interrelated programming.

Villa Terrace Decorative Arts Museum
2220 North Terrace Ave, **Milwaukee, WI 53202**
☎ 414-271-3656
HRS: 12-5 W-S DAY CLOSED: M, Tu HOL: LEG/HOL!
ADM: Y ADULT: $2.00 CHILDREN: F (under 12) STUDENTS: $2.00 SR CIT: $2.00
&: Y; To first floor galleries ℗ Y H/B: Y
PERM/COLL: DEC/ART; PTGS, SCULP, GR 15-20

Villa Terrace Decorative Arts Museum with its excellent and varied collections is located in a historic landmark building.

Oshkosh

The Paine Art Center and Arboretum
1410 Algoma Blvd, **Oshkosh, WI 54901**
☎ 414-235-4530
HRS: 11-4 Tu-S, 11-7 F DAY CLOSED: M HOL: LEG/HOL!
ADM: Y ADULT: $3.00 CHILDREN: F (under 12) STUDENTS: $2.00 SR CIT: $2.50
&: Y ℗ Y; On-street parking MUS/SH: Y GR/T: Y GR/PH: CATR! H/B: Y S/G: Y
PERM/COLL: FR & AM: ptgs, sculp, gr 19, 20; OR: silk rugs, dec/art

Collections of paintings, sculpture and decorative objects in period room settings are featured in this historic 1920's Tudor Revival home surrounded by botanic gardens. **NOT TO BE MISSED:** "The Bronco Buster" sculpture by Frederic Remington

ON EXHIBIT/97:

01/15/97–04/27/97	ANIMALS IN ART — In works from the permanent collection, the focus is animals as subject matter in all media.
05/06/96–07/06/97	BLAKELOCK: A VISIONARY IN CONTEXT WT*

Racine

Charles A. Wustum Museum of Fine Arts
2519 Northwestern Ave, **Racine, WI 53404**
☎ 424-636-9177
HRS: 1-5 Tu, W, F-S; until 9 M, T HOL: LEG/HOL!
&: Y; Main floor only ℗ Y; Free MUS/SH: Y GR/T: Y GR/PH: CATR! H/B: Y S/G: Y
PERM/COLL: SCULP; WPA works on paper; Crafts

In an 1856 Italianate style building on acres of landscaped sculpture gardens you will find Racine's only fine arts museum. It primarily supports active, regional living artists.

WISCONSIN

Sheboygan

John Michael Kohler Arts Center
608 New York Avenue, **Sheboygan, WI 53082-0489**
☎ 414-458-6144
HRS: 10-5 M-W, F; 10-9 T; 12-5 Sa, S HOL: 12/31, 1/1, EASTER, MEM/DAY, THGV, 12/24, 12/25
&: Y ℗ Y MUS/SH: Y GR/T: Y GR/PH: CATR! H/B: Y
PERM/COLL: CONT: cer; DEC/ART

This multi-cultural center is located in the 1860's villa of John Michael Kohler, founder of the plumbing manufacturing company. Special exhibitions at the Center offer unique perspectives on art forms, artists, and various artistic concepts that have received little exposure elsewhere.

ON EXHIBIT/97: Because of expansion plans, schedules are not finalized. Call!
11/03/96–02/02/97 DENISE MARIKA (Working Title) — Video sculpture questioning what is public or private space.

11/03/96–02/02/97 RUDY ROTTER (Working Title) — This 82 year old self-taught artist has worked in a variety of media for 40 years, first in clay, wood and stone, then in industrial and commercial castoffs.

Wausau

Leigh Yawkey Woodson Art Museum
700 North Twelfth Street, **Wausau, WI 54403-5007**
☎ 715-845-7010
HRS: 9-4 Tu-F, 12-5 Sa-S DAY CLOSED: M HOL: LEG/HOL!
&: Y; 2 of three floors ℗ Y; Free GR/T: Y GR/PH: CATR! DT: Y TIME: ! S/G: Y
PERM/COLL: GLASS 19, 20; STUDIO GLASS; PORCELAIN; WILDLIFE; ptgs, sculp

An English style mansion surrounded by gracious lawns and sculpture gardens is home to this museum whose new sculpture garden features permanent installations in addition to the annual installation of 5-8 temporary pieces.

ON EXHIBIT/97:
01/11/97–02/02/97 ART FROM THE DRIVER'S SEAT: AMERICANS AND THEIR CARS — Paintings, drawings, photographs and etchings from the Terry and Eva Herndon Collection will be featured in an exhibition that allows the visitor to look into the rear view mirror at the history of America's relationship with the automobile. BROCHURE WT

04/12/97–06/08/97 FLIGHT OF THE CRANES TO EXTREMADURA — In 1994 a group of artists followed the cranes that breed in northern Europe to their winter feeding grounds in an ecologically important landscape in southwestern Spain. This selection of 60 works provides a portrait of the flight, landscapes, Extremenos and their traditional way of life, and the animals and plants of the Spanish countryside.

06/14/97–08/24/97 THERE ON THE TABLE: THE AMERICAN STILL LIFE — From classical realism to early abstraction, the still life paintings of the late 19th to mid-20th-century in this exhibition attest to the endless and fertile use of this topic as subject matter in art.
 BROCHURE WT

06/14/97–07/13/97 ARTHUR B. SINGER 1917-1996 — A retrospective emphasizing the balance between realism and design that Singer brought to his interpretation of birds.

07/19/97–08/24/97 CONTEMPORARY REALISM FROM CHINA WT

09/06/97–11/09/97 BIRDS IN ART — In the 21st annual presentation of "Birds in Art," artists from around the world interpret the wonder of flight and the marvel of wingtips.

11/15/97–02/22/98 WORDS AND IMAGES: THE NARRATIVE WORKS OF THE PINKNEYS — The collaborative process of making books for children will be addressed in this exhibition of works by African-American father and son illustrators Pinkney and their wives.

West Bend

West Bend Art Museum
300 South 6th Ave, **West Bend, WI 53095**
☎ 414-334-9638
HRS: 10-4:30 W-Sa, 1-4:30 S DAY CLOSED: M, Tu HOL: LEG/HOL!
Ⓟ Y GR/T: Y GR/PH: CATR! S/G: Y
PERM/COLL: ACADEMIC ART WORK; REG: 1850-1950

This community art center and museum is dedicated to the work of Wisconsin's leading artists from early white settlements to the present. One of its prize features is the Walter A. Zuin Doll House which was first built in 1911 and completed four generations later, and contains more than 700 miniature items.

ON EXHIBIT/97:

01/25/97–03/02/97	A/C ART ASSOCIATION-WEST ALLIS — Started as the Allis Chalmers Sketch Club in 1947, this group of professional, semi-professional and skilled amateur artists meet regularly and are dedicated to encouraging continued artistic learning experiences.
01/25/97–02/23/97	BUILDINGS AND LANDSCAPES WT
03/01/97–04/13/97	KIMONOS: THE EXPRESSION OF INNER HARMONY — A representative selection of kimonos and obis from 600 B.C. to the present showing the variety of designs and styles as well as the development of exquisite colors.
03/08/97–04/13/97	INSPIRATION AND CONTEXT: THE DRAWINGS OF ALBERT PALEY — 44 drawings and 5 maquettes will be featured in a 20 year survey of jewelry, sculpture and entry gates designed by Paley, an internationally acclaimed artist who changed contemporary metalworking from a utilitarian craft into a dynamic art form. WT
04/19/97–06/01/97	TALES OF ENCHANTMENT: LEGENDS AND MYTHS — The exhibition celebrates storytelling and a child's visual interpretation on a global scale.
06/07/97–07/13/97	SELECTED WORKS OF MARY BOURKE/SELECTED WORKS OF ANNE STRETTON — Mary Bourke paints figurative scenes often using herself and her twin sons to convey a surreal, carnival-like interpretation of the world. Anne Stretton explores the mystery and beauty of color and surface in two dimensional mixed media works.
07/19/97–09/07/97	MIDWEST WATERCOLOR SOCIETY ANNUAL EXHIBITION
09/13/97–10/26/97	NATURALLY DRAWN: DRAWINGS FROM THE COLLECTION OF THE LEIGH YAWKEY WOODSON ART MUSEUM — An intimate glimpse into the creative processes used by 60 artists is provided in these drawings, many of which were taken directly from artists' sketchbooks. CAT
09/13/97–10/26/97	WARHOL: ENDANGERED SPECIES WT
11/01/97–12/07/97	PACIFIC RIM INTERNATIONAL PRINT EXHIBITION — A juried biennial exhibition open to all artists living in the coastal area of the Pacific Ocean.
12/13/97–01/11/98	FRIENDS OF THE WEST BEND ART MUSEUM AND WASHINGTON COUNTY RESIDENTS ANNUAL JURIED ART EXHIBITION — A partially juried annual event.

WYOMING

Big Horn

Bradford Brinton Memorial Museum
239 Brinton Road, **Big Horn, WY 82833**
☎ 307-672-3173
HRS: 9:30-5 daily May 15-LAB/DAY; Other months by appt!
ADM: Y ADULT: $3.00 CHILDREN: F (under 12) STUDENTS: $2.00 SR CIT: $2.00
&: Y ℗ Y MUS/SH: Y H/B: Y
PERM/COLL: WESTERN ART; DEC/ART; NAT/AM: beadwork

Important paintings by the best known Western artists are shown in a fully furnished 20 room ranch house built in 1892 and situated at the foot of the Big Horn Mountain. **NOT TO BE MISSED:** "Custer's Fight on the Little Big Horn" by Frederic Remington

ON EXHIBIT/97: The 1997 Exhibition will feature Hans Kleiber. The Patio Room Gallery features a changing exhibition every 3 weeks during the summer season.

Casper

Nicolaysen Art Museum
400 East Collins Drive, **Casper, WY 82601-2815**
☎ 307-235-5247
HRS: 10-5 Tu-S, 10-8 T DAY CLOSED: M HOL: 1/1; THGV; 12/24; 12/25
F/DAY: 4-8 1st & 3 T ADM: Y ADULT: $2.00 CHILDREN: $1.00 (under 12) SR CIT: $2.00
&: Y ℗ Y MUS/SH: Y GR/T: Y GR/PH: CATR! DT: Y TIME: ! H/B: Y
PERM/COLL: CARL LINK ILLUSTRATIONS; REG

The roots of this Museum reside in the commitment of Wyoming people to the importance of having art and culture as an integral part life. **NOT TO BE MISSED:** The Discovery Center, an integral part of the museum, complements the educational potential of the exhibitions

ON EXHIBIT/97:

12/07/96–02/16/97	COLORADO ARTISTS
12/14/96–02/09/97	CROW INDIAN PHOTOS — Photographs by Joseph Henry Sharp (1859-1953) of Native-Americans in Montana.
02/15/97–04/13/97	LAYL MCDILL — Colorful quilts, sculptures and clothing
02/22/97–04/27/97	PASTEL EXHIBIT
04/19/97–06/15/97	DON RODELL — An internationally acclaimed wildlife artist
05/03/97–07/13/97	WYOMING ARTS COUNCIL VISUAL ARTS FELLOWSHIP RECIPIENTS

Cheyenne

Wyoming State Museum
Barrett Building, 2301 Central Ave., **Cheyenne, WY 82002**
☎ 307-777-7022 (or 7024)
HRS: 8:00-5 M-F DAY CLOSED: S HOL: LEG/HOL!
&: Y ℗ Y; Metered on nearby streets MUS/SH: Y GR/T: Y GR/PH: CATR! S/G: Y
PERM/COLL: PLAINS INDIAN COLLECTION; REG/W & CONT

The Wyoming State Museum is part of the Capital Complex area which includes the historic State Capitol building and the Governor's Mansion. **NOT TO BE MISSED:** Wyoming in WWII

Cody

Buffalo Bill Historical Center
720 Sheridan Ave., **Cody, WY 82414**
✆ 307-587-4771
HRS: 7am-8 PM daily JUNE-SEP, 8-5 daily Oct, 8-8 W-S MAY, 10-2 T-S NOV-APRIL
ADM: Y ADULT: $8.00 CHILDREN: $2.00 (6-12) STUDENTS: $4.00 SR CIT: $6.50
&: Y ℗ Y MUS/SH: Y ¶ Y; "Great Entertainer Eatery" GR/T: Y GR/PH: CATR! S/G: Y
PERM/COLL: WESTERN/ART: 19, 20; AM: firearms; CULTURAL HISTORY OF THE PLAINS INDIANS

The complex includes the Buffalo Bill, Plains Indian, and Cody Firearms museums as well as the Whitney Gallery which contains outstanding paintings of the American West by such artists as George Catlin, Albert Bierstadt, Frederic Remington and contemporary artists James Barna, Harry Jackson and Fritz Scholder. **NOT TO BE MISSED:** The Whitney Gallery of Western Art

Colter Bay

Grand Teton National Park, Colter Bay Indian Arts Museum
Colter Bay, WY 83012
✆ 307-739-3594
HRS: 8-5 daily 5/13-6/1 & Sept, 8-8 daily 6/1-LAB/DAY, Closed 10/1 HOL: Closed 10/1-5/13/96
&: Y ℗ Y
MUS/SH: Y
PERM/COLL: NAT/AM: artifacts, beadwork, basketry, pottery, musical instruments

Organized into categories and themes, the Davis I. Vernon collection of Indian art housed in this museum is a spectacular assembly of many art forms including porcupine quillwork, beadwork, basketry, pottery, masks, and musical instruments. **NOT TO BE MISSED:** Sitting Bull's beaded blanket strip, (Sioux, South Dakota, ca. 1875)

Jackson Hole

National Museum of Wildlife Art
2820 Rungius Road, **Jackson Hole, WY 83001**
✆ 307-733-5771
HRS: Summer: 10-5 daily, Winter: 9-5 daily HOL: 1/1, THGV, 12/25
ADM: Y ADULT: $4.00 STUDENTS: $3.00 SR CIT: $3.00
&: Y ℗ Y; Free parking lots
MUS/SH: Y GR/T: Y GR/PH: CATR!
PERM/COLL: WILDLIFE ART AND ARTIFACTS

One of the few museums in the country to feature wildlife, the collection, exhibited in its new facility, is styled to sensitize visitors to Native American wildlife and the habitat necessary to sustain this priceless natural heritage. PLEASE NOTE: The museum offers special admission rates for families. **NOT TO BE MISSED:** Works by Carl Rungius

ON EXHIBIT/97:
08/21/96–05/13/97	NEW ACQUISITIONS
10/02/96–08/08/97	CHARLES LIVINGSTON BULL — Original illustrations dating from 1903-1930 by this highly revered illustrator, painter, muralist, writer, taxidermist and naturalist.

National Museum of Wildlife Art - continued

12/06/96–05/26/97	THE WEST OF JULIUS SEYLER — German born Seyler was influenced by European masters, Impressionists and Fauvists. Many of his most remarkable paintings were created in Montana among the Blackfeet Indians between 1913 and 1916.
05/02/97–08/03/97	GEORGIA O'KEEFFE: AN ARTIST'S LANDSCAPE — 40 black and white photographs from Todd Webb's 30 year record dating from 1955 to 1981 which show the artist in the New Mexico landscape which so influenced her paintings, drawings and sculpture. WT
05/30/97–07/27/97	BIRDS IN ART — In the 21st annual presentation of "Birds in Art," artists from around the world interpret the wonder of flight and the marvel of wingtips. WT
06/20/97–06/08/98	FIELD SKETCHES OF WILLIAM R. LEIGH
08/01/97–01/12/98	FLY FISHING: PAINTINGS AND SCULPTURE
12/05/97–05/31/98	THREE VIEWS OF WYOMING: BILL GOLLINGS, THOMAS MORAN AND HANS KLEIBER WT

Rock Springs

Community Fine Arts Center
Affiliate Institution: Rock Springs Library
400 "C" Street, **Rock Springs, WY 82901**
☎ 307-362-6212
HRS: 12-5 & 6-9 M, T; 10-12 & 1-5 Tu, W, F; 12-5 Sa DAY CLOSED: S HOL: LEG/HOL !
&: Y GR/T: Y DT: Y
PERM/COLL: AM: 19, 20

The art gallery houses the nationally acclaimed Rock Springs High School Collection, and is owned by the students. **NOT TO BE MISSED:** Loren McIver's "Fireplace," the first American woman to exhibit at the Venice Biennial (1962).

Selected Listing of Traveling Exhibitions

1997 LOS ANGELES JURIED EXHIBITION
07/16/97–08/10/97 Watts Towers Arts Center, Los Angeles, CA
07/16/97–09/07/97 Los Angeles Municipal Art Gallery, Los Angeles, CA

A PASSION FOR THE PAST: THE COLLECTION OF BERTRAM K. AND NINA FLETCHER LITTLE AT COGSWELL'S GRANT
05/03/97–07/06/97 Museum of American Folk Art, New York, NY
11/16/97–01/25/98 The Minneapolis Institute of Arts, Minneapolis, MN

A SLAVE SHIP SPEAKS: THE WRECK OF THE HENRIETTA MARIE
11/96–01/97 Gaston County Museum of Art and History, Dallas, NC
11/08/96–01/25/97 Spirit Square Center for Arts and Education, Charlotte, NC

AFFINITIES OF FORM: ARTS OF AFRICA, OCEANIA AND THE AMERICAS FROM THE RAYMOND AND LAURE WIELGUS COLLECTION
01/15/97–03/16/97 Albany Museum of Art, Albany, GA
01/15/97–03/16/97 Georgia Museum of Art, Athens, GA
09/20/97–11/09/97 Norton Gallery and School of Art, West Palm Beach, FL

AFTER THE PHOTO - SECESSION: AMERICAN PICTORIAL PHOTOGRAPHY, 1910-1955
02/08/97–05/04/97 The Minneapolis Institute of Arts, Minneapolis, MN
08/23/97–10/19/97 Worcester Art Museum, Worcester, MA
11/15/97–02/08/98 Montgomery Museum of Fine Arts, Montgomery, AL

ALEX KATZ: UNDER THE STARS, AMERICAN LANDSCAPES
03/15/97–05/04/97 Norton Gallery and School of Art, West Palm Beach, FL
06/19/97–09/14/97 Portland Museum of Art, Portland, ME

ALONE IN A CROWD: PRINTS BY AFRICAN-AMERICAN ARTISTS OF THE 1930'S - 1940'S FROM THE COLLECTION OF REBA AND DAVE WILLIAMS
02/01/97–03/23/97 High Museum of Art, Atlanta, GA
04/22/97–07/06/97 The Cleveland Museum of Art, Cleveland, OH

AMERICA SEEN: PEOPLE AND PLACE
01/19/97–03/09/97 The Philbrook Museum of Art Inc, Tulsa, OK
04/08/97–05/24/97 Philharmonic Center for the Arts, Naples, FL
08/14/97–10/19/97 Albany Museum of Art, Albany, GA

AMERICAN NAIVE PAINTINGS FROM THE NATIONAL GALLERY OF ART
12/14/96–02/09/97 Samuel P. Harn Museum of Art, Gainesville, FL
07/01/97–11/01/97 Williams College Museum of Art, Williamstown, MA

THE AMERICAN SCENE AND THE SOUTH: PAINTINGS AND WORKS ON PAPER, 1930-1946
02/07/97–04/06/97 Mobile Museum of Art, Mobile, AL
05/17/97–07/13/97 Samuel P. Harn Museum of Art, Gainesville, FL
09/14/97–11/09/97 The Columbus Museum, Columbus, GA

AMERICAN STILL LIFE AND INTERIORS, 1915-1994: SELECTIONS FROM THE METROPOLITAN MUSEUM OF ART
02/28/97–05/25/97 The Arkansas Arts Center, Little Rock, AR
06/20/97–08/17/97 Orange County Museum of Art, Newport Beach, Newport Beach, CA
09/14/97–11/09/97 The Philbrook Museum of Art Inc, Tulsa, OK

AMERICAN VIEWS: OIL SKETCHES BY THOMAS HILL
01/25/97–03/09/97 Crocker Art Museum, Sacramento, CA
09/26/97–12/01/97 The Currier Gallery of Art, Manchester, NH

AN ENDURING LEGACY: MASTERPIECES FROM THE MR. AND MRS. JOHN D. ROCKEFELLER III COLLECTION
04/19/97–06/15/97 San Diego Museum of Art, San Diego, CA
06/97–09/97 Michael C. Carlos Museum of Art and Archaeology, Atlanta, GA

Selected Listing of Traveling Exhibitions

AN OCEAN APART: CONTEMPORARY VIETNAMESE ART FROM THE UNITED STATES AND VIETNAM
01/17/97–03/30/97	Orange County Museum of Art, Laguna Beach, Laguna Beach, CA
06/14/97–07/28/97	Pensacola Museum of Art, Pensacola, FL

ANYTHING CAN HAPPEN IN A COMIC STRIP
04/25/97–06/08/97	The Freeport Art Museum and Cultural Center, Freeport, IL
05/25/97–07/20/97	Mitchell Museum, Mount Vernon, IL

APPEAL TO THIS AGE: PHOTOGRAPHY OF THE CIVIL RIGHTS ERA, 1954-1968
12/21/96–02/23/97	The Chrysler Museum, Norfolk, VA
04/01/97–06/01/97	Bowdoin College Museum of Art, Brunswick, ME

ARCHIBALD KNOX, 1864-1933
02/97–05/97	The Wolfsonian, Miami Beach, FL
04/25/97–06/22/97	Delaware Art Museum, Wilmington, DE

ART FROM THE DRIVER'S SEAT: AMERICANS AND THEIR CARS
01/11/97–02/02/97	Leigh Yawkey Woodson Art Museum, Wausau, WI
03/16/97–05/04/97	Gilcrease Museum, Tulsa, OK
05/25/97–07/13/97	Flint Institute of Arts, Flint, MI
08/01/97–09/28/97	Mobile Museum of Art, Mobile, AL
10/12/97–11/30/97	The Columbus Museum, Columbus, GA
12/07/97–01/24/98	Hunter Museum of American Art, Chattanooga, TN

ART IN BLOOM
03/31/97–04/07/97	Museum of Fine Arts-St. Petersburg Florida, St. Petersburg, FL
04/09/97–04/12/97	The Montclair Art Museum, Montclair, NJ

THE ART OF JOHN BIGGERS: VIEW FROM THE UPPER ROOM
01/24/97–04/20/97	Museum of Fine Arts, Boston, Boston, MA
05/17/97–07/27/97	Cincinnati Art Museum, Cincinnati, OH

THE ARTS OF REFORM AND PERSUASION, 1885-1945
02/22/97–05/18/97	The Carnegie Museum of Art, Pittsburgh, PA
11/15/97–02/01/98	Indianapolis Museum of Art, Indianapolis, IN
11/23/97–02/01/98	The Minneapolis Institute of Arts, Minneapolis, MN

ASIAN TRADITIONS/MODERN EXPRESSION: ASIAN AMERICAN ARTISTS AND ABSTRACTION, 1945-1970
03/23/97–07/31/97	Jane Voorhees Zimmerli Art Museum, New Brunswick, NJ
12/07/97–02/15/98	Fisher Gallery, University of Southern California, Los Angeles, CA

BAULE: AFRICAN ART/WESTERN EYES
04/19/97–07/06/97	The Art Institute of Chicago, Chicago, IL
09/97–01/98	Yale University Art Gallery, New Haven, CT

BEARING WITNESS: CONTEMPORARY WORKS BY AFRICAN AMERICAN WOMEN ARTISTS
02/01/97–03/30/97	Fort Wayne Museum of Art, Fort Wayne, IN
11/04/97–01/04/98	Polk Museum of Art, Lakeland, FL

BEATRICE MANDELMAN: TAOS MODERNIST
02/09/97–03/16/97	University of Arizona Museum of Art, Tucson, AZ
04/08/97–06/08/97	Nora Eccles Harrison Museum of Art, Logan, UT

BEING AND TIME: THE EMERGENCE OF VIDEO PRODUCTION
01/24/97–03/29/97	Cranbrook Academy of Art Museum, Bloomfield Hills, MI
05/24/97–07/27/97	Portland Art Museum, Portland, OR

BIRDS IN ART
05/30/97–07/27/97	National Museum of Wildlife Art, Jackson Hole, WY
09/06/97–11/09/97	Leigh Yawkey Woodson Art Museum, Wausau, WI

Selected Listing of Traveling Exhibitions

BRITISH ART TREASURES FROM RUSSIAN IMPERIAL COLLECTIONS IN THE HERMITAGE
02/16/97–05/11/97 The Toledo Museum of Art, Toledo, OH
06/27/97–09/07/97 The Saint Louis Art Museum, St. Louis, MO

CALIFORNIA IMPRESSIONISTS
02/07/97–04/13/97 Cummer Gallery of Art, Jacksonville, FL
08/15/97–10/05/97 Crocker Art Museum, Sacramento, CA

CANYONLAND VISIONS & CROSSING THE FRONTIER
07/12/97–09/28/97 Phoenix Art Museum, Phoenix, AZ
10/97–01/98 Autry Museum of Western Heritage, Los Angeles, CA

CARIBBEAN VISIONS: CONTEMPORARY PAINTING AND SCULPTURE
01/11/97–03/09/97 Middlebury College Museum of Art, Middlebury, VT
04/13/97–06/15/97 Wadsworth Atheneum, Hartford, CT

CATHERINE E. B. COX AWARD EXHIBITION
12/19/96–01/19/97 Honolulu Academy of Arts, Honolulu, HI
06/14/97–05/98 DeCordova Museum and Sculpture Park, Lincoln, MA

CERAMIC GESTURES: NEW VESSELS BY MAGDALENE ODUNDO
09/18/96–01/02/97 National Museum of African Art, Washington, DC
01/17/97–03/16/97 Indiana University Art Museum, Bloomington, IN
04/29/97–07/06/97 The Saint Louis Art Museum, St. Louis, MO

CHARLES SHEELER IN DOYLESTOWN: AMERICAN MODERNISM AND THE PENNSYLVANIA TRADITION
04/06/97–06/22/97 Allentown Art Museum, Allentown, PA
08/23/97–11/02/97 Amon Carter Museum, Fort Worth, TX
12/09/97–03/01/98 Cincinnati Art Museum, Cincinnati, OH

CRITIQUES OF PURE ABSTRACTION
01/10/97–03/02/97 Krannert Art Museum, Champaign, IL
04/04/97–05/25/97 Frederick R. Weisman Art Museum At the University of Minnesota, Minneapolis, MN

CROSSING THE FRONTIER: PHOTOGRAPHS OF THE DEVELOPING WEST, 1849 TO THE PRESENT
09/26/96–01/28/97 San Francisco Museum of Modern Art, San Francisco, CA
04/11/97–06/08/97 Yale University Art Gallery, New Haven, CT

CROWN POINT PRESS
06/08/97–09/01/97 National Gallery of Art, Washington, DC
10/04/97–01/04/98 The Fine Arts Museums of San Francisco, San Francisco, CA

CURRIER AND IVES
02/15/97–05/26/97 The Norman Rockwell Museum at Stockbridge, Stockbridge, MA
06/25/97–10/12/97 The Baltimore Museum of Art, Baltimore, MD

DALE CHIHULY: INSTALLATIONS 1964-1995
03/02/97–05/11/97 The Minneapolis Institute of Arts, Minneapolis, MN
06/22/97–09/14/97 The Dixon Gallery & Gardens, Memphis, TN
10/25/97–01/04/98 Albright-Knox Art Gallery, Buffalo, NY

DALE CHIHULY: SEAFORMS
04/17/97–08/03/97 Middlebury College Museum of Art, Middlebury, VT
09/19/97–11/09/97 Everson Museum of Art, Syracuse, NY

DAWOUD BEY: PORTRAITS 1975-1995
01/97–04/97 Wadsworth Atheneum, Hartford, CT
03/29/97–06/01/97 Jersey City Museum, Jersey City, NJ
03/30/97–05/97 Addison Gallery of American Art, Andover, MA
09/05/97–10/25/97 Forum for Contemporary Art, St. Louis, MO

Selected Listing of Traveling Exhibitions

DISCOVERING ELLIS RULEY
| 11/26/96–01/26/97 | Portland Art Museum, Portland, OR |
| 03/01/97–04/27/97 | The Detroit Institute of Arts, Detroit, MI |

DISCOVERY AND DECEIT: ARCHAEOLOGY AND THE FORGER'S CRAFT
| 10/11/96–01/05/97 | The Nelson-Atkins Museum of Art, Kansas City, MO |
| 02/08/97–05/18/97 | Michael C. Carlos Museum of Art and Archaeology, Atlanta, GA |

DRAWINGS FROM THE O'NEAL COLLECTION
| 01/10/97–02/23/97 | The Arkansas Arts Center, Little Rock, AR |
| 04/17/97–06/01/97 | The Patrick & Beatrice Haggerty Museum of Art, Milwaukee, WI |

EARL CUNNINGHAM: PAINTING AN AMERICAN EDEN
| 11/10/96–02/02/97 | William A. Farnsworth Library and Art Museum, Rockland, ME |
| 02/16/97–03/29/97 | Westmoreland Museum of American Art, Greensburg, PA |

EAST MEETS WEST: INDONESIAN FILM POSTERS FROM THE JOHN PFAHL COLLECTION
| 10/05/96–03/15/98 | George Eastman House, International Museum of Photography and Film, Rochester, NY |
| 04/15/97–07/06/97 | The Cleveland Museum of Art, Cleveland, OH |

ELECTRONIC SUPER HIGHWAY: NAM JUNE PAIK IN THE '90'S
02/14/97–04/27/97	The Jacksonville Museum of Contemporary Art, Jacksonville, FL
07/13/97–09/14/97	The Nelson-Atkins Museum of Art, Kansas City, MO
11/06/97–01/04/98	Honolulu Academy of Arts, Honolulu, HI

ELVIS + MARILYN: 2 X IMMORTAL
| 11/24/96–02/23/97 | San Jose Museum of Art, San Jose, CA |
| 04/17/97–06/08/97 | Honolulu Academy of Arts, Honolulu, HI |

ENCOUNTERS WITH MODERN ART: WORKS FROM THE ROTHSCHILD FAMILY COLLECTIONS
| 09/22/96–01/26/97 | National Gallery of Art, Washington, DC |
| 03/02/97–05/11/97 | Philadelphia Museum of Art, Philadelphia, PA |

EXPLORATIONS IN THE CITY OF LIGHT: AFRICAN-AMERICAN ARTISTS IN PARIS, 1945-1965
| 01/12/97–03/23/97 | Modern Art Museum of Fort Worth, Fort Worth, TX |
| 04/11/97–06/01/97 | Milwaukee Art Museum, Milwaukee, WI |

FAIRFIELD PORTER: AN AMERICAN PAINTER
02/28/97–06/08/97	Albany Institute of History & Art, Albany, NY
09/07/97–01/11/98	Neuberger Museum of Art, Purchase, NY
10/05/97–11/16/97	The Parrish Art Museum, Southampton, NY

FAY JONES: A TWENTY-YEAR RETROSPECTIVE
| 01/14/97–02/23/97 | Museum of Art, Pullman, WA |
| 03/20/97–07/22/97 | Seattle Art Museum, Seattle, WA |

THE FIGURE IN 20TH CENTURY SCULPTURE
12/08/96–01/20/97	The Art Museum of Southeast Texas, Beaumont, TX
02/21/97–04/13/97	Elizabeth Myers Mitchell Art Gallery, Annapolis, MD
07/31/97–09/14/97	Krasl Art Center, St. Joseph, MI
10/12/97–11/30/97	University of Kentucky Art Museum, Lexington, KY

FRANK STELLA: A COLLECTION OF PRINTS, 1967-1995
| 04/20/97–06/08/97 | Huntsville Museum of Art, Huntsville, AL |
| 06/15/97–08/03/97 | Wiregrass Museum of Art, Dothan, AL |

FREEDOM OF EXPRESSION
| 03/97–04/97 | Gaston County Museum of Art and History, Dallas, NC |
| 03/07/97–04/18/97 | Spirit Square Center for Arts and Education, Charlotte, NC |

Selected Listing of Traveling Exhibitions

FUNDAMENTAL SOUL: THE HAGAR GIFT OF SELF-TAUGHT AFRICAN AMERICAN ART
02/22/97–04/06/97 Mitchell Museum, Mount Vernon, IL
04/26/97–06/14/97 Springfield Art Association, Springfield, IL

GLASS TAPESTRY: PLATEAU BEADED BAGS FROM THE ELAINE HORWITCH COLLECTION
03/22/97–06/01/97 Autry Museum of Western Heritage, Los Angeles, CA
07/02/97–09/02/97 The Museum At Warm Springs Oregon, Warm Springs, OR

GOLD, JADE, AND FORESTS: PRE-COLUMBIAN TREASURES OF COSTA RICA
01/22/97–02/32/97 Palm Springs Desert Museum, Inc., Palm Springs, CA
04/05/97–06/01/97 Portland Art Museum, Portland, OR
09/12/97–11/05/97 Georgia Museum of Art, Athens, GA

GUY ROSE: AMERICAN IMPRESSIONIST
12/04/96–01/19/97 Greenville County Museum of Art, Greenville, SC
04/27/97–07/27/97 The Montclair Art Museum, Montclair, NJ

HALL OF MIRRORS: ART AND FILM SINCE 1945
09/21/96–01/05/97 Wexner Center for the Arts, Columbus, OH
10/11/97–01/25/98 Museum of Contemporary Art, Chicago, IL

HANANIAH HARARI
01/26/97–03/30/97 Neuberger Museum of Art, Purchase, NY
05/04/97–07/27/97 The Montclair Art Museum, Montclair, NJ

HARRY CALLAHAN
02/11/97–04/06/97 High Museum of Art, Atlanta, GA
04/27/97–07/06/97 The Detroit Institute of Arts, Detroit, MI
07/12/97–09/28/97 Museum of Contemporary Art, Chicago, IL

HELLO AGAIN: A NEW WAVE OF RECYCLED ART AND DESIGN
02/08/97–07/27/97 Oakland Museum of California, Oakland, CA
09/24/97–11/16/97 Los Angeles Municipal Art Gallery, Los Angeles, CA

HERB RITTS: WORK
10/23/96–02/97 Museum of Fine Arts, Boston, Boston, MA
10/23/97–01/04/98 Albany Museum of Art, Albany, GA

HEROIC PAINTING
01/25/97–03/23/97 The Contemporary Arts Center, Cincinnati, OH
07/19/97–09/28/97 Mississippi Museum of Art, Jackson, MS
10/22/97–12/14/97 University Gallery, University of Massachusetts, Amherst, MA

HOGARTH AND THE SHOWS OF LONDON
02/01/97–03/30/97 Spencer Museum of Art, Lawrence, KS
04/26/97–06/29/97 Elvehjem Museum of Art, Madison, WI

HOSPICE: A PHOTOGRAPHIC INQUIRY
MID/97–MID/97 Portland Art Museum, Portland, OR
06/07/97–07/20/97 San Diego Museum of Art, San Diego, CA
08/19/97–10/26/97 Telfair Museum of Art, Savannah, GA
11/15/97–01/11/98 Norton Gallery and School of Art, West Palm Beach, FL

IMAGES IN IVORY: PRECIOUS OBJECTS OF THE GOTHIC AGE
03/08/97–06/01/97 The Detroit Institute of Arts, Detroit, MI
06/22/97–08/31/97 Walters Art Gallery, Baltimore, MD

Selected Listing of Traveling Exhibitions

IN THE SPIRIT OF RESISTANCE: AFRICAN-AMERICAN MODERNISTS AND THE MEXICAN MURALIST SCHOOL
01/03/97–03/02/97 African American Museum, Dallas, TX
06/20/97–08/17/97 California Afro-American Museum, Los Angeles, CA
12/06/97–02/01/98 The Dayton Art Institute, Dayton, OH

INSPIRATION AND CONTEXT: THE DRAWINGS OF ALBERT PALEY
03/08/97–04/13/97 West Bend Art Museum, West Bend, WI
04/25/97–06/22/97 Delaware Art Museum, Wilmington, DE

IRWIN KREMEN: COLLAGE AND SCULPTURE
12/96–02/97 Sheldon Memorial Art Gallery and Sculpture Garden, Lincoln, NE
05/02/97–06/97 The Arkansas Arts Center, Little Rock, AR

IT'S ONLY ROCK & ROLL
03/22/97–06/15/97 Phoenix Art Museum, Phoenix, AZ
12/11/97–02/09/89 Lowe Art Museum, Coral Gables, FL

JAY DeFEO: MAJOR WORKS
03/19/97–05/25/97 University of California Berkeley Art Museum, Berkeley, CA
03/19/97–06/01/97 Museo Italoamericano, San Francisco, CA

JEFF WALL
02/13/97–05/11/97 Hirshhorn Museum and Sculpture Garden, Washington, DC
07/13/97–10/05/97 The Museum of Contemporary Art, Los Angeles, Los Angeles, CA

THE JEWELRY OF TONE VIGELAND
04/29/97–06/22/97 Cooper-Hewitt, National Museum of Design, Smithsonian Institution, New York, NY
07/17/97–09/09/97 The Currier Gallery of Art, Manchester, NH

JILL EGGERS: PAINTINGS
06/13/97–07/06/97 Saginaw Art Museum, Saginaw, MI
08/30/97–11/23/97 Monterey Museum of Art, Monterey, CA

JOHN MCLAUGHLIN: WESTERN MODERNISM/EASTERN THOUGHT
02/09/97–04/20/97 The Museum of Fine Arts, Houston, Houston, TX
07/19/97–08/31/97 Joslyn Art Museum, Omaha, NE

JOSEPH CORNELL: BOXES AND COLLAGES
03/15/97–05/04/97 Norton Gallery and School of Art, West Palm Beach, FL
09/18/97–01/04/98 The Menil Collection, Houston, TX

KINSHIPS: ALICE NEEL LOOKS AT THE FAMILY
02/19/97–04/27/97 University Art Museum, Santa Barbara, Santa Barbara, CA
02/22/97–04/27/97 Santa Barbara Museum of Art, Santa Barbara, CA
08/30/97–10/26/97 Boise Art Museum, Boise, ID
11/06/97–01/11/98 Smith College Museum of Art, Northampton, MA

LASTING IMPRESSIONS: THE DRAWINGS OF THOMAS HART BENTON
01/24/97–03/23/97 Tucson Museum of Art, Tucson, AZ
06/05/97–07/27/97 Lowe Art Museum, Coral Gables, FL
11/16/97–01/11/98 Memphis Brooks Museum of Art, Memphis, TN

LEROY ARCHULETA: A TO Z
11/09/96–01/11/97 Mississippi Museum of Art, Jackson, MS
06/28/97–08/31/97 The Art Museum of Southeast Texas, Beaumont, TX
09/13/97–10/31/97 University Art Museum, Lafayette, LA

Selected Listing of Traveling Exhibitions

LIFE CYCLES: THE CHARLES E. BURCHFIELD COLLECTION
05/16/97–07/13/97 Everson Museum of Art, Syracuse, NY
09/12/97–11/09/97 The Art Museum at Florida International University, Miami, FL
11/28/97–01/25/98 Montgomery Museum of Fine Arts, Montgomery, AL

LITTLE GEMS OF AMERICAN PAINTING FROM THE MANOOGIAN COLLECTION
11/16/96–01/19/97 Grand Rapids Art Museum, Grand Rapids, MI
02/01/97–03/09/97 Art Center of Battle Creek, Battle Creek, MI
03/21/97–05/11/97 Kalamazoo Institute of Arts, Kalamazoo, MI

LOUIS REMY MIGNOT
10/20/96–01/19/97 North Carolina Museum of Art, Raleigh, NC
02/12/97–05/04/97 National Academy of Design, New York, NY

MANUEL NERI: IDEAS/EARLY WORKS, 1953-1978
02/01/97–05/05/97 The Corcoran Gallery of Art, Washington, DC
06/07/97–09/14/97 San Jose Museum of Art, San Jose, CA

MARK ROTHKO: THE SPIRIT OF MYTH, EARLY PAINTINGS FROM THE 1930'S AND 1940'S
01/18/97–03/02/97 Hearst Art Gallery, Moraga, CA
03/97–06/97 Sheldon Memorial Art Gallery and Sculpture Garden, Lincoln, NE
06/28/97–09/07/97 Orange County Museum of Art, Laguna Beach, Laguna Beach, CA

MASTERPIECES FROM THE PIERPONT MORGAN LIBRARY COLLECTIONS
02/15/97–04/27/97 The Fine Arts Museums of San Francisco, San Francisco, CA
07/01/97–09/28/97 High Museum of Art, Atlanta, GA

MATISSE, PICASSO, AND FRIENDS: MASTERWORKS ON PAPER FROM THE CONE COLLECTION
11/17/96–01/19/97 The Cleveland Museum of Art, Cleveland, OH
05/18/97–07/13/97 The Museum of Fine Arts, Houston, Houston, TX

MEMORIES OF CHILDHOOD
06/07/97–08/17/97 Fort Wayne Museum of Art, Fort Wayne, IN
08/24/97–10/10/97 University of Arizona Museum of Art, Tucson, AZ

MERET OPPENHEIM: BEYOND THE TEACUP
02/06/97–04/06/97 Bass Museum of Art, Miami Beach, FL
05/10/97–07/08/97 Joslyn Art Museum, Omaha, NE

MEXICAN MASKS OF THE 20TH CENTURY: A LIVING TRADITION
02/08/97–03/30/97 Mesa Southwest Museum, Mesa, AZ
04/10/97–05/25/97 Lowe Art Museum, Coral Gables, FL
09/27/97–11/22/97 Sangre DeCristo Arts & Conference Center & Children's Center, Pueblo, CO

MICHAEL LUCERO: SCULPTURE '76 -'95
04/05/97–07/06/97 Kemper Museum of Contemporary Art & Design, Kansas City, MO
09/12/97–01/04/98 Renwick Gallery of the National Museum of American Art, Washington, DC

MICHELANGELO AND HIS INFLUENCE: DRAWINGS FROM WINDSOR CASTLE
01/19/97–03/30/97 Kimbell Art Museum, Fort Worth, TX
04/12/97–06/22/97 The Art Institute of Chicago, Chicago, IL

MINGEI: JAPANESE FOLK ART FROM THE MONTGOMERY COLLECTION
01/11/97–02/09/97 The Society of the Four Arts, Palm Beach, FL
09/13/97–11/30/97 Fresno Metropolitan Museum, Fresno, CA
12/20/97–02/08/98 Blanden Memorial Art Museum, Fort Dodge, IA

MODERN MASTERS FROM THE COLLECTION OF ALEXANDER E. AND DINA RACOLIN
06/01/97–07/06/97 Neuberger Museum of Art, Purchase, NY
07/25/97–09/07/97 The Frances Lehman Loeb Art Center At Vassar College, Poughkeepsie, NY

Selected Listing of Traveling Exhibitions

MONET AND THE MEDITERRANEAN
06/08/97–09/07/97	Kimbell Art Museum, Fort Worth, TX
10/17/97–01/04/98	The Brooklyn Museum of Art, Brooklyn, NY

MUNCH AND WOMEN: IMAGE AND MYTH
01/25/97–03/09/97	San Diego Museum of Art, San Diego, CA
04/05/97–06/01/97	Portland Art Museum, Portland, OR
09/06/97–11/07/97	Yale University Art Gallery, New Haven, CT

NANCY GRAVES: EXCAVATIONS IN PRINT
11/09/96–01/12/97	The George D. and Harriet W. Cornell Fine Arts Museum, Winter Park, FL
02/21/97–05/04/97	Memphis Brooks Museum of Art, Memphis, TN
09/05/97–11/16/97	Elizabeth Myers Mitchell Art Gallery, Annapolis, MD
12/12/97–02/22/98	Middlebury College Museum of Art, Middlebury, VT

NATIONAL ASSOCIATION OF WOMEN ARTISTS TRAVELING EXHIBITION
12/06/96–02/23/97	Midwest Museum of American Art, Elkhart, IN
03/23/97–05/04/97	Muscatine Art Center, Muscatine, IA

NEW ART IN CHINA, 1989-1994
06/07/97–08/10/97	Chicago Cultural Center, Chicago, IL
09/06/97–11/02/97	San Jose Museum of Art, San Jose, CA

ON THE ROAD: ART AND THE AUTOMOBILE
05/11/97–07/25/97	Kresge Art Museum, East Lansing, MI
08/07/97–09/21/97	Saginaw Art Museum, Saginaw, MI

OUT OF THE ORDINARY: COMMUNITY TASTES AND VALUES IN CONTEMPORARY FOLK ART
02/07/97–08/31/97	The Hudson River Museum of Westchester, Yonkers, NY
10/04/97–11/11/98	The Museums at Stony Brook, Stony Brook, NY

PAINTING ABSTRACT: GREGORY AMENOFF, JOHN L. MOORE, KATHERINE PROTER
01/17/97–02/23/97	Boston University Art Gallery, Boston, MA
05/30/97–07/27/97	Cedar Rapids Museum of Art, Cedar Rapids, IA

THE PAINTINGS OF CHARLES BURCHFIELD: NORTH BY MIDWEST
03/23/97–05/18/97	Columbus Museum of Art, Columbus, OH
06/14/97–08/17/97	Burchfield-Penney Art Center, Buffalo, NY

THE PEALE FAMILY: CREATION OF AN AMERICAN LEGACY, 1770-1870
01/25/97–04/06/97	The Fine Arts Museums of San Francisco, San Francisco, CA
04/25/97–06/06/97	The Corcoran Gallery of Art, Washington, DC

PERSONAL PASSION, PROFITABLE PURSUIT: THE KATHERINE HARVEY COLLECTION OF NATIVE AMERICAN FINE ART
10/96–03/97	The Heard Museum, Phoenix, AZ
10/12/96–03/24/97	The Heard Museum, Phoenix, AZ

PETAH COYNE: RECENT SCULPTURE
10/26/96–02/10/97	The Corcoran Gallery of Art, Washington, DC
03/29/97–06/22/97	High Museum of Art, Atlanta, GA

PETER FISCHLI AND DAVID WEISS: IN A RESTLESS WORLD
11/16/96–01/19/97	Institute of Contemporary Art, Philadelphia, PA
02/08/97–04/13/97	Wexner Center for the Arts, Columbus, OH

PHOTOGLYPHS: RIMMA GELOVINA AND VALERIY GERLOVIN
11/27/96–02/08/97	Telfair Museum of Art, Savannah, GA
04/29/97–06/01/97	Pensacola Museum of Art, Pensacola, FL

THE PHOTOGRAPHS OF DOROTHEA LANGE
> 02/09/97–03/30/97 The Columbus Museum, Columbus, GA
> 08/30/97–12/26/97 Montgomery Museum of Fine Arts, Montgomery, AL

THE PHOTOMONTAGES OF HANNAH HOCH
> 10/20/96–02/02/97 Walker Art Center, Minneapolis, MN
> 02/27/97–05/20/97 The Museum of Modern Art, New York, NY

PICASSO CERAMICS
> 12/10/96–01/25/97 Philharmonic Center for the Arts, Naples, FL
> 04/26/97–09/14/97 Museum of Arts and Sciences, Daytona Beach, FL

PICASSO: THE EARLY YEARS 1892-1906
> 03/30/97–07/27/97 National Gallery of Art, Washington, DC
> 09/10/97–01/04/98 Museum of Fine Arts, Boston, Boston, MA

PICTORIALISM INTO MODERNISM: THE CLARENCE H. WHITE SCHOOL OF PHOTOGRAPHY
> 02/01/97–03/30/97 Spencer Museum of Art, Lawrence, KS
> 09/28/97–11/23/97 University of Kentucky Art Museum, Lexington, KY

PLAIN PICTURES: IMAGES OF THE AMERICAN PRAIRIE
> 11/23/96–02/23/97 Amon Carter Museum, Fort Worth, TX
> 04/19/97–07/27/97 Joslyn Art Museum, Omaha, NE

PLAINS INDIAN DRAWINGS, 1865-1935: PAGES OF A LIVING HISTORY
> 01/31/97–03/30/97 Milwaukee Art Museum, Milwaukee, WI
> 04/25/97–07/13/97 Joslyn Art Museum, Omaha, NE
> 08/07/97–10/19/97 The Frick Art Museum, Pittsburgh, PA

POINTS OF ENTRY, FINDING AMERICA: SEVEN EMIGREE PHOTOGRAPHERS AND THE CHANGING AMERICAN VISION, 1932-1956
> 02/11/97–04/12/97 High Museum of Folk Art & Photography Galleries At Georgia-pacific Center, Atlanta, GA
> 09/18/97–11/30/97 The Miami Art Museum of Dade County, Miami, FL

THE PRINTS OF JOHN deMARTELLY
> 04/06/97–05/18/97 The Nelson-Atkins Museum of Art, Kansas City, MO
> 10/26/97–12/19/97 Kresge Art Museum, East Lansing, MI

THE RADIANT OBJECT: SELF-TAUGHT ARTISTS FROM THE VOLKERSZ COLLECTION
> 11/15/96–01/12/97 Fresno Art Museum, Fresno, CA
> 03/27/97–06/01/97 Cheney Cowles Museum, Spokane, WA

RAISED BY WOLVES: PHOTOGRAPHS AND DOCUMENTS OF RUNAWAY KIDS BY JIM GOLDBERG
> 03/06/97–05/18/97 Los Angeles County Museum of Art, Los Angeles, CA
> 06/20/97–09/09/97 San Francisco Museum of Modern Art, San Francisco, CA

RE-ALIGNING VISIONS: SOUTH AMERICAN DRAWING (1960-1990)
> 05/06/97–08/31/97 El Museo Del Barrio, New York, NY
> 10/24/97–12/97 The Arkansas Arts Center, Little Rock, AR

REALMS OF HEROISM: INDIAN PAINTINGS FROM THE BROOKLYN MUSEUM
> 04/11/97–06/22/97 Hood Museum of Art, Hanover, NH
> 10/24/97–01/04/98 Bayly Art Museum of the University of Virginia, Charlottesville, VA

REDISCOVERING THE LANDSCAPE OF THE AMERICAS
> 01/10/97–03/30/97 Art Museum of South Texas, Corpus Christi, TX
> 09/27/97–11/16/97 Memorial Art Gallery, Rochester, NY

Selected Listing of Traveling Exhibitions

RODIN: SCULPTURE FROM THE IRIS AND B. GERALD CANTOR COLLECTION
01/20/97–03/23/97	Norton Gallery and School of Art, West Palm Beach, FL
04/25/97–06/15/97	Krannert Art Museum, Champaign, IL
07/19/97–10/12/97	Montgomery Museum of Fine Arts, Montgomery, AL
11/97–01/98	University of Arizona Museum of Art, Tucson, AZ

ROMARE BEARDON AS PRINTMAKER
02/01/97–03/30/97	Museum of Art and Archaeology, Columbia, MO
07/20/97–09/14/97	South Bend Regional Museum of Art, South Bend, IN
10/05/97–11/15/97	Grinnell College Print & Drawing Study Room, Grinnell, IA

ROY DeCARAVA: A RETROSPECTIVE
11/14/96–01/26/97	Los Angeles County Museum of Art, Los Angeles, CA
02/22/97–05/04/97	Addison Gallery of American Art, Andover, MA
06/15/97–08/09/97	The Saint Louis Art Museum, St. Louis, MO
09/07/97–11/16/97	The Museum of Fine Arts, Houston, Houston, TX

RUDOLF KOPPITZ, 1884-1936: VIENNESE "MASTER OF THE CAMERA"
| 04/19/97–06/01/97 | David Winton Bell Gallery, Providence, RI |
| 06/13/97–08/31/97 | The Patrick & Beatrice Haggerty Museum of Art, Milwaukee, WI |

RUTH BERNHARD AT 90: KNOWN AND UNKNOWN
12/11/96–02/09/97	The Detroit Institute of Arts, Detroit, MI
03/01/97–04/27/97	Cincinnati Art Museum, Cincinnati, OH
07/13/97–09/15/97	Samuel P. Harn Museum of Art, Gainesville, FL
10/97–11/97	The Arkansas Arts Center, Little Rock, AR

SEEKING IMMORTALITY: CHINESE TOMB SCULPTURE FROM THE SCHLOSS COLLECTION
| 10/06/96–03/16/97 | The Bowers Museum of Cultural Art, Santa Ana, CA |
| 09/12/97–11/09/97 | The Taft Museum, Cincinnati, OH |

THE SELF AND THE OTHER: PERSONHOOD AND IMAGES AMONG THE BAULE, COTE D'IVOIRE, WEST AFRICA
| 02/22/97–04/27/97 | University Art Museum, Santa Barbara, Santa Barbara, CA |
| 02/22/97–04/27/97 | Santa Barbara Museum of Art, Santa Barbara, CA |

SHAKER: THE ART OF CRAFTSMANSHIP
02/02/97–03/30/97	Wichita Art Museum, Wichita, KS
05/17/97–07/13/97	Munson-Williams-Proctor Institute Museum of Art, Utica, NY
10/11/97–01/05/98	Delaware Art Museum, Wilmington, DE

SOL LeWITT PRINTS 1970-1995
| 02/02/97–03/23/97 | The Cleveland Museum of Art, Cleveland, OH |
| 06/15/97–09/07/97 | The Detroit Institute of Arts, Detroit, MI |

SOLES OF THE WEST - WESTERN SOUL
| 02/15/97–03/30/97 | Paris Gibson Square Museum of Art, Great Falls, MT |
| 08/01/97–09/01/97 | Hockaday Center for the Arts, Kalispell, MT |

THE SPIRIT OF MONTMARTRE: CABARETS, HUMOR, AND THE AVANT-GARDE 1875-1905
| 03/22/97–04/13/97 | The Society of the Four Arts, Palm Beach, FL |
| 08/04/97–10/27/97 | Samuel P. Harn Museum of Art, Gainesville, FL |

SPLENDORS OF IMPERIAL CHINA: TREASURES FROM THE NATIONAL PALACE MUSEUM, TAIPEI
| 01/26/97–04/06/97 | National Gallery of Art, Washington, DC |
| 05/02/97–09/15/97 | Orlando Museum of Art, Orlando, FL |

Selected Listing of Traveling Exhibitions

STILL TIME: PHOTOGRAPHS BY SALLY MANN, 1971-91
 02/01/97–03/09/97 David Winton Bell Gallery, Providence, RI
 04/16/97–06/15/97 Greenville County Museum of Art, Greenville, SC

THE STUDIO MUSEUM IN HARLEM: 25 YEARS OF AFRICAN-AMERICAN ART
 02/06/97–04/06/97 Memorial Art Gallery, Rochester, NY
 04/19/97–06/29/97 Heckscher Museum of Art, Huntington, NY
 09/18/97–11/16/97 Lowe Art Museum, Coral Gables, FL

TALKING PICTURES: PEOPLE SPEAK OUT ABOUT THE PHOTOGRAPHS THAT SPEAK TO THEM
 12/08/96–02/16/97 Center for Creative Photography, Tucson, AZ
 03/04/97–05/11/97 Louisiana Arts and Science Center, Baton Rouge, LA

TALKING QUILTS: POSSIBILITIES IN RESPONSE
 01/15/97–03/01/97 Hockaday Center for the Arts, Kalispell, MT
 03/15/97–04/20/97 Custer County Art Center, Miles City, MT
 05/07/97–06/21/97 Paris Gibson Square Museum of Art, Great Falls, MT

TEMPLE AND VILLAGE: PATTERNS AND PRINTS OF INDIA
 03/01/97–04/13/97 Mitchell Museum, Mount Vernon, IL
 11/20/97–12/30/97 Krasl Art Center, St. Joseph, MI

THERE ON THE TABLE: THE AMERICAN STILL LIFE
 11/19/96–01/05/97 Louisiana Arts and Science Center, Baton Rouge, LA
 01/26/97–03/16/97 The Columbus Museum, Columbus, GA
 06/14/97–08/24/97 Leigh Yawkey Woodson Art Museum, Wausau, WI

THOMAS EAKINS AND THE SWIMMING PICTURE
 12/19/96–04/27/97 Museum of Art, Providence, RI
 01/17/97–04/27/97 Fine Arts Center Galleries, University of Rhode Island, Kingston, RI

THOMAS EAKINS: THE ROWING PICTURES
 10/11/96–01/14/97 Yale University Art Gallery, New Haven, CT
 02/19/97–05/15/97 The Cleveland Museum of Art, Cleveland, OH

TOO JEWISH? CHALLENGING TRADITIONAL IDENTITIES
 01/29/97–03/23/97 UCLA at the Armand Hammer Museum of Art and Cultural Center, Los Angeles, CA
 04/20/97–06/29/97 The Contemporary, Baltimore, MD

TREASURES OF THE TERVUREN MUSEUM: THE ROYAL MUSEUM OF CENTRAL AFRICA, TERVUREN, BELGIUM
 06/25/97–10/19/97 National Museum of African Art, Washington, DC
 11/09/97–01/25/98 Kimbell Art Museum, Fort Worth, TX

TURN, TURNING, TURNED
 07/26/97–08/30/97 Mitchell Museum, Mount Vernon, IL
 12/15/97–01/19/98 The Old Jail Art Center, Albany, TX

TURNER WATERCOLORS FROM MANCHESTER
 03/16/97–05/11/97 Memphis Brooks Museum of Art, Memphis, TN
 06/01/97–07/23/97 Indianapolis Museum of Art, Indianapolis, IN
 08/09/97–10/05/97 Joslyn Art Museum, Omaha, NE

TWO HUNDRED YEARS OF ENGLISH NAIVE ART 1700-1900
 02/15/97–03/16/97 The Society of the Four Arts, Palm Beach, FL
 04/09/97–06/01/97 Fresno Metropolitan Museum, Fresno, CA
 06/21/97–08/17/97 San Diego Museum of Art, San Diego, CA

Selected Listing of Traveling Exhibitions

ULTRA-REALISTIC SCULPTURE BY MARK SIJAN
01/15/97–03/02/97	McAllen International Museum, McAllen, TX
09/05/97–11/09/97	Dane G. Hansen Memorial Museum, Logan, KS

UNIVERSAL LIMITED ART EDITIONS: FORTY YEARS, 1957-1997
04/27/97–06/15/97	The Nelson-Atkins Museum of Art, Kansas City, MO
07/27/97–09/27/97	Denver Art Museum, Denver, CO
10/29/97–01/04/98	UCLA at the Armand Hammer Museum of Art and Cultural Center, Los Angeles, CA

THE VELVET YEARS, 1965-1967: WARHOL'S FACTORY, PHOTOGRAPHS BY STEPHEN SHORE
03/18/97–04/26/97	University Art Museum, Long Beach, CA
08/21/97–10/11/97	Asheville Art Museum, Asheville, NC

WAKE UP LITTLE SUZY/WARNINGS: PREGNANCY AND POWER BEFORE ROE VS. WADE
01/13/97–02/09/97	Emerson Gallery, Clinton, NY
06/09/97–07/31/97	Hofstra Museum, Hempstead, NY

THE WEST IN AMERICAN ART: SELECTIONS FROM THE HARMSEN COLLECTION
03/29/97–05/04/97	Center for the Arts, Inc., Vero Beach, FL
08/03/97–11/30/97	Palm Springs Desert Museum, Inc., Palm Springs, CA

THE WHITE HOUSE COLLECTION OF AMERICAN CRAFTS
05/11/97–07/13/97	Colby College Museum of Art, Waterville, ME
09/07/97–11/16/97	Tampa Museum of Art, Tampa, FL

WHIRLIGIGS AND WEATHERVANES: CONTEMPORARY SCULPTURE
04/26/97–06/08/97	Montgomery Museum of Fine Arts, Montgomery, AL
06/28/97–09/21/97	The Museums At Stony Brook, Stony Brook, NY
10/02/97–11/16/97	Museum of the Southwest, Midland, TX

WILLIAM WEGMAN: PHOTOGRAPHS, PAINTINGS, DRAWINGS AND VIDEO
11/29/96–02/02/97	Boise Art Museum, Boise, ID
05/31/97–08/24/97	San Jose Museum of Art, San Jose, CA

WORDS AND IMAGES: THE NARRATIVE WORKS OF THE PINKNEYS
10/26/96–01/18/97	Cedar Rapids Museum of Art, Cedar Rapids, IA
11/15/97–02/22/98	Leigh Yawkey Woodson Art Museum, Wausau, WI

WORLDS WITHIN WORLDS: THE RICHARD ROSENBLUM COLLECTION OF CHINESE SCHOLAR'S ROCKS
01/18/97–03/30/97	Phoenix Art Museum, Phoenix, AZ
05/10/97–07/20/97	Arthur M. Sackler Museum, Cambridge, MA
09/05/97–11/16/97	Seattle Asian Art Museum, Seattle, WA

Selected Listing of Exhibitions
with Acoustiguide Tours Available

As of the closing date of this publication, these are the temporary exhibitions for which Acoustiguide tours are currently planned. This list is subject to change. Additional exhibitions are frequently added throughout the year. For an up-to-date listing, or an inquiry on a specific exhibition, please call 212-974-6600

Art Institute of Chicago, Chicago, IL
5/20/97–06/22/97 CHARLES RENNIE MACKINTOSH
04/19/97–07/06/97 BAULE ART

Denver Museum of Natural History, Denver, CO
10/22/96–03/17/97 IMPERIAL TOMBS OF CHINA

Metropolitan Museum of Art, New York, NY
01/21/97–04/21/97 GIAMBATTISTA TIEPOLO
03/18/97–07/06/97 THE GLORY OF BYZANTIUM

Museum of Contemporary Art, Chicago, IL
11/16/96–03/23/97 ART IN CHICAGO, 1945-1995

Museum of Modern Art, Belgium
05/10/96–02/02/97 FROM ENSOR-TO DELVAUX

Museum of Modern Art, New York, NY
05/14/97–09/02/97 STILL LIFE/CÉZANNE

National Gallery, London, England
02/26/97–05/18/97 DISCOVERING THE ITALIAN BAROQUE

National Gallery of Art, Washington, DC
01/26/97–04-06/97 SPLENDORS OF IMPERIAL CHINA
02/16/97–05/11/97 THE VICTORIANS
03/30/97–07/27/97 PICASSO: THE EARLY YEARS

Royal Academy of Arts, London, England
01/23/97–04/06/97 BRAQUE, THE LATE WORKS
03/20/97–06/08/97 THE BERLIN OF GEORGE GROSZ

Accoustiguide Audio Tours
of Permanent Collections in 1997

Art Gallery of South Australia, Adelaide, Australia
Auckland Museum, New Zealand
Deutsche: Historiches Museum, Berlin, Germany
International Center of Photography, New York
Kunsthaus, Zurich, Switzerland
Louvre, Paris, France
Mercer Museum, Pennsylvania
Municipal Museum of The Hague, s'Gravenhage
Museum of Contemporary Art, Chicago, IL
Museum of Contemporary Art, San Diego, CA
Museum of Costume, Bath, England
Museum of Modem Art, New York, NY
National Gallery of Art, Washington D.C.
National Gallery of Australia, Canberra, Australia

National Museums & Galleries, Merseyside, England
National Palace Museum, Taipei
Palace of the Legion of Honor, San Francisco, CA
Pennsylvania Academy of Fine Art, Philadelphia, PA
Pergamon Museum, Berlin, Germany
Philadelphia Museum of Art, Philadelphia, PA
Salvador Dali Museum, St. Petersburg, FL
Shanghai Museum, People's Republic of China
Singapore Art Museum
Tate Gallery, London, England
Toledo Museum of Art, Ohio
Van Gogh Museum, Amsterdam, The Netherlands
Walker Art Center, Minneapolis, MN
Whitney Museum, New York, NY

Special Acknowledgment from Accoustiguide

Accoustiguide is pleased to sponsor the publication of On Exhibit; this invaluable, comprehensive and innovative guide to art museums and special exhibitions throughout the US.

As the inventor of the museum audio tour service in 1958, Accoustiguide was a pioneer in the use of technology to communicate with the museum visitor. Since that time, we have set the intellectual standard around the world for providing art interpretation through audio. It is only fitting then, that in expanding our mission to incorporate the new technology of the 1990's, we have formed an alliance with our friends at On Exhibit to deliver this information to a broader audience through the new digital media.

1997 promises to be a very exciting year for special exhibitions and we have many wonderful and enlightening tours scheduled throughout the year. Please look for the ◠ symbol indicating those exhibitions which will have an Accoustiguide Audio Tour.

We would like to thank Patti Sowalsky and Judith Swirsky for their herculean efforts in conceiving this enormous project and bringing it to fruition year after year, and Robert Abrams and Abbeville Press for ensuring that it reaches its rightful audience.

Stephen L. Limpe
CEO & President
Accoustiguide Corporation

New York,
January, 1997

Alphabetical Listing of Museums

A. R. Mitchell Memorial Museum of Western Art, Trinidad, CO .. 81
Abby Aldrich Rockefeller Folk Art Center, Williamsburg, VA 397
Academy of the Arts, Easton, MD ... 191
Ackland Art Museum, Chapel Hill, NC .. 308
Addison Gallery of American Art, Andover, MA ... 193
Adirondack Museum, Blue Mountain Lake, NY ... 261
African American Museum, Dallas, TX .. 372
African Art Museum of the S. M. A. Fathers, Tenafly, NJ 253
Afro-American Historical and Cultural Museum, Philadelphia, PA 345
Akron Art Museum, Akron, OH .. 318
Albany Institute of History & Art, Albany, NY .. 259
Albany Museum of Art, Albany, GA .. 128
Albrecht-Kemper Museum of Art, Saint Joseph, MO .. 233
Albright-Knox Art Gallery, Buffalo, NY .. 265
Aldrich Museum of Contemporary Art, Ridgefield, CT .. 88
Alexandria Museum of Art, Alexandria, LA ... 179
Alford House - Anderson Fine Arts Center, Anderson, IN 153
Allegheny Highlands Arts and Crafts Center, Clifton Forge, VA 392
Allen Memorial Art Museum, Oberlin, OH .. 326
Allentown Art Museum, Allentown, PA ... 337
Alternative Museum, New York, NY .. 274
Amarillo Museum of Art, Amarillo, TX ... 369
American Museum of The Moving Image, Astoria, NY .. 260
American Sport Art Museum and Archives, Daphne, AL ... 16
American Visionary Art Museum, Baltimore, MD .. 187
Americas Society, New York, NY .. 275
Amon Carter Museum, Fort Worth, TX ... 375
Anchorage Museum of History and Art, Anchorage, AK ... 22
Anderson Gallery, School of the Arts, Richmond, VA .. 395
Andy Warhol Museum, Pittsburgh, PA .. 350
Appleton Museum of Art, Ocala, FL ... 117
Archer M. Huntington Art Gallery, Austin, TX ... 369
Arkansas Arts Center, The, Little Rock, AR .. 31
Arlington Museum of Art, Arlington, TX .. 369
Armand Hammer Museum of Art , Los Angeles, CA .. 45
Arnot Art Museum, Elmira, NY ... 268
Art Center of Battle Creek, MI ... 213
Art Center, Waco, TX .. 384
Art Complex Museum, Duxbury, MA ... 201
Art Gallery, Lower Columbia Coll. Fine Arts Gall., Longview, WA 400
Art Gallery, University of New Hampshire, Durham, NH 245
Art Institute of Chicago, Chicago, IL .. 140
Art Museum at Florida International University, Miami, FL 113
Art Museum of South Texas, Corpus Christi, TX .. 371
Art Museum of Southeast Texas, Beaumont, TX .. 370
Art Museum of the Americas, Washington, DC .. 91
Art Museum of Western Virginia, Roanoke, VA ... 396
Art Museum, Princeton, NJ ... 252
Arthur M. Sackler Gallery, Washington, DC .. 91
Arthur M. Sackler Museum, Cambridge, MA ... 197
Arts & Science Center For Southeast Arkansas, Pine Bluff, AR 32
Asheville Art Museum, Asheville, NC .. 308
Asia Society, New York, NY .. 276
Asian Art Museum of San Francisco, San Francisco, CA .. 59
Asian Cultures Museum and Educational Center, Corpus Christi, TX 372
Aspen Art Museum, Aspen, CO .. 76
ASU Art Museum, Tempe, AZ ... 28

Alphabetical Listing of Museums

Augustana College Gallery of Art, Rock Island, IL . 151
Austin Museum of Art at Laguna Gloria, Austin, TX . 370
Autry Museum of Western Heritage, Los Angeles, CA . 40

Bakersfield Museum of Art, Bakersfield, CA . 33
Ball State University Museum of Art, Muncie, IN . 158
Baltimore Museum of Art, Baltimore, MD . 188
Barnes Foundation, Merion Station, PA . 344
Bass Museum of Art, Miami Beach, FL . 114
Bates College Museum of Art, Lewiston, ME . 183
Bayly Art Museum, University of Virginia, Charlottesville, VA . 391
Beck Center for the Cultural Arts, Lakewood, OH . 325
Bellevue Art Museum, Bellevue, WA . 399
Belmont, Fredericksburg, VA . 392
Bennington Museum, Bennington, VT . 388
Berkshire Museum, Pittsfield, MA . 206
Birger Sandzen Memorial Gallery, Lindsborg, KS . 171
Birmingham Museum of Art, Birmingham, AL . 16
Blanden Memorial Art Museum, Fort Dodge, IA . 165
Blount Bridgers House, Tarboro, NC . 314
Bob Jones University Collection of Sacred Art, Greenville, SC . 358
Boca Raton Museum of Art, Boca Raton, FL . 102
Boise Art Museum, Boise, ID . 138
Boston Athenaeum, Boston, MA . 194
Boston College Museum of Art, Chestnut Hill, MA . 200
Boston Public Library, Boston, MA . 194
Boston University Art Gallery, Boston, MA . 194
Bowdoin College Museum of Art, Brunswick, ME . 183
Bowers Museum of Cultural Art, Santa Ana, CA . 70
Bradford Brinton Memorial Museum, Big Horn, WY . 414
Brandywine River Museum, Chadds Ford, PA . 339
Brevard Art Center and Museum Inc., Melbourne, FL . 112
Bronx Museum of the Arts, Bronx, NY . 262
Brookgreen Gardens, Murrells Inlet, SC . 359
Brooklyn Museum of Art, Brooklyn, NY . 263
Bruce Museum, Greenwich, CT . 83
Buffalo Bill Historical Center, Cody, WY . 415
Burchfield-Penney Art Center, Buffalo, NY . 265
Busch-Reisinger Museum, Cambridge, MA . 198
Bush-Holley House Museum, Greenwich, CT . 84
Butler Institute of American Art, Youngstown, OH . 328

C. M. Russell Museum, Great Falls, MT . 237
Cahoon Museum of American Art, Cotuit, MA . 201
Calvin College Center Art Gallery, Grand Rapids, MI . 217
Canajoharie Library and Art Gallery, Canajoharie, NY . 266
Canton Museum of Art, Canton, OH . 319
Cape Ann Historical Association, Gloucester, MA . 203
Cape Museum of Fine Arts, Dennis, MA . 201
Caramoor Center for Music and the Arts, Katonah, NY . 272
Carnegie Art Museum, Oxnard, CA . 51
Carnegie Museum of Art, Pittsburgh, PA . 351
Cartoon Art Museum, San Francisco, CA . 60
Castellani Art Museum-Niagara University, Niagara Falls, NY . 295
Cedar Rapids Museum of Art, Cedar Rapids, IA . 162
Center For Creative Photography, Tucson, AZ . 29
Center for Curatorial Studies and Art, Annandale on Hudson . 260
Center for Research in Contemporary Arts, Arlington, TX . 369

Center for the Arts Yerba Buena Gardens, San Francisco, CA ... 60
Center for the Arts, Inc., Vero Beach, FL ... 125
Center Gallery of Bucknell University, Lewisburg, PA ... 343
Central Iowa Art Association, Marshalltown, IA ... 166
Chaim Gross Studio Museum, New York, NY ... 276
Charles Allis Art Museum, Milwaukee, WI ... 408
Charles B. Goddard Center, Ardmore, OK ... 330
Charles H. MacNider Museum, Mason City, IA ... 166
Charles Hosmer Morse Museum of American Art, Winter Park, FL ... 127
Cheekwood - Nashville's Home of Art and Gardens, Nashville, TN ... 366
Cheney Cowles Museum, Spokane, WA ... 404
Chesterwood, Stockbridge, MA ... 208
Chicago Cultural Center, Chicago, IL ... 142
China Institute Gallery, New York, NY ... 276
Chrysler Museum, Norfolk, VA ... 394
Cincinnati Art Museum, Cincinnati, OH ... 319
City Hall Council Chamber Gallery, Charleston, SC ... 357
Civic Fine Arts Center, Sioux Falls, SD ... 362
Cleveland Museum of Art, Cleveland, OH ... 321
Cloisters, New York, NY ... 277
Clymer Museum, Ellensburg, WA ... 400
Coit Tower, San Francisco, CA ... 61
Colby College Museum of Art, Waterville, ME ... 186
College Art Gallery, New Paltz, NY ... 274
Colorado Springs Fine Arts Center, Colorado Springs, CO ... 77
Colter Bay Indian Arts Museum, Colter Bay, WY ... 415
Columbia Museum of Arts & Gibbes Planetarium, Columbia, SC ... 358
Columbus Museum of Art, Columbus, OH ... 322
Columbus Museum, Columbus, GA ... 133
Community Fine Arts Center, Rock Springs, WY ... 416
Concord Art Association, Concord, MA ... 200
Connecticut State Art Museum, Storrs, CT ... 89
Contemporary Arts Center, Cincinnati, OH ... 320
Contemporary Arts Museum, Houston, TX ... 377
Contemporary Museum, Honolulu, HI ... 136
Contemporary, Baltimore, MD ... 189
Cooper-Hewitt, National Museum of Design, New York, NY ... 277
Coos Art Museum, Coos Bay, OR ... 334
Corcoran Gallery of Art, Washington, DC ... 92
Corning Museum of Glass, Corning, NY ... 267
Cowboy Artists of America Museum, Kerrville, TX ... 379
Cranbrook Academy of Art Museum, Bloomfield Hills, MI ... 214
Crocker Art Museum, Sacramento, CA ... 56
Crooked Tree Arts Council, Petoskey, MI ... 219
CU Art Galleries, Boulder, CO ... 76
Cummer Gallery of Art, Jacksonville, FL ... 109
Curtis Center Museum of Norman Rockwell Art, Philadelphia, PA ... 345
Custer County Art Center, Miles City, MT ... 239

Dahesh Museum, New York, NY ... 278
Dahl Fine Arts Center, Rapid City, SD ... 362
Dallas Museum of Art, Dalas, TX ... 373
Dane G. Hansen Memorial Museum, Logan, KS ... 171
Danforth Museum of Art, Framingham, MA ... 203
Danville Museum of Fine Arts & History, Danville, VA ... 392
Davenport Museum of Art, Davenport, IA ... 163
David and Alfred Smart Museum of Art, Chicago, IL ... 143
David Winton Bell Gallery, Providence, RI ... 355

Alphabetical Listing of Museums

Davis Museum and Cultural Center, Wellesley, MA .. 209
Dayton Art Institute, Dayton, OH ... 324
DeCordova Museum and Sculpture Park, Lincoln, MA 203
DeLand Museum of Art, DeLand, FL ... 105
Delaware Art Museum, Wilmington, DE ... 90
Denison University Gallery, Granville, OH .. 325
Dennos Museum Center, Traverse City, MI ... 221
Denver Art Museum, Denver, CO ... 78
Des Moines Art Center, Des Moines, IA .. 163
DeSaisset Museum, Santa Clara, CA ... 72
Detroit Institute of Arts, Detroit, MI .. 215
Dia Center for the Arts, New York, NY ... 278
Discovery Museum, Bridgeport, CT ... 82
Dixon Gallery & Gardens, Memphis, TN .. 365
Donald Sheehan Art Gallery, Walla Walla, WA .. 405
Douglas F. Cooley Memorial Art Gallery, Portland, OR 335
Dowd Fine Arts Gallery, Cortland, NY ... 268
Downey Museum of Art, Downey, CA ... 35
Drawing Center, New York, NY ... 279
Dubuque Museum of Art, Dubuque, IA .. 164
Duke University Museum of Art, Durham, NC .. 310
Dumbarton Oaks Research Library & Collection, Washington, DC 93

Edward M. Smith Gallery, Davidson, NC .. 310
Edwin A. Ulrich Museum of Art, Wichita, KS .. 173
Egyptian Museum and Planetarium, San Jose, CA .. 67
Eiteljorg Museum of Am. Indians & Western Art, Indianapolis, IN 156
El Museo Del Barrio, New York, NY .. 279
El Paso Museum of Art, El Paso, TX ... 374
Elizabeth Myers Mitchell Art Gallery, Annapolis, MD 187
Elvehjem Museum of Art, Madison, WI .. 407
Emerson Gallery, Clinton, NY .. 267
Equitable Gallery, New York, NY ... 280
Erie Art Museum, Erie, PA ... 341
Evansville Museum of Arts & Science, Evansville, IN 155
Evergreen House, Baltimore, MD .. 189
Everhart Museum, Scranton, PA ... 353
Everson Museum of Art, Syracuse, NY .. 305

Fallingwater, Mill Run, PA .. 344
Favell Museum, Klamath Falls, OR .. 335
Fayette Art Museum, Fayette, AL ... 17
Fayetteville Museum of Art, Fayetteville, NC ... 311
Federal Reserve Board Art Gallery, Washington, DC 93
Fine Arts Center Galleries, Kingston, RI ... 354
Fine Arts Museums of San Francisco, CA ... 61
Fisher Gallery, University of S. California, Los Angeles, CA 41
Fitchburg Art Museum, Fitchburg, MA .. 202
Five Civilized Tribes Museum, Muskogee, OK .. 330
Fleisher Museum, Scottsdale, AZ ... 26
Flint Institute of Arts, Flint, MI ... 216
Florence Griswold Museum, Old Lyme, CT ... 88
Florence Museum of Art, Science & History, Florence, SC 358
Florida Gulf Coast Art Center, Inc., Belleair, FL 102
Florida International Museum, St. Petersburg, FL ... 120
Florida State University Museum of Fine Arts, Tallahassee, FL 122
Fogg Art Museum, Cambridge, MA ... 199
Fort Smith Art Center, Fort Smith, AR .. 31

Fort Wayne Museum of Art, Fort Wayne, IN . 155
Forum for Contemporary Art, St. Louis, MO . 234
Frances Godwin & Joseph Ternbach Museum, Flushing, NY . 269
Frances Lehman Loeb Art Center, Vassar College, Poughkeepsie, NY . 297
Fred Jones Jr. Museum of Art, Norman, OK . 331
Frederic Remington Art Museum, Ogdensburg, NY . 296
Frederick R. Weisman Art Museum, Minneapolis, MN . 222
Frederick R. Weisman Museum of Art, Malibu, CA . 47
Freedman Gallery, Reading, PA . 352
Freeport Art Museum and Cultural Center, Freeport, IL . 148
Freer Gallery of Art, Washington, DC . 94
Fresno Art Museum, Fresno, CA . 35
Fresno Metropolitan Museum, Fresno, CA . 36
Frick Art Museum, Pittsburgh, PA . 352
Frick Collection, New York, NY . 280
Friends of Photography, Ansel Adams Center, San Francisco, CA . 63
Friends of the Middle Border Museum , Mitchell, SD . 361
Fuller Lodge Art Center and Gallery, Los Alamos, NM . 255
Fuller Museum of Art, Brockton, MA . 197

Gallery 825/Los Angeles Art Association, Los Angeles, CA . 41
Gallery of Contemporary Art, Colorado Springs, CO . 77
Gallery of Fine Arts-Topeka & Shawnee County, Topeka, KS . 172
Gari Melchers Estate and Memorial Gallery, Fredericksburg, VA . 392
Gaston County Museum of Art and History, Dallas, NC . 310
Genesee Country Museum, Mumford, NY . 274
George D. & Harriet W. Cornell Arts Museum, Winter Park, FL . 127
George E. Ohr Arts and Cultural Center, Biloxi, MS . 228
George Eastman House, Rochester, NY . 299
George Gustav Heye Center , New York, NY . 280
George Walter Vincent Smith Art Museum, Springfield, MA . 207
Georgia Museum of Art, Athens, GA . 129
Georgia O'Keeffe Home and Studio, Abiquiu, NM . 254
Gibbes Museum of Art, Charleston, SC . 357
Gilcrease Museum, Tulsa, OK . 332
Glencairn Museum: Academy of the New Church, Bryn Athyn, PA . 338
Grand Rapids Art Museum, Grand Rapids, MI . 217
Great Plains Art Collection, Lincoln, NE . 241
Greater Lafayette Museum of Art, Lafayette, IN . 158
Greenville County Museum of Art, Greenville, SC . 359
Greenville Museum of Art, Inc, Greenville, NC . 312
Grey Art Gallery and Study Center, New York, NY . 281
Grinnell College Print & Drawing Study Room, Grinnell, IA . 165
Guggenheim Museum Soho, New York, NY . 282
Guild Hall Museum, East Hampton, NY . 268

Haggin Museum, Stockton, CA . 75
Hall of Fame for Great Americans, Bronx, NY . 262
Hammond Museum, North Salem, NY . 296
Hammonds House Galleries and Resource Center, Atlanta, GA . 129
Hampton University Museum, Hampton, VA . 393
Harwood Museum of the University of New Mexico, Taos, NM . 258
Heard Museum, The, Phoenix, AZ . 23
Hearst Art Gallery, Moraga, CA . 49
Hearst Castle, San Simeon, CA . 69
Heckscher Museum of Art, Huntington, NY . 271
Henry Art Gallery, Seattle, WA . 402
Herbert F. Johnson Museum of Art, Ithaca, NY . 271

Alphabetical Listing of Museums

Heritage Center Inc, Pine Ridge, SC . 362
Hermitage Foundation Museum, Norfolk, VA . 394
Hibel Museum of Art, Palm Beach, FL . 118
Hickory Museum of Art, Hickory, NC . 313
High Museum of Art, Atlanta, GA . 130
High Museum of Folk Art & Photography Galleries , Atlanta, GA . 131
Hill-Stead Museum, Farmington, CT . 83
Hillwood Museum, Washington, DC . 94
Hiram Blauvelt Art Museum, Oradell, NJ . 252
Hirshhorn Museum and Sculpture Garden, Washington, DC . 95
Hispanic Society of America, New York, NY . 282
Historic New Orleans Collection, New Orleans, LA . 180
Hobson Pittman Memorial Gallery, Tarboro, NC . 314
Hockaday Center for the Arts, Kalispell, MT . 238
Hofstra Museum, Hempstead, NY . 270
Honolulu Academy of Arts, Honolulu, HI . 136
Hood Museum of Art, Hanover, NH . 245
Housatonic Museum of Art, Bridgeport, CT . 82
Howard University Gallery of Art, Washington, DC . 95
Hoyt Sherman Place, Des Moines, IA . 164
Hudson River Museum of Westchester, Yonkers, NY . 307
Hunt Institute for Botanical Documentation, Pittsburgh, PA . 351
Hunter Museum of American Art, Chattanooga, TN . 364
Huntington Library, , San Marino, CA . 69
Huntington Museum of Art, Inc, Huntington, WV . 406
Huntsville Museum of Art, Huntsville, AL . 18
Hyde Collection, Glens Falls, NY . 269

Indian Center Museum, Wichita, KS . 174
Indiana University Art Museum, Bloomington, IN . 153
Indianapolis Museum of Art - Columbus Gallery, Columus, IN . 154
Indianapolis Museum of Art, Indianapolis, IN . 157
Institute of American Indian Arts Museum, Santa Fe, NM . 256
Institute of Contemporary Art, Boston, MA . 195
International Center of Photography, New York, NY . 282
International Museum of Cartoon Art, Boca Raton, FL . 103
International Museum of Photography and Film, Rochester, NY . 299
Iris & B. Gerald Cantor Art Gallery, Worcester, MA . 212
Iroquois Indian Museum , Howes Cave, NY . 270
Irvine Museum, Irvine, CA . 37
Isamu Noguchi Garden Museum, Long Island City, NY . 273
Islip Art Museum, East Islip, NY . 268

J. B. Speed Art Museum, Louisville, KY . 176
J. Paul Getty Museum, Malibu, CA . 47
J. Wayne Stark University Center Galleries, College Station, TX . 371
Jacksonville Museum of Contemporary Art, Jacksonville, FL . 110
Jacques Marchais Museum of Tibetan Art, Staten Island, NY . 302
James & Meryl Hearst Center for the Arts, Cedar Falls, IA . 162
James A. Michener Art Museum, Doylestown, PA . 340
Jane Voorhees Zimmerli Art Museum, New Brunswick, NJ . 249
Jersey City Museum, Jersey City, NJ . 247
Jewish Museum, New York, NY . 283
Joan Lehman Museum of Contemporary Art, North Miami, FL . 116
John A. Noble Collection at Snug Harbor, Staten Island, NY . 303
John and Mable Ringling Museum of Art, Sarasota, FL . 120
John Michael Kohler Arts Center, Sheboygan, WI . 412
Johnson Cnty Community College Gallery of Art, Overland Park, KS . 171
Joslyn Art Museum, Omaha, NE . 242
Judah L. Magnes Memorial Museum, Berkeley, CA . 33

Alphabetical Listing of Museums

Kalamazoo Institute of Art, Kalamazoo, MI ... 218
Katonah Museum of Art, Katonah, NY ... 272
Kemper Museum of Contemporary Art & Design, Kansas City, MO 231
Kennedy Museum of American Art, Athens, OH ... 318
Kent State University Art Galleries, Kent, OH ... 325
Kimbell Art Museum, Fort Worth, TX .. 375
Knoxville Museum of Art, Knoxville, TN .. 364
Krannert Art Museum, Champaign, IL ... 139
Krasl Art Center, St. Joseph, MI .. 220
Kresge Art Museum, East Lansing, MI ... 216
Kykuit, Tarrytown, NY .. 306

La Salle University Art Museum, Philadelphia, PA .. 346
Laband Art Gallery, Los Angeles, CA ... 42
Lakeview Museum of Arts and Sciences, Peoria. IL ... 150
Lancaster Museum/Art Gallery, Lancaster, CA .. 38
Laumeier Sculpture Park & Gallery, St. Louis, MO .. 235
Lauren Rogers Museum of Art, Laurel, MS .. 229
Leanin' Tree Museum of Western Art, Boulder, CO ... 76
Lehigh University Art Galleries, Bethlahem, PA .. 338
Leigh Yawkey Woodson Art Museum, Wausau, WI .. 412
Lemoyne Art Foundation, Inc., Tallahassee, FL ... 123
Long Beach Museum of Art, Long Beach, CA ... 38
Longview Art Museum, Longview, TX ... 379
Los Angeles County Museum of Art, Los Angeles, CA ... 42
Los Angeles Municipal Art Gallery, Los Angeles, CA .. 44
Louisiana Arts and Science Center, Baton Rouge, LA ... 179
Louisiana State Museum, New Orleans, LA .. 181
Lowe Art Museum, Coral Gables, FL .. 103
Lyman Allyn Art Museum, New London, CT ... 87

Mabee-Gerrer Museum of Art, Shawnee, KS .. 332
Madison Art Center, Madison, WI .. 407
Maier Museum of Art, Lynchburg, VA ... 393
Maitland Art Center, Maitland, FL .. 112
Margaret Harwell Art Museum, Poplar Bluff, MO ... 233
Martin D'Arcy Gallery, Chicago, IL .. 143
Mary and Leigh Block Gallery, Evanston, IL .. 148
Maryhill Museum of Art, Goldendale, WA .. 400
Massachusetts Museum of Contemporary Art, North Adams, MA 205
Masur Museum of Art, Monroe, LA ... 180
Mattress Factory, Ltd, Pittsburgh, PA ... 352
McAllen International Museum, McAllen, TX .. 380
McNay Art Museum, San Antonio, TX ... 382
Mead Art Museum, Amherst, MA ... 192
Meadow Brook Art Gallery, Rochester, MI ... 219
Meadows Museum of Art of Centenary College, Shreveport, LA 182
Meadows Museum, Dallas, TX ... 374
Memorial Art Gallery, Rochester, NY .. 300
Memphis Brooks Museum of Art, Memphis, TN .. 365
Menil Collection, Houston, TX .. 377
Meridian Museum of Art, Meridian, MS .. 229
Mesa Southwest Museum, Mesa, AZ ... 23
Metropolitan Museum of Art, New York, NY ... 284
Mexican Fine Arts Center Museum, Chicago, IL .. 144
Mexican Museum, San Francisco, CA .. 63
Miami Art Museum of Dade County, Miami, FL .. 113
Miami University Art Museum, Oxford, OH .. 326

437

Alphabetical Listing of Museums

Miami-Dade Comm. College Kendall Campus Art Gallery, Miami, FL .. 114
Michael C. Carlos Museum of Art and Archaeology, Atlanta, GA .. 131
Michelson Museum of Art, Marshall, TX ... 380
Middle Tennessee State Univ. Photo. Gallery, Murfreesboro, TN .. 366
Middlebury College Museum of Art, Middlebury, VT ... 389
Midwest Museum of American Art, Elkhart, IN ... 154
Mill Grove, the Audubon Wildlife Sanctuary, Audubon, PA .. 337
Milwaukee Art Museum, Milwaukee, WI ... 409
Mingei International Museum of Folk Art, San Diego, CA ... 57
Minneapolis Institute of Arts, Minneapolis, MN .. 224
Minnesota Museum of American Art, St. Paul, MN .. 226
Mint Museum of Art, Charlotte, NC ... 309
Mississippi Museum of Art, Jackson, MS .. 228
Mississippi Museum of Art, Tupelo, MS ... 230
Missoula Museum of the Arts, Missoula, MT ... 240
MIT-List Visual Arts Center , Cambridge, MA .. 199
Mitchell Museum, Mount Vernon, IL .. 149
Mobile Museum of Art Downtown, Mobile, AL .. 20
Mobile Museum of Art, Mobile, AL ... 19
Modern Art Museum of Fort Worth, TX ... 376
Modern at Sundance Square, Fort Worth, TX ... 376
Montclair Art Museum, Montclair, NJ ... 248
Monterey Museum of Art, Monterey, CA ... 48
Montgomery Gallery, Claremont, CA .. 34
Montgomery Museum of Fine Arts, Montgomery, AL ... 20
Morris Museum of Art, Augusta, GA .. 133
Mount Holyoke College Art Museum, South Hadley, MA .. 206
MSC Forsyth Center Galleries, College Station, TX ... 371
Mulvane Art Museum, Topeka, KS .. 173
Munson-Williams-Proctor Institute Museum of Art, Utica, NY .. 306
Muscarelle Museum of Art, Williamburg, VA ... 398
Muscatine Art Center, Muscatine, IA ... 167
Museo De Las Americas, Denver, CO .. 78
Museo ItaloAmericano, San Francisco, CA ... 64
Museum at Warm Springs Oregon ... 336
Museum for African Art, New York, NY ... 287
Museum of African American Art, Los Angeles, CA ... 44
Museum of African American Art, Tampa, FL ... 123
Museum of American Art, Philadelphia, PA .. 346
Museum of American Glass at Wheaton Village, Millville, NJ .. 248
Museum of Ancient & Modern Art, Penn Valley, CA ... 54
Museum of Art and Archaeology, Columbia, MS .. 231
Museum of Art and History at McPherson Center, Santa Cruz, CA .. 73
Museum of Art, Providence, RI .. 355
Museum of Art, Pullman, WA .. 401
Museum of Arts and Sciences, Daytona Beach, FL .. 104
Museum of Contemporary Art, Chicago, IL ... 144
Museum of Contemporary Art, Los Angeles, CA .. 44
Museum of Contemporary Art, San Diego, CA .. 37
Museum of Contemporary Photography , Chicago, IL .. 146
Museum of East Texas, Lufkin, TX ... 380
Museum of Fine Art, Ft. Lauderdale, FL .. 106
Museum of Fine Arts, Boston, MA .. 196
Museum of Fine Arts, Houston, TX ... 378
Museum of Fine Arts, Missoula, MT .. 240
Museum of Fine Arts, Springfield, MA .. 207
Museum of Fine Arts-St. Petersburg, FL ... 121
Museum of Modern Art, New York, NY .. 288

Museum of National Center of Afro-American Artists, Boston, MA .. 197
Museum of Nebraska Art, Kearney, NE .. 241
Museum of New Mexico, Santa Fe, NM .. 256
Museum of Outdoor Arts, Englewood, CO ... 79
Museum of Photographic Arts, San Diego, CA ... 57
Museum of the City of New York, New York, NY .. 288
Museum of the Southwest, Midland, TX ... 381
Museum of Western Art, Denver, CO .. 79
Museums at Hartwick, Oneonta, NY ... 296
Museums at Stony Brook, Stony Brook, NY .. 304
Museums of Abilene, Inc., Abilene, TX .. 368
Muskegon Museum of Art, Muskegon, MI .. 218

Nassau County Museum of Fine Art, Roslyn Harbor, NY ... 301
National Academy of Design, New York, NY ... 290
National Arts Club, New York, NY .. 290
National Cowboy Hall of Fame, Oklahoma City, OK .. 331
National Gallery of Art, Washington, DC .. 96
National Museum of African Art, Washington, DC ... 97
National Museum of American Art, Washington, DC .. 98
National Museum of the American Indian, New York, NY ... 280
National Museum of Wildlife Art, Jackson Hole, WY ... 415
National Museum of Women in the Arts, Washington, DC ... 99
National Portrait Gallery, Washington, DC .. 99
Nelson-Atkins Museum of Art, Kansas City, MO .. 232
Neuberger Museum of Art, Purchase, NY .. 298
Nevada Museum of Art/E. L. Weigand Gallery, Reno. NV ... 244
New Britain Museum of American Art, New Britain, CT ... 85
New England Center For Contemporary Art, Inc., Brooklyn, CT ... 82
New Jersey Center for Visual Arts, Summit, NJ .. 252
New Jersey State Museum, Trenton, NJ .. 253
New Museum of Contemporary Art, New York, NY .. 290
New Orleans Museum of Art, New Orleans, LA ... 181
New-York Historical Society, New York, NY ... 291
Newark Museum, Newark, NJ ... 249
Newark Public Library, Newark, NJ ... 250
Newport Art Museum, Newprt, RI ... 354
Nicolaysen Art Museum, Casper, WY .. 414
Nora Eccles Harrison Museum of Art, Logan, UT ... 386
Nordic Heritage Museum, Seattle, WA ... 404
Norman Rockwell Museum at Stockbridge, MA ... 208
North Carolina Museum of Art, Raleigh, NC ... 314
North Dakota Museum of Art, Grand Forks, ND .. 317
Norton Gallery and School of Art, West Palm Beach, FL .. 125
Norton Simon Museum, Pasadena, CA ... 53
Noyes Museum, Oceanville, NJ .. 250

Oak Ridge Arts Center, Oak Ridge, TN .. 367
Oakland Museum of California, Oakland, CA ... 50
Ogelthorpe University Museum, Atlanta, GA ... 132
Ogunquit Museum of American Art, Ogunquit, ME ... 184
Oklahoma City Art Museum, Oklahoma City, OK .. 331
Olana State Historic Site, Hudson, NY .. 270
Old Jail Art Center, Albany, TX .. 368
Omniplex, Oklahoma City, OK .. 332
Orange County Museum of Art, Laguna Beach, CA .. 38
Orange County Museum of Art, Newport Beach, CA ... 49
Oriental Institute Museum, Chicago, IL ... 146

Alphabetical Listing of Museums

Orlando Museum of Art, Orlando, FL ... 117
Oscar Howe Art Center, Mitchell, SD .. 361
Owensboro Museum of Fine Art, Owensboro, KY 177

Pacific Asia Museum, Pasadena, CA .. 54
Palm Springs Desert Museum, Inc., Palm Springs, CA 52
Palmer Museum of Art, University Park, PA 353
Palo Alto Cultural Center, Palo Alto, CA 53
Paris Gibson Square Museum of Art, Great Falls, MT 238
Parrish Art Museum, Southampton, NY .. 302
Parthenon, Nashville, TN .. 366
Patrick & Beatrice Haggerty Museum of Art, Milwaukee, WI 410
Peale Museum, Baltimore, MD ... 190
Peninsula Fine Arts Center, Newport News, VA 393
Pennsylvania Academy of the Fine Arts, Philadelphia, PA 346
Pensacola Museum of Art, Pensacola, FL 119
Philadelphia Museum of Art, Philadelphia, PA 347
Philbrook Museum of Art Inc, Tulsa, OK 333
Philharmonic Center for the Arts, Naples, FL 115
Philip and Muriel Berman Museum of Art, Collegeville, PA 340
Phillips Collection, Washington, DC .. 100
Phippen Museum of Western Art, Prescott, AZ 26
Phoenix Art Museum, Phoenix, AZ ... 24
Photographic Archives, Lousiville, KY ... 177
Picker Art Gallery, Hamilton, NY ... 269
Pierpont Morgan Library, New York, NY 292
Plains Art Museum, Moorehead, MN ... 226
Polish Museum of America, Chicago, IL 147
Polk Museum of Art, Lakeland, FL .. 111
Portland Art Museum, Portland, OR .. 335
Portland Museum of Art, Portland, ME .. 185
Pratt Manhattan Gallery, New York, NY 292
Provincetown Art Association and Museum, PProvincetown, MA 206
Purdue University Galleries, West Lafayette, IN 160

QCC Art Gallery, Bayside, NY .. 261
Queens Museum of Art, Queens, NY ... 299
Quincy Art Center, Quincy, IL ... 150

R. W. Norton Art Gallery, Shreveport, LA 182
Radford University Galleries, Radford, VA 395
Rahr-West Art Museum, Manitowoc, WI 408
Redwood Library and Athenaeum, Newport, RI 354
Renwick Gallery , Washington, DC ... 101
Reynolda House, Museum of American Art, Winston-Salem, NC 315
Rhode Island Black Heritage Society, Providence, RI 356
Rice University Art Gallery, Houston, TX 379
Richard L. Nelson Gallery, Davis, CA .. 35
Richmond Art Museum, Richmond, IN ... 159
Riverside Art Museum, Riverside, CA .. 55
Roberson Center for the Arts and Sciences, Binghampton, NY 261
Robert Hull Fleming Museum, Burlington, VT 388
Rockford Art Museum, Rockford, IL ... 151
Rockford College Art Gallery / Clark Arts Center, Rockford, IL 152
Rockwell Museum, Corning, NY ... 267
Rodin Museum, Philadelphia, PA .. 348
Roland Gibson Gallery, Potsdam. NY ... 297
Rose Art Museum, Waltham, MA .. 209

Rosenbach Museum & Library, Philadelphia, PA . 348
Rosenwald-Wolf Gallery, Philadelphia, PA . 348
Roswell Museum and Art Center, Roswell, NM . 255
Rotunda Gallery, Brooklyn, NY . 264
Rubelle & Norman Schafler Gallery, Brooklyn, NY . 264

Saginaw Art Museum, Saginaw, MI . 219
Saint Louis Art Museum, St. Louis, MO . 235
Saint-Gaudens National Historic Site, Cornish, NH . 245
Salina Art Center, Salina, KS . 172
Salmagundi Museum of American Art, New York, NY . 292
Salt Lake Art Center, Salt Lake City, UT . 386
Salvador Dali Museum, St. Petersburg, FL . 122
Samuel P. Harn Museum of Art, Gainesville, FL . 108
San Angelo Museum of Fine Arts, San Angelo, TX . 382
San Antonio Museum of Art, San Antonio, TX . 383
San Diego Museum of Art, San Diego, CA . 58
San Francisco Art Institute Galleries, San Francisco, CA . 64
San Francisco Craft & Folk Art Museum, San Francisco, CA . 65
San Francisco Museum of Modern Art, San Francisco, CA . 65
San Jose Museum of Art, San Jose, CA . 68
Sangre DeCristo Arts Center, Pueblo, CO . 80
Santa Barbara Museum of Art, Santa Barbara, CA . 71
Santa Monica Museum of Art, Santa Monica, CA . 73
Schick Art Gallery, Saratoga Springs, NY . 302
Schumacher Gallery, Columbus, OH . 323
Schweinfurth Memorial Art Center, Auburn, NY . 260
Scottsdale Center For The Arts, Scottsdale, AZ . 27
Seattle Art Museum, Seattle, WA . 402
Sewall-Belmont House, Washington, DC . 101
Shelburne Museum, Shelburne, VT . 390
Sheldon Art Museum, Middlebury, VT . 389
Sheldon Memorial Art Gallery and Sculpture Garden, Lincoln, NE . 241
Sheldon Swope Art Museum, Terra Haute, IN . 160
Sid Richardson Collection of Western Art, Fort Worth, TX . 376
Sidney Mishkin Gallery of Baruch College, New York, NY . 293
Silvermine Guild Art Center, New Canaan, CT . 85
Sioux City Art Center, Sioux City, IA . 168
Sioux Indian Museum and Crafts Center, Rapid City, SD . 362
Slater Memorial Museum, Norwich, CT . 88
Smith College Museum of Art, Northampton, MA . 205
Snite Museum of Art, Notre Dame, IN . 159
Snug Harbor Cultural Center, Staten Island, NY . 303
Society of Illustrators Museum of Am. Illustration, New York, NY . 293
Society of the Four Arts, Palm Beach, FL . 119
Solomon R. Guggenheim Museum, New York, NY . 293
Sonoma County Museum, Santa Rosa, CA . 74
Sordoni Art Gallery, Wilkes-Barre, PA . 353
South Bend Regional Museum of Art, South Bend, IN . 159
South Dakota Art Museum, Brookings, SD . 361
Southeast Museum of Photography, Daytona Beach, FL . 105
Southeastern Center for Contemporary Art, Winston-Salem, NC . 315
Southern Alleghenies Museum of Art, Loretto, PA . 343
Southern Ohio Museum and Cultural Center, Portsmouth, OH . 327
Southern Vermont Art Center, Manchester, VT . 388
Spartanburg County Museum of Art, Spartanburg, SC . 360
Spencer Museum of Art, Lawrence, KS . 170
Spirit Square Center for Arts and Education, Charlotte, NC . 309

Alphabetical Listing of Museums

Springfield Art Association, Springfield, IL .. 152
Springfield Art Museum, Springfield, MO .. 234
Springfield Museum of Art, Springfield, OH .. 327
Springville Museum of Art, Springville, UT .. 387
St. Johnsbury Athenaeum, St. Johnsbury, VT ... 390
St. John's Museum of Art, Wilmington, NC .. 315
Stanford University Museum and Art Gallery, Stanford, CA 74
Stark Museum of Art, Orange, TX ... 382
State Museum of Pennsylvania, Harrisburg, PA .. 342
Staten Island Institute of Arts and Sciences, Staten Island, NY 304
Stedman Art Gallery, Camden, NJ .. 247
Sterling and Francine Clark Art Institute, Williamstown, MA 210
Storm King Art Center, Mountainville, NY ... 273
Studio Museum in Harlem, New York, NY .. 294
Sunrise Museums, Charleston, WV ... 406
SUNY Plattsburgh Art Museum, Plattsburgh, NY .. 296
Sweet Briar College Art Gallery, Sweet Briar, VA ... 397
Sylvia Plotkin Judaica Museum, Phoenix, AZ ... 25

T. W. Wood Gallery and Arts Center, Montpelier, VT .. 390
Tacoma Art Museum, Tacoma, WA ... 405
Tacoma Public Library/Thomas Handforth Gallery, Tacoma, WA 405
Taft Museum, Cincinnati, OH .. 320
Tampa Museum of Art, Tampa, FL .. 124
Tekakwitha Fine Arts Center, Sisseton, SD ... 363
Telfair Museum of Art, Savannah, GA ... 135
Terra Museum of American Art, Chicago, IL ... 147
Texas A&M University, College Station, TX ... 371
Thomas Cole Foundation, Catskill, NY ... 266
Thorne-Sagendorph Art Gallery, Keene, NH .. 246
Timken Museum of Art, San Diego, CA .. 59
Toledo Museum of Art, Toledo, OH .. 328
Totem Heritage Center, Ketchikan, AK ... 22
Triton Museum of Art, Santa Clara, CA .. 73
Trout Art Gallery, Carlisle, PA ... 338
Tucson Museum of Art, Tucson, AZ .. 29
Tufts University Art Gallery, Medford, MA .. 204
Turner Museum, Denver, CO .. 79
Tweed Museum of Art, Duluth, MN .. 222
Tyler Museum of Art, Tyler, TX ... 384

UCR/California Museum of Photography, Riverside, CA ... 55
University Art Galleries, Vermillion, SD ... 363
University Art Museum and Jonson Gallery, Albuquerque, NM 254
University Art Museum, Albany, NY ... 259
University Art Museum, Lafayette, LA .. 180
University Art Museum, Long Beach, CA .. 39
University Art Museum, Santa Barbara, CA .. 72
University Galleries, Nashville, TN ... 367
University Gallery, University of Massachusetts, Amherst, MA 192
University Museum, Carbondale, IL .. 139
University Museum, Edwardsville, IL .. 147
University Museum, Indiana, PA ... 343
University of Arizona Museum of Art, Tucson, AZ ... 30
University of California Berkeley Art Museum, Berkeley, CA 33
University of Iowa Museum of Art, Iowa City, IA ... 166
University of Kentucky Art Museum, Lexington, KY .. 176
University of Maine Museum of Art, Orono, ME ... 184
University of Michigan Museum of Art, Ann Arbor, MI ... 213
University of Oregon Museum of Art, Eugene, OR ... 334

University of Pennsylvania Museum of Archaeol., Philadelphia, PA . 349
USF Contemporary Art Museum, Tampa, FL . 124
Utah Museum of Fine Arts, Salt Lake City, UT . 387
UWM Art Museum, Milwaukee, WI . 411

Valley Art Center, Inc, Clarkston, WA . 399
Vanderbilt University Fine Arts Gallery, Nashville, TN . 367
Ventura County Museum of History & Art, Ventura, CA . 75
Virginia Beach Center for the Arts, Virginia Beach, VA . 397
Virginia Museum of Fine Arts, Richmond, VA . 395

Wadsworth Atheneum, Hartford, CT . 84
Walker Art Center, Minneapolis, MN . 225
Walker Art Collection of the Garnett Public Library, Garnett, KS . 170
Walter Anderson Museum of Art, Ocean Springs, MS . 230
Walters Art Gallery, Baltimore, MD . 190
Washington County Museum of Fine Arts, Hagerstown, MD . 191
Washington State Capital Museum, Olympia, WA . 401
Washington University Gallery of Art, St. Louis, MO . 236
Waterloo Museum of Art, Waterloo, IA . 169
Watts Towers Arts Center, Los Angeles, CA . 46
Weatherspoon Art Gallery, Greensboro, NC . 311
West Bend Art Museum, West Bend, WI . 413
Western Heritage Center, Oklahoma City, OK . 331
Westmoreland Museum of American Art, Greensburg, PA . 342
Wexner Center for the Arts, Columbus, OH . 323
Wharton Esherick Museum, Paoli, PA . 344
Whatcom Museum of History and Art, Bellingham, WA . 399
Wheelwright Museum of the American Indian, Santa Fe, NM . 258
Whistler House & Parker Gallery, Lowell, MA . 204
Whitney Museum of American Art at Champion, Stamford, CT . 89
Whitney Museum of American Art, New York, NY . 294
Wichita Art Museum, Wichita, KS . 174
Wichita Center for the Arts, Wichita, KS . 175
Wichita Falls Museum and Art Center, Wichita Falls, TX . 385
Wilkes Art Gallery, North Wilkesboro, NC . 313
William A. Farnsworth Library and Art Museum, Rockland, ME . 185
William Benton Museum of Art, Storrs, CT . 89
William H. Van Every Gallery, Davidson, NC . 310
Williams Center for the Arts, Easton, PA . 341
Williams College Museum of Art, Williamstown, MA . 210
Wiregrass Museum of Art, Dothan, AL . 17
Wolfsonian, Miami Beach, FL . 115
Woodmere Art Museum, Philadelphia, PA . 350
Woolaroc Museum, Bartlesville, OK . 330
Worcester Art Museum, Worcestor, MA . 212
Words & Pictures Museum, Northampton, MA . 205
Wright Museum of Art, Beloit, WI . 407
Wright State University Galleries, Dayton, OH . 324
Wyoming State Museum, Cheyenne, WY . 414

Yale Center for British Art, New Haven, CT . 86
Yale University Art Gallery, New Haven, CT . 87
Yeiser Art Center, Paducah, KY . 178
Yellowstone Art Center, Billings, MT . 237
Yeshiva University Museum, New York, NY . 294

Zanesville Art Center, Zanesville, OH . 329
Zigler Museum, Jennings, LA . 179

ON EXHIBIT

ABOUT THE AUTHORS

Patti Sowalsky is an art collector and enthusiast. She was a docent at the Corcoran Gallery for many years, and planned and led all their out-of-gallery tours. She was chosen docent of the year in 1990. She represented American art collectors at a conference held in Moscow in June 1989, co-sponsored by Grand Central Art Galleries Educational Association and the Soviet Ministry of Culture and Artists Union. Her experience and involvement in art has included lecturing and tours with a partner for the Fine Arts Forum in Washington, and research for the core collection of the National Museum of Women in the Arts. Her special interests, in addition to her art collection, include travel, gardening and courses in contemporary art.

Judith Swirsky has been associated with the arts in Brooklyn as both staff and volunteer for more than forty years. She is listed in *Who's Who in American Women* and has received many awards. She has held both curatorial and volunteer administration positions at The Brooklyn Museum. While Executive Director of the Grand Central Art Galleries Educational Association she coordinated the 1989 Moscow Conference. She is now an independent curator and artists' representative. In addition to visiting museums, galleries and art collections, Judith enjoys travel, music, cooking, and entertaining.